DIVE INTO

MONSTER HUNTER: WORLD

CONTENTS

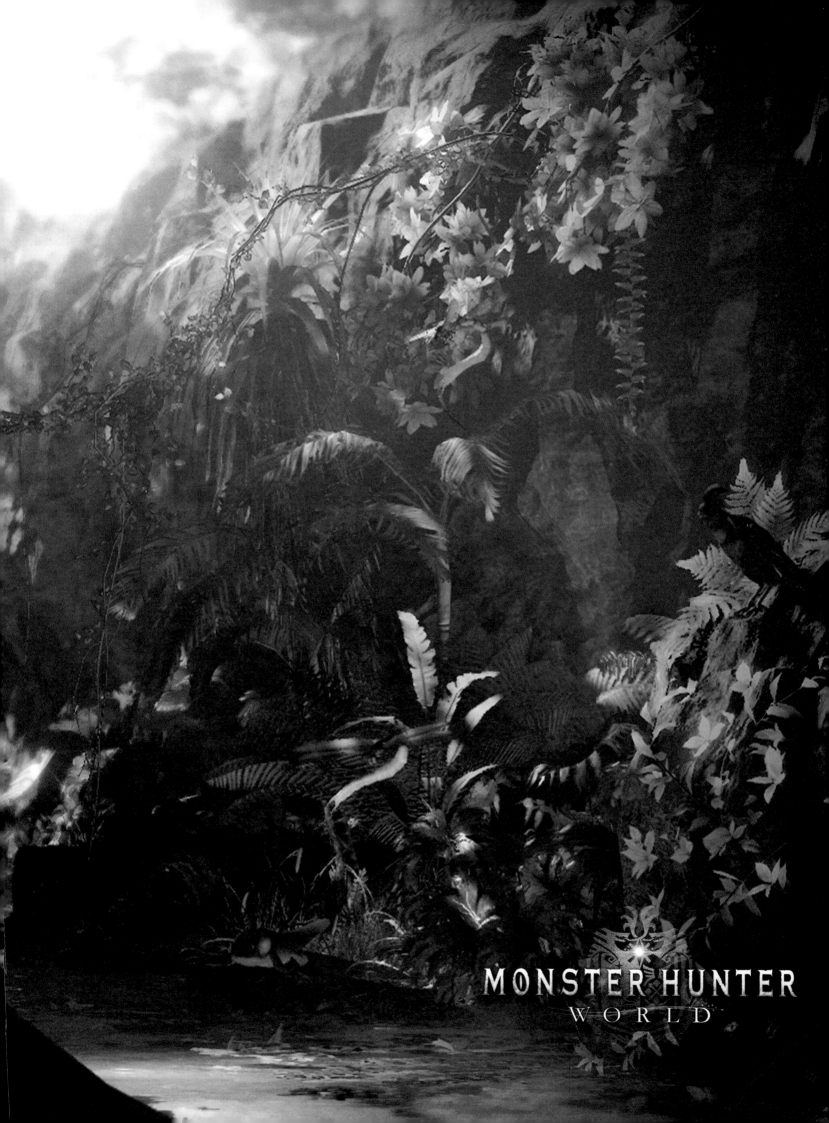

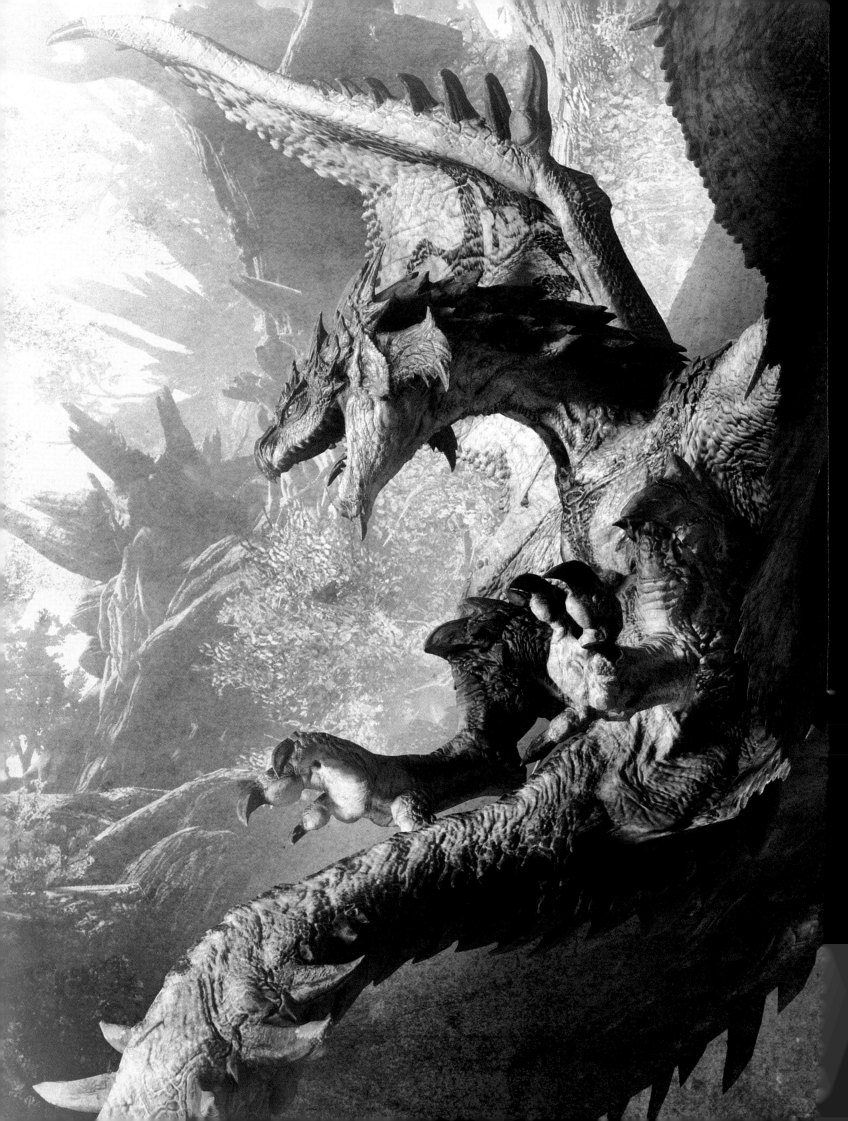

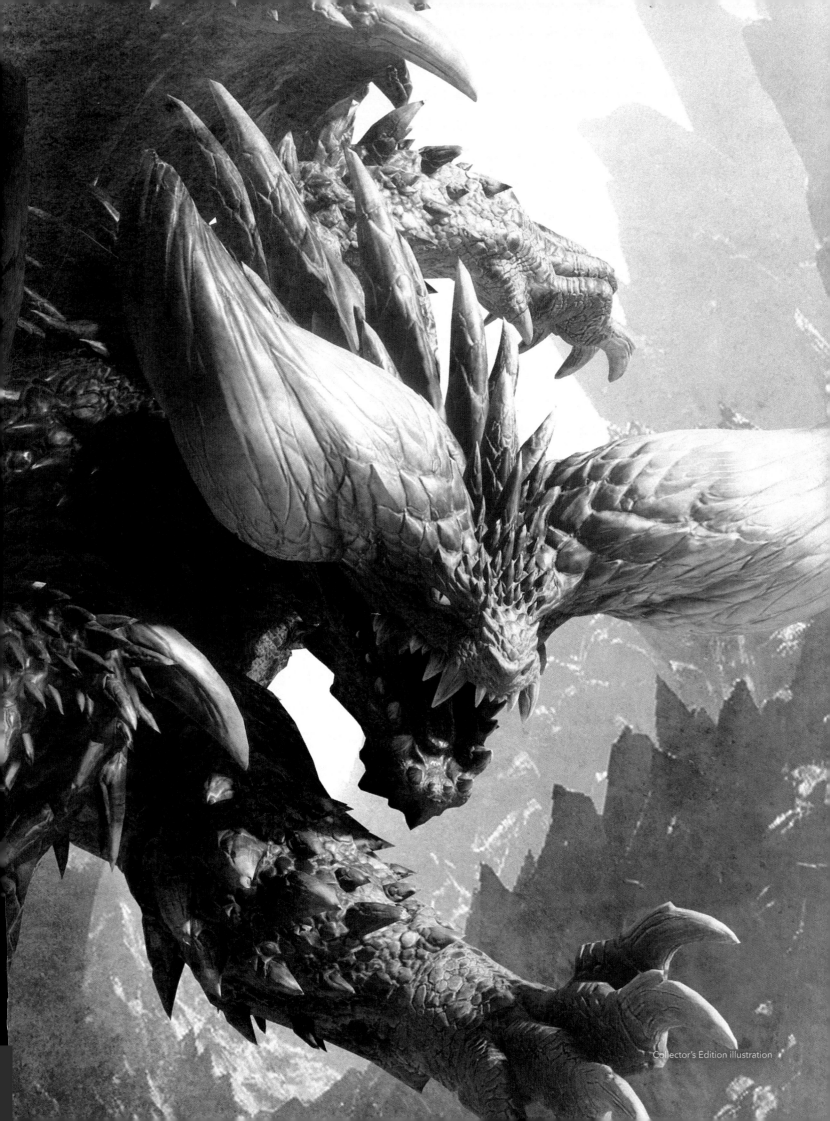

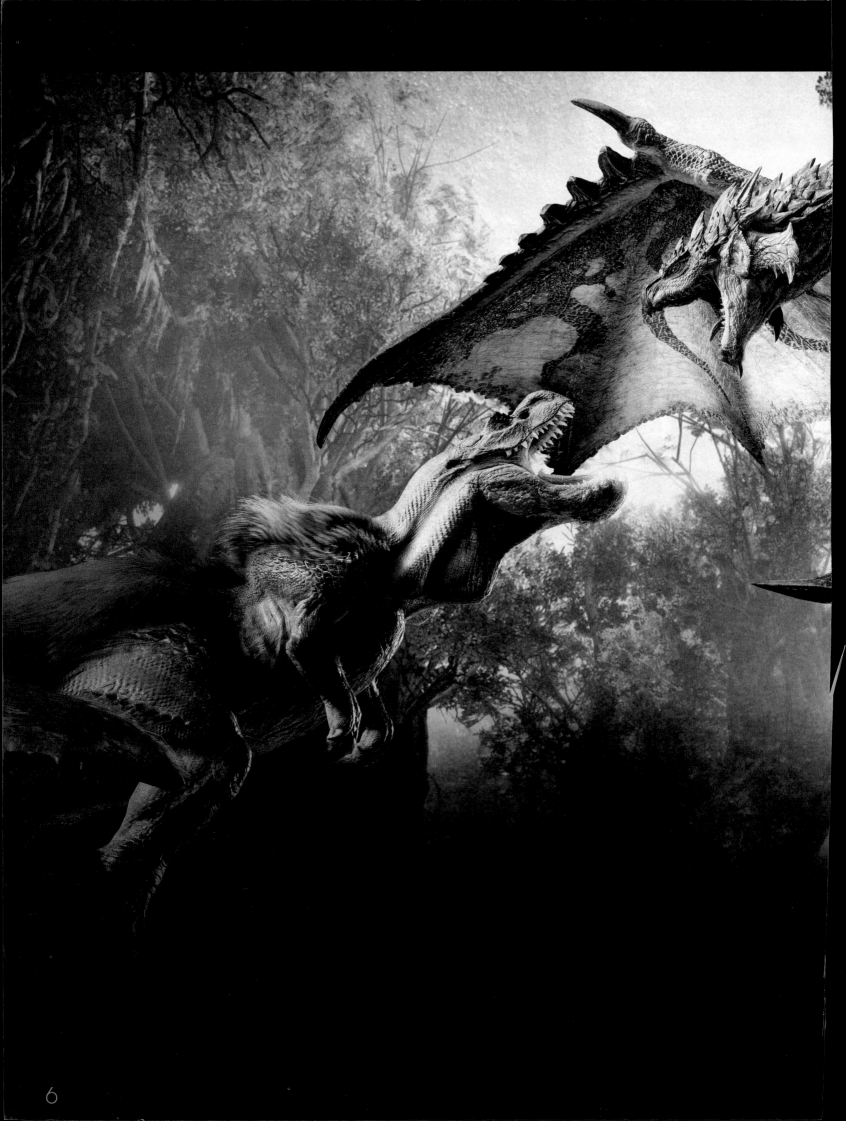

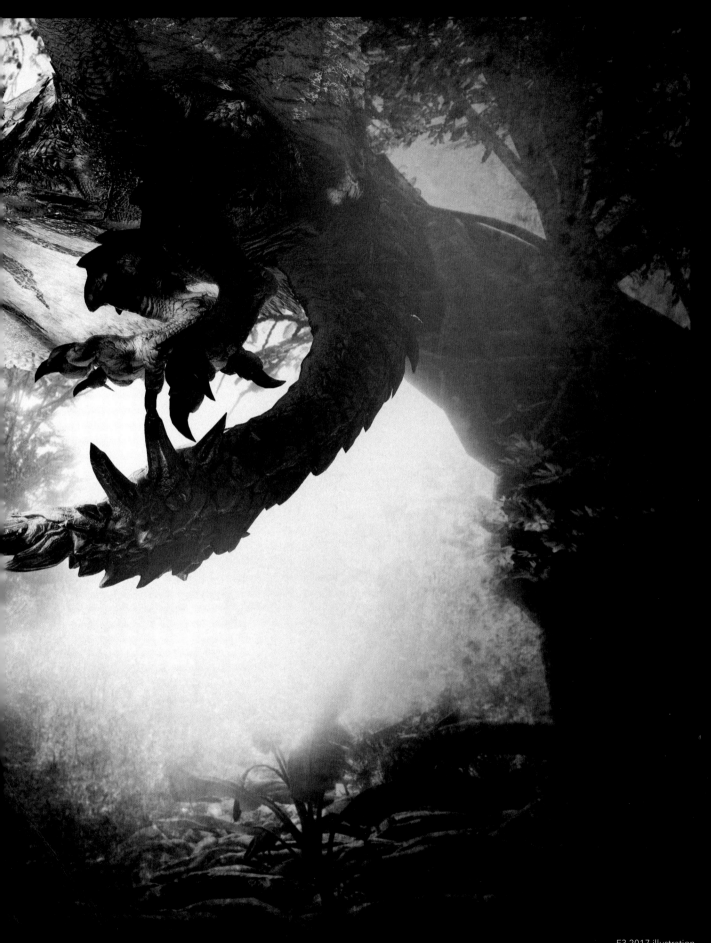

E3 2017 illustration

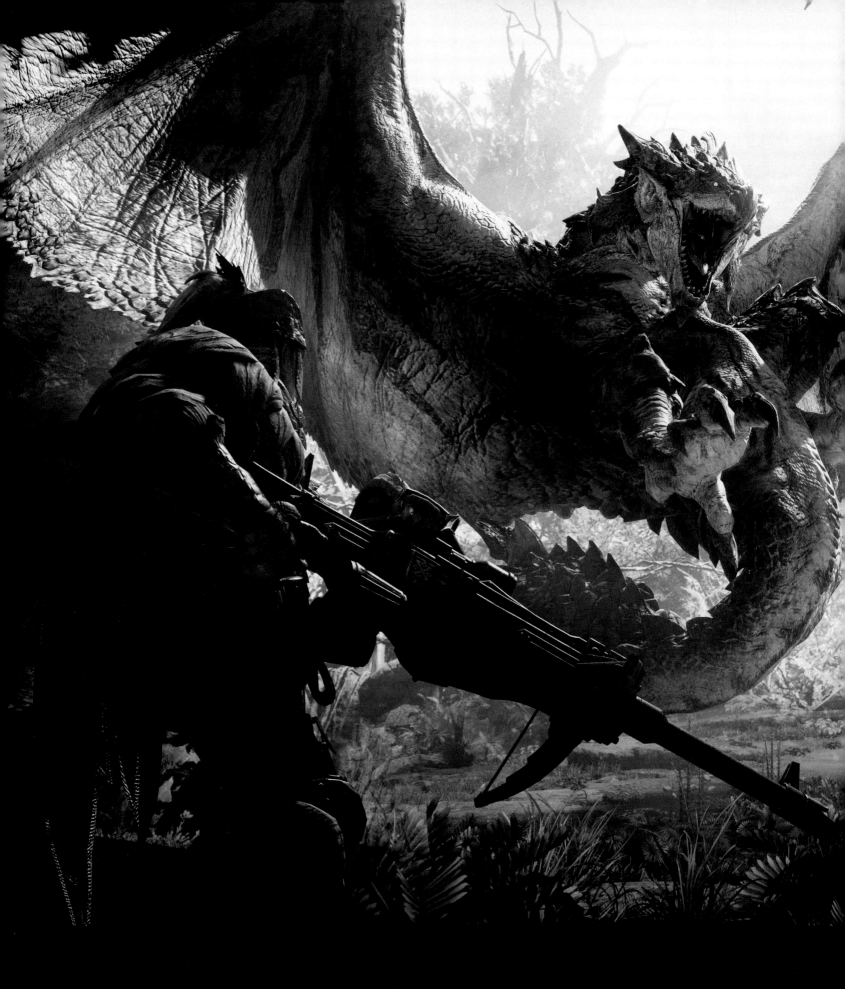

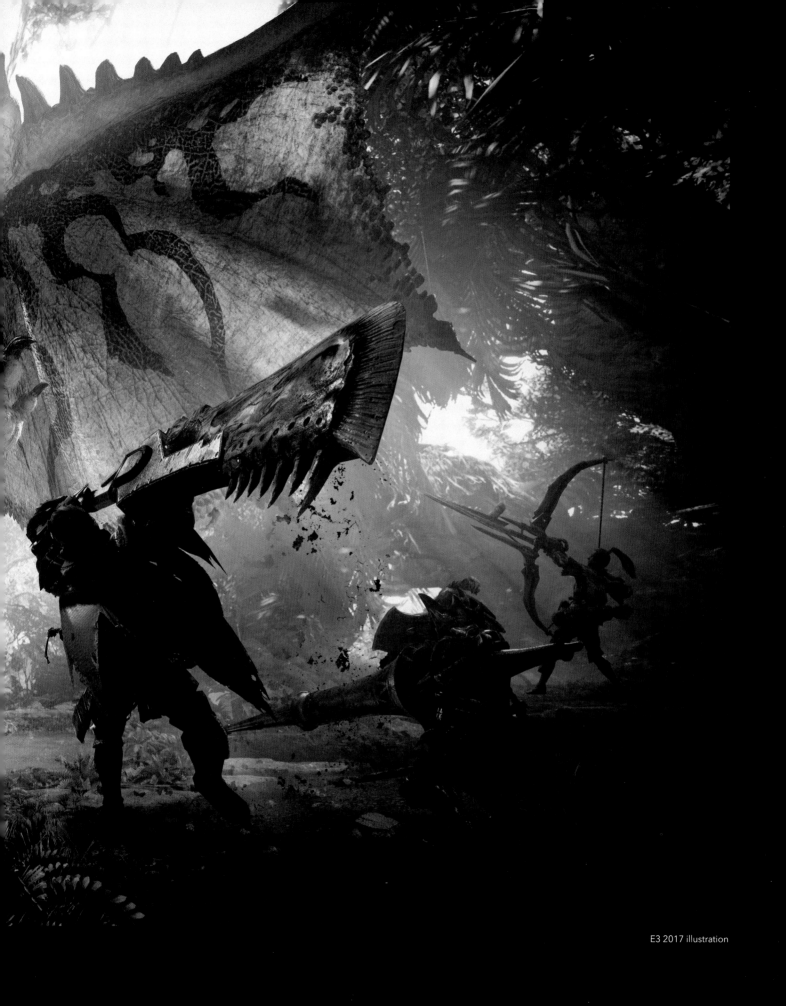

E3 2017 illustration

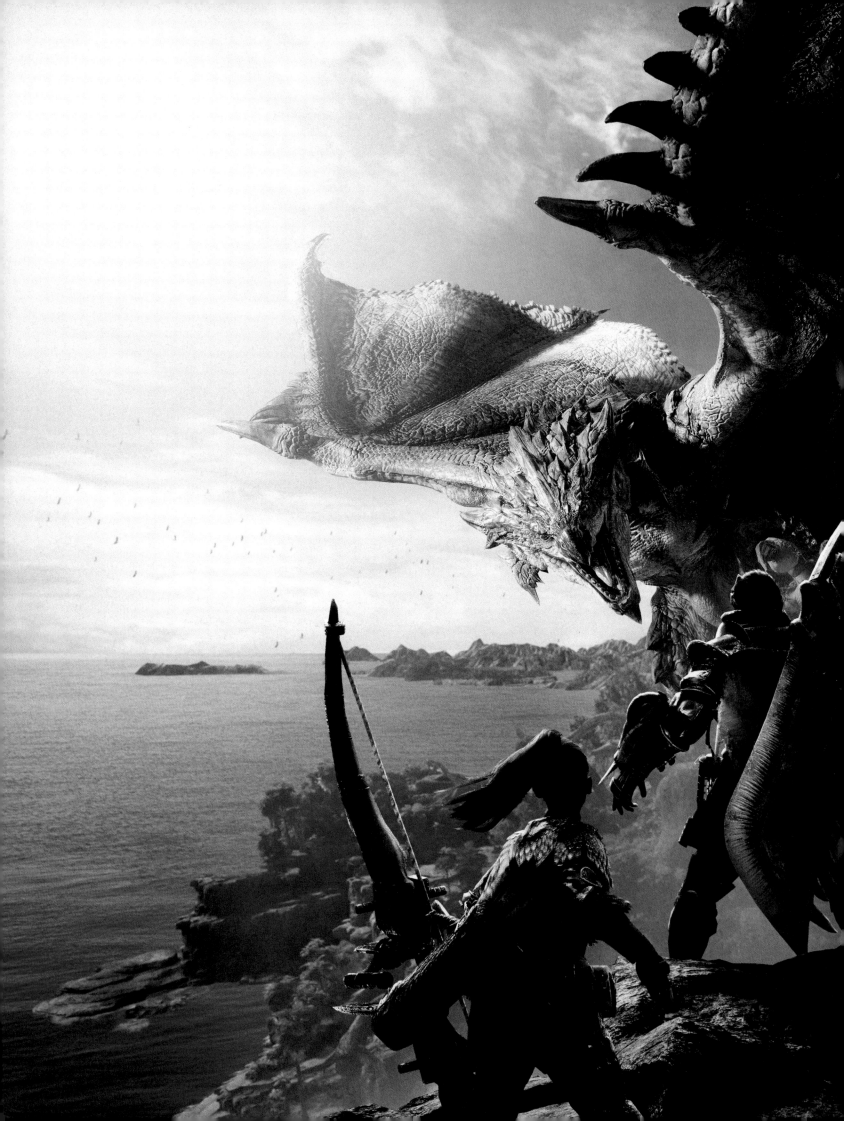

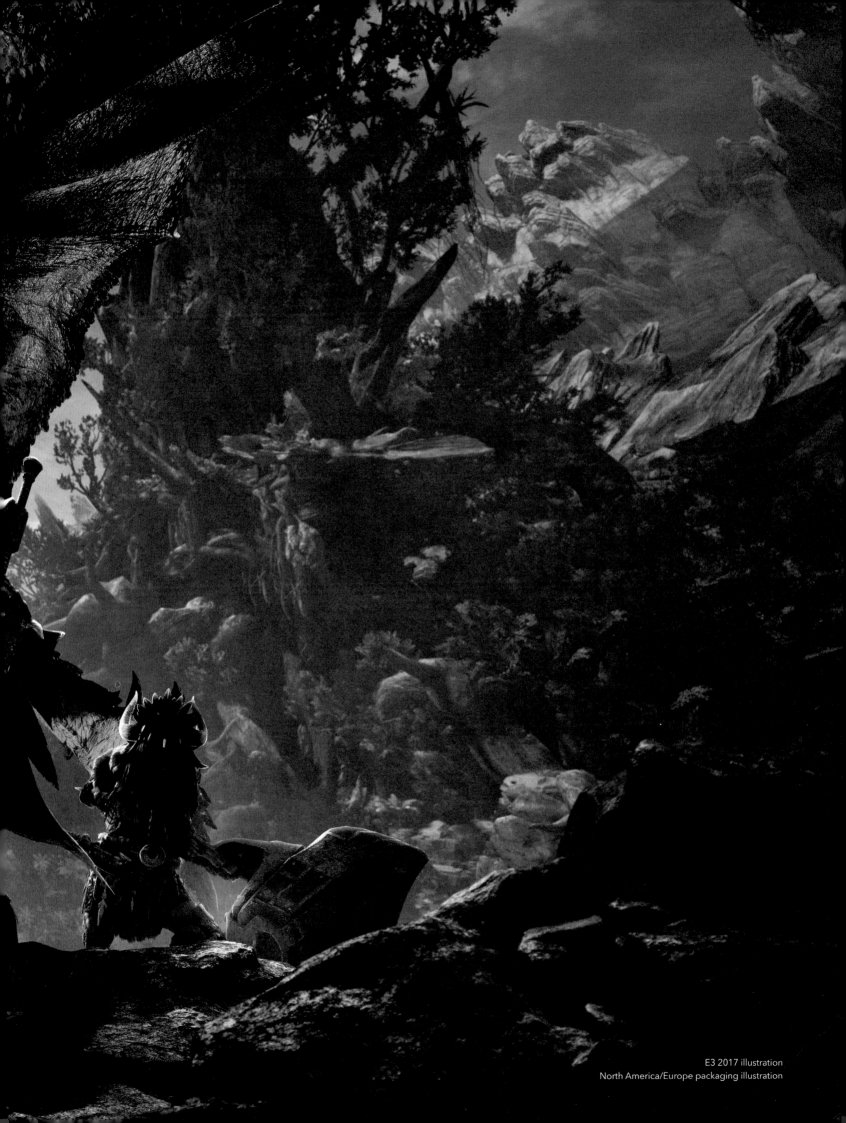

E3 2017 illustration
North America/Europe packaging illustration

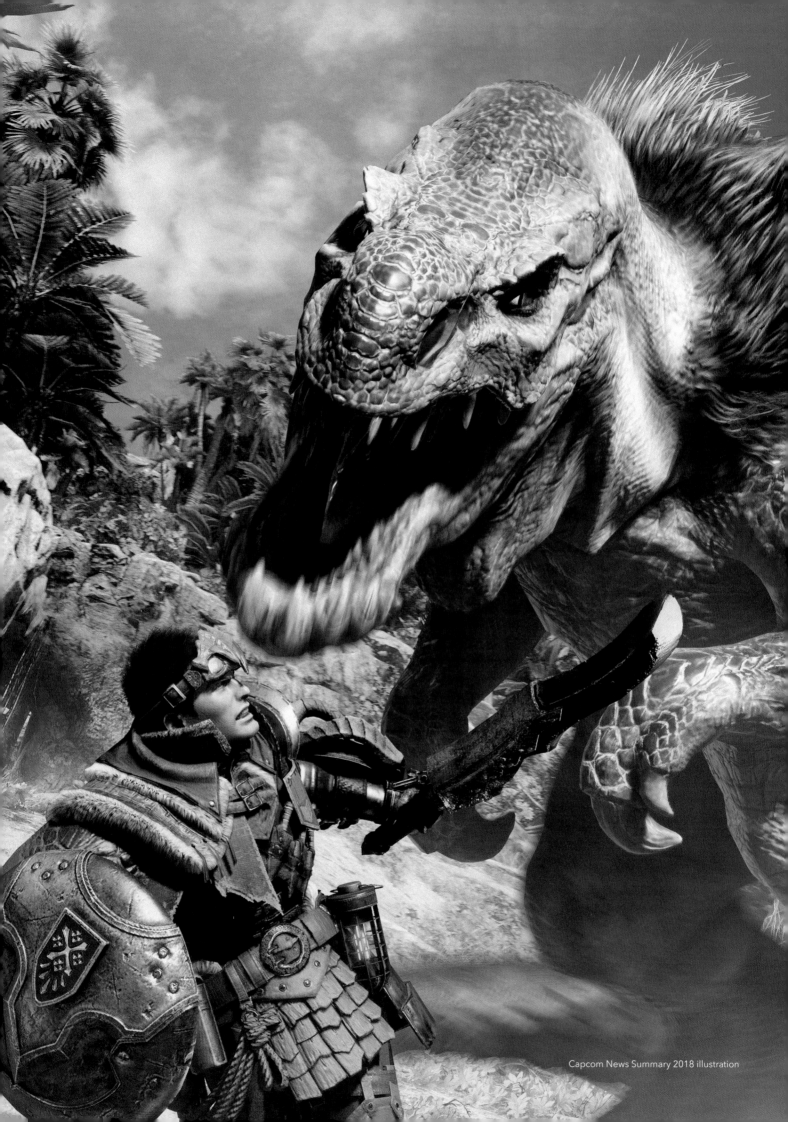

Capcom News Summary 2018 illustration

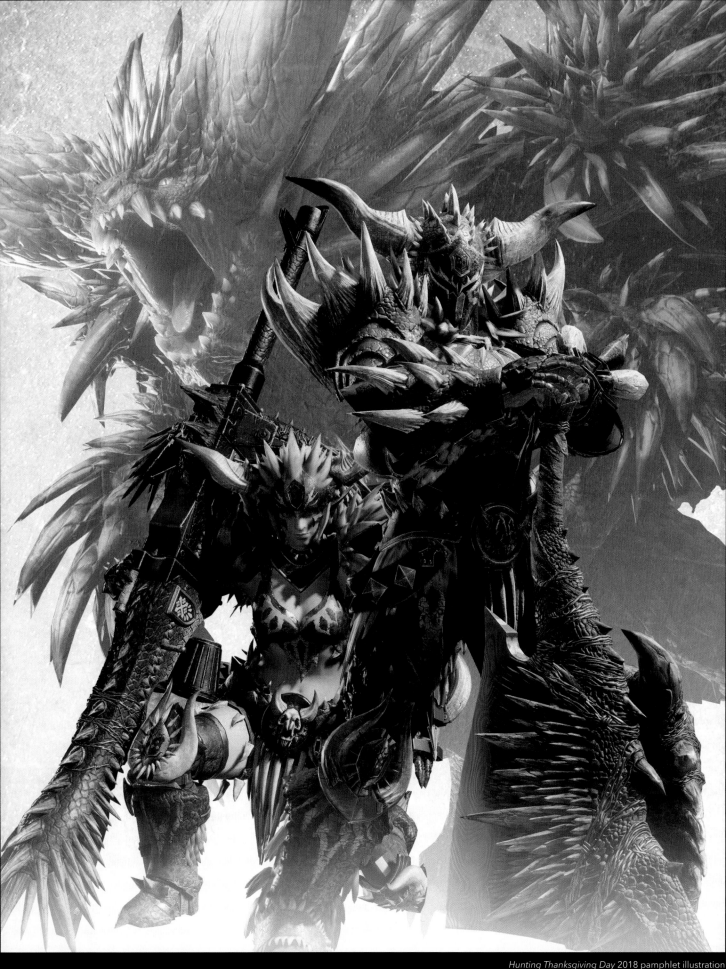

Hunting Thanksgiving Day 2018 pamphlet illustration

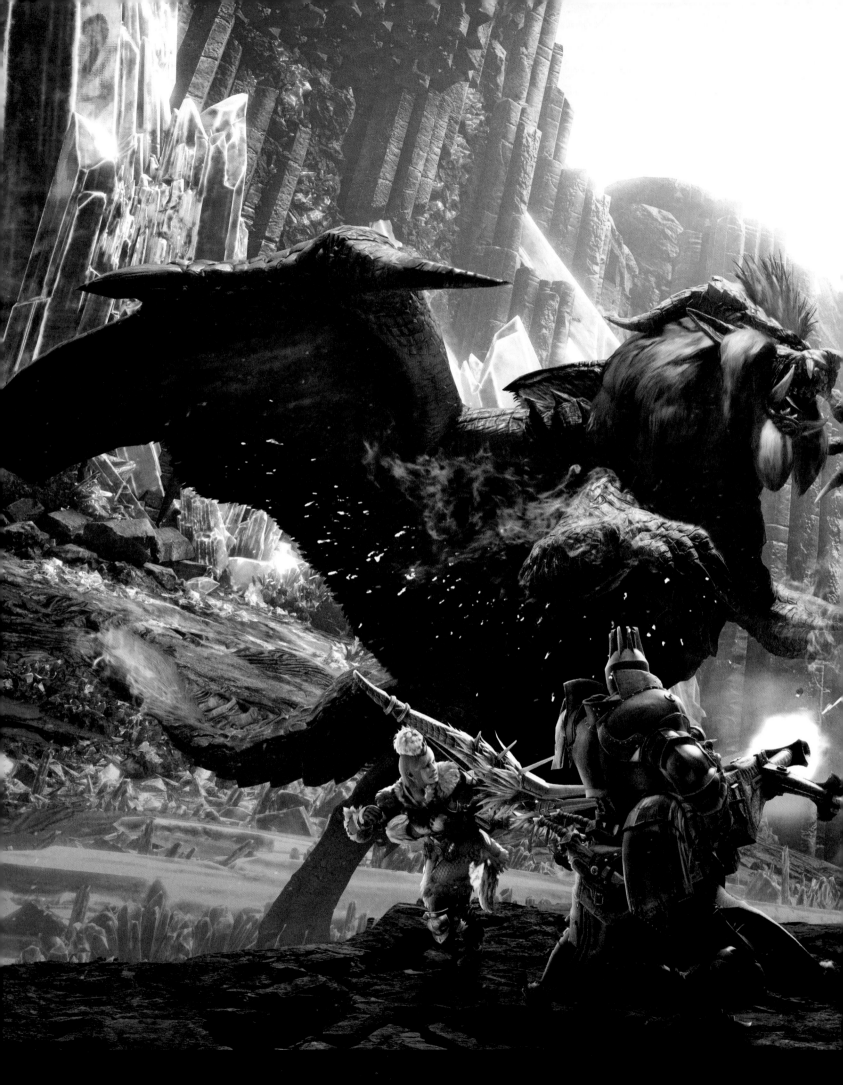

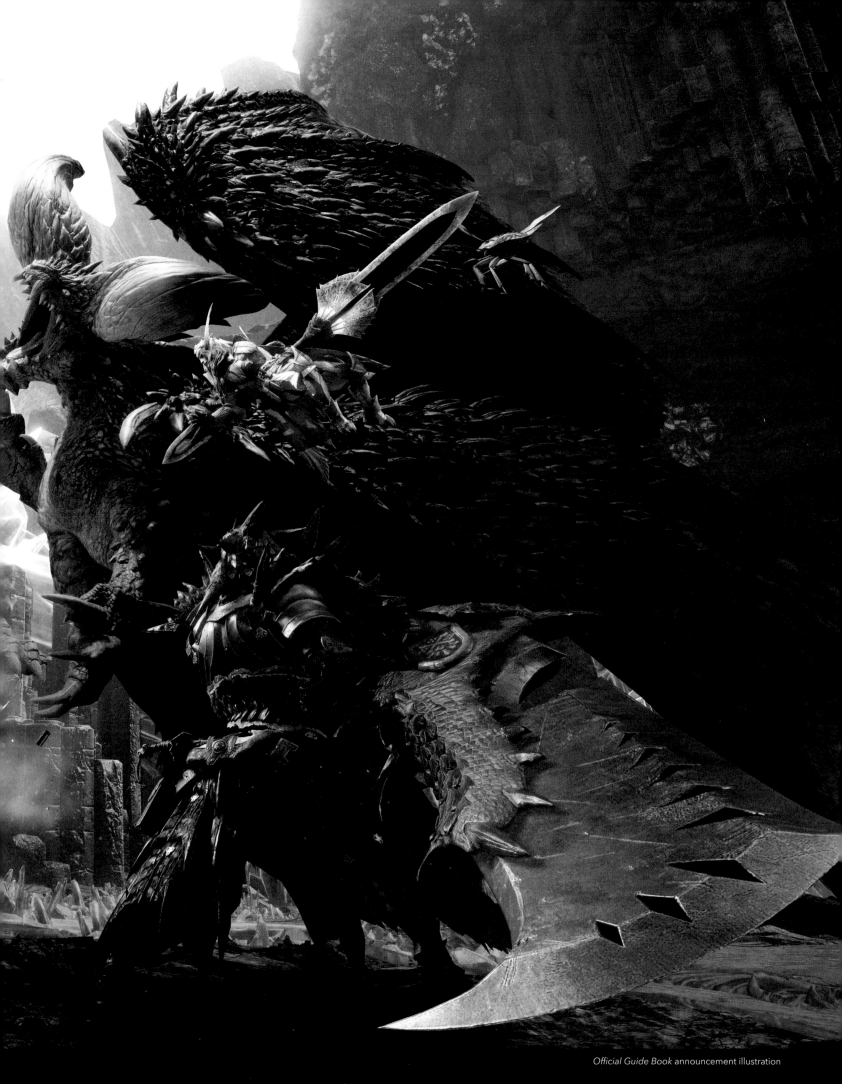

Official Guide Book announcement illustration

Package (back) illustration

Weekly Famitsu 9/21/2017 issue illustration

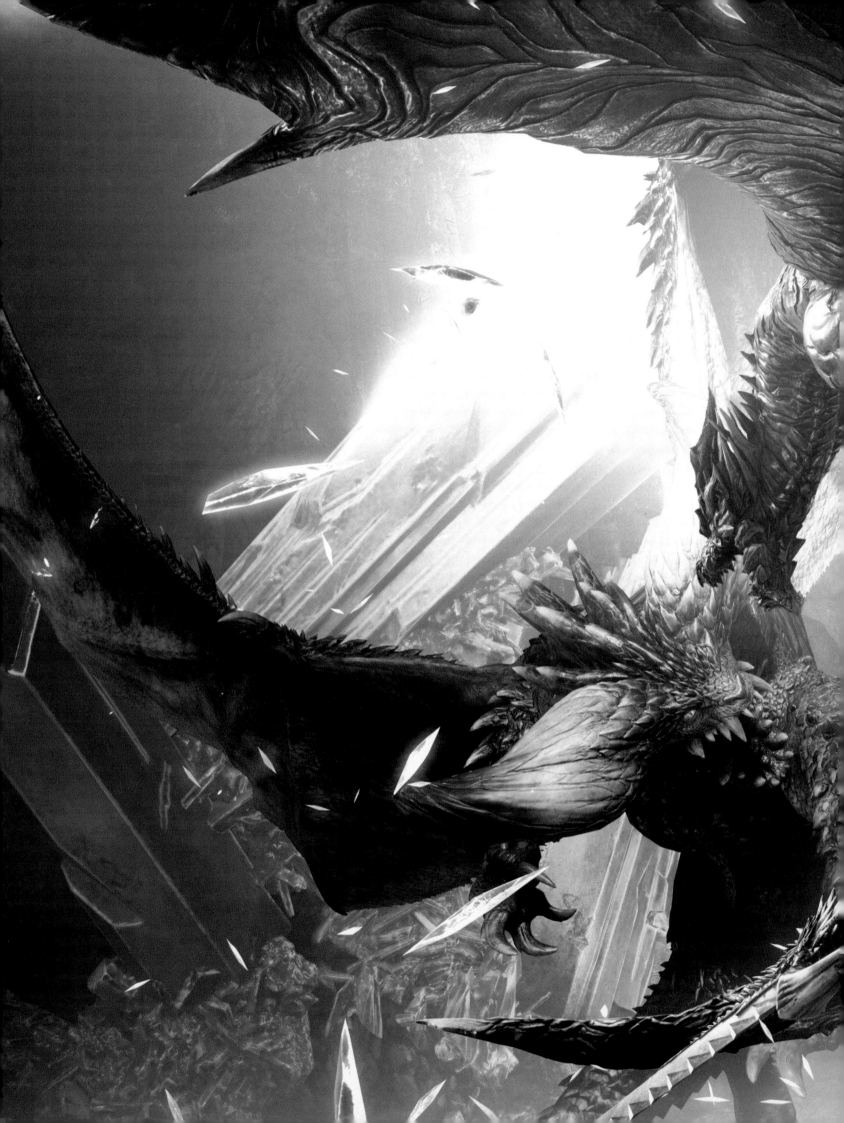

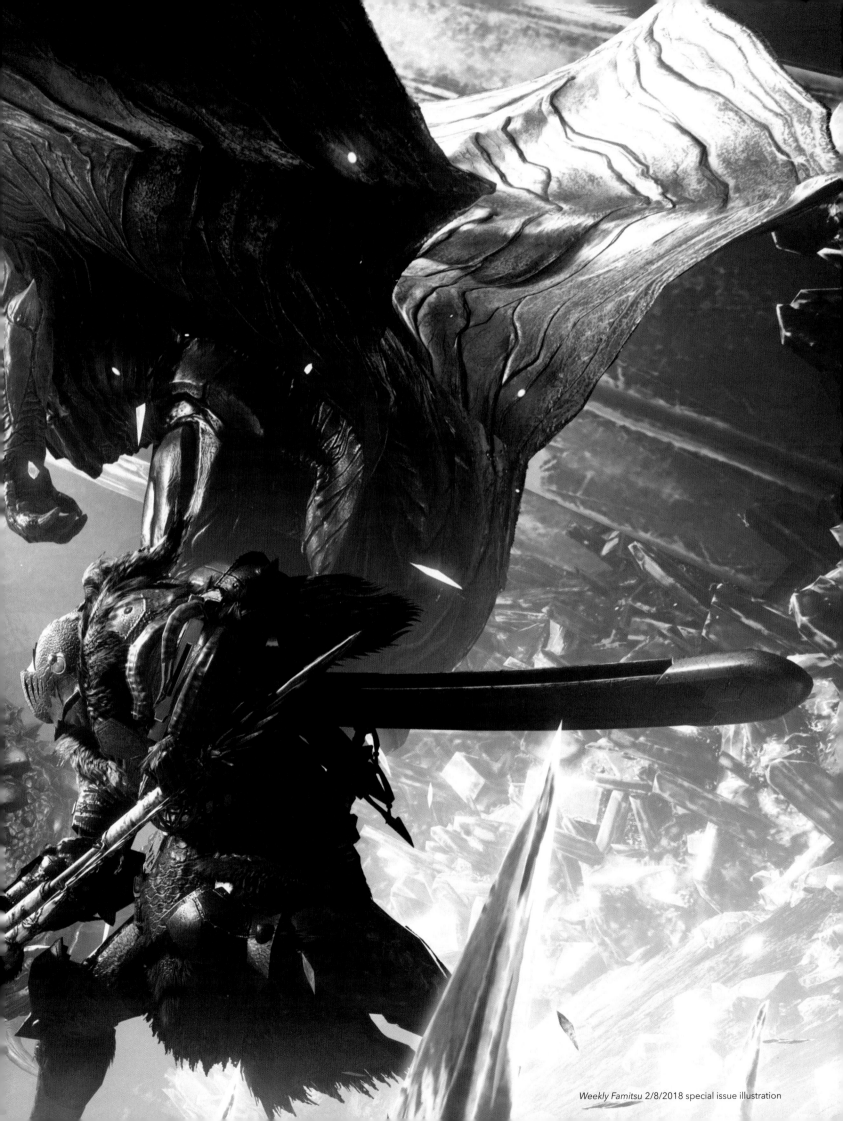

Weekly Famitsu 2/8/2018 special issue illustration

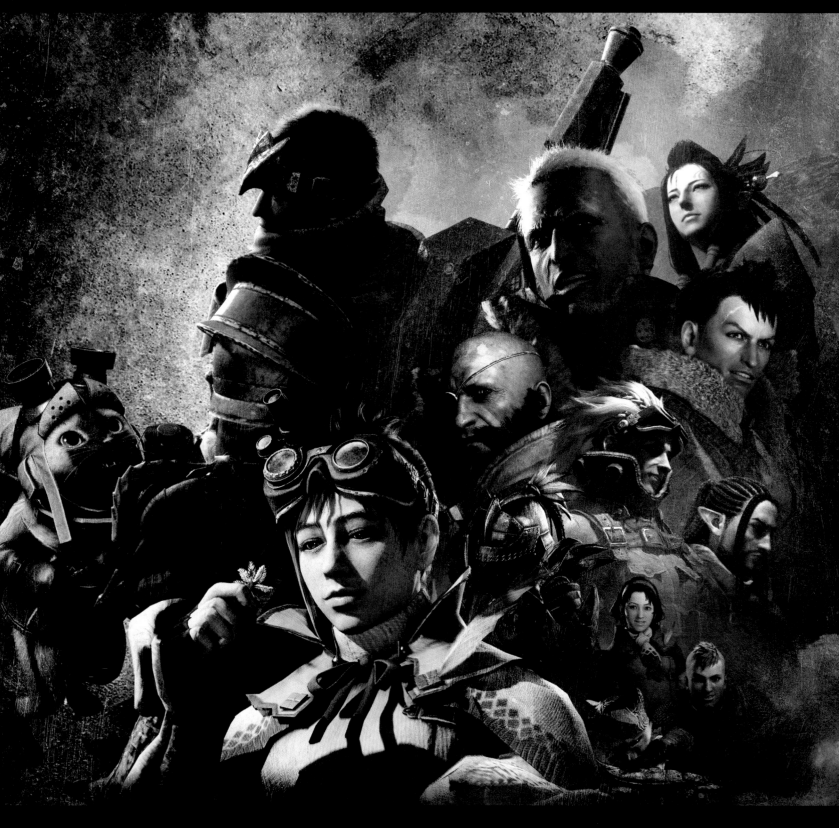

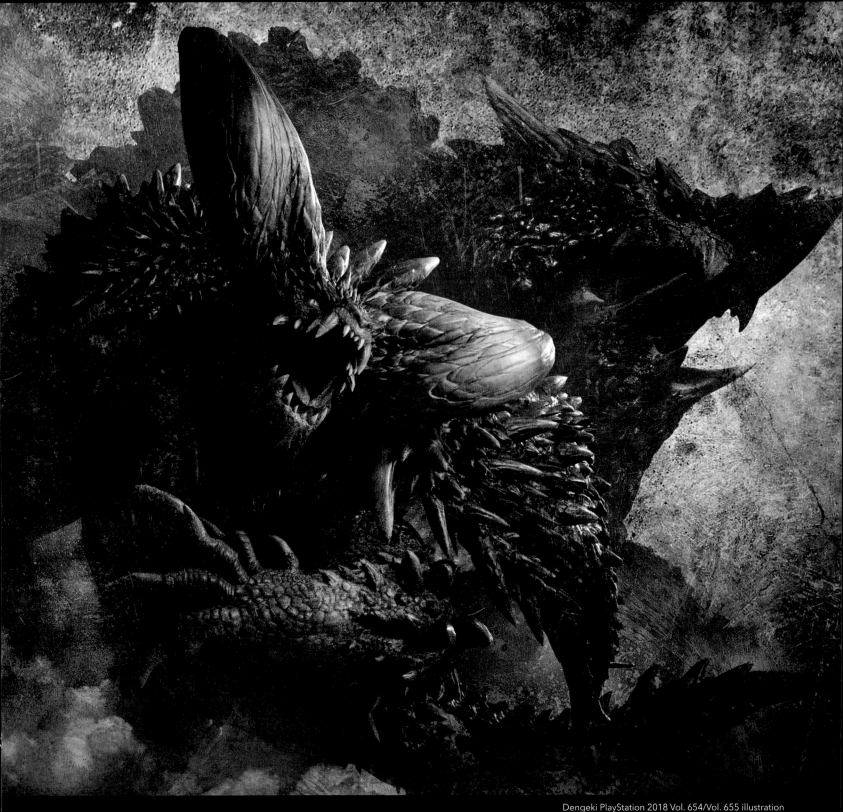

Magazine illustration

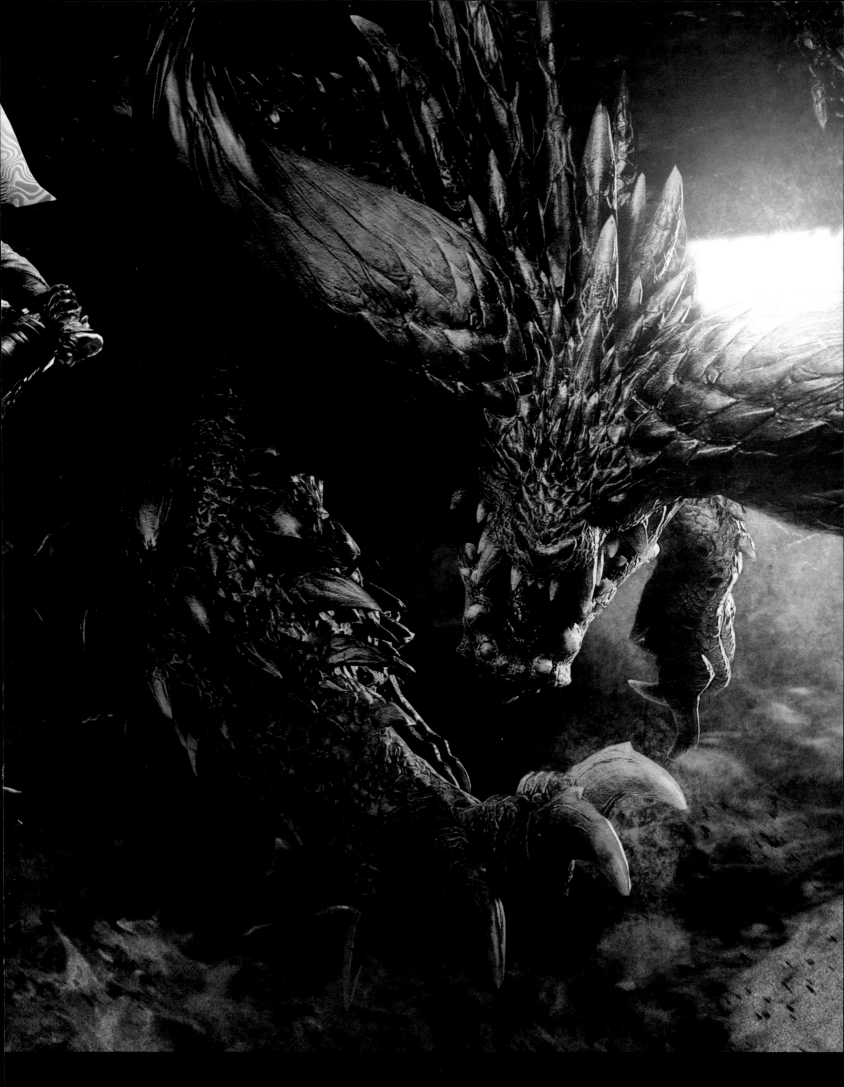

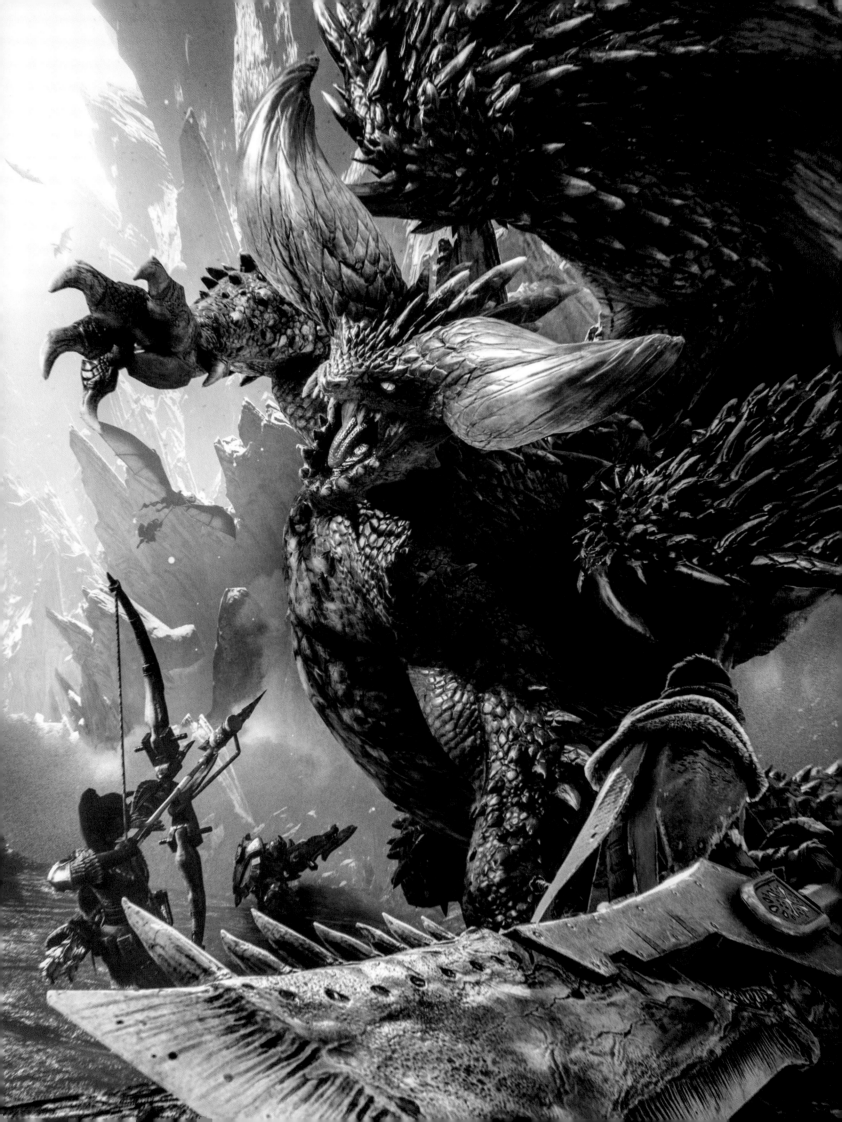

MONSTER HUNTER
WORLD

Packaging illustration

CHAPTER 1
Characters & Base

Elder Dragons are paranormal creatures far beyond the ordinary that, when ready to die, travel across the seas toward the far, far away New World in a migration called the Elder Crossing.

This migration happens in fixed cycles, and in order to unravel its mysteries, key members of the Research Commission are dispatched there from the Old World. Information on these members and their base Astera is compiled here.

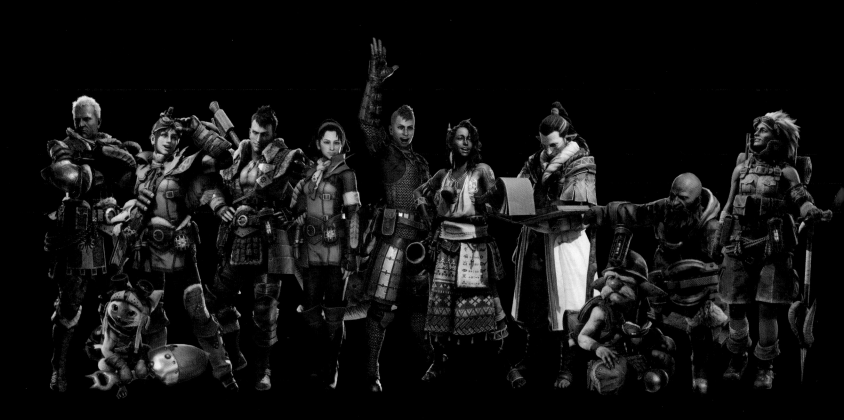

The Research Commission: Deployment Summaries

【First Fleet】

About forty years ago, the First Fleet left for the New World. A collection of individuals with extremely high fundamental abilities, it could almost be said that they were too distinctive. Currently, most of them have returned to their homes in the Old World.

【Second Fleet】

Seeking to advance their technology, this fleet was made up mostly of technicians and engineers. They were primarily tasked with crafting weapons and armor, developing machinery, and constructing a foothold in the New World. Having no fears about smashing existing common wisdom and beliefs, this collection of individuals was overflowing with a can-do spirit.

【Third Fleet】

Seeking to spur their investigations further, this fleet was made up of scholars. After landing in the New World, they converted their boat into an airship, but they encountered a monster while crossing the Great Ravine and were unable to avoid making a crash landing there. At present, they are continuing their research in the Coral Highlands where they are stranded.

【Fourth Fleet】

This fleet was assembled with the aim of expanding explorations. It was a collection of personnel with superior management skills, and it also had many hunters. It had a good overall balance of youth and experience.

【Fifth Fleet】

This is a fleet of hunters dispatched to follow the crossing of Zorah Magdaros and is the largest of all the fleets. Expectations are high for this assemblage of exceptional individuals to bring fair winds to the research, and it is hoped that their investigations will be the last.

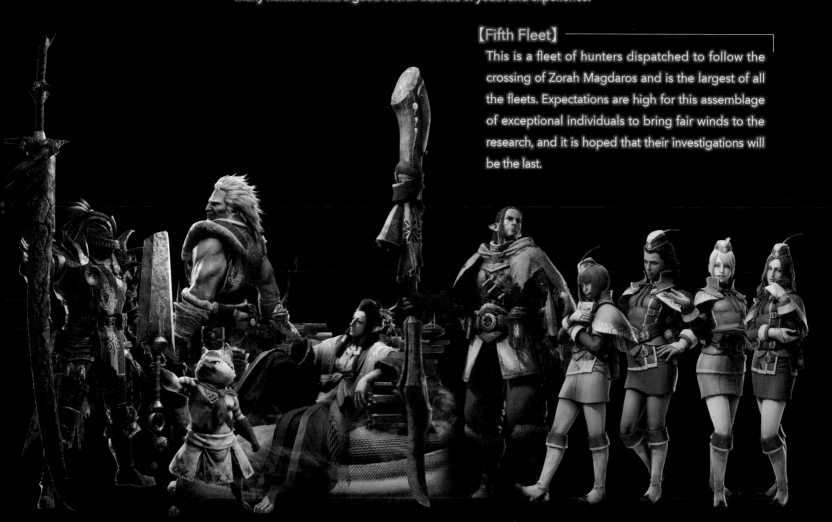

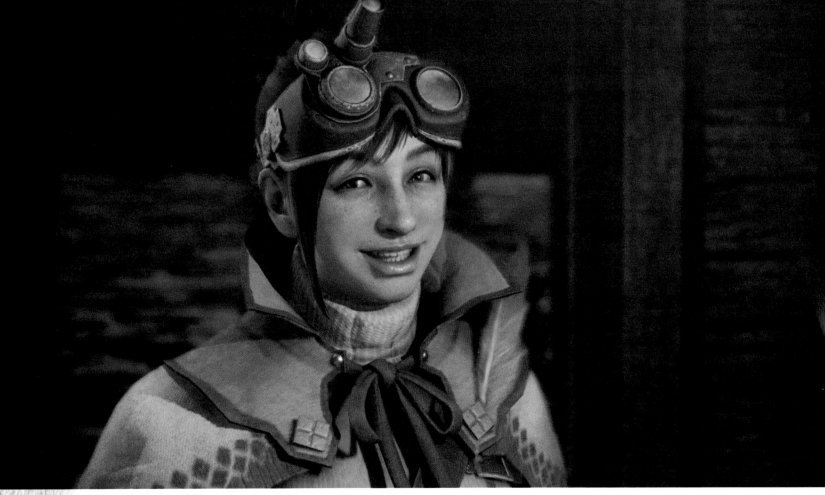

The Handler is a master of pulling together and managing information. Even without the abilities required for hunting monsters, she has abundant knowledge and analytical ability, and she contributes in various ways to research into ecosystems and other matters.

"A wild and wondrous New World

is waiting for us out there!"

When heading off into the field, she prepares cooked and preserved foods to support the hunter. She diligently learns recipes from the Meowscular Chef and accurately reproduces them on hunts.

| CHARACTER |

Abilities as a Handler

Among the people who are partnered up with hunters, the Handler stands out. Through her duties and investigations, her zest for research is clear. She is quite often walking out in the field herself, providing guidance. (She is later even called a "super-active handler.") She often finds herself in predicaments, which makes her ability to take action crucial. She is full of advice about organisms and utilizing the environment, and she also supports the hunter when it comes to meals, making her a reliable partner.

| CHARACTER |

The Path to an A-List Recommendation

After hearing about the First Fleet's journey from her grandfather, a member of that fleet, the Handler became interested in the Commission and the New World. This time, the Guild approached her to be a Fifth Fleet A-Lister, the reason being that the Commander requested tough handlers. Her ability to act and her cheerful nature earn her a certain amount of esteem from the Guild.

| CHARACTER |

Her Plan to Catalog Every Edible in the New World

She aspires to be a good handler, and one of her major objectives in going to the New World is fulfilling her dream of creating an encyclopedia that specializes in the flavors of edibles in the New World. She loves to eat, and at camp she displays spectacular skill at cooking. Her motto is "If in doubt, take a bite!" She professes to love Exciteshrooms. Incidentally, eating an Exciteshroom brings a risk of negative health effects, so eating them uncooked in the New World is to be avoided, and they are mainly used as Smoke Bomb material.

The Handler also secretly requests Botanical Research to cultivate mushrooms. Her research records contain many entries on things that can be eaten outdoors, and the Meowscular Chef, who runs the base Canteen, has to admit her superiority in insatiable cravings and curiosity for these "foods." A large, round table in one corner of the Canteen has been provided for her exclusive use, and the Handler can often be seen there, looking over a mountain of material and heartily stuffing her face with meats and fruits. According to the Huntsman, her grandfather was also a merry man who loved to eat.

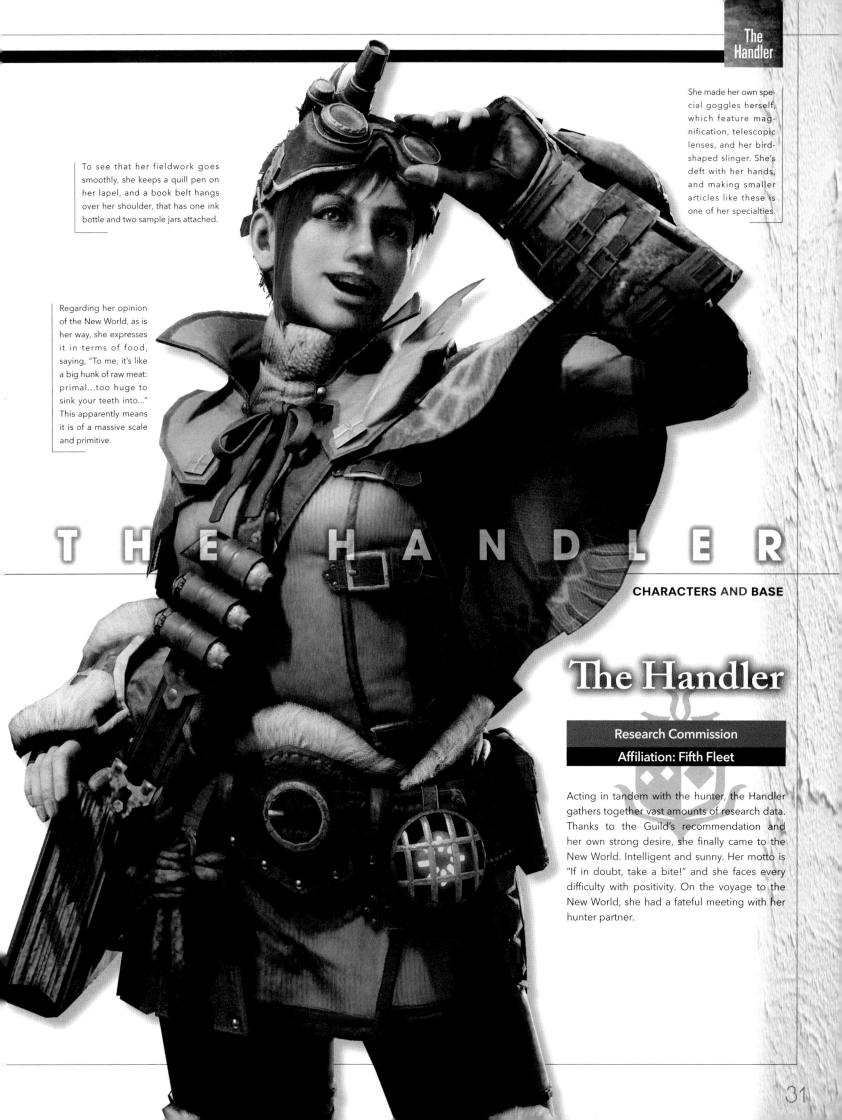

To see that her fieldwork goes smoothly, she keeps a quill pen on her lapel, and a book belt hangs over her shoulder, that has one ink bottle and two sample jars attached.

She made her own special goggles herself, which feature magnification, telescopic lenses, and her bird-shaped slinger. She's deft with her hands, and making smaller articles like these is one of her specialties.

Regarding her opinion of the New World, as is her way, she expresses it in terms of food, saying, "To me, it's like a big hunk of raw meat: primal...too huge to sink your teeth into..." This apparently means it is of a massive scale and primitive.

THE HANDLER

CHARACTERS AND BASE

The Handler

Research Commission
Affiliation: Fifth Fleet

Acting in tandem with the hunter, the Handler gathers together vast amounts of research data. Thanks to the Guild's recommendation and her own strong desire, she finally came to the New World. Intelligent and sunny. Her motto is "If in doubt, take a bite!" and she faces every difficulty with positivity. On the voyage to the New World, she had a fateful meeting with her hunter partner.

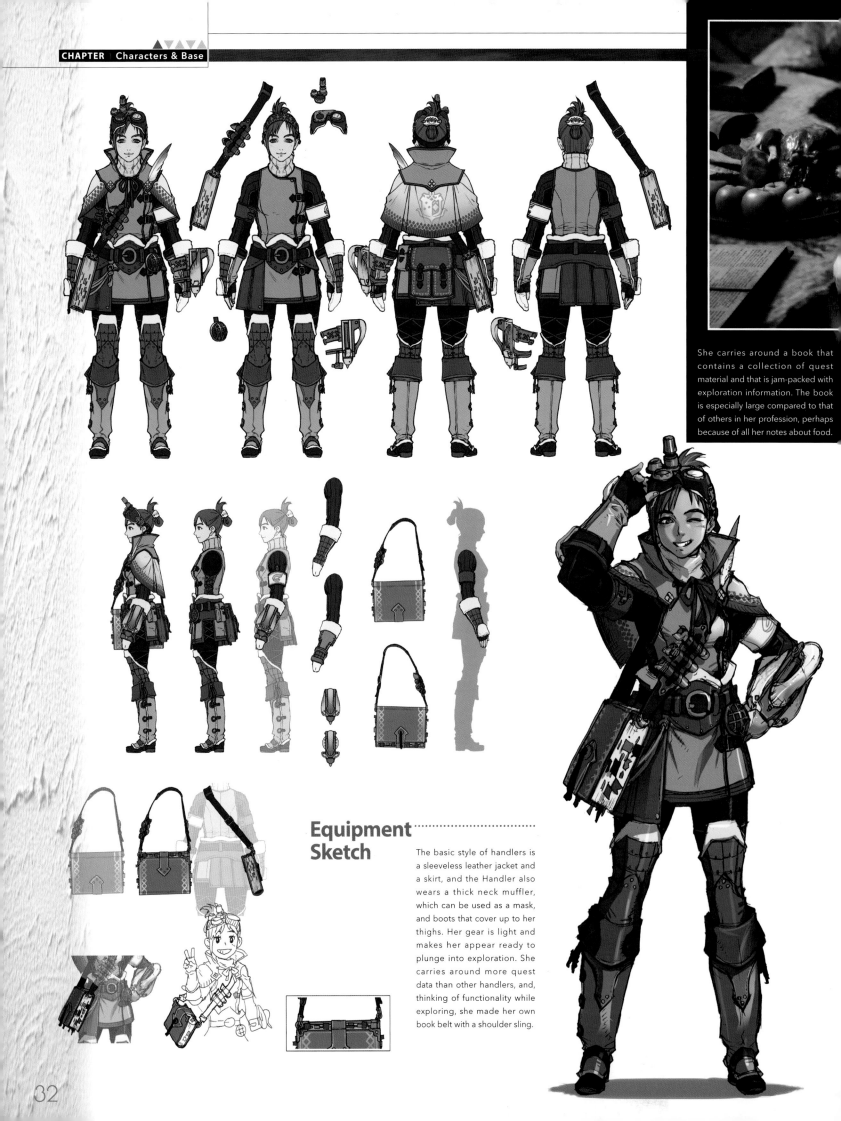

She carries around a book that contains a collection of quest material and that is jam-packed with exploration information. The book is especially large compared to that of others in her profession, perhaps because of all her notes about food.

Equipment Sketch

The basic style of handlers is a sleeveless leather jacket and a skirt, and the Handler also wears a thick neck muffler, which can be used as a mask, and boots that cover up to her thighs. Her gear is light and makes her appear ready to plunge into exploration. She carries around more quest data than other handlers, and, thinking of functionality while exploring, she made her own book belt with a shoulder sling.

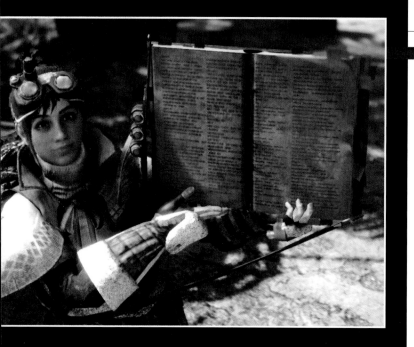

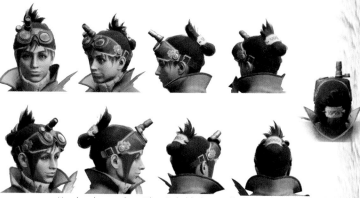

Handmade goggles with switchable lenses. Underneath is a leather hair band. The hair clasp, which gathers up her long hair, is crafted from a monster bone.

"I'm feeling like our research is about to hit a turning point!"

COSTUME

■ The Handler's Change of Outfits

In addition to her outfit as part of the Research Commission, the Handler wears various other outfits. Here we introduce her wearing some special outfits which the Hunter gave her as presents.

TOPIC | Who is the Guildmarm?

The Guildmarm first appears in the fourth entry in the series, *Monster Hunter 4G* (*Monster Hunter 4 Ultimate* in the West). She is a Guild Receptionist who travels with the Caravan.

She loves learning about large monsters and authored *So Notable*, which collects investigation reports. She loves frogs and made a pouch that looks like one. She has many things in common with the Handler.

※ Image from "Monster Hunter 4G."

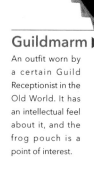

Guildmarm ▶

An outfit worn by a certain Guild Receptionist in the Old World. It has an intellectual feel about it, and the frog pouch is a point of interest.

Astera 3 Star Chef Coat ▶

With a chef's hat and an apron, this outfit makes the Handler look like a cook in every way. Plus she keeps Scoutflies in the front pocket?! It seems like she should wear this getup during the "Food Chain Dominator" Special Assignment.

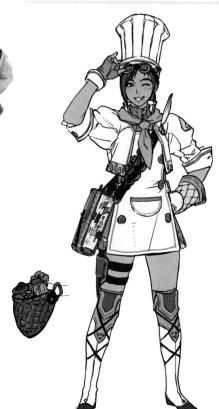

Palico

Research Commission
Affiliation: Fifth Fleet

A Felyne partner that joins the Fifth Fleet hunter in their travels, coming to the New World along with their A-List hunting partner. Palicoes provide support with various weapons and tools used in hunting and, being Lynians, can also use their own physical abilities to contribute to investigations in the New World.

KEY WORDS [Felyne]

A small Lynian that inhabits the Old World and outwardly looks like an animal. Lynians have their own culture and customs, but many of them wish to interact with other species. They are intensely curious, and their ability to learn the languages of other cultures is excellent.

Palicoes have a strong trust in their hunters, due to having worked together for a long time. They show obedient responses to instruction and have an extremely amiable personality.

Perhaps due to their curiosity, Palicoes tend to run about all over the place and work hard when gathering materials on investigations, taking advantage of their physical abilities and environmental adaptability.

CHARACTERS AND BASE

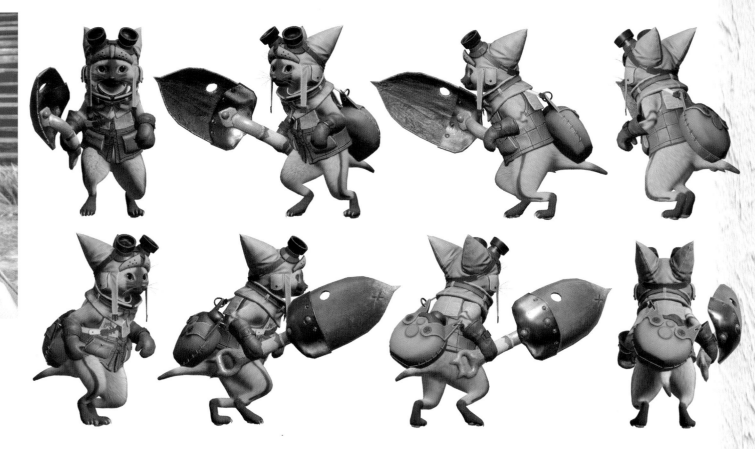

CHARACTER

■As a Palico

Among the Felynes, who are positive and active in their interactions with people, some have abilities that the Guild desires and so are called Palicoes. Palicoes are permitted to work along with hunters. In the Commission, Palicoes are not designated as A-List, but they take part in the Fifth Fleet as accompanying partners.

CHARACTER

■Relationship as Partners

The Palico met the hunter, their present partner, in the Old World and carried out several requests for them. Perhaps because of that long association, the Palico wanted to be taken along on the next fleet so the hunter could see them making good use of Palico Gadgets. That reveals their trust and affection for their partner.

Equipment Sketch

Because of a Commission regulation that Old World materials taken to the New World be kept to an absolute minimum, the Palico also wears entry-level leather gear. This simple yet highly functional design has many fans. His beloved acorn-shaped weapon can also be used as a shovel, and the large flask is full of recovery medications.

"If we run across any Tailraiders, I'll try to ask them for help."

Felynes are omnivorous. Palicoes eat the same foodstuffs as humans, but the hunters give them things like meat that has been processed for their consumption. It is said that Felynes that coexist with people have definitely developed more gourmet tastes than when they were wild.

TOPIC | Palicoes as Linchpins in Interactions with Other Cultures

Many types of Lynians live in the New World. Each has their own culture and linguistic systems, so direct interaction is difficult, but Palicoes are highly active as go-betweens. They can understand human languages, and thanks to their ability to learn languages, they can actualize interactions with Lynians as they investigate evidence of them. Sometimes they exchange information, and sometimes they join in on hunts. These things forge friendly relationships. Finally, they can also learn the languages of small monsters and can control those small monsters by feeding them. It wouldn't be an exaggeration to say they are indispensable in the current investigation of the New World.

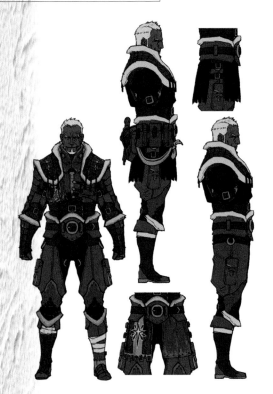
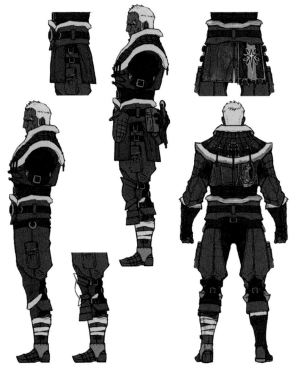
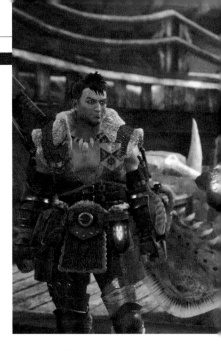

·········· **Equipment Sketch**

This long-loved gear is truly well-worn, and the passage of time can be felt all over it. The banner of the First Fleet hangs from the right side, and the left leg of the uniform is reinforced for walking support as well.

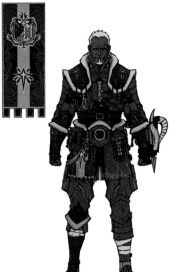
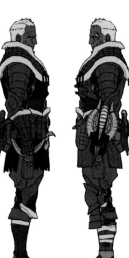
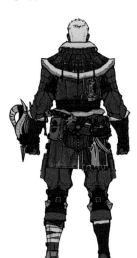

"We do have a quest that will challenge even you, our Sapphire Star!"

CHARACTER

■The Leader Entrusted with the Commission

When the First Fleet commenced their activities, the Admiral led them and the Commander was his aide. Since the Admiral often left Astera to explore, leadership of the Commission fell to the Commander. He is a superior hunter, an intellectual who utilizes detailed observations and consideration. He's popular due to acting with prudence and valuing courage and harmony with nature.

CHARACTER

■He Proposed the Use of the Scoutflies

The Commander discovered the Scoutflies, their pale green light, and their tendency to swarm in response to the smell given off by people and things. He then researched how they could be made useful in monster investigations. As a result, they are now indispensable standard equipment in New World investigations.

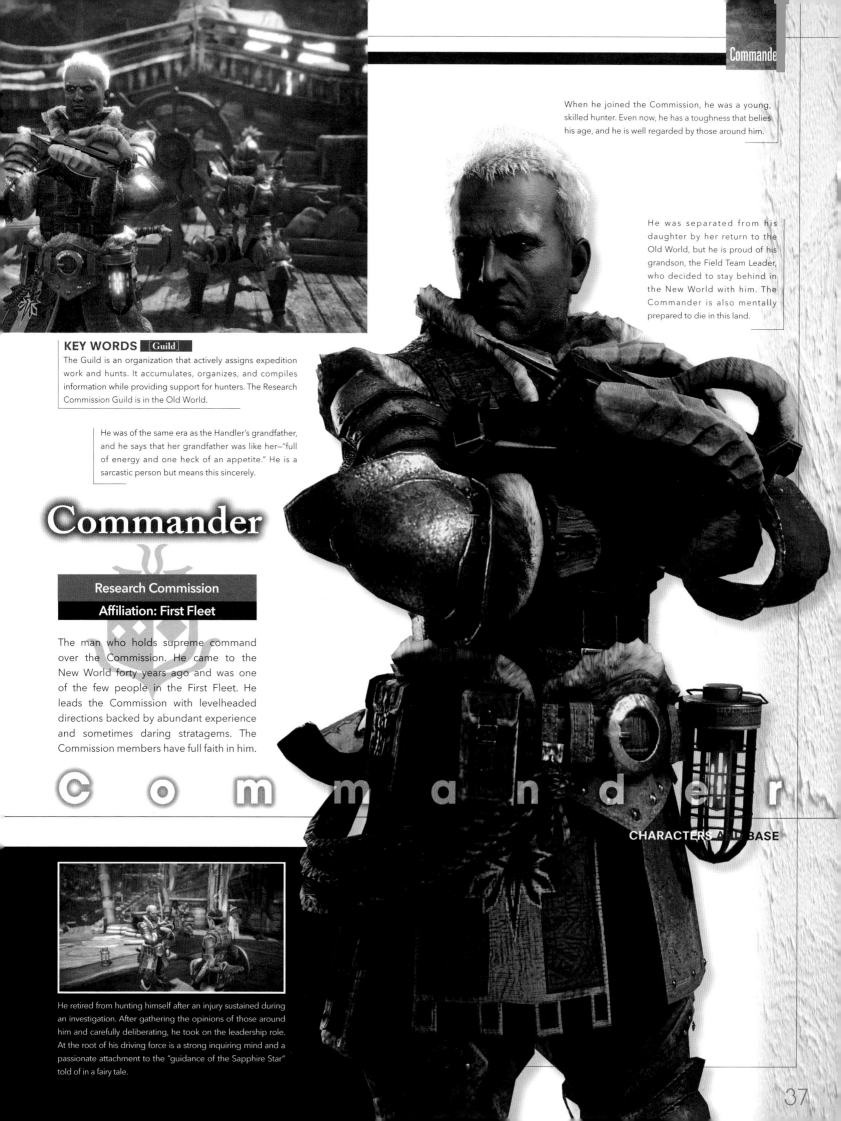

When he joined the Commission, he was a young, skilled hunter. Even now, he has a toughness that belies his age, and he is well regarded by those around him.

He was separated from his daughter by her return to the Old World, but he is proud of his grandson, the Field Team Leader, who decided to stay behind in the New World with him. The Commander is also mentally prepared to die in this land.

KEY WORDS 〔Guild〕

The Guild is an organization that actively assigns expedition work and hunts. It accumulates, organizes, and compiles information while providing support for hunters. The Research Commission Guild is in the Old World.

He was of the same era as the Handler's grandfather, and he says that her grandfather was like her—"full of energy and one heck of an appetite." He is a sarcastic person but means this sincerely.

Commander

Research Commission
Affiliation: First Fleet

The man who holds supreme command over the Commission. He came to the New World forty years ago and was one of the few people in the First Fleet. He leads the Commission with levelheaded directions backed by abundant experience and sometimes daring stratagems. The Commission members have full faith in him.

Commander

CHARACTERS AND BASE

He retired from hunting himself after an injury sustained during an investigation. After gathering the opinions of those around him and carefully deliberating, he took on the leadership role. At the root of his driving force is a strong inquiring mind and a passionate attachment to the "guidance of the Sapphire Star" told of in a fairy tale.

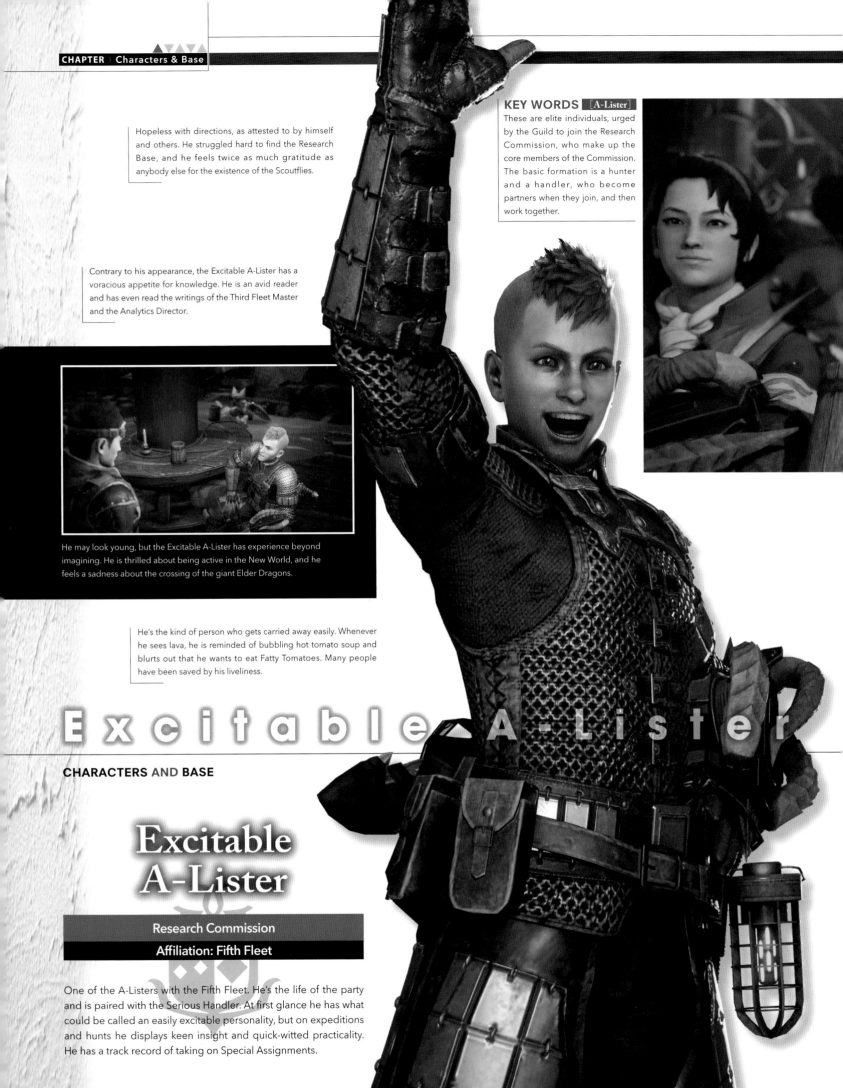

Hopeless with directions, as attested to by himself and others. He struggled hard to find the Research Base, and he feels twice as much gratitude as anybody else for the existence of the Scoutflies.

Contrary to his appearance, the Excitable A-Lister has a voracious appetite for knowledge. He is an avid reader and has even read the writings of the Third Fleet Master and the Analytics Director.

He may look young, but the Excitable A-Lister has experience beyond imagining. He is thrilled about being active in the New World, and he feels a sadness about the crossing of the giant Elder Dragons.

He's the kind of person who gets carried away easily. Whenever he sees lava, he is reminded of bubbling hot tomato soup and blurts out that he wants to eat Fatty Tomatoes. Many people have been saved by his liveliness.

Excitable A-Lister

CHARACTERS AND BASE

Excitable A-Lister

Research Commission

Affiliation: Fifth Fleet

One of the A-Listers with the Fifth Fleet. He's the life of the party and is paired with the Serious Handler. At first glance he has what could be called an easily excitable personality, but on expeditions and hunts he displays keen insight and quick-witted practicality. He has a track record of taking on Special Assignments.

Equipment Sketch

His hairstyle makes an impression with its shaved sides and hair on top, and he wears rare alpha armor from the Chainmail sets through the Hunter sets. Gathering materials is his specialty, and he elevates his defense to the limit before the voyage each time. He is also blessed with good luck by nature, and he is proud to have never lacked even for rare materials on assignments in the Old World.

CHARACTER
■A Master Hunter Who Can Use Any Weapon

He carried out many Special Assignments from the Guild in the Old World. He is skillful at learning how to use any weapon or item in a short time, so he is generally experienced in every weapon type. His dexterity and agility could be said to already be at an expert level. In the New World, his preference is a one-handed sword.

CHARACTER
■He Hides a Past Mistake in His Heart

Thanks to his mentor's advice, he never neglects his armor, but he has been incautious before. While on a large-scale assignment in the Old World, he was put through the mill with a certain monster. A novice, he exposed his mentor and others to danger due to negligence. This bitter experience motivated his growth in the New World.

"My mentor used to say that only two things will save you in the end: strong armor, and remembering to do that one thing you forgot."

TOPIC The Veteran Hunter He Looked Up to as a Mentor

The mentor that the Excitable A-Lister sometimes speaks of is possibly the man who uses dual blades and was the leader of a group called "the Ace Hunters" that took on Special Assignments from the Guild. That man was full of conviction and pride and had an upright, serious personality. The Guild has great faith in the Excitable A-Lister, and he undertakes many Special Assignments even now. Dual blades were one of the Excitable A-Lister's specialties to begin with, so having learned some things from his mentor, he has many points in common with him. The image on the right resembles the Excitable A-Lister. Is this how he looked when his mentor saved his life?

※ Image from Monster Hunter 4G.

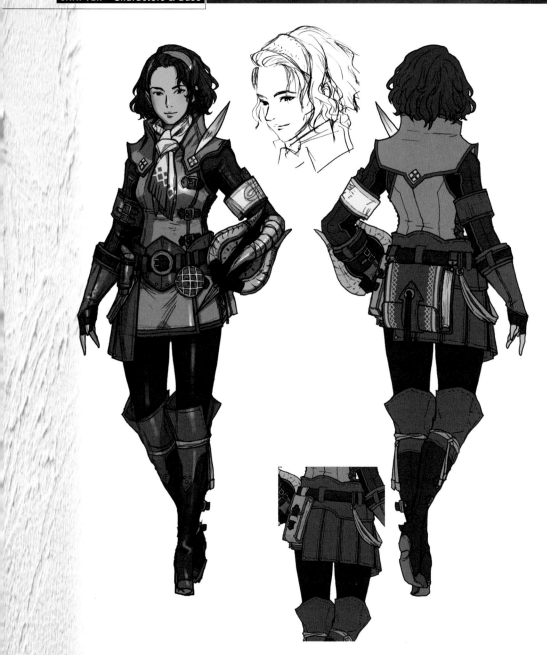

.................................. **Equipment Sketch**

With a mantle that emphasizes ease of movement and a coat that she sometimes removes, the Serious Handler's outfit is standard handler gear but also chic. The scarf around her neck makes that fashionable impression stand out. The insect cage for Scoutflies, which handlers carry around, is a compact type, and her expedition data is attached to her belt.

"You have to think outside the box to survive here. My partner's not good at everything, but he's good at that."

The Serious Handler says that when she saw Zorah Magdaros appear with the dawn, it was like a scene from a fairy tale. When it comes to the operation to capture him, she reports on the situation at the site, and endeavors to find his magmacores.

| CHARACTER |

■A Master Hunter Who Can Use Any Weapon

Whenever the Serious Handler finds something new, she wants to look at it, interact with it, and see what it does. She searches for the data gathered by the compilers of the Fourth Fleet, and she also shows an interest in the Handler's personal project to catalog every last edible and potable in the New World. When she visited the Rotten Vale, the unique ecosystem there moved her heart, and she was surprised and excited by the many flora, fauna, and monsters she saw there for the first time.

| CHARACTER |

■She Joined the Commission in Spite of Opposition

She wants to be free without having to live in a prescribed way. She left home in defiance of opposition from her parents and relatives. Her elder sister was the only one who approved of her joining the Commission. However, after actually being in Astera, she has come to understand just how much those around her were trying to protect her, and she plans to return to her family when their mission is complete.

Soon after arriving in Astera, the Serious Handler displays her excellent abilities as a handler by providing information on the surrounding fields and the small-scale monsters that inhabit them.

When she reads the Handler's *New World Edibles Compilation Project*, a fountain of enthusiasm for the material wells up in her. As fellow handlers, it seems they have much in common.

Serious Handler

Research Commission
Affiliation: Fifth Fleet

A handler who has come to the New World as one of the A-Listers of the Fifth Fleet and serves as the partner of the Excitable A-Lister. She has read various academic texts and has a wide breadth of knowledge in many areas. She has a strong spirit, and those around her acknowledge her intelligence and quick comprehension.

She is entranced with the traditional fairy tale "The Tale of the Five." She especially loves that certain elements of the story are left ambiguous.

Serious Handler

CHARACTERS AND BASE

TOPIC | A Much-Sought-After and Invaluable Handler

Seeking to start making major inroads this time, the Research Commission's fifth deployment boasts the largest number of personnel ever. In regards to recruitment, there are also self-nominated enlistments, and after a strict examination process, those who make the passing grade win the right to join up. The hunters and handlers of the Fifth Fleet's A-List are supposed to work together in a partner system, but the number of handlers available is still quite small. As a result, being able to partner with a handler is in itself very much a mark of status for a hunter.

The Field Team Leader learned swordsmanship from the Huntsman, who is an expert hunter, and also learned about science from the Chief Ecologist. Even though he is young, his abilities are the real deal.

CHARACTER

■A Man Who Has Decided that the New World Is His Home

"You want to come along?" asked the Field Team Leader's parents when they returned to the Old World. He decided to stay. The New World is his home, and he wants to protect "the old man" and everyone in Astera. Now, he is fulfilling those desires.

CHARACTER

■Contributing to the Commission

The Field Team Leader is a pleasant young man who teaches by providing expertise on expeditions. As a hunter, his skill is high, but he occasionally incurs the wrath of his own teachers when he shirks his studies, so he was not suited to being a researcher or handler.

To expand the scope of the exploration of the Rotten Vale, he proposed converting the Third Fleet's vessel into an airship. Perhaps he inherited this penchant for bold ideas from the Commander.

Field Team Leader

CHARACTERS AND BASE

Field Team Leader

Research Commission
Affiliation: None

The Field Team Leader is a young man who skillfully manages the hands-on fieldwork done by the field teams. The Commander is his grandfather, and he is the sole member of the Commission who was born and raised in the New World. As an experienced hunter who lives in the New World, he provides everyone in the Fifth Fleet with varied types of information. One can also catch glimpses of his caring and kindness towards the Commander too.

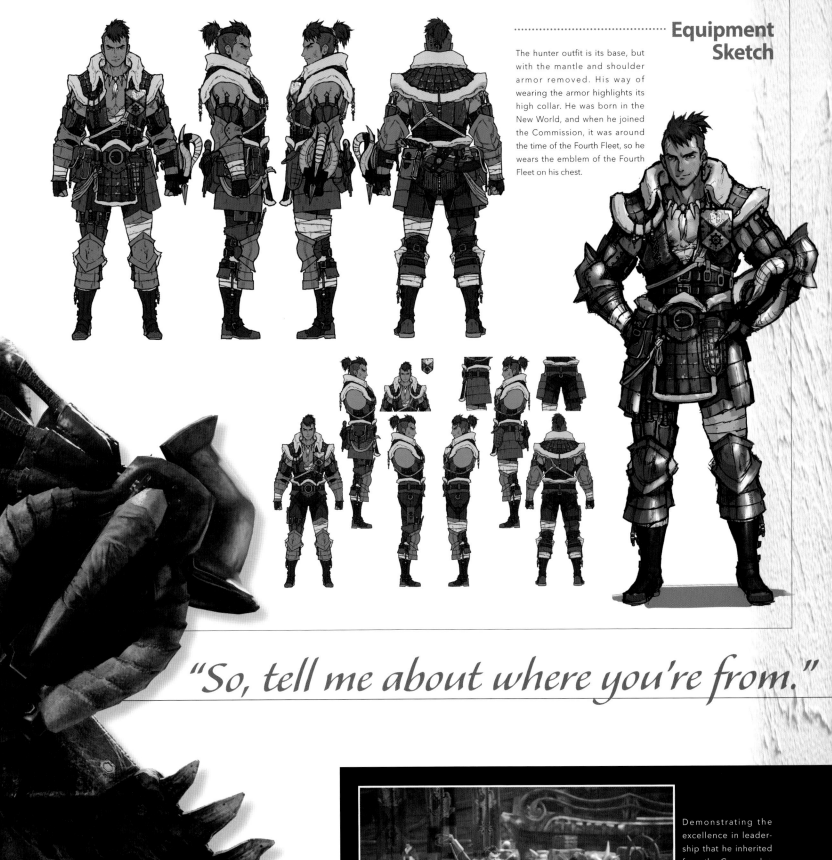

Equipment Sketch

The hunter outfit is its base, but with the mantle and shoulder armor removed. His way of wearing the armor highlights its high collar. He was born in the New World, and when he joined the Commission, it was around the time of the Fourth Fleet, so he wears the emblem of the Fourth Fleet on his chest.

"So, tell me about where you're from."

Demonstrating the excellence in leadership that he inherited from the Commander, he manages the Field Team. He not only leads expeditions, he also recruits personnel himself, and is actively engaged in making contact with all relevant departments as well.

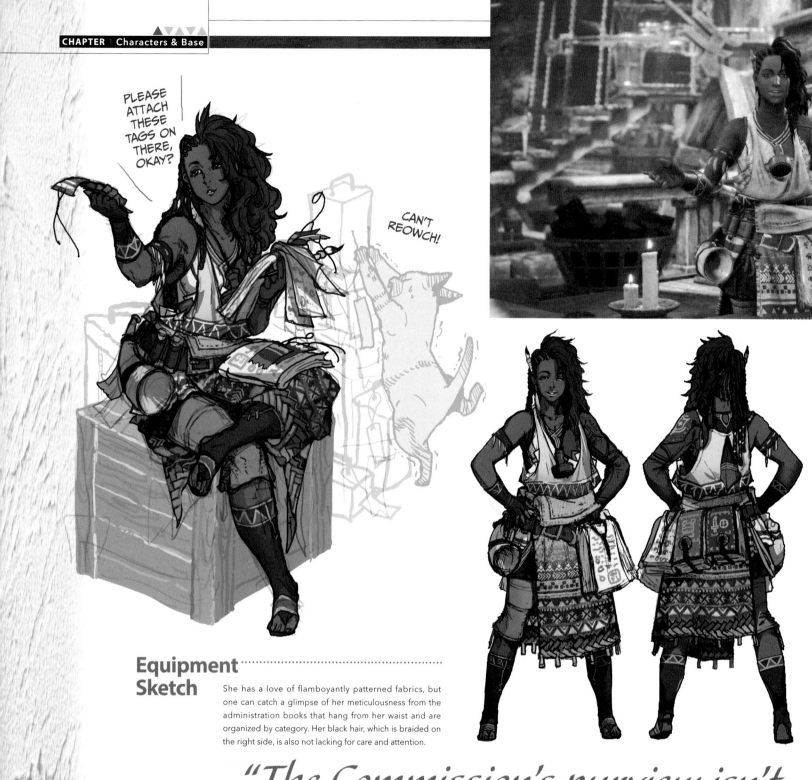

PLEASE ATTACH THESE TAGS ON THERE, OKAY?

CAN'T REOWCH!

Equipment Sketch

She has a love of flamboyantly patterned fabrics, but one can catch a glimpse of her meticulousness from the administration books that hang from her waist and are organized by category. Her black hair, which is braided on the right side, is also not lacking for care and attention.

"The Commission's purview isn't limited to just monsters."

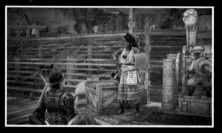

She and the two other heads in the Resource Center are commonly known as "the Leaders." She runs headquarters along with them, and she also gives instructions for the preparation of camps in new areas.

CHARACTER

■After Living a Life Seeking Stimulation

When asked about coming to the New World with the Fourth Fleet, the Provisions Manager half-jokingly said, "I used to run a black market in the Old World. Let's just say that being here is a better use of my 'skills.'" She doesn't have any family, and even if there were a regular boat service returning to the Old World, "It would be boring to go back." She is a prisoner to the thrill of the unknown.

CHARACTER

■A Talent for Managing the Provisions Team

She loves keeping things tidy and organized, but she loves the charm of a good mess even more. When it comes to managing provisions, the importance of orderliness doesn't need to be explained, but being able to enjoy messiness is common in creative people. The flashes of inspiration born of her messes are also sometimes creatively necessary.

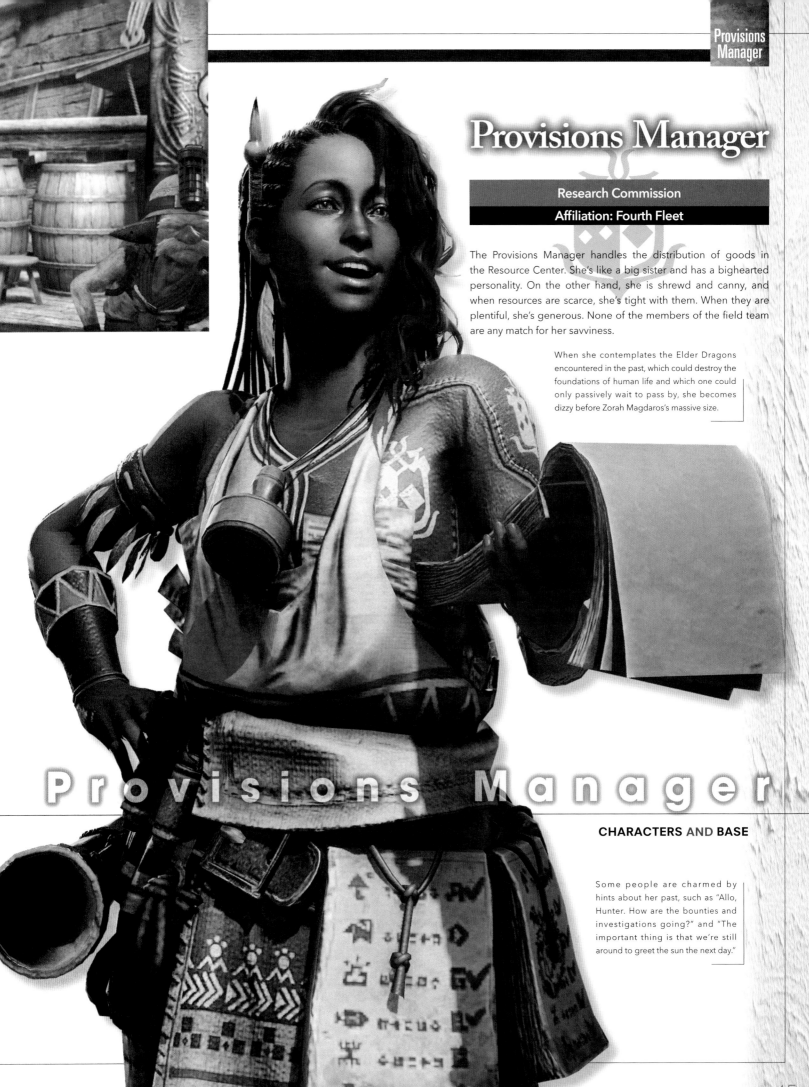

Provisions Manager

Research Commission
Affiliation: Fourth Fleet

The Provisions Manager handles the distribution of goods in the Resource Center. She's like a big sister and has a bighearted personality. On the other hand, she is shrewd and canny, and when resources are scarce, she's tight with them. When they are plentiful, she's generous. None of the members of the field team are any match for her savviness.

When she contemplates the Elder Dragons encountered in the past, which could destroy the foundations of human life and which one could only passively wait to pass by, she becomes dizzy before Zorah Magdaros's massive size.

CHARACTERS AND BASE

Some people are charmed by hints about her past, such as "Allo, Hunter. How are the bounties and investigations going?" and "The important thing is that we're still around to greet the sun the next day."

45

After using metaphors about the New World "rooting" for things and "signs from the heavens," the Analytics Director sometimes adds a punch line as if he were making a human jest.

KEY WORDS [Wyverians]

A race existing since ancient times, and which has a unique knowledge differing from that of humans. Their outward distinguishing characteristics include long ears, four digits on each hand and foot, and long heels on their feet. They have extremely long lifespans, but their fertility is low so they are few in number at present.

He's normally verbose, but when talk of the Third Fleet comes up, he suddenly lapses into silence and his gaze wanders off. His sister met with an accident soon after he summoned her to the New World, and it is possible he feels some guilt about that.

Analytics Director

CHARACTERS AND BASE

Analytics Director

Research Commission
Affiliation: Second Fleet

The Analytics Director is the person in charge of all investigations and deliveries in the Resource Center. He is one of those genius scholars who are called odd and eccentric, and he has excellent human resource management skills. He also has a deep connection with the Guild, which deploys the Commissions. His academic jokes have a universal reputation for never being funny.

Equipment Sketch

The Analytics Director wears the standard robe of scholars and always has an academic text in his hands. He has a habit of tying a brush to the end of his long braided hair so that the precious implement is not lost.

ANTIQUE BOOK

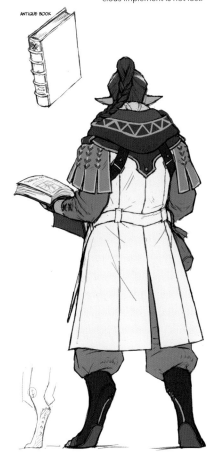

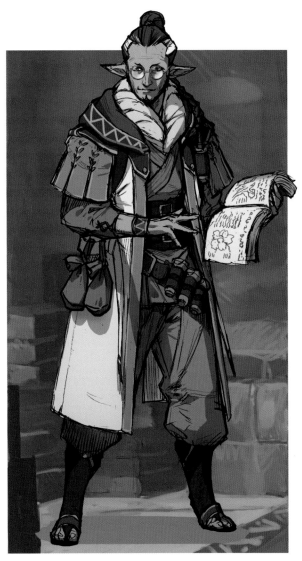

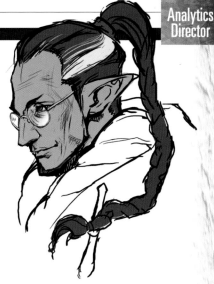

CHARACTER

■ **The Position of a Leader and the Duties of a Researcher**

His main role is analyzing all the data from investigations in the Resource Center. He also decides how projects progress and assigns personnel. His days are spent busily reporting to the Commander and the Guild with instructions and progress reports. Buffeted by these day-to-day duties, he sometimes grumbles that his true desperate wish is to be immersed in his own studies. After arriving in the New World with the Second Fleet, he became far too busy, so he asked his sister to join him there as well.

CHARACTER

■ **An Unexpected Faculty for Managing Scholars**

Scholars often bury themselves in study and act accordingly. The best way to keep them in line is to let each of them do what they enjoy most. He is confident that this is the best method for the current lineup.

"Each Elder Crossing means we have to re-create our maps. But it's easy! We just 'cross' out the old landmarks...ha ha!"

He is deeply knowledgeable about biology, botany, and other natural sciences, and his excitement and craving for investigating the Elder Crossing surpasses even his hard work redrawing the Wildlife Map.

TOPIC Similar Siblings?

The Third Fleet Master is the Analytics Director's younger sister. Though they both deny it, it must be said that they are similar in their talent as researchers, their unconventional imagination, and their tendency to tell unfunny jokes, among other things. One also senses their blood relationship in the way they both often mistakenly think they have lost their glasses.

I'VE LOST MY GLASSES.

Chief Botanist

"The tree itself is an amalgam of many different plants, so we leverage that property in our agricultural work."

Chief Botanist

A Wyverian who studies flora, the Chief Botanist is the young director of Botanical Research. He focuses on ancient trees to unravel the mysteries of the ecosystem. He forgot about the arrival of the Fifth Fleet. He is deeply interested in plants and uses them even when drawing metaphors about people.

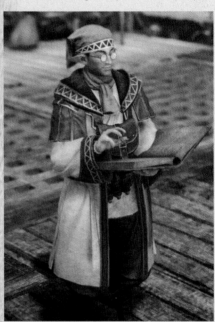

Missing Biologist

This Wyverian scholar is a passionate investigator. Once, he became so immersed in observing Nergigante attacking a Barroth that he needed to be rescued. According to the Handler's grandfather, "The scholar's enthusiasm sometimes runs ferociously wild." He wears turbans, wraps on his arms, and leggings to keep out sand.

Captain

The Captain is an experienced sailor who has mastered all types of ships. To make sure that the fleet is safely sent off and welcomed, he always keeps an eye on the New World's uniquely harsh conditions. When he was a novice, he joined the First Fleet and came to the New World.

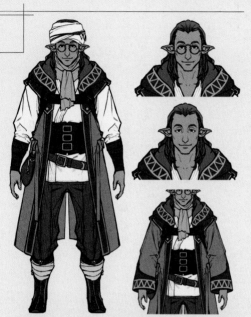

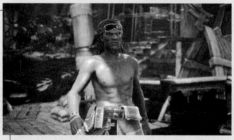

Staring out at the sea in silence every day, he reads the waves. That skill is useful when it comes to things like scheduled trade ships.

Provisions Stockpile

A man in the Fourth Fleet who deals with the Provisions Stockpile. He's an old friend of the Provisions Manager and came to the New World as her right-hand man. He has a good nose for figuring out what resources are needed. He is frugal and strict when it comes to accounting.

He spotted a woman who ran numerous lawless markets and became her apprentice.

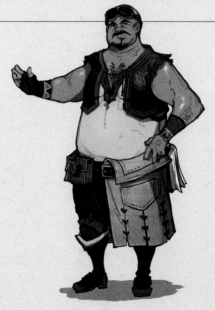

Many merchants wear an apron on one side like this man.

Smart Biologist

The Smart Biologist is a Wyverian who once belonged to an organization that studies Elder Dragons. He applies himself and is even more passionate about endemic life than he is about Elder Dragons. He seeks hunters who can capture monsters and other endemic life.

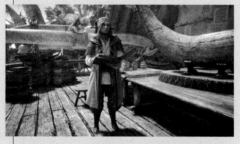

He attaches identifying marks to captured monsters and releases Scoutflies for follow-up studies.

OTHERS

CHARACTERS AND BASE

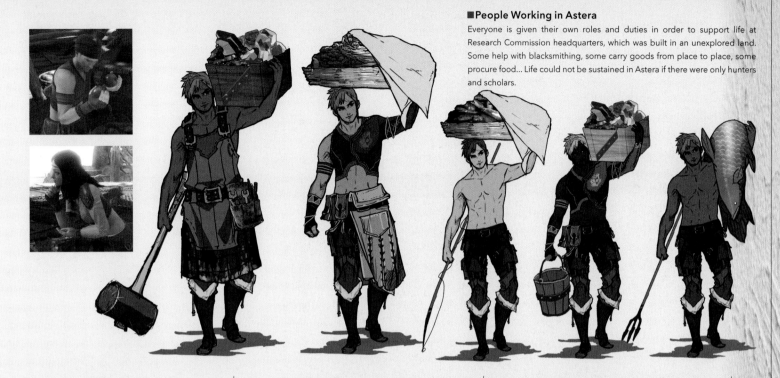

People Working in Astera
Everyone is given their own roles and duties in order to support life at Research Commission headquarters, which was built in an unexplored land. Some help with blacksmithing, some carry goods from place to place, some procure food... Life could not be sustained in Astera if there were only hunters and scholars.

Armory

A woman from the Second Fleet runs the Armory workshop. She manages all of the weapons in Astera. She also makes efforts to develop Specialized Tools and seeks hunters to aid that development. Needless to say, the hunters of the Fifth Fleet have caught her attention.

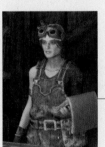

She sells ready-made articles, manages the provision of arms and armor in Astera, and creates many Specialized Tools.

Feisty Fiver

A hunter who uses a heavy bowgun and protects scholars. He is often baffled by their bravery.

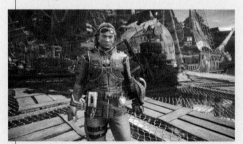

When a scholar investigating tracks strayed from his escort and went missing in the Wildspire Waste, he joined the advance search party.

Cool Fiver

A dual blade user with a cool vibe. She decided to travel to the New World after reading a report. It detailed everything about the Commission, and it even had an account of Rathalos flying in the sky. When she read it, she got goose bumps. It brought tears to her eyes.

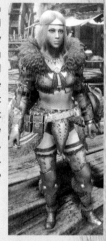

Fiver Bro

A hunter who does nothing but eat at the Canteen and accept assignments from the Meowscular Chef to find ingredients. He has discovered many ingredients, and the Guild appreciates him for that.

He happily accepted the Guild's recommendation. The Canteen menu was mentioned in leaflets about the Fifth Fleet.

Forceful Fiver

Fascinated by unknown monsters, she came to make a name for herself. However, since falling in love with the mission, she has realized that it's not all about her.

Timid Fiver

Due to his interest in weapons used in the New World, this hunter enlisted. On days off, he polishes his weapon and helps at the Resource Center.

Easygoing Fiver

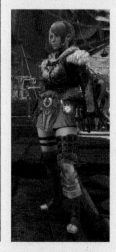

It is said that the only folks who come to the New World are geniuses, weirdos, and troublemakers, and the Easygoing Fiver is proof. When speaking of being thrown into the sea by Zorah Magdaros, she claims she actually enjoyed everything. She sometimes mistakes the Admiral for a Rajang, but she is quite tough.

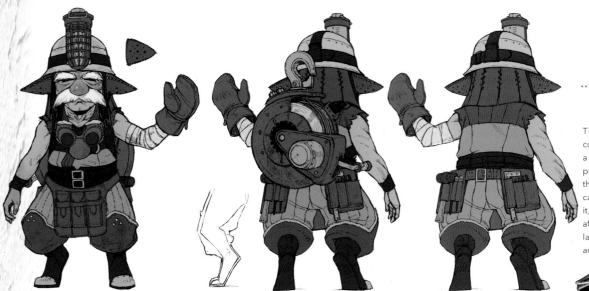

Equipment Sketch

The Tech Chief wears a tool bag containing his favorite implements and a mitten on his left hand, and he takes pride in the rope system for climbing that he carries on his back. His Scoutfly cage has a reflector plate installed in it, and has been improved so it can be affixed to his helmet and be used as a lantern while working. His large ears and nose are protected by leather pads.

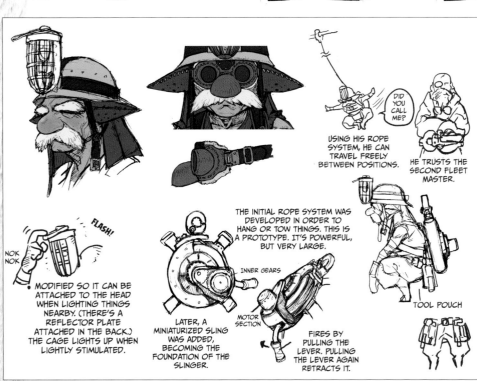

USING HIS ROPE SYSTEM, HE CAN TRAVEL FREELY BETWEEN POSITIONS.

DID YOU CALL ME?

HE TRUSTS THE SECOND FLEET MASTER.

FLASH!

NOK NOK

MODIFIED SO IT CAN BE ATTACHED TO THE HEAD WHEN LIGHTING THINGS NEARBY. (THERE'S A REFLECTOR PLATE ATTACHED IN THE BACK.) THE CAGE LIGHTS UP WHEN LIGHTLY STIMULATED.

THE INITIAL ROPE SYSTEM WAS DEVELOPED IN ORDER TO HANG OR TOW THINGS. THIS IS A PROTOTYPE. IT'S POWERFUL, BUT VERY LARGE.

INNER GEARS

LATER, A MINIATURIZED SLING WAS ADDED, BECOMING THE FOUNDATION OF THE SLINGER.

MOTOR SECTION

FIRES BY PULLING THE LEVER. PULLING THE LEVER AGAIN RETRACTS IT.

TOOL POUCH

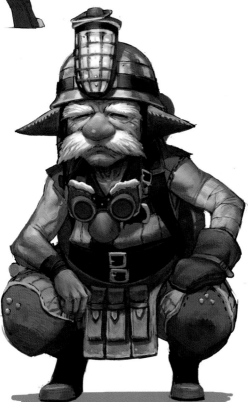

"Lucky for you, that's where I excel!"

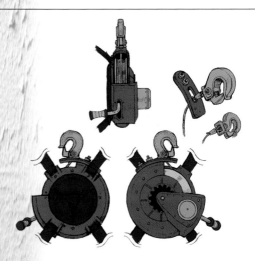

CHARACTER

■ Astera's Longest-Serving Engineer

The Tech Chief set foot in the New World as part of the First Fleet and was a leading figure in the construction of Astera from scratch in a place where there was nothing. When they first landed, there were only two engineers in the group, including him. During those first ten years, until the Second Fleet arrived, creating a base was very hard work. Even so, he maintained the credo "success is mostly about preparation." He says that he prefers preparation to actually carrying things out, and he is said to have a craftsman's spirit through and through.

CHARACTER

■ Creating the Basis of the Rope System

He calls himself the New World's top inventor, and the first model of the rope system that hunters carry on their backs was created by him. It was used for getting around between points, and the slingers later developed by the Second Fleet Master employ one part of its mechanism. Even so, one can sense a fixation in his daring to continue to use such a rustic rope system. In addition, he is also laying down the groundwork to blur the lines between blademasters and gunners through the look of the armor of the hunters.

He does all sorts of work, big and small, and is familiarly called "the old engineer" by the Second Fleet Master, the Armory, and other engineers.

He can't stay calm if he hasn't gathered enough things together. If he hears from the Meowscular Chef that the Canteen is short on ingredients, he'll order their delivery even if it's outside his jurisdiction.

Tech Chief

Research Commission

Affiliation: First Fleet

A Wyverian who manages all of Astera's mechanical equipment and materials in the Resource Center. He is proficient in working with arms and armor and also in construction. He designed and assembled Astera, the Commission's largest base, and where many people reside. He was famous as an inventor back home and is known for his forthright but eccentric personality.

CHARACTERS AND BASE

The First Fleet was said to have been a collection of geniuses, weirdos, and troublemakers, and he is an exceptional genius and troublemaker. He hates being bored, and invention is his reason for living.

Second Fleet Master

Research Commission
Affiliation: Second Fleet

The leader who bound together the Second Fleet, which was made up mostly of engineers. He happens to be flexible in his thinking and has no issues with making refinements and alterations to existing items. He has been creating gear for the hunters through stubborn obsession and assured skills. He makes good use of those skills as Astera's arms and armor smithy.

He likes to create new gear himself using Elder Dragon material from expeditions. His dreams as a technical expert are fulfilled through the Elder Dragon investigations.

Hunters from his period and earlier have retired and returned home for reasons of age, among other things, but technicians who live for the craft remain in the New World.

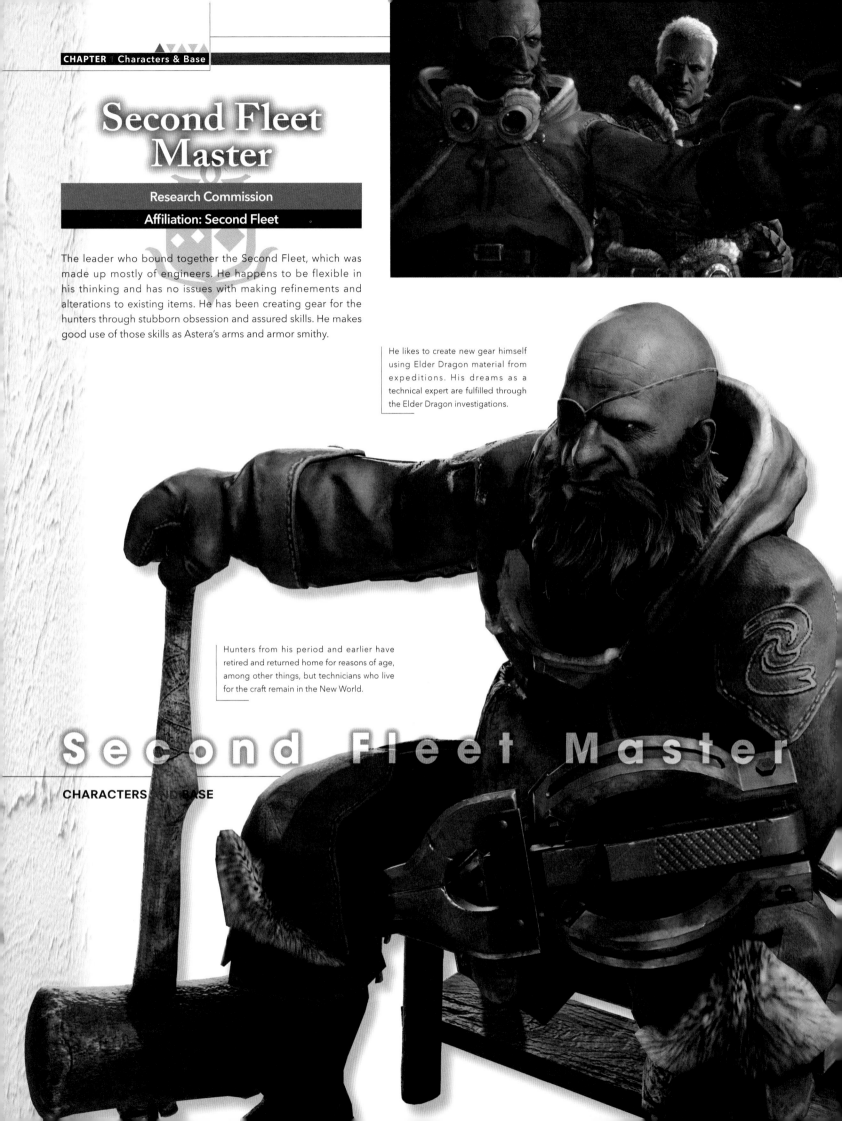

Second Fleet Master

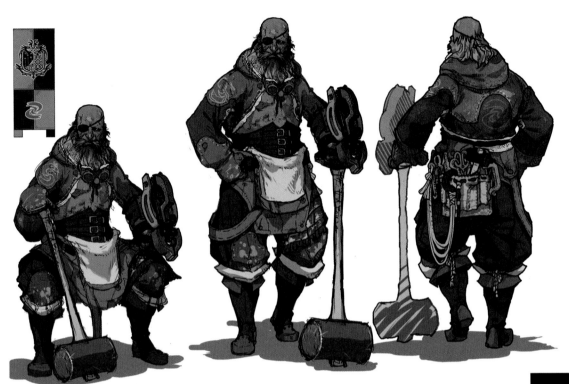

Equipment Sketch

He dresses in a blacksmith's style, mainly in leather. He sometimes works with large implements in his lap, so he wears a metal armor apron on his left thigh. His slinger is of a rough design and is an archetype of the slingers that are popular in Astera now. He revamped it after consulting with the hunters. The motivation behind his idea for the prototype model was that his back was ailing him and he needed a better way to get around. His slinger is shaped like pliers and is also useful for grasping tools and bringing them to him. After many years of continuously staring into flames to do his work, his eyesight has deteriorated markedly in one eye and he now wears an eye patch to protect it. He claims to live for the craft, but there's no winning against his hazy vision.

CHARACTER

■ Leader of the Engineering Team

Most of the Second Fleet was made up of engineers. Aiming to strengthen infrastructure in the New World, the First Fleet requested engineers with can-do spirits. He served as the leader of this group of engineers and is renowned not just for his technical skills, but also his imagination.

CHARACTER

■ A Flexible Imagination and Continuing Advancements

He displays an innate creativity regarding expeditions. He produces Charms with techniques from the First Wyverians and surpasses the enhancement limits of equipment with Streamstones. He is proud of constructing the Special Arena in the Great Ravine as well.

The Tech Chief holds him in high esteem, saying, "I've stared into the flames long enough to burn away most of my sight, but I still can't hold a candle to that Wyverian wizardry he does." When he comes to work on equipment, he never fails to have advice for the hunters.

"Don't hoard your materials. Use them to create equipment that will serve you better."

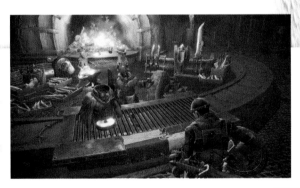

TOPIC | Innovating Armor Specs! Standardizing Blademaster and Gunner Gear

It was the Second Fleet engineers who proposed that the barriers between blademaster and gunner gear should be removed when it comes to the development of armor in the New World. "Sure, some folks balked at the idea, but no one stopped it," he reflects. In a situation in which materials are rare, such efforts by these engineers have become a major asset.

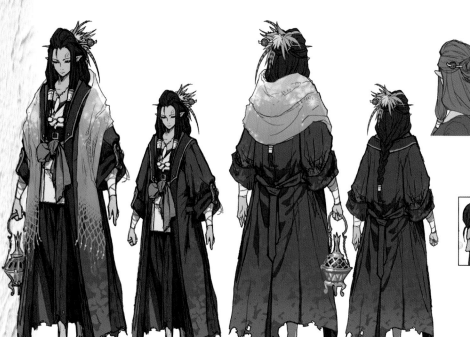

Equipment Sketch

The Wyverians place great importance on nature and harmony, so few of them wear heavy equipment like hunters. The Third Fleet Master wears the unlined clothing preferred by Wyverians and a largish scholar's robe that hangs loosely. The floral patterns on her robe are stains that were made during the course of experiments. The hem is ragged. Her beautifully woven shawl is one of her favorite things to wear.

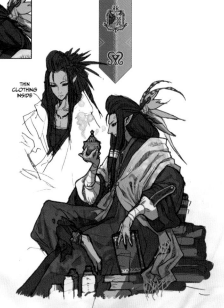

THIN CLOTHING INSIDE

CHARACTER
■ She Joined the Commission at Her Brother's Invitation

The Third Fleet was made up mainly of scholars in order to accelerate New World investigations. She led them and made the voyage after being requested to do so by her older brother. She has a strong appetite for research and shows a deep interest in the Elder Crossing and in the ecosystem of the Rotten Vale.

CHARACTER
■ She Attempted to Fly the Third Fleet's Ship in the Sky

Seeking to expand into the northern reaches of the New World, she proposed converting the vessel they arrived in into an airship. This unconventional and bold idea bore fruit, but after being attacked by a monster soon after crossing the Great Ravine, her and her crew were trapped in the Coral Highlands for the past twenty years. However, she does not regret her decision.

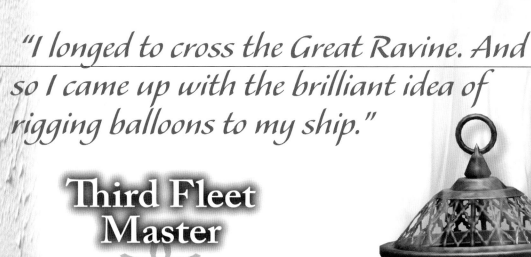

"I longed to cross the Great Ravine. And so I came up with the brilliant idea of rigging balloons to my ship."

Third Fleet Master

Research Commission
Affiliation: Third Fleet

The Third Fleet Master is the leader of the group of scholars that made up the Third Fleet. She is called eccentric and weird, but she is a genius of a scholar. Her specialty is neuroscience, with a focus on olfactory perception. After arriving in the New World, she tried to cross the Great Ravine with an airship, but she met with disaster and now continues her research in the Coral Highlands where they crashed.

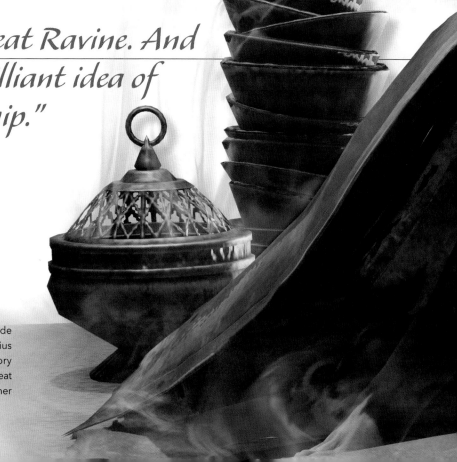

Impeded by the precarious terrain of the Great Ravine, the scholars of the Third Fleet have been left behind in the Coral Highlands. The First Fleet's Tracker, who visits at times, is their main means of communication.

She feels emotional and respectful towards things she hasn't seen before, and when she sees a bird for the first time, she plucks one feather from it in commemoration. She has arranged these into a hair ornament.

She says she doesn't believe in coincidence, and that's why she became a researcher. She also reasons, "They say that to have is to want more. Maybe Xeno'jiiva could never have enough."

Third Fleet Master

CHARACTERS AND BASE

Jovial Scholar

"I was aware that Zorah Magdaros was an enormous beast, but I am in shock over how gargantuan it really is..."

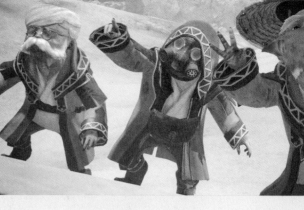

The scholars are masses of curiosity. Seeking to collect evidence regarding Zorah Magdaros themselves, they hitch a wagon and set off on an expedition.

■ Bare Face of the Three Scholars

Each scholar hides their face. The Upbeat Scholar wears a conical hat and a cloth mask. The Lively Scholar wears a hood and a dust mask. The Jovial Scholar has a turban and a mustache.

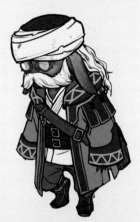

▼Upbeat Scholar ▼Lively Scholar ▼Jovial Scholar

The Three Scholars

The Upbeat Scholar, Jovial Scholar, and Lively Scholar always operate together, so they are collectively known as "the three scholars." They are Wyverians who don't hesitate to proceed to a location themselves if it is for research. Also, according to the Smart Biologist, they form "the Go-Getters," and they also help with follow-up studies on captured monsters.

Chief Ecologist

The Chief Ecologist carries out various monster studies. He is a Wyverian, and no one surpasses his knowledge of New World monsters. He's difficult, but also kind to the hunters. He's bad at tidying up. He is focused on the migration of the Elder Dragons, and he is absorbed in researching the secret of Zorah Magdaros. He greatly anticipates field reports.

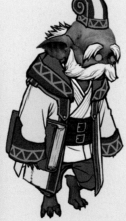

He sees information gained from captured monsters as precious, and his opinion is that rewards for captures should be upped.

Impatient Biologist

A Wyverian scholar of the Third Fleet who is well versed in monster ecology. She traveled to the New World along with her husband, who aspires to the same academic path. In their current research, she is making every effort to deduce where Zorah Magdaros is headed.

Laid-Back Botanist

A Wyverian Third Fleet scholar who studies plants and fungi. The wide varieties of fruits and seeds that can be cultivated in the Ancient Forest and the spread of Harvest Boxes are due to her research.

Wyverian Trends

Conical sun-blocking hats are a popular item with the Wyverians of Astera. Most wear shades of blue, creating a sense of unity. The formal uniform of a researcher includes a scholar's robe and hat. That said, there do seem to be some rebels among them.

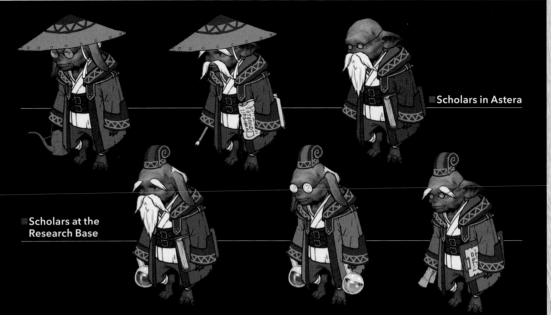

Scholars in Astera

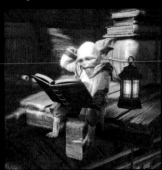

Scholars at the Research Base

Lynian Expert

This Third Fleet Wyverian scholar researches the Lynians of the New World, starting with the Grimalkynes. She is called "Kitty Gran" by friendly hunters and Palicoes. The never-ending sneezing that started when she began this research is a source of anxiety.

She dispatches the other Palicoes of the Fifth Fleet from the Research Base to various locations where they conduct research as "Tailraider Safaris." Without her research, this venture would not have been realized.

Shy Scholar

A Wyverian scholar of the Third Fleet who is studying the language of Lynians and First Wyverians. She says their language is more about vibrations. She also says that nature is a cruel, unforgiving mistress.

Cheerful Scholar

A scholar who studies the Rotten Vale and dreams of flying. Perhaps that's why he studies Flying Wyverns. When the Third Fleet Master proposed crossing the Great Ravine in an airship, he quickly agreed.

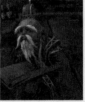

Third Fleet Provisions

A Wyverian scholar entrusted with managing resources at the Research Base. He prides himself on being more on top of things than anyone else. He keeps field samples and materials tidy and in order. He's convinced that their study of the Coral Highlands and the Rotten Vale has led to at least one truth: "Life is beautiful."

The scholars of the Third Fleet all have a weakness for alcohol. They make requests for the procurement of ingredients for Master Ale and Ratha Whiskey. "But keep it secret from the people in Astera," they say.

Elder Melder

A Wyverian scholar of the Third Fleet who conducts research into Melding—a unique art that is known across the New World. He does his work at the Research Base, but later on he moves to Astera. He creates Charms and valuable materials.

Mixing things in the Melding Pot apparently causes him to be struck by an incomparable sleepiness. The burden on his back is also harsh.

OTHERS
CHARACTERS AND BASE

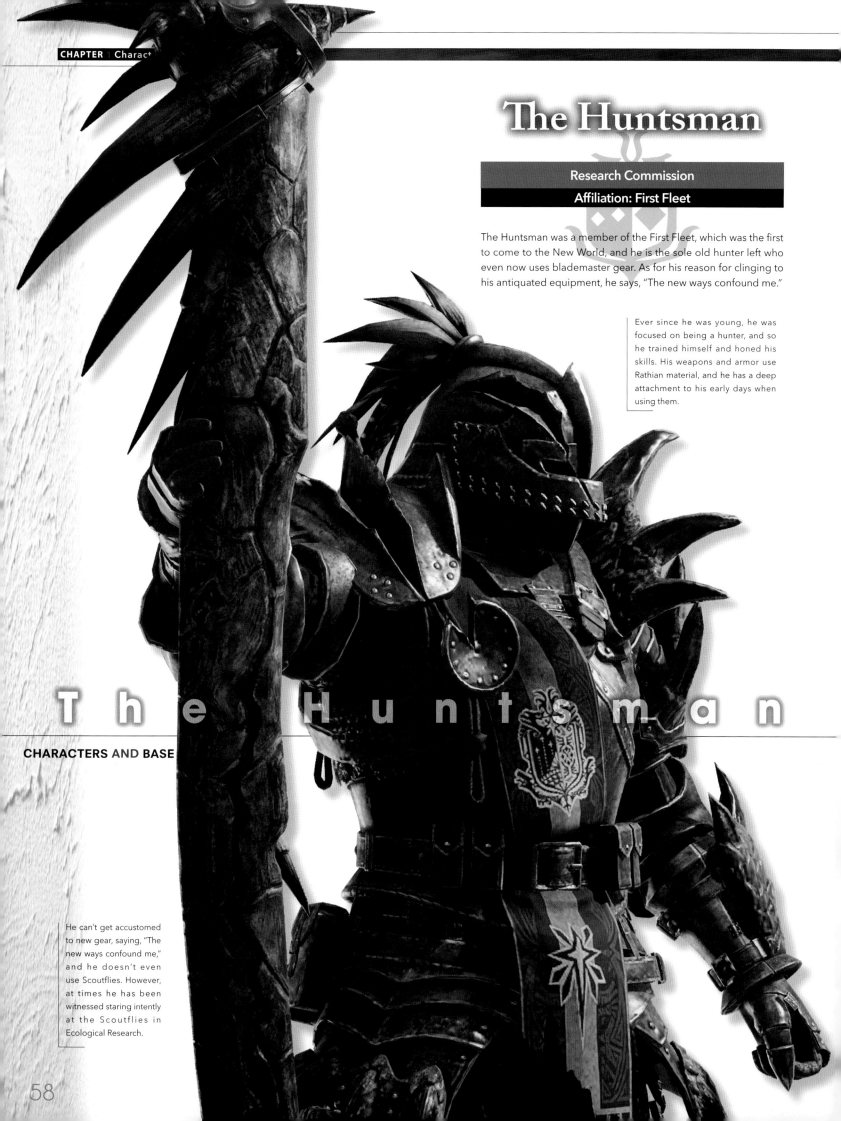

The Huntsman

Research Commission

Affiliation: First Fleet

The Huntsman was a member of the First Fleet, which was the first to come to the New World, and he is the sole old hunter left who even now uses blademaster gear. As for his reason for clinging to his antiquated equipment, he says, "The new ways confound me."

Ever since he was young, he was focused on being a hunter, and so he trained himself and honed his skills. His weapons and armor use Rathian material, and he has a deep attachment to his early days when using them.

CHARACTERS AND BASE

He can't get accustomed to new gear, saying, "The new ways confound me," and he doesn't even use Scoutflies. However, at times he has been witnessed staring intently at the Scoutflies in Ecological Research.

Equipment Sketch

He only uses Rathian set equipment, has the flag of the First Fleet over his shoulder, and carries a long sword. His armor is similar to the blademaster gear of the Old World and differs in detail from the combination blademaster/gunner gear that is the mainstream in present Astera. He actually doesn't even equip a slinger either. The Field Team Leader taught him how to use a slinger, but the Huntsman struggles to take to it.

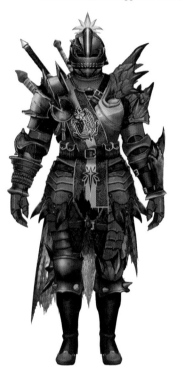

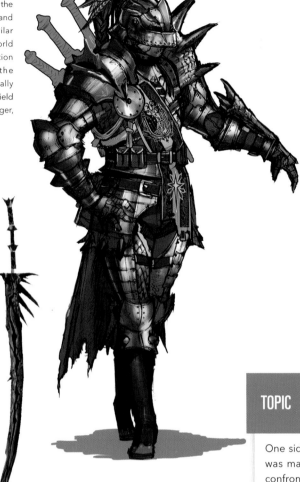

CHARACTER

■ A Single-Minded Blademaster, a Reticent Expert

He is proficient in all types of close-range weapons and is a master of the long sword in particular. He commenced his expeditions in the New World forty years ago, and he is still in active service as a hunter, even now taking on various missions. He is also the one who trained the Commander's grandson, the Field Team Leader, in swordsmanship. He doesn't say much, but he carries out his missions and expeditions in an upright manner, and many hunters are inspired by and admiring of his way of life.

CHARACTER

■ Takes Assignments as the Commander's Right-Hand Man

He is normally found sitting in one corner of headquarters, but he frequently disappears. During the Zorah Magdaros capture operation, he accepts a request from the Commander and heads off to investigate Nergigante. One can surmise the depth of his ability from the fact that he does not rely on handlers or Scoutflies and is able to function on experience and instinct.

TOPIC | Recollections Carved into Old Wounds

One side of his helm has a large scar gouged into it. This was made by an Elder Dragon called Teostra, which he confronted on several occasions in the Old World. At the time, he had two rivals whom he competed against day after day, honing his skills. One was a fierce warrior type, the other more playful. He often reminisces about that time.

"When braving new territory, keep your senses sharp. And if those fail you, let instinct and spirit be your guide."

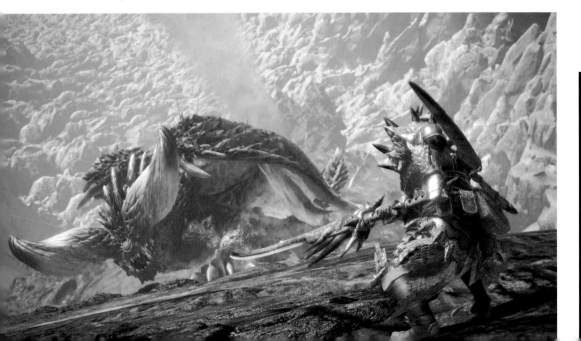

In times of crisis, he displays refined fighting maneuvers, but, perhaps because of his age, he also sometimes falls asleep in a sitting position. When lying down in bed, it seems his old hunter nature shows through.

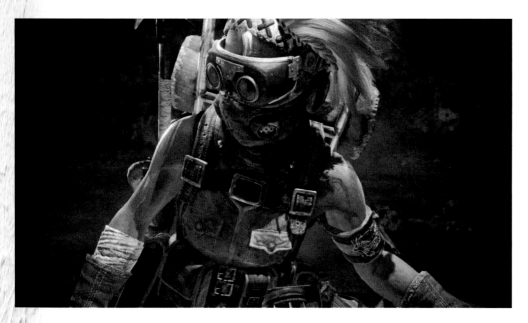

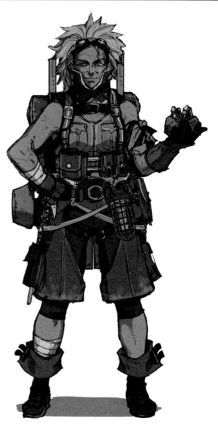

The Tracker is well acquainted with geography and monster ecology, and she makes use of a variety of things as in her continued solo investigations. She became friends with the Third Fleet Master, and sometimes they meet for tea. She also feels comfortable with the messy state of the Research Base.

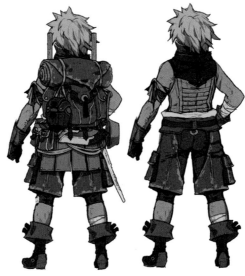

Equipment Sketch

She wears a vest jacket and shorts that look like chain mail gear with the armor taken off. A fleet flag is wrapped around her left arm. This is very light gear for a hunter, but the Tracker is never without her anti-effluvium goggles and mask. She made her slinger herself, and it can also be used as a staff. The Tracker holds it in both hands when firing it.

"Look. It's raining life."

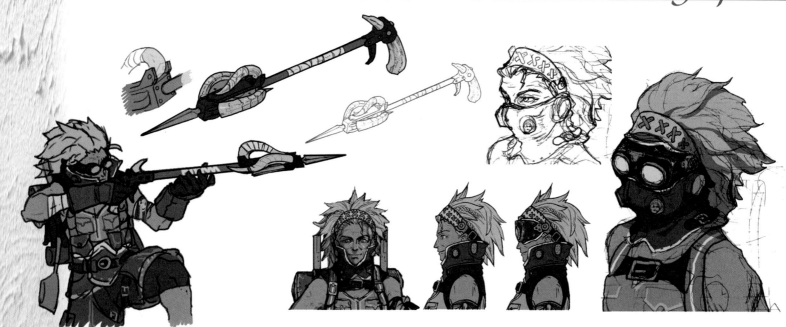

The Tracker

Research Commission

Affiliation: First Fleet

The Tracker is a member of the First Fleet, a combination of hunter and handler. She truly believes in the importance of compiling data and first proposed the hunter/handler buddy system. She is strong in the natural sciences as a whole and can explore the Rotten Vale by herself. She also rediscovered the Research Base after contact had been lost when it flew off as an airship, and she has acted as its means of communication with Astera since. Upon arriving in the New World, she refrained from operating as a hunter and instead devoted all her time to field work—compiling data, surveying locales, and conducting research.

CHARACTER

■A Hunter That Holds Court on the Importance of Research

The First Fleet was a collection of personnel with extremely high fundamental abilities, but building infrastructure was still difficult. Relying on individuals was especially inefficient and dangerous when it came to expeditions. The Tracker proposed pairs for exploratory work: a handler to organize information and a hunter with exceptional physical abilities. As a result, the Fourth Fleet onward saw great progress in their investigations.

The number of people that can cross the Great Ravine like she does is limited. Hindered by the harsh environmental conditions there, she often went several months or even years without contacting the Research Base.

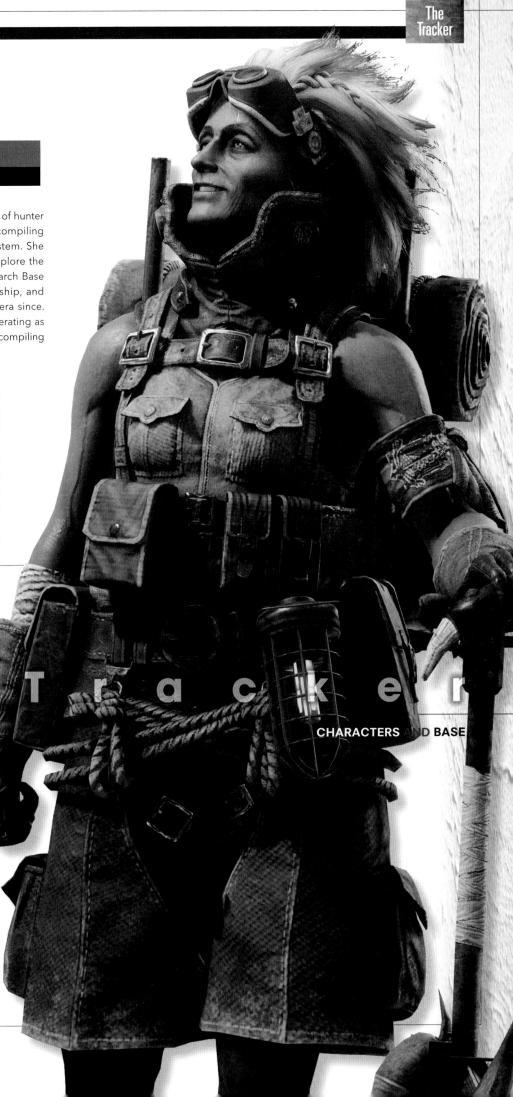

T h e T r a c k e r

CHARACTERS AND BASE

She meets the hunter by chance, rescuing them after they had fallen into the Rotten Vale. Afterwards, she feels a kind of concern for the Handler, who is a data compiler like her.

CHARACTER

■Pursuing the Principle of Life

The Tracker seeks the origins of life, due to a strong desire to see how it changes, and so she has been exploring the Rotten Vale and the mystery of the Elder Crossing for many long years. She has reached one hypothesis. The arrival of the Fifth Fleet indicates that it's time for the long-awaited validation of her ideas.

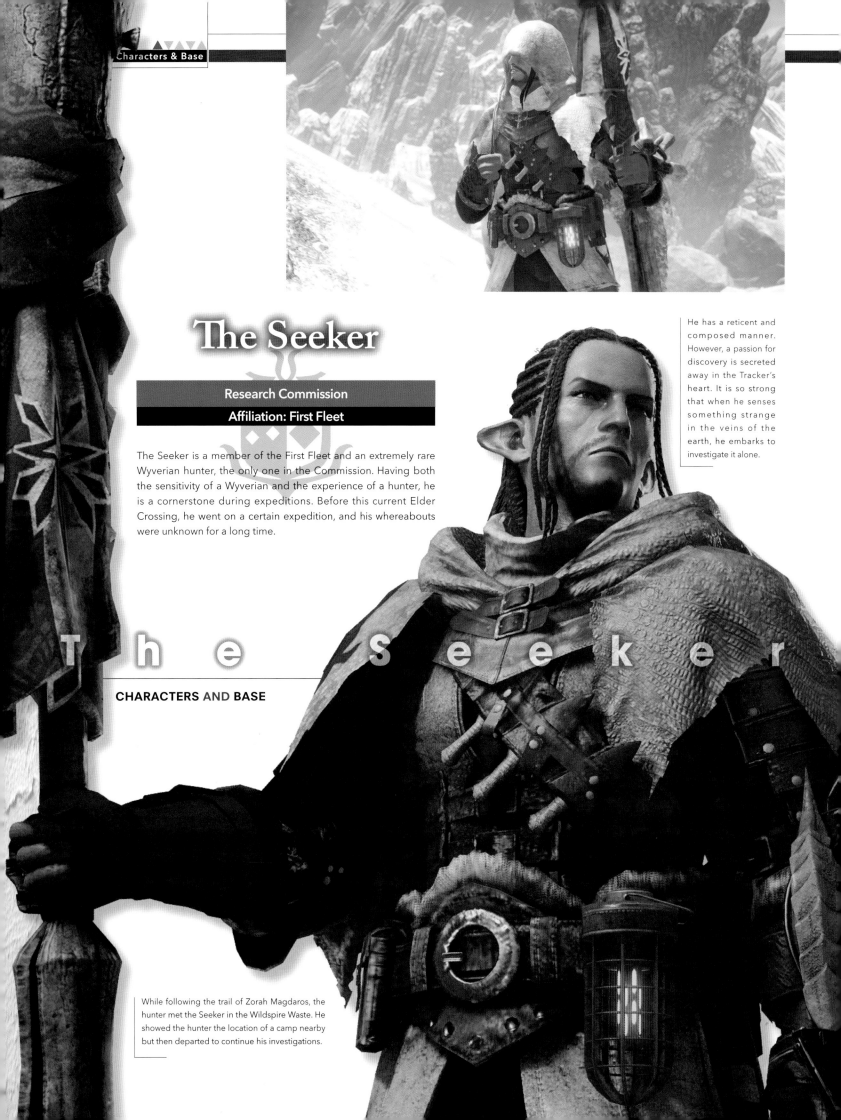

The Seeker

Research Commission

Affiliation: First Fleet

The Seeker is a member of the First Fleet and an extremely rare Wyverian hunter, the only one in the Commission. Having both the sensitivity of a Wyverian and the experience of a hunter, he is a cornerstone during expeditions. Before this current Elder Crossing, he went on a certain expedition, and his whereabouts were unknown for a long time.

He has a reticent and composed manner. However, a passion for discovery is secreted away in the Tracker's heart. It is so strong that when he senses something strange in the veins of the earth, he embarks to investigate it alone.

CHARACTERS AND BASE

While following the trail of Zorah Magdaros, the hunter met the Seeker in the Wildspire Waste. He showed the hunter the location of a camp nearby but then departed to continue his investigations.

Equipment Sketch

The Seeker wears the same type of armor as the Commander, but his is differently colored. Since the bone structure of Wyverians' legs differs from that of humans, he wears leggings made from animal hide. He carries an insect glaive wrapped in a fleet banner, but he uses it mainly as a staff and a tool to clear paths.

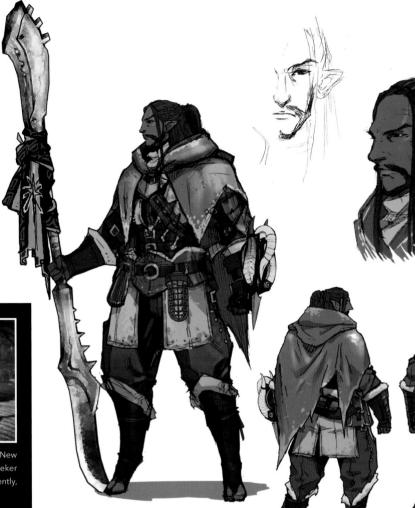

The five remaining members of the First Fleet in the New World often work alone now. Among them, the Seeker and the Commander feel the passage of time differently, but they have built a relationship of mutual trust.

"It seems so easy... Follow the trail, find the truth..."

TOPIC On the Differences of Wyverian Ages and Physiques

Wyverians have life spans that are said to be many times longer than those of humans. The Seeker and the Third Fleet Master are considered to be young for Wyverians, but rumor has it that even they are well over a hundred years old. There are also large differences in body size depending on the individual and their ethnicity.

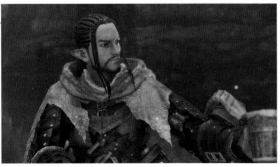

Some of them take up key positions in organizations because they are valued for their abundant experience, gained from living for long periods. However, few Wyverians actively interact with humans.

CHARACTER

■The Un-Wyverian Profession of Hunting

By nature, Wyverians prefer nature and harmony and hate conflict. They live impressively long lives. Also, due to their excellent intelligence, they have a great appetite for knowledge, and no small number of them seek out sensory experiences. However, those who become hunters like the Seeker and travel about the world are rare.

CHARACTER

■What Did He Set Off in Search Of?

For the past forty years, he has felt the flow of tremendous energies. A sudden rise prompted him to journey forth in search of the cause. It was as if something were leading him... Later, he said, "Perhaps Xeno'jiiva had me in its clutches all along, and I was merely doing its bidding. Perhaps I still am..."

Piscine Researcher

He's a lone-wolf angler seeking new discoveries. Fishing is his reason for living. He conquered every variety of fish in the Old World and got hooked by the Commission. He heads piscine research for the endemic life field guide. Basically, he catches, records, and then releases.

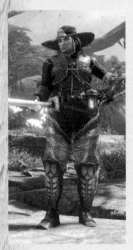

Besides his research into fish species, he is also looking for companions to fish side by side with. He is the best person to ask about the art of fishing and fish. He can also sometimes be seen catching real whoppers.

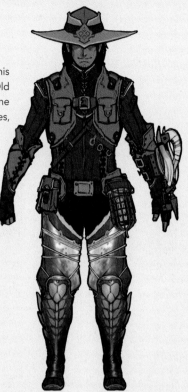

He dresses in the style of a fisherman with his wide-brimmed hat, leather vest, and boots appropriate for water.

Lynian Researcher

A wizened Wyverian scholar who seeks out the places Lynians live and is often outdone by the swift and sly Grimalkynes, so he needs the aid of a hunter. He once served the Endemic Life Researcher along with the Piscine Researcher, but now they worry about him.

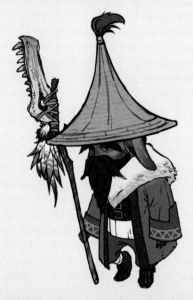

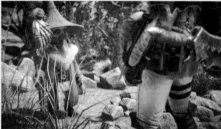

He once collapsed during an exploration, and a certain Grimalkyne helped him. The staff he carries was given to him by that same Grimalkyne. He dreams of understanding the Lynian language so he can say "Thank you" to him in his own tongue.

Soft-Spoken Fourth

The young Soft-Spoken Fourth visits the Chamber of the Five before he tackles a tough hunt because it fills him with courage. He also explains the meaning of each fleet banner.

Endemic Life Researcher

No one surpasses this passionate scientist in knowledge and techniques for catching endemic life. She is one of those responsible for compiling data for the endemic life field guide, and she herself is in charge of smaller animals and insects. She sometimes becomes too engrossed in her observations and forgets to report to Astera, leading to a scolding by the Lynian Researcher. Apparently, her excuse is "I can't take my eyes off these ants."

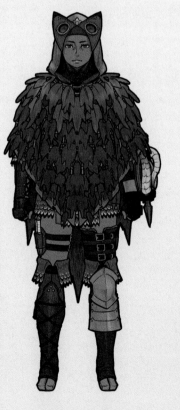

Actually, she is the next head of a certain distinguished family. She joined the Fourth Fleet along with two attendants.

OTHERS

CHARACTERS AND BASE

64

Airship Engineer

A Second Fleet engineer. At their request, he converted the Third Fleet's vessel into an airship, and he feels responsible for their crash. The Third Fleet has been stuck for decades, and he searches for a way to rescue them.

When he arrives at the Research Base, he devotes his energy to converting it into an airship a second time. Afterwards, he helps the scholars with their investigations.

Research Hunter

Back in the Old World, this hunter researched Elder Dragons and ended up writing a report about his findings. As soon as the Guild read it, he found himself on board one of the Commission's ships to the New World.

He serves as the leader of a small field team. He also exchanged opinions with the Impatient Biologist about monster ecology.

Sisterly Fourth

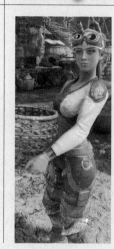

A handler who came to the New World after the Fourth Fleet's massive recruitment call to expand the scope of their investigations. Before this migration, she had apparently explored to the edge of the Great Ravine but was hindered from getting farther due to the steep cliffs.

Hot-Blooded Fourth

A hunter who dreamed about joining the Commission since he was little. Once he saw the leaflet seeking hunters for the Fourth Fleet, he signed up and was accepted. In the New World, he was guided by the Huntsman and other members of the Fourth Fleet. He helps rescue the Fifth Fleet when they're tossed into the sea.

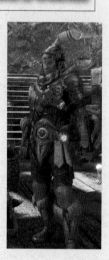

Gentle Fourth

This hunter volunteered for the Commission because he was attracted to the good pay. He has a lot of siblings and his family never has enough of anything, so he never throws any materials away, even if their use is unclear.

Fun Fourth

A handler who reluctantly came to the New World at the urging of his hunter partner. He is sarcastic and complains often, but he does his research well.

Eager Fourth

He wanted to achieve greatness as a hunter, so he invited his reluctant handler partner to the New World. After completing a long-term mission back home, the Guild sent him to the Commission.

Poogie

The Commission's mascot. As people pet it and make it feel good, it becomes more affectionate. Poogie will sometimes detect hidden things in the area when being carried. Many Commission members enjoy buying outfits for Poogie, a practice they find therapeutic.

It has been given many names by different people. Also, if one takes Poogie to the Canteen, it will get angry and run away.

■ Emperor's New Duds

■ White Jammies

■ Memorial Stripes

■ Hog in a Frog

■ Apprentice Fiver

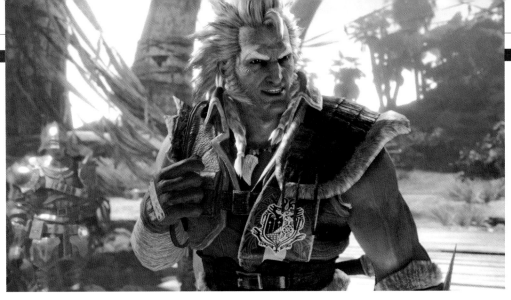

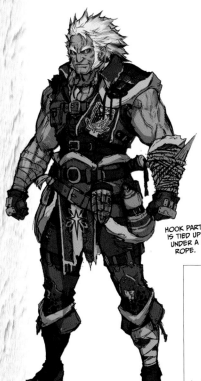

HOOK PART IS TIED UP UNDER A ROPE.

Equipment Sketch

The Admiral's gear is based around leather, and he has added a shoulder pad to his left arm. Below it his fleet banner hangs. A rope is wrapped around his left arm with a hook attached to it that looks like an arrowhead. He uses this alongside his muscular arms (which he is proud of) instead of a slinger. Apparently he uses ammo like Scatternuts by just throwing them.

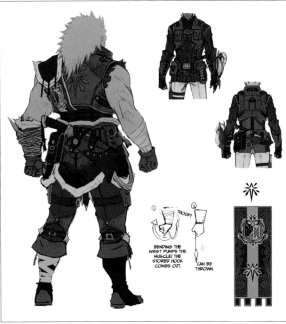

THOOP!

BENDING THE WRIST PUMPS THE MUSCLE! THE STORED HOOK COMBS OUT.

CAN BE THROWN.

CHARACTER
■As the One Who Leads the Commission

The Admiral was shocked upon learning that the Seeker had gone missing. He felt disappointed in himself. The Seeker did the thinking, the Commander the directing, the Tracker the searching, and the Huntsman the fieldwork. His role was to lead the others, and that's what he had done until then.

CHARACTER
■How He Ended Up Going Farther Afield

It was when the Second Fleet arrived in the New World that he saw a particular mysterious monster for the first time, alone with his Palico. He took a team out to track it but never managed to find it. The rest of the team thought he was seeing things, and he became the laughingstock of the Commission. But the monster he encountered would later come to be called Nergigante.

"If you ever feel lost, just pick a direction and run! Soon your troubles will vanish in the dust behind you."

The Admiral doesn't show his face much in Astera. He says, "Honestly, the main reason I come back here is to eat," and he boasts about the deliciousness of the cooking of the Meowscular Chef, who was his partner in the old days.

TOPIC — "A Man as Fierce as a Rajang"

A Rajang is a large fanged beast monster with a name that means "gold lion" in the Old World. When angered, parts of its jet-black fur turn golden, and it has powerful arms that boast exceptionally fantastic strength. The Admiral has an uncommonly large frame with a brawny, muscular physique and mane-like blond hair. Combined with his booming voice and heroic appearance, it's no surprise the Admiral was once confused for a Rajang by a member of the Fifth Fleet.

※ Image is from *Monster Hunter 4G*.

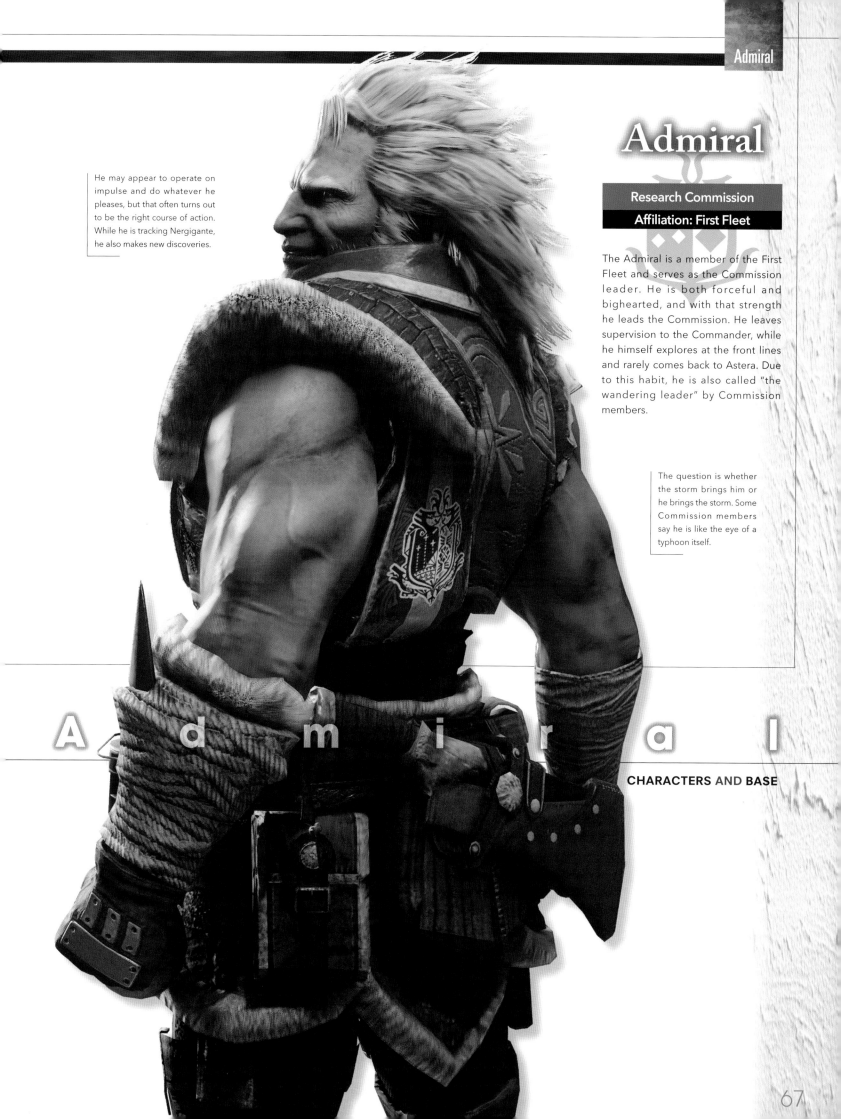

He may appear to operate on impulse and do whatever he pleases, but that often turns out to be the right course of action. While he is tracking Nergigante, he also makes new discoveries.

Admiral

Research Commission

Affiliation: First Fleet

The Admiral is a member of the First Fleet and serves as the Commission leader. He is both forceful and bighearted, and with that strength he leads the Commission. He leaves supervision to the Commander, while he himself explores at the front lines and rarely comes back to Astera. Due to this habit, he is also called "the wandering leader" by Commission members.

The question is whether the storm brings him or he brings the storm. Some Commission members say he is like the eye of a typhoon itself.

Admiral

CHARACTERS AND BASE

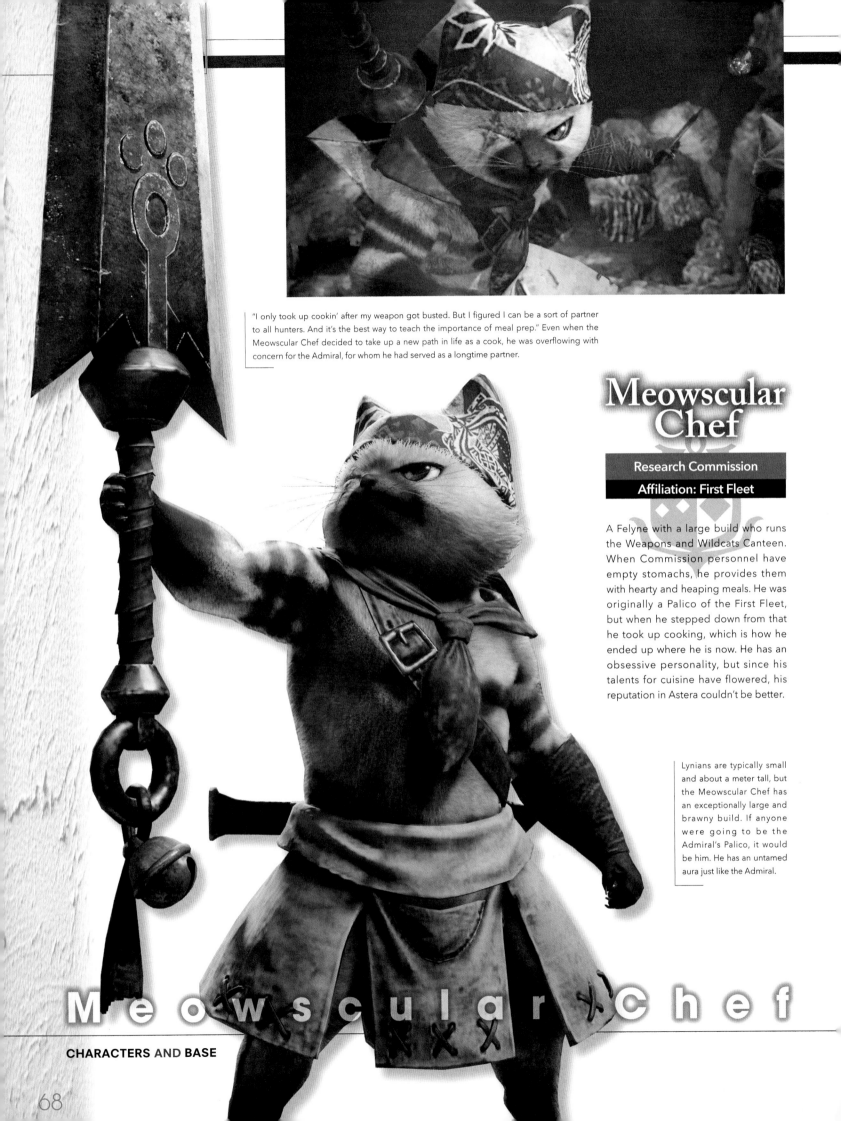

"I only took up cookin' after my weapon got busted. But I figured I can be a sort of partner to all hunters. And it's the best way to teach the importance of meal prep." Even when the Meowscular Chef decided to take up a new path in life as a cook, he was overflowing with concern for the Admiral, for whom he had served as a longtime partner.

Meowscular Chef

Research Commission

Affiliation: First Fleet

A Felyne with a large build who runs the Weapons and Wildcats Canteen. When Commission personnel have empty stomachs, he provides them with hearty and heaping meals. He was originally a Palico of the First Fleet, but when he stepped down from that he took up cooking, which is how he ended up where he is now. He has an obsessive personality, but since his talents for cuisine have flowered, his reputation in Astera couldn't be better.

Lynians are typically small and about a meter tall, but the Meowscular Chef has an exceptionally large and brawny build. If anyone were going to be the Admiral's Palico, it would be him. He has an untamed aura just like the Admiral.

M e o w s c u l a r C h e f

CHARACTERS AND BASE

The Fiver Bro takes assignments from him to gather whatever ingredients the chef asks for, and the chef describes him as "a man who can get it done" and "a man obsessed with gains."

CHARACTER

■ The Battle That Made Him Realize He Had to Retire as a Palico

When he was a Palico, he accompanied the Admiral and fought monsters. One day, they faced a fierce foe and his weapon broke. Perhaps it had deteriorated after a long life of hunting or perhaps he was physically declining. Either way, he decided to retire as a Palico after that incident.

CHARACTER

■ He Obsesses About How Meat Is Cooked!

After he became a cook, he poured his heart into supporting personnel through food. Recently, he has been making many ingredient requests and developing new items. He exhibits a particular fixation on meat dishes. After acquiring an enormous steel hot plate, he prepares meats with his spectacular sword work.

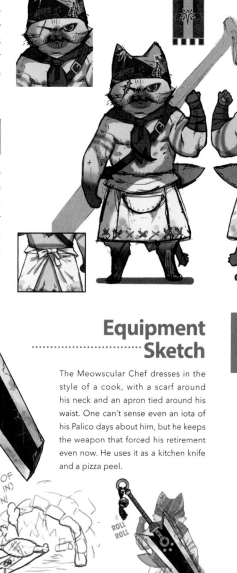

SHOPPING IS SO MUCH FUN!

ROLL ROLL

CHOP!

WHACK!

TAKE IT OUT OF (AND PUT IT IN) THE OVEN!

ROLL ROLL

Equipment Sketch

The Meowscular Chef dresses in the style of a cook, with a scarf around his neck and an apron tied around his waist. One can't sense even an iota of his Palico days about him, but he keeps the weapon that forced his retirement even now. He uses it as a kitchen knife and a pizza peel.

TOPIC

Searching for the Equipment He Used when He Was Active

According to those who know about the Meowscular Chef's Palico days, he loved equipment made in the Old World. However, because of his large physique, ready-made articles didn't suit him. What he wore wasn't ordinary Palico-sized equipment, but probably special-ordered items one or two sizes larger.

※ Image is from *Monster Hunter 4G.*

"Hey, Scrawny. Ready to get your pre-hunt on?!"

Guild Receptionists

Research Commission

Affiliation: Fourth Fleet, Fifth Fleet

The First Fleet's ship was converted into a tavern and Gathering Hub called the Celestial Pursuit and is managed by these four women. Dispatched by the Guild, these women provide information on quests and events and sell goods. They are assigned their own roles and are in charge of those affairs.

◀Hub Lass

Guild Receptionists

CHARACTERS AND BASE

The Celestial Pursuit is a tavern that was preparing to open in the lead-up to the Fifth Fleet's activities. The Event Manager is affiliated with the Fourth Fleet, but the other three are Fifth Fleet members. They were tasked with their duties soon after arriving in the New World.

▶Event Manager

▶Arena Lass

▶Hub Provisions

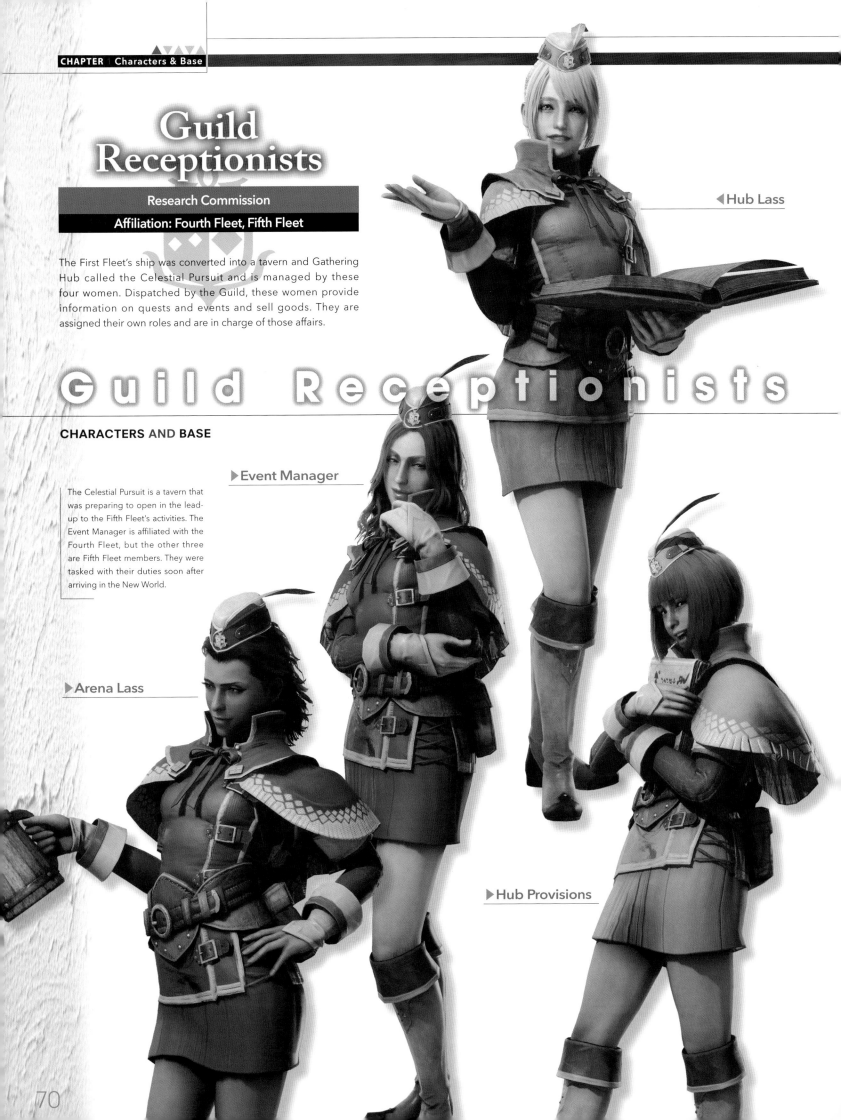

CHARACTER

■ The Job of the Receptionists

While overseeing the interactions of the hunters with each other, these women hurriedly work at their duties and have been recognized by the Guild as being superior human resources. This is because they are knowledgeable in a wide array of fields, starting with monster ecology, which allows their work to proceed smoothly. As for their duties at the Celestial Pursuit, the Event Manager is in charge of Squad administration, while the Hub Lass and Arena Lass give out their quests for their respective domains. Beside them, Hub Provisions handles the procurement and sale of goods.

KEY WORDS [Celestial Pursuit]

A tavern where one can meet many hunters and where friendships are deepened. It is located at the highest point in Astera, and members of the Commission gave it a name with a profound meaning.

"Welcome to the Celestial Pursuit! Ready for some questing?"

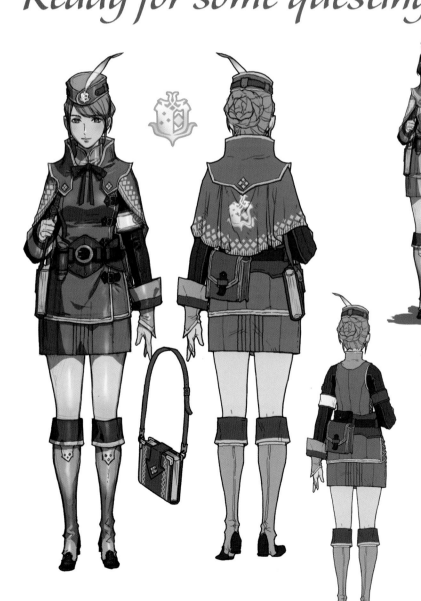

Equipment Sketch

The Guild Receptionists wear uniforms issued by the Guild. Unlike the hunters and handlers, they don't go out into the field, so naturally they do not have any weapons or even Scoutflies. What they do carry with them is a book of information on a shoulder strap, a pouch containing implements needed for their work, and an ink bottle attached to their waists. The colors of their uniforms are left up to them to decide according to their own preferences.

The Celestial Pursuit is operated on a shift system by Commission members, including these women. At times when business is slow, such as when hunters are few, they all help to feed the resident Mernos.

Meals Felynes

These are three of the Felynes that work at the Canteen run by the Meowscular Chef. One regulates the oven temperature, one is entrusted with the pot, and the other carries food up to the Celestial Pursuit Gathering Hub. They take their jobs very seriously.

▼Oven Felyne ▼Soup Felyne

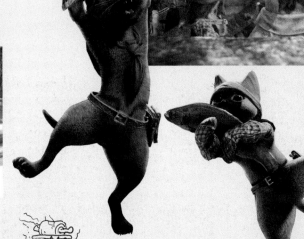

The Meowscular Chef is in charge of giant steaks and the final touches on all the dishes. Basically, the food is prepared after he divvies up the work among a great number of Felynes.

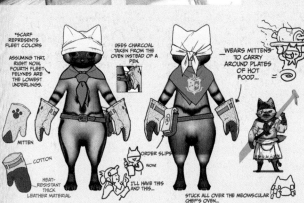

*SCARF REPRESENTS FLEET COLORS

ASSUMING THAT, RIGHT NOW FOURTH FLEET FELYNES ARE THE LOWEST UNDERLINGS.

USES CHARCOAL TAKEN FROM THE OVEN INSTEAD OF A PEN.

WEARS MITTENS TO CARRY AROUND PLATES OF HOT FOOD...

WHOAA...!

MITTEN

COTTON

HEAT-RESISTANT THICK LEATHER MATERIAL

ORDER SLIPS

WOW!

I'LL HAVE THIS AND THIS...

STUCK ALL OVER THE MEOWSCULAR CHEF'S OVEN...

▼Feeder Felyne

Meals fill up the hunters' stomachs and give them strength. As the Canteen gets bigger, it can handle a growing number of ingredients, so the meals become even more sumptuous.

Uniform of the Meals Felynes. They are never without their thick oven mitts to protect their paws. The Canteen Felynes' scarves represent the First Fleet, while the Feeder Felyne's scarf represents the Third Fleet.

Room Service

A white-furred Felyne that is permanently assigned to your room. He explains the training area to the hunter, helps the hunter move in, and manages the endemic life captured by the hunter. He doesn't show it, but he seems to struggle with caring for the wilder endemic life. He originally shared responsibility for the living quarters, but now works exclusively in the Private Quarters.

He is constantly concerned for the welfare of the hunter, his master. When the hunter is away, he cleans the room and makes the bed with skill.

Worker Felynes

These Felynes from the Research Base always seem busy with maintenance. Since the base is full of elderly Wyverian scholars, they are a crucial source of labor. Many of them are particular about cleanliness.

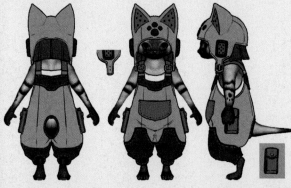

Their work uniform consists of highly functional overalls. They carry around small tools in the front and side pockets. There are small holes in the helmet to prevent overheating.

OTHERS
CHARACTERS AND BASE

"NYA NYA NYA? (And the other one wants this as well?)"

Grimalkynes

Lynians that reside in the New World. They are small, and they have an untamed air. They resemble Felynes not just in their figure, but also in their physical abilities and culture. They are regarded by some scholars as a possible ancestor species of the Felynes. Palicoes can understand their language from the doodle traces they leave in their territory. However, they are extremely wary, and if one tries to approach them carelessly, they will likely dash away.

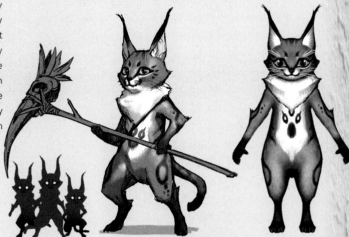

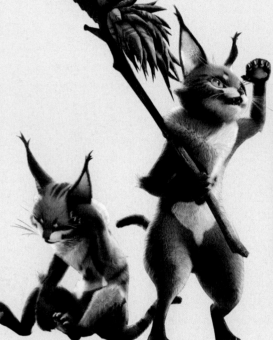

The Grimalkyne culture can be seen in the places they live, and their use of tools and fire reveals a high intelligence. They have also been witnessed using traps and hunting in groups. If one forms a cooperative relationship with them, they are reliable allies.

■ Water Raft

They are not good swimmers, so to travel across water, they create rafts out of natural materials. Using a large leaf with fine straw laid down in it creates increased buoyancy and stability.

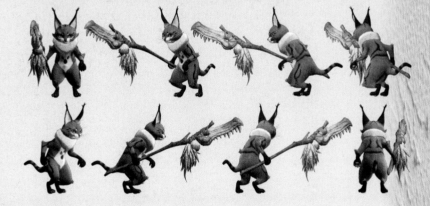

TOPIC
Regional Variations Seen in Their Coats

Grimalkynes form tribes in each habitat and differ in their cultures and coats. The pictures are, from left: Ancient Forest Bugtrappers, Wildspire Waste Protectors, Coral Highlands Troupers, and Rotten Vale Plunderers. No physical differences have been confirmed other than their coats.

Gajalakas

This Lynian discovered in the New World is small, but unlike Felynes and Grimalkynes, Gajalakas have a humanlike physique. Their language is unique, and analysis of their traces is needed to establish communication. Their culture enjoys dancing but is still warlike. Except for a few friendly people, anyone who approaches them is considered a target for elimination. Lynians who wear similar masks exist in the Old World too, and they are generally referred to as Gajalakas.

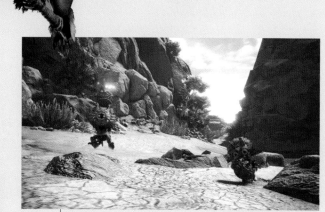

Gajalakas dwell in caverns throughout the land, and some will give help to hunters. This cooperation is the result of the Lynian Researcher's careful study.

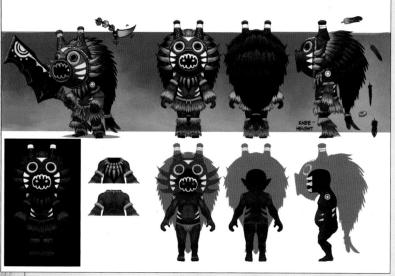

The Gajalaka wear a straw cape that covers part of their body and a large mask. The mask, which is made to look like a certain monster, is meant to indicate bravery, among other things.

They can attack by throwing bombs. In the New World, it is relatively easy to create explosives from natural materials, but one can recognize their keen intelligence and daring in this creation.

■ Gajalaka Raft

Their rafts are made of earthenware and have beds of straw. The three feet on the rafts' underbellies are a unique trait. Pointing the feet in the direction of the craft's movement stabilizes travel on water. This is a simple but also extremely thoughtful design. Gajalakas have a unique culture, which includes this type of earthenware in addition to necklaces and certain religious views.

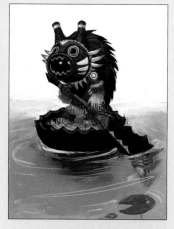

■ Gajalaka Weapons

The Gajalaka coat their weapons in various types of toxins. One depletes health, one induces Paralysis, and another induces Sleep. They are respectively purple, yellow, and blue, and their masks are also colored to match.

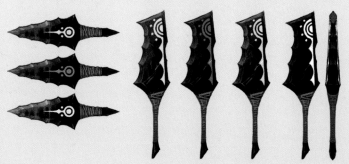

"LAKA LAKA! (If you're ever in trouble, I'll be there. That's a master's duty!)"

First Wyverians

The First Wyverians have been living in the New World since ancient times. They keep their faces hidden, so it's impossible to know their ages. While they give tips and item support to passing hunters, it seems that they are testing something. They have observed the Commission for a long time and learned human language. They judge things by a unique standard of values and are generally mysterious.

■Elusive and Ubiquitous Beings

One feels a presence and discovers that a mysterious being is suddenly *there*. Some First Wyverians have revealed facts about the Elder Crossing to the Commission.

▼Ancient Wyverian

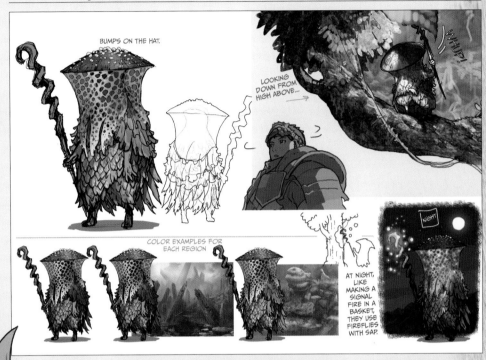

BUMPS ON THE HAT.

LOOKING DOWN FROM HIGH ABOVE...

WHUP!

COLOR EXAMPLES FOR EACH REGION

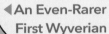

AT NIGHT, LIKE MAKING A SIGNAL FIRE IN A BASKET, THEY USE FIREFLIES WITH SAP.

NIGHT

◀An Even-Rarer First Wyverian

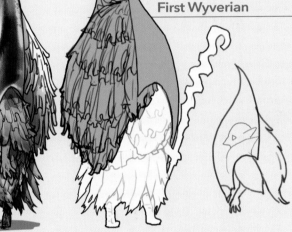

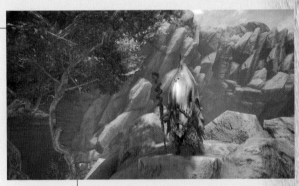

A rare First Wyverian who wears a large dazzling mask. He gives different items from other First Wyverians.

TOPIC

Dealing with Gajalakas as Small Monsters

The Gajalakas scattered around each location are often hostile. This is because, much like the Grimalkynes, several tribes exist among them, and the hunter will not have not interacted with all of them. Their attacks induce abnormal status effects, and though they are small, the Gajalakas are very dangerous. Common knowledge says that driving them away with Flash Pods and Scatternuts is best.

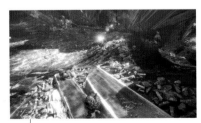

Gajalakas operate in groups, threatening enemies and attacking in unison anyone who approaches.

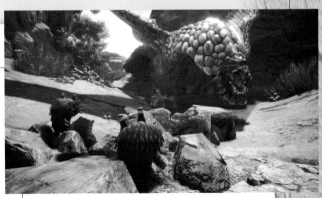

Many hunters have nearly died due to the abnormal status effects of the Gajalaka. But some skilled hands are able to use the Gajalaka against large monsters.

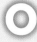 O T H E R S

Extended **World Gallery**

Character Pictorials

Many design drawings were made from various concepts during the creation of the characters. Here we present some of them, with a focus on the key figures that are active in Astera. An abundance of variations in character and equipment designs were drawn for the Handler, who is the player's partner. It's interesting to compare these to what she looks like now.

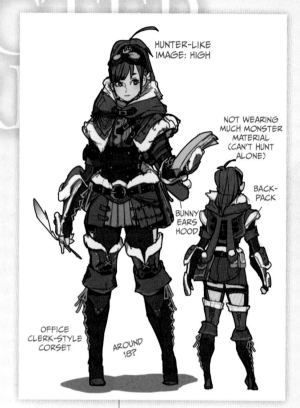

HUNTER-LIKE IMAGE: HIGH

NOT WEARING MUCH MONSTER MATERIAL (CAN'T HUNT ALONE)

BACK-PACK

BUNNY EARS HOOD

OFFICE CLERK-STYLE CORSET

AROUND 18?

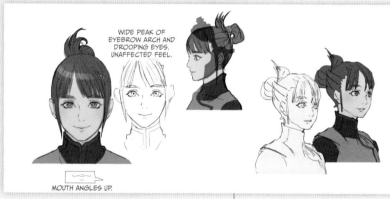

WIDE PEAK OF EYEBROW ARCH AND DROOPING EYES. UNAFFECTED FEEL.

MOUTH ANGLES UP.

Her large eyes here give the impression of an openhearted and bright, positive personality. With the wide peak of her eyebrow arch, eyes that slant down, and a mouth that angles up at the edges, her expression has a soft, innocent feel.

This design creates an energetic and active impression. These clothes have a strong hunter vibe about them, while the corset gives the design a feminine outline.

The Handler

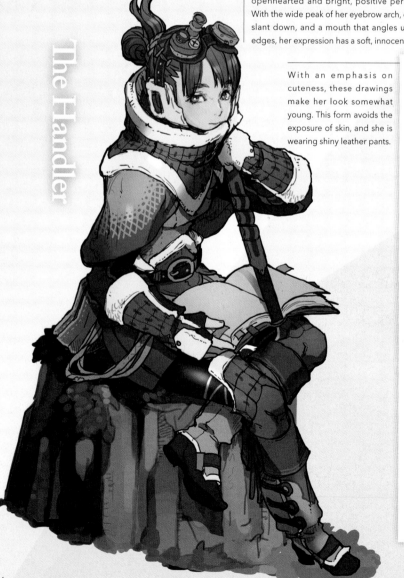

With an emphasis on cuteness, these drawings make her look somewhat young. This form avoids the exposure of skin, and she is wearing shiny leather pants.

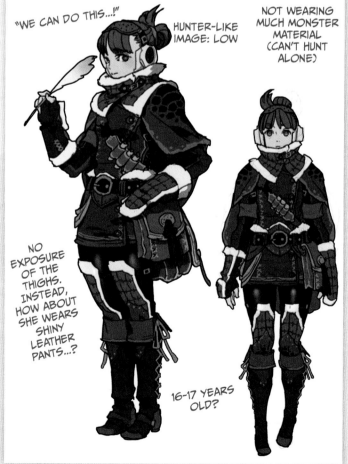

"WE CAN DO THIS...!"

HUNTER-LIKE IMAGE: LOW

NOT WEARING MUCH MONSTER MATERIAL (CAN'T HUNT ALONE)

NO EXPOSURE OF THE THIGHS. INSTEAD, HOW ABOUT SHE WEARS SHINY LEATHER PANTS...?

16-17 YEARS OLD?

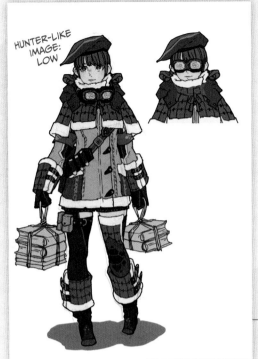

HUNTER-LIKE
IMAGE:
LOW

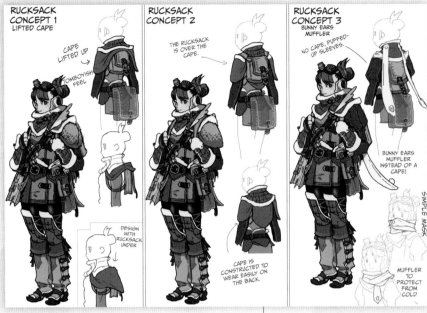

RUCKSACK
CONCEPT 1
LIFTED CAPE

CAPE
LIFTED UP

TOMBOYISH
FEEL

DESIGN
WITH
RUCKSACK
UNDER

RUCKSACK
CONCEPT 2

THE RUCKSACK
IS OVER THE
CAPE.

CAPE IS
CONSTRUCTED TO
WEAR EASILY ON
THE BACK.

RUCKSACK
CONCEPT 3
BUNNY EARS
MUFFLER

NO CAPE, PUFFED-
UP SLEEVES.

BUNNY EARS
MUFFLER
INSTEAD OF A
CAPE!

SIMPLE MASK

MUFFLER
TO
PROTECT
FROM
COLD

Her face without her prescription goggles is cute, and her plaited hairstyle and modest outfit give her an innocent feel. Her specialty is jumping to conclusions too quickly.

The way she would wear the rucksack and the interaction of the cape with the outfit were also considered in detail, as were the strongly distinctive puffy-sleeve garments and bunny-ears muffler.

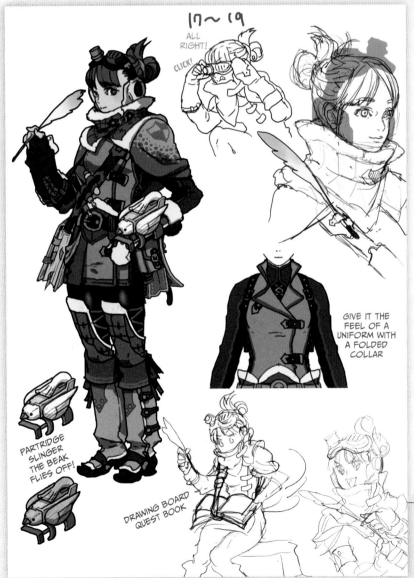

17~19

ALL
RIGHT!

CLICK!

GIVE IT THE
FEEL OF A
UNIFORM WITH
A FOLDED
COLLAR

PARTRIDGE
SLINGER
THE BEAK
FLIES OFF!

DRAWING BOARD
QUEST BOOK

The Handler, estimated to be between seventeen and nineteen years old. The jacket has a collar that emphasizes the uniform-like feel. Her slinger, which she made herself, has the feel of a toy.

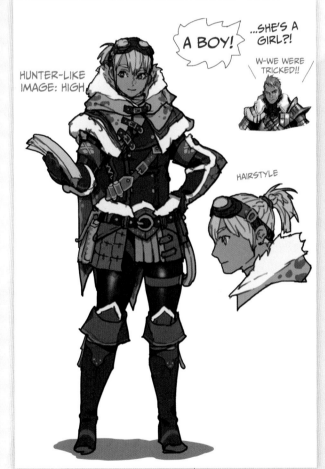

HUNTER-LIKE
IMAGE: HIGH

A BOY!

...SHE'S A
GIRL?!

W-WE WERE
TRICKED!!

HAIRSTYLE

These are sketches of Active Boy, which got mixed into the Active Girl (meaning the Handler) development. The idea, for example, was that the Handler would look like a girl but actually be a boy.

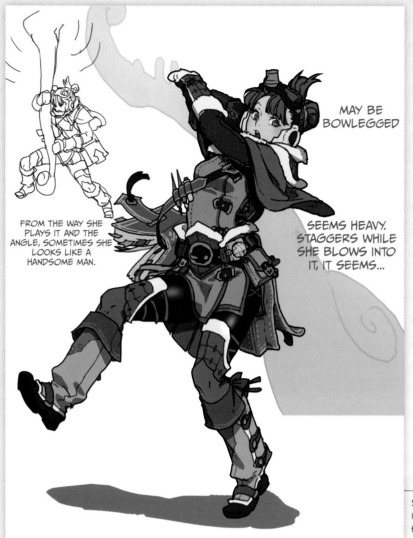

MAY BE BOWLEGGED

FROM THE WAY SHE PLAYS IT AND THE ANGLE, SOMETIMES SHE LOOKS LIKE A HANDSOME MAN.

SEEMS HEAVY. STAGGERS WHILE SHE BLOWS INTO IT, IT SEEMS...

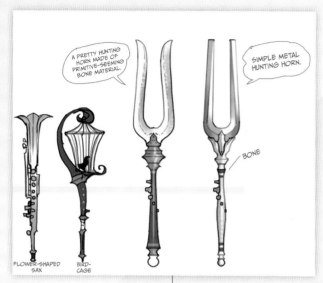

A PRETTY HUNTING HORN MADE OF PRIMITIVE-SEEMING BONE MATERIAL.

SIMPLE METAL HUNTING HORN.

BONE

FLOWER-SHAPED SAX

BIRD-CAGE

Supposing that perhaps the Handler would give direct support to the Hunter, these designs show her carrying a hunting horn. Though she is unused to handling it, you can sense her giving it her all.

Several ideas for the type of hunting horn the Handler would use. The motifs were tuning forks, saxophones, a bird cage, etc., apparently according to the needs of the hunter.

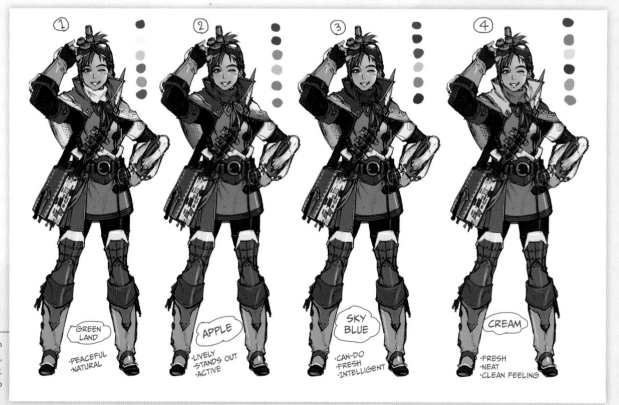

① GREEN LAND
·PEACEFUL
·NATURAL

② APPLE
·LIVELY
·STANDS OUT
·ACTIVE

③ SKY BLUE
·CAN-DO
·FRESH
·INTELLIGENT

④ CREAM
·FRESH
·NEAT
·CLEAN FEELING

A stylish neck... Through variations on the cape, the ties, and the color of the neck warmer, final adjustments were made to the design of the character.

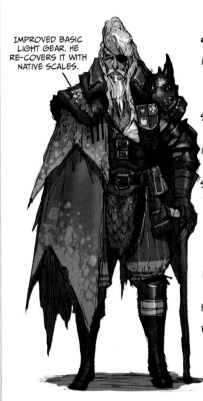

IMPROVED BASIC LIGHT GEAR. HE RE-COVERS IT WITH NATIVE SCALES.

COMMISSION LEADER DESIGN
MEMBER OF THE FIRST FLEET. DUE TO PAIN IN HIS LEG, HE CAN'T OVERDO THINGS, BUT HE IS STILL IN ACTIVE SERVICE AND GOES ON EXPEDITIONS EVEN NOW. HE CONTINUALLY MAKES IMPROVEMENTS TO HIS GEAR AND TREATS IT WITH CARE SINCE HE EXPERIENCED A TIME WITH THE FIRST FLEET WHEN THEY HAD NOTHING AT ALL.

HE'S NOT GOOD WITH THE SLINGER, WHICH WAS DEVELOPED LATER, SO HE DOESN'T USE ONE.

HE GETS BY SOMEHOW WITH SKILLFUL ROPE WORK AND PRIDE IN HIS STRENGTH.

The Commander is drawn in a way that gives the impression of an aged warrior or a pirate. He does rope work without a slinger, and his design also includes elements of the Admiral.

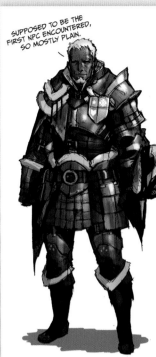

SUPPOSED TO BE THE FIRST NPC ENCOUNTERED, SO MOSTLY PLAIN.

COMMISSION MEMBER DESIGN 4
THE FIRST TO MEET THE PLAYER AND GUIDE THEM TO HQ.

HE IS THE YOUNGEST AND BRAWNIEST OF THE FIRST FLEET.

WE'RE THINKING HE'LL TEACH THE PLAYER MANY THINGS THROUGH THE TUTORIALS, SO HIS EQUIPMENT AND THINGS ARE ALMOST THE SAME AS THE PLAYER'S.

Commander

Gives the strong impression of being in active service and is close to the current version of the Commander. One can also see aspects of the Field Team Leader's roles in this design, so initially it seems he did not have a grandson.

Excitable A-Lister

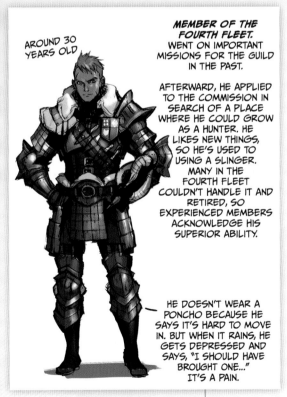

AROUND 30 YEARS OLD

MEMBER OF THE FOURTH FLEET.
WENT ON IMPORTANT MISSIONS FOR THE GUILD IN THE PAST.

AFTERWARD, HE APPLIED TO THE COMMISSION IN SEARCH OF A PLACE WHERE HE COULD GROW AS A HUNTER. HE LIKES NEW THINGS, SO HE'S USED TO USING A SLINGER. MANY IN THE FOURTH FLEET COULDN'T HANDLE IT AND RETIRED, SO EXPERIENCED MEMBERS ACKNOWLEDGE HIS SUPERIOR ABILITY.

HE DOESN'T WEAR A PONCHO BECAUSE HE SAYS IT'S HARD TO MOVE IN. BUT WHEN IT RAINS, HE GETS DEPRESSED AND SAYS, "I SHOULD HAVE BROUGHT ONE..." IT'S A PAIN.

His age was imagined to be a slightly older thirty, and he is a former rookie hunter of the Fourth Fleet. At first, it was thought he would have some connection to previous entries in the series.

Third Fleet Master

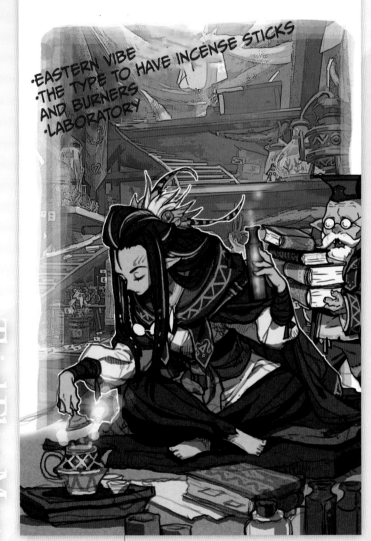

•EASTERN VIBE
•THE TYPE TO HAVE INCENSE STICKS AND BURNERS
•LABORATORY

In a setting much like a laboratory, she is depicted as having a Wyverian-like atmosphere. When it comes to tea, she first enjoys its fragrance.

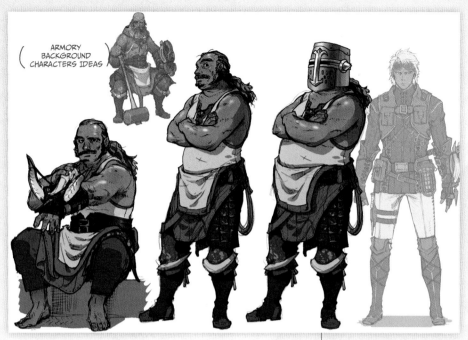

ARMORY BACKGROUND CHARACTERS IDEAS

Commission Members

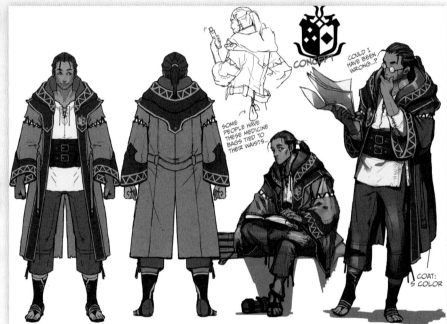

CONCEPT

COULD I HAVE BEEN WRONG...?

SOME PEOPLE HAVE THESE MEDICINE BAGS TIED TO THEIR WAISTS.

COAT: S COLOR

These are designs for the Commission member that became the Second Fleet Master, including such details as the equipment used in place of a corset for back pain and a unique slinger.

These design drawings are of a Commission member who was elevated to a key figure. The drawings suggest that since the Third Fleet's ship is stuck, he has half given up.

Meowscular Chef

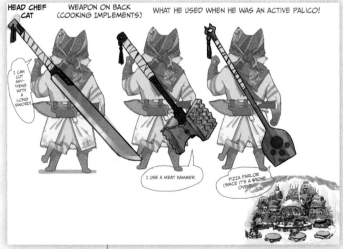

HEAD CHEF CAT | WEAPON ON BACK (COOKING IMPLEMENTS) | WHAT HE USED WHEN HE WAS AN ACTIVE PALICO!

I CAN CUT ANYTHING WITH A LONG SWORD!

I USE A MEAT HAMMER.

PIZZA PARLOR (SINCE IT'S A STONE OVEN!)

Several cooking-implement motifs were considered for the Meowscular Chef's weapon. They were abandoned, however, because they were too on the nose.

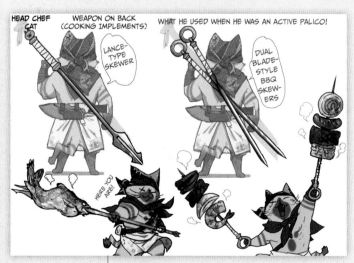

HEAD CHEF CAT | WEAPON ON BACK (COOKING IMPLEMENTS) | WHAT HE USED WHEN HE WAS AN ACTIVE PALICO!

LANCE-TYPE SKEWER

DUAL BLADE-STYLE BBQ SKEWERS

HERE YOU ARE!!

The backstory of him retiring from being a Palico, becoming the head chef, and using his old weapons as cooking tools was too humorous.

First Wyverians

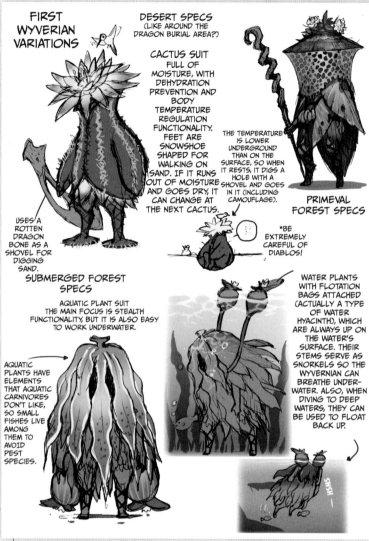

FIRST WYVERIAN VARIATIONS

DESERT SPECS
(LIKE AROUND THE DRAGON BURIAL AREA?)

CACTUS SUIT
FULL OF MOISTURE, WITH DEHYDRATION PREVENTION AND BODY TEMPERATURE REGULATION FUNCTIONALITY. FEET ARE SNOWSHOE SHAPED FOR WALKING ON SAND. IF IT RUNS OUT OF MOISTURE AND GOES DRY, IT CAN CHANGE AT THE NEXT CACTUS.

USES A ROTTEN DRAGON BONE AS A SHOVEL FOR DIGGING SAND.

THE TEMPERATURE IS LOWER UNDERGROUND THAN ON THE SURFACE, SO WHEN IT RESTS, IT DIGS A HOLE WITH A SHOVEL AND GOES IN IT (INCLUDING CAMOUFLAGE).

PRIMEVAL FOREST SPECS

*BE EXTREMELY CAREFUL OF DIABLOS!

SUBMERGED FOREST SPECS

AQUATIC PLANT SUIT
THE MAIN FOCUS IS STEALTH FUNCTIONALITY, BUT IT IS ALSO EASY TO WORK UNDERWATER.

AQUATIC PLANTS HAVE ELEMENTS THAT AQUATIC CARNIVORES DON'T LIKE, SO SMALL FISHES LIVE AMONG THEM TO AVOID PEST SPECIES.

WATER PLANTS WITH FLOTATION BAGS ATTACHED (ACTUALLY A TYPE OF WATER HYACINTH), WHICH ARE ALWAYS UP ON THE WATER'S SURFACE. THEIR STEMS SERVE AS SNORKELS SO THE WYVERIAN CAN BREATHE UNDERWATER. ALSO, WHEN DIVING TO DEEP WATERS, THEY CAN BE USED TO FLOAT BACK UP.

Encounters with First Wyverians are rare, so details about them are unclear, but it could be said that particular regional flavors can be seen in their outer clothing, depending on the areas in which they live.

Taking on the role of Elder Melder, this First Wyverian was designed with a pot on his head. The leaves of his outer garment are medicinal herbs.

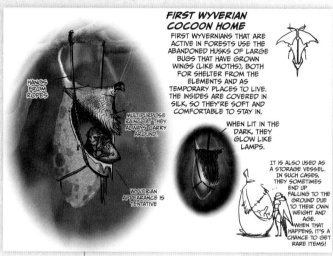

FIRST WYVERIAN COCOON HOME
FIRST WYVERIANS THAT ARE ACTIVE IN FORESTS USE THE ABANDONED HUSKS OF LARGE BUGS THAT HAVE GROWN WINGS (LIKE MOTHS), BOTH FOR SHELTER FROM THE ELEMENTS AND AS TEMPORARY PLACES TO LIVE. THE INSIDES ARE COVERED IN SILK, SO THEY'RE SOFT AND COMFORTABLE TO STAY IN.

HANGS FROM ROPES

MULTIPURPOSE RAINCOAT THEY ALWAYS CARRY AROUND.

WYVERIAN APPEARANCE IS TENTATIVE

WHEN LIT IN THE DARK, THEY GLOW LIKE LAMPS.

IT IS ALSO USED AS A STORAGE VESSEL. IN SUCH CASES, THEY SOMETIMES END UP FALLING TO THE GROUND DUE TO THEIR OWN WEIGHT AND AGE. WHEN THAT HAPPENS, IT'S A CHANCE TO GET RARE ITEMS!

The idea was considered that perhaps First Wyverians that live in the forest temporarily use the cocoons left behind by giant bugs for sleeping in and storage.

FIRST WYVERIAN [RARE] CONCEPTS

NUTS

COTTON BOLLS

OVERALL HAS A PLAIN FEEL... NOT MUCH SENSE OF BEING RARE.

BUG HUSK

Design drawings of candidates for masks that reveal the wearer's high status. Compared to the high-impact masks that ended up being used, these are less striking in appearance at a glance.

FIRST WYVERIAN [RARE]

RARE FLOWERS THAT ALMOST NEVER BLOSSOM BLOOM HERE.

GOLDEN CHRYSALIS VIBE

NIGHT TIME

FIREFLIES INSIDE MUSHROOM CAP

THIS RARE WYVERIAN ALSO HAS GLOWING FLOWERS.

A First Wyverian who was conceived with high status and resplendence in mind. Not only did this stand out too much, Scoutflies would have probably reacted to it too.

Astera

Research Commission

Headquarters

With the Guild at its core, the Research Commission was formed in order to solve the mystery of the Elder Crossings. The base of their research activities is here in Astera. It has been forty years since the First Fleet arrived and established this as a major stronghold, which was built by the hands, skills, efforts, and labor of many people. In this section, we present Astera's background and its various facilities, and take a look at concept drawings from the time of its construction.

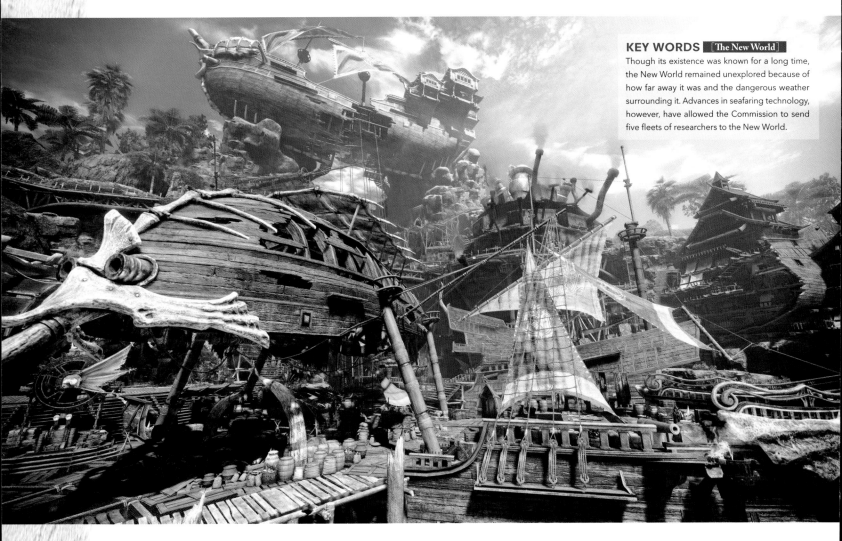

KEY WORDS [The New World]

Though its existence was known for a long time, the New World remained unexplored because of how far away it was and the dangerous weather surrounding it. Advances in seafaring technology, however, have allowed the Commission to send five fleets of researchers to the New World.

Commander

"When we got here, we left the ship up there on the rocks and immediately set to building Astera from the ground up."

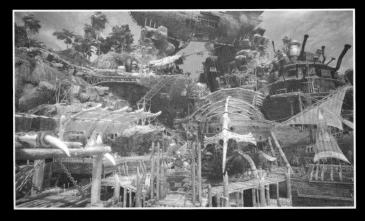

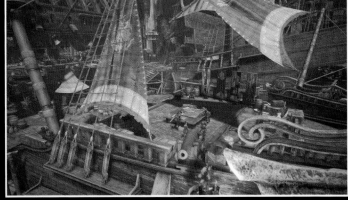

BASE

■ A Base Founded Around a Ship Run Aground

The First Fleet was deployed in pursuit of Kushala Daora. During a storm, the crew had a chance encounter with a mysterious Elder Dragon. The ship was split and tossed on top of a cliff, but it still eventually became a foothold for research projects. What's more, the waterfall flowing right below it turned out to be a stroke of good luck for the First Fleet.

BASE

■ Dreams of Enlarging the Base

The First Fleet found it difficult to secure enough resources to upgrade their base at first and expanded the base by recycling their ship. They had no choice but to wait for further deployments to do any full-scale work, however, so they poured their efforts into reinforcing the ship atop the cliff.

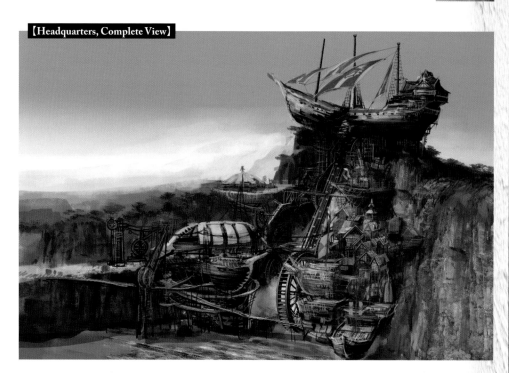

【Headquarters, Complete View】

Construction Concept Designs

These designs were made around the time when ideas for enlarging the base were being refined by the Second Fleet. It is evident that expanding the residential area has been the number one objective ever since.

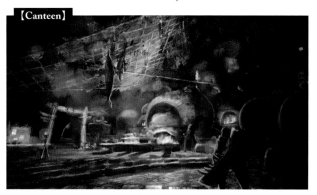

【Canteen】

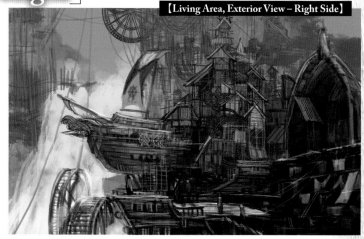

【Living Area, Exterior View – Right Side】

A S T E R A

CHARACTERS AND BASE

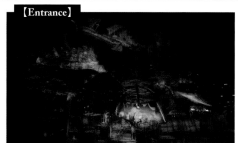

【Entrance】

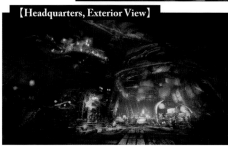

【Headquarters, Exterior View】

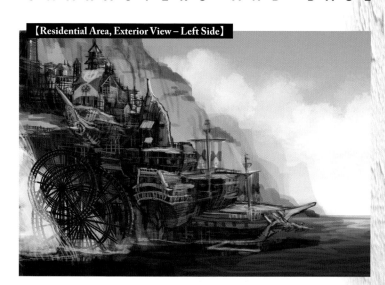

【Residential Area, Exterior View – Left Side】

BASE

■Tradeyard Improvements

The Tradeyard was built so that large amounts of resources could be managed efficiently, and it is overflowing with Commission activity. The arcade-like roofing that covers the walkways is a distinctive feature and is one way to make great use of the bottom of a ship. Currently, distribution is run by Fourth Fleet administrators.

BASE

■Facilities Around the Tradeyard

Within the Tradeyard are facilities such as the Resource Center and the Provisions Stockpile. On its western side are Ecological Research and Botanical Research, and far back on the east side is the command area where councils are held. At the back is a lift that is powered by the flow of water from the waterfall.

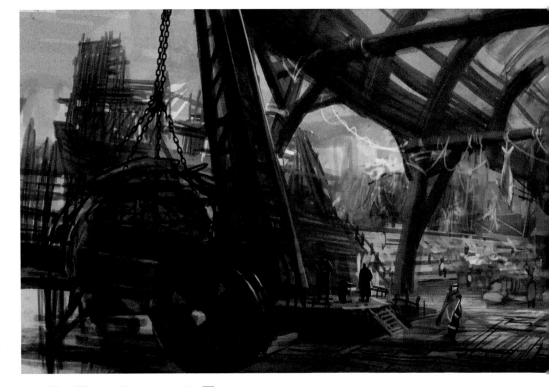

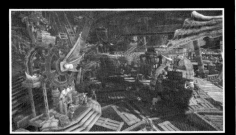
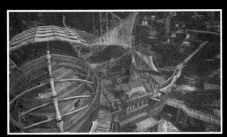
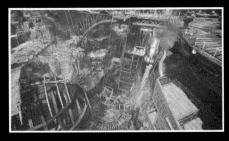

Tradeyard

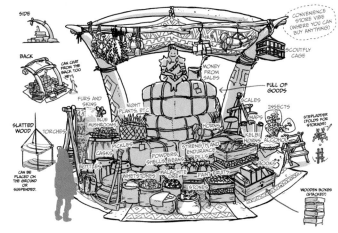

■Provisions Stockpile

A place where Commission members can purchase hunting gear and daily necessities. The Provisions Stockpile trades in merchandise while standing atop a pile of boxes and being surrounded by a large number of goods.

■Resource Center

The place where the section heads do their administration. They can also be seen using giant gears to send and receive goods from storage under the floor.

The various assignments for hunters are posted on this board. It used to be one large board, but now they use a smaller version located in two different locations.

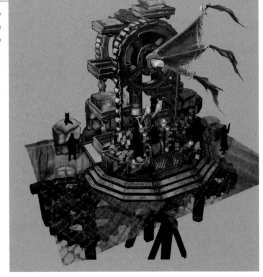

■Quest Board

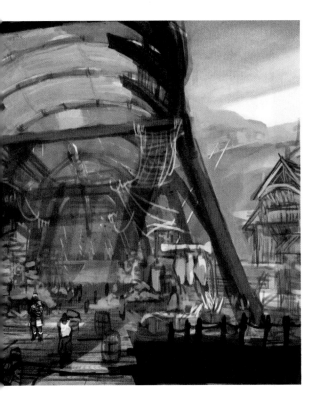

■Command

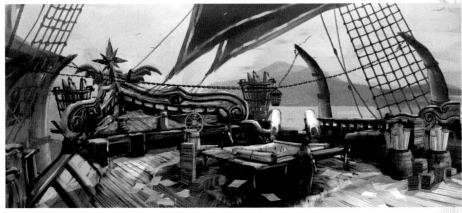

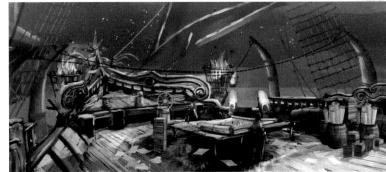

The place where council meetings are held by the Commander. A map of the continent is spread out on the central table. At present, the ship's figurehead has been removed.

■Melding Pot

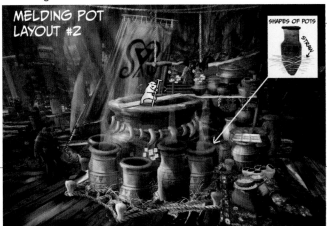

The Melding Pot is where the Elder Melder takes materials discovered in the New World and creates new materials from them. After the arrival of the Fifth Fleet, it was built next to the Resource Center.

■Lift (1F)

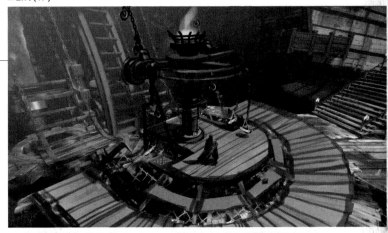

TOPIC Travel Lift Mechanism

Constructed mainly by members of the Second Fleet, the lifts make it markedly easier to travel within headquarters and to transport goods. The lifts are made up of a hook, which constantly travels between the upper and lower levels, and a steel bar called an anchor, which is connected to the hook. Safety is the responsibility of the individual user.

■Anchor

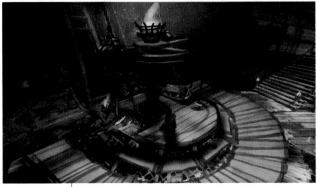

There are stairs to the right and left, but using this lift makes it easy to come and go between the second floor Workshop, third floor Canteen, and fourth floor Gathering Hub.

■Ecological Research

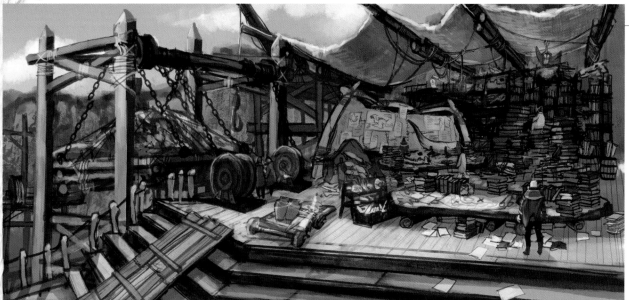

The Chief Ecologist hates cleaning, so reference tomes and documentary records are scattered everywhere in bothersome piles. Apparently, this was the scene when this facility was first opened as well, so it has barely changed at all. The Chief Ecologist can sometimes be seen studying captured monsters.

■Botanical Research

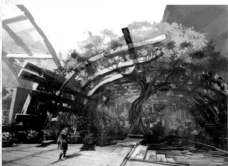

Level 1

Level 3

Level 2

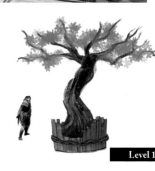

The Ancient Tree saw significant growth thanks to the results of the Chief's research, and he believes it will grow beyond the Canteen on the third floor one day. In addition, the Chief cultivated some plants via grafting. This is why things like apples and grains can be found in Astera, though they aren't yet in abundance.

| BASE |

■Function of Ecological Research

Ecological Research is a facility that researches New World monsters, endemic life, and other ecological matters. Its staff gathers data on things such as monster hunts and research advances. Thanks to reports from field teams, they have assembled detailed dossiers. Similar to Botanical Research, it is made up of mostly of Third Fleet scholars.

| BASE |

■Function of Botanical Research

This facility investigates the local vegetation, monsters, and creatures of the New World. It is set in an ecosystem that surrounds the gigantic Ancient Tree located immediately west of Astera. At present, the Chief Botanist is dutifully studying that tree. The cultivation of plants, insects, and mushrooms is accelerated by the Ancient Tree's overflowing life force.

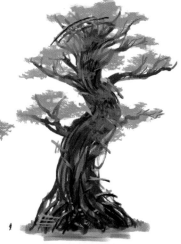

■Growth of the Ancient Tree

A particular characteristic of the Ancient Tree is that it draws from the surrounding plant life to grow. As a result, it is natural that many bugs gather in it and that it bears fruit. However, it is thought that there must be a special reason for its gigantic size and rapid growth.

Level 1

Level 2

Level 3

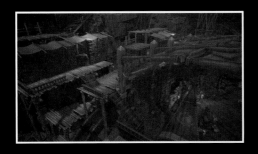

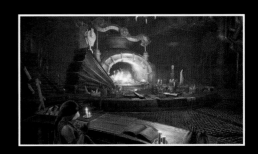

■Lift (2F)

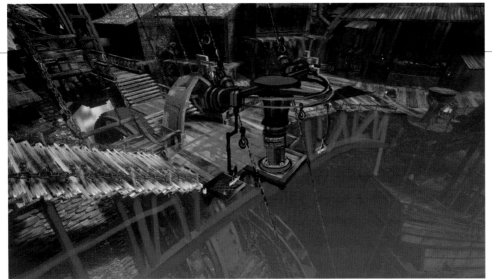

Workshop

BASE

■Function of the Smithy

This facility has a massive furnace and is mostly staffed by Second Fleet members who produce and enhance weapons and armor, among other things, using superior processing techniques. They also process materials necessary for construction in Astera. Also present is the Armory, which sells ready-made weapons and armor.

■Smithy, Exterior View

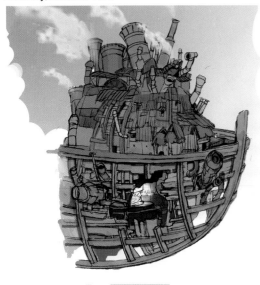

■Smithy

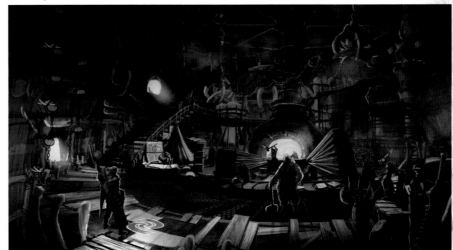

Completed weapons and armor are placed on a conveyer belt and displayed in front of the customer on the workshop's counter. The placement of the Armory was later reevaluated, and it was moved closer to the entrance.

The Smithy was made using material from the Second Fleet's ship. When it was thought that the ship's power could be diverted as is to the workshop, the designers made drawings like this one.

At the Smithy's back door are steps that continue up to a high ground where one can enjoy a view of Astera and its environs from a lookout point. It's a secret, therapeutic spot for Commission members.

■Living Quarters

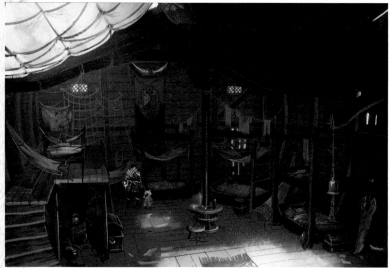

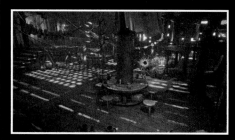

■Private Quarters

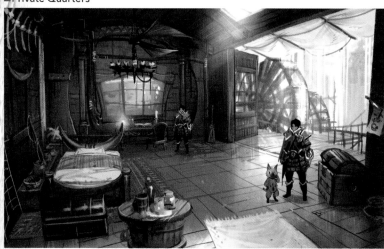

Compared to the living quarters, the private quarters are a remarkably comfortable residence. It has an aquarium for enjoying aquatic endemic life.

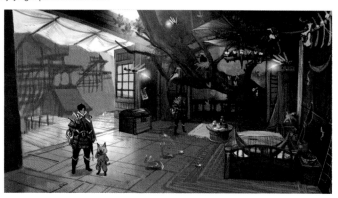

■Private Suite

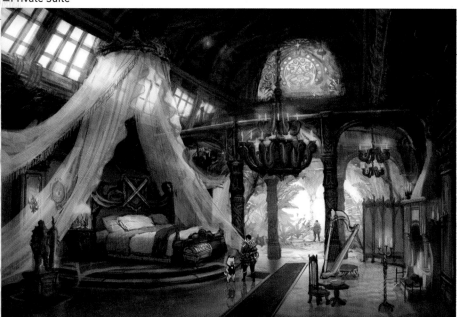

Your Room

The private suite is a conversion of the Chamber of the Five in the Gathering Hub, and it has luxurious furnishings. A gentle light shines in through the stained glass.

■Palico Trunk

Room Service

"Welcome home, Meowster."

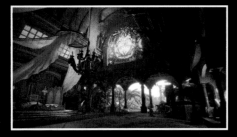
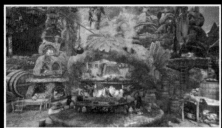
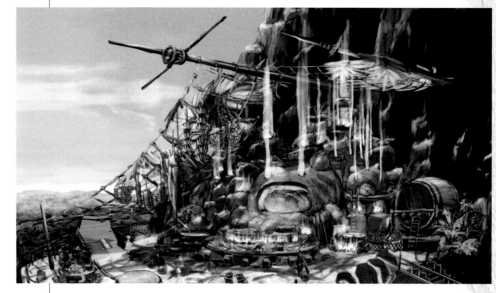

Canteen

■Oven

| Level 1 | Level 2 | Level 3 |

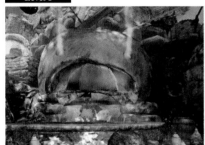

AT LEVEL 2, HOT CHARCOAL IS PLACED INSIDE THE STONE OVEN TO INCREASE THE HEAT.

THE INSIDE IS DARK SO WE WANT TO BRING THE LIGHT FROM UNDERNEATH. THERE IS CHARCOAL, SO IT'S OKAY WITHOUT.

TO PREVENT SMOKE ESCAPING, ADJUST THE MOUTH TO MAKE IT SMALLER IN ALL THREE STAGES (WOULD ALSO LIKE TO LOWER THE POSITION OF THE EYES)

COLLAR OF LEAVES

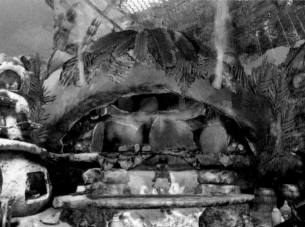

The Meowscular Chef has plans to enlarge this stone oven to keep up with the energetic efforts of the hunters. As the Canteen is upgraded, its dishes become more lavish. Further, food prepared here can also be delivered to the Gathering Hub.

BASE

■Function of Your Room

These rooms are where hunters rest up and get their gear in order and are even a place to keep endemic life. Those who have been recognized for their contributions can move into more pleasant rooms, so many hunters are eager to escape from the shared-use living quarters. One won't see the Handler here, as partners are assigned their own separate living quarters.

BASE

■Function of the Canteen

The Weapons and Wildcats canteen, run by the Felyne head chef, is on the third floor of Astera. Smoked foods and grilled dishes are prepared in the huge oven and stove, while soups are boiled in the cauldron. Many Commission members eat here and then head out on expeditions. In the evening, the seats are full of Commission personnel. The Canteen is thriving.

TOPIC An Indispensable Wagon for Transporting Foods and Resources

These wagons are used for transport in Astera. The frames are made from wood and bones, but the wheels have soft planks for cushioning.

Despite its limitations, it has a very creative design. Multiple barrel wagons hitched together can carry captured monsters.

■Wagon

■Barrel Wagon

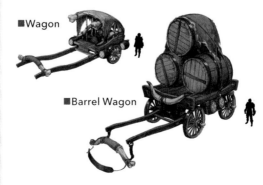

Gathering Hub

■Gathering Hub, Exterior View

When its center section was seriously damaged, the First Fleet's ship was left as is, shipwrecked on top of a rocky crag. It is now used as the Gathering Hub. Recently, the sails were repurposed to keep out the sun.

KEY WORDS [Fast Travel]

A means of travel using a Wingdrake that flies to specific locations. If it is made to remember the smells of Astera, a camp, or the one who summons it, it can be called with a whistle before a hunter attaches to it with a slinger. After specifying the destination, it will head to that location. The Farcaster item has a strong smell, which lets the Wingdrake know the situation is urgent.

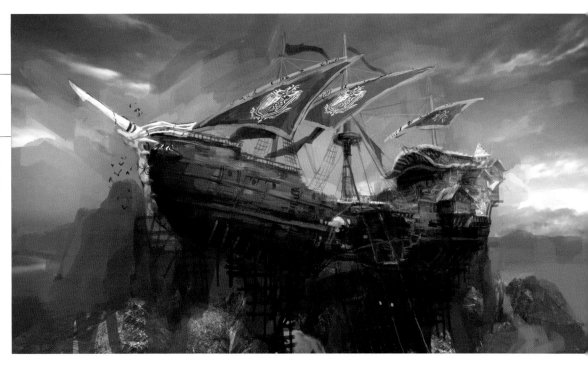

■Layout

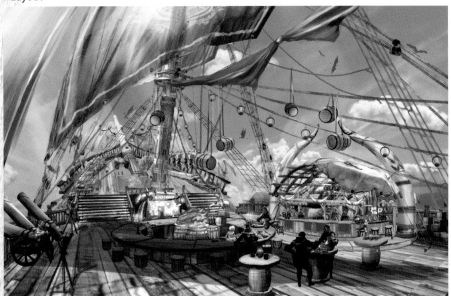

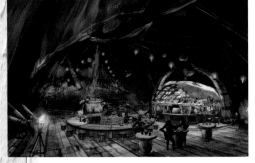

The positions of the circular dining counter and quest counter on the deck were planned to make it a place where many hunters could interact.

| BASE |

■Function of the Gathering Hub

Every day, members eat with associates here and then set off on expeditions. At the bow of the ship is the quest departure door, where Wingdrakes can be seen waiting for a signal. Incidentally, the barrel set up for arm wrestling on the deck seems to be a long-standing custom. The hunters like it for some reason.

| BASE |

■Regarding the Chamber of the Five

At the stern is a cabin that has been remodeled into a hall called the Chamber of the Five. Its large window depicts "The Tale of the Five," which has been passed down as a fairy tale and is the basis for the Commission's sigils. This place strengthens the hearts of those who live in Astera. Sometimes, the Commander visits it alone.

■Compound Beer Server

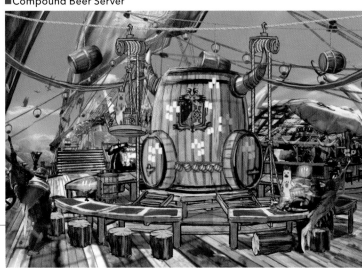

The beer server is positioned inside the circular counter, and the inside of the barrel is sectioned so it can pour beer and wine separately from multiple spouts.

■Lift (4F)

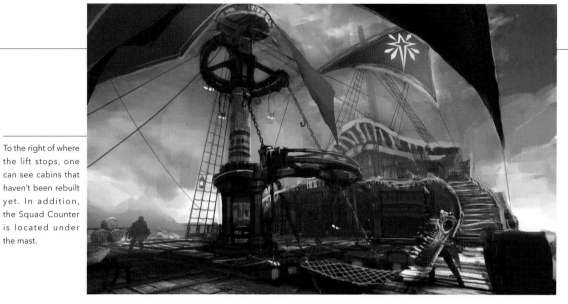

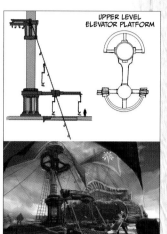

UPPER LEVEL ELEVATOR PLATFORM

To the right of where the lift stops, one can see cabins that haven't been rebuilt yet. In addition, the Squad Counter is located under the mast.

■Quest Counter

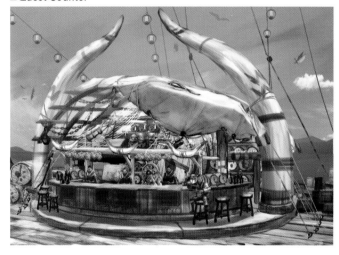

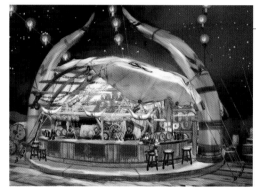

This is where hunters accept quests. The tavern was a facility that Commission personnel eagerly anticipated, and many people cooperated in its construction.

■Quest Departure Exit

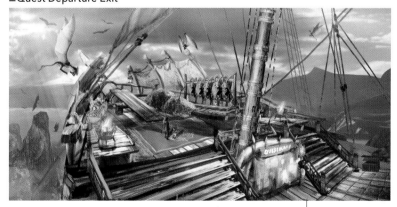

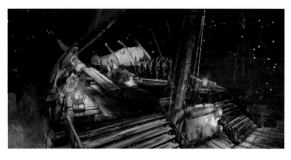

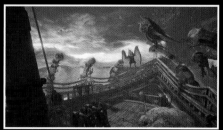

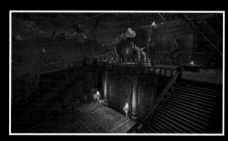

There used to be a scaffolding board needed in order to approach the Wingdrakes, but now that the hunters are accustomed to handling the Wingdrakes, it has been removed.

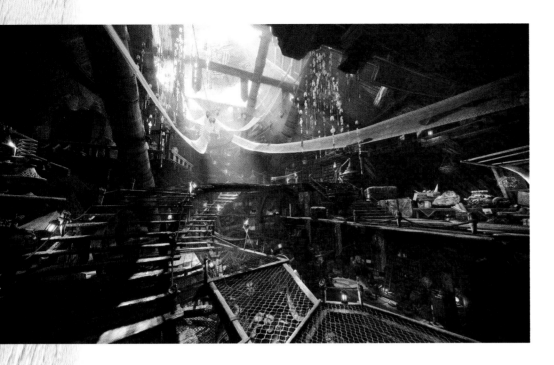

Research Base

Research Commission

Commission Headquarters

The Research Base is located north of Astera, at the end of a precipitous stretch of mountains called the Great Ravine. It is the Third Fleet's ship, but because it was converted into an airship, its interior structure was also modified. Here, Third Fleet scholars led by the Third Fleet Master carry out observations and research on the Rotten Vale.

| BASE |

■Aiming for the Deeper Reaches of the New World

After coming to Astera, it was the Third Fleet Master's desire to go farther. Shortly after, their converted airship took flight, but they were attacked and shipwrecked. The Third Fleet was made up almost entirely of scholars, so they couldn't progress or retreat. Ever since, they have been there in a state of isolation, unable to return to Astera these past twenty years.

| BASE |

■Stationary in a Foothold for Research

The Coral Highlands and Rotten Vale are unique ecosystems. As luck would have it, the place where the airship was forced to land is near lands abundant with subjects for the scholars' research. The area around the crash site is difficult for large monsters to approach, so the scholars live in relative safety. They also do research on Lynians and melding here.

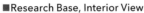
■Research Base, Interior View

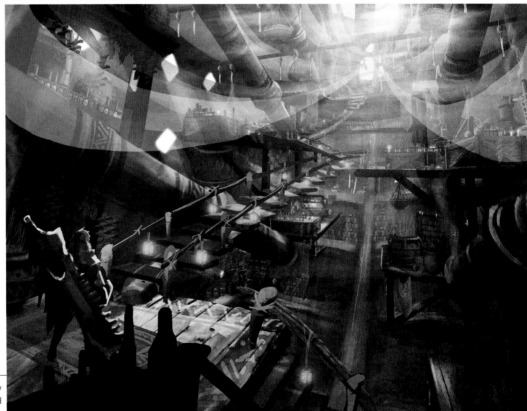

The ship was badly damaged in the accident twenty years ago, and the remaining bow of the ship is pointed downwards. As a consequence, simple staircases were built that connect landings to each other.

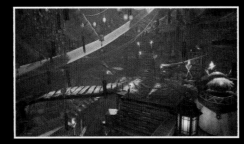

Third Fleet Master

"I don't necessarily want to reach the truth, because then it would all be over."

■Research Base, Lower Level

The lower level is a place where Palicoes wander around. At the direction of the Lynian Expert, they are deployed to investigate various locations.

■Research Base, Upper Level

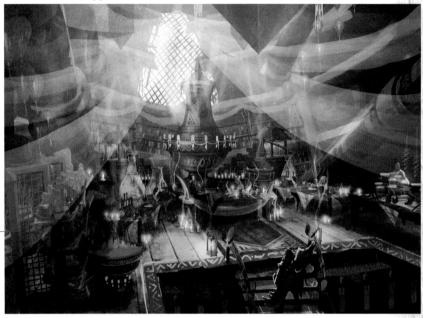

In the upper level is the special seat where the Third Fleet Master sits. Behind her is a gigantic incense burner. This burner and the other incense burners placed here and there fill the interior of the ship with fragrances.

Life in Astera

Astera Watcher Memoir

Here, I would like to present aspects of life in Astera from several perspectives from the time of the arrival of the Fifth Fleet. What is life like in the New World? I will write it down in a simple way.

❖Regarding the Food Situation

Looking around Astera, the first thing that surprises you is that you don't see any facilities like farms to handle the burden of food self-sufficiency. Most of the grains, fruits, and root crop foods you see in the Tradeyard were brought here by the Fifth Fleet in their crossing. Without that replenishment of goods, I expect we would have no choice but to rely mainly on whatever is harvested from the Ancient Forest or the Wildspire Waste. Why is there no self-sufficiency with crops?

The reason is that there are strict restrictions on seeds and seedbeds that can be brought over from the Old World. In Botanical Research, they cultivate local fruits, but in our present circumstances, that alone is not enough to sustain the food situation.

However, the vegetation appears to be close to that of the Old World in many ways, and it's probably a happy thing that residents here can partake of foods that are deeply familiar like honey, blue mushrooms, and plumpkins…setting aside whether the flavor is good or bad. Many of the fish that can be caught without too much risk are of varieties that we are used to eating. The fish can be preserved for long periods if they are dried, so they are the most popular food in Astera. Besides fish, one's eye is drawn to the red shrimp at the Provisions Stockpile, which seems to be quite a valuable food and is said to be a popular delicacy.

The other main sources of protein are monster meat and eggs. Of course, procuring such things involves danger, so often they are acquired through assignments given to hunters. The Ancient Forest, which is not that far from Astera, is a relatively safe place where endemic life like Shepherd Hares and Revoltures dwell, and the small monster Aptonoth. We can see that, to a certain extent, it is necessary to secure them for food. Right now, a big order of ingredients for alcohol like grains and fruits is scheduled for delivery, so they say the tavern is hurriedly making preparations to get to work.

❖An Introduction to the Monetary Economy

Back in the days of the First Fleet, there was no economy in Astera. As the number of people and roles increased, the resources that different Commission personnel needed also changed, and they started using money as something with a standard value. It's not unusual for some people to join the Commission looking to bring back their earnings from the New World to make a name for themselves back home. The Guild provides assistance managing financial matters in Astera, as they do with food and other things. Rewards and payment are received from the Guild upon returning to the Old World.

❖Comfort in the Living Area

The residential area where Commission members live was constructed using roughly six ships that follow the line of the cliff to eastern Astera. With each crossing, one new ship is left behind as a ferryboat, and an older boat is reused for materials in the living area. Living here is surprisingly pleasant. Everyone has built relationships that are like family, and in the end the splendid view is the most pleasant thing of all. Through trying to cope with damage caused by the salt from the sea is hard work, by reusing ship parts for building materials, the living area has proven resistant to salt damage, and some other materials are also treated with anti-salt counter-measures.

■Fifth Fleet Ship

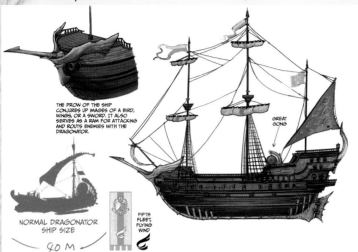

THE PROW OF THE SHIP CONJURES UP IMAGES OF A BIRD, WINGS, OR A SWORD. IT ALSO SERVES AS A RAM FOR ATTACKING AND ROUTS ENEMIES WITH THE DRAGONATOR.

NORMAL DRAGONATOR SHIP SIZE

40 M

FIFTH FLEET FLYING WIND

Fifth Fleet Ship

This ship carried the Fifth Fleet to the New World. It is about forty meters long. Its hull is the standard for the Guild, and the figurehead is a large monster's hyoid bone and can also be used for attacks. Two Dragonators are affixed to the ship's nose, and the lever is on the deck. Later, the ship acquired a massive Dragonator.

While following Zorah Magdaros's migration, the Fifth Fleet's ship was lifted up by the Elder Dragon's gigantic frame. That the hull remained mostly undamaged was the silver lining in a dark cloud.

■Dragonator – Firing Lever ■Fifth Fleet Ship (Sails Raised, Dragonators Firing)

①BONE

②IRON

MOVEMENT

THERE IS NO #5 (IT DOESN'T DO CIRCLES)

LEVER BEFORE ACTIVATION (WHEN CLOSED)
①IRON DOOR

①WOODEN DOOR

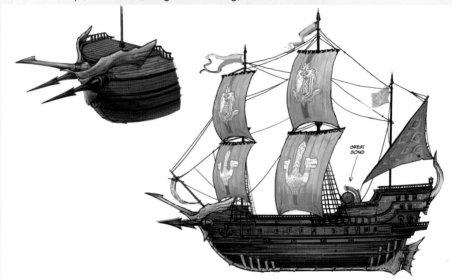

GREAT GONG

■Remodeled Ship

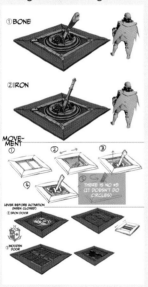

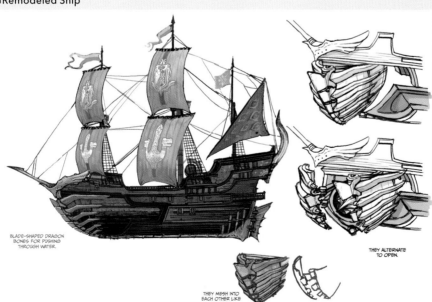

BLADE-SHAPED DRAGON BONES FOR PUSHING THROUGH WATER.

THEY ALTERNATE TO OPEN.

THEY MESH INTO EACH OTHER LIKE A ZIPPER.

■Remodeled Ship (Dragonator – Deployment Operation)

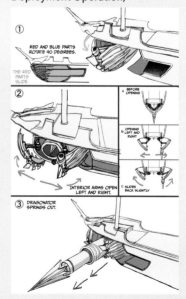

① RED AND BLUE PARTS ROTATE 90 DEGREES.
THE RED PARTS SLIDE.

②
A BEFORE OPENING
B OPENING LEFT AND RIGHT
INTERIOR ARMS OPEN LEFT AND RIGHT.
C SLIDES BACK SLIGHTLY.

③ DRAGONATOR SPRINGS OUT.

O T H E R S
C H A R A C T E R S A N D B A S E

■Research Base - Exterior View

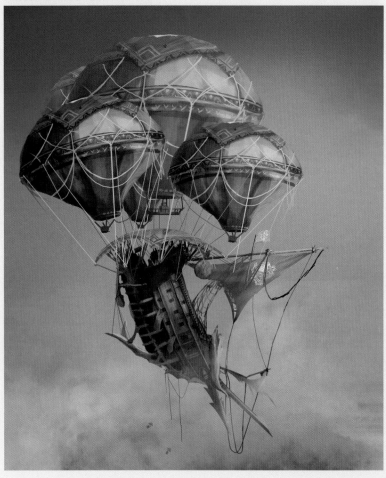

Third Fleet Ship

After twenty years, the Third Fleet's ship once again took sail as an airship. The living area was once in the stern, which was wrecked by their crash landing. Now the living area is at the bow. It has been rebuilt so the stern side is tilted up via balloons.

In a small space next to the Smithy, a man searches for a means of rescuing the stranded Third Fleet. A miniature airship model is on his desk.

In order to achieve their objective, the Third Fleet's ship made a new departure using hot air balloons. The fleet's banner trails from the mast, capturing the wind.

Checkpoint

A gigantic gate built on the road that leads to the Ancient Forest and the Wildspire Waste, which are quite close to Astera. It prevents incursions by monsters, and the bars are operated by a handle on the inside. The bottoms have been sharpened to points, but not to increase their ability to kill and injure monsters. Rather, the focus was smoother operation thanks to reduced weight.

■Checkpoint, Exterior View

■Checkpoint (Opening and Closing Operation)

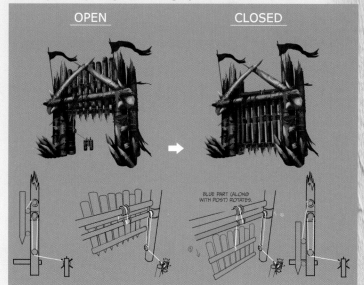

OPEN CLOSED

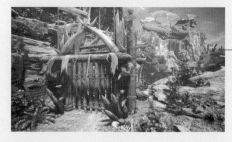

The checkpoint is necessary to prevent monsters from entering Astera. A smell that monsters dislike has been worked into the timber, and they won't approach the gate unless something is very wrong.

Extended **World Gallery**
Base **Illustrations**

Collected here is some of the art for Astera's design, depicting a place that was built as a base of operations in an unexplored land through the efforts of Commission personnel. One can probably see the trial and error that they went through, from ideas for a base as imagined by the First Fleet when they departed the Old World, to the construction of the present Astera after they actually arrived in the New World. Of course, they could never have imagined that the First Fleet's ship would end up on top of a rocky crag like it did.

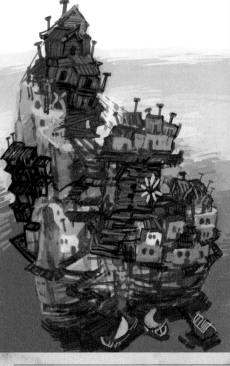
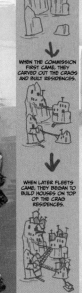

ORIGINALLY THEY WERE ORDINARY SEASHORE CRAGS.

WHEN THE COMMISSION FIRST CAME, THEY CARVED OUT THE CRAGS AND BUILT RESIDENCES.

WHEN LATER FLEETS CAME, THEY BEGAN TO BUILD HOUSES ON TOP OF THE CRAG RESIDENCES.

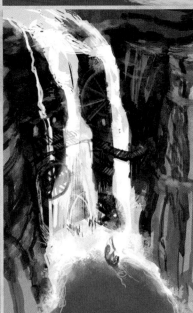

❖ Research Commission Headquarters Construction Concepts

When the Commission was first sent to the New World, scholars and artisans imagined the topography and thought up various configurations for a base. Ideas included building in the space between seaside cliffs, in eroded terrain below a shoreline, or behind a giant waterfall. Making use of a rocky tract or connecting boats used in the voyage over into floating houses were regarded as likely options.

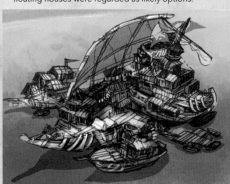

ON TOP OF THE SHIP ARE MORE SHIPS, AND HOUSES ARE BUILT ON TOP OF THAT, SO THE EXTENSIONS ARE QUITE CHAOTIC.

❖ The Shipwreck of the First Fleet

Everyone in the First Fleet was upbeat about the stranding of their ship. And everyone in the Second Fleet, which arrived with the aim of expanding the base, displayed an eagerness to grapple with reusing the damaged ship. In the end, the abandoned ship was made useful even while straddling two jutting crags. Later on, the Third Fleet ship, which became the Research Base, made partial use of the idea of setting up in a cave.

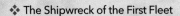
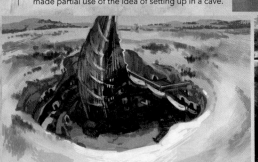
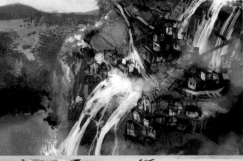
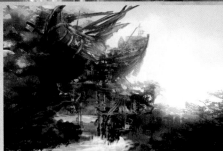
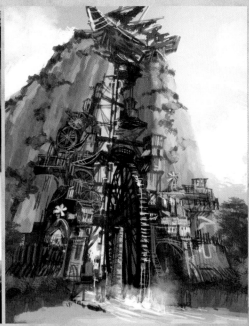

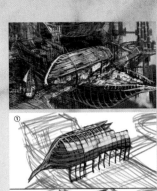

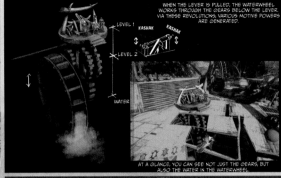

THE BOTTOM OF THE SHIP FORMS THE ROOF.

WHEN THE LEVER IS PULLED, THE WATERWHEEL WORKS THROUGH THE GEARS BELOW THE LEVER VIA THESE REVOLUTIONS, VARIOUS MOTIVE POWERS ARE GENERATED.

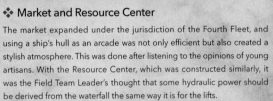

AT A GLANCE, YOU CAN SEE NOT JUST THE GEARS, BUT ALSO THE WATER IN THE WATERWHEEL.

❖ Market and Resource Center

The market expanded under the jurisdiction of the Fourth Fleet, and using a ship's hull as an arcade was not only efficient but also created a stylish atmosphere. This was done after listening to the opinions of young artisans. With the Resource Center, which was constructed similarly, it was the Field Team Leader's thought that some hydraulic power should be derived from the waterfall the same way it is for the lifts.

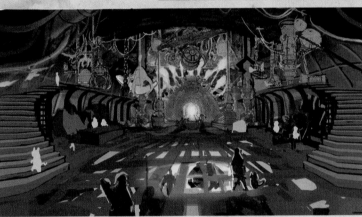

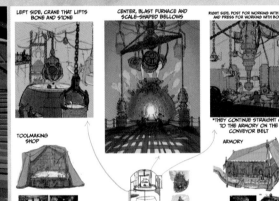

LEFT SIDE, CRANE THAT LIFTS BONE AND STONE

CENTER, BLAST FURNACE AND SCALE-SHAPED BELLOWS

RIGHT SIDE, POST FOR WORKING WITH IRON AND PRESS FOR WORKING WITH BONE

TOOLMAKING SHOP

*THEY CONTINUE STRAIGHT ON TO THE ARMORY ON THE CONVEYOR BELT

ARMORY

CAULDRON

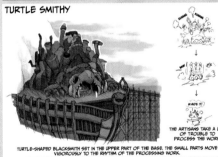

TURTLE SMITHY

TURTLE-SHAPED BLACKSMITH SET IN THE UPPER PART OF THE BASE. THE SMALL PARTS MOVE VIGOROUSLY TO THE RHYTHM OF THE PROCESSING WORK.

THE ARTISANS TAKE A LOT OF TROUBLE TO PROCESS THE WORK.

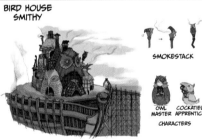

BIRD HOUSE SMITHY

SMOKESTACK

OWL MASTER / COCKATIEL APPRENTICE

CHARACTERS

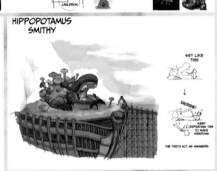

HIPPOPOTAMUS SMITHY

SET LIKE THIS

THE TEETH ACT AS HAMMERS.

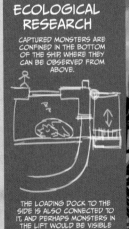

ECOLOGICAL RESEARCH

CAPTURED MONSTERS ARE CONFINED IN THE BOTTOM OF THE SHIP, WHERE THEY CAN BE OBSERVED FROM ABOVE.

THE LOADING DOCK TO THE SIDE IS ALSO CONNECTED TO IT, AND PERHAPS MONSTERS IN THE LIFT WOULD BE VISIBLE TOO.

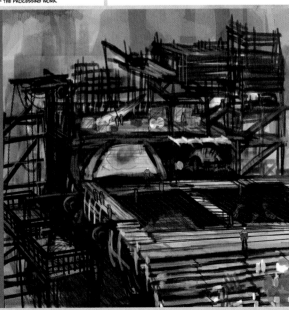

❖ Facility Construction Designs

The equipment inside the Smithy was designed to make use of the Second Fleet ship's power. The young artisans suggested fanciful animal motifs for the exterior, but the Second Fleet Master dismissed their ideas. The shape that Ecological Research has taken, where archives are stacked up in stages, is close to the current completed image. The Botanical Research art is a concept design of what was to come.

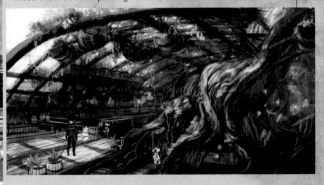

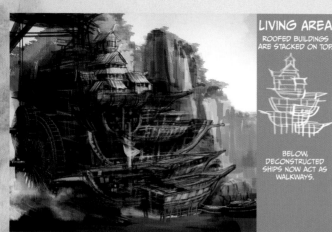

LIVING AREA
ROOFED BUILDINGS ARE STACKED ON TOP.

BELOW, DECONSTRUCTED SHIPS NOW ACT AS WALKWAYS.

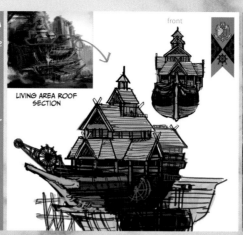

LIVING AREA ROOF SECTION

front

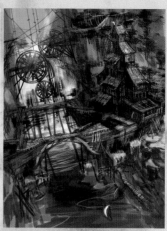

❖ The Creation of HQ's Living Area

For the extension of the living area, it was thought that stacked ship hulls could be used. A long period of time was spent on the construction. There was also a proposal to use the ships vertically, but after considering the construction of rooms in them, that idea was abandoned. There are also plans to build an upper-level residential area in the lower part of the First Fleet's ship exclusively for hunters who have been recognized as being the very best.

❖ Designing the Canteen

The Canteen is indispensable, and the Meowscular Chef's input was considered in its creation. A daring design featuring a huge fish tank in the gathering area would probably have been overwhelming if it were actually built. There were also plans to make a mobile kitchen for camp meals, but that hasn't been implemented yet.

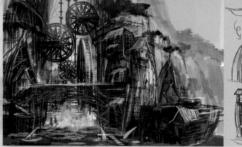

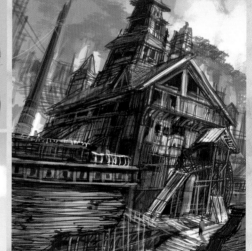

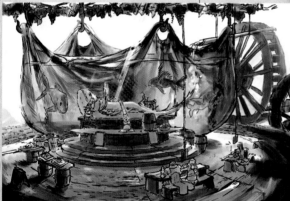

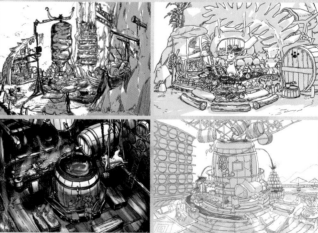

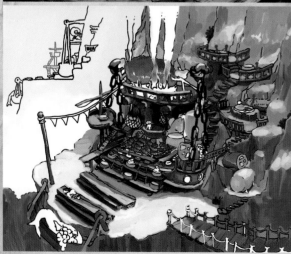

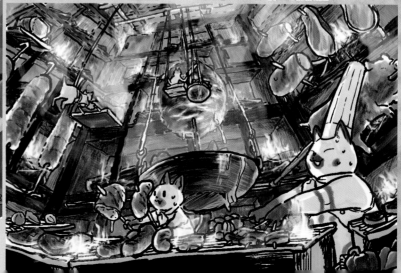

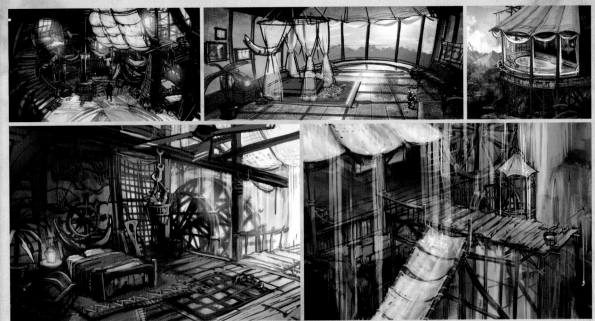

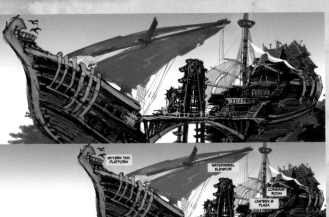

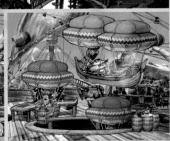

❖ Gathering Hub Layout Concepts

During the creation of the tavern, there were also proposals to build a stairwell up to the nose of the ship, but there were concerns about drunk Commission members falling off it, so the idea was nixed. As far as deliveries from the Canteen, it was suggested that they be transported by Wingdrake and balloon. However, the Meowscular Chef said that these ideas should be abandoned.

❖ The Grade of Your Room

In the living area, each room is graded according to comfort and convenience. Grades are decided according to the degree of one's contributions to Commission activities, from living quarters to private quarters, and finally private suites. This plays a role in motivating Commission personnel.

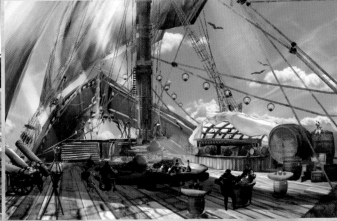

❖ Trial and Error with the Research Base

The interior was conceived by the Third Fleet Master, to the anguish of the Airship Engineer. They set half the hull vertically, and the signs of their hard work can be seen around the footholds and scaffolding.

AN AIRSHIP THAT FLOATS THANKS TO DEEP-SEA GAS. IN THE LATTER HALF OF THE STORY, IT BECOMES THE PLAYER'S BASE. THE FRONT OF THE SHIP IS NOW USED AS A RESIDENTIAL AREA.

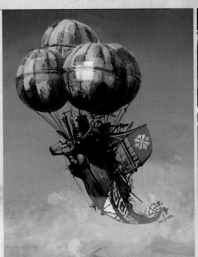

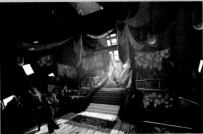

CHAPTER 2
Field Exploration

A massive amount of setting and concept art was drawn during the development of *Monster Hunter: World*. This chapter explores the vastness of the New World from the perspective of a member of the Fifth Fleet. In addition, Executive Art Director Kaname Fujioka and Director Yuya Tokuda provide behind-the-scenes stories about the environment and their conception to explain how the New World was both constructed and given life.

Fifth Fleet Diary Entry Exploring the Possibilities of the New World

The Fifth Fleet's research of the New World had come to an end. I was later finally able to explore Astera. I was recovering from an injury I had sustained when our ship collided with Zorah Magdaros just before the Fifth Fleet arrived in the New World. By the time I was able to return to action, my fellow hunters had solved the mystery of the Elder Crossing, which occurs in a ten-year cycle, and reached the Confluence of Fates with a handler after Xeno'jiiva was slain.

Although I was happy to hear about their achievements, I was also disappointed I wasn't there with them. So I declined the order to return and decided to remain here. I couldn't leave with the way things were because I was overcome with a desire to retrace their steps. During the forty years since this world was discovered along with the Elder Crossing, the people of Astera always placed the ecosystem first, not tampering with it more than necessary... To be exact, according to the stories I heard while I was recovering, the people of Astera had explored the Ancient Forest and the Wildspire Waste. However, due to seismic activities caused by the migration of the Elder Dragons every ten years, the environment and ecosystem were thrown out of balance. They say that every time that happens, the Wildlife Map is redrawn and research is halted. But I was told the Elder Crossing was different this time. Perhaps it has something to do with the changes to Zorah Magdaros's movements. I couldn't contain myself thinking about it. While many in the Fifth Fleet were conducting new research, I began my journey in the New World by retracing their steps. I was determined to present a new theory that only I could come up with. The following are the thoughts of one who belatedly retraced the path they once travelled.

The myth of the elephant's graveyard is at the foundation of the concept of the New World. Realistically, it may seem far-fetched, but it's believed that fewer elephant corpses are found than should be based on their population or that they go to die where they won't be discovered. I thought a powerful creature like an Elder Dragon would not leave its corpse exposed. It knows its own energy and therefore would seek a place of death appropriate for its kind. That is how I came up with stories about their behavior and the concept of the New World. (*Tokuda*)

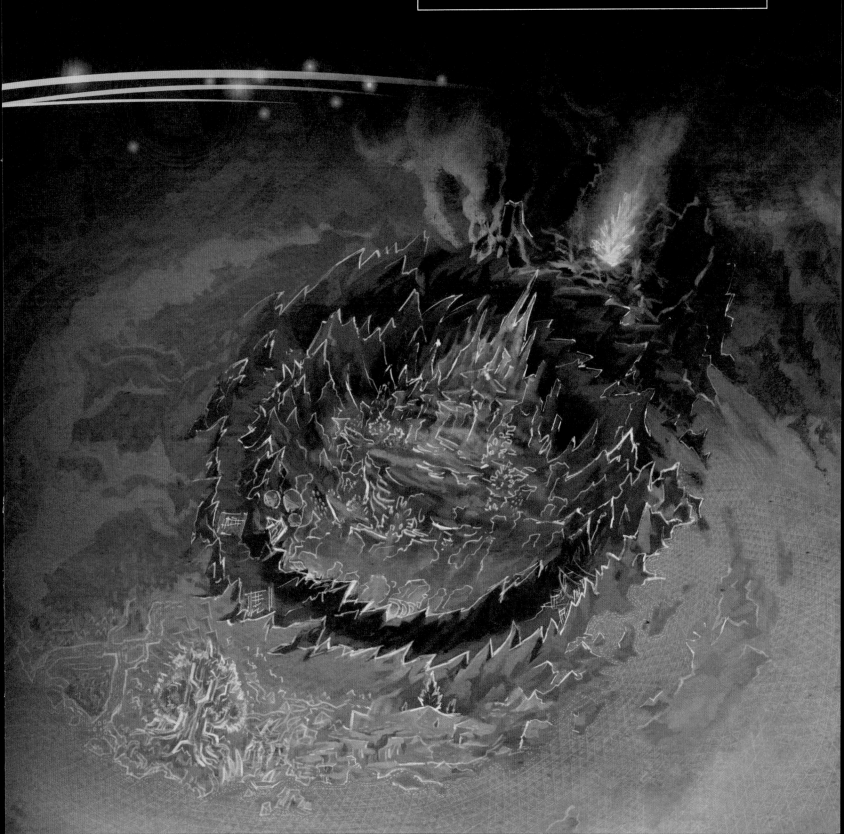

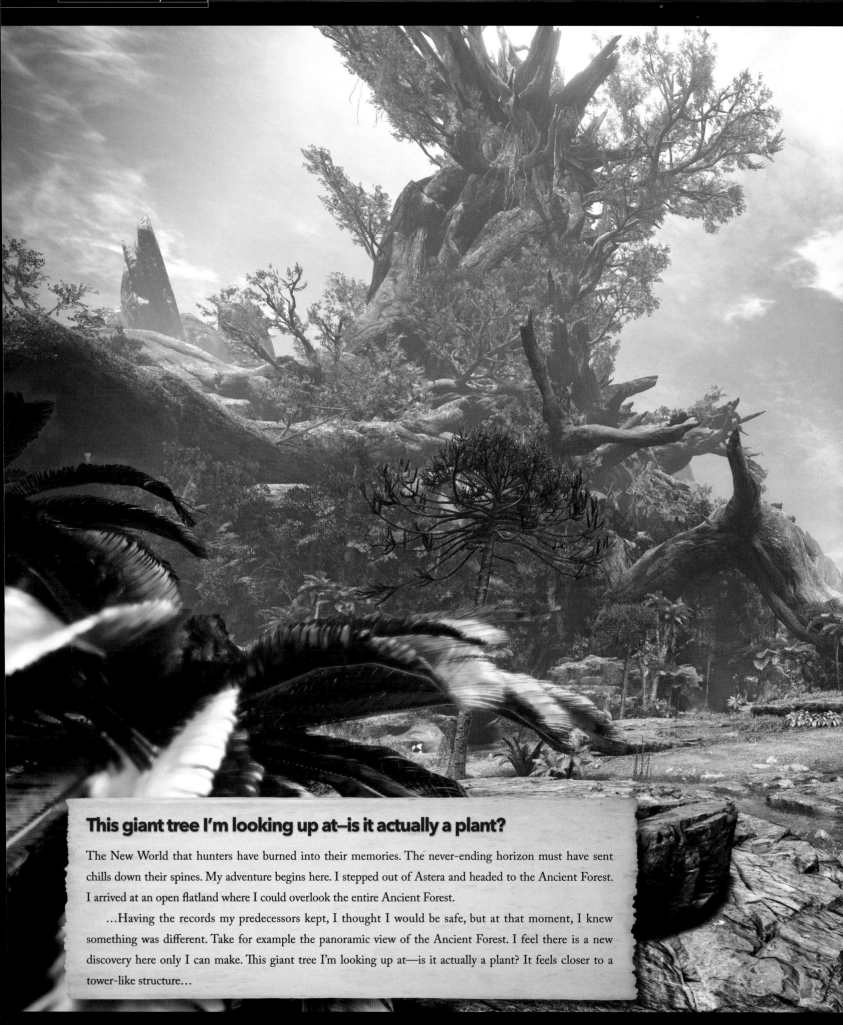

This giant tree I'm looking up at—is it actually a plant?

The New World that hunters have burned into their memories. The never-ending horizon must have sent chills down their spines. My adventure begins here. I stepped out of Astera and headed to the Ancient Forest. I arrived at an open flatland where I could overlook the entire Ancient Forest.

...Having the records my predecessors kept, I thought I would be safe, but at that moment, I knew something was different. Take for example the panoramic view of the Ancient Forest. I feel there is a new discovery here only I can make. This giant tree I'm looking up at—is it actually a plant? It feels closer to a tower-like structure...

Ancient Forest

A vast forest teeming with life. The trees growing entwined with one another tower into the sky, creating the giant Ancient Forest. The Ancient Forest is home to all the creatures in the forest, creating one ecosystem.

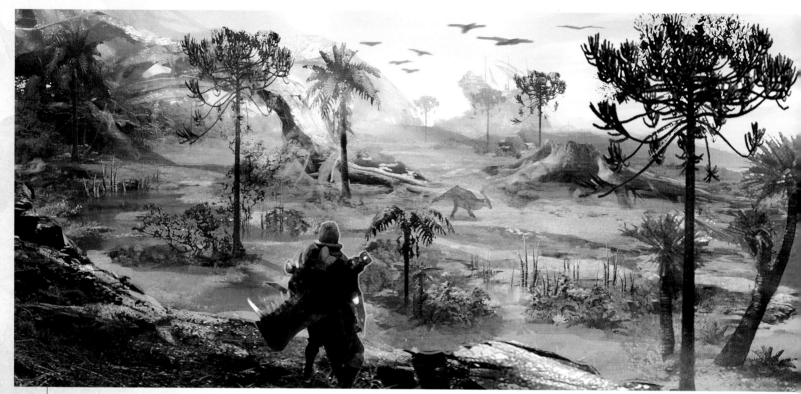

THE COASTAL PLAIN: Spreading at the end of a narrow path from the first camp ever built in the New World is the awe-inspiring great plain. The lush vegetation of the lowland swamp, the sounds of herbivores, the breeze. It is truly a vivacious world that is like an encapsulation of all life living in the New World.

THE FOREST OF TURFS: I entered the thick forest. Spores travel on the wind from the north, but I smelled blood. Proof that this area belongs to the carnivores. A pack of small monsters known as Jagras was looking at me. Branches and roots spread everywhere, and around me are the skeletal remains of creatures.

THE GLIMMERING WATER: Aptonoth playfully gather and graze. Much of the vegetation in the lowland swamp area does not grow tall, making the area an ideal feeding ground for herbivores. It is clear that this area, with nothing to block the wind or sunlight, has all the right conditions for vegetation to thrive.

FOREST WHERE THE JAGRAS PRANCE: A giant branch arcs across the area, and high-humidity plants wrap the trees. The Jagras restlessly move across the giant branch. Their den is spread across the muddy ground. Sleeping there is their leader, the Great Jagras.

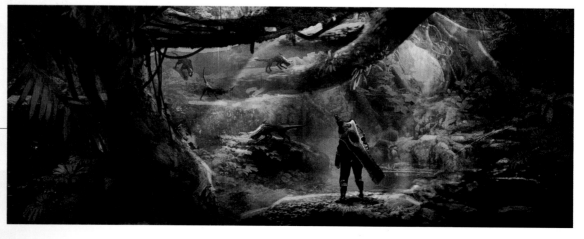

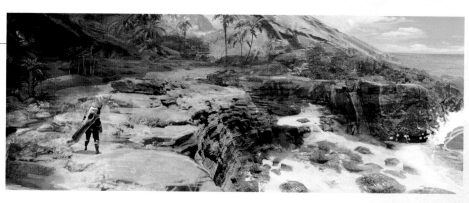

WHITE SANDY SHORE: A flat area along the ocean with dry winds and shrubs. A gentle wave crashes on the white sandy beach. It is a sunny and temperate area, but Anjanaths, dangerous Brute Wyverns, are known to appear nearby. I can see animals sunbathing on the beach.

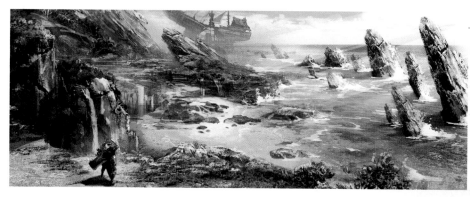

ASTERA OUTCROPS: Rock outcrops along the shore that can be seen to the north of the white sandy beach. The numerous tall outcrops turn Astera into a natural fortress. The outcrops are irregularly shaped, as if they were formed by some powerful force besides waves.

A variety of environments can be seen with every few steps in the Ancient Forest and the woodland that spreads below it.

People call them adventurers, travelers, challengers, or hunters. Hunters have traversed many areas over the years. Volcanic regions with raging fires, jungles where countless plants and animals live, cold lands that freeze every living creature, the peaks of mountains that extend to the heavens, the bottoms of canyons that reach to the depths of the earth, or unexplored regions where giant structures that could not have been constructed by modern humanity exist…

Where we arrived was the New World. In this land we came to by following the Elder Crossing, our predecessors had built Astera. The purpose of the Fifth Fleet was to use the groundwork they had laid to meticulously research the New World. The land adjacent to Astera is a woodland that spreads below the Ancient Forest, where massive ancient trees that reach into the heavens stand.

The varying environments we saw every few steps surprised us. It quickly changes from a broad-leaved forest along the shore to a swampy, tropical jungle. And the countless, massive, most ancient trees that you have ever seen. Looking up at a trunk that is almost as big as a mountain, you can't help but feel that there is something about the New World that you have never felt before. It is not your imagination. Perhaps pursuing that feeling, in addition to researching the Elder Crossing, is my mission.

Production Backstory

PRODUCTION NOTES
Ancient Forest Design Concept

The very first field we tested was the Ancient Forest. It was already decided that we would emphasize ecosystems, so we had two features we had to test. The first test was whether an ecosystem could be felt. The other was concentrated topography, creating a field that includes elements of topography that players can take advantage of so they can experience variations in elevation and a dense ecosystem. Fujioka suggested incorporating a landmark that could serve as a visual hook. That is how the Ancient Tree was added. Incorporating landmarks that serve as hooks became a common theme. (*Tokuda*)

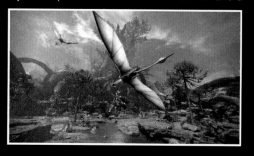

TOPIC **Ancient Forest Area Composition**

It can be divided into the lower level, the middle level where you can climb the Ancient Tree, and the upper level near the peak. The Ancient Tree is designed to be a tower for an ecosystem that includes a wide variety of plants and animals.

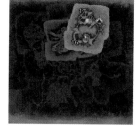

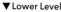

▼Lower Level

▼Middle Level ▲Upper Level

Leaning on and connecting to one another. A collective of trees that appear as one. That is the Ancient Forest.

Many of the drawings you see here were created by the researchers who made the trip with me. I sincerely hope my new observations live up to their incredible drawings. It hasn't been long since I entered the Ancient Forest, but the place has already left an indelible impression on me. I described the Ancient Forest as a giant structure.

That is perhaps not just an impression, but the truth. I realize this opinion may sound absurd, but if you ignore its scale, it is clear that this place is organic. Trees have taken root around larger trees, leaning on and connecting with one another. A collective of trees that appear like one. That is the Ancient Forest.

However, I do not want to dismiss just yet my hunch that the Ancient Forest is some kind of structure. With the discovery of the Confluence of Fates as one turning point and the people of Astera conducting new research, is it necessary to challenge what has already been accepted? I am not sure myself...

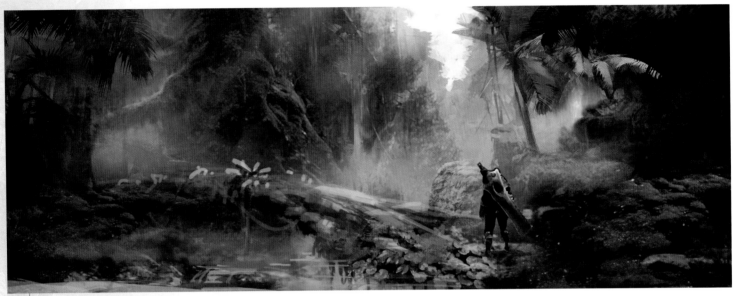

A DENSE, FOGGY FOREST: A deep, green forest where giant trees stand tall, moss covering the roots exposed at the surface. Spores fill the air like fog. The fantastic atmosphere can make one believe one has wandered into another world.

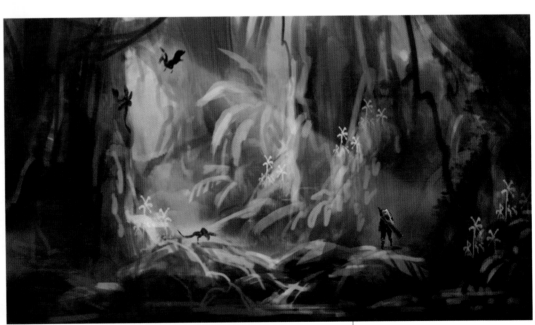

VEGETATION WITHIN THE FOREST: Deep in the forest surrounded by giant trees. Woodland Pteryx fly between branches where light enters. The rare Forest Pteryx can also be seen at times.

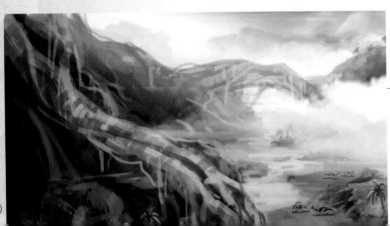

EXPOSED ROOTS: When you approach the Ancient Tree, its roots can be seen. The moisture flowing out of the trunk creates fog. It feels as if you have climbed up a giant tree that extends to the heavens and are standing above the clouds, but this is still only the lower level.

Ancient
Forest

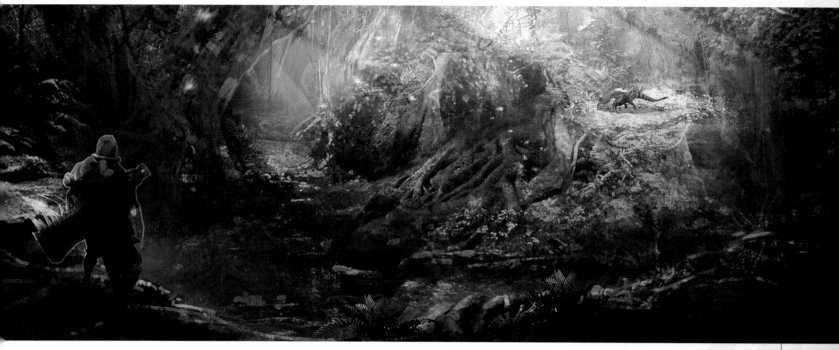

SPORE-FILLED FOREST: Moss and plants grow around pools of water. Past the sunlight entering the area are numerous endemic life-forms, hurriedly sipping on water. This beautiful space with spores fluttering all around is tranquil but also full of life.

PAST THE GREEN TUNNEL: The trunk of a giant tree arcs, creating a natural tunnel. Groundwater has seeped to the surface, providing an oasis for the endemic life. With the Vigorwasps flying around, it is also the perfect resting place for us.

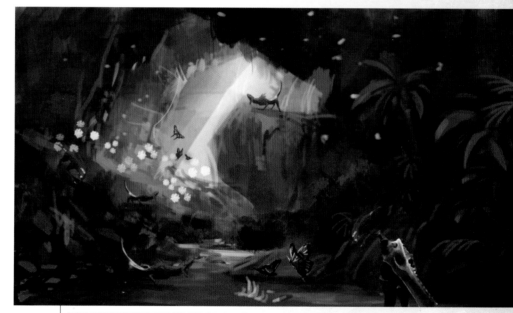

FROM THE BOTTOM OF THE DEEP, GREEN HOLE: Past the moss-covered rock face is an open area. An arcade surrounded by walls of moss. The opening up top makes one feel as if they are looking up at the surface from the bottom of a giant hole. Vibrant blue Cobalt Flutterflies make their home here.

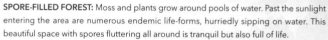

**Production
Backstory**

PRODUCTION NOTES
Birth of the Ancient Forest

It was decided early on that the first field would be a forest. We thought, "What kind of landmark can we put in it?" We decided to include a symbolic tree made up of multiple trees twisted into one, similar to a tree that stands near the house I grew up in. At first glance, it appears to be one giant tree, but it actually has many different plants inter-twined. Being able to walk into it also matched our concept. That is how the Ancient Forest was born. (*Fujioka*)

DARK WATER'S EDGE: A dark area past the forest of spores. Many varieties of Gourmet Shroomcaps grow on the ground and on the trunks of trees, indicating the high humidity of this area. You can see changes in endemic life, as very little light reaches this area.

GOUGED GIANT TREES: Sprouts grow from fallen trees, and vines wrap around tree trunks. The trees have been hollowed out, allowing us to walk inside. I'm curious how these trees became this way.

ORANGE-SPRINKLED VINES: To the northwest is a forest of Scatternuts. The orange Scatternuts fill this place with color compared to the moss- and vine-filled forest of spores. Scatternut shells can be found on the ground.

THE FOREST'S FEEDING GROUND: Jagras prance around in this low-humidity area. It is an area suited for small monsters to hunt, but it is also an ideal location for them to be ambushed.

I witnessed an almost strangely perfected ecosystem in the Ancient Forest.

We circle around the Ancient Forest, conducting our research. It is easy to see that this environment is ideal for life. Sea breeze can often create an unsuitable environment, but this coastal area is unaffected thanks to the Ancient Forest. A jungle spreads across the coastal area north of the Ancient Forest, which is not typical. This entire forest should be covered in white sand due to the sea breeze.

Providing nutrients to the soil, shedding leave as nutrients, attracting herbivores seeking plants and carnivorous monsters that prey on them. Becoming a wall against the breeze and a breakwater against the waves. Those are the benefits the Ancient Forest provides the area.

Where does the Ancient Forest derive its nutrients? That was discovered by the struggles of the Fifth Fleet and the people of Astera. The Ancient Forest grew in size thanks to the circulation of recycled nutrients processed by the Rotten Vale. These nutrients seeped deep into the water that courses through the ground, flowing underneath the entire New World. It was not detected during the last Elder Crossing, but rapid growth has been confirmed four times in the past. Rapid growth happens every time an Elder Crossing takes place. I have no reason to question this natural cycle, but this ecosystem, exemplified by the Ancient Forest being born

from it, gives me a strange feeling. It is almost too perfect.

Giant trees came together to create the Ancient Forest. Could something other than the Everstream create this? Perhaps there was a mastermind that placed this landmark, the Ancient Forest, as the entrance to the New World and created this mild and humid environment suitable for life. It is easy to say it was the work of the gods or simply coincidence. A flow of Everstream unseen by people or creatures exists below the New World, like veins in a living creature. Maybe I'm not so willing to accept this too-perfect phenomenon. I must continue my research.

Production Backstory

As with all life in the fields, we begin by thinking about what would be at the bottom of the food chain in that environment. For example, the environments in the Ancient Forest differ depending on the location, which determines the humidity, temperature, and sunlight. The higher the elevation, the lower the humidity and the more wind. Areas of high humidity would have moss and fungi... What would inhabit an environment like that? We would start there and slowly add *Monster Hunter: World*'s original touches. How would monsters behave? How would they interact with the landscape? We would start at the bottom of the food chain and then work our way to the top. We experimented using the Ancient Forest as a template. (*Fujioka*)

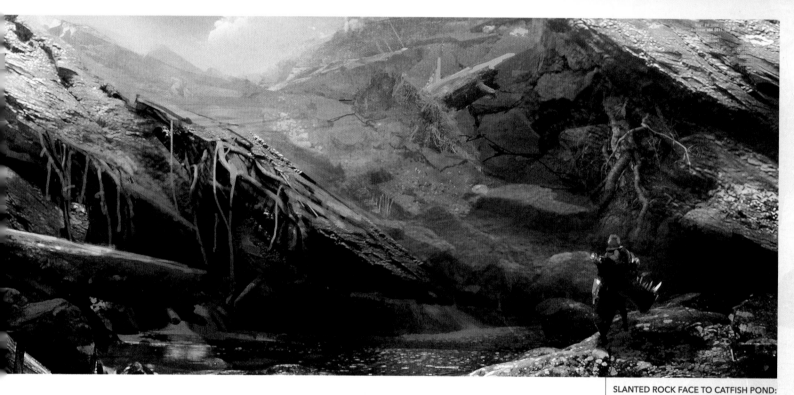

SLANTED ROCK FACE TO CATFISH POND: A pond to the northwest of the camp. The rock face is at an incline, so traversing the slope requires attention. Large cracks in the rock and fallen trees can be found here.

PEAK OF THE ROCK FACE: Many varieties of freshwater species inhabit the pond. A knot of Paratoads lives above the rocks. We must be careful when moving or encountering monsters.

GAME TRAIL IN THE JUNGLE: A thick forest grows near the water. It is a treasure trove of life. Mosswine can be found here.

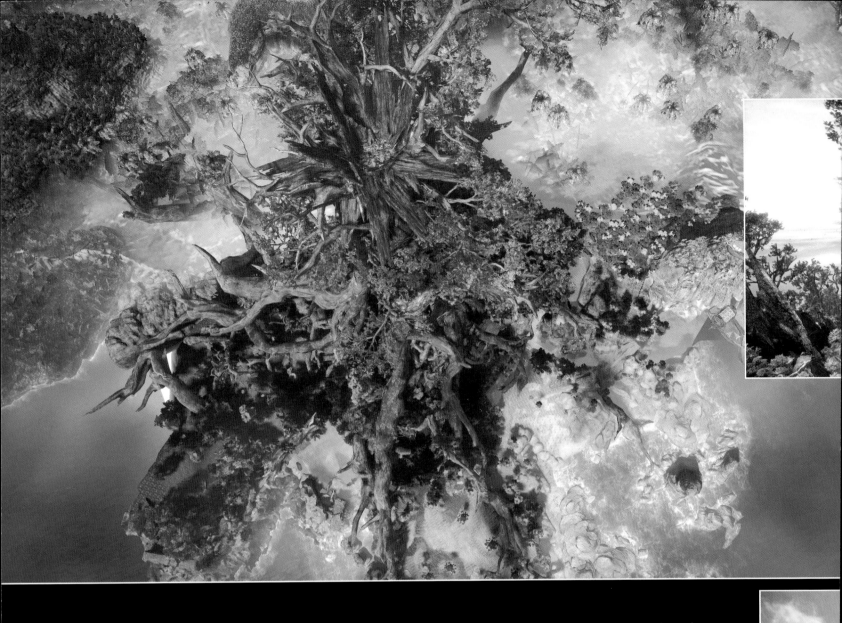

Landscape Beauty
-Ancient Forest-

What exists at its peak, at its center? The landscape, created by countless plants with roots firmly spread into the land, entwining into one giant tree, reflects the power and splendor of nature and the compassion to nurture life. The scenery is simply breathtaking. Its beauty overshadows the strange power that dwells here, and even the natural threats.

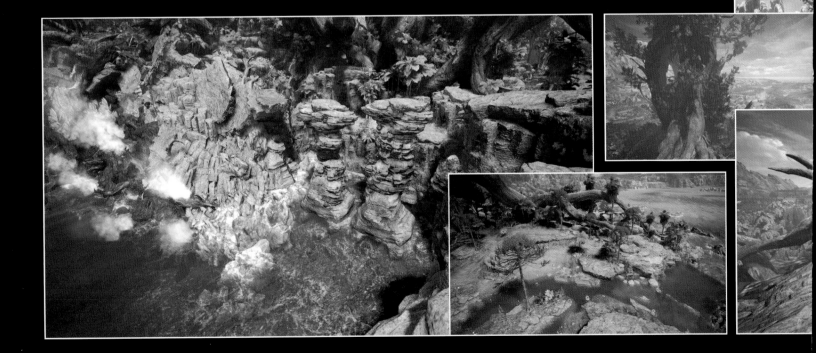

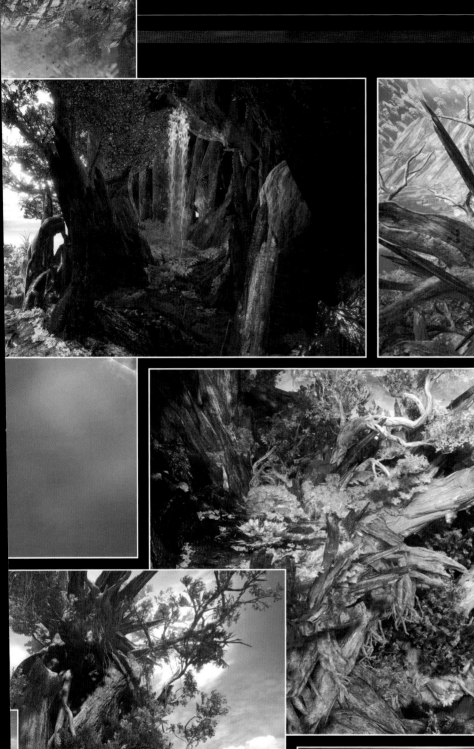

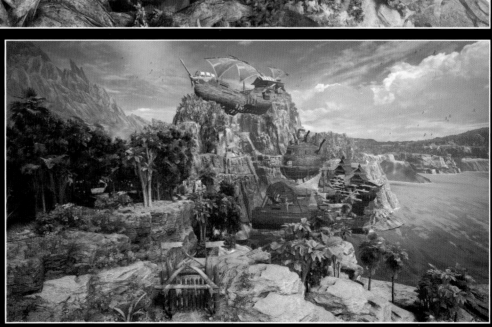

111

BATTLEFIELD ON THE GIANT BRANCH: An area where giant trees grow from the roots of the Ancient Tree. You can travel on the branches, but you may run into a turf war between large monsters. Visibility is low due to the thick vegetation.

FOREST CONTINUES UPWARD: Giant trees grow from the Ancient Tree as if they were grafted on. It is possible to move upwards and downwards by using these vines.

The temperature rose the more I climbed. The ecosystem of the endemic life also slowly changed.

My research enters the second half. I finally entered the Ancient Forest. There are areas where I can use the vines to climb, but most of the climbing entails walking up the giant branches. I was surprised. It was no different from climbing a mountain. The trunks have hollow, room-like spaces inside. Monsters like Anjanaths crush the trunks to travel through the trees. While traveling up this giant, three-dimensional mazelike tower created by nature, the landscape slowly changed. Changes in elevation affect climate and the environment. It was no different here. The temperature rose the more I climbed as the density of trees raised the

humidity. The ecosystem of the endemic life also slowly changed. I have discussed the history of the Ancient Forest many times, but now I would like to discuss how the countless giant trees, serving as cuttings to form one giant tree, were introduced here. Artificial forestation would have been impossible. This is the New World. This vast wilderness remains because humans had not disturbed it. If so, it would be natural to think animals brought the trees here. Like an insect spreading pollen, it's perhaps possible that animals can connect ecosystems. But I expanded my view. What if a branch, stuck in the whiskers of a large monster that made its home here, fell

and created a new plant… Could it have grown this massive after many, many years? The accepted theory is that the forest grew from the flow of the ancient Everstream. Should we accept that as the truth?

I ask because it was the First Fleet that arrived here forty years ago that pointed to that landmark-like tree and called it the Ancient Tree. That tells us, when taking a look at the past few decades of explosive growth thanks to a surge in the Everstream, that the observable growth of the Ancient Tree is only slight. There is value in pursuing another theory for the Ancient Tree's growth. I believe something powerful existed here before the Ancient Forest was formed.

TIGHT ROPING ACROSS BRANCHES AND VINES: A three-dimensional passage that connects the Ancient Forest's lower and middle levels. It's possible to move up or down using the roots and branches hanging in the air. Large monsters steer clear of this area, but it is easy to get lost. You can fall upside down to the lower tier if you are not careful.

WATER TANK INSIDE THE ANCIENT TREE: A turquoise pond where the sun shines through… Or so it appears, but this is actually inside the Ancient Tree. Rainwater and water seeping out from the trees have pooled over ground where trunks and branches have fallen. Aquatic organisms like fish can be found here. Where did they come from?

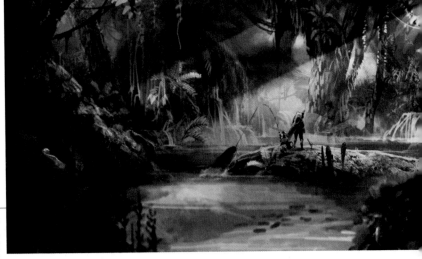

FOREST CREATED BY THE ROOTS: A space between the roots of the trees of the Ancient Forest. The many massive column-like roots lift the soil and rocks, creating a cave-like area. Water drips from the tops of the trees. A pack of Kestodons visits the watering hole.

CAVE CREATED BY THE ROOTS: Many varieties of insects make their home in the cave. Many of them can be collected too. The cave is too small for large monsters to enter. However, smaller carnivorous monsters like the Jagras can.

TOPIC

Full View of the Upper Level of the Ancient Forest

The Ancient Forest provides many levels to explore. It is easy to lose your sense of direction in this three-dimensional structure. The dense branches obstruct your view, forcing you to learn the layout through repeated visits.

Production Backstory

PRODUCTION NOTES
Game Design of the Ancient Forest

MH was originally designed to become more difficult as you go deeper into the fields. We did not want to change that. We experimented with ways to retain that concept while having numerous camps and ecosystems in the field. In the first area just outside the first camp, you will find herbivorous monsters like the Aptonoths, some Anjanaths if you go deeper, and then Rathalos even farther in. The habitat was designed to mimic a food chain with the Rathalos at the top of it. The game design also reflects natural humidity, which Fujioka suggested including. As a result, you will find stronger monsters as the environment branches off from lower to higher humidity. Designing the game with the ecosystem in mind heightens the player's sense of searching and exploring. (*Tokuda*)

CYLINDRICAL TUNNEL OF VINES: The firm ground is formed out of tightly packed vines, allowing travel without risk. Brute Wyverns sleep in nearby caves.

GREEN SUSPENSION BRIDGE: A pathway made of vines. The light shining through this area makes for a beautiful view. It is well ventilated and warm compared to the lower level. The vines provide cover from the Wyverns above.

I felt as if the Ancient Forest was a microcosm of the link between life and the environment throughout the New World.

Sure, the ivy and vines are stronger than man-made ropes, but I would like to raise another question. The Ancient Forest's climbing route is complex and a harsh environment where large monsters fight for their turf. That is exactly why I feel inspired. If the Ancient Forest and the rumblings of the creatures and the land were created with a purpose, due to someone's will... Perhaps even this sturdy path made of vines was also created intentionally.

Let me change the subject. The hunters that landed in the New World have found a new way to hunt thanks to the Scoutflies. The Commander discovered them here in the New World, studied their behavior, and domesticated them. I was taught that they are invaluable as guides in the exploration of the New World. As a matter of fact, the Scoutflies' tracking ability helped the Fifth Fleet discover and research all kinds of monsters, and even enabled the discovery of Xeno'jiiva. Scoutflies do not glow when they sense the attributes of lightning-storing large monsters. Instead, they are attracted to them and memorize their scent. It is said that Scoutflies can be seen flying in many areas due to the increased activity that comes with every Elder Crossing, just like the Ancient Forest itself. Then why didn't I encounter other Scoutflies besides my own during my expedition? I was later told the string of events caused by Zorah Magdaros had some kind of effect on the Scoutflies... However, is that all?

The Scoutflies and tracking. Perhaps there is something to the Scoutflies' tendency to gather around tracks that has yet to be solved. Tracks are records of a monster's behavior, and the Scoutflies react and gather around their scent. I will leave this as another research topic for now.

During this trip, I felt as if the Ancient Forest was a microcosm of the link between life and the environment throughout the New World. Just as the New World creates nutrients from the Coral Highlands, which are then circulated by the Everstream after being processed by the Rotten Vale, this Ancient Forest supports life along the coast. In the Ancient Forest, life drops to the ground to decay, providing nutrients that will give birth to new life.

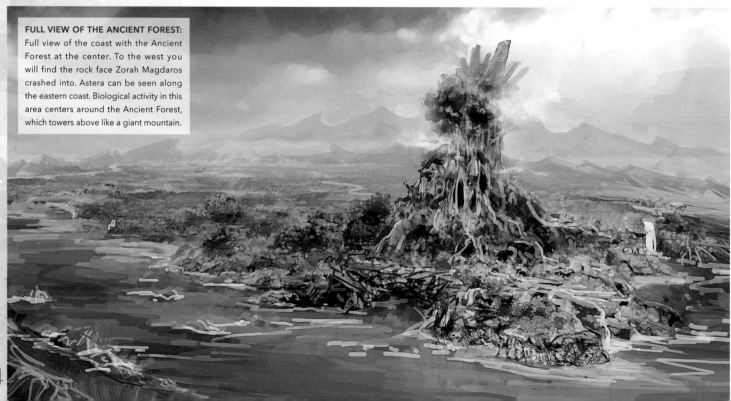

FULL VIEW OF THE ANCIENT FOREST: Full view of the coast with the Ancient Forest at the center. To the west you will find the rock face Zorah Magdaros crashed into. Astera can be seen along the eastern coast. Biological activity in this area centers around the Ancient Forest, which towers above like a giant mountain.

Ancient Forest

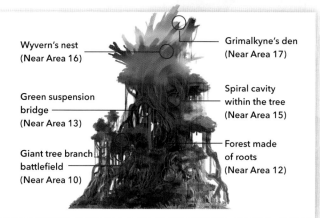

TOPIC Diagram of the Ancient Forest

The Ancient Forest is so massive that it is almost like a fortress or a giant castle. A Wyvern's nest is located in the upper level, a corridor made of ivy in the middle level, and at the roots are caves formed from soil and rocks pushed to the surface.

Wyvern's nest (Near Area 16)

Grimalkyne's den (Near Area 17)

Green suspension bridge (Near Area 13)

Spiral cavity within the tree (Near Area 15)

Giant tree branch battlefield (Near Area 10)

Forest made of roots (Near Area 12)

LOOKING DOWN AT THE TREE'S SPIRAL CAVITY: There is a portion of the Ancient Tree that has been hollowed out, and an area with footholds allows you to enter the cavity. You can walk around using the vines, branches, and trunk.

LOOKING UP AT THE TREE'S SPIRAL CAVITY: Water, flowing from the upper level, descends like a waterfall. The giant protruding branches remind me of a Wyvern's neck. A peaceful area with only the sounds of deep green water.

Production Backstory

PRODUCTION NOTES

What We Wanted to Express with the Ancient Forest

We designed this area while keeping in mind what would be important for an open field in *Monster Hunter: World*. What we wanted to achieve was not only the joy of moving in an expansive space, but a game design or expression that would make the player want to investigate everything they see. In other words, we emphasized designing areas that hid distant information, including side roads that would tempt players to take detours. We wanted to express the joy of discovery via Scoutflies, for example. With a landmark like the Ancient Forest in the distance, you'll slowly climb up to the Ancient Forest as you explore the nearby densely vegetated areas. We wanted to allow players to enjoy the entire field while exploring all kinds of things around them. It was decided early on that the first field should include jungles and forests that allowed players to walk around and experiment. Instead of presenting a wide-open field like the Wildspire Waste from the get-go, the Ancient Forest was, from a game-design perspective, more what we wanted to create. *(Fujioka)*

In the Ancient Forest, the contrast between the coastal areas and dense forest environments is extremely vivid.

The forest of the Ancient Tree. After I had researched the entire area, looking around at all the work produced by researchers, I discovered a certain characteristic of the New World. When comparing drawings, I found an aspect that differed from the documents I had created with my fellow hunters.

It was the pace of the changing environment. For example, in the Ancient Forest, contrast between the coastal areas and dense forest environments is extremely vivid. It was a feeling I never felt in any of my other research. You can almost physically feel the changes. In other words, the degree of change is extreme, as if the areas have been delineated and defined with specific functions.

I feel some kind of purpose here too. Perhaps it's just my imagination. I must have that illusion because the New World has been streamlined so that every ecosystem can function efficiently.

The food chain, absorption and disposal—it all functions efficiently. Nothing is wasted.

The beauty of its function and design gives me the illusion that this was created for a purpose. I would like that to be the conclusion of what I felt at the Ancient Forest. There are more mysteries I'd like to pursue, but I will put down my pen for now.

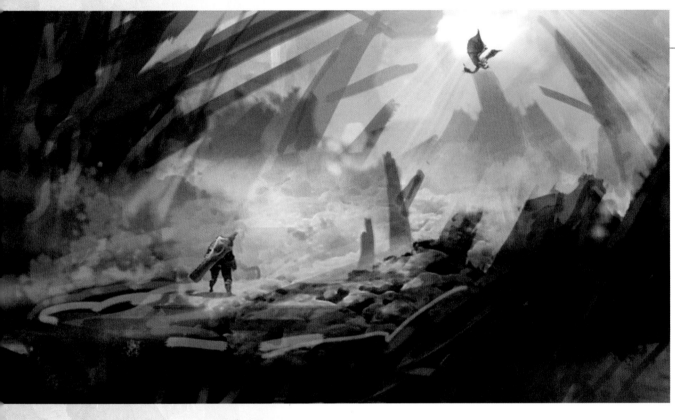

WYVERN'S NEST: The upper level of the Ancient Forest. The high elevation brings stronger winds and lower temperatures compared to the lower levels. Rathalos nests made from trees and branches can be seen as well as dense fog.

WATER SOURCE AT THE UPPER LEVEL: There is a water source created from rainwater just about the Wyvern's nest. The large volume of water makes it a reservoir, but the various streams reveal the fragility of a natural reservoir. A mining area can also be found behind the water source.

WATER SOURCE AT THE UPPER LEVEL (ALTERNATE ANGLE): A reservoir atop the foggy Ancient Forest. The Wvyerns use it as a watering hole, but no creature besides the Rathalos, which sits at the top of the food chain, is reckless enough to drink from it. The lower-level forest and sea can be seen from here. This natural dam can burst at times. There is enough water and force to push not only us, but large monsters down as well.

WATERING HOLE AT THE LOWER LEVEL OF THE ANCIENT FOREST: There is a reservoir filled with fallen leaves and trees at the roots of the inner cavity. Water from the upper level has filled this area, like a waterfall inside a cave.

GRIMALKYNE DEN: An area at the uppermost level of the Ancient Forest, home to the native Lynians. They look similar to Felynes, but they are more cautious and require more attention when approaching.

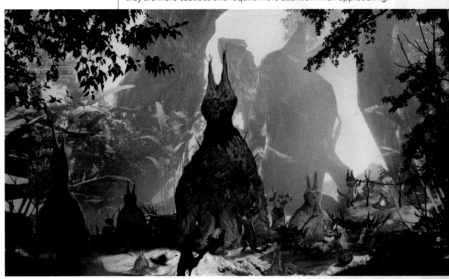

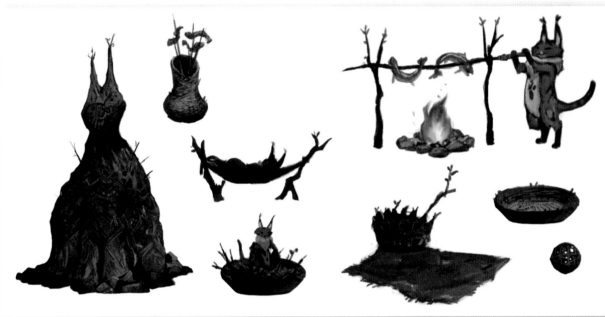

GRIMALKYNE LIFESTYLE: Drawings of the Grimalkyne den. They seem to live humbly in their homes built at the upper level of the Ancient Forest. Their high intelligence can be seen in their use of fire and water, collecting of leaves and nuts, and using the hides of animals and trees as beds. Their designs and decorations also indicate they have developed a sense of art.

Production Backstory

PRODUCTION NOTES
Ancient Forest Design Concept

The Rathalos nest near the top of the Ancient Forest was placed there because we initially had a game-design concept of dropping Rathalos using water. In order to do that, we needed to include an area where water can be pooled. We discussed how water can pool at the top of a tree. The designers suggested an area in the Ancient Forest that was destroyed by lightning, creating a natural reservoir. As a result, although the Ancient Forest itself was damaged by lightning, the pooled water is distributed to the lower levels, creating a unique ecology that can be seen from the exterior. (*Fujioka*)

The forests, marshes, and desert came together to create a unique environment.

The white and tan ground. Dead trees, rocks, and a dry wind that blows across their dark crevices. It was the next land that awaited us. It was called the Wildspire Waste. The forests, marshes, and desert came together to create a unique environment. It was once called a wasteland, but it is not accurate to describe it as barren. They say the Everstream flows into this area too.

It is hard to imagine that this realm, with its wasteland and exposed rocks, is connected by land to the Ancient Forest, which is so rich with life. But I did witness many life-forms desperately trying to survive. It was just like in the Ancient Forest… No, perhaps the creatures were filled with even more hunger and vitality. Perhaps it can be said that this life force was born because three different environments are entwined here… I will now explain how I reached that conclusion.

Wildspire Waste

A vast arid region with marshes that receive water from the Ancient Forest. There are giant spires in the sandy area, and colorful vegetation grows near the water. Creatures adapted to the differing environments make this two-faced land their home.

SOUTHWESTERN CAMP: The first campsite set up between rocks. Water crashes down from the cracks of the rocks. A suitable area with plenty of water.

Production Backstory

PRODUCTION NOTES
Wildspire Waste Design Concept

We wanted players to have access to another field besides the Ancient Forest from the early stages. We wanted to create a wide, spacious area that was the complete opposite of the dense Ancient Forest. However, simply being wide-open was not enough. We decided it should contain water, sand, and the three elements of the forest so the player can get the sense that it is connected to the Ancient Forest. And as a land-mark, we placed giant spires that would stand out in this wasteland. (*Tokuda*)

WASTELAND SURROUNDED BY ROCK FACES: A rocky wasteland just outside the camp. A brownish-red canyon can be seen in the distance. There is much less vegetation here compared to the Ancient Forest, but it does exist here and there. Geologic strata can be seen in the rock faces, indicating that this area was created by an immense force.

We traversed a wooded and rocky lowland.

This area begins with a wasteland. Although it is not far from the dense Ancient Forest, the area features a sudden change to a rocky and inhospitable environment. The extreme change in environment I felt the other day originated here. I will explain why. Due to its lower altitude, perhaps the Everstream is not evenly distributed in this area when compared to the Ancient Forest. To be more specific, it may appear as if the low altitude makes the distance between the Everstream to the surface short, but I suspect the layers and layers of geological strata evident in the canyon were created by large-scale crustal movement, and this has resulted in a complex foundation that blocks the flow of the Everstream.

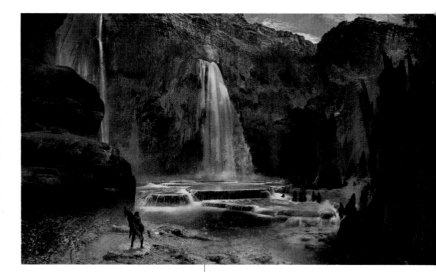

A WATERFALL AT THE ENTRANCE: The water here is clear and good for fishing. The landscape is beautiful, with refreshing breezes and colorful surroundings.

SILENT FOREST: The area suddenly changes to a thick forest and muddy ground. It has the characteristics of a marshland, similar to what you may find in the Ancient Forest, but brown rock faces can be seen in the distance. It seems Rathians feed on the moss and mushrooms that grow here.

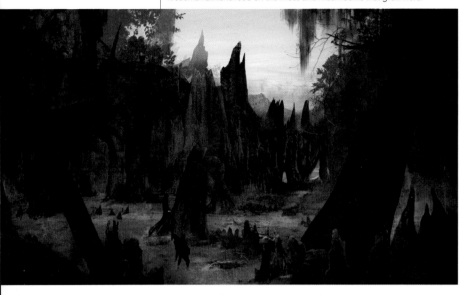

TOPIC Wildspire Waste Area Composition

Unlike the three-dimensional and varying elevations of the Ancient Forest, the Wildspire Waste is flat. A number of large cavities exist below-ground, but exploration is generally done at the surface.

▼ Lower Level ▼ Middle Level ▲ Upper Level

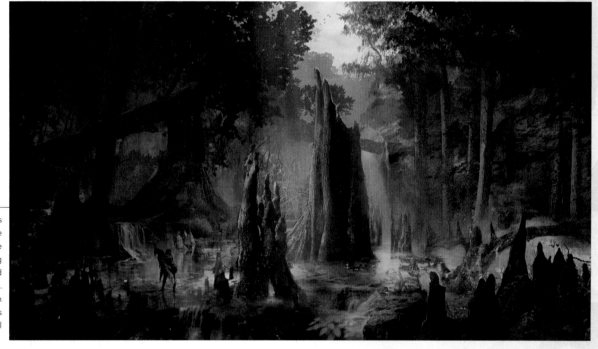

TRACES DEEP IN THE FOREST: As you step deeper into the forest, the marshland conditions grow and the canopy blocks the sunlight. Seeking limited sunlight, the bushes and moss grow in concentrated areas. Are the dead trees and broken trunks a result of monsters? Or has this come about through natural causes?

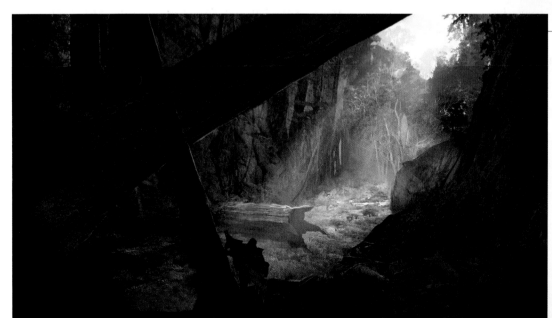

FOREST OF POISONOUS PLANTS: The color of the ground changes where what little light enters. Purplish moss and ocher ferns are noticeable. Indigenous Poisoncups can also be found here. This is the end of the forest area.

SHALLOW, REDDISH-PURPLE MARSH: An open marsh area southeast of the camp. The ground is covered with reddish-purple grass and flowers. The colorful vegetation can lead one to fall into crevices. Caution is required.

CLIMBING THE SPIRES: The forest's lower level can be found at the midway point between the wasteland and the forest. There is a great view once you reach the upper level. I can see giant spires and canyons in the distance.

APCEROS NEST: A rocky flatland south of the marshland. The ground is covered in short bushes, and the Apceros that feed on it can be seen. You can find herbivore eggs, but you should expect to be attacked by their parents.

Does the same energy flow here as it does in the Ancient Forest?

This area can finally be seen past the swampy marshland, steep hills, and rocks gouged out like caves. This is the Wildspire Waste. Looking at past observations, it has become known that this area also underwent rapid growth every time an Elder Crossing took place. My colleagues who have already traversed the area mentioned that the Wildspire stands out as being much larger than the rest of the spires, but I was told it does not compare to the giant trees of the Ancient Forest. However, even from afar, I knew that was wrong. Like the Ancient Tree, it is worthy of being described as "awe-inspiring." Was this really built by Carrier Ants? Can creatures of their size actually build something this massive? I got the feeling the essence of the Wildspire lay elsewhere.

As I mentioned before, while the Everstream's energy is evenly distributed throughout the Ancient Forest, here at the Wildspire it is unbalanced. Thinking back, the rocks protruding over the ocean that can be seen from the coastal area of the Ancient Forest were not created by waves. Perhaps the great power of the Everstream that flowed into the ocean water compressed, carved, and pushed the rocks of the ocean floor to the surface. I say that because the same types of rocks can be found here. In addition, cavities carved into the ground and rocks can be seen here. These rocks are not uniform in appearance either. You may find rocks carved into the shape of a gate and unnaturally leveled as well.

If the Everstream is unbalanced here, does the same energy flow here as it does in the Ancient Forest? While gazing at the approaching Wildspire, I thought perhaps the energy of the Everstream flows unevenly around the Wildspire. The Wildspire and the surrounding landscape deviates far from the laws of nature. I imagine the underground cavities and the carved rocks are evidence of that.

Crustal movements caused by repeated Elder Crossings may have changed not the flow, but the outlets for the Everstream energy in this wasteland that once thrived on the energy source found at the bottom of the Rotten Vale. The spires I see in the distance may be the proof of rapid growth every time an Elder Crossing takes place.

CENTRAL CAMP: A safe campsite surrounded by rocks and a water supply. Climb the ivy to return to the wasteland.

LEDGE-FILLED WASTELAND: A rocky wasteland on the way to the Wildspire. Repeated climbing and descending of the ledges can cause one to lose one's sense of direction. It is a desolate area with dead trees, but monsters are known to fight each other here.

WASTELAND VALLEY CORRIDOR: A valley corridor that travels from north to south. The beautiful valley floor connects the Wildspire Waste to the southern marshland. A stream created by groundwater and the water from the river cuts through here.

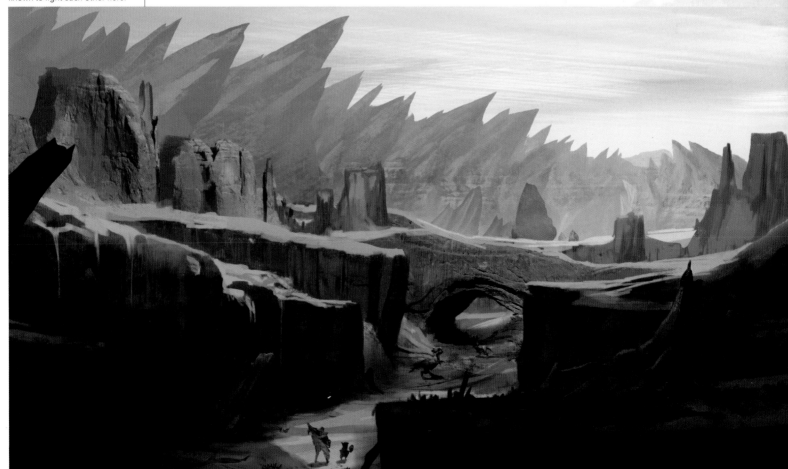

SPIRE ECOSYSTEM: Spires of various sizes scattered throughout a desolate desert. In contrast to the bleak and fantastic conditions, it is an area where you will find not only Carrier Ants and Flashflies, but large monsters as well.

If the Ancient Tree was a giant tower, the Wildspire would be an ancient temple.

Thick, black polka-dot patterned columns tower around a giant spire. It is an unusual sight. It's as if a temple once stood here and only the columns remain. If the Ancient Tree was a giant tower, the Wildspire would be an ancient temple. As I mentioned earlier, Carrier Ants, invigorated by the Everstream, are believed to have built these spires. Some in Astera believe the ants receive energy from the soil and mushrooms that have been exposed to bioenergy, thereby cultivating

energy. Either way, if I were to compare these ants to humans, this place would be an ancient temple. The rapid growth associated with the Elder Crossing is tied to that, but I would like to present a new theory about these spires. These spires are illuminated by Flashflies at night. Flashflies use a unique organ to glow, but do they glow simply to attract winged ants? The existence of the Everstream is now common knowledge, but perhaps it is the Flashflies that tell us its

location, that it flows unevenly through the spires, and the workings of the New World. I cannot say for certain, but combining it with the hypothesis below makes it seem feasible. The glow of Flashflies, like a star-filled sky, raised another question.

The golden glow of the Flashflies and the light emitted by Scoutflies when they are tracking felt the same to me. Scoutflies learn a monster's scent from their tracks and have a tendency to gather around that scent. When they do, they emit a unique glow, as if they are resonating together. When looking at that, I see more than natural behavior. I sense another's presence. Scoutflies and Flashflies, their behavior of glowing and where they glow. Monster tracks and giant spires.

If those similarities point to an origin that is influenced by the Everstream, the source of life… I could not help but theorize that this light was visual proof that the Everstream existed.

MOONLIGHT SANDSTORM: A giant sandstorm that periodically occurs. It's as if the ground below is being swallowed by quicksand.

BOGGY AREA: At the southern edge of the Wildspire Waste, a bog where Barroths make their home. The bog greatly restricts movement and is difficult to traverse.

Raging Sandstorm

Sandstorms often occur in the Wildspire Waste, alongside heavy rain in the Ancient Forest, turbulence in the Coral Highlands, and acid rain in the Rotten Vale. Changes in weather due to Elder Dragons have also been detected. Different endemic life-forms appear depending on these conditions.

Production Backstory

PRODUCTION NOTES
Wildspire Landmark

I can mention this now, but the spire as a landmark was decided upon at the very end of development. Our initial idea was to create a marshland so the Lagiacrus could appear. But upon further testing we realized that would be difficult. So, while leaving elements of water, we added a sandy environment later. We weren't sure what to call it. "Wasteland and Swamp"... Hmm... (*Tokuda*)

The sandy environment originally had spires, but it was not a feature that would be present throughout the field. It would've been difficult to call one specific area the Wildspire Waste in an area where forests and swamps also existed. So, we spread the spires from just outside the camp, for example, to a variety of locations. In other words, we changed it into an area where many spires stood. (*Fujioka*)

WILDSPIRE WASTE: A desert where small-to-medium-sized spires center around a particularly large spire. The spires appear like rocks during the day, but at night the parasitic Flashfly larvae glow, making the entire area shine. They glow to attract winged ants to feed their larvae. It is said that every Flashfly in the New World is born here and only leaves its nest once it matures.

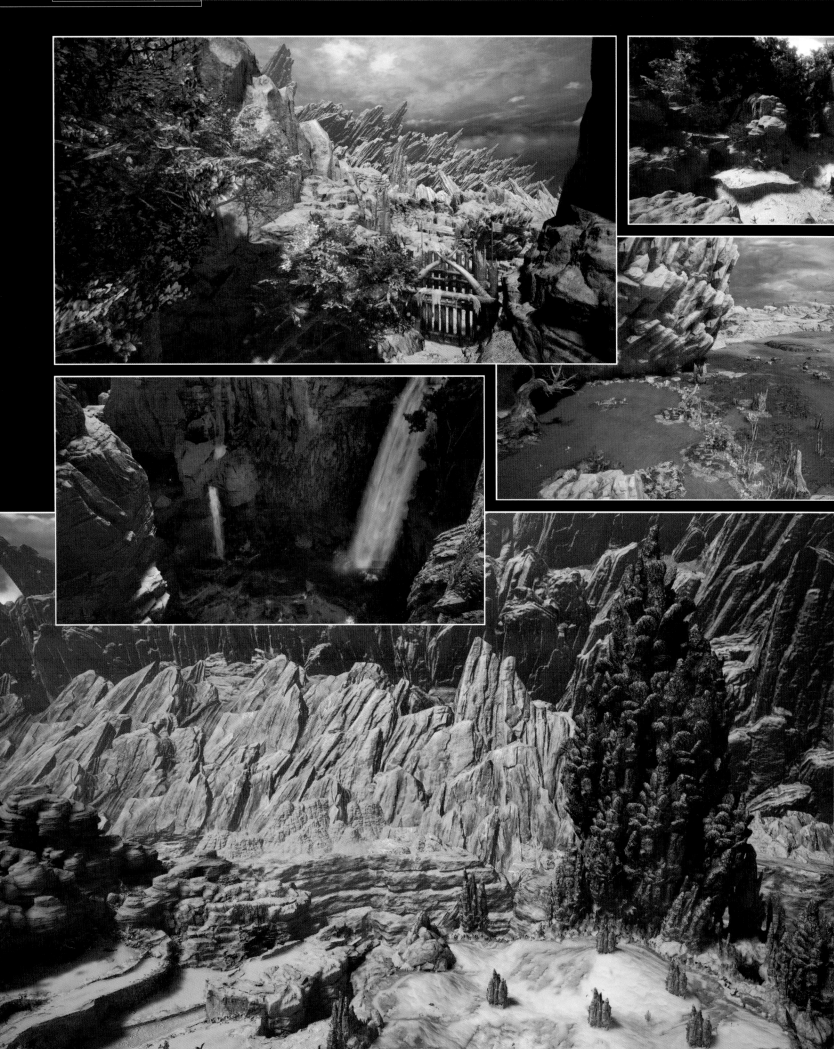

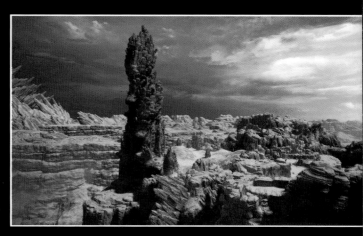

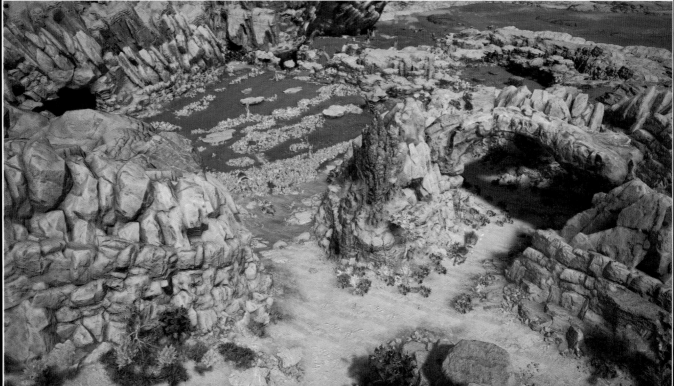

Landscape Beauty
-Wildspire Waste-

A desolate land with scarce vegetation due to the effects of the dry winds blowing along the steep rock faces. The beautiful streams blessed by the Ancient Forest soak into the land and turn to swamps here. Violent sandstorms rage at times, turning it into an even harsher environment... The giant spires, formed tall and thick, appear as if they are in a competition to stand taller than the canyons.

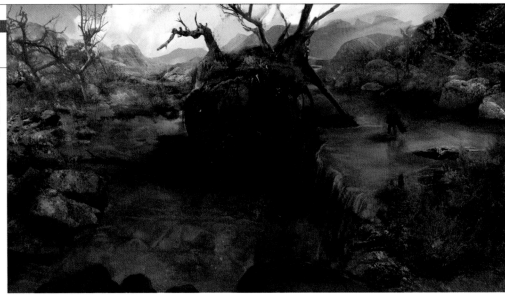

BORDER BETWEEN THE ROCKS AND WATER: Ledged area dividing the swamps and clean waters. Both dead trees and lush aquatic plants can be seen because the environments are divided by a boundary.

When viewed on a long time line, this land is still in transition.

We once again find water in the wasteland. However, it appears different from the woodlands south of the Wildspire Waste. Much of the water here is mixed with dirt, turning most of the area into bog. That is because, unlike the southern areas, the soil here isn't as hard and the ground is not as rocky. I would like to dig a little deeper into this.

I have claimed the energy of the Everstream is unevenly distributed, but the surface layer of the Wildspire Waste greatly benefits from the Ancient Forest. That is evident in these swamplands. The water and organic materials like dead leaves, grass, and roots flowing in from the Ancient Forest turn the soil here into mud. There is no way to know when movements of the earth's crust, changes to the Everstream caused by the

Elder Crossing, and the water flowing in from the Ancient Forest turned this area into a swampland. However, perhaps we should think that this area, like other wastelands, was once lush and green like the Ancient Forest. There are no records of the Wildspire Waste ever being damp in our records. But I can understand why the Diablos were called the rulers of this land. More interviews must be conducted, but others before me must have reached the same conclusion.

That said, this swampland has an established ecosystem and cycle, led by monsters like the Jyuratodus. Taking that into account, it is safe to say the Ancient Forest and the Wildspire Waste have both nurtured life from ancient times. In other words, when viewed on a long time line, this land is still in transition. Our civilization too

appears vibrant and our competition fierce when the advancement of technology is significant. It appears peaceful when growth stops, which is a sign that momentum has also been lost. The life force I felt here at the wasteland was an infinitely raging torrent of energy because it is still developing.

MUDDY SWAMPS: Area farther past the swamplands where mud and water collect. You will find dead trees and leaves washed up here. The swamps are deep and very difficult to traverse. The Jyuratodus sleep here.

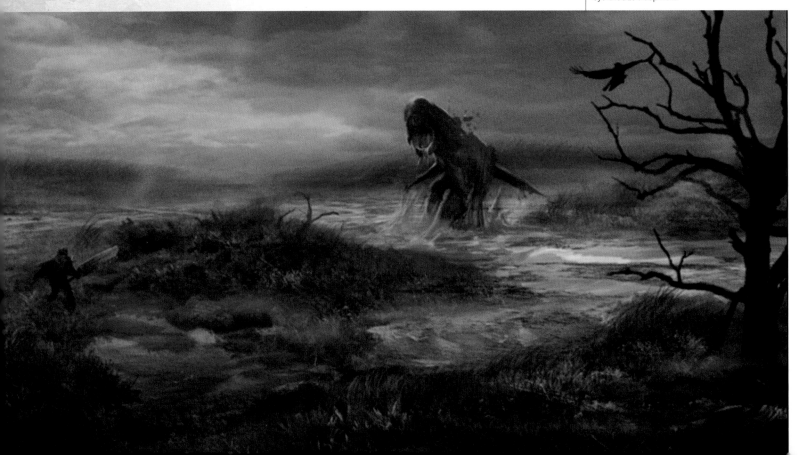

CAVERN CAMP: A camp set up in an underground corridor that runs from north to south. It is quite tight but is safe if you watch your step. A steep cliff lies next to it.

LIMESTONE CAVE: Groundwater flows here from the forest above. You will find icicle-like stalactites, which indicate the age of the cavern.

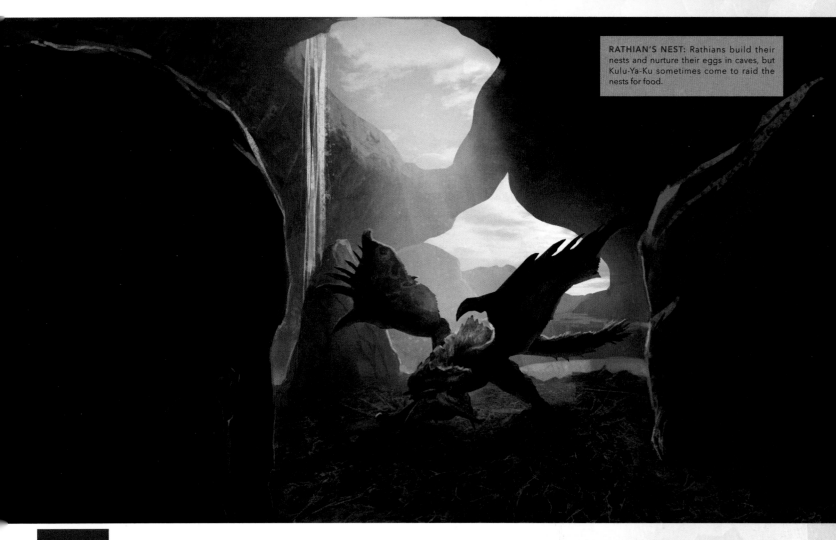

RATHIAN'S NEST: Rathians build their nests and nurture their eggs in caves, but Kulu-Ya-Ku sometimes come to raid the nests for food.

Production Backstory

PRODUCTION NOTES
Size of the Spires

The spires are so big because they were designed based on the Rotten Vale and Coral Highlands. We considered all the ecosystems—the fauna and flora of the Coral Highlands, the Rotten Vale that decomposes them like a person's stomach. The broken-down energy is distributed by the Everstream to all kinds of places, helping the Ancient Forest and the spires to grow as big as they are. We designed the area once that concept was accepted. (*Fujioka*)

We first considered the ecosystem and the circulation of the New World. When it comes to the field, the ecosystem plays a big role, so we began by thinking of what kinds of monsters would live there. After deciding that energy begins circulating from the Rotten Vale, we first came up with the Ancient Forest and then the Wildspire Waste. The spires growing as big as they do did not feel strange to me, considering the effects of the Everstream. For example, when energy is brought near the spires by the Everstream, the fungus and soil there would be revitalized. The Carrier Ants carry that into their spires and actively culture and break them down, causing the spires to grow. If an Elder Crossing takes place, an explosive amount of energy is suddenly restored, and the spires grow rapidly in size. The end result of that process being repeated is the massive size of the spires. (*Tokuda*)

The wind blowing from the Great Ravine dried out this land, carved the ground, and created this cavern.

There was a vast cavern below the spires. Although I had heard of its existence, I could not hide my surprise after seeing the variation of elevation and depth. It was connected to the surface by a pitfall created by quicksand, which fills up depending on the movement of the sand. I have seen underground caverns before travelling to the New World, usually where groundwater carves paths in areas with thick bedrock or sandy soil. But this area was unlike either of those. It is not hard to imagine that the wind blowing from the Great Ravine dried out this land, carved the ground, and created this cavern. But I cannot help but feel a larger power at work here…

I believe that power is the Everstream running deep below the New World, as I have repeatedly claimed. The Everstream is the origin of the New World. In other words, the Elder Dragons' energy ignites the cycle of death and rebirth once again. I cannot yet prove my new theory. It is simply a supplement to what my fellow hunters decoded about the Elder Crossing. I feel there has to be something that can corroborate it…

NORTHEAST CAMP: A camp built below the spires. Even though large monsters' nest exist close by, a campsite can be built here if you take advantage of the topography.

UNDERGROUND CAVERN FILLED WITH SAND: An underground cavern where the strata of the land is visible. Sand has filled the cracks of the giant rock face. It constantly falls like a waterfall. A Diablos nest can be found one level below.

A CURTAIN OF HUNDREDS OF MILLIONS OF GRAINS OF SAND: Large amounts of sand falling from the surface create a huge racket. Even with the noise, the Diablos, with its keen sense of hearing, will still detect oddities and attack.

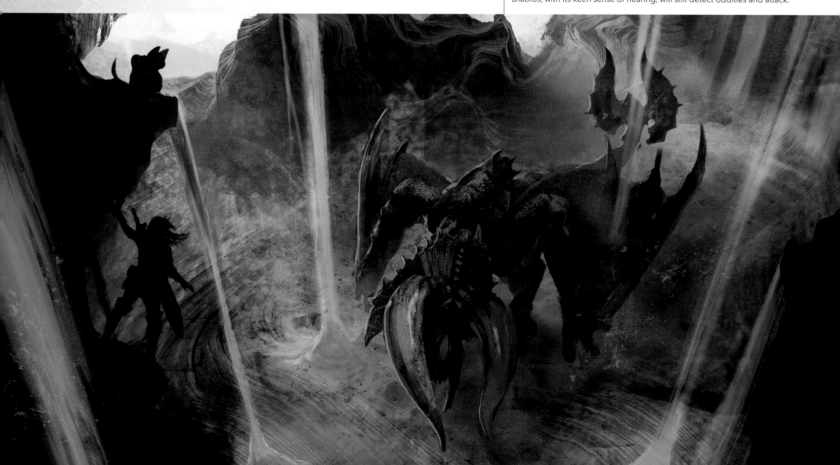

GRIMALKYNES IN THE UNDERGROUND DESERT: The Grimalkynes' underground den at the northern tip of the Wildspire Waste. The Grimalkynes that live here all care for one another and are courageous. It seems they choose habitats that are difficult for monsters and humans to reach.

INSIDE THE SPIRES: A cavern within a spire. This one has already been used up and abandoned, but the fossils remaining in its walls show the transitions the New World went through.

Production Backstory

PRODUCTION NOTES

Designing the Wildspire Waste's Food Chain

Unlike the obvious food chain of Great Jagras, Anjanath, and then Rathalos in the Ancient Forest, we placed the Rathian, Barroth, and then the Jyuratodus, three equally strong monsters, as the apexes of the forest, desert, and swamp, respectively. By doing so, we wanted to instigate various conflicts between them. We placed the Diablos further in as the final objective, resulting in a level design different from the Ancient Forest. (*Tokuda*)

The Diablos were placed there because they prefer a dry area, but why? Perhaps the answer is that they have always lived there. Monsters that are at the apex of a particular area all have abnormally strong attachments to their territory. (*Fujioka*)

Coral Highlands

A coral reef highland with a wide variety of elevations. It is a rich and strange ecosystem, with traits of both land and sea. Upwelling winds carry the coral reefs' eggs across the highlands, making it the foundation for all biota that feed on it.

The extraordinary beauty, the sense that the boundary between fantasy and reality had crumbled.

I was told by my predecessors that all they could do was sigh. Of all the territories I've explored, many were beautiful. As an explorer, I was certain I could not be surprised. But when I arrived here, I was instantly taken aback by the extraordinary beauty, the sense that the boundary between fantasy and reality had crumbled. A supernatural sight that made me think I had wandered into a fairy tale I read as a child was in front of me. I jumped into the Coral Highlands, certain that I would formulate a new theory, but in this fantastic, almost sacred, world, I was not sure I could maintain my composure...

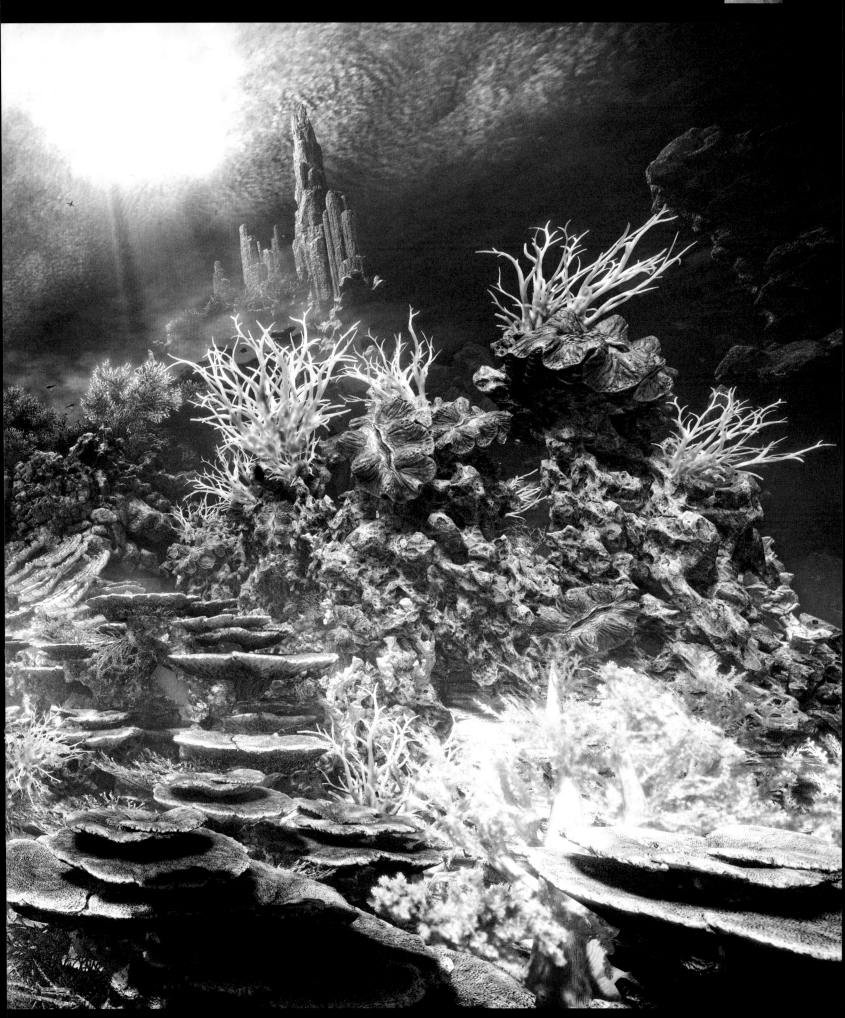

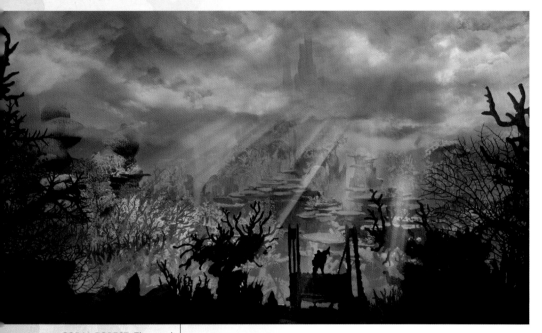

CORAL FOREST: The coral reefs are almost like trees or flowers covering the ground. A colorful forest of coral reefs spreads in front of my eyes.

CAMPSITE: The highland peak, located above a cluster of coral. A beautiful sight both up close and from afar.

The nutrients for these coral reefs come from the Rotten Vale below these highlands.

A world so colorful it will almost make you dizzy. That is the Coral Highlands. The coral reefs spawn eggs into the air, which attracts and provides rich nutrients to carnivores. The plentiful bait attracts even more predators. The carcasses of their prey become nutrients for the coral reefs. After leaving the Wildspire Waste and crossing the Great Ravine, the elevation rose and I arrived at this highland. The population of ecosystems in high-altitude areas is generally small and frag-

ile. A natural paradise that invalidates that idea exists here. However, the allure I felt the moment I stepped into this land continues. It makes me think the Coral Highlands, like coral reefs, contain something like poison. According to scholars in Astera, it contains no such substance, but do the creatures that gather here truly come only for the plentiful nutrients? Perhaps they too have a sense of aesthetics like ours, one that exists in another dimension far away from this world, within them.

I would like to go over the characteristics of the Coral Highlands. The nutrients of the Coral Highlands itself is provided by the Rotten Vale, which lies deeper below the lower level of this plateau. Because the creatures that gather in the Coral Highlands are catalysts for the Rotten Vale's unique ecosystem as well, it can be said that these two lands have a symbiotic relationship.

TOPIC ## Coral Highlands Composition

The varying elevations and numerous areas to explore at each level give the impression that this area is complex. It's important to use the air currents or special transportation methods like the Glider Mantle to traverse the highland.

▼Lower Level

▼Middle Level

▼Upper Level

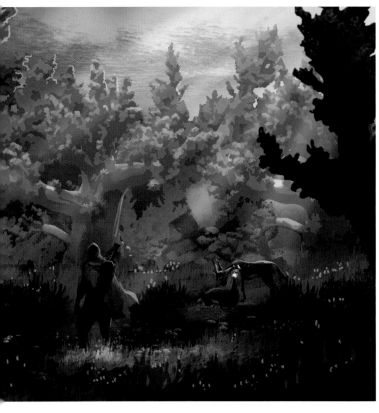

Production Backstory

The Coral Highlands was designed to surprise midlevel players who have cleared the Ancient Forest and the Wildspire Waste in both gameplay and design. It was necessary to introduce the varying elevations of the area to make it challenging, and due to its connection with the Rotten Vale, it includes a rich ecosystem. When thinking about how we could create an area so rich in life and visually stunning, we came up with bringing the ocean's ecosystem to the surface. From there, we started by narrowing down visuals that would be convincing. In other fields, plants are at the bottom of the food chain, whereas in the Coral Highlands, it is the coral reefs' eggs that support the ecosystem. (*Tokuda*)

ARCH-SHAPED ROCKS: An open area where monsters like the Paolumu fly around. There are rocks shaped like bridges. Shooting Wedge Beetles with a slinger allows you to move upward.

CORAL CAVE: The coral reefs shut out light like a roof, making the area feel like a cave. Inactive coral reefs are scattered like small houses. They can be used as temporary shelters.

SHAMOS NEST: A giant, bluish, soft coral reef spreads across the ground in the dark.

135

A variety of coral that adapted to the ancient Everstream survived on land and evolved in a unique way.

Many varieties of coral exist. The most abundant and thriving in these highlands are broadleaf-like peach, light-blue, and light-purple coral. Depending on the location, you will find ivy-like coral that grow vertically like kelp and flat, oddly shaped varieties as well.

As the name Coral Highlands suggests, most of this area is composed of coral reefs. Some are rocky and jut out like rocks, and some are like giant, rocky structures. These coral are the foundation of the food chain. The various varieties of coral attract a wide spectrum of creatures. The more species there are, the more complex the path of survival, fertility, and evolution becomes for its creatures.

Coral exist in the ocean. That is a known fact. Then how do they survive on land and how did they bring prosperity to this area? How did they evolve to become an unbelievably colorful endemic species here? The answer is none other than the Everstream.

I theorize that a variety of coral that adapted to the ancient Everstream were successful in surviving on land and evolved in a unique way.

TOPIC | ## The Construction of Ropelifts Was Helpful in Researching the Highlands

After repeated exploration of the Coral Highlands, the Airship Engineer constructed ropelifts. The ropelifts allow us to quickly move vertically. It is an essential bit of equipment in this area, with its widely varying elevations.

ROPELIFT TO ASTERA: Since its construction, traversing the Coral Highlands has become effortless. The Third Fleet ship, modified to be a research base, hovers in the sky.

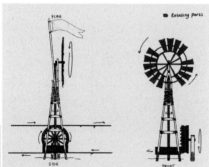

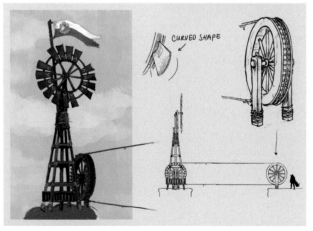

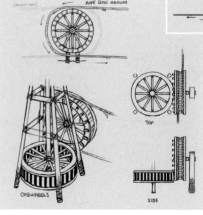

Ropelift Design Plans

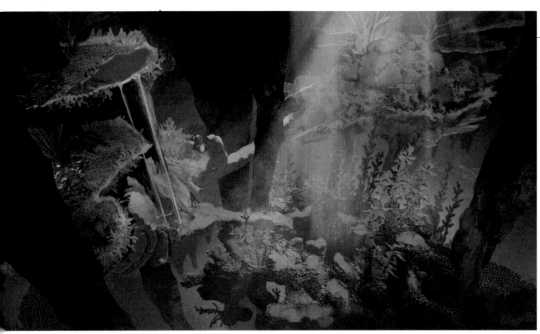

CORAL REEF NEAR THE ROTTEN VALE:
A lower-level area near the Rotten Vale.
Upwelling wind blows from the bottom. The
coral are covered in sand-colored matter.

**Production
Backstory**

PRODUCTION NOTES
Coral Reef Design

Initially, the designer submitted artwork where
fish were swimming, but we were not plan-
ning on an underwater field, and we couldn't
have fish flying in the air. But the artwork itself
was very interesting, so we wanted to come
up with something other than fish floating in
the air.

That's where the idea of an area where
strong updrafts blow came from. The area was
meant to be rich with life, so everything at its
foundation was tied to the coral. Since coral
are organic, they are rich in minerals. The eggs
they spawn are carried by the wind, which in
turn attracts other creatures. Since the founda-
tion is a chunk of organic matter, we wanted
the area to be full of life. (*Fujioka*)

TZITZI-YA-KU NEST: There
are colorful seashells
stacked on top of each
other on the coral reef. They
reflect the flashes emitted
by the Tzitzi-Ya-Ku.

TABLE CORAL: A beautiful
area with flat coral stacked
like a terrace farm. Many
monsters come and go here.
Vigorwasps and Sporepuffs
also inhabit the area.

A DARK CLIFF: A sight that can be seen by climbing up a bluish, dark cliff. The color of the cliff makes you think you are looking up at the surface of the water from a trench.

PRODUCTION NOTES
Coral Reef Carcass

Production Backstory

The white area near the peak is made of dead coral because the farther you get from the Rotten Vale, the less energy becomes available for use. The less sunlight there is, the more coral bleaching and stacking takes place. The lower level is colorful, but it slowly turns from soft coral to hard coral, becoming bleached and eventually dying. I think it's interesting that the opposite takes place here. (*Tokuda*)

We wanted to give the users a visual cue by giving the coral a color gradation. For example, if the coral is pink, they will know they are on the lower level. (*Fujioka*)

CAVE WITH WATERFALL: A cave surrounded by a wall created by dead coral. It's a great place to collect bug specimens.

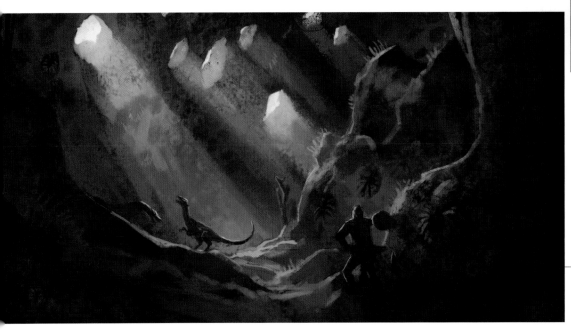

Production
Backstory

PRODUCTION NOTES
The Relationship Between
Wind and Creatures

By making the updraft powerful, we set this highland up to be more suitable for creatures that can ride the wind. The higher they can travel, the more advantages they have. In the Coral Highlands, instead of large flying monsters like the Rathalos, monsters like the Legiana that fly using a membrane are at the apex. (*Fujioka*)

LIGHT PEEKING INTO THE CORAL DOME: A coral dome with multiple holes. It has discolored, turning yellow, and is home to the Paolumu and Shamos, which avoid light sources.

These land coral are unique organisms that stack on top of each other while going through the cycle of life and death.

I mentioned earlier that there are different types of coral. In addition to those, I'd like to talk about dead coral. They are hard like bone and often provide homes to creatures. The light that enters through the holes created from their deterioration can sometimes turn them into a natural stained-glass window. Coral in the ocean feed on plankton, but these land-based coral feed on the corpses that fall in the Rotten Vale by absorbing nutrients from the ground. If coral that inhabits the ocean becomes terrestrial due to the Everstream, they may feed on animals, but the way they feed on them is closer to plants. In other words, the farther these land coral get from the bottom of the ravine, the more hindrances to their biological activities abound, thus bringing them closer to death. Colorful young coral will turn brown and eventually become bleached, brittle matter that falls to the bottom of the ravine. These land coral are unique organisms that stack on top of each other while going through the cycle of life and death.

I cannot help feeling dizzy seeing this fantasy-like world repeating the circle of life.

CORAL DOME: This is the external facade of a coral dome that is home to Paolumus. The sand-colored dome is striking against the beautiful pale-blue walls.

TOPIC Updraft blowing

Strong winds constantly blow in the Coral Highlands. The winds blowing through the cracks of the coral on the upper level send coral eggs into the air. The strong winds also help flying monsters like the Legiana and the Paolumu traverse the area. However, another high-pressure updraft blows here. It begins at the bottom of the ravine before traveling through the complex topography of the Rotten Vale, turning into a powerful updraft.

There are several spots in the Coral Highlands where this wind can be felt. It has become possible for us to travel on these winds and take shortcuts by locating all of those spots and identifying the direction of the wind.

Landscape Beauty
-Coral Highlands-

The Coral Highlands is a mysterious basin surrounded by huge canyons that has been greatly affected by the Everstream. The gradation of life, as described in the previous descriptions and commentary, becomes more evident when viewed from a different angle. The coral that became the foundation of the New World may still exist among the bleached coral.

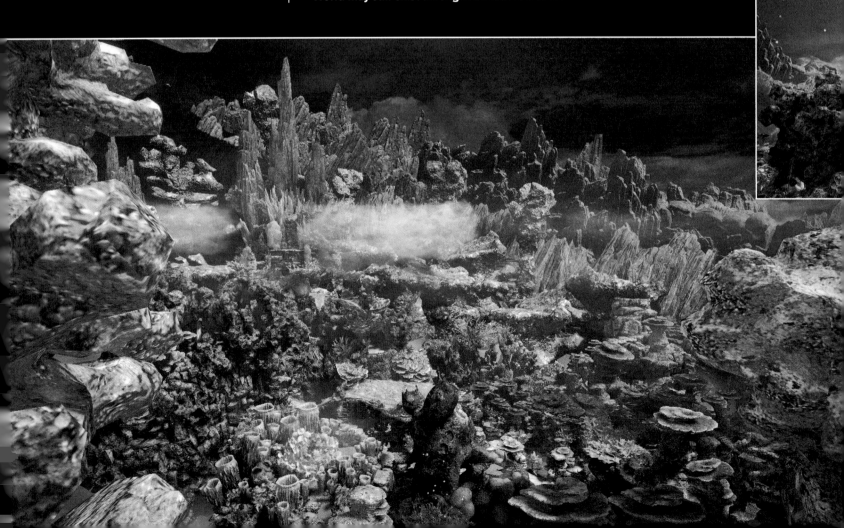

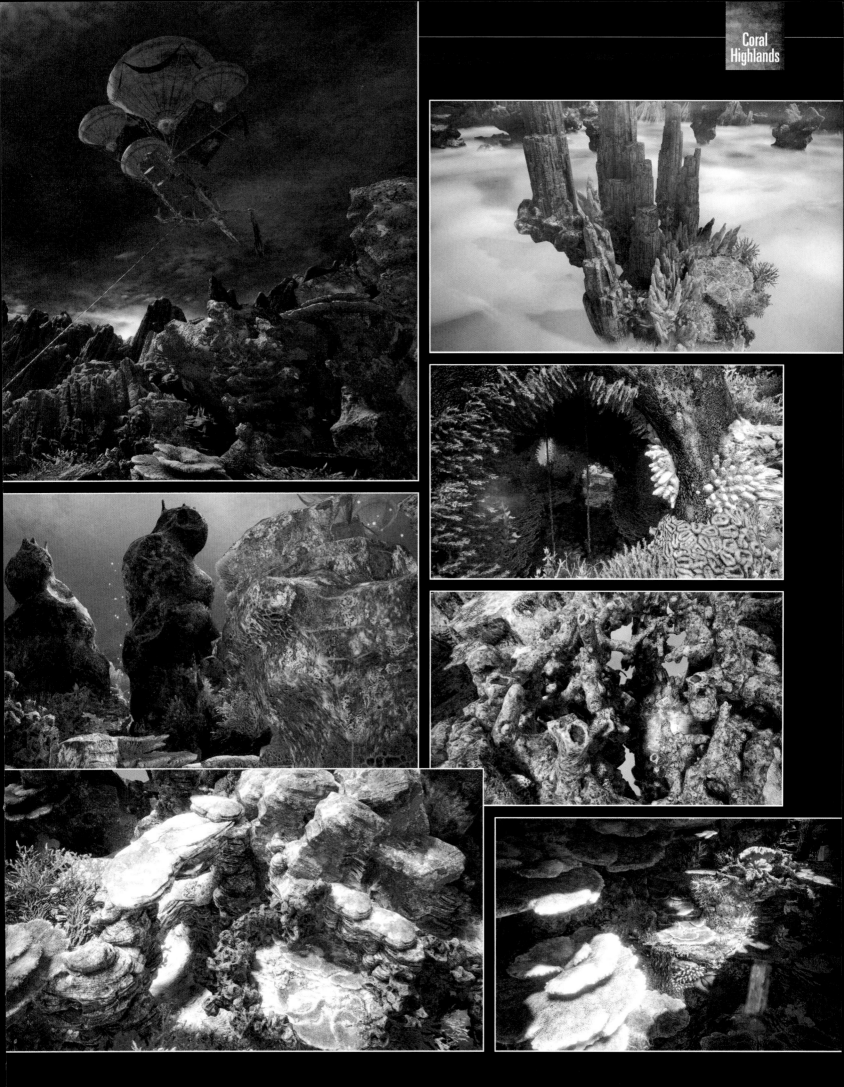

DYING CORAL CAVE: A dark area in the north. Most of the coral are dead and bleached. The surviving coral are brown or red, indicating poor growth conditions.

MUSHROOM-LIKE CORAL PILLARS: Dead, bleached coral, shaped like mushrooms, are lined up as if floating in a haze. They can be used as footholds to travel up and down.

DEAD, COILING CORAL: A circular hill lined with dead coral. Legianas fly around while an updraft blows from the cliff.

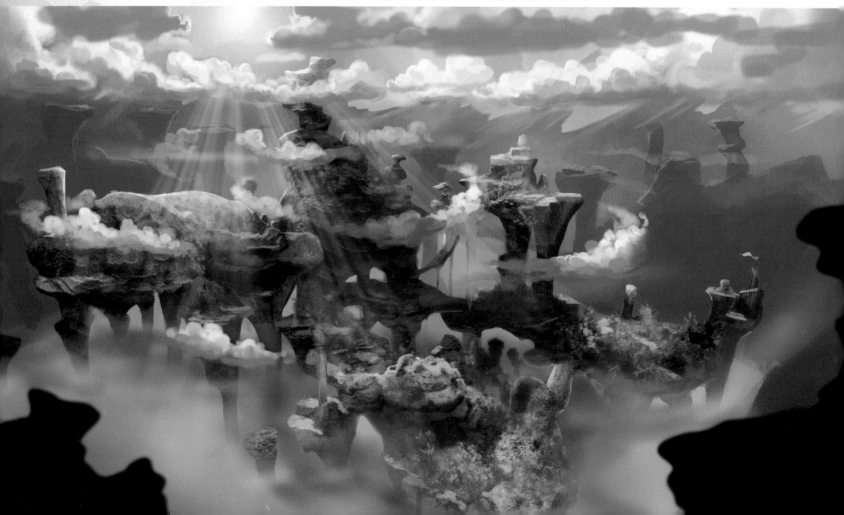

The Coral Highlands was conceived with the idea that the Rotten Vale was the foundation of the New World. Coral can grow in the ocean by feeding on the nutrients in the water, but how does the Coral Highlands get its nutrients? We decided from the beginning that the Rotten Vale below is the decomposer and the Everstream the distributer. Unlike the Ancient Forest or the Wildspire Waste, where nutrients are received by certain organisms, the entire Coral Highlands receives the nutrients. The coral are affected by the energy and grow on top of each other to create the highlands. However, the farther you get from the Vale, the fewer nutrients there are, so the higher areas are composed of stacked dead coral. (*Fujioka*)

VERTICAL CAVES: There is a series of vertical caves in the north that is essentially a cemetery of dead, bleached coral. Brightmoss glows in pools of water in this dark area.

I cannot help but feel sadness. But that is the law of nature.

After witnessing the gorgeous beauty of the coral, I cannot help but feel sadness. But that is the law of nature.

Once the age of flourishing life passes, there is only death. Corpses become ash and fall to the Vale. Exploring this area brings me back to reality. The coral cannot defy death. There is a world below that consumes them. But after exploring this area, I regained my calm. It is an undeniable fact that the Everstream is at the foundation of the New World. No new theories are needed to explain that…

Then what is this purpose I keep feeling in these lands? Will that purpose be made clear by continuing this journey…?

TOPIC ### Elevations of the Coral Highlands

This drawing is a side view of the Coral Highlands. The coral, growing upward using energy taken from the Everstream, are stacked so high that they break through the clouds. As you move toward the lower level, sunlight is blocked, turning the bottom of the ravine into a world of darkness.

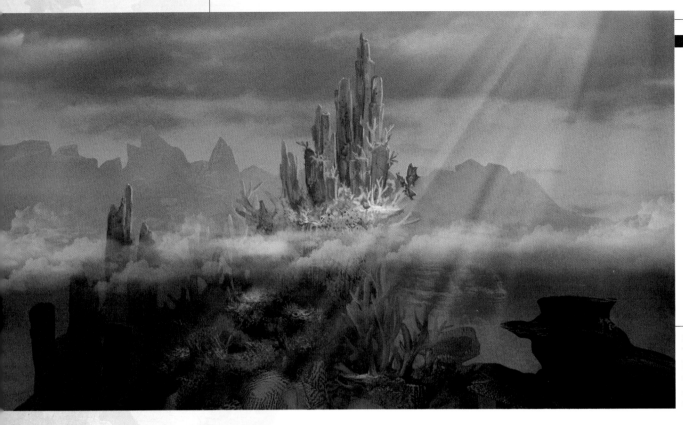

The peak of the Coral Highlands sits above the clouds and is filled with dead coral. The flatlands shine white from the sunlight.

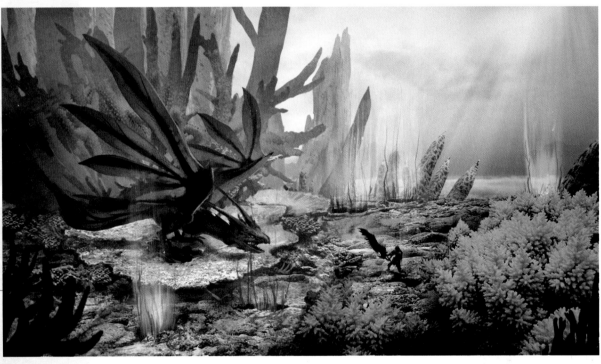

LEGIANA NEST: The Legiana, sitting atop the food chain of this ecosystem, makes its home at the peak. Updrafts blow through the cracks in the ground.

The structural, functional beauty of the New World can be felt in its perfect ecosystem and monsters...

The Legiana, like some of the Elder Dragons of the Old World, are considered beautiful monsters. I viewed them as worthy inhabitants of the beautiful Highlands, but what surprised me was that their nests were made near the peak of the Highlands. It is the farthest point from the bottom of the ravine and filled with dead, bleached coral. I fantasized that Legiana would choose a beautiful spot to build their nests because they have the intelligence to admire beauty. However, the monster that sits atop the food chain in this ecosystem chose a graveyard to build their nests. There are monsters here that collect beautiful seashells like the Tzitzi-Ya-Ku, but I feel that is only to protect themselves from predators. That is different from the appreciation of beauty I felt from the Legianas. Perhaps it is ludicrous to think monsters can have an appreciation of beauty. As I was mulling that over, I remembered repeatedly writing about a purpose or will inherent in the design of the New World. Is it the monsters' will? The structural, functional beauty of the New World can be felt in its perfect ecosystem and monsters... If those were created... I cannot help but say that that is an extraordinary thought.

However, the Third Fleet's research has been impeded by the Legianas for a long time. If the New World was a body, the Coral Highlands and the Rotten Vale are its vital organs. Perhaps the Legianas are trying to defend it. If so, the spot they chose to make their home makes sense. Or perhaps I am thinking too much. Research requires hypotheses to advance, but you also have to draw the line somewhere... I will keep my imagination in check for now and move on.

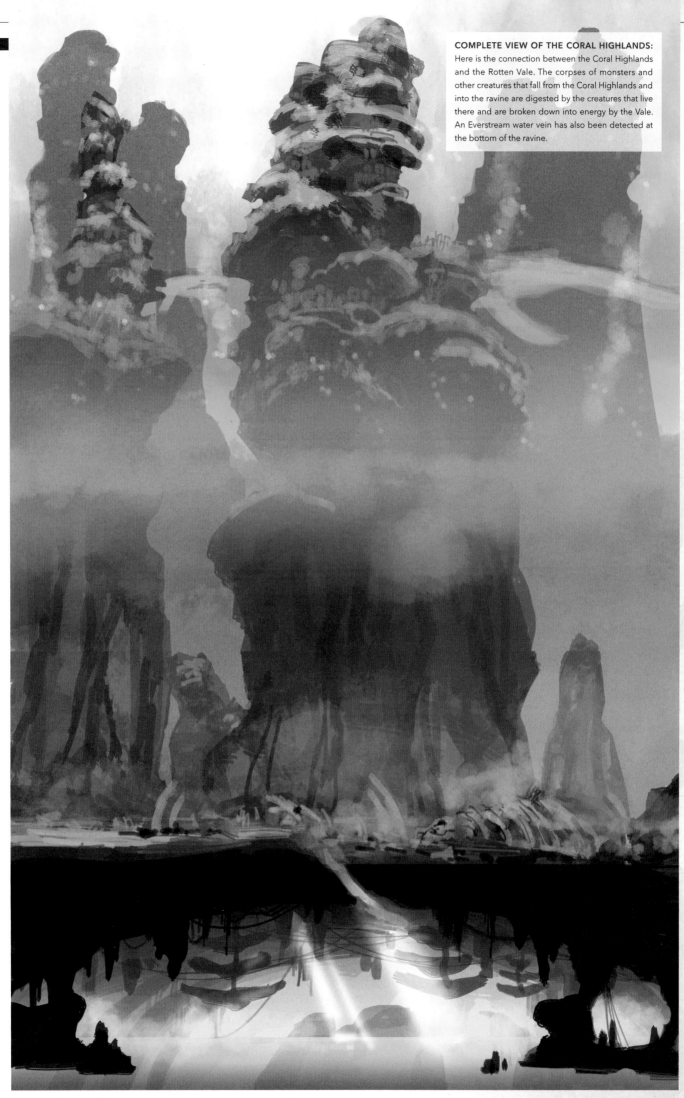

COMPLETE VIEW OF THE CORAL HIGHLANDS:
Here is the connection between the Coral Highlands and the Rotten Vale. The corpses of monsters and other creatures that fall from the Coral Highlands and into the ravine are digested by the creatures that live there and are broken down into energy by the Vale. An Everstream water vein has also been detected at the bottom of the ravine.

The digestive system of the New World.

It has a stench that makes you cover your nose and mouth. I smelled it from the lower level of the Coral Highlands, but it is now getting stronger. The rotting corpses of creatures and the ferocious monsters that feed on them, and the smaller endemic life scavenging what's left of the corpses. One must get past the poisonous smoke, the effluvium, to reach this valley. The Rotten Vale can be called the digestive system of the New World. I can tell that the excitement for exploration I had in the Coral Highlands is waning from the putridness that is attacking my five senses. But I cannot stop moving. We have approached the latter half of our research.

Rotten Vale

The corpses falling from the Coral Highlands form layers of carrion and bone in the Rotten Vale, providing an important foundation for the ecosystem, and particularly the bacterial life unique to this valley.

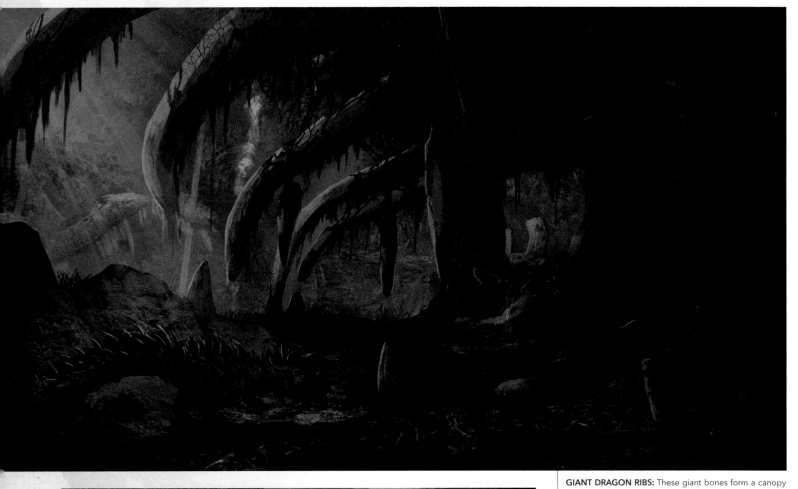

GIANT DRAGON RIBS: These giant bones form a canopy at our camp. It is a dim, rocky area, but it is located near the upper level of the Rotten Vale. The bones fall at times, but that can be useful when hunting large monsters.

CAMP: The first place we arrived at in the Rotten Vale was a rocky area covered in dark ash. You can faintly see the coral when you look up at the misty sky. Very little sunlight reaches the area. The mound of sand that fell from above tells us we are underground.

A sight completely unlike the Coral Highlands lay before me.

Traveling through a giant, mountain-like monster's rotten body... I think that best describes this place. This dismal and savage area filled with a foul stench is truly hellish, just as the members of the Fifth Fleet who arrived here before me said. The difficult road to get here must have been hard even for the most experienced hunters.

The Rotten Vale is a world that exists below the Coral Highlands. Although the two areas are connected by land, the environments are like night and day. The air in the Coral Highlands smelled sweet due to the coral eggs floating in the air. But here in the Rotten Vale, the only smell is the foul stench of rotting flesh. There are scavengers that feed on corpses by choice here. The monsters that inhabit the Rotten Vale and the microscopic organisms in the air are those scavengers. What seems to be fog at first glance is actually a type of bacteria. The effluvium is a collective of those microscopic organisms. The effluvium, besides being poisonous, can turn creatures aggressive. The phrase "Where there is light, there is shadow" crossed my mind. A sight completely unlike the Coral Highlands lay before me. I would like to begin unravelling this harsh environment.

TOPIC Rotten Vale Area Composition

The Rotten Vale is a vast valley at the bottom of the Highlands. Not only are there a wide variety of elevations, there are many giant coiling paths. The environment changes depending on the level.

▼Lower Level ▼Middle Level ▼Upper Level

PLAZA OF BONE AND FLESH: Stones, bones, and flesh, formed into a walkable layer by bacteria. It is sturdy enough to run on and can be used to make pitfalls to trap large monsters.

SPINE PATH: A path resembling the spine of a giant dragon. This area seems to be made up of bones of giant monsters. Giant rib- and spine-like structures can be found in the upper level.

Production Backstory

PRODUCTION NOTES
Rotten Vale's Game Design

We wanted to surprise players who reached the middle of the game both environmentally and visually. Players must learn to coexist with the poisonous effluvium, bacteria that decomposes flesh, while expanding their safety zone in this field. The ecosystem had been decided upon already, so we placed appropriate monsters that would make the field more difficult. It was also decided early on to make this field a three-tiered field. The upper level would be the bone area, the middle level effluvium, and the lower level acid. We changed things up, both visually and gameplay-wise. (*Tokuda*)

FOOTING THAT SMELLS LIKE DEATH: A floor created by layers of monster corpses entangled with bacteria on top of a giant bone. The ground of the Rotten Vale is formed by bones and rotten flesh that have fallen from the world above and are connected by a glutinous fluid.

In the process of the creation of life and growth, digestion is essential.

The suffocating stench can almost threaten one's ability to think, but in terms of the New World's cycle of life, the Rotten Vale can be considered the most vital area. In the process of the creation of life and growth, digestion is essential. This area is responsible for all of that. I wrote earlier that the Ancient Forest was a microcosm of the New World. Just as fallen leaves become mulch in the Ancient Forest, this area is mulch for the entire New World.

I struggled to remain conscious here. The pleasant scent of the Coral Highlands and the stench of death in the Vale are almost like traps to keep us away from the truth of the New World. As I have repeatedly commented, the New World's smooth natural transitions may have been artificially constructed.

Although the Everstream is credited for it, it is impossible to visually or physically verify that fact. Yet the scholars of Astera do not seem to question it. I once presented my own theory at the Wildspire Waste. I am not a scholar, but by continuing this exploration, I am beginning to feel that my theory is true. My thoughts faded due to the stench and thick fog, but I will keep moving forward, believing there is something more up ahead.

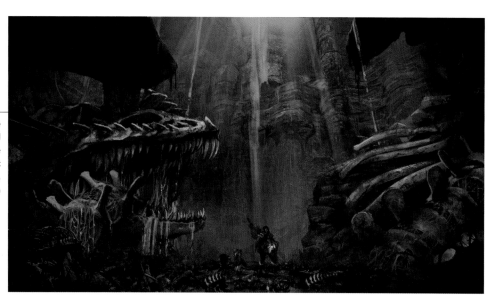

FEEDING GROUND: This area is where the Radobaan feed. You will find piles of refuse and bones here. Sometimes a turf war between the Radobaan and the Great Girros erupts. The giant skull on the left is not the giant dragon's skull, but the bone at the center with the fibers of flesh wrapped around it can be used as a trap.

GIANT DRAGON'S SKULL: A dome-like area inside the skull of a giant dragon. You can sense its size due to the Radobaan using it as a nest. Parts of the skull have eroded, indicating how long it has been since the beast took its last breath.

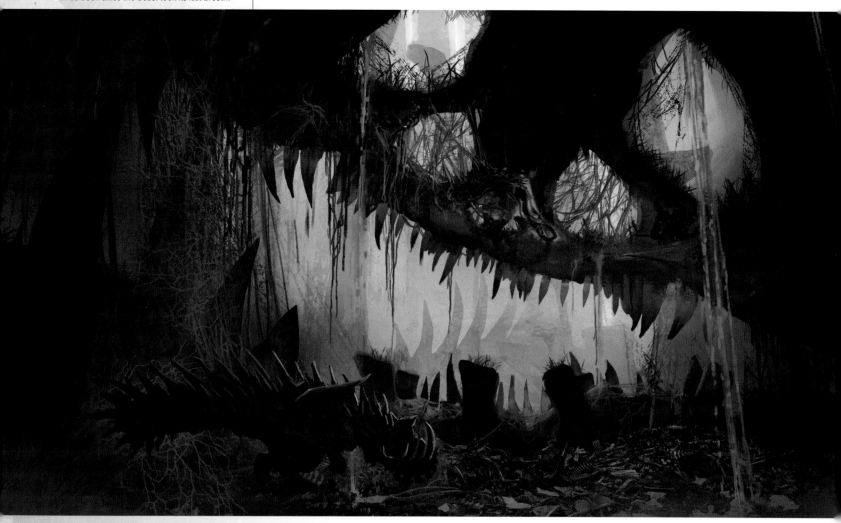

ROTTEN CORAL: Pillars and remains of coral, which may have fallen from above, can be found here. Living coral that falls soon dies from the poisonous effluvium.

DARK POISONOUS FOREST: An area where the connection of ecosystems can be somewhat felt. Spore-like plants grow in this dark, damp area. Only organisms that can counteract the poison of the effluvium with their own poison can survive here.

Production Backstory

I will explain the three levels of the Rotten Vale. The uppermost level consists of undecomposed organic matter that has fallen from the Coral Highlands. Everything that falls from that level is decomposed by the bacteria in the middle level. The refined matter that falls from there is then further decomposed by acid in the lower level and eventually turned into energy. (*Fujioka*)

We wanted whatever was not decomposed by the effluvium to be decomposed by acid and then absorbed into the Everstream as energy. This area is patterned after a human stomach. (*Tokuda*)

TOPIC ## Giant Corpses Constitute the Rotten Vale

▶Serpent King Dragon
Dalamadur

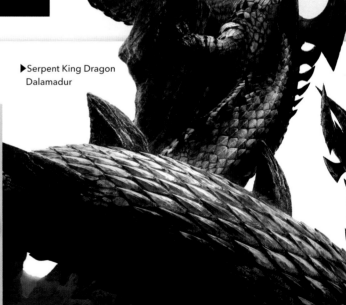

Bones have created paths in the Rotten Vale. According to the hunters who have encountered them, they appear to belong to the Elder Dragon Dalamadur. Like Zorah Magdaros, Dalamadur must've died here in ancient times. They were only spoken of in fairy tales until their recent discovery. But why are they here, and why were they not discovered in the Old World until recently? Is there a connection? There are accounts that Dalamadur was not large enough to cover the entire valley. It is yet unknown whether the corpses are from a related species, or Dalamadur individuals that reached the Vale and grew in size. It also appears as if several of them are lying on top of each other... There is no way to know the truth at this point.

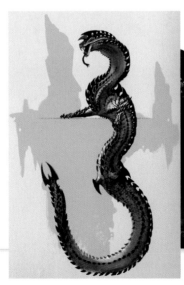

※ Image from *Monster Hunter 4G.*

GAS EMITTED FROM ROTTING FLESH: In the area between the upper and middle levels, effluvium constantly permeates the atmosphere and propagates by infesting the corpses of creatures. Large monsters periodically fall here from the Coral Highlands.

GREAT GIRROS NEST: A tight space, but it is divided between the upper and lower levels. The Great Girros nests on the upper level while rotting flesh emits effluvium on the lower level.

PRODUCTION NOTES

Production Backstory

Positional Relationship with the Coral Highlands

The Coral Highlands sits directly above the Rotten Vale. The Vale is a basin with a powerful ecosystem surrounded by giant valleys. Although it is believed that the matter that decomposes there is later distributed to the Ancient Forest and the Wildspire Waste as energy through the Everstream, it is the Elder's Recess that is the real story. What's actually absorbing the energy created by this process is the Xeno'jiiva. (*Fujioka*)

EFFLUVIUM POOL: Numerous holes leading to Great Girros nests can be found. Effluvium is always present, and a reddish-brown liquid drips from the sky.

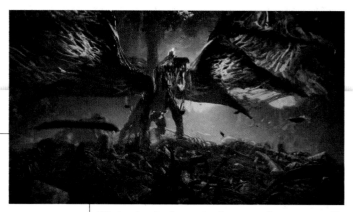

Effluvium is not poisonous to all creatures. Some monsters like the Vaal Hazak will cover itself in effluvium for biogenic purposes.

TOPIC

Erupting Effluvium and Its Cause

The Coral Highlands is a treasure trove of nutrients for life. Endemic life and small to large monsters feed on coral eggs. Some will die due to competition. Their corpses fall to the bottom of the valley and are consumed by carnivorous monsters that prefer rotting flesh. They then decompose even further, thanks to the effluvium, which function like the human digestive system. There are toxins in the effluvium that are harmful to many creatures on land.

NARROW, EFFLUVIUM-FILLED PASSAGE: Piles of both smaller and larger monsters are found here. Some even fell from above during our exploration. The area is filled with the toxin of effluvium and the stench of decay. Odogaron can be seen wandering in search of food.

PUDDLES OF YELLOW ACID: The middle level of the Rotten Vale resembles the lowest level. Rainwater and fluids from the rotting corpses of giant dragons drips down to form yellow ponds. The bones of a giant dragon are visible on the ceiling.

This is a terrain where only those that can coexist with poison are permitted to live.

The stench has gotten even worse, but maybe because I've gotten used to it or my sense of smell is not properly functioning, I am able to maintain consciousness now, unlike when I first arrived. That is how I know that up ahead lies the real effluvium-filled world of death. It is not those that can withstand the toxins here that survive, but those that can store those toxins as nutrients within themselves.

I was told that Vaal Hazak coexists with effluvium and uses it when feeding. In other words, this is a terrain where only those that can coexist with poison are permitted to live.

Vaal Hazak is an Elder Dragon... It has already been proven that the Elder Crossing and the Everstream derive from the corpses of Elder Dragons. As proof of that, Vaal Hazak chose this area, the final destination in the Elder Crossing, as

a home. This means Vaal Hazak is different from the dragons that traveled here and died.

The Everstream and Elder Dragons are deeply connected to the origins of the New World. Thanks to that connection, this abundant and rich natural area was formed. If I go deeper down to where Vaal Hazak lives, I feel like my thoughts will begin to make sense...

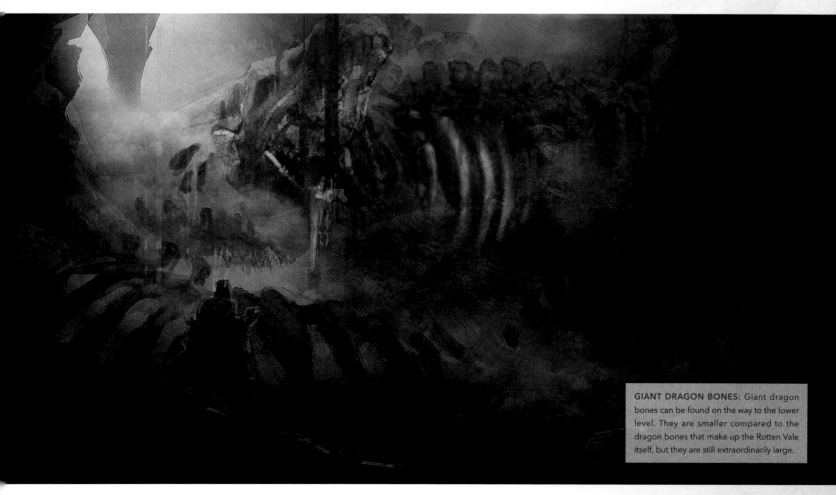

GIANT DRAGON BONES: Giant dragon bones can be found on the way to the lower level. They are smaller compared to the dragon bones that make up the Rotten Vale itself, but they are still extraordinarily large.

Landscape Beauty
-Rotten Vale-

When viewed from a different angle, the three overlapping layers of fields that constitute the Rotten Vale become obvious. This area was originally a place where Elder Dragons came to die, the digestive system of the New World, but it is also a world with filled with beautiful color gradations as you move toward the lower levels. Even if that beauty is a beauty of death swirling with effluvium...

PIT OF ROTTING FLESH: The entrance to the lower level of the Rotten Vale. The effluvium is suddenly thin here. In the middle of the opening is an area where corpses and bones have been dragged. Humans cannot travel safely here, as Odogaron will leap over the pit to attack them.

ODOGARON NEST: An enclosed area made from collected corpses. It's a dark, suffocating space, but you will find bacteria emitting a pale green light in certain parts.

PATHWAYS DEEPER IN: These rocky pathways are on the lower level, between the Odogaron's reddish graveyard and the pale area that has been hardened with dark-brown rocks. This must be the original color of the world underground.

SECOND CAMP: Campsite located on the middle level. A giant conch fossil can be found. There is a mound of fossilized bones along the ledge to the north. Bones of large monsters can also be found here.

It is without doubt the translucent acid puddles that create this overwhelming scenery.

When I arrived at the lower level, I was surprised by the sublime sight of scattered reflections of pale light. Is this really the Rotten Vale? It had a beauty different from the Coral Highlands. The first thought that crossed my mind was the purity of this area. However, I came to my senses when I saw Vaal Hazak's nest, a pile of rotten flesh.

It is without doubt the translucent acid puddles that create this overwhelming scenery. The puddles in the middle level are discolored yellow. How did they become so transparent here? Just as corpses decompose as they make their way down to the lower level, fluids too must become purified. In other words, the lower level of the Rotten Vale is like the final stage of digestion, with all impurities filtered out. The acid puddles must get their pale glow from the effluvium as well. As the effluvium or the dead bacteria tissues are filtered, the material collects in these puddles to give it that pale glow.

My colleagues' research has already made clear that these acid puddles play an important role in the cycle of life in the New World. But as I stared at the pale glow, I recalled everything I had seen. The glowing Scoutflies gathering around tracks, the Flashflies at the Wildspire Waste, and now these acid puddles.

Their glow indicates the existence of the Everstream that forms the foundation and cycle of the New World...

I believe that all life here exists due to the will of an outside force. That is now becoming closer to a certainty. For example, the rain can be thought of as an acquired process to minimize the damage caused by the effluvium, which in turn serves as a hotbed of biological activity. While the effluvium is essential for the energy cycle of the New World, it can also be toxic to creatures. If rain periodically limits the effluvium from becoming overly active, perhaps there is a mind at work to decide when that would be... To take it a step further, perhaps all life here, including ourselves, were invited here by somebody's will. And that will may be related to the glow down here. Somebody is guiding us with light... That was the thought I had.

BEAUTIFUL POND OF DEATH: In this area with acid puddles, water drips from above. The mysterious beauty will capture you, but it is a very dangerous area. This place is like our stomach, in that it converts decomposed organic matter into energy.

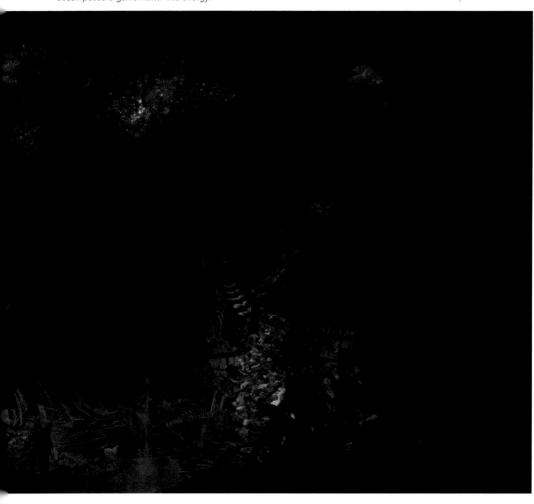

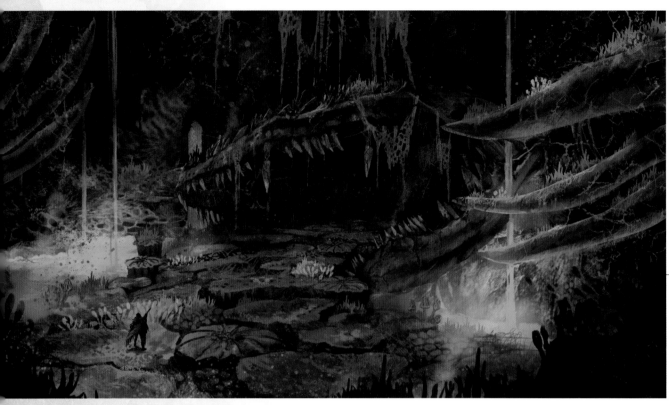

SKULL OF AN ELDER DRAGON AT THE ROTTEN SEA: A beautiful pale area where spores of bacteria float. There is another skull of a giant dragon here with bite marks on it. The effluvium turns the Raphinos in this area more aggressive.

Perhaps the Grimalkynes know how the Elder Dragons, the Everstream, and the New World were created.

I would like to dig deeper into the Grimalkynes of the New World. We cannot converse with them like we can with Feylnes, but they are without a doubt intelligent creatures. They lead a civilized life. Whenever I came across them in the Ancient Forest I thought, "Why do they build homes in a place that could be considered the end of the world?" Although their homes are secure, one home I found here was near Vaal Hazak's nest.

Since we cannot speak to them, it is difficult to ask them why, but perhaps they know how Elder Dragons, the Everstream, and the New World were created. That is why they intentionally choose to live in a place like this, to feel the monsters close to them, hoping to coexist with them.

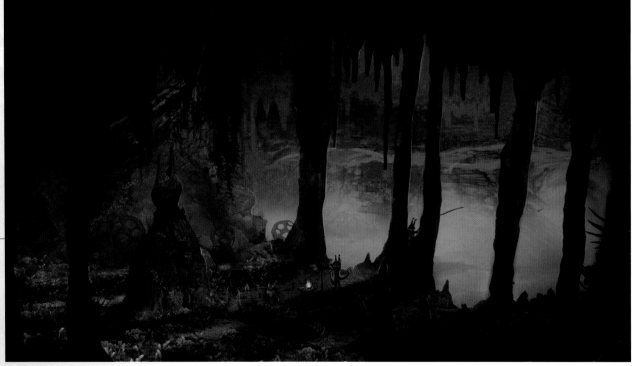

LYNXES DEEP IN THE ROTTEN SEA: The Grimalkynes live beyond the acid puddles. Elder Dragons can sometimes be seen here, and there is a body of water where fish live too.

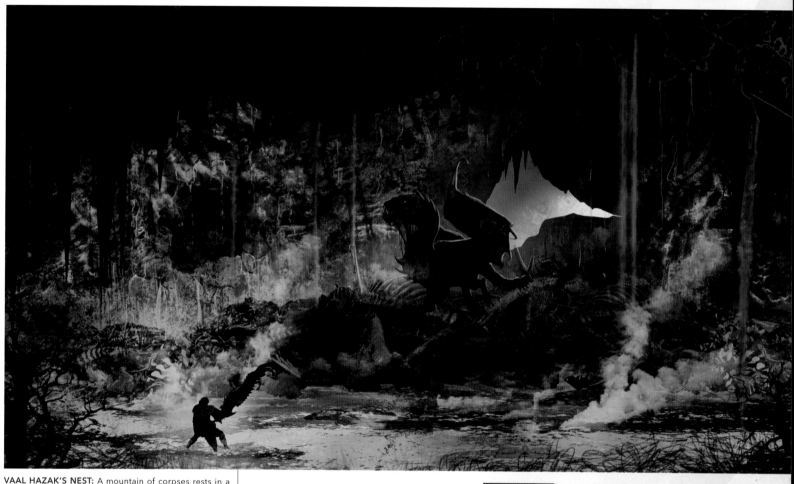

VAAL HAZAK'S NEST: A mountain of corpses rests in a wide-open area. An orange light comes in through the giant tunnel cave. Vaal Hazak hides by mimicking its surroundings. Signs of the Everstream can be seen at the nest.

DIMLY LIT PATH: I see the pale glimmer of acid through a crack in the wall of spores. The lower level near the Everstream is quiet, far different from the hell-like conditions in the upper level.

Production Backstory

PRODUCTION NOTES
Rotten Vale History

In ancient times, the release of Zorah Magdaros's bioenergy and an equal-sized explosion caused sudden tectonic movements on land and in the ocean floors. The coral from back then have gone extinct, but varieties that survived in the atmosphere through the Everstream successfully adapted to life on land. Perhaps the underground cavity was created below layers of the coral's growth. As organic matter and corpses of Elder Dragons fell into that cavity, an ecosystem of decomposers feeding on it developed. The remains of the Dalamadur that came later established the foundation of the Rotten Vale. Still later, Elder Dragons like Xeno'jiiva that attract other Elder Dragons were born to form the cycle of the New World. (*Tokuda*)

Elder's Recess

An untouched land filled with strong energy. At its center is a giant crystal formation called the Elder's Recess that is surrounded by areas of lava flow and jagged basalt formations. Many powerful monsters live here, and we believe the Elder Dragons gather here.

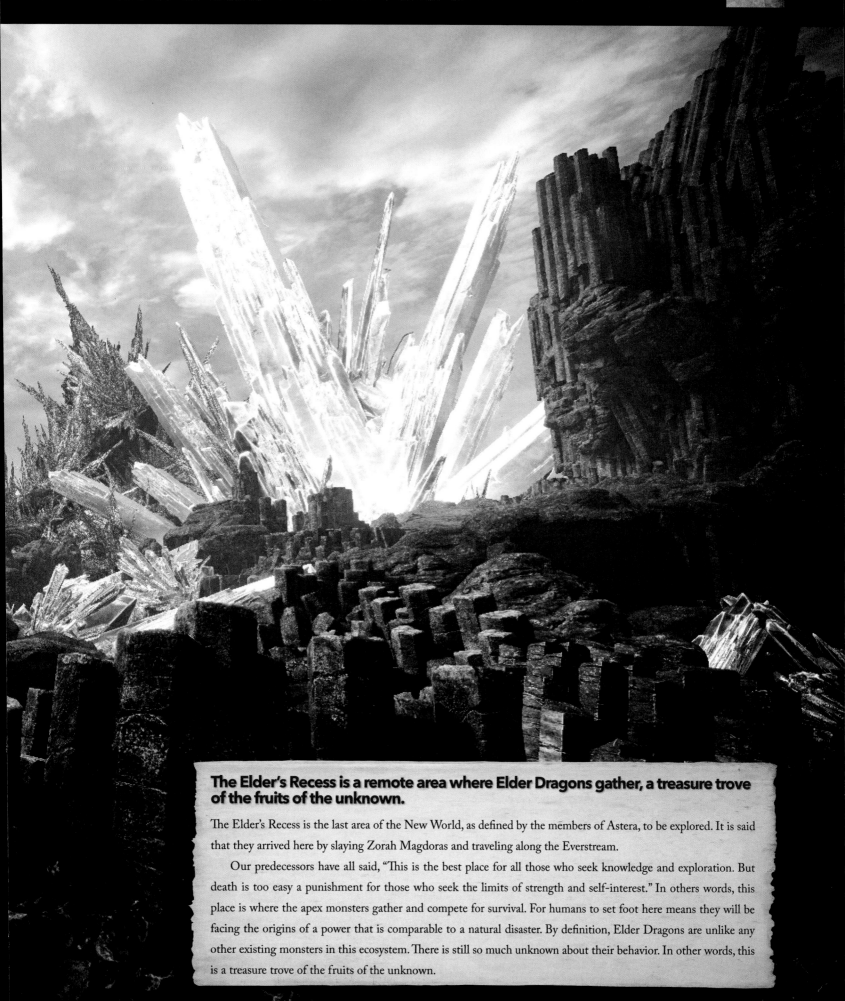

The Elder's Recess is a remote area where Elder Dragons gather, a treasure trove of the fruits of the unknown.

The Elder's Recess is the last area of the New World, as defined by the members of Astera, to be explored. It is said that they arrived here by slaying Zorah Magdoras and traveling along the Everstream.

Our predecessors have all said, "This is the best place for all those who seek knowledge and exploration. But death is too easy a punishment for those who seek the limits of strength and self-interest." In others words, this place is where the apex monsters gather and compete for survival. For humans to set foot here means they will be facing the origins of a power that is comparable to a natural disaster. By definition, Elder Dragons are unlike any other existing monsters in this ecosystem. There is still so much unknown about their behavior. In other words, this is a treasure trove of the fruits of the unknown.

Past the Everstream...was a giant, towering crystal formation under dark clouds.

The Coral Highlands and the Rotten Vale lie in a recess surrounded by a great valley. The Commission arrived at that land from the south by traveling over the Great Ravine that Zorah Magdaros crossed over. A calm valley stretches to the north of the recess as well, but members of Astera pursued Zorah Magdaros and discovered a path beyond the valley as they were exploring the Everstream. Past the Everstream, lying in the middle of a rocky area over the mountain range, was a giant, towering crystal formation under dark clouds. Nobody ever expected to find anything like it in what could be called the end of the New World. I had heard about it, but looking up at it I thought that this structure was like a castle for gods and could not have been born from the energy of the Everstream or the Elder Dragons.

But the increase in Elder Crossings over the past several decades has been attributed to Xeno'jiiva trying to hatch itself by attracting Elder Dragons. Xeno'jiiva attracts them using a pheromone that can only be sensed by a handful of creatures. Then why did Elder Dragons like the Dalamadur come to the New World seeking their place of death in ancient times when the Xeno'jiiva did not exist? Do monsters even have wills of their own? What do they seek besides procreation and feeding, and where are they going? That may be where the key to it all lies.

EVERSTREAM THAT CONNECTS THE ELDER'S RECESS: This area past the giant underground cave was previously unexplored. What explorers discovered was a giant, blinding crystal formation guarded by erupting lava.

ELDER'S RECESS AND CAMP: A campsite near a crack created by the path of the Everstream, with a giant crystal formation at its center. The basaltic formations to its right and the lava streams to its left should tell you everything about this place.

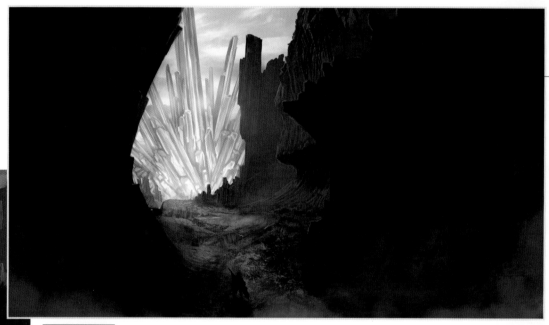

STONE PILLAR CAVE PASSAGE EXIT: The Elder's Recess is the crystallization of the Everstream, the bioenergy of the Elder Dragons themselves. Its contrast with the oddly shaped black rocks around it makes it stand out.

CURVED STONE WALL SLOPE: The stone walls are unnaturally curved. The Uragaans have been known to roll and turn down the slope. Perhaps it was smooth until the Uragaans carved it.

TOPIC · Elder's Recess Area Composition

The Elder Dragons' bioenergy in the Everstream gathers here, crystallizes, and protrudes from the ground. Below the volcanic mountain range is a vast magma bed that vents lava and crystals to the surface.

▲Upper Level ▼Lower Level

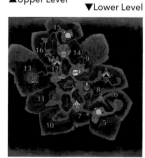

Production Backstory

PRODUCTION NOTES

Elder's Recess Game Design

This advanced field is aimed at experienced players who have made it late into the game. We tried to make it simple to play because the monsters are strong. We wanted it to be an Elder Dragon map, and we placed crystallized energy as landmarks throughout. We felt it would be too difficult if the only monsters were Elder Dragons, so we added original monsters like the Dodogama, Lavasioth, and Uragaan. We developed the map by connecting areas so they would encounter one another. (*Tokuda*)

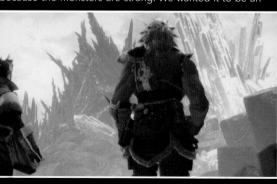

ELDER DRAGON BATTLEGROUNDS:
An open area with a gigantic crystal formation where Elder Dragons stare each other down. The overwhelming sight gives you the illusion you have wandered into the world of the gods. Pieces of the crystal are scattered around. It is also possible to mine for rare minerals here.

It is not an exaggeration to call this overwhelming black-and-white landscape a giant natural shrine.

Perhaps I should call it a joint performance by giant sublime rocks. This area to the north of the Coral Highlands should have been rocky. Maybe it became an ever-evolving environment due to the deaths of Elder Dragons. The effects of the Everstream from the Rotten Vale created the crystals, and then that power attracted monsters. It is not an exaggeration to call this overwhelming black and white landscape a gigantic natural shrine.

But it was not the gods that created this shrine. It was the Elder Dragons. I mean that, of course, in an indirect sense. When the Elder Dragons' extraordinary bioenergy was released into the New World, it spread crystals everywhere, causing a ripple of continued expansion.

The elements of the world always influence one another. If that can be called symbiosis, we hunters have had a symbiotic relationship with monsters as predators since ancient times. The Elder Dragons have also been powerful and mysterious creatures. Our history is intertwined with the Elder Dragons that at times fled, defended themselves, and caused natural-disaster-like events. This mysterious part of the Elder Dragons' behavior has been identified by the Fifth Fleet.

I was forced to believe, after witnessing this giant shrine, that the fact that the Elder Dragons sought the New World and we were drawn here by them affirms that there is a symbiosis between us.

Production Backstory

PRODUCTION NOTES
Elder's Recess Design

We thought, after creating one ecosystem after another, that it might be interesting to create a field where the ecosystem was less obvious. The concept art we first received from the designers had Elder Dragons in a place with no organic matter. The sky was red, and all you could see were crystals. We thought it was great, but at the same time we prided ourselves on our ecosystems. We wanted a reason for the Xeno'jiiva to be there. So we decided this area would be called the Elder's Recess, where you find crystallized Elder Dragon energy everywhere, and placed a gigantic crystal formation at the center. We thought we could design the formation of the environment and its ecosystem by tying it to the Xeno'jiiva. (*Fujioka*)

TOPIC Genesis of the Giant Crystal

The crystals in the Elder's Recess are crystallized Elder Dragon bioenergy. Many Elder Dragons came to the Rotten Vale to die for tens of thousands of years. Their energy would rise to the surface as crystals through the Everstream. I had not seen anything like it until I reached the New World. These crystals are not simply an aggregate of energy, but an invaluable element of the New World. The Elder Dragons and the Everstream brought and nurtured all kinds of life here.

KUSHALA DAORA'S NEST: An open area with small cliffs scattered throughout. You can traverse the area quickly by utilizing the Wedge Beetles. Kushala Daora's nest can be found at the summit where strong winds blow.

STONE PILLAR INLET: Stone cliff where steam from the lava pouring into the ocean rises. The moisture spreads like a cloud, making the rocks appear as if they are floating.

PILE OF ROCKS: Where the Uragaans sleep. There is a pile of rocks at the bottom of a grooved pit. Uragaans freely roll around on the curved slopes.

LAVA STREAM VALLEY: An underground area inside a volcano. Lava flows out from the cracks. There is a giant crystal cave to the north where Wyverians and Gajalakas can be seen.

CRYSTAL VALLEY: The area that connects the volcanic, stone pillar, and crystal areas. It stretches east to west, and many monsters roam this valley.

Production Backstory

PRODUCTION NOTES

Elder Dragons of the Elder's Recess

Only Nergigante discovered and chose the Elder's Recess as their home after Zorah Magdaros's failed Elder Crossing. They must've driven out the Gajalakas through sheer frustration. Considering the huge number of crystals, a great number of Elder Dragons must have arrived and died in the New World since ancient times. (*Tokuda*)

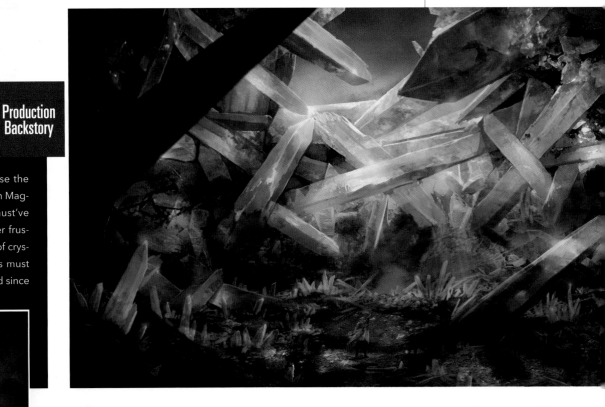

STONE PILLAR CAVE CAMP: A campsite surround by crystal pillars, close to the giant crystal formation at the center. It is a useful area to both confront and evade monsters. It is surprisingly relaxing to quietly gaze at these crystals.

EXPLORING THE UNDER-GROUND STONE PILLARS: There is a path carved out by the Gajalakas that leads to their hideout. At night, the Gajalakas begin dancing. We were attacked when they noticed us.

HILL WITH A VIEW OF THE GIANT CRYSTAL FORMATION: A wide-open area with ledges and slopes. It is a place many monsters, including Elder Dragons, visit, making it a highly contested area. Nergigante can also be found fighting here.

Responding to a distress signal from the New World in the name of research.

I've proposed new theories since arriving in the New World, but I would like to end that because, like I've said from the beginning, they are merely speculation. I imagine it would take an unbelievable amount of time to prove. I suspected that the people of Astera went along with the theory, proposed by the First Wyverians, that the Xeno'jiiva attract Elder Dragons. That is why I followed my colleagues to the New World and proposed many new theories. I would like to derive some kind of conclusion here.

It all connects if you believe the New World itself is a giant organism. If the Elder Dragons provide energy to the Everstream with their deaths, perhaps they are a species that can use that energy as well. I have not witnessed Xeno'jiiva yet, but according to what I was told, it is an Elder Dragon that emits light. Perhaps that light is Everstream energy…

This giant creature we call the New World beckons Elder Dragons to their deaths, creates environments for its creatures, and connects them using the Everstream. We can almost say we too were drawn here. Maybe the tracks the Scoutflies are attracted to, the Flashflies flying around the Wildspire, and the incandescent bacteria of the acid puddles suggest the existence of the power of the Everstream.

In other words, it can be said that Xeno'jiiva was drawn not to the bioenergy of the Elder Dragons, but to the massive ecosystem of the New World. To take that a step further, we were not exploring the New World, but responding to a distress signal from the New World in the name of research. The Commander gave Scoutflies their name because they could guide us in our exploration. But perhaps the Scoutfiles are the guiding light the New World itself generated to bring us here.

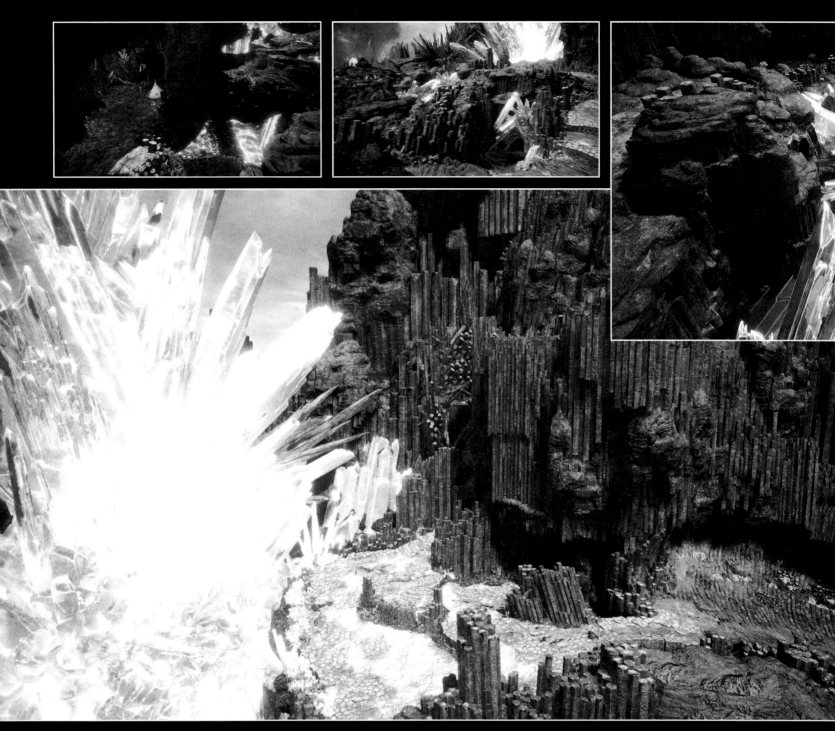

Landscape Beauty
-Elder's Recess-

The black ground containing molten rock, the white silver crystals, and the red lava. These three colors are merged to create the unique landscape of the Elder's Recess. When viewed from an angle not ordinarily possible, you can see tall basaltic rock formations and volcanic activity. At first glance, it may appear as if no life exists here. Only the strongest survive in its harsh conditions.

SULFUR LAVA CAVE: A section of the volcanic cave. There is sulfur caked on the walls, and the molten ground is brittle and will shatter with impact.

MASTER OF THE LAVA LAKE: A flat, rocky area surrounded by lava. It is home to the Lavasioth. Lava flows down from the crater like an avalanche.

What causes the fierce territorial battles between monsters in the New World?

Territorial disputes between monsters in the Elder's Recess are growing more and more intense. Lavasioth, Uragaan, Dodogama... Powerful, Elder Dragon-like monsters continue to fight for turf here. We have encountered conflicts between monsters in the Old World, but we are not even in their sights here. In other words, we are not considered a threat. We are visitors to these monsters in the New World. Considered in that light, it makes sense that they would fight over territory without paying any attention to us. But I speculated about another reason. What if they are competing for food that is not the Everstream...? What if they wander the lands, carving out territory and competing with other monsters for it? The New World is a land of discovery and surprises.

FLOATING LAVA ISLAND: Here, lava falls from above like waterfalls. We are surrounded by lava here. Despite the harsh conditions, territorial battles between monsters are fierce here.

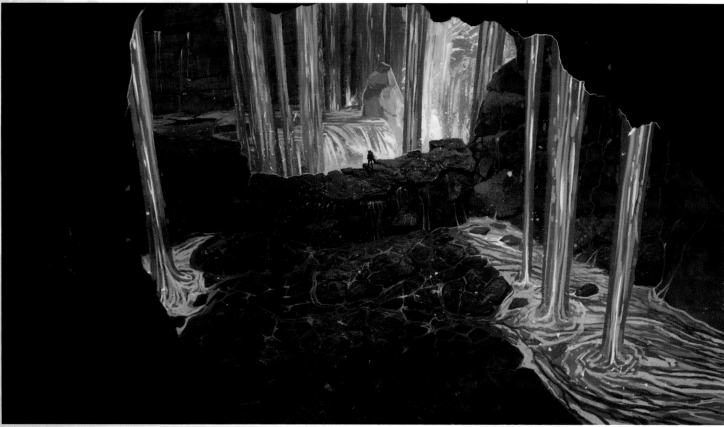

TOPIC ## The Unique Ecosystem of the Elder's Recess

Amber can be collected at the Elder's Recess. Amber is fossilized tree resin that is found in strata. Judging by an amber-encased horseshoe crab, a form of endemic life not normally seen here, we can theorize that this land is in constant motion and at one point had vegetation. Tectonic activity caused over the years by Elder Crossings has turned this place into a rocky area.

Various creatures can be found in these chunks of amber. Collecting samples and studying them will reveal what the ecosystem used to be like.

SULFUR CAVE: This is where Teostra room. Their tendency to prefer hot areas is the same as Teostra in the Old World.

LAVA WATERFALL BASIN: Eruptions occur between the cracks like a geyser. Home to Teostra and Lunastra. Ordinarily it is impossible for humans to enter this severe environment.

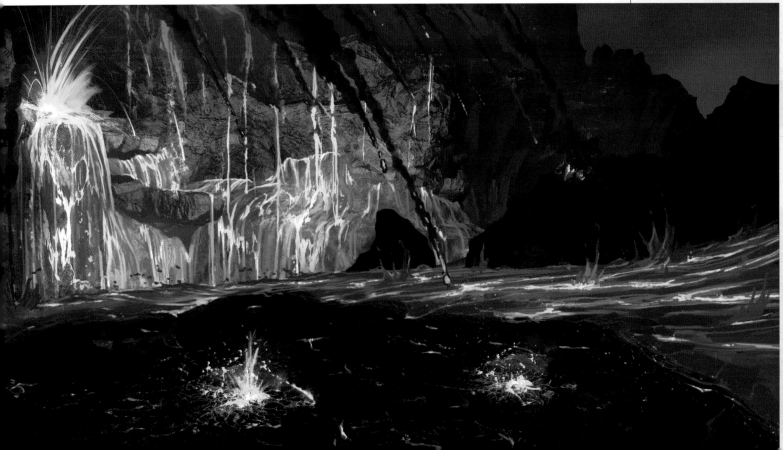

THORN CRYSTALS: An area filled with young thorny crystals. It's an undulating terrain where these sharp crystals continue to grow.

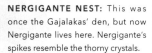

NERGIGANTE NEST: This was once the Gajalakas' den, but now Nergigante lives here. Nergigante's spikes resemble the thorny crystals.

The First Wyverians were connected to the Elder Dragons in ancient times. I can't help but think they share the same ancestor.

The Elder Crossing and the Everstream carry out the will of the New World. I made a wild remark that they have psychological implications for creatures too.

It's possible we too were indirectly drawn here to the New World. If so, the Ancient Forest appearing like a giant tower, feeling as if the Wildspire Waste was intentionally built, the idea that the Coral Highlands and the Rotten Vale together create a near-perfect ecosystem, and the nonrandom cycle of nature all make sense. It is easy to dismiss them as miracles, but by collecting more evidence, I seek to strengthen my argument.

If the Elder Dragons are equally, no, perhaps even more intelligent than we are, then what are they? The only known intelligent life-forms in this land are humans, Lynians such as the Felynes and Grimalkynes, and the Wyverians. The First Wyverians, native to the New World, are also Wyverians.

Wyverians live longer than humans, but their total population is small and they have their own knowledge and culture. Yet, there are very few cases of conflict with humans. I personally believe they have blended in and built a positive relationship with us.

I was told the words *dragon* and *wyvern* share the same origin. That is another connection between us. The fact that they live longer than

us means they have more life force than us. That goes without saying. But it may also connect them to the Elder Dragons and the Everstream somehow.

The First Wyverians we met in the New World are connected to the Wyverians and the Elder Dragons from ancient times. I can't help but think they share the same ancestor.

They have their own unique technology, and some have been known to be similar in size to large monsters. If there was a time when such Wyverians flourished, it makes me believe it is possible that they created this near-perfect environment of the New World.

SULFUR HOT SPRING CAMP: The heat emanating from the sulfur-heated rainwater has created a nice hot spring. The mossy-colored hot spring is rich in nutrients, making it a perfect home for bacteria.

GAJALAKA SETTLEMENT: This is a Lynian Gajalaka settlement in a sulfur cave. Their languages differ from the Grimalkyne, and they have a unique temperament. Contrary to their appearance, they are surprisingly hostile.

GAJALAKA TOOLSHED: A section of the settlement. They have the intelligence to use tools in their daily lives like the Grimalkyne. You will find many handcrafted tools scattered around.

**Production
Backstory**

PRODUCTION NOTES
What Is the Elder's Recess Crystal?

An Elder's Recess crystal is the aggregation of Elder Dragon bioenergy. Our initial idea was that when creatures with powerful bioenergy like the Elder Dragons died, they would be melted by the acid in the Rotten Vale, but what was not dissolved would remain and crystallize. I had the designers base their designs around an ammolite. (*Tokuda*)

We wanted to include volcanoes and lava as symbols that the land itself creates energy, which would require the presence of molten rocks and black minerals. We wanted to add some color to the environment by placing strange, shiny crystals around. At first glance, they're crystals, but in event scenes, I think you'll see they shine with all kinds of colors. How it's seen is up to the person. Streamstones are where these crystals are incorporated into the game design, and they're given to you by the Grimalkyne upon clearing the game. Streamstones allow players to use energy in the Elder's Recess in ways they weren't able to before. By progressing through the story and exploring the Elder's Recess, they can enjoy the game at another level. (*Fujioka*)

TOPIC | Gajalaka Writing and Cave Wall Patterns

Unlike humans, the Gajalakas use a pictorial form of writing. By learning their written language, secret paths can be unveiled. If possible, I would like to become fluent in their written language to learn the history about the New World that has been passed down to them. But that would take a very long time.

......Gajalaka Hideout

......Sweathall

......Waterfall

......Lightstone Hill

......Ritual Hall

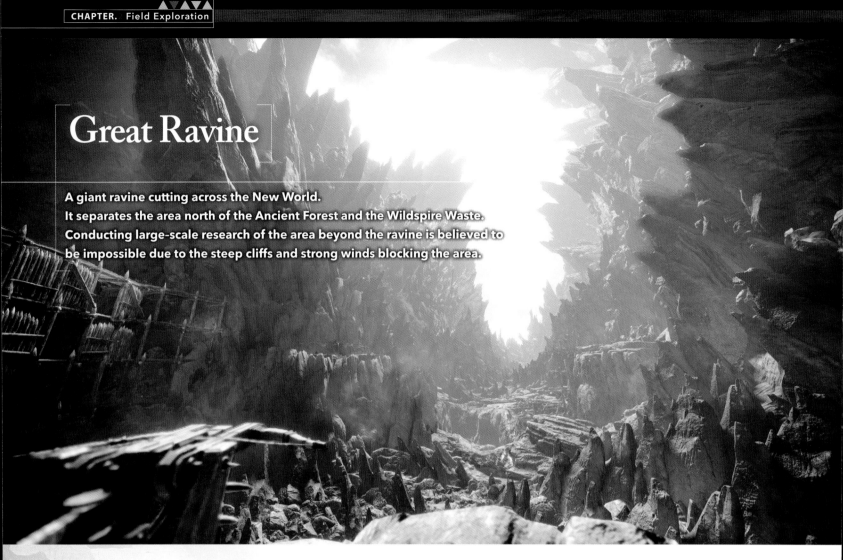

Great Ravine

A giant ravine cutting across the New World.
It separates the area north of the Ancient Forest and the Wildspire Waste.
Conducting large-scale research of the area beyond the ravine is believed to
be impossible due to the steep cliffs and strong winds blocking the area.

Surveying the site of Zorah Magdaros's capture.

It is said that right before Zorah Magdaros appeared, the hunters' Scoutflies all simultaneously pointed in the same direction. Scoutflies sniff out monsters and light the way as if they can read their masters' minds. The Scoutflies of many hunters here to slay Zorah Magdaros all glowed and flew in the same direction. Despite the fierce battle ahead, some said that the sight of the Scoufflies was as beautiful as the first time they set foot in the Coral Highlands. The Great Ravine, which we could not cross until the arrival of the Fifth Fleet, stood in our way. The mission of capturing Zorah Magdaros here ended in failure, but because of it, we were allowed to set foot in this land. Every time I cross the Great Ravine, I am reminded of the power of Zorah Magdaros, which moves forward while destroying nature's obstacles.

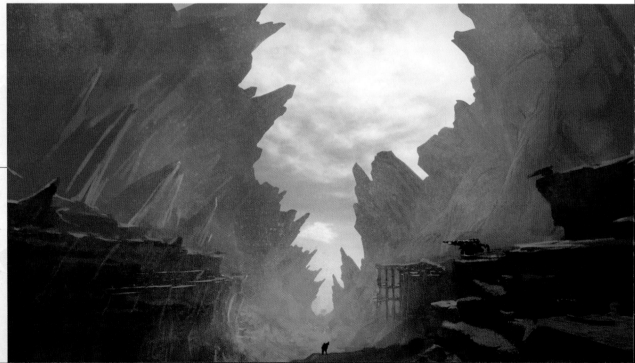

FORTRESS BUILT BY THE RAVINE: The fortress the Commission quickly built upon receiving information that Zorah Magdaros was close by. They could not deny their lack of preparation for the capture of such a gigantic creature, but it is impressive that they built this in the time they were given.

■ Binder Ballista

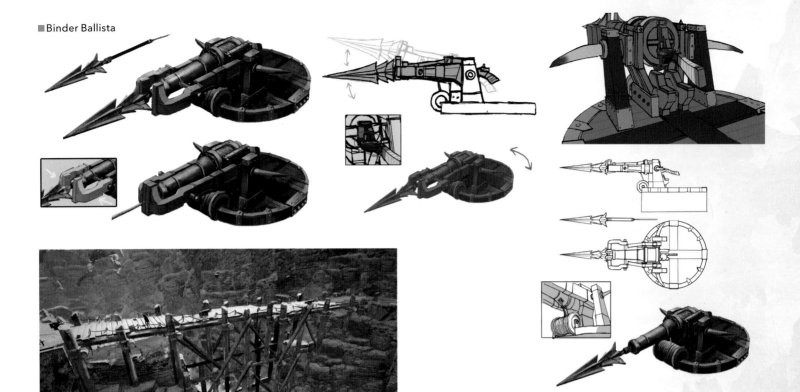

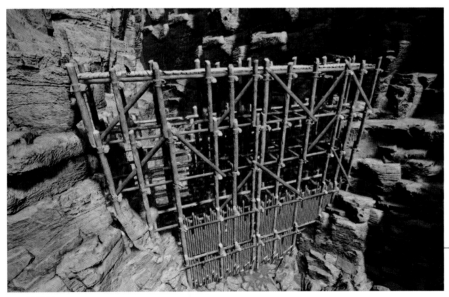

THE GREAT RAVINE FORTRESS: A section of the fortress built in haste. The people of Astera waited here to capture Zorah Magdaros.

Great Ravine Area Composition

This mountain range consists of numerous rocky mountains north of the Ancient Forest and Wildspire Waste. Even the Commission thought twice about setting foot in this area.

THE GREAT RAVINE FORTRESS 2: This section of the fortress was built in haste. Unfortunately, this fortress was destroyed by Zorah Magdaros. A hastily built fortress could not stop the progress of an Elder Dragon.

Production Backstory

PRODUCTION NOTES
Rocky Area to Be Crossed

The rocky mountain range that surrounds the Coral Highlands is the Great Ravine. We wanted to achieve a contiguous feeling with it, the idea that there is something beyond the Wildspire Waste that could be crossed. We wanted the players to feel excited about what lies beyond it. It is a blindfold of sorts. We also wanted the players to enjoy how different it is from the Coral Highlands. (*Fujioka*)

The Ancient Forest and the Wildspire Waste are fantastic, but they are still based in reality. The Coral Highlands and the Rotten Vale are even more fantastic. We wanted to create an ecosystem here that would feel realistic to the players. We wanted players to play in a more familiar setting before entering a unique world by placing the Great Ravine in between the fields. (*Tokuda*)

Everstream

A giant tunnel that spans the New World contains the Everstream. It is filled with intense heat due to the flowing lava.

The Everstream is the lifeblood of the New World.

I was told that the Everstream was an underground cavity. I imagined the Everstream would be like a river of light until I actually saw it. But there was no glowing torrent. When the bioenergy given off at the moment of an Elder Dragon's death is released into the Everstream, the New World is engulfed in an ocean of fire… Our mission was to guide Zorah Magdaros, a bomb with a lit fuse, to sea before that happened. That great battle seems like it never took place now. All that's left are the broken weapons and the heat of lava in this great cavity. The operation's success in the Everstream not only saved the New World, but became the path of truth that leads to the Elder's Recess. This land will leave a lasting impression in the memory of the Commission.

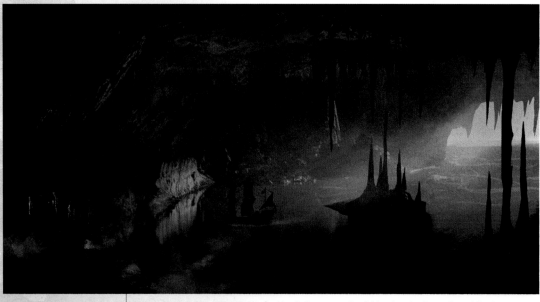

THE LAST LINE OF DEFENSE: The final battle line to stop Zorah Magdaros's advance by guiding it out to sea.

TOPIC Everstream Area Composition

Zorah Magdaros was headed toward the Elder's Recess from the Rotten Vale. We built a fortress to guide it toward the inlet.

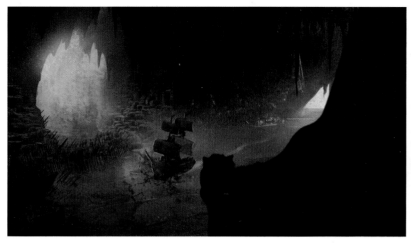

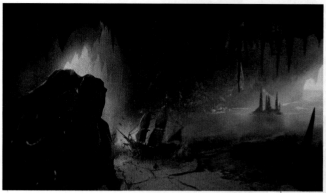

THE VOLCANO DRAGON APPEARS: Zorah Magdaros appeared three times, crossing the sea and traveling underground while seeking its place of death. Slaying this Elder Dragon went against the laws of nature.

■High-Capacity Cannon

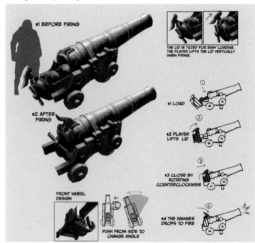

One of the tools used to shoot down Zorah Magdaros. Although not as powerful as the Dragonator, it can be fired rapidly, making it an effective means of diversion.

STOP ZORAH MAGDAROS: The hunters gave their all in this battle, and even leapt onto Zorah Magdaros from above and used the stalactites in the cave as weapons. Although Nerigante interfered, the combined power of the forces from Astera made the operation a success.

Production Backstory

PRODUCTION NOTES
Everstream Game Design

Initially, Zorah Magdaros was not supposed to pass through this area. It was supposed to die in the Rotten Vale. But it was called here by Xeno'jiiva to make one last stand. The Commission guided Zorah Magdaros to the waters of the New World to live out its life. Maybe another New World will be created there from the bioenergy of Zorah Magdaros, though that would be tens of thousands of years from now. (*Tokuda*)

THE THIRD BATTLE: Supplies arrived in time to fire the Dragonator during the capture operation at the Great Ravine. The battle was finally over.

177

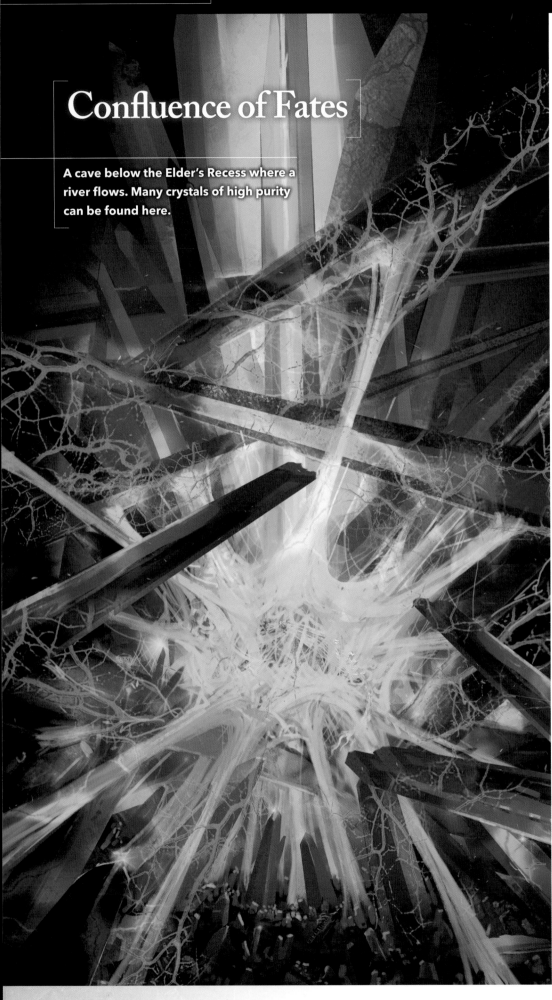

Confluence of Fates

A cave below the Elder's Recess where a river flows. Many crystals of high purity can be found here.

What is Xeno'jiiva to the New World?

Xeno'jiiva learned of the coming deaths of Elder Dragons and redirected them from the Rotten Vale to the Confluence of Fates to aid its own birth. I ponder once again what Xeno'jiiva means to this serene New World. I suggested that Xeno'jiiva is a calamity, a distress signal from the New World. However, isn't it possible that it organized the Everstream energy in the New World? Did we...did humans end the cycle of nature when we subdued Xeno'jiiva? No, we did not. Xeno'jiiva's existence became untenable when it gathered too much Everstream energy. Looking up at the heart of this New World, I am proud, as a member of the Fifth Fleet, that we were able to stop Xeno'jiiva.

TOPIC | **Confluence of Fates Area Composition**

The underground cave connected to the Everstream collapsed during the battle against Xeno'jiiva. Perhaps it turned this place into a mere shell of itself by using it as a nursery.

▲Upper Level　　▼Lower Level

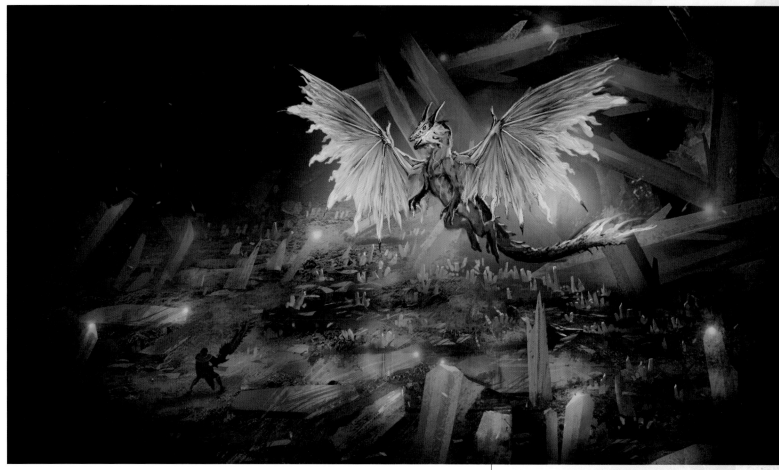

NEW ELDER DRAGONS HATCHING FROM COCOONS: They say they appeared emitting light as if they were responding to intruders. It was the birth of a new breed. All those present quickly understood the creatures were dangerous.

EXPOSED CONFLUENCE: The battle against the Xeno'jiiva collapsed the underground ceiling, connecting it to the Elder's Recess and its brilliant red glow. The power of Elder Dragons nurtured in the Elder's Recess is without equal.

TOPIC Everstream Energy Nurturing Great Existences

Xeno'jiiva, named after it was subdued, collected Everstream energy for its own birth over the course of many years. The giant crystal formation in the middle of its nursery bed indicates the vast amount of energy it had stored.

■New World Cycle Illustration

A cross-sectional view of the New World. If the Eversteam is like the veins of a creature, the Elder's Recess is the heart where energy is activated. Like its name suggests, this underground confluence is the center where energy is sucked up and stored. It is perhaps the womb that gave birth to Xeno'jiiva.

Arena

An isolated facility built by the people of Astera to investigate the local ecology via various devices and research the habits of monsters. Equipment is limited here to prevent use of excessive force against captured monsters.

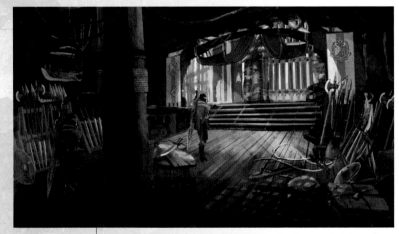

A research facility built by the people of Astera to study monsters and train.

Monsters captured in the New World are transported to an area next to the research facility via wooden tracks. Once there, they are carefully examined by researchers under the supervision of Astera's highly skilled hunters. Monsters that receive treatment, also for the purposes of research, are carted away to the open sea and eventually to a small island southeast of Astera. The Arena was built using bones and wood, and is big enough for multiple large monsters to roam. The monsters transported here will face off against hunters who have studied in the training facility behind Astera and have field experience in the New World.

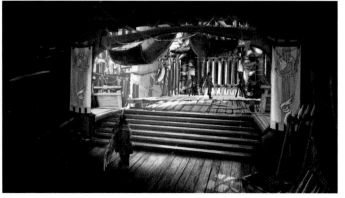

WAITING INSIDE THE SHIP: Hunters entering the Arena reach the island from Astera by this ship. The place where the fleet flags hang also serves as their waiting room. The entrance of the Arena is onshore to the rear of the ship.

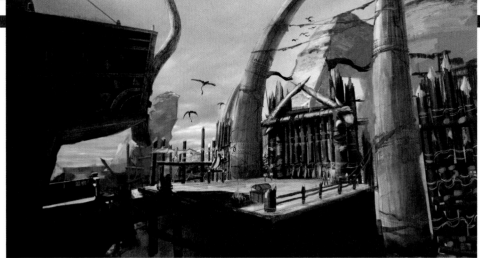

ARENA ENTRANCE: The entrance features a monster-bone-like objet d'art. The lower part of this opened fence is sharpened like a monster's mouth. You can head farther into the Arena using a Wingdrake.

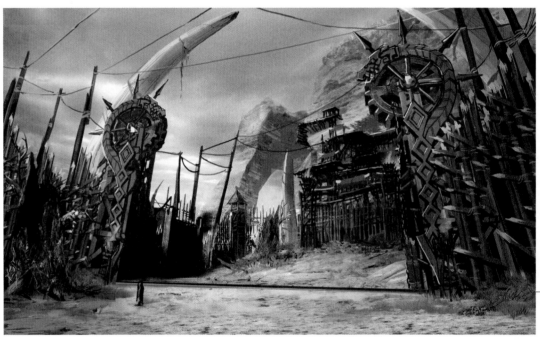

TOPIC | Arena Area Composition

The Arena is an isolated facility on a small island. The field is divided laterally by a fence.

A TESTING GROUND: The main area of the Arena is a sand and rock substrate.

■ **Monster Entrance**

■ **Fence Pulley**

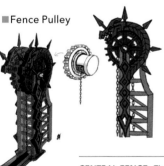

Monster load-in entrance and fence using a pulley. The fence is decorated with a dragon design.

CENTRAL FENCE: The fence at the center can be lowered by a lever to divide the field. It is used when studying multiple monsters.

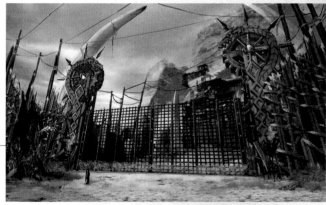

Production Backstory

PRODUCTION NOTES

Why It's on a Small Island

When thinking of where hunters would train and study monsters, we figured an isolated place would be better. Of course, it is used for battle in the game, but we placed it far enough away so that Astera would be just barely visible to add some depth to the environment. Captured monsters would be studied in Astera and then transported to the Arena by ship. (*Fujioka*)

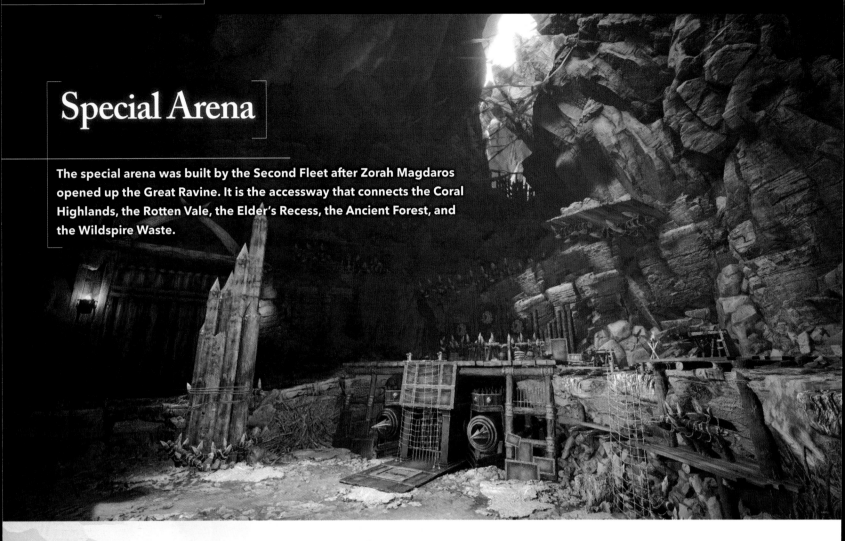

Special Arena

The special arena was built by the Second Fleet after Zorah Magdaros opened up the Great Ravine. It is the accessway that connects the Coral Highlands, the Rotten Vale, the Elder's Recess, the Ancient Forest, and the Wildspire Waste.

The bedrock of the Great Ravine is a natural fortress.

If the Arena was man-made, the Special Arena is a natural fortress using the bedrock of the Great Ravine. This place, discovered by the people of Astera, is a waypoint on the path to the Coral Highlands and is the only land route of the New World that has lasted for decades, if not for several hundred years. It is used by various kinds of creatures. The Special Arena is more of a research facility for captured monsters rather than a battleground. Although it is a pathway, it is possible to detain monsters inside the Arena as well. It is a precarious place. Powerful monsters like Elder Dragons or other flying monsters may attack at any time, even though it is defended by numerous weapons.

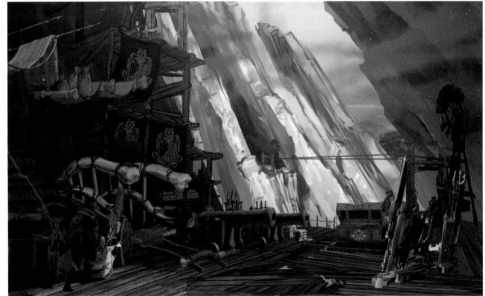

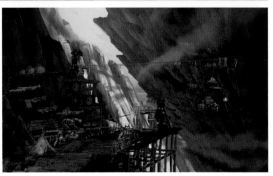

CAMPSITE: A campsite built on a simple scaffold using wood from the Great Ravine. One must take the ropelift through heavy winds to reach the Special Arena.

TOPIC Special Arena Area Composition

The Special Arena was built inside the Great Ravine. It is only accessible by crossing the ravine on a ropelift.

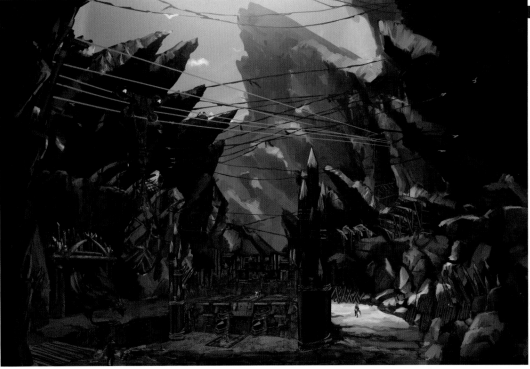

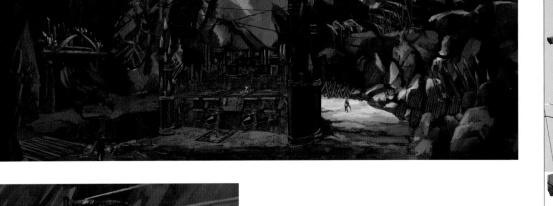

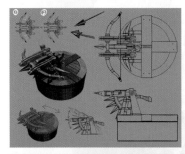

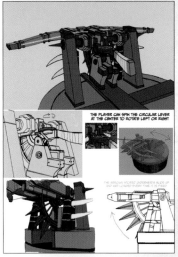

FALLING BOULDER PULLEY TRAP: An anti-monster falling boulder device that is activated using a lever. Designed to drop boulders on monsters below.

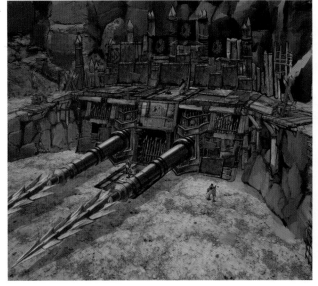

■Ballista

Cannons and ballista are set at elevated positions and can be fired towards the center. Ballista are large, cannon-like bows and are mainly used against monsters.

■Dragonator

A weapon system with giant spinning metal harpoons. Loading it can be time-consuming, but it is highly effective against monsters, and it even forced Zorah Magdaros to change course. It is humanity's hope.

PRODUCTION NOTES
A Place to Research Monsters

When Zorah Magdaros crossed the Great Ravine, it caused tectonic activity. A spot to build the Special Arena was then discovered. Zorah Magdaros caused changes to the area's geography, and subsequently to the movements of creatures. This resulted in a place where all kinds of monsters pass by. Therefore, it can be used to capture research subjects. (*Fujioka*)

At the art stage, it was crawling with monsters. We thought about fishing monsters out one by one early on. (*Tokuda*)

Extended **World Gallery**
Camp Setup Guide

Camps become research stations when visiting the different fields in the New World. Camps are a place to prepare equipment, get some rest, and even have the handlers cook food. While research is important, finding suitable campsites is also an important job of Hunters. This guide details how camps are set up.

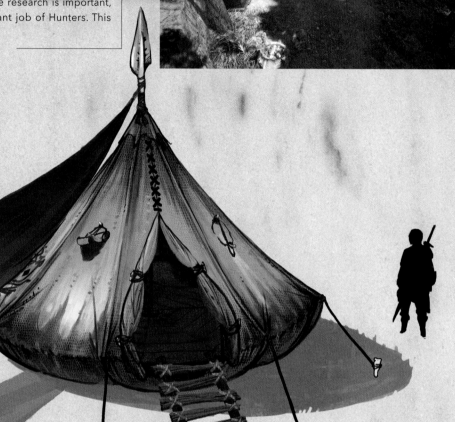

Compact and Comfortable Camp Living

Besides the southwest camp in the Ancient Forest and the eastern camp used by the seekers in the Wildspire Waste, camps are built by the Fifth Fleet as they explore new areas.

The tents used in these camps are simple, but they are very functional. Each tent consists of a single pole with fabric draped conically around it. It is relatively easy to carry as well. There is enough space inside for hunters and Palicoes to comfortably rest. Hunters can maintain their weapons or sharpen their knives while recuperating. Some even feed the Palicoes inside.

There is a cooking area with a small stone oven and a dining area near the tents. Bags for supply boxes and Palico equipment are also present, making it a well-organized area for a temporary research station.

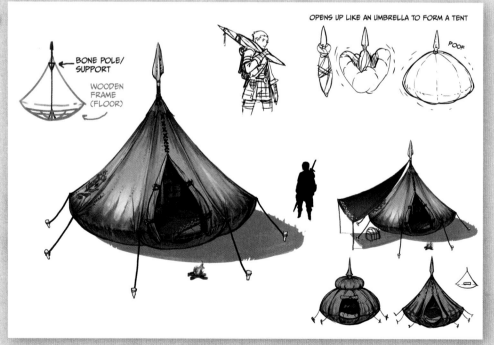

BONE POLE/ SUPPORT

WOODEN FRAME (FLOOR)

OPENS UP LIKE AN UMBRELLA TO FORM A TENT

POOF

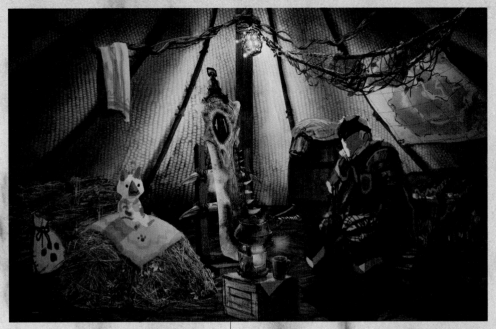

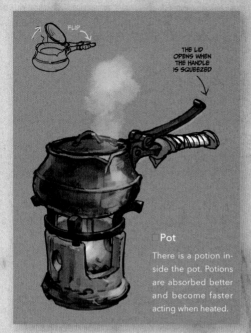

Pot

There is a potion inside the pot. Potions are absorbed better and become faster acting when heated.

THE LID OPENS WHEN THE HANDLE IS SQUEEZED

FLIP

Inside the tent. A hunter sits on a chair built from branches while a Palico takes a break on soft straw. There was a time when Scoutflies were used inside lanterns.

Mealtime. Some handlers not only manage quests, but also cook using stone ovens.

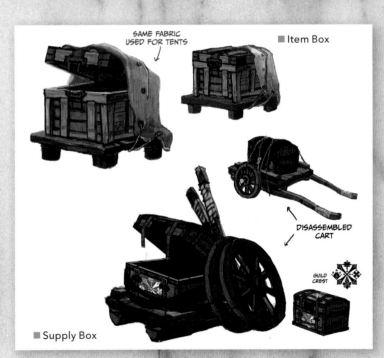

SAME FABRIC USED FOR TENTS

■ Item Box

DISASSEMBLED CART

GUILD CREST

■ Supply Box

The fabric used for tents is the same fabric that covers item boxes in Astera. Carts used to transport supply boxes are disassembled and stored.

■ Palico Bag

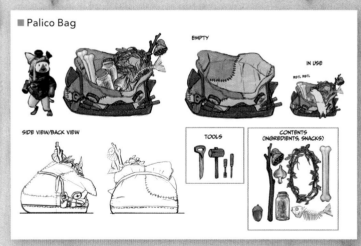

EMPTY

IN USE

SIDE VIEW/BACK VIEW

TOOLS

CONTENTS (INGREDIENTS, SNACKS)

TOPIC

Camp Safety and Convenience

Camps are set up in areas that are difficult for large monsters to reach. They are usually placed in wooded areas or in caves, but campsites near water where fishing is possible are also popular with hunters. Thanks to speedy travel using Wingdrakes, moving between camps has become much easier and thus made research more efficient.

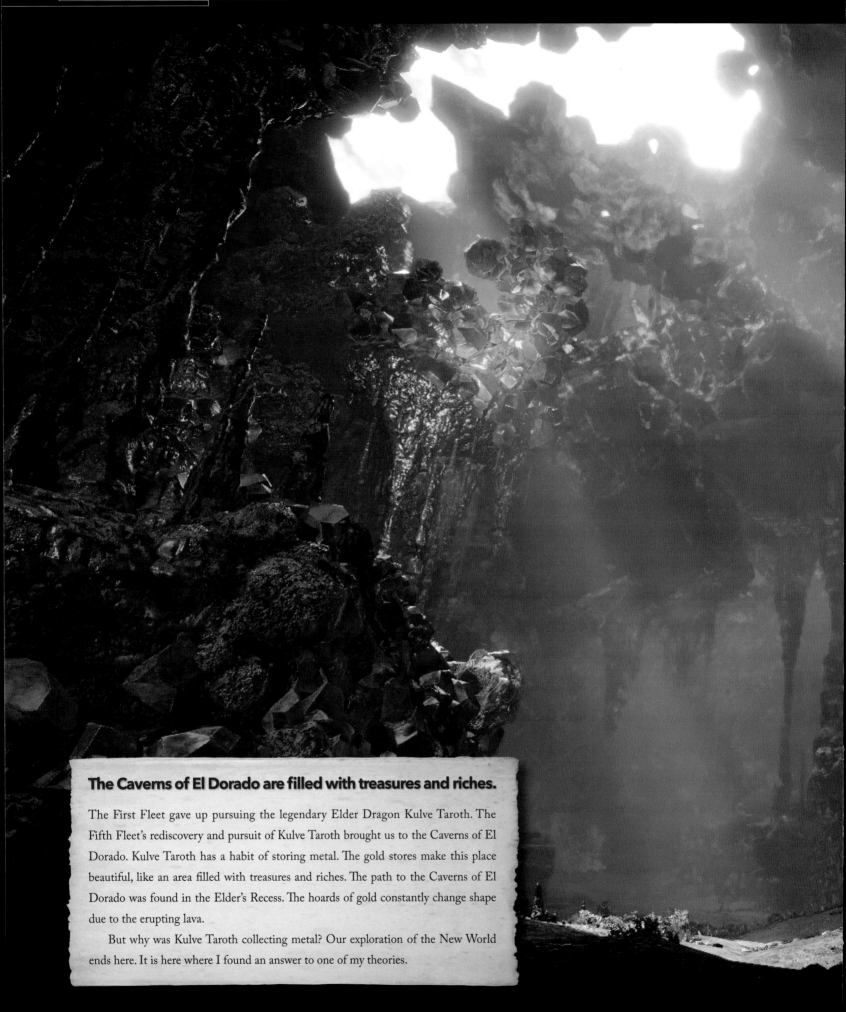

The Caverns of El Dorado are filled with treasures and riches.

The First Fleet gave up pursuing the legendary Elder Dragon Kulve Taroth. The Fifth Fleet's rediscovery and pursuit of Kulve Taroth brought us to the Caverns of El Dorado. Kulve Taroth has a habit of storing metal. The gold stores make this place beautiful, like an area filled with treasures and riches. The path to the Caverns of El Dorado was found in the Elder's Recess. The hoards of gold constantly change shape due to the erupting lava.

But why was Kulve Taroth collecting metal? Our exploration of the New World ends here. It is here where I found an answer to one of my theories.

Caverns of El Dorado

This land was discovered with the reemergence of Kulve Taroth. It's a unique landform that was created by the effects of the Everstream and the metal that Kulve Taroth had been storing for years. A massive geothermal energy source exists where Kulve Taroth is said to live, but it is yet to be found.

It does not seem like Kulve Taroth collects metal and gold as food or nutrients.

It does not seem like Kulve Taroth collects metal and gold as food or nutrients. Indeed, it uses those to coat itself. Some believe it is a kind of protective layer in order to survive in this intensely hot environment, but I do not share their thoughts. I actually believe it is done simply to make itself appear larger and more beautiful.

How did I arrive at this conclusion? Creatures, including the Elder Dragons, in the New World coexist with nature. They are filled with life and do not seem merely fixated on surviving, no matter what the environment is like. They are instead filled with the joy of living the life they have been given.

If the death of Xeno'jiiva unleashed the Everstream and awakened Kulve Taroth, the idea that it covers itself in gold for protection seems unlikely.

UNDERGROUND ROCK CAVERN: Being in this rocky cavern has not given me the impression I'm in El Dorado yet. There is endemic life that is only found here.

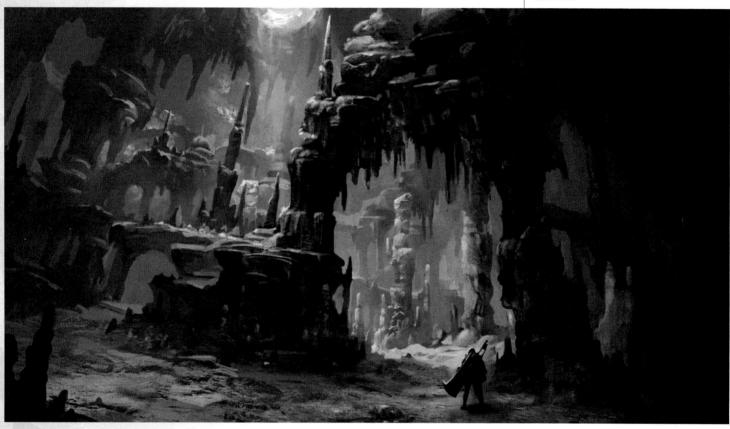

| TOPIC | Shimmering Gold and a Unique Ecosystem |

The Everstream helps life prosper and diversify. It helps the environment evolve as a whole. Kulve Taroth covering itself with gold proves it too is evolving. The endemic life must be on a path of evolution as well.

There are many rare endemic life-forms here, and many of them cover themselves in gold. Perhaps there is a mimetic purpose to it as well.

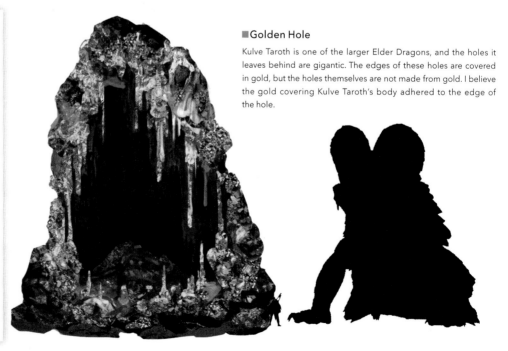

■Golden Hole

Kulve Taroth is one of the larger Elder Dragons, and the holes it leaves behind are gigantic. The edges of these holes are covered in gold, but the holes themselves are not made from gold. I believe the gold covering Kulve Taroth's body adhered to the edge of the hole.

TOPIC Caverns of El Dorado Area Composition

Approach the Caverns of El Dorado from the rocky area at the surface. The lowest level is Kulve Taroth's nest, where hot lava erupts.

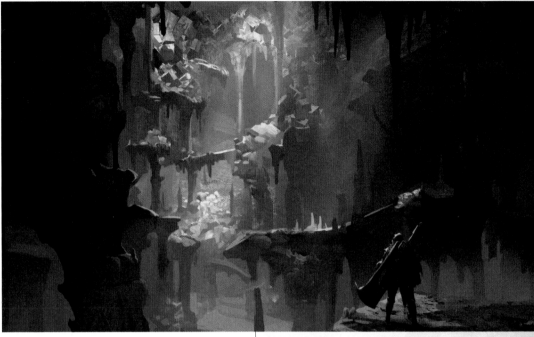

GOLDEN SHRINE: The sunlight reflecting off the giant gold rocks gives the cavern a golden hue. The tall golden pillars give the illusion that you have wandered into the castle of a god.

STONE PILLARS OF THE GOLDEN SHRINE: The interior of the cavern and its high ceiling are marked by stone pillars. The surfaces of the stone pillars are plated with gold collected by Kulve Taroth.

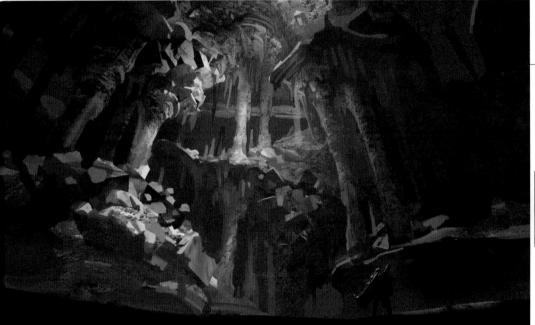

Production Backstory

PRODUCTION NOTES
Caverns of El Dorado's
Game Design

You can travel deeper into the Caverns by battling Kulve Taroth. The better you perform, the further you can advance. The field was designed to allow players to do all kinds of things and enjoy it multiple times. The lower you go, the closer you get to the Everstream, and the hotter it gets. Since it is a new field, we wanted to create a unique ecosystem, so we created endemic life specific to this field. (*Tokuda*)

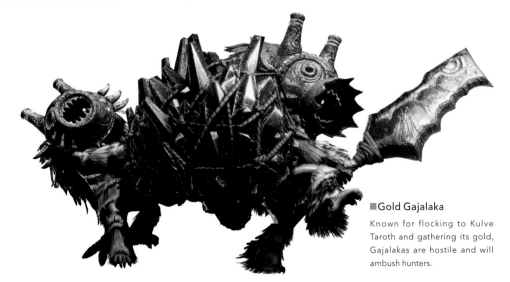

■Gold Gajalaka

Known for flocking to Kulve Taroth and gathering its gold, Gajalakas are hostile and will ambush hunters.

SCORCHING HOT: This scorching underground area is where Kulve Taroth lives. The flames reflect off the gold, creating the illusion of a shimmering red-brown temple. The air is so hot that it's overwhelming.

The New World is a beautiful yet perfectly efficient environment like El Dorado.

Having arrived at the Caverns of El Dorado, I would like to present a conclusion for my new theory. As a handler, I have traveled and recorded my journey through the New World with hunters in search of possibilities for humanity. I conclude that the New World supports the growth and evolution of nature with the Everstream. In addition, the creatures most adept at utilizing the power of the Everstream are undoubtedly the Elder Dragons, while we humans are the most ill-equipped to do so. But humans have knowledge and wisdom.

As I have mentioned before, I seem to have a particular attachment to the Everstream, and even to the New World itself. The Sapphire Star that guides us has the power to attract and recognize all of the creatures in the New World. It is a will, an energy. I believe we were guided here by its light.

Do you recall me comparing the Ancient Forest to a tower? Looking back at it now, that idea may not be so outlandish. Perhaps the Elder Dragons and other creatures have grown envious of modern conveniences created by human

ingenuity. That feeling became the will of the New World, turning the Ancient Forest, the Wildspire Waste, the Coral Highlands, the Elder's Recess, and the Caverns of El Dorado into a beautiful yet perfectly efficient environment. Laugh if you want. This is still an unknown world wrapped in many mysteries. Anyway, my colleagues are calling for me.

I will put down my pen for now. Our journey will continue.

■Gold Mountain

This area contains rocks covered in gold melted by Kulve Taroth, as well as mountains made of pure gold. This vast amount of gold may play a role in the birth of new endemic species.

EVER-CHANGING AREA OF FLAMES: The stone pillars that were originally black have been coated in gold and constantly change shape due to the heat emitted from Kulve Taroth. Are the flames and heat here created by volcanoes or...?

190

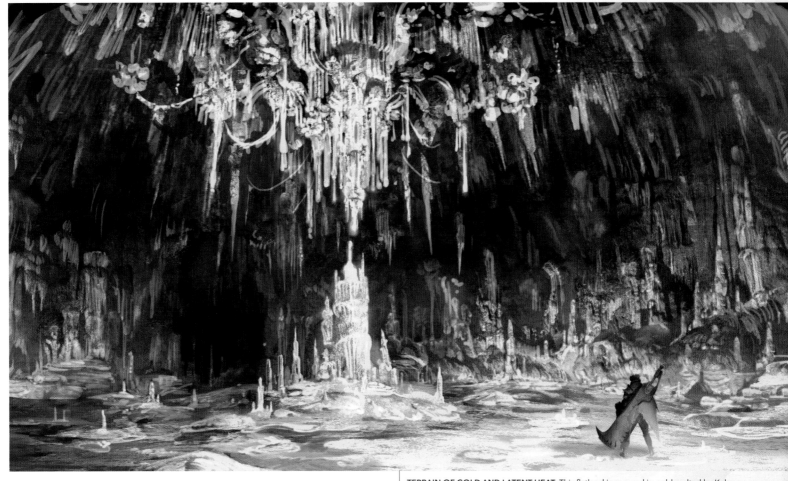

TERRAIN OF GOLD AND LATENT HEAT: This flatland is covered in gold melted by Kulve Taroth's heat. The ceiling is adorned with gold reminiscent of palace decorations.

DECADENT CEILING: A place where Kulve Taroth removes its gold armor and exercises all of its power. This is most likely a gold vault, a sanctuary for Kulve Taroth.

■ Kulve Taroth's Power

Kulve Taroth creates large holes as it moves about the area. You can see the power of the monster by comparing the size of a person to the monster.

**Production
Backstory**

PRODUCTION NOTES
Location of the Caverns of El Dorado

We cannot pinpoint its location. Kulve Taroth doesn't exist because the Caverns of El Dorado exist. It is more like the Caverns of El Dorado exist because of the presence of Kulve Taroth. If Kulve Taroth were to leave, the area would dry up, and it would no longer be the Caverns of El Dorado. Also, there may be several Kulve Taroths. Therefore, if a Kulve Taroth finds a spot matching its size, that spot will then become the Caverns of El Dorado. There may be a more magnificent Caverns of El Dorado somewhere in the New World. (*Fujioka*)

The first time the First Fleet witnessed Kulve Taroth was through a crack in the Wildspire Waste. The crack is very long, so they could not specify the exact location of the Caverns of El Dorado. The Caverns of El Dorado discovered by the Fifth Fleet was deep inside a crack found in the Elder's Recess. So perhaps the Kulve Taroth witnessed by the First and Fifth Fleets were different. (*Tokuda*)

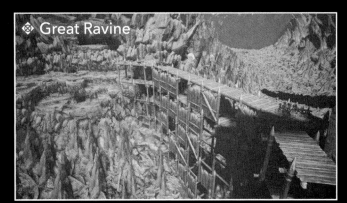

Great Ravine

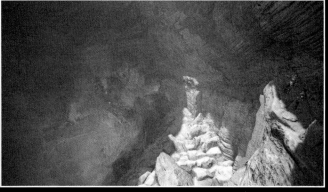

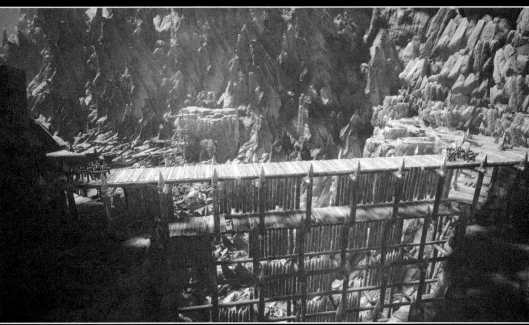

Landscape Beauty
-Others-

The expressions of nature in the New World are glimpses that eloquently express both the generosity and harshness of nature. Meanwhile, the Everstream is greatly influencing the ecosystem. Humans have only set foot in a small corner of the New World. It will take years to establish a solid foundation and live together with nature.

Everstream

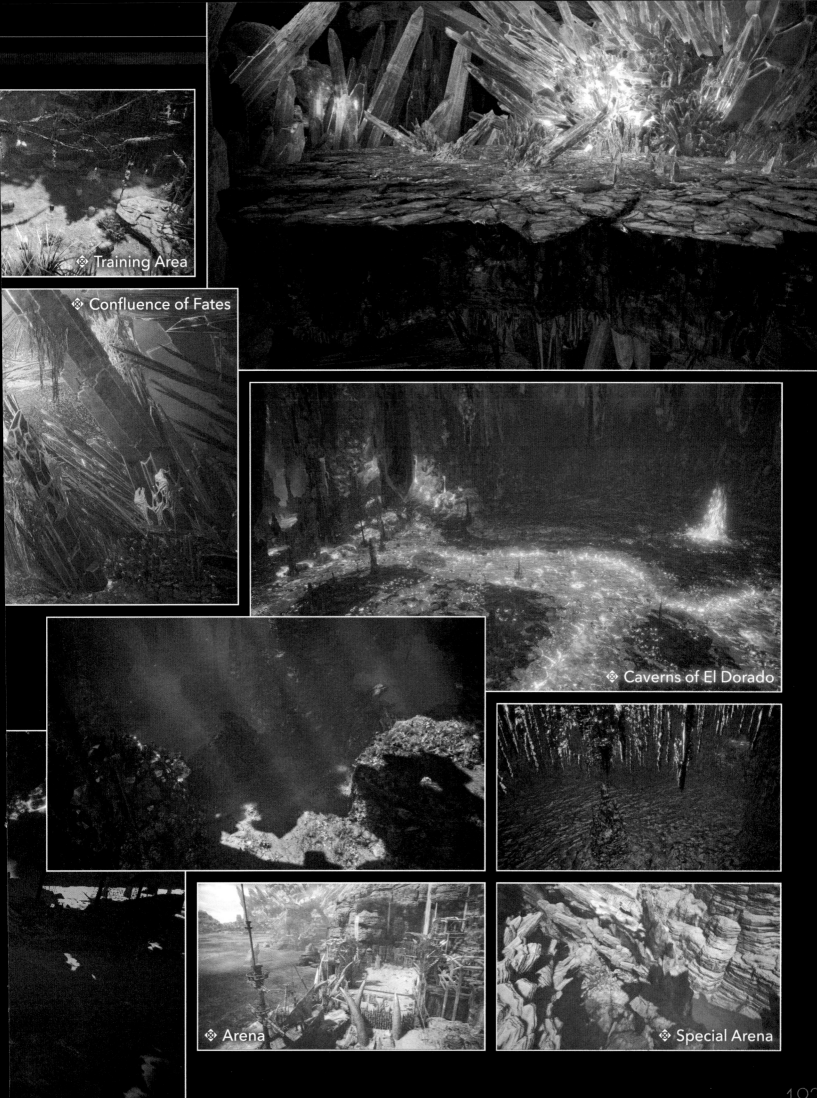

◈ Training Area

◈ Confluence of Fates

◈ Caverns of El Dorado

◈ Arena

◈ Special Arena

193

IVY TRAP: Ivy effective for trapping large monsters. Used by chopping off hanging ivy or chopping down the tree itself.

Extend **World Gallery**
Surviving in the Natural Environment of the New World

ENVIRONMENT TRAPS

Many natural traps can be found in the New World. Hiding behind a fallen tree when being chased by a monster, using ivy or rocks to attack monsters, or using quicksand to dramatically alter the landscape are all viable survival strategies. Most of them can be used to hunt monsters with some creativity. Here, I would like to discuss some of the more prominent natural traps.

"Use everything you can. Observe your surroundings. Use your imagination. Use not only your body, but your head. That is the hunter in the New World."

With the Commander's words in mind, the ecosystem of the New World has not yet completely revealed itself... I hope you can unravel all of its hidden truths.

DAM: A flash flood that swallows monsters occurs when the section holding the water back is destroyed.

QUICKSAND: The ground collapses and forms quicksand when the Diablos just beneath it is agitated. Falling through it will send you to the lower level.

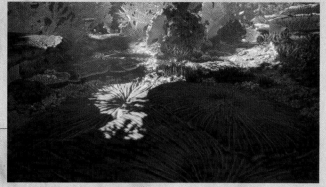

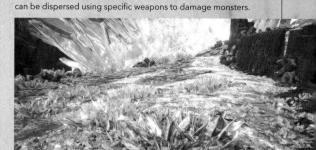

ELDER'S RECESS CRYSTALS: The fine pieces of crystal on the ground can be dispersed using specific weapons to damage monsters.

SOFT CORAL: This coral bends when struck hard enough and can be used to capture large monsters by making them trip.

UPDRAFT: A strong updraft unique to the Coral Highlands. You can fly upward by using a Glider Mantle.

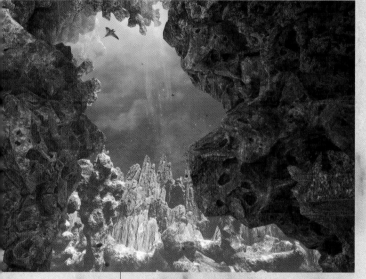

LAVA SPOUT: Lava periodically erupts from the cracks. It not only damages monsters but can blow hunters away as well.

FALLING BOULDERS: Damage monsters by dropping hanging stalactites or crystals on them. There are also bones that pierce the ground and become obstacles.

TOPIC

Gaining Cooperation of the Inhabitants Is Also Environmental Cooperation

If you establish a relationship with the indigenous Lynians like the Grimalkynes and Gajalakas, they may help you when you're trying to ride a large monster. Capturing monsters with ivy traps and shelling them with Meowlotov Cocktails are a form of environmental cooperation as well.

The Grimalkyne method of capturing large monsters using ivy can restrain them for a long time. You can see their desperation.

MURALS

Extended World Gallery
Interpreting First Wvyerian Murals

Monsters and humans appear alike to the eyes of the First Wyverians living in nature. The mysterious murals found across the New World were discovered to be depictions of what they observed. These are murals that have been translated thanks to a particular First Wyverian.

Round furry ones flying on the wind.

[Glossary]

Human = hunter, Ferocious one = Anjanath, Red one = Rathalos, Green one = Rathian, Cat = Grimalkyne, Bird-like one = Kulu-Ya-Ku, Big volcano-like one = Zorah Magdaros, White one = Legiana, Round furry one = Paolumu, Meteor = ominous thing, Useful thing = item, Strong one = Nergigante, Bringer of storm = Kushala Daora, Handprint = Self-assertion, nice, oh really?, etc.

Humans hunting ferocious one. Red one flying far away.

Saw human trying to steal bird-like one's eggs. Drew sandy plain. Good view. Big spiky wall in back.

Saw lots of meteor from cat's nest.

Human and strong one fighting.

Nest of red one and green one on top of Ancient Forest.

Big volcano-like one came from ocean. Spiky ravine formed after it flew by.

Meteor seen from high up.

Feeling of space.

Cat's nest on top of Ancient Forest. They grilling big fish.

Night with big red moon above spiky ravine. Saw boat stuck.

Place with lots of cats. Useful things here.

Saw bringer of storm high up in the Elder's Recess.

Bird-like ones carrying eggs. Chased by humans and lost their eggs.

White one on top of coral. Strong wind blows when that one comes.

Camp. Humans cooking. Fish are useful. one comes.

Handprints

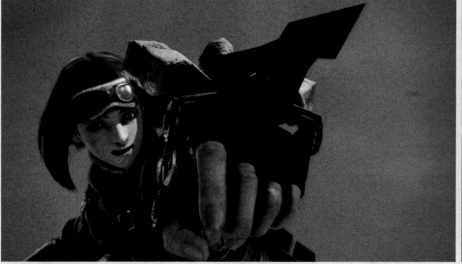

Possibilities of the New World Expanded by the Slinger

Slingers are standard equipment for hunters in the New World. It is a small bowgun mounted to the left forearm of the hunter's armor. By manipulating the grip, hunters can fire special tools or ropes. This invention greatly expanded the scope of research in the New World.

❖ ❖ ❖

❖ Traveling Long Distances by Grappling Wingdrakes

One of the basic functions of the Slinger is to fire a rope. By taming Wingdrakes, known as Mernos in Astera, and grappling them with a hook attached to the end of the rope fired by a Slinger, fast travel, a form of long-distance travel between fields and camps, became possible. The significance of this is immeasurable. The length of the rope is approximately five meters. Besides hanging from Wingdrakes, the Slinger has many other uses, such as hooking on to vines to climb walls or remounting monsters after

being flung off. It can be used to prevent falls from high areas by hooking on to tree branches, but that is dependent on the experience level of the user.

❖ Moving with Ropes Using Wedge Beetles

This rope can be used on an endemic species of the New World called the Wedge Beetle to easily reach distant footholds and high areas. It is possible to hang from Wedge Beetles and swing like a pendulum as well. There are many mysteries to the Wedge Beetles, but we believe they exist across the New World. Ascertaining their locations will be of great help in our research.

❖ Capturing Endemic Life Using Capture Nets

While the Slingers have proven useful as a method of movement, the Capture Net that was developed as a standard feature of the Slinger has been receiving high praise from researchers. As its name suggests, it is not intended to be a weapon. However, some have found creative uses for it, such as preventing the dispersal of Neopterons when hunting or detonating large barrel bombs to send a shock wave through endemic life. Its usefulness is widely known.

❖ Making Use of Tools and Indigenous Objects

In addition to the Capture Net, the Slinger can be loaded with Flash Pods, Throwing Knives, or various objects that can be found in the field and used as projectiles. Up until now, these objects were used as thrown

tools. However, the introduction of the Slinger allowed everybody to fire objects with high accuracy. Natural objects in the field that can be fired by the Slinger vary greatly, ranging from rocks to Slinger Torches and even the Piercing Pods and Dragon Pods that monsters drop. Their effects have been useful in research and hunting, and as such, they are employed by many hunters.

◆ ◆ ◆

The scenes depicted in the murals of the First Wyverians are a direct result of this invention. It is an essential item in our continued research of the New World.

Objects That Can Be Fired by the Slinger and Their Effects

Besides inflicting damage from a distance, Slinger ammunition can have a wide range of effects. Below is a partial list.

■ Scatternut/Crystalburst

Besides driving away small monsters, it can knock out large monsters, make them drop the rocks they are holding, or trip rolling monsters. It can also reduce or negate an Elder Dragon's special state.

■ Brightmoss

Illuminates dark areas and can knock out a flying monster by firing it multiple times at its head. Can be used to attract Neopterons or drive away small monsters that have an aversion to light.

■ Slinger Puddle Pod

Contains Watermoss and can cleanse monsters that cover themselves in mud and reduce the effects of burning or charged states. It can also free a hunter from a muddy state.

■ Slinger Torch Pod

Contains Torch Pods and can attract Neopterons or drive away monsters with an aversion to fire. It harms monsters with low fire resistance and softens areas hardened by lava.

■ Slinger Dragon Pod

Contains Dragon Pods and reduces or negates an Elder Dragon's special state.

CHAPTER 3
Monsters and Endemic Life

Humans, Lynians, endemic life, and of course, monsters. Of the multitudinous creatures living in this world, it is believed that the majority of them coexist as small parts of a much greater ecosystem. This chapter serves as a compilation of our successful ecological research concerning the monsters that may pose a threat to other races as well as the endemic life that is so deeply rooted in the ecological environment. This chapter also includes behind-the-scenes production commentary from Executive Art Director, Kaname Fujioka, and Director Yuya Tokuda.

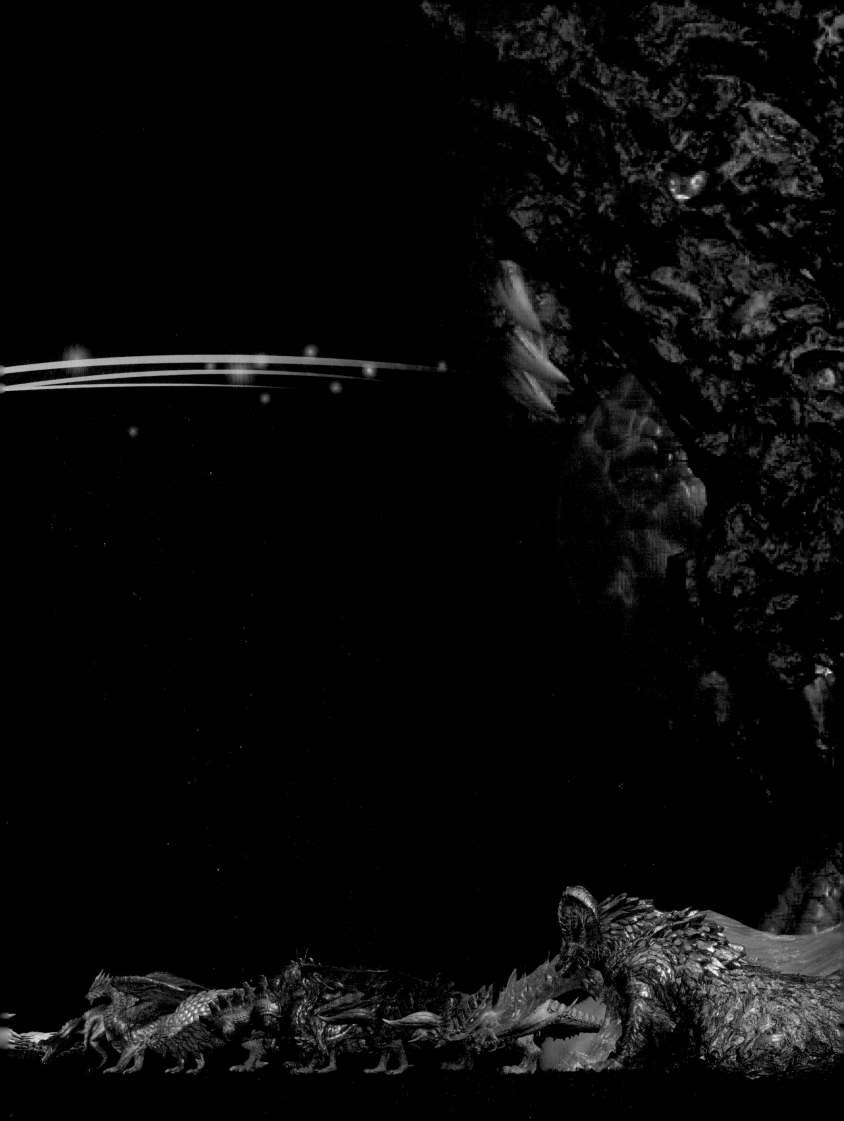

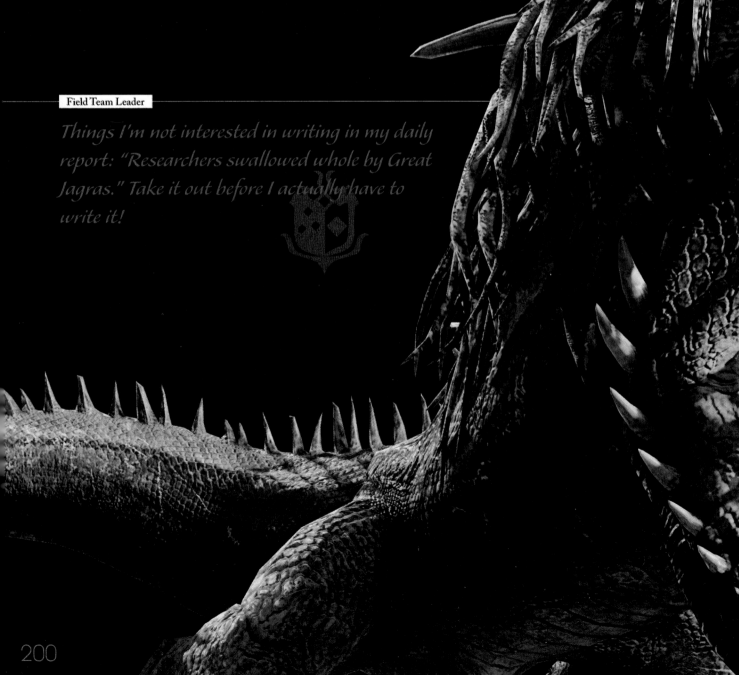

Fanged Wyvern

GREAT JAGRAS

AKA ▶ The Great Glutton

MONSTER DATA

- ▶ Full length: approx. 1109.66 cm
- ▶ Full height: approx. 373.28 cm
- ▶ Foot size: approx. 153 cm
- ▶ Known habitat: Ancient Forest

INTRODUCTION

Leader of the Jagras, this Fanged Wyvern resides in the Ancient Forest. This is a male Jagras that left its pack and survived to adulthood by displaying a voracious appetite, which it satiates by preying on Aptonoths and herbivorous wyverns, swallowing them whole. When hungry it has been spotted baring its fangs at opponents far above its own level; it has even been reported that a Great Jagras gave chase to a researcher who carelessly approached him. The Great Jagras's bottomless hunger is believed to be comparable to that of much larger monsters. It possesses a remarkably flexible stomach, which it weaponizes after swallowing its prey whole. Great Jagras has shown a certain degree of cleverness in using its expanded stomach for bombarding foes and has even been known to regurgitate the half-digested contents of its stomach or stomach acid and projecting it at threats.

Field Team Leader

Things I'm not interested in writing in my daily report: "Researchers swallowed whole by Great Jagras." Take it out before I actually have to write it!

200

Sightings of the Great Jagras have been reported from multiple locations around the Ancient Forest as he searches for prey in many different areas.

ECOLOGY

■ Taking Advantage of Stomach Acid

A Great Jagras's stomach secretes acid in large quantities, which is what allows him to consume his prey whole. Unfortunately, the acid is so powerful that it can break down the wall of his stomach. This is why a Great Jagras with an empty stomach is certain to be found skulking around the Ancient Forest searching for prey to gobble up.

GREAT JAGRAS

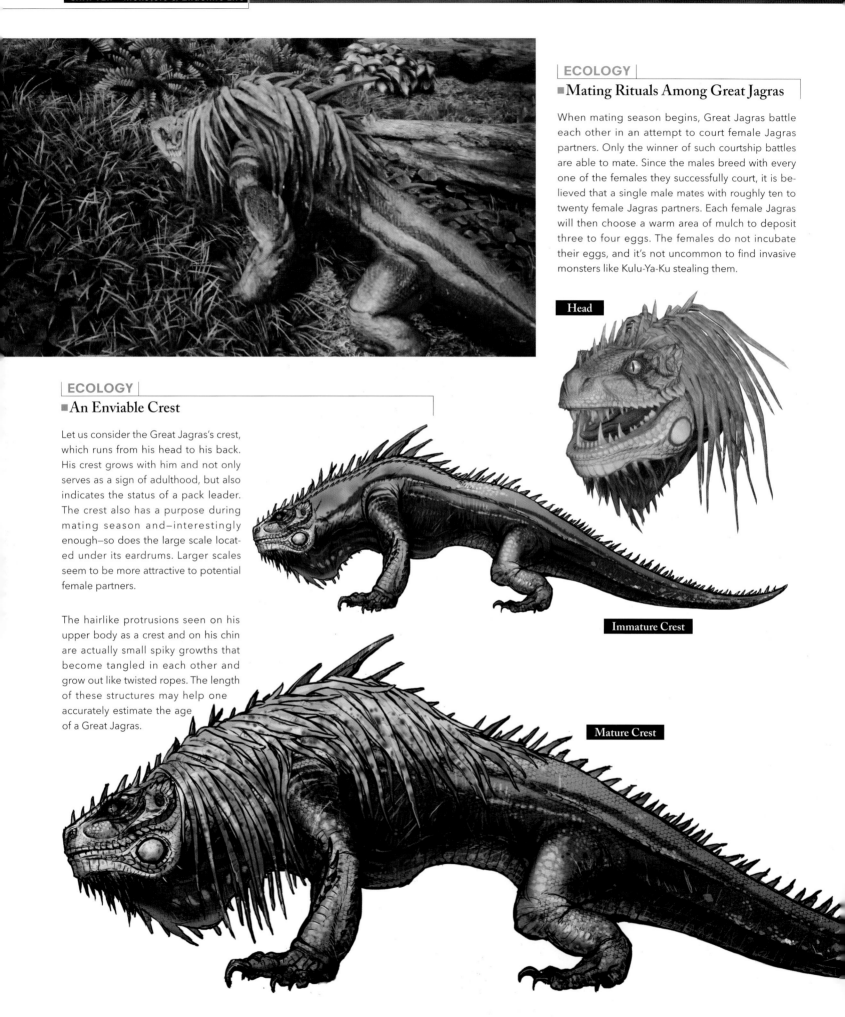

■Mating Rituals Among Great Jagras

When mating season begins, Great Jagras battle each other in an attempt to court female Jagras partners. Only the winner of such courtship battles are able to mate. Since the males breed with every one of the females they successfully court, it is believed that a single male mates with roughly ten to twenty female Jagras partners. Each female Jagras will then choose a warm area of mulch to deposit three to four eggs. The females do not incubate their eggs, and it's not uncommon to find invasive monsters like Kulu-Ya-Ku stealing them.

Head

ECOLOGY

■An Enviable Crest

Let us consider the Great Jagras's crest, which runs from his head to his back. His crest grows with him and not only serves as a sign of adulthood, but also indicates the status of a pack leader. The crest also has a purpose during mating season and—interestingly enough—so does the large scale located under its eardrums. Larger scales seem to be more attractive to potential female partners.

The hairlike protrusions seen on his upper body as a crest and on his chin are actually small spiky growths that become tangled in each other and grow out like twisted ropes. The length of these structures may help one accurately estimate the age of a Great Jagras.

Immature Crest

Mature Crest

| ECOLOGY |

■ Great Jagras Pack Dynamics

The Jagras tend to run in packs that include male and female members. However, males that have matured leave their pack and begin a solitary life. Individuals that survive this experience to maturity become Great Jagras and return to their region of origin, where they battle the leader of the local Jagras pack for dominance in an attempt to create a new generation of leadership.

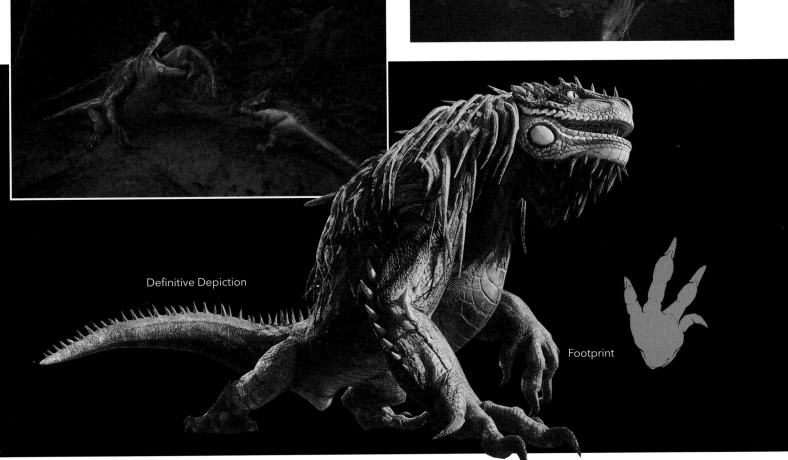

Definitive Depiction

Footprint

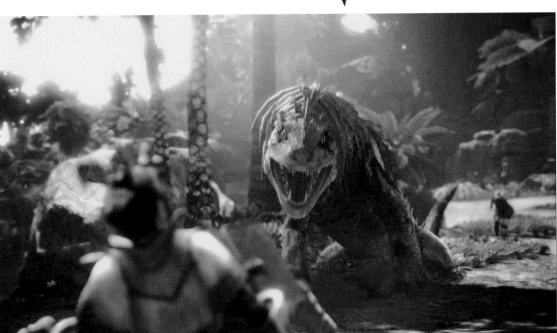

◾ A Strong Stomach for Violence

A Great Jagras's stomach may indeed be this monster's most defining characteristic. Remarkably flexible, it is capable of containing an entire Aptonoth swallowed whole. Nothing but the utmost caution should be exercised in the presence of a Great Jagras whose stomach has swollen to a "full" state after consuming his prey. He will not usually go out of his way to interact with invasive foes while in this state, but should he be drawn into conflict, he will brazenly attack with his massive stomach. Make no mistake; while his movements may be slower, he is still formidable. On the other hand, his expanded stomach is considerably softer than usual and a strong attack to it may cause him to regurgitate its contents.

Great Jagras are known to overwhelm prey with their front legs or crush it before displaying their uncanny ability to swallow prey whole.

◾ The Benefits of Regurgitation

By secreting large amounts of stomach acid, the Great Jagras aims to digest its prey as fast as possible. A unique trait of the Great Jagras is that he does not digest his prey to completion and often regurgitates the partially digested contents of his stomach. Rather than fully digesting a single source of prey, the most effective way for the Great Jagras to maximize nutritional absorption is to continually ingest and partially digest new prey. This trait is helpful to Jagras packs that are able to regularly feed on the remnants of the Great Jagras's partially digested meal, which incidentally factors in to expanding their habitat.

Analysis

◾ On Jagras's Symbiosis with Great Jagras

The Great Jagras does not always move with its Jagras pack, while the Jagras are known to leave dealing with intruders largely to their Great Jagras leader. The proof of this loyalty to their leader may be witnessed when their Great Jagras becomes enraged or finds its life in danger. One reason for this relationship may be rooted in preserving their shared eating habits. Jagras mainly prey on Shepherd Hares and other small animals, but they prefer the partially digested material regurgitated by Great Jagras, which is significantly higher in nutritional value. This behavior is believed to be one of the pillars upon which their symbiotic relationship rests. Interestingly enough, there have also been reports of Great Jagras preying on Jagras, which is why Jagras may occasionally be found in treetops, fleeing from a hungry Great Jagras. (*Excerpt from a biologist's paper*)

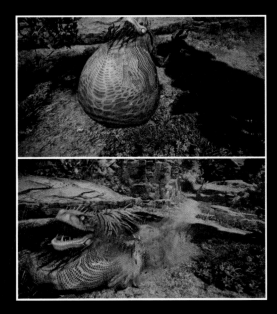

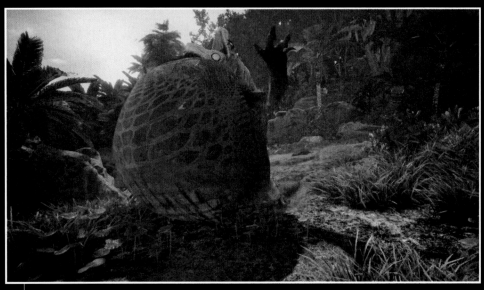

ECOLOGY

■In an Acidic Relationship

A Great Jagras's strongest weapon is indeed his fully expanded stomach. When his stomach is full, the Great Jagras frequently utilizes his impressive physique to overwhelm foes by crushing them. Although his agility decreases, his increased repertoire of attacks, along with his imposing size, means he's still a threat.

However, once the entire contents of his stomach are fully digested, the Great Jagras becomes fatigued easily and will scurry off in search of another small monster to prey on. The Great Jagras's hunger is at the foundation of his behavior.

Here the Great Jagras attacks with his distended stomach. While he is skillful with frontal clawing or biting attacks, he's somewhat sluggish when responding to assaults on his flanks.

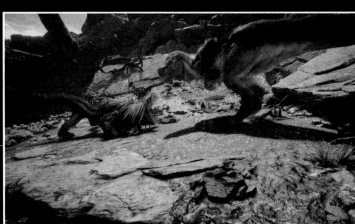

When hungry, the Great Jagras is known to grow even more feral and will unabashedly attack monsters above his own rank. This is but one of the reasons he bears the nickname "The Great Glutton."

Skeletal View

PRODUCTION NOTES

A Monster Stuffed with Content

Up until this point, the first monsters players have encountered have been mid-sized ones, and even though they were the player's very first battle, the monsters could be a little difficult to land hits on. That's why we made a monster that increases its size. We believe this not only makes it easier to play but also helps pull the player into the environment. We developed him with the intention of giving players a deep experience. (*Tokuda*)

From a level-design standpoint, mid-sized monsters teach players gameplay mechanics before they move on to larger monsters. Players typically progress from something like a Girros to a Great Girros, which is why we always create those small-sized monsters, but…Great Jagras blows by even mid-sized monsters and is closer to the large monsters when it comes to how much effort we put into him. [laughs] His physique changes, the Jagras gather around him when he vomits—I mean, there's just so much content dedicated to him. He's one of the first monsters we created for this game, and by bringing all of that content together, from his ecological behavior, to his movement, to even the detail on his textures, we used him as a litmus test to answer the question, "How far can we take Monster Hunter World?" (*Fujioka*)

KULU-YA-KU

ECOLOGY
■ The Importance of Eggs to Kulu-Ya-Ku

Kulu-Ya-Ku's main food sources are the eggs of flying and herbivorous wyverns, though it doesn't seem to show a preference toward species. After pilfering a nest, it will return to its own abode and devour the egg. This protective behavior reduces its chances of being spotted by any foes. On average a Kulu-Ya-Ku consumes the highly nutritious yolk of three to four eggs every day.

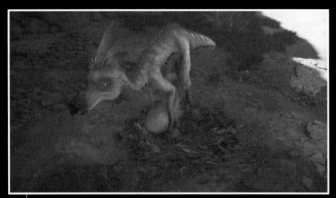

While the parent or parents are away, Kulu-Ya-Ku sneaks into the nest and skillfully digs up a buried egg that it then steals. It is highly efficient at this process, which takes less than a minute from start to finish.

ECOLOGY
■ A Wide-Ranging Monster

Kulu-Ya-Ku avoid repeatedly targeting a single nest. This is why you can easily spot them traversing the Wildspire Waste's swamps and forests, and almost everywhere in between. Outside of eating and sleeping, the Kulu-Ya-Ku spends most of its time surveying nests, staying hydrated by drinking water several times a day, and frequently grooming the decorative feathers on its arms, which also aid in marking territory.

Kulu-Ya-Ku's legs are well-adapted to the rocky ground of its wasteland habitat and boasts the ability to bound over and through precipitous cliffs.

ECOLOGY
■ Natural Protections

Kulu-Ya-Ku is a cautious monster and is not known to go out of its way to attack others. However, if it feels that it is in danger, Kulu-Ya-Ku will attempt to dig up a boulder for use in battle. The boulder serves not only as a melee or projectile weapon, it also shields the Kulu-Ya-Ku's sensitive head and beak from enemy attacks. Once holding a boulder, the normally reticent Kulu-Ya-Ku may become emboldened and has been known to attack monsters stronger than itself, such as the mighty Diablos. Its well-developed forelimbs are unusually powerful, with one account describing a Kulu-Ya-Ku lifting a boulder weighing as much as 300 kg. It may surprise you that there are researchers whose entire field of study is dedicated to studying the pectoral muscles of the Kulu-Ya-Ku.

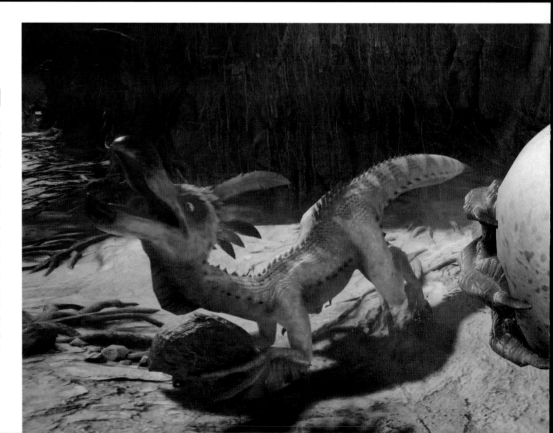

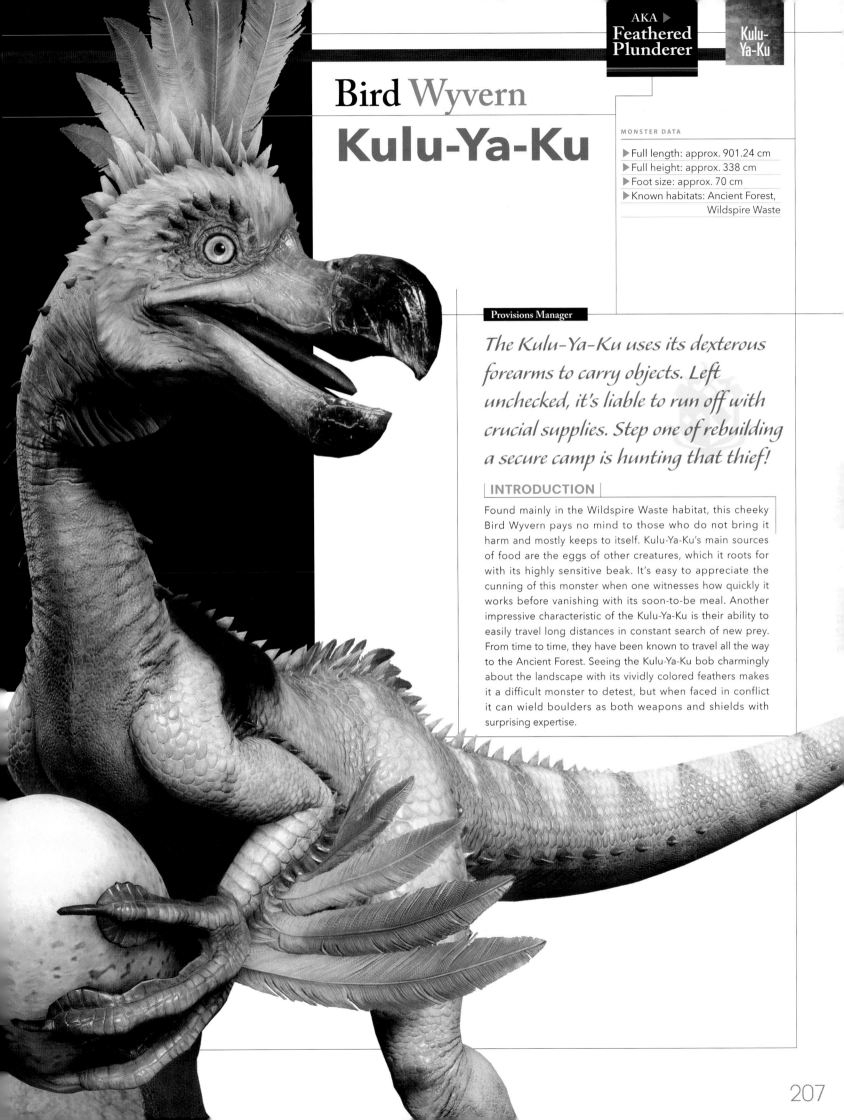

Bird Wyvern
Kulu-Ya-Ku

MONSTER DATA

▶ Full length: approx. 901.24 cm
▶ Full height: approx. 338 cm
▶ Foot size: approx. 70 cm
▶ Known habitats: Ancient Forest,
 Wildspire Waste

Provisions Manager

The Kulu-Ya-Ku uses its dexterous forearms to carry objects. Left unchecked, it's liable to run off with crucial supplies. Step one of rebuilding a secure camp is hunting that thief!

INTRODUCTION

Found mainly in the Wildspire Waste habitat, this cheeky Bird Wyvern pays no mind to those who do not bring it harm and mostly keeps to itself. Kulu-Ya-Ku's main sources of food are the eggs of other creatures, which it roots for with its highly sensitive beak. It's easy to appreciate the cunning of this monster when one witnesses how quickly it works before vanishing with its soon-to-be meal. Another impressive characteristic of the Kulu-Ya-Ku is their ability to easily travel long distances in constant search of new prey. From time to time, they have been known to travel all the way to the Ancient Forest. Seeing the Kulu-Ya-Ku bob charmingly about the landscape with its vividly colored feathers makes it a difficult monster to detest, but when faced in conflict it can wield boulders as both weapons and shields with surprising expertise.

The Kulu-Ya-Ku gained the nickname "Scratching Bird" from the way it claws at the ground to dig for objects.

ECOLOGY

A Versatile Claw

Kulu-Ya-Ku's forelimbs end in three digits, with the middle digit considerably longer than the outer digits, making its clawed hands perfect for grasping round objects. Furthermore, the "fingertips" of these digits are quite wide and are covered in lines of countless subcutaneous bumps. These bumps serve as natural grips for whatever object the Kulu-Ya-Ku holds in its grasp, be it a slippery egg or a rigid boulder. Aside from being one means of attacking an invasive foe, the Kulu-Ya-Ku's sharp claws also aid in digging up eggs or boulders.

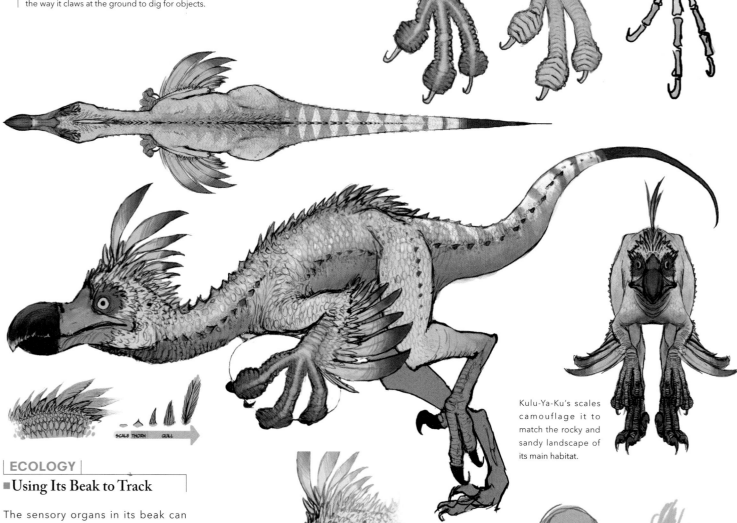

Outer View

Inner View

Skeletal View

SCALE THORN QUILL

Kulu-Ya-Ku's scales camouflage it to match the rocky and sandy landscape of its main habitat.

ECOLOGY

Using Its Beak to Track

The sensory organs in its beak can detect minute changes in whatever its beak touches. This is how it easily roots out buried eggs or boulders. When a Kulu-Ya-Ku beak is unintentionally struck, its reflexive response is to drop whatever it might be carrying. For this reason, immature Kulu-Ya-Ku will situate their stolen eggs on the ground and smash them open with rocks so that the egg white trickles out, leaving behind the yolk. This is one proposed explanation for why even mature Kulu-Ya-Ku only consume the yolks of the eggs they pilfer.

Kulu-Ya-Ku's tongue is covered with barb-like structures that prevent a slippery egg yolk from sliding out of its mouth.

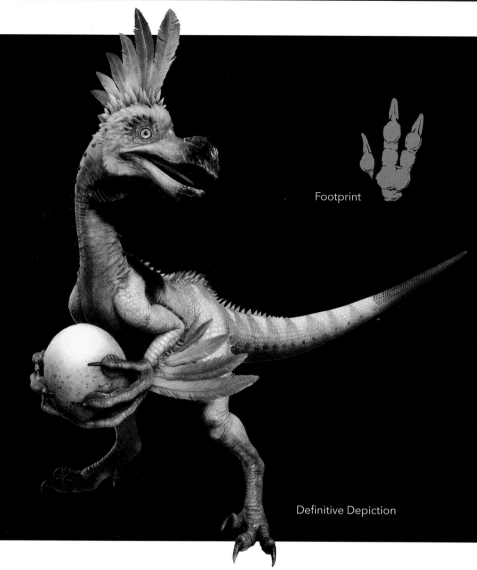

Footprint

Definitive Depiction

ECOLOGY
■ The Influence of Plumage During Mating

A Kulu-Ya-Ku may be camouflaged by its scales, but note the feathers growing on its head and forelimb. These large and vividly colored feathers are a key ingredient in helping males attract females. They're also useful in marking a Kulu-Ya-Ku's territory, as it sloughs them off throughout the regions it frequents. There are also circles of thought that contend these decorative feathers are the remains of ancient wings that the Kulu-Ya-Ku lost through evolution.

ECOLOGY
■ Brooding Their Colorful Eggs

During mating season, females will lay two eggs per pairing. The male and female each take one egg to parent. This practice reduces the chances of their eggs being targeted by natural enemies or competing Kulu-Ya-Ku. What's more, to prevent a Kulu-Ya-Ku from mistakenly preying on its own egg, Kulu-Ya-Ku eggs boast an exceptionally unique coloring compared to other eggs. While brooding their eggs, some Kulu-Ya-Ku may simply fast until their egg hatches. However, albeit rarely, some Kulu-Ya-Ku have been known to succumb to their hunger during fasting and consume the contents of their own egg.

Analysis
■ Impacts of the Elder Crossing on Behavioral Territory

Kulu-Ya-Ku's main habitat is the Wildspire Waste, which allows them to frequently prey on Aptonoth eggs as well as those of herbivorous and flying wyverns. Occasionally Kulu-Ya-Ku may be spotted in the Ancient Forest. There are various opinions on this topic, but Kulu-Ya-Ku's appearance in the Ancient Forest has often coincided with the mating season of Great Jagras, which—considering the substantial distance between regions—suggests that the Kulu-Ya-Ku are specifically targeting Great Jagras eggs, an entirely plausible explanation. Delving further, recent reports suggest that the energy from Zorah Magdaros's crossing to the New World is drawing the Kulu-Ya-Ku closer to the region and expanding its range of activity. (From a biologist's notes)

Production Backstory
PRODUCTION NOTES
A Charming, Quirky, and Tough Monster

Kulu-Ya-Ku shows up with Pukei-Pukei, along with several action-heavy monsters. So, we created a monster that players could have fun with thanks to its unique traits. We decided on a monster that could stir the pot by stealing the eggs of other monsters. By making it hold a boulder instead of eggs, we could teach the player that attacks can bounce off hardened monsters. We encouraged players to use their slinger by making Kulu-Ya-Ku drop its boulder after being hit. If there was a Kulu-Ya-Ku that didn't drop its rock, they'd have the ultimate defense. They have enough strength to hold a boulder, so if they were smart they'd win a fight by just crushing a hunter. [laughs] (Tokuda)

This is a monster that changes its attitude on the fly, so from a design standpoint we wanted to make Kulu-Ya-Ku very expressive. One moment it's carrying a boulder, so it's very confident in itself and takes on opponents it normally wouldn't. But if it drops that boulder the next minute it's scampering away. Since it was supposed to feed on eggs, I thought the action of pecking might fit it well, and that's how it became bird-like. (Fujioka)

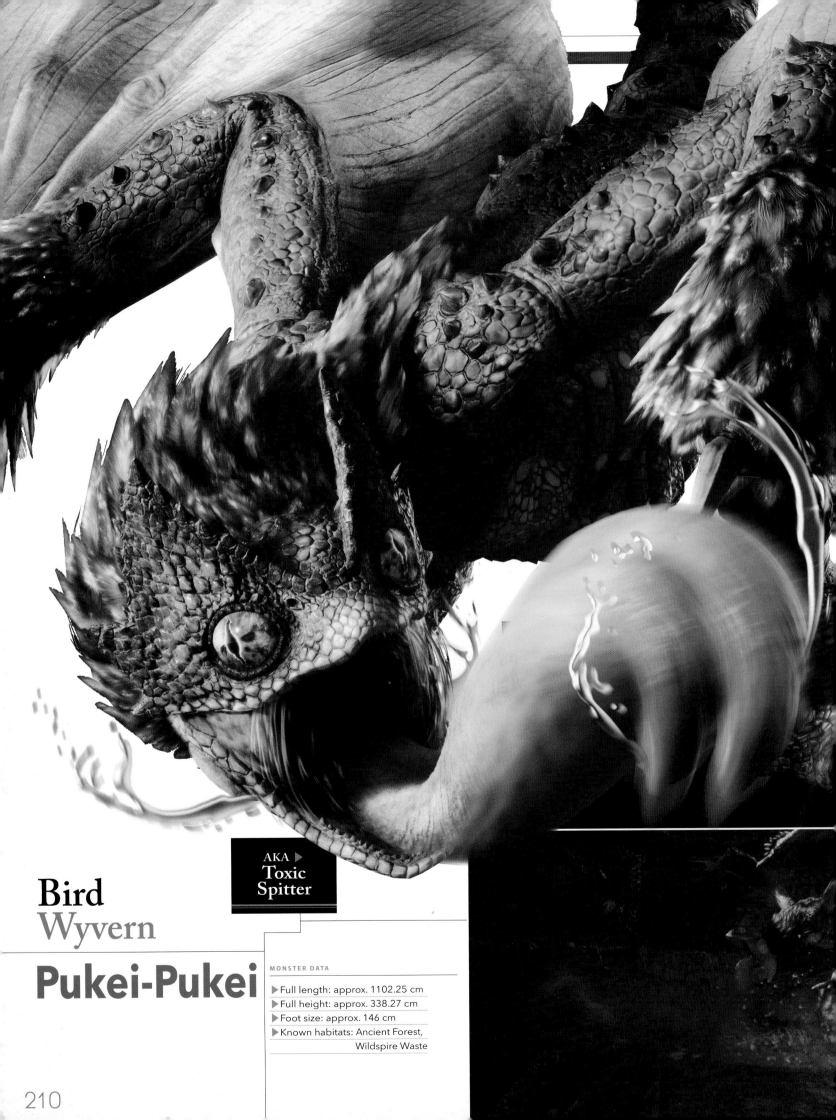

Bird
Wyvern

Pukei-Pukei

MONSTER DATA

▶ Full length: approx. 1102.25 cm
▶ Full height: approx. 338.27 cm
▶ Foot size: approx. 146 cm
▶ Known habitats: Ancient Forest, Wildspire Waste

INTRODUCTION

Pukei-Pukei lives in the Ancient Forest and feeds mainly on Scatternuts and other plants. The Ancient Forest is a very easy place for the Pukei-Pukei to call home, with its wide variety of plant life. By eating plants and thereby spreading their seeds, it has created a somewhat rare symbiotic relationship with the forest itself. The territorial Pukei-Pukei uses its poisonous mucus to defend its home. While known to dominate enemies it considers weaker than itself, it runs from strong foes.

The Handler

The Pukei-Pukei prefers a plant-based diet. We're more likely to cross paths with them if we press farther into the forest, where they hunt for food.

ECOLOGY

■ Showdown with a Show-Off

Pukei-Pukei are wary and territorial, building nests in places with heavy vegetation and spending most of their waking hours patrolling their territory. They're very perceptive and quick to spot intruders, and they adjust their attitude to meet the threat at hand. If they consider their opponent to be weak, Pukei-Pukei stand their ground and unleash a merciless spray of poison. On the other hand, if that intruder happens to be a Rathalos or another monster beyond their level of strength, they may panic and eventually flee. Having the ability to determine the difference between an intruder's strength and its own allows the Pukei-Pukei to run away and hopefully live to see another day. Some might call this cowardice, but at the root of such a display might be wisdom.

Pukei-Pukei are likely to stand up to human-sized hunters, but should an Anjanath arrive on the scene they will quickly stand down. Some have even been known to flee their own territory.

PUKEI-PUKEI

ECOLOGY

■ Natural Camouflage

The Pukei-Pukei's natural camouflage is well suited to its forest home. However, in the event that something in its surroundings changes, the Pukei-Pukei's plumage will change colors. The Pukei-Pukei's plumage is covered in fine crystalline particles, so if it alters the angle or form of its feathers, the light refracting through these particles also changes, making it appear as if the Pukei-Pukei's plumage has suddenly changed.

If, for example, a Pukei-Pukei were to be attacked by a weaker monster, it might change its feathers to a bright red to convey its aggressiveness. If a Pukei-Pukei were to be attacked by a monster it recognized as stronger than itself, it might tuck in its body and fold in its feathers, turning them a cream-like color.

Green plumage is helpful, as Pukei-Pukei's territory is usually in areas of rich vegetation. The Pukei-Pukei stores poison gas in its colorful tail.

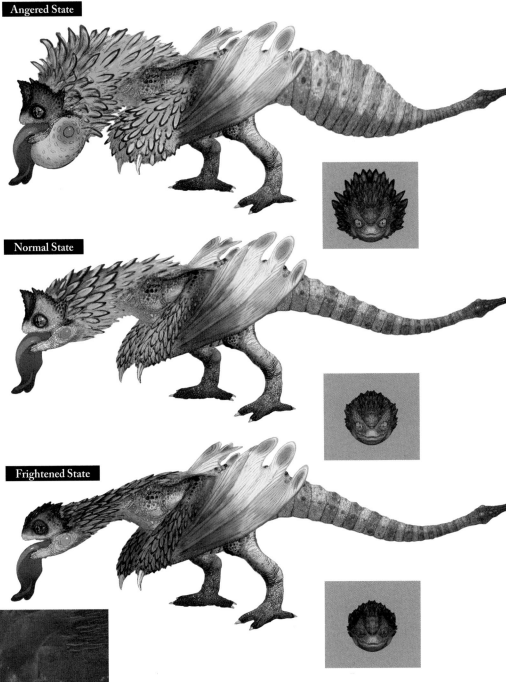

Angered State

Normal State

Frightened State

While many monsters have excellent eyesight, the Pukei-Pukei excels at spotting targets. It is able to identify a Great Jagras or Anjanath from far away and react accordingly.

ECOLOGY

■ Incredibly Perceptive Eyes

The secret of Pukei-Pukei's astounding perception lies in its unusually large and spherical eyes. According to one scholar, a study of the Pukei-Pukei's eyes revealed that compared to the eyes of other creatures, their eyes contain a strikingly large number of color-receptor cells. These superb photoreceptors are capable of differentiating between many variants of red, blue, green, violet, and yellow. With its oblong pupils that control the amount of light allowed into its eyes, Pukei-Pukei can even distinguish between colors in the dark. This uncanny ability to discern colors allows Pukei-Pukei to recognize threatening monsters in an instant and vacate dangerous areas in the blink of an eye.

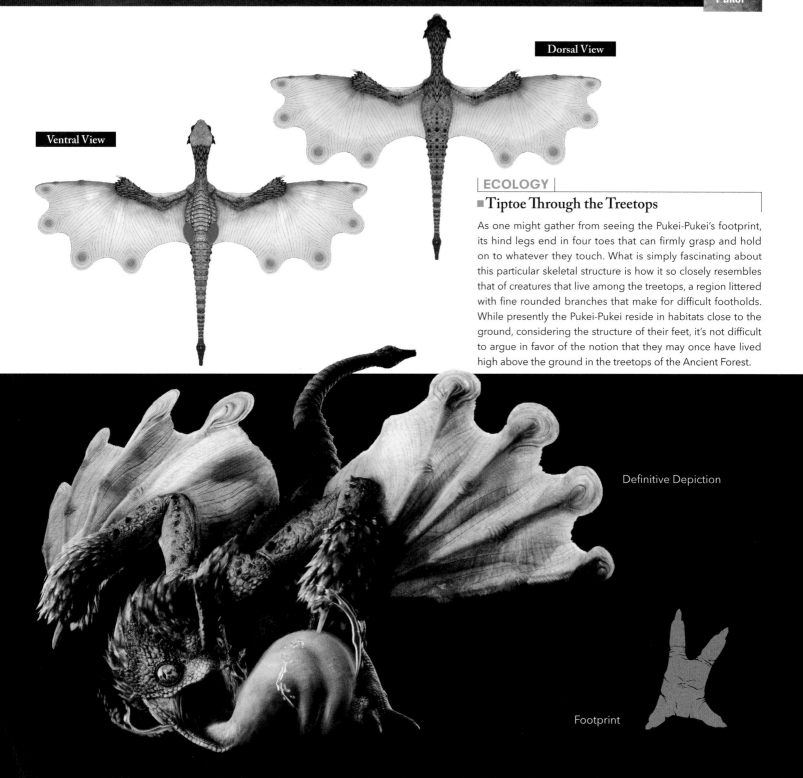

Dorsal View

Ventral View

Definitive Depiction

Footprint

ECOLOGY

■ Tiptoe Through the Treetops

As one might gather from seeing the Pukei-Pukei's footprint, its hind legs end in four toes that can firmly grasp and hold on to whatever they touch. What is simply fascinating about this particular skeletal structure is how it so closely resembles that of creatures that live among the treetops, a region littered with fine rounded branches that make for difficult footholds. While presently the Pukei-Pukei reside in habitats close to the ground, considering the structure of their feet, it's not difficult to argue in favor of the notion that they may once have lived high above the ground in the treetops of the Ancient Forest.

Analysis

■ A Connection to the Ancient Forest

Pukei-Pukei holds a deep connection to the Ancient Forest. Many of the seedlings from the plants in the Ancient Forest are covered by thick, resilient shells that more often than not fail to successfully germinate. However, when a Pukei-Pukei eats these same seeds and breaks the shell, tiny seedlings fall to the ground where they can successfully germinate. Pukei-Pukei even assists in the spreading of seedlings across multiple regions of the forest when they fall from its mouth during travel or when it deposits dung. This is perhaps why, above all, the region around a Pukei-Pukei's nest has especially diverse flora.

Some speculate that this relationship between Pukei-Pukei and the forest has existed for a very long time. Based on the structure of its foot, the Pukei-Pukei is believed to have once roosted in the treetops of the Ancient Forest before being forced out of its habitat by Rathalos at some point. This theory supports the belief that Rathalos migrated to the New World long ago. (*Excerpt from the book* Theories on New World Ecology)

ECOLOGY

■Poison Gas Is Its Weapon

Pukei-Pukei feeds mainly on plants like Poisoncups and stores these foods in its chin and tail. In conflict, it will mix these with the contents of its poison-producing sacs and release a combination of the materials from its mouth. Depending on which plants are mixed, the Pukei-Pukei can create a variety of toxins. A sporepuff base will create a mist-like spray, while Scatternuts make a poison bubble that bursts and spreads on contact. Furthermore, when these plant and poison mixtures are given time to ferment, they create a highly volatile poison vapor. When this vapor combines with the fluid of the Pukei-Pukei's poison sacs, it forms a very powerful poison gas. The Pukei-Pukei stores this gas in its highly elastic tail and will release it as a last resort when facing strong opponents. The plants that it feeds on are not only for sustenance, but also for self-defense.

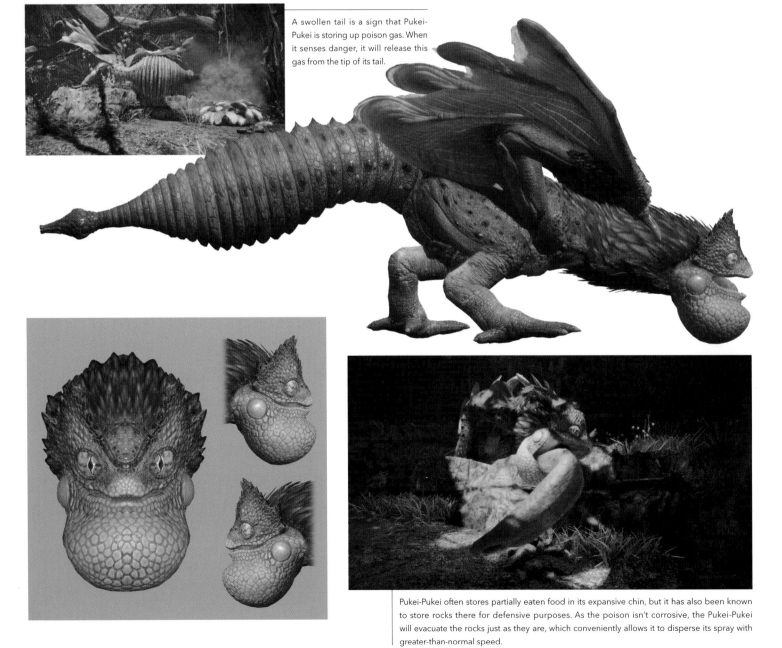

A swollen tail is a sign that Pukei-Pukei is storing up poison gas. When it senses danger, it will release this gas from the tip of its tail.

Pukei-Pukei often stores partially eaten food in its expansive chin, but it has also been known to store rocks there for defensive purposes. As the poison isn't corrosive, the Pukei-Pukei will evacuate the rocks just as they are, which conveniently allows it to disperse its spray with greater-than-normal speed.

ECOLOGY

■ An Incredibly Strong Tongue

A Pukei-Pukei's tongue is highly elastic, comparable to that of its tail. Near the center of its tongue is a specialized bone called the "hyoid." When this bone is pushed forward, it pulls the surrounding muscle along with it and extends. Research shows that a Pukei-Pukei's tongue can stretch beyond four meters long. The tongue's elasticity is so powerful that a single human's strength is insufficient to stretch the tongue by force; only the Pukei-Pukei's well-developed hyoid and surrounding muscles allow it to stretch its tongue at will. Through clever use of its tongue, Pukei-Pukei can easily grasp food or even thwart invaders from a significant distance.

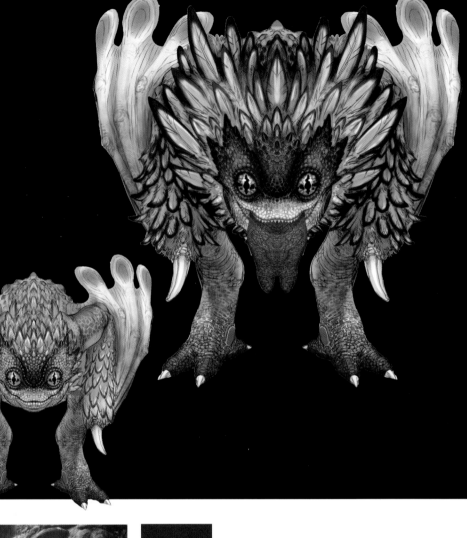

Pukei-Pukei's skillful control of its tongue allows it to snatch high-growing Scatternuts while airborne. The tongue's resilience also aids Pukei-Pukei in the consumption of plant life covered in hard shells.

Pukei-Pukei uses its tongue for whiplike attacks. The speed of its strike is so fast that it is difficult for even skilled hunters to accurately predict its movement.

ECOLOGY

■ Cuckoo-Bird Tactics Among the Young

Pukei-Pukei is somewhat of a rarity when it comes to reproductive habits since it utilizes Mernos nests for brood parasitism. During breeding season, a Pukei-Pukei waits for a small window when a Mernos has vacated its nest and proceeds to deposit its ovum among the Mernos's eggs. The Pukei-Pukei chick then hatches before the Mernos's young do, at which time it instinctually pushes the other eggs out of the nest. This ensures that only the Pukei-Pukei chick receives the care that the Mernos unwittingly provides for it. A young Pukei-Pukei leaves the nest, learns to fly of its own accord, and naturally seeks out vegetation for sustenance.

Production Backstory

PRODUCTION NOTES

Teaching the Player to Utilize Their Surroundings

Utilizing your surroundings is a big part of the game, and in that respect Pukei-Pukei is like the player's teacher. Pukei-Pukei uses its surroundings to grow stronger, which is designed to motivate the player to use the environment as well by utilizing poisoncups or gaining experience with slinger use. We designed this monster so that through its exaggerated actions, the player could easily learn about success and failure. Early in the planning phase, Pukei-Pukei was going to assume the role of the standard Flying Wyvern "teacher" for describing the flow of action to the player, but that role went to Great Jagras. Instead, we focused on making Pukei-Pukei teach players about the environmental components of gameplay. (*Tokuda*)

Ultimately this monster became a tricky opponent, but I'm just glad that its quirkiness still shines through. It's very colorful, and the basis of our goal with Pukei-Pukei's design concept was being able to determine its emotions simply by viewing its silhouette. For instance, when the Pukei-Pukei comes across a strong monster, it has a very unique way of reacting. To best express that we used a design that included plumage, which made it possible to easily show whether it was trying to be threatening or was spooked. (*Fujioka*)

Extended **World Gallery**
Unidentified Creatures Log [I]

Regarding the New World, in recent years the Research Commission has been discovering new monsters, one after another. Some of the earliest findings were a myriad of analytical and hypothetical reports related to the Great Jagras, Kulu-Ya-Ku, and Pukei-Pukei. What you see here is a small part of those reports. These reports have aged considerably, and it is difficult to discern whether they're based on theories or actual sightings, but all the same, in the spirit of sharing information, we're happy to present these findings to the public.

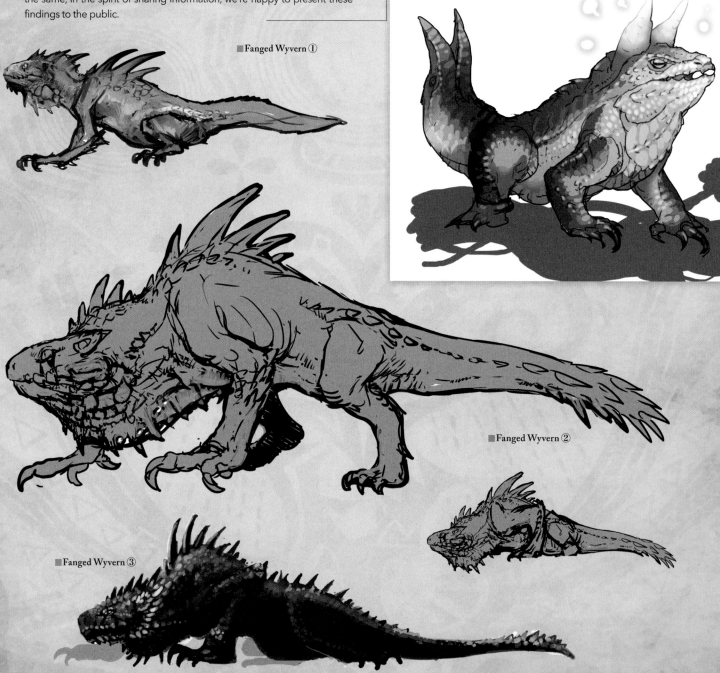

■ Fanged Wyvern ④

■ Fanged Wyvern ①

■ Fanged Wyvern ②

■ Fanged Wyvern ③

❖ **Similar to "The Great Glutton"**

Fanged Wyverns #1-3: The "hair" around its neck is tiny spikes. Such hairlike growth may not be seen in these depictions, and the tail spikes are quite different.

Fanged Wyvern #4: An individual who emits a guiding light. It's capable of lighting its tail, which resembles its horns. Is this to confuse foes?

❖ **Similar to "Feathered Plunderer"**

Bird Wyverns #1-2: "There's a Bird Wyvern walking around holding an egg." This report surprised everyone. The idea seemed absurd, which led some scholars to believe it carried objects with a feathered tail.

Bird Wyverns #3-7: Upon hearing that it carried eggs and boulders as well, sketches of derivatives with well-developed forelimbs circulated.

❖ **Similar to "Toxic Spitter"**

Bird Wyvern #8: Its colorful head decoration indicates the creature's poisonous nature, but that's where the similarities end.

Bird Wyverns #9-10: Records exist of creatures with jagged beaks and others who seem to be an amalgamation of various life-forms.

Bird Wyvern #11: This report clearly exhibits how confusing the information flowing in must have been at the time.

CREATURES LOG

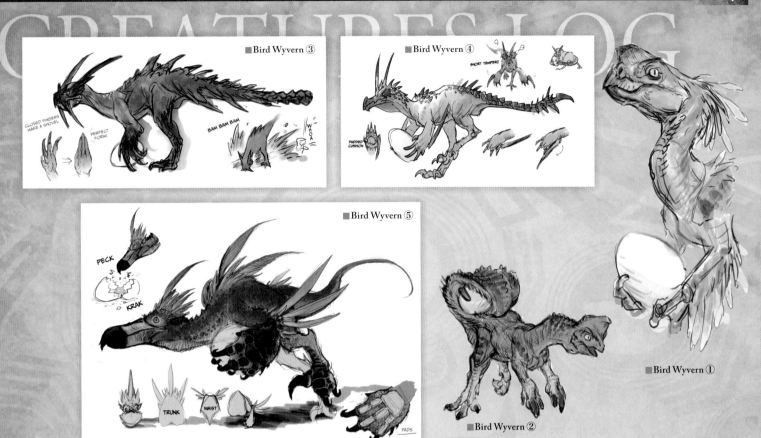

■ Bird Wyvern ③

CLOSED FINGERS MAKE A SHOVEL

PERFECT FORM!

BAM BAM BAM

WHOA

■ Bird Wyvern ④

SHORT TEMPER!

PADDED CUSHION

■ Bird Wyvern ①

■ Bird Wyvern ⑤

PECK

KRAK

TRUNK

WAIST

PADS

■ Bird Wyvern ②

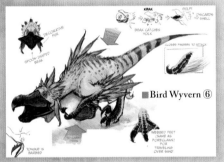

DECORATIVE FUR

SPOON-SHAPED BEAK

KRAK

GULP!

DISCARDS SHELL

BEAK CATCHES YOLK

CLOSED FINGERS TO ATTACK

TONGUE IS BARBED

WEBBED FEET (SAME AS FORE-CLAWS) FOR TRAVELING OVER SAND

■ Bird Wyvern ⑥

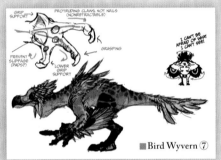

GRIP SUPPORT

PROTRUDING CLAWS NOT NAILS (NONRETRACTABLE)

GRASPING

PREVENT SLIPPAGE (PADS?)

LOWER GRIP SUPPORT

I CAN'T BE AFRAID OF WHAT I CAN'T SEE!

■ Bird Wyvern ⑦

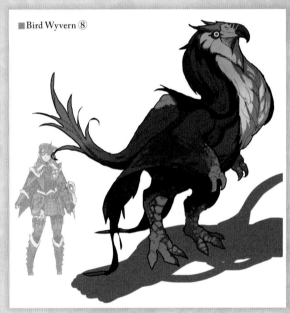

■ Bird Wyvern ⑧

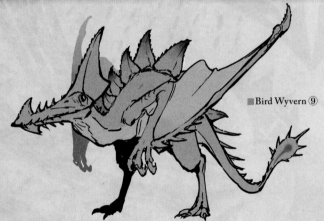

■ Bird Wyvern ⑨

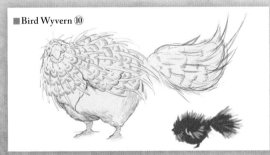

■ Bird Wyvern ⑩

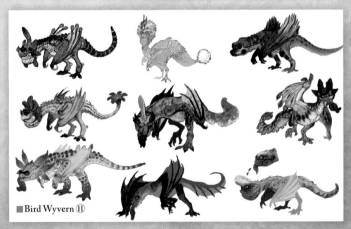

■ Bird Wyvern ⑪

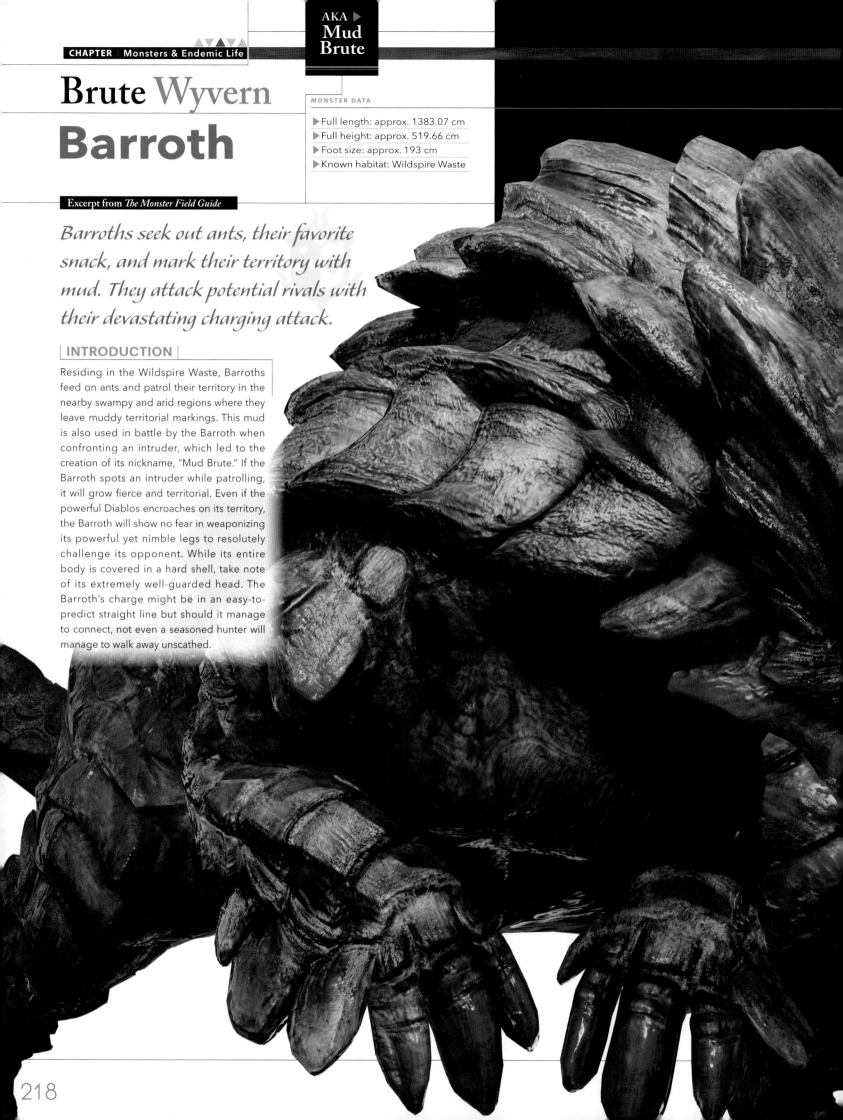

AKA ▶
Mud Brute

Brute Wyvern
Barroth

MONSTER DATA

▶ Full length: approx. 1383.07 cm
▶ Full height: approx. 519.66 cm
▶ Foot size: approx. 193 cm
▶ Known habitat: Wildspire Waste

Excerpt from *The Monster Field Guide*

Barroths seek out ants, their favorite snack, and mark their territory with mud. They attack potential rivals with their devastating charging attack.

INTRODUCTION

Residing in the Wildspire Waste, Barroths feed on ants and patrol their territory in the nearby swampy and arid regions where they leave muddy territorial markings. This mud is also used in battle by the Barroth when confronting an intruder, which led to the creation of its nickname, "Mud Brute." If the Barroth spots an intruder while patrolling, it will grow fierce and territorial. Even if the powerful Diablos encroaches on its territory, the Barroth will show no fear in weaponizing its powerful yet nimble legs to resolutely challenge its opponent. While its entire body is covered in a hard shell, take note of its extremely well-guarded head. The Barroth's charge might be in an easy-to-predict straight line but should it manage to connect, not even a seasoned hunter will manage to walk away unscathed.

BARROTH

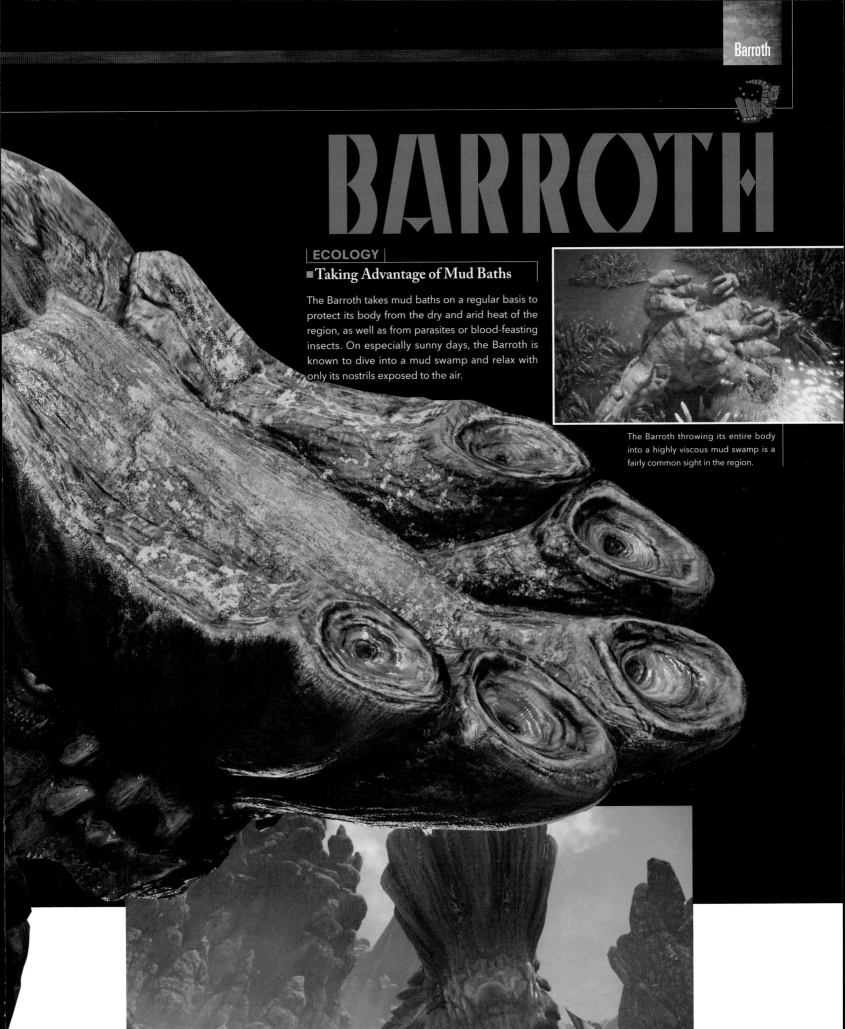

| ECOLOGY |
■ Taking Advantage of Mud Baths

The Barroth takes mud baths on a regular basis to protect its body from the dry and arid heat of the region, as well as from parasites or blood-feasting insects. On especially sunny days, the Barroth is known to dive into a mud swamp and relax with only its nostrils exposed to the air.

The Barroth throwing its entire body into a highly viscous mud swamp is a fairly common sight in the region.

ECOLOGY

■ Intimidating and Slowing Enemies

The territorial Barroth will intimidate invaders by using the muddy material covering its body. The highly viscous mud will significantly slow down the movement of a target and may even bring it to a complete stop. However, the mud also acts as a defensive shield for the Barroth. If it loses too much of this muddy barrier, the Barroth may even retreat to search for a mud bath.

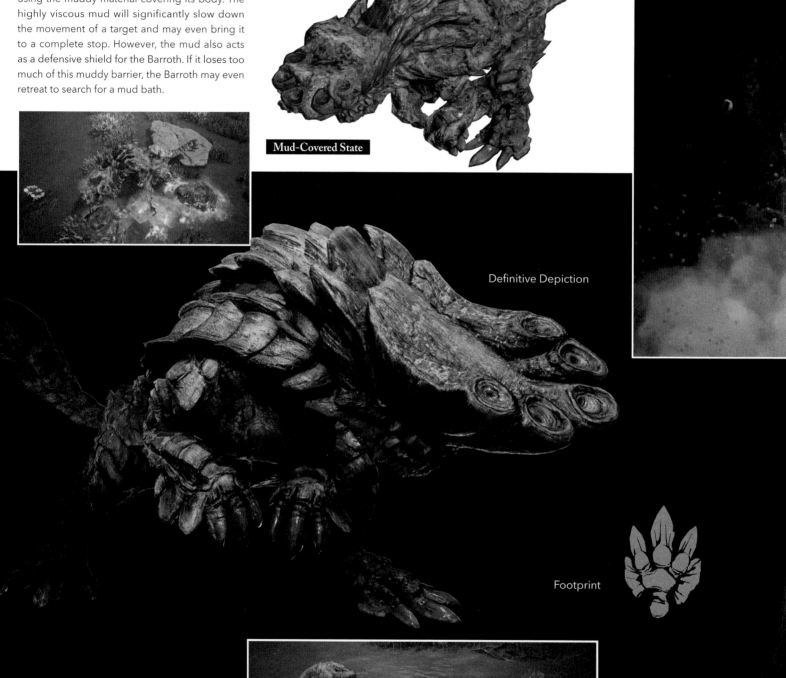

Mud-Covered State

Definitive Depiction

Footprint

ECOLOGY

■ Breathing Under the Mud

The nostrils located on top of its head are specially adapted to suit the Barroth when it's mud bathing in marshes. When angered by an intruder's attack, the Barroth is known to exhale sharply through these nostrils. In fact, the Barroth has evolved a number of nostrils so that it may exchange plenty of air while mud bathing.

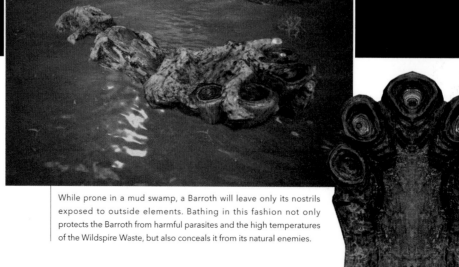

While prone in a mud swamp, a Barroth will leave only its nostrils exposed to outside elements. Bathing in this fashion not only protects the Barroth from harmful parasites and the high temperatures of the Wildspire Waste, but also conceals it from its natural enemies.

■Barroth of the Old and New Worlds

Barroths in the Old World compete fiercely with each other during the dry season. There are more than a few Barroths who lose their lives in such battles due to cranial damage from powerful headbutts. While a male Barroth typically mates with only one female, reports suggest that if a swamp is considerably wide, a male may mate with several females. However, territorial battles between males have not been witnessed in the New World, so it's possible the local ecology has altered their behavior. Regardless, the head is still a crucial part of its anatomy, which is why it is covered in the hardest shell of the Barroth's body—a shell that the Barroth meticulously grooms in the same way as its Old World relatives.

As a Barroth matures, it must groom its head to account for changes in the head's weight and balance. In order to remove dirt and grime from its nostrils, a Barroth may frequently be seen rubbing its head against the ground.

| ECOLOGY |

■A Muddy Relationship

You might be surprised that a Barroth utilizes mud even for breeding habits. The female (or females) accepted into a male's marsh will build a mound of mud, in which they will lay ten to twenty eggs. Both males and females share duties in brooding; males will keep a sharp eye out for intruders and protect the females and their eggs. As for the eggs, they're kept warm by geothermal heat and usually hatch in a few months. Until they reach an appropriate size, the hatchlings will feed on small mud-dwelling insects. Hatchlings resemble their parents from birth, and their cranial region develops with maturity. The Barroth's powerful legs also develop during these early days, as young Barroth are forced to wade through viscous mud. The above information is all we know about the behavioral ecology of Barroths residing in the Old World, and we expect our observations of New World Barroth to show similar findings.

Analysis

■Dutifully Patrolling a Wide Region

The Barroth leads a surprisingly regimented daily life. Starting from the swamp of Area 9, it passes through the arid Areas 5 and 6 before coming to the Wildspire Waste in Area 8, marking its path the entire way. It covers itself in mud in Area 4 before returning to Area 9, where it submerges itself. The Barroth then repeats this trek. However, it should be noted that the Barroth is not often observed feeding while on this loop. Incidentally, the Barroth is quick to respond to provocation from a slinger, so a hunter would be wise to engage it while a natural enemy is nearby. (*A researcher's notes*)

Production Backstory

The Environmental Utility Tutorial Monster Returns

The point of this monster's entire existence is basically to say to the player, "Okay, here's how you dodge a charge and then follow it up with an attack." We brought it in as soon as we came up with the Wildspire Waste. We thought expanding on Barroth would create an easy-to-understand tutorial experience. It's designed to be a stopping block for players so that once they learn how to deal with it, it's easy. We added environmental elements by having Barroth coat itself in mud. If the player uses aspects of the terrain to their advantage when avoiding Barroth's charges, they'll be greatly rewarded, so I think this variation of Barroth is much easier to deal with than in past titles. (*Tokuda*)

Originally its design played with the idea of how the hardness of a monster's body could change by coating it in mud. Previously, the player had no choice but to spam attacks. Now we have the slinger and a few other useful options for fighting, which are big changes that allow players more ways to react to the toughness of a monster's body than ever before. As a roaming monster, Barroth is most easily dealt with if the player takes advantage of its turf wars with Jyuratodus. (*Fujioka*)

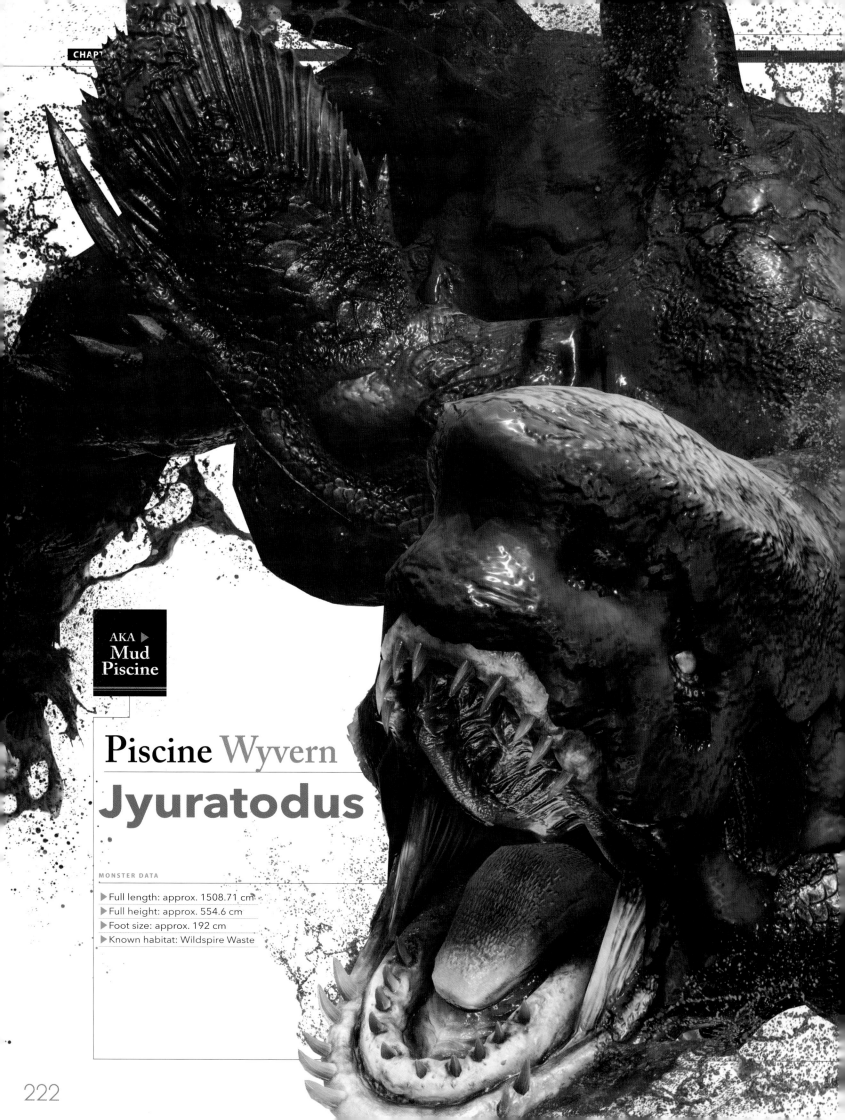

AKA ▶
**Mud
Piscine**

Piscine Wyvern

Jyuratodus

MONSTER DATA

▶ Full length: approx. 1508.71 cm
▶ Full height: approx. 554.6 cm
▶ Foot size: approx. 192 cm
▶ Known habitat: Wildspire Waste

JYURATODUS

Though usually found in its den, two to three times a day a Jyuratodus may be witnessed moving to a shallow mud pool where it takes a mud bath.

ECOLOGY
■ Coating Its Scales with Mud

Jyuratodus's daily life is literally a muddy situation. Its scales are extremely sensitive to arid conditions, where they become brittle and the monster's cutaneous respiration also plummets in efficacy. Jyuratodus regularly stays well moisturized by covering itself in a thick layer of mud. In fact, being predisposed to wetland conditions, the Jyuratodus usually spends most of its days submerged in the waters of its marshy den. This is why the Jyuratodus is a strongly territorial monster that will not hesitate to attack any intruder who disturbs its otherwise peaceful existence. The Jyuratodus attempts to reduce such intrusions by marking the outskirts of its territory with mud.

ECOLOGY
■ Fighting Dirty

Mud doesn't just protect the Jyuratodus. It's also useful in battle. Jyuratodus regularly stores mud and dirt within its body and mixes it with a special water inside its water sac to make a very thick mud concoction. The Jyuratodus will expel this highly viscous mixture at an enemy in hopes of hitting it and significantly impeding its movement. Jyuratodus is also instinctively aware that many other creatures suffer limited movement in marshlands and will skillfully utilize a variety of offensive maneuvers that take advantage of this disparity, such as attacking from the depths of the swamp.

Excerpt from *The Monster Field Guide*

A large Piscine Wyvern that inhabits the swamps of the Wildspire Waste. It uses mud to capture prey, and it's known to battle Barroth over territory.

INTRODUCTION

The Jyuratodus is a Piscine Wyvern that resides mainly in the swamps of the Wildspire Waste. To protect itself from enemies, Jyuratodus covers itself in a heavy layer of mud. Jyuratodus clearly excels at moving through marshes, but it can move about on the land just as easily by using well-developed fins that have become hind legs. Jyuratodus are highly territorial and are known to attack intruders without remorse. One must exercise the utmost caution so as not to fall prey to their razor-sharp fangs or muddy expectoration.

ECOLOGY

■ A Plurality of Fins

Jyuratodus are capable of walking on two legs when they cross over obstacles or hunt Apceros. These hind legs were originally extremely powerful fins and are dexterously tucked in close to the Jyuratodus's body while it swims. Even excluding these hind legs, you may be wondering why a Jyuratodus has more fins than a standard fish. The surprising benefit of these numerous fins is that they serve a dual purpose of improving balance by distributing its body weight while the massive Jyuratodus is on land, and aiding propulsion and balance when the monster is swimming. In order to deal with gravity on land and buoyancy in water, the Jyuratodus slightly adjusts its many fins when moving about. Recent findings of ancient Piscine Wyvern fossils with numerous fins suggest that Jyuratodus has maintained this body structure for a very long time.

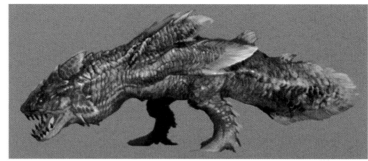

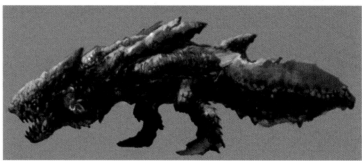

Note the Jyuratodos's four dorsal fins, large pectoral fins, and hind legs. Although difficult to discern while covered in mud, the Jyuratodos is covered in scales that allow for cutaneous gas exchange in addition to respiration via its lungs.

Not known to be nimble on two legs, Jyuratodus is typically limited in its movements on land while hunting for prey.

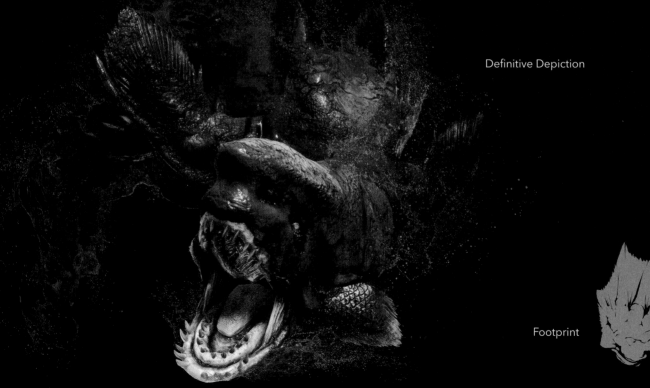

Definitive Depiction

Footprint

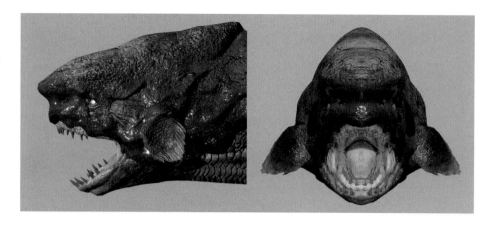

ECOLOGY
■ Feeding Just Once Per Day

A Jyuratodus only feeds about once per day by preying on Aptonoths or other water-seeking herbivorous wyverns. The inside of its mouth is lined with rows of sharp meat-tearing fangs arranged on a dental plate, and its powerful jaw can crack open its prey's bones. An analysis of Jyuratodus's feeding remains suggests that they prefer to eat organs, a trait probably related to their juvenile feeding habits.

ECOLOGY
■ A Muddy Buddy

While traveling through marshes, the Jyuratodus leaves behind muddy piles that serve as natural boundary markers for its territory. However, the competing Barroths often destroy these markers while roaming through marshes, leading to territorial conflict between the two monsters should they cross paths. As their natural abilities and strength are comparable, many consider them to be fierce rivals.

ECOLOGY
■ Spawning in the Rain

Jyuratodus predominantly spawn during the rainy season. Large numbers of Jyuratodus gather in the marshlands where the females directly release their unfertilized eggs. Male Jyuratodus will respond in turn by depositing their gametes in the same vicinity with hopes of fertilizing the eggs. This reproductive ritual creates a rather novel scenes as the surface of the marsh will suddenly and violently appear to undulate. Although many eggs are successfully fertilized and even hatch, only a small handful of the hatchlings survive to maturity due to predation by other fish and cannibalism among juvenile Jyuratodus. Since this ritual only occurs during particularly turbulent rainy seasons, it's a rare event that hasn't been recorded in recent years.

Analysis
■ The Feeding Habits of Juvenile Jyuratodus

Jyuratodus are carnivorous from a young age and display a unique feeding behavior. They enter the body of their prey through its mouth, nostrils, or even an open wound. They will then proceed to devour the prey from the inside out. Note the barbed spines seen on the gills of adult Jyuratodus. These are believed to be remnants from its juvenile form, where the spikes would prevent the Jyuratodus from being expelled from their prey's body. (*A biologist's paper*)

Production Backstory

PRODUCTION NOTES
A Piscine Wyvern with Roots in the Mud

We were looking for a form that would express Jyuratodus as the definitive "Lord of the Wetlands," which is why it looks like a lungfish Piscine Wyvern. There are several monsters like this one, and we used them to pull the player deeper into the world by giving them mud-based behaviors. One of the great things we were able to do is have it create mounds of mud that the player could walk on. Marsh areas are traditionally difficult for players to move around in, but with those mounds we made the environment less about restrictions and more about enjoying the gameplay. We also thought about how to keep that advantage in check by allowing the Barroth to break down those mounds. (*Tokuda*)

We've learned from the past that no matter what options we give the player, it doesn't matter if we restrict their movement. That's why this time every monster has been designed with the topography and geography in mind. Up until now, small monsters have been a detriment to the player, but in *Monster Hunter: World*, if you understand their behavior you can flip them to your advantage. We wanted Jyuratodus to have an ancient aesthetic, so we made it look primitive with a plain silhouette. (*Fujioka*)

TOBI-KADACHI

ECOLOGY

■ Lightning in the Treetops

The Tobi-Kadachi spends most of its days moving about its spacious territory among the treetops of the Ancient Forest and is rarely seen on the ground. Moving about the forest this way is beneficial to Tobi-Kadachi, as rubbing its body against trees allows it to build up static electricity in its fur. The monster's physical prowess and acrobatic skill make it possible to live a lifestyle that would otherwise be very difficult in a dense forest habitat. Its speed and agility are unmatched by any monster in the Ancient Forest.

With a single leap Tobi-Kadachi can cross over cliffs or complex terrain that would be difficult to navigate for hunters. Trying to keep an eye on one is difficult when studying it, let alone trying to face it in combat.

Excerpt from *The Monster Field Guide*

Its penchant to brush against the ground and the trees as it moves around builds up static electricity within its fur.

Fanged Wyvern
Tobi-Kadachi

MONSTER DATA

▶ Full length: approx. 1300.52 cm
▶ Full height: approx. 329.22 ccm
▶ Foot size: approx. 134 cm
▶ Known habitat: Ancient Forest

INTRODUCTION

You're standing in the forest when suddenly a shadow blurs by overhead. The sun is shining, but you think you glimpse a flash of lightning. You peer into the forest, and glaring back at you are a pair of glowing red eyes that vanish in an instant. The Fanged Wyvern Tobi-Kadachi patrols the giant treetops of the Ancient Forest. Moving stealthily, Tobi-Kadachi are almost always charged with static electricity, which they retain in spikes dotting the coat of their fur-covered bodies. In conflict a Tobi-Kadachi can go toe-to-toe with much stronger monsters by flitting about the treetops from where it will launch confusing attacks while its large tail crackles with electricity. Although unconfirmed, Tobi-Kadachi is believed to be a persistent hunter.

Here the Tobi-Kadachi uses its well-adapted claws and feet to cling vertically to a tree trunk.

ECOLOGY
■ Up in the Treetops

The three digits of Tobi-Kadachi's foreleg feet are ideal for grasping objects. Its inner footpads also provide excellent grip for holding unstable or slippery limbs. Their hooked claws require constant sharpening, so it's not unusual to find claw marks in unusually high spots on tree trunks. As one might expect, these are clear demarcations of the Tobi-Kadachi's territory.

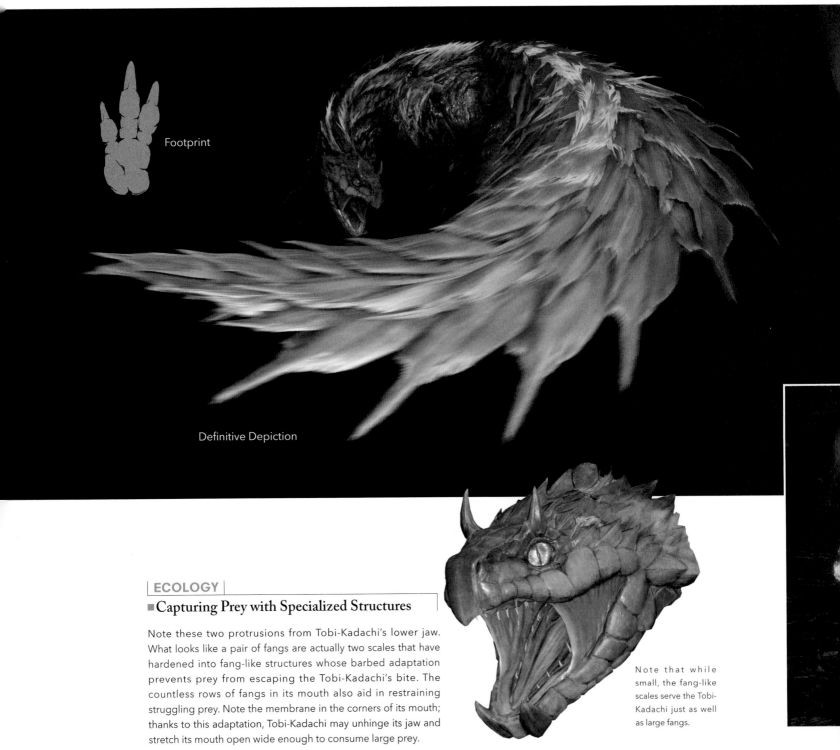

Footprint

Definitive Depiction

ECOLOGY
■ Capturing Prey with Specialized Structures

Note these two protrusions from Tobi-Kadachi's lower jaw. What looks like a pair of fangs are actually two scales that have hardened into fang-like structures whose barbed adaptation prevents prey from escaping the Tobi-Kadachi's bite. The countless rows of fangs in its mouth also aid in restraining struggling prey. Note the membrane in the corners of its mouth; thanks to this adaptation, Tobi-Kadachi may unhinge its jaw and stretch its mouth open wide enough to consume large prey.

Note that while small, the fang-like scales serve the Tobi-Kadachi just as well as large fangs.

Analysis

■Various Hypotheses on Tobi-Kadachi Ecology

Little by little, we're understanding more about Tobi-Kadachi through hunting and capture efforts—efforts that have brought forth several interesting hypotheses about its behavior. We believe that a Tobi-Kadachi favors attacking intruders with its mouth or tail over attacking with its claws. In this way it avoids risking damage to its claws, which are so valuable for maneuvering through treetops. Currently we don't have much information on their breeding habits, but we do know that they lead mainly solitary lives without forming social groups. Even though coupling behavior or juvenile Tobi-Kadachi have not been witnessed, it's been hypothesized that the size of a male Tobi-Kadachi's tail is directly proportional to its strength and plays a role in attracting a mate. (*Excerpt from a report on the New World*)

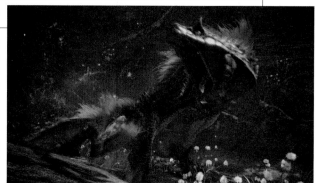

ECOLOGY

■If Snakes Could Fly

A master tree climber like Tobi-Kadachi is made even more stealthy thanks to the gliding webbing located between its fore and hind legs. When moving about or hunting prey, the webbing masks the sound of its movements, letting it dart silently along the very edges of its prey's vision before moving in for the kill. Research has shown that even with seemingly unlimited movement, the Tobi-Kadachi will almost always choose to attack a target from behind.

When not in use, the Tobi-Kadachi's gliding webbing is folded and stored. Bending its wrist inward will push out a connected shaft of needle-shaped cartilage that expands the webbing instantaneously.

ECOLOGY

■Tobi-Kadachi Is in Charge

Tobi-Kadachi accumulates static electricity by rubbing its fur coat against trees. When in conflict with an enemy, if the Tobi-Kadachi is excited it will ruffle its coat and release this charge throughout its body. In this charged state, the Tobi-Kadachi is capable of adding devastating electrical charges to its biting and tail attacks. Some have even suggested that these electrical impulses may enhance its physical capabilities. While we know much about Tobi-Kadachi's hunting habits, reports of its eating habits are scarce. We believe this might be because Tobi-Kadachi is highly energy efficient and in addition to having a low metabolism, may be able to spend several days without feeding.

While often on the move, from time to time Tobi-Kadachi may stop to rub its body or tail against a tree, leaving behind some fur. This habitual behavior not only builds a static charge but the deposited fur also serves as a territorial marker.

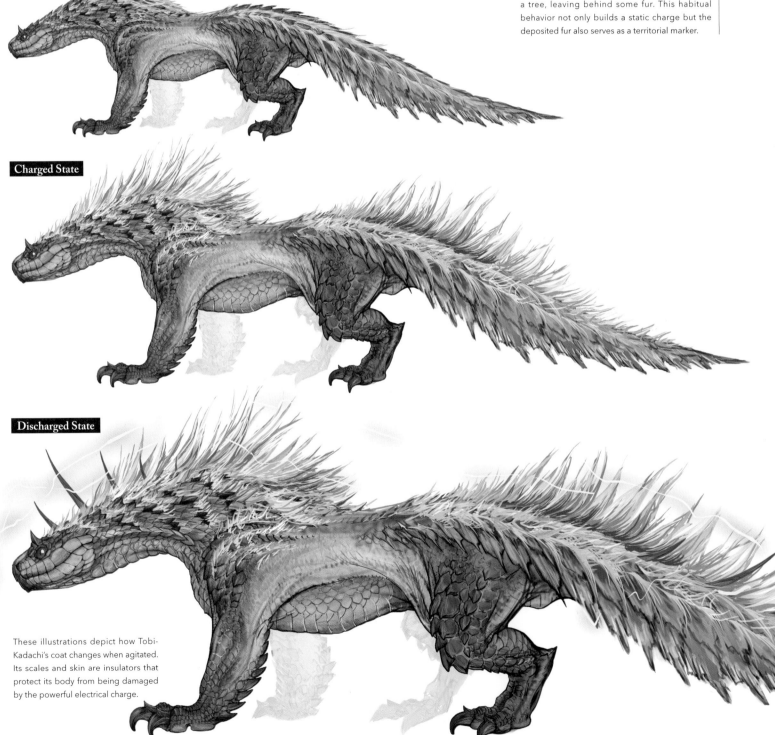

Normal State

Charged State

Discharged State

These illustrations depict how Tobi-Kadachi's coat changes when agitated. Its scales and skin are insulators that protect its body from being damaged by the powerful electrical charge.

ECOLOGY
■ Rapid Electricity Generation

Tobi-Kadachi's means of storing electricity comes from the countless needlelike electrodes dotting its fur. Usually hidden from view, these electrodes store up static electricity generated by Tobi-Kadachi's movements. When a certain amount of electricity is accumulated, Tobi-Kadachi's hair will stand on end, exposing the electrodes. The electricity arcing between them wraps the monster's entire body in a flickering pale-blue light. When attacking, Tobi-Kadachi presses these needles against its victim to electrocute them. These external electric shocks interfere with the victim's biological electrical signals and often cause them to lose consciousness.

In addition to using its movement through the forest for static generation, in conflict Tobi-Kadachi can also ruffle its coat and self-generate electricity to a certain extent.

An image of Tobi-Kadachi discharging. This can severely limit or even stop the movement of its victim.

ECOLOGY
■ High-Tension Tail

A Tobi-Kadachi's tail is equal in length to and sometimes longer than its main body. It goes without saying that a larger tail means more surface area, which in turns gives the monster greater potential for electrical buildup and achieving its charged state faster. Simply put, the stronger a Tobi-Kadachi is, the more well developed its tail will be. The scales seen along the Tobi-Kadachi's back down to the end of its tail are not unlike the tail feathers of a bird, and they become softer as they reach the end of the tail, allowing greater flexibility and static buildup.

Production Backstory

PRODUCTION NOTES
A Speedy Foe and an Unlikely Ally

Tobi-Kadachi is a swift monster that was designed to hit the player with unfamiliar tactics just as they're getting used to the system in order to get them thinking about how to deal with tricky movements and combos. We also wanted to make it electricity based so it would open the option for players to create lightning-attribute weaponry in order to deal with Anjanaths. I told Fujioka's team that I wanted Tobi-Kadachi's habitat to be ecologically unique from the other monsters, which is why the player will encounter it in the treetops while climbing up and around the Ancient Tree. (*Tokuda*)

At first, we had this electric-catfish-like design, but we couldn't come up with any ideas for how it would move freely about the treetops. We let that go and started fresh by thinking about how a snake slithers up tree trunks. What came out of that line of thought was a snake that has four limbs, and instead of slithering through trees, it glides through them. We tied it all together with the concept of storing up static electricity that it could use to hunt prey. But you can't actually see Tobi-Kadachi hunting in the game, so it probably takes its food up to the treetops and feeds somewhere off-screen. (*Fujioka*)

Brute Wyvern
Anjanath

MONSTER DATA

▶ Full length: approx. 1646.46 cm
▶ Full height: approx. 625.75 cm
▶ Foot size: approx. 182 cm
▶ Known habitats: Ancient Forest,
Wildspire Waste

Field Team Leader

*That's an Anjanath, and it's
one of the forest's biggest
troublemakers.*

INTRODUCTION

Residing in the Ancient Forest, the warlike Anjanath is a ferocious monster. Although we shouldn't judge books by their covers, sometimes what you see is what you get, especially with this warmongering muscle-bound Brute Wyvern whose key feature is its impressive jaw lined with massive spikes. Another defining characteristic is its lust for herbivorous wyvern prey, which it will pursue even as far as the Wildspire Waste. This greed has a direct effect on Anjanath's aggressive instinct. It will not differentiate between serious threats or harmless wanderers; it sees anything that enters its territory as prey and will attack it relentlessly. And yet, at times, Anjanath's light, feathery plumage and uncharacteristic sunbathing habits make it seem charming. You'll soon forget such ideas when it's shooting explosive flames in your face.

ANJANATH

ECOLOGY

■A Fine-Feathered Fiend

Of all the Brute Wyverns, only the Anjanath has feathers. Although their arms and legs are partially covered in shell-like skin, most of its soft skin is exposed. The monster's naturally vivid pinkish hue is due to the translucent quality of its skin making its internal blood flow visible. We believe that Anjanath's body temperature is easily influenced by the weather, and, considering correlation between body temperature and physical exertion, the insulating feathers help Anjanath maintain a high body temperature so it can stay ready to snap into action. It's speculated that young Anjanath display a significantly more developed coat of feathers and that these feathers naturally slough as the monster matures, but as of this writing, juvenile Anjanath have not been spotted.

Here we see an Anjanath casually sunbathing. According to one study, it was seen performing this behavior an average of three times per day.

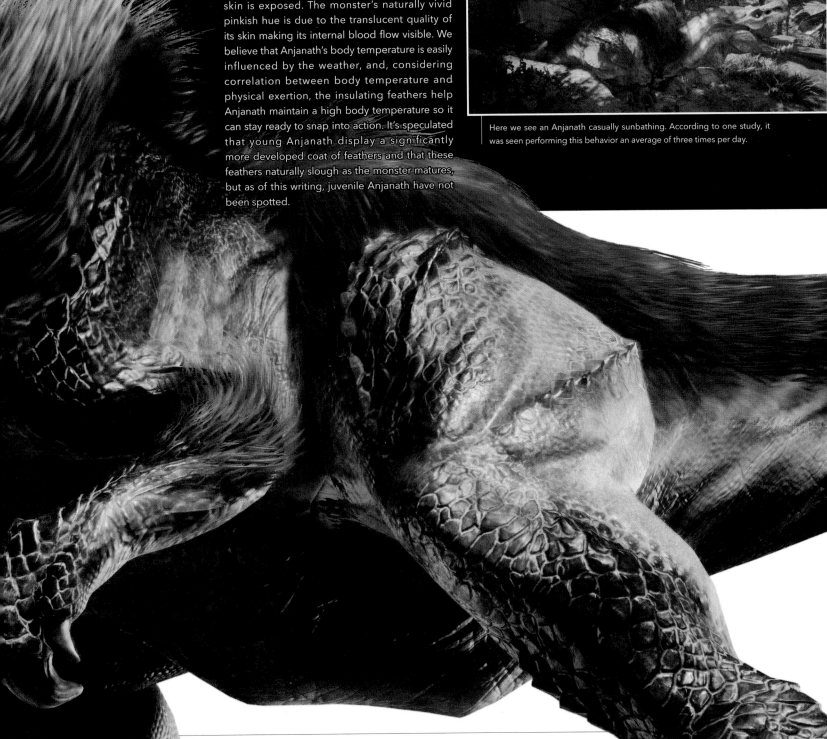

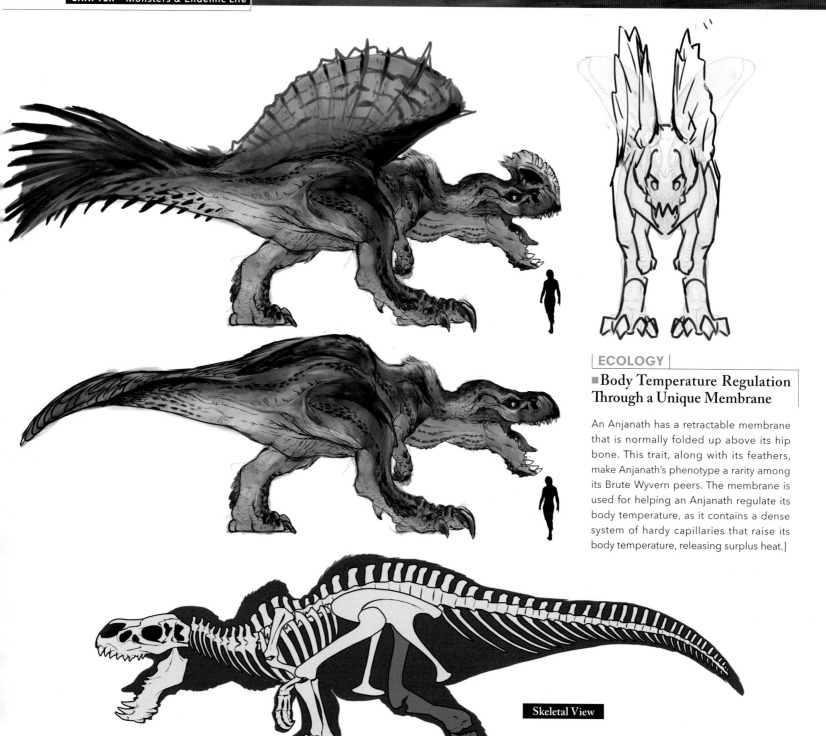

ECOLOGY

■Body Temperature Regulation Through a Unique Membrane

An Anjanath has a retractable membrane that is normally folded up above its hip bone. This trait, along with its feathers, make Anjanath's phenotype a rarity among its Brute Wyvern peers. The membrane is used for helping an Anjanath regulate its body temperature, as it contains a dense system of hardy capillaries that raise its body temperature, releasing surplus heat.]

Skeletal View

ECOLOGY

■Setting Boundaries in a Relationship

Anjanaths have a habit of roaming alone and do not form herds. The ferocity with which they'll use their powerful jaws to tear into intruding Great Jagras or Tobi-Kadachi is a sign of their strength as solitary creatures. But even the mighty Anjanath is at a disadvantage against an airborne Rathalos. As for their eating habits, while they prefer Aptonoths, they do not roast their prey's flesh with their flaming breath. They prefer the earthy taste of raw herbivore meat.

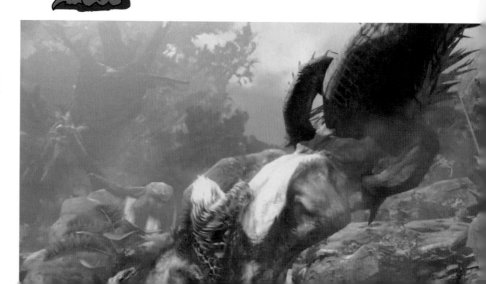

Analysis

■ Territorial Roaming Traits

The Anjanath regularly stomps through its expansive territory in the Ancient Forest, toppling tree roots and climbing up sharp cliffs with its powerful clawed forearms. The monster has been known to mark its territory by expectorating mucus up to thirty times a day. Its impressive eating habits are nothing to scoff at, as Anjanaths prey on Aptonoth up to five times a day as they move through Areas 1, 4, and 8—apparently the easiest areas for them to carry out hunts. Their post-meal routine usually goes something like this: sleeping, hydrating (upwards of five times a day), and finally sunbathing. Evidently, there are two behavioral quirks of the Anjanath that could be used to a hunter's advantage. Feeding an Anjanath raw meat will cause it to seek out water. Additionally, a hungry Anjanath will chase after fleeing Aptonoth. Through some clever manipulation and patience, a skillful hunter could lure an Anjanath into an advantageous hunting region. (*A researcher's notes*)

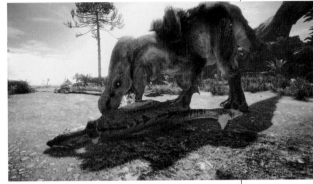

Apart from the radial ruffling of dorsal plumage on an Anjanath's tail, there are also retractable spikes lining the tail's ventral side. These dorsal tail feathers are independently controlled, allowing for different patterns of ruffling.

Normal	When Brushed

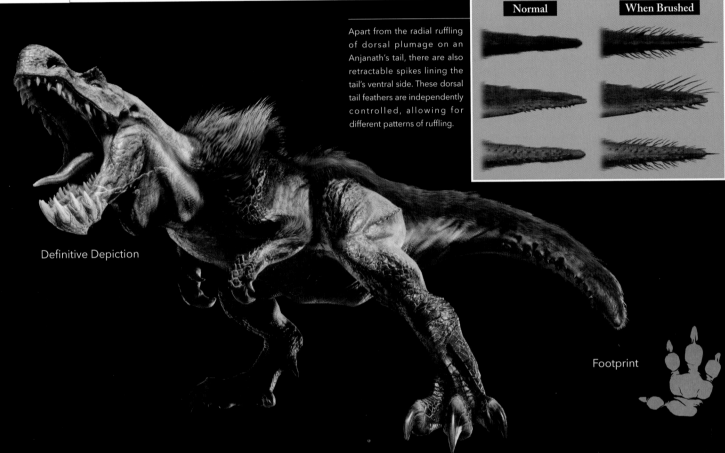

Definitive Depiction

Footprint

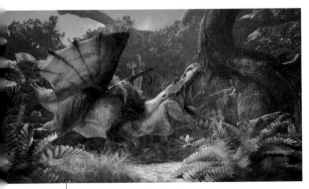

Note the Anjanath's diaphanous membrane seen here. Sweat glands haven't been found on its body, so much of Anjanath's temperature control is largely aided by using these cartilage-lined flaps. Although mainly used when spotting prey or expressing anger, it is likely that these flaps are also utilized for communication between Anjanath.

ECOLOGY
■ Protected on All Sides

As the Anjanath's iron bite is its fiercest weapon, this monster must strategize to deal with pesky opponents trying to approach its rear. To this end, Anjanath uses its hind legs and tail for a variety of maneuvers and attacks designed to position the opponent in front of it. One such attack with its tail is noted for generating a powerful gust of wind when its dorsal tail feathers are raised. The tail's spiked ventral side is just as deadly when swung from side to side. Anjanath is known to ruffle its tail when it spots prey or is angered. Outside of conflict it may swing its powerful tail when bothered by tiny insects.

CURVED WHEN STANDING STRAIGHT

235

ECOLOGY

■ Seeking Through Smell

Among the Brute Wyverns, an Anjanath's sense of smell is superb, allowing it to accurately determine the location and distance of its prey, which is why they are often spotted using their noses to sniff out prey. The root of this accuracy appears to be Anjanath's unique ability to unfurl it nostrils. By raising the outer layer of skin called a "nose hood," Anjanath exposes its nasal cavities, markedly increasing the effectiveness of its olfactory senses. If you're wondering why hit-and-run stealth tactics don't work on Anjanath, it's all thanks to this sharp nose. No amount of hiding can save a target whose scent the Anjanath has learned. Additionally, the Anjanath can also project a flammable mucus from its nostrils that can be used for both attacking and marking territory. We think that this mucus is produced in organs connected to the nostrils.

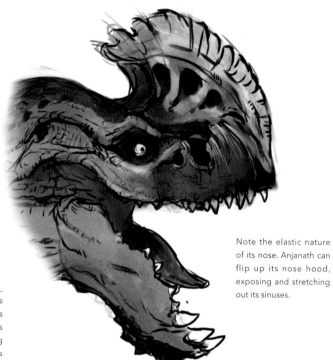

Note the elastic nature of its nose. Anjanath can flip up its nose hood, exposing and stretching out its sinuses.

While Anjanath usually exposes its fleshy nostrils to follow scents or expel mucus, it also opens them when angered, which—along with the thin membranes on its back—make for easy-to-target weak points.

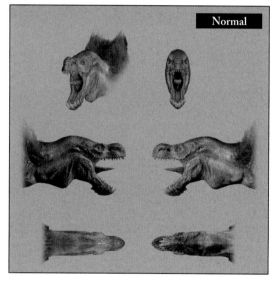

Normal

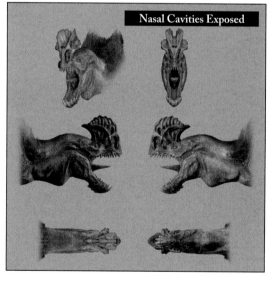

Nasal Cavities Exposed

SNIFF SNIFF

WIBBLE WOBBLE

FWOOP

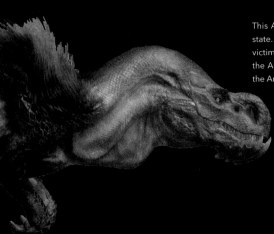

This Anjanath's neck is glowing red in its "fired up" state. In this condition it may inflict burn damage on victims it bites, but this is a double-edged sword for the Anjanath. If the heat explodes while in its mouth, the Anjanath will be left reeling.

ECOLOGY
■So Angry It Could Breath Fire

An enraged Anjanath will begin to accumulate fire in its mouth. Identifiable when its throat takes on a reddish hue, this state is called "fired up." An Anjanath stores a substance that promotes combustion inside a specialized throat organ. When it releases this substance along with mucus from its nasal cavities, exposure to oxygen causes the mixture to burst into flame. This novel mechanism is how the Anjanath is capable of spewing fire.

An enraged Anjanath is not the same as a fired up Anjanath. A fired up Anjanath is an Anjanath that is overcome with rage. As they do not use fire attacks when hunting, this level of aggressive behavior seems to be initiated by life-or-death battles with invaders or other Anjanaths.

Anjanath can spew its fiery breath in a long straight line or clear the area around its head. Some shades of fatigue may be glimpsed in Anjanath after it uses this attack, suggesting that it requires all of its strength to pull off.

While an Anjanath may stay fired up for some time, it has its limits. When an Anjanath can no longer internally contain the heat, it will expel it all at once.

ECOLOGY
■A Hunting Monster

Watching the Anjanath utilize its fire breath gives us a glimpse into how this monster proves itself to be a highly skilled hunter. While fired up, Anjanath will use its lower jaw or physique to drive its prey into a tough situation. Then, and only then, when the victim shows even the slightest hint of leaving an opening, will Anjanath unleash ruthless waves of fiery breath. Anjanath is not a rampaging brute, but instead shows signs of being a calculating hunter.

Production Backstory

PRODUCTION NOTES
Bringing Players into Intermediate Gameplay

We wanted a monster that could introduce intermediate gameplay by having it be strong against weapons across the board. We wanted it to force the player to guard, evade, and use recovery items, teaching them about the essentials of action-oriented success and failure. We wanted to give it a trait that would allow it to root out players who were trying to hide from it too. At the very start we decided on a four-legged Great Jagras, a two-legged Anjanath, and the flying Rathian, before figuring out how to best place them in the Ancient Forest. (Tokuda)

Since the playing field is littered with objects that obscure the player, we wanted to make it possible for the player to be pursued based on scent. Anjanath's design is our team's take on the hypothesis that dinosaurs had feathers. Not only that, but early in the production cycle I was trying to see how I could challenge myself by being expressive with feathers. Anjanath's plumage makes it look like a vulture. (Fujioka)

Flying Wyvern
Rathian

INTRODUCTION

Known for its powerful legs and talent for terrestrial hunting, even among other Flying Wyverns, Rathian has earned the nickname "Queen of the Land." In the Old World, she is feared for her devastating fireball and poisonous-tail attacks. In the New World, she flexes her regal muscle in the Ancient Forest and Wildspire Waste, displaying unique behaviors and traits that differentiate her from Old World Rathians. Rathians are often spotted with their mates, and whenever the female Rathian finds herself in trouble, the male Rathalos is sure to show a behavior we have also witnessed in New World individuals. However, when it comes to brooding roles, we have noticed some significant differences between Old World and New World individuals.

MONSTER DATA

▶ Full length: approx. 1754.37 cm
▶ Full height: approx. 577.22 cm
▶ Foot size: approx. 260 cm
▶ Known habitats: Ancient Forest, Wildspire Waste

Excerpt from *The Monster Field Guide*

Wyverns known only as the "Queens of the Land." They overpower their prey with their venomous tails and powerful legs.

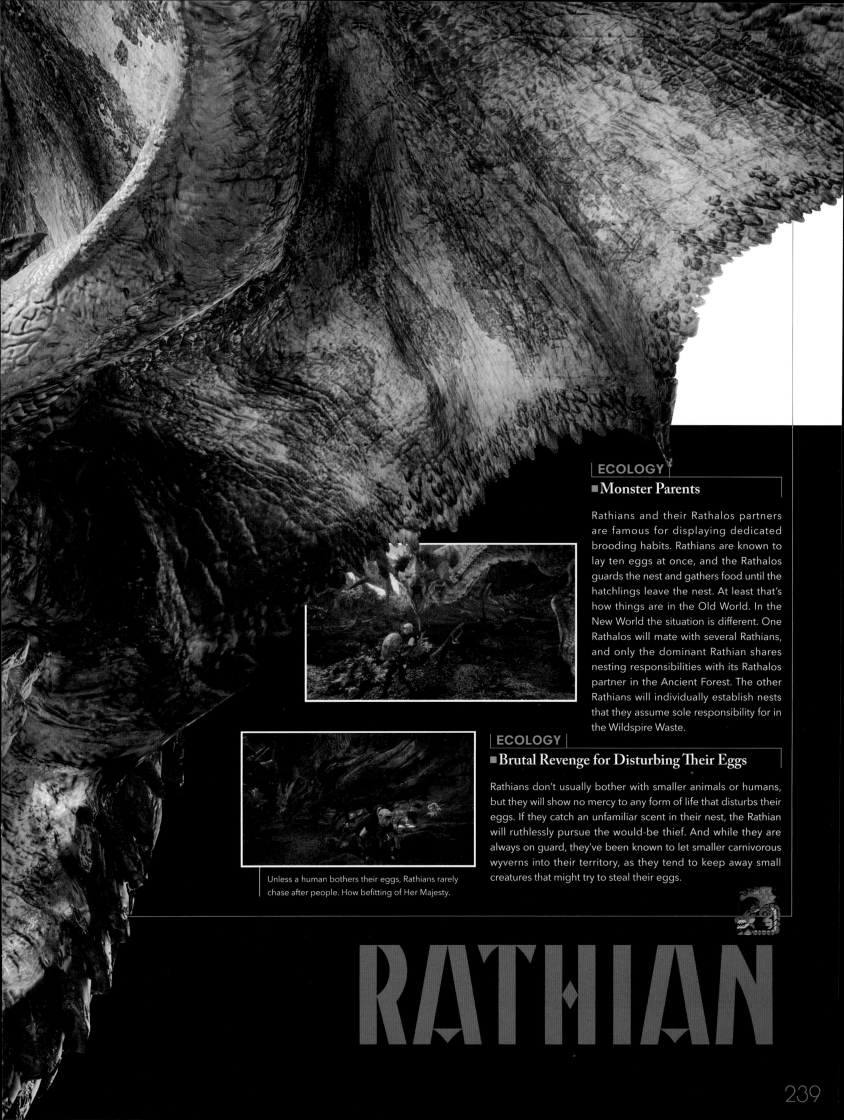

ECOLOGY
■ Monster Parents

Rathians and their Rathalos partners are famous for displaying dedicated brooding habits. Rathians are known to lay ten eggs at once, and the Rathalos guards the nest and gathers food until the hatchlings leave the nest. At least that's how things are in the Old World. In the New World the situation is different. One Rathalos will mate with several Rathians, and only the dominant Rathian shares nesting responsibilities with its Rathalos partner in the Ancient Forest. The other Rathians will individually establish nests that they assume sole responsibility for in the Wildspire Waste.

ECOLOGY
■ Brutal Revenge for Disturbing Their Eggs

Rathians don't usually bother with smaller animals or humans, but they will show no mercy to any form of life that disturbs their eggs. If they catch an unfamiliar scent in their nest, the Rathian will ruthlessly pursue the would-be thief. And while they are always on guard, they've been known to let smaller carnivorous wyverns into their territory, as they tend to keep away small creatures that might try to steal their eggs.

Unless a human bothers their eggs, Rathians rarely chase after people. How befitting of Her Majesty.

RATHIAN

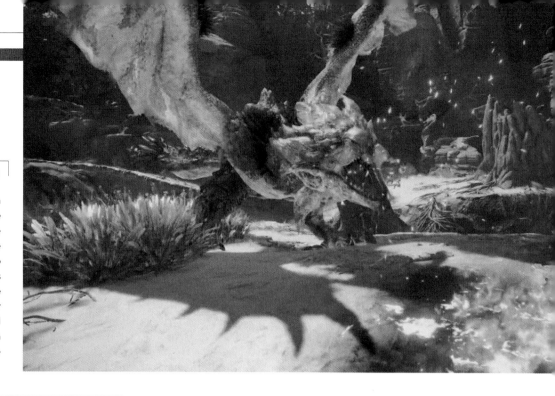

ECOLOGY

■ Traveling Through the Desert Alone

As of this writing, Rathian nests have been confirmed in the Ancient Forest and Wildspire Waste. The Rathians that populate the Wildspire Waste are individuals who have failed to become a Rathalos's alpha female. They are forced to guard their nests by themselves, so it goes without saying that Wildspire Waste Rathians are significantly more vigilant of their nests than their Ancient Forest counterparts. This is also believed to have an effect on the relationship between Wildspire Waste Rathians, causing them to be confrontational with their own species.

Rathian nests are made from decaying plant life and other bits and pieces. Nutrients from these materials seep out over time and accumulate as a flammable oil. Rathians have been known to intentionally set fire to this oil in order to fend off smaller pesky monsters.

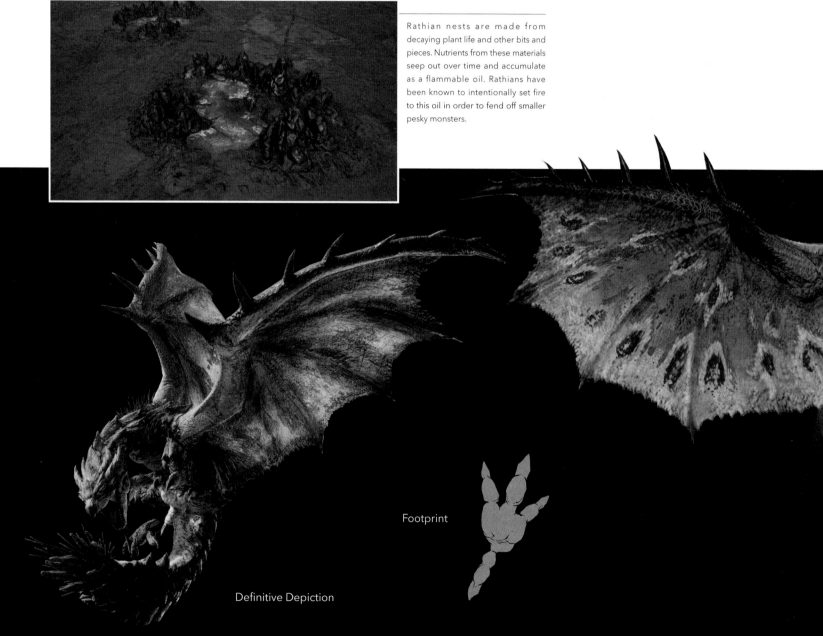

Footprint

Definitive Depiction

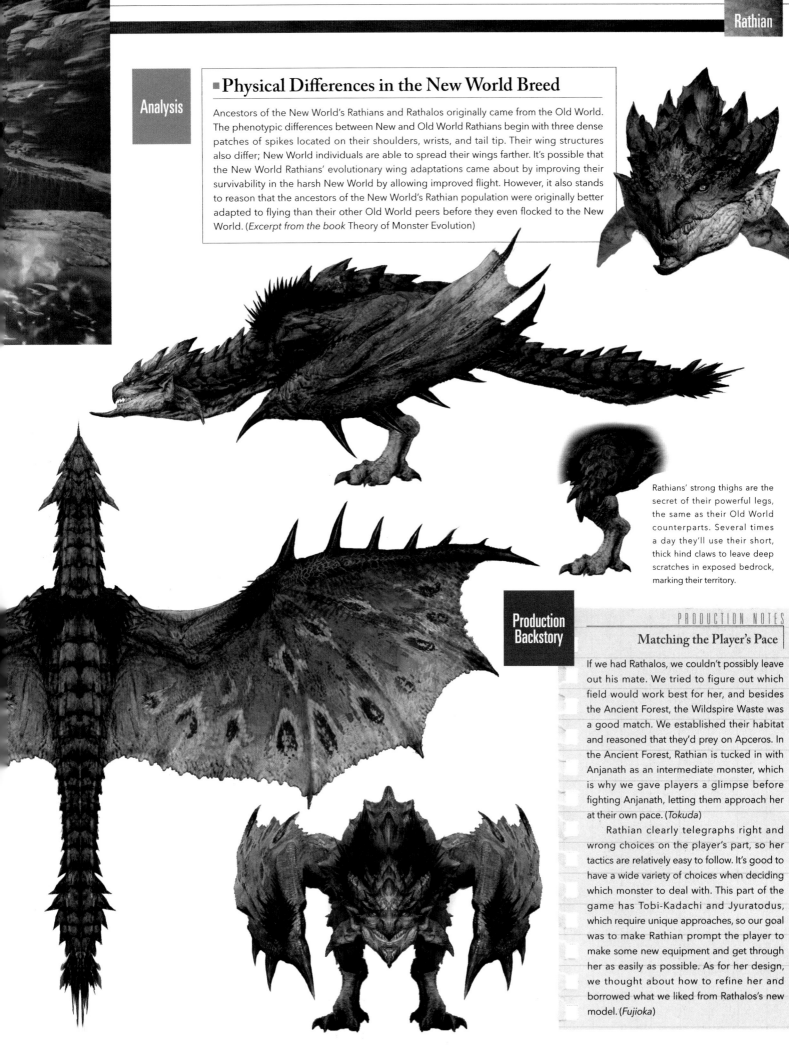

Analysis

■ Physical Differences in the New World Breed

Ancestors of the New World's Rathians and Rathalos originally came from the Old World. The phenotypic differences between New and Old World Rathians begin with three dense patches of spikes located on their shoulders, wrists, and tail tip. Their wing structures also differ; New World individuals are able to spread their wings farther. It's possible that the New World Rathians' evolutionary wing adaptations came about by improving their survivability in the harsh New World by allowing improved flight. However, it also stands to reason that the ancestors of the New World's Rathian population were originally better adapted to flying than their other Old World peers before they even flocked to the New World. (*Excerpt from the book* Theory of Monster Evolution)

Rathians' strong thighs are the secret of their powerful legs, the same as their Old World counterparts. Several times a day they'll use their short, thick hind claws to leave deep scratches in exposed bedrock, marking their territory.

Production Backstory

PRODUCTION NOTES

Matching the Player's Pace

If we had Rathalos, we couldn't possibly leave out his mate. We tried to figure out which field would work best for her, and besides the Ancient Forest, the Wildspire Waste was a good match. We established their habitat and reasoned that they'd prey on Apceros. In the Ancient Forest, Rathian is tucked in with Anjanath as an intermediate monster, which is why we gave players a glimpse before fighting Anjanath, letting them approach her at their own pace. (*Tokuda*)

Rathian clearly telegraphs right and wrong choices on the player's part, so her tactics are relatively easy to follow. It's good to have a wide variety of choices when deciding which monster to deal with. This part of the game has Tobi-Kadachi and Jyuratodus, which require unique approaches, so our goal was to make Rathian prompt the player to make some new equipment and get through her as easily as possible. As for her design, we thought about how to refine her and borrowed what we liked from Rathalos's new model. (*Fujioka*)

241

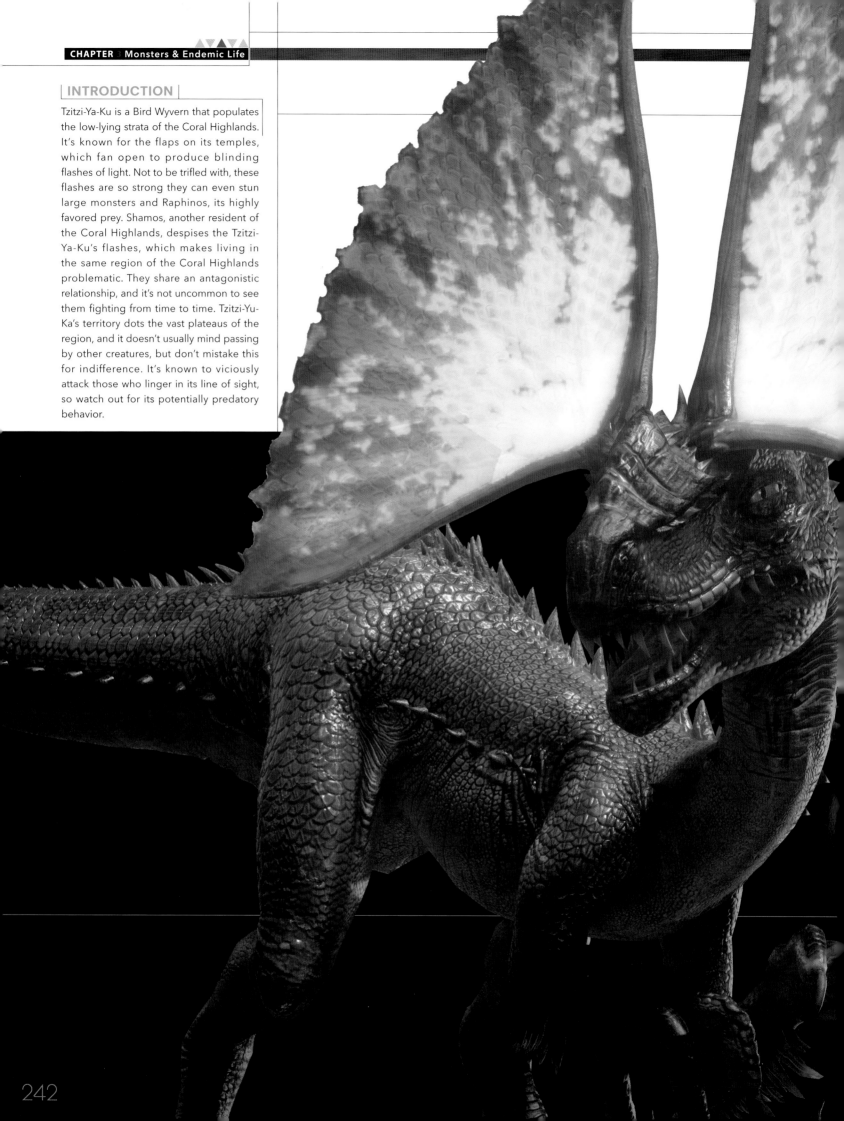

| INTRODUCTION |

Tzitzi-Ya-Ku is a Bird Wyvern that populates the low-lying strata of the Coral Highlands. It's known for the flaps on its temples, which fan open to produce blinding flashes of light. Not to be trifled with, these flashes are so strong they can even stun large monsters and Raphinos, its highly favored prey. Shamos, another resident of the Coral Highlands, despises the Tzitzi-Ya-Ku's flashes, which makes living in the same region of the Coral Highlands problematic. They share an antagonistic relationship, and it's not uncommon to see them fighting from time to time. Tzitzi-Yu-Ka's territory dots the vast plateaus of the region, and it doesn't usually mind passing by other creatures, but don't mistake this for indifference. It's known to viciously attack those who linger in its line of sight, so watch out for its potentially predatory behavior.

Bird Wyvern
Tzitzi-Ya-Ku

MONSTER DATA

▶ Full length: approx. 894.04 cm
▶ Full height: approx. 351.53 cm
▶ Foot size: approx. 99 cm
▶ Known habitat: Coral Highlands

The Three Scholars

We've heard talk of the Coral Highlands' Tzitzi-Ya-Ku, how it emits flashes of light to blind its enemies. We must know the mechanics involved. Field team, please hunt one for our studies!

ECOLOGY
■ Sharp Moves with Sharper Claws

Of all the Bird Wyverns in the New World, Tzitzi-Ya-Ku's claws are the longest and sharpest. Besides shredding prey, they also help the Bird Wyvern navigate the Coral Highland's uneven landscape. When hunting high and low, Tzitzi-Ya-Ku skillfully use their claws like picks to climb vertical cliff faces.

Legwork and sharp claws help Tzitzi-Ya-Ku overcome cliffs they can't clear with a jump.

ECOLOGY
■ Extremely Powerful Legs

Tzitzi-Ya-Ku's arsenal doesn't end with its claw and flashy flaps. Its extraordinary long-distance jumping also allows it to head off dazed prey attempting to escape. Gaining grip on the ground with its claws, Tzitzi-Ya-Ku can push off of the ground with its full body weight for maximum speed and distance to finish off a target.

TZITZI-YA-KU

Normal Conditions

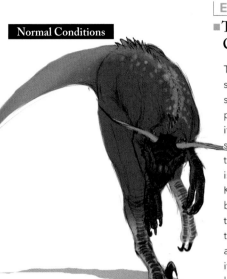

■ The Entertainers of the Coral Highlands

Tzitzi-Ya-Ku's forehead contains a specialized organ that stores a unique substance possessing the ability to produce a flash. Tzitzi-Ya-Ku stretches out its luminescent flaps and stimulates the substance, causing it to be reflected off of the flaps for a powerful flash. This ability is particularly helpful when the Tsitzi-Ya-Ku hunts Raphinos. The powerful flash blinds the airborne Raphinos, sending them plummeting to the ground. As to the nature of this unique substance, there are several ideas related to its origin, and it may derive from the Tzitzi-Ya-Ku itself, luminescent coral, the Flying Meduso, or some other life-form.

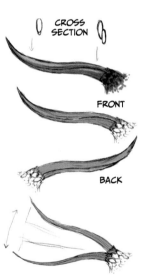

CROSS SECTION

FRONT

BACK

These light-emitting flaps, which resemble antennae when closed, are controlled by two bones that act as a single unit, spreading them like wings.

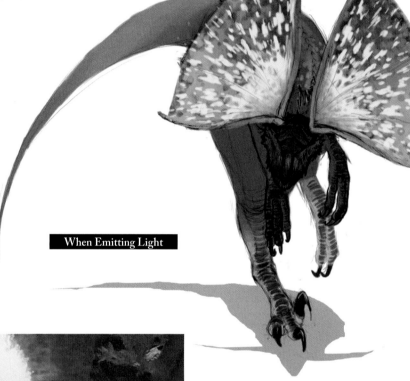

When Emitting Light

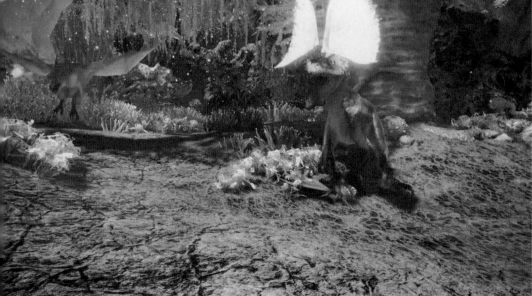

Analysis

■ Seashell Collector: Tzitzi-Ya-Ku

The walls of Tzitzi-Ya-Ku's nest are artistically decorated with beautiful shells that the monster has collected from around the Coral Highlands. The luster on each shell can reflect the Tzitzi-Ya-Ku's flash and diffuse the effect throughout its nest. There were reports of a hunter who was on the cusp of victory when they were blinded by a flash and suffered an unexpected retaliation… While this tricky quirk suggests Tzitzi-Ya-Ku displays such decorative behavior for defensive purposes, another explanation suggests that the decorations are a form of competition within the species. The decorative nest may in fact be an appeal to female Tzitzi-Ya-Ku as a physical representatiion of a male individual's strength. (*Excerpt from a biologist's paper*)

Definitive Depiction

Footprint

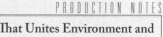

ECOLOGY

■ Vivid Coloring Aids Blending into Coral

The Tzitzi-Ya-Ku's lustrous coloration comes from the vivid purple scales covering its body. Although at first glance Tzitzi-Ya-Ku might seem like it would stand out, it blends right in with the colorful topography of the Coral Highlands—a superb example of evolution fitting an environment. The largest benefits of this coloring are reaped when Tzitzi-Ya-Ku sunbathes or sleeps. When defenseless, this monster relies on confusion to deal with enemies and prevent itself from being attacked.

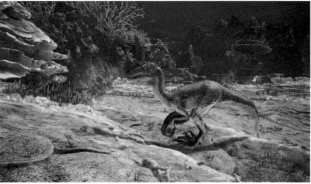

Tzitzi-Ya-Ku's scales will reflect different colors, but even that doesn't ruin its camouflage in the vivid landscape of the Coral Highlands.

Production Backstory

PRODUCTION NOTES

A Flash That Unites Environment and Playfulness in the Coral Highlands

Tzitzi-Ya-Ku was conceived of as a predator that interferes with the playing field but can also be useful to hunters. Our theme for the region is based on undersea life, which is where the bioluminescence concept came from. We tied that into how Tzitzi-Ya-Ku's flashes work; they drop Wingdrakes, but they also work well in concert with its behavioral ecology and the gameplay. (*Tokuda*)

We wanted Tzitzi-Ya-Ku to be a grounded monster. That goes for its flash too, which is different from past iterations because it doesn't affect the whole field. We made it possible for the player to identify safe areas because the zone in front of the ear flaps lights up while everything behind the monster is safe. We added shells to its nest to increase the flash's effect, so it's a challenge on its home turf. Unfortunately, it was too late when we realized that by the time most players let Tzitzi-Ya-Ku retreat that far, its ear flaps are already broken. Bit of a miscalculation on our part. [laughs] (*Fujioka*)

Extended **World Gallery**
Unidentified Creatures Log [II]

Here are some more intriguing research records gathered from various sources. This time we're looking at Tobi-Kadachi, Anjanath, and Tzitzi-Ya-Ku. While they're all illustrated examples of ecological conjecture, the most surprising are most certainly the Anjanath-like individuals. A word of caution before you pore over these findings—these illustrations are from unconfirmed reports, so utilize them at your own risk.

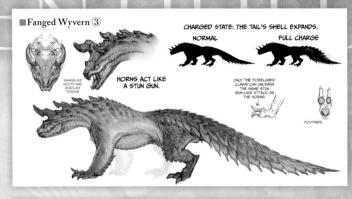
■ Fanged Wyvern ③

CHARGED STATE: THE TAIL'S SHELL EXPANDS.

NORMAL FULL CHARGE

HORNS ACT LIKE A STUN GUN.

SNAKELIKE MOUTH AND BIRDLIKE TONGUE

ONLY THE FORELIMBS' CLAWS CAN UNLEASH THE SAME STUN GUN-LIKE ATTACK AS THE HORNS.

FOOTPADS

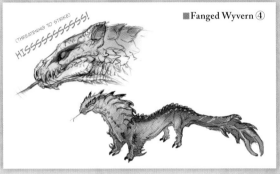
■ Fanged Wyvern ④

(THREATENING TO STRIKE)
HISSSSSSSSSSSS!

■ Fanged Wyvern ①

DISCHARGE

■ Fanged Wyvern ②

■ Fanged Wyvern ⑤

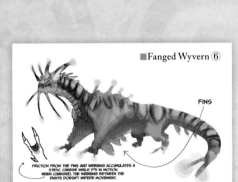
■ Fanged Wyvern ⑥

FINS

FRICTION FROM THE FINS AND WEBBING ACCUMULATES A STATIC CHARGE WHILE IT'S IN MOTION. WHEN CHARGED, THE WEBBING BETWEEN THE DIGITS DOESN'T IMPEDE MOVEMENT.

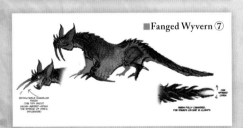
■ Fanged Wyvern ⑦

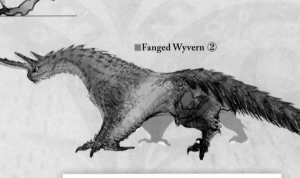

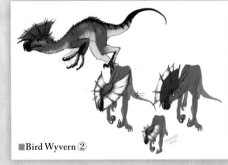
■ Bird Wyvern ②

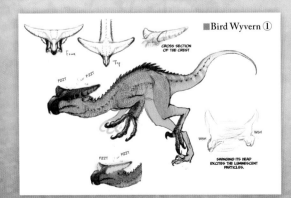
■ Bird Wyvern ①

CROSS SECTION OF THE CREST

SWINGING ITS HEAD EXCITES THE LUMINESCENT PARTICLES.

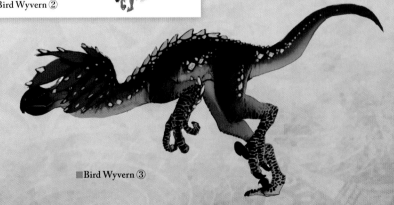
■ Bird Wyvern ③

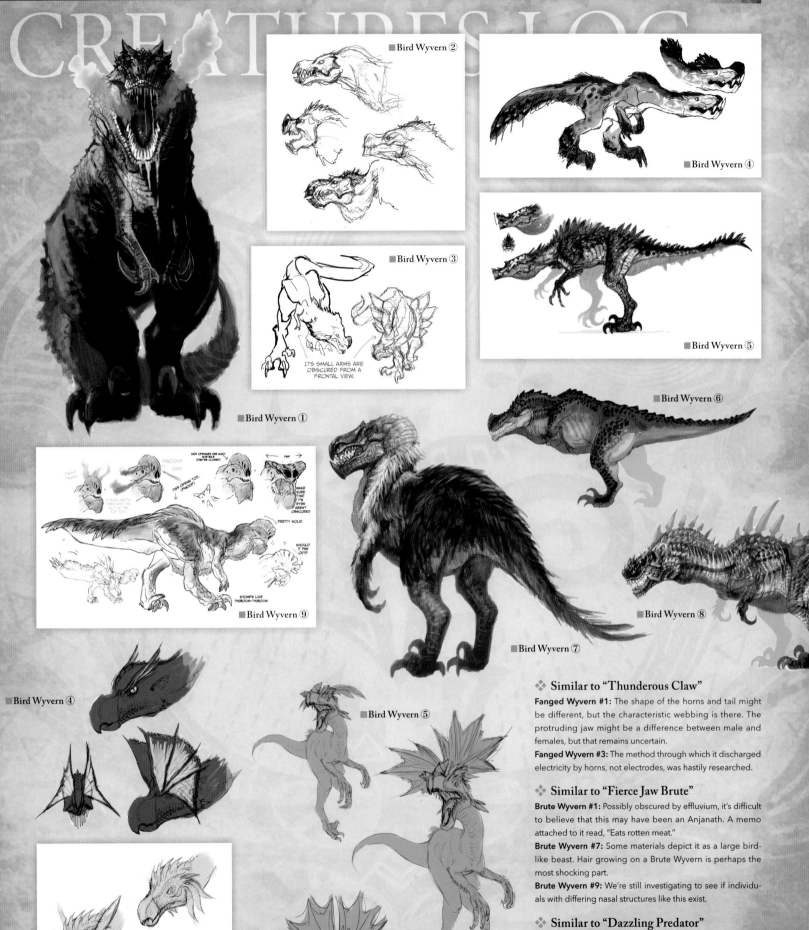

CREATURES LOG

■ Bird Wyvern ②

■ Bird Wyvern ④

■ Bird Wyvern ③

ITS SMALL ARMS ARE OBSCURED FROM A FRONTAL VIEW.

■ Bird Wyvern ⑤

■ Bird Wyvern ①

■ Bird Wyvern ⑥

■ Bird Wyvern ⑨

■ Bird Wyvern ⑦

■ Bird Wyvern ⑧

■ Bird Wyvern ④

■ Bird Wyvern ⑤

■ Bird Wyvern ⑥

❖ Similar to "Thunderous Claw"

Fanged Wyvern #1: The shape of the horns and tail might be different, but the characteristic webbing is there. The protruding jaw might be a difference between male and females, but that remains uncertain.

Fanged Wyvern #3: The method through which it discharged electricity by horns, not electrodes, was hastily researched.

❖ Similar to "Fierce Jaw Brute"

Brute Wyvern #1: Possibly obscured by effluvium, it's difficult to believe that this may have been an Anjanath. A memo attached to it read, "Eats rotten meat."

Brute Wyvern #7: Some materials depict it as a large bird-like beast. Hair growing on a Brute Wyvern is perhaps the most shocking part.

Brute Wyvern #9: We're still investigating to see if individuals with differing nasal structures like this exist.

❖ Similar to "Dazzling Predator"

Bird Wyvern #2: The luminescent organ emits a faint light to which bacteria on the monster's crest react, amplifying the effect… Or at least that's how it appears some tried to explain the Tzitzi-Ya-Ku's flash effect at one point.

Bird Wyvern #3: Seems like it might have inhabited the Ancient Forest… The way its crest covers and exposes its shiny head seems quite unfortunate.

INTRODUCTION

Paolumu is a Flying Wyvern that feasts on land-coral eggs; this monster's territory lies in the verdant central plateaus of the Coral Highlands. As its prey differs from that of other large predatory monsters in the same region, Paolumu doesn't normally battle over resources and exhibits a comparatively placid personality. This is a rare specimen of Flying Wyvern whose body is covered in a fluffy down, which accentuates its already charming facial features. This makes the Paolumu something akin to a lovable mascot of the Coral Highlands, albeit a mascot that will bare its fangs and rain suffering on anything that brings it harm. Parts of its skin contains a rubbery substance. Thanks to this substance, Paolumu can expertly wield its elastic neck pouch or tail to deal with an enemy. This same material is prized as an ingredient for specialized tool and arms crafting.

ECOLOGY

▪ Devouring Eggs in the Coral Highlands

Of all the large monsters that inhabit the Coral Highlands, only Paolumus feed on land-coral eggs as their main source of sustenance. Their feeding behavior is truly a sight to behold. When a Paolumu discovers coral eggs floating in the air, it will draw the surrounding air into its mouth, bringing the eggs along with it for consumption. While feeding, they maintain low-altitude flight and release the unnecessary abundance of air from their mouths before repeating the same routine until their appetite is sated.

Paolumus usually feed like this once or twice a day. In order to properly maintain their large frame on a diet of such tiny eggs, Paolumus usually spend a substantial amount of time feeding.

PAOLUMU

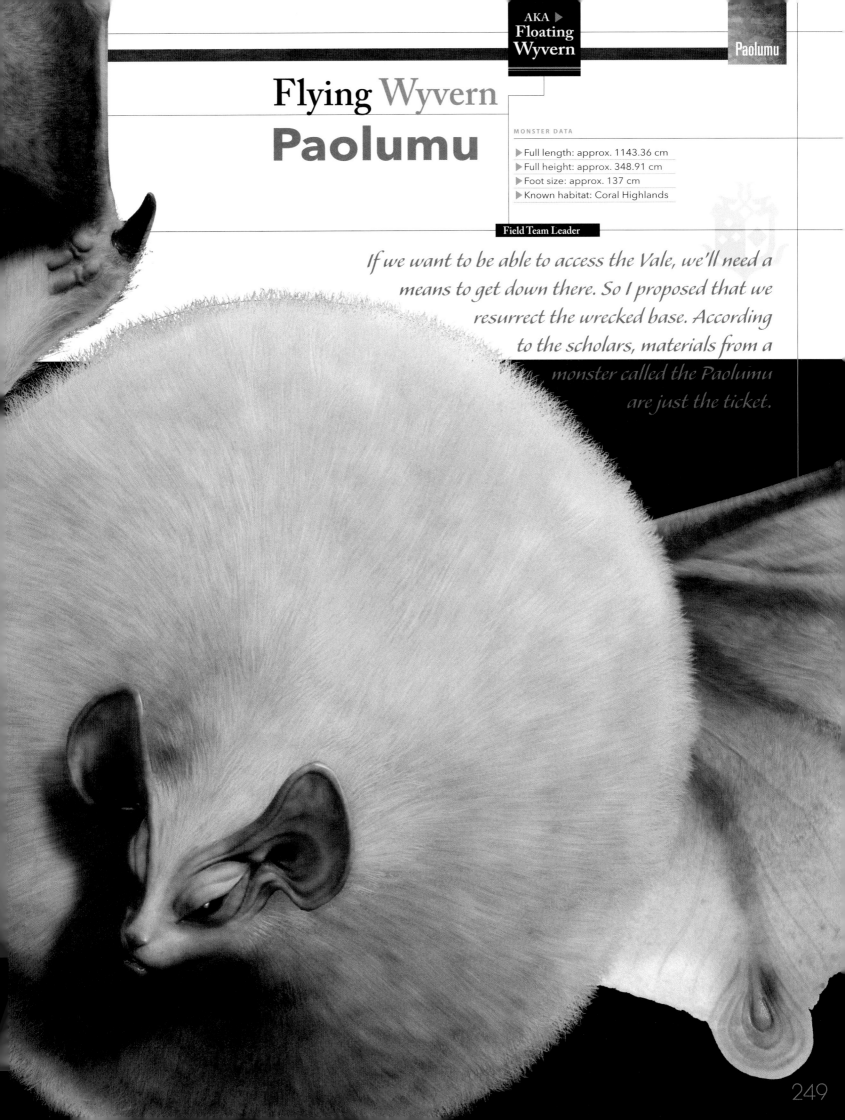

Flying Wyvern
Paolumu

MONSTER DATA

▶ Full length: approx. 1143.36 cm
▶ Full height: approx. 348.91 cm
▶ Foot size: approx. 137 cm
▶ Known habitat: Coral Highlands

Field Team Leader

If we want to be able to access the Vale, we'll need a means to get down there. So I proposed that we resurrect the wrecked base. According to the scholars, materials from a monster called the Paolumu are just the ticket.

249

ECOLOGY

■ Inflating Its Dewlap and Dancing Through the Air

The Paolumu's neck pouch is unique among all known monsters. It's highly elastic, and by sucking in air the Paolumu can expand the pouch to a diameter greater than that of its own body. The constant upwelling winds—which blow from the ground up—allow the Paolumu to ride the winds when its neck pouch is full. Additionally, by expelling stored air, Paolumu can change course at will, showing refined control over its aerial movement. The monster does not seem to inflate the neck pouch while it is on the ground or while it is airborne unless it is threatened. The neck pouch's inflated state also seems to be an attempt by the Paolumu to appear larger and more threatening to its enemies.

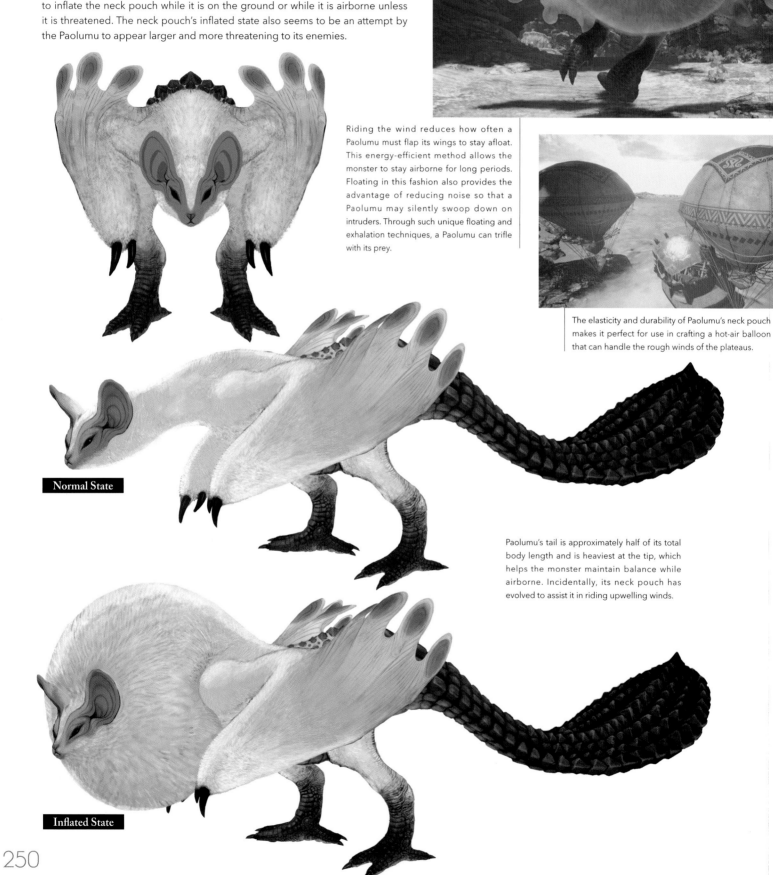

Riding the wind reduces how often a Paolumu must flap its wings to stay afloat. This energy-efficient method allows the monster to stay airborne for long periods. Floating in this fashion also provides the advantage of reducing noise so that a Paolumu may silently swoop down on intruders. Through such unique floating and exhalation techniques, a Paolumu can trifle with its prey.

The elasticity and durability of Paolumu's neck pouch makes it perfect for use in crafting a hot-air balloon that can handle the rough winds of the plateaus.

Paolumu's tail is approximately half of its total body length and is heaviest at the tip, which helps the monster maintain balance while airborne. Incidentally, its neck pouch has evolved to assist it in riding upwelling winds.

Normal State

Inflated State

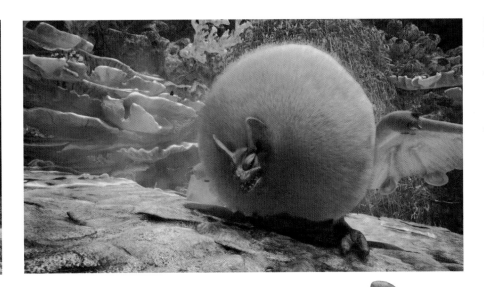

ECOLOGY

■ Using Stored Air as a Weapon

As a master of manipulating air, Paolumu uses its air-filled neck pouch as a weapon against enemies and excels at expelling air just as well as it inhales it. The force of air expelled by Paolumu is so powerful that it can even hinder the movement of enemies and territorial invaders. Even should the air run out, the Paolumu simply needs to inhale more to replace its stock. Given its unlimited nature, one might say that air is a Paolumu's most powerful weapon.

Firing compressed air like a bullet to send an opponent tumbling is one of Paolumu's specialties.

Definitive Depiction

Footprint

ECOLOGY

■ Large Ears for Echolocation

While Paolumu's ears are quite large, its sense of hearing is not particularly well developed. Screamer pods don't seem to affect Paolumu, which suggests that its ears are not adapted for ambient noise as much as they are for catching ultrasound. Paolumu navigates the complicated and tangled Coral Highlands with ultrasonic waves emitted from its mouth. The monster's large ears detect the echoes of these waves, allowing it to avoid obstacles by accurately determining their distance and location. At least, this is our best conjecture as to how Paolumu can move through the twisting land coral with such ease.

ECOLOGY

■ Repelling Enemies with its Tough Rubbery Tail

The Paolumu's large tail is flat and quite hard compared to the rest of its soft body. The easiest way for an airborne Paolumu to attack an enemy on the ground is with its tail, so it's no surprise that Paolumu tails have evolved to be quite long and tough. A Paolumu can easily change the shape of its rubbery tail by balling it into a hard, rounded shape. Paolumu can launch precise strikes on opponents, smacking them with the sharp protrusions on the dorsal side of the tail. The combination of a Paolumu's erratic flight pattern and its tail attacks are exceedingly difficult to deal with in battle not only for hunters, but for other monsters as well.

Here the Paolumu can be seen whirling around for a whiplike tail attack. The vigorous movement causes the tail to stretch, extending the attack's range.

Tail: Cross Section

RELATIVE SIZE OF THE TAIL FROM THE SIDE

Analysis

■ Luring Enemies to Advantageous Ground

Where a Paolumu rests to catch its breath from a battle is actually different from where it roosts for sleep. Generally, Paolumus roost in the lower region of Area 10, but if they're trying to recover from battle wounds, you'll find them sleeping in Area 9. This area is a series of large coral domes whose ceilings are dotted with holes. These holes are just big enough for the Paolumu to fit through, and by flying in and out of them while concealing its flight path from the unfortunate opponent, a Paolumu can launch silent strikes on a confused target. The Paolumu is likely aware that this area is advantageous to its abilities and willingly leads would-be assailants here for the very purpose of putting them at a disadvantage in battle. (*From a certain researcher's notes*)

ECOLOGY

■Fur-Covered Wings and Sharp Claws

The surface area of Paolumu's wings is on the smaller end of the scale. While quite difficult to spot, there are also digit-like structures on the interior of each wing. This tells us that the Paolumu's wings were originally arms that evolved into wings alongside the development of its neck pouch.

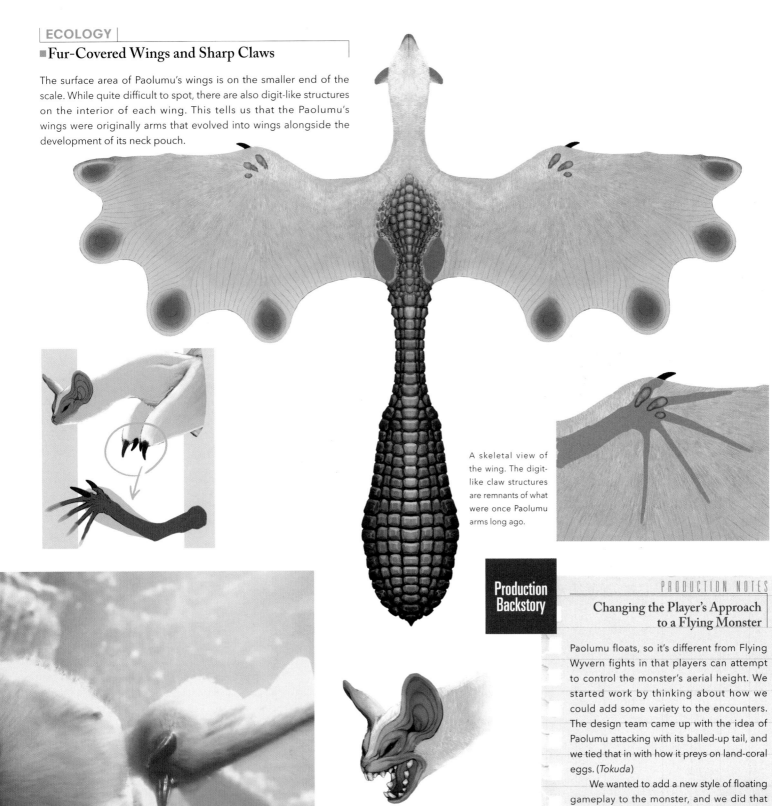

A skeletal view of the wing. The digit-like claw structures are remnants of what were once Paolumu arms long ago.

Normally its large ears and eyes are quite charming, but when in battle or on guard it will bare its fangs, revealing a chilling expression.

Production Backstory

PRODUCTION NOTES

Changing the Player's Approach to a Flying Monster

Paolumu floats, so it's different from Flying Wyvern fights in that players can attempt to control the monster's aerial height. We started work by thinking about how we could add some variety to the encounters. The design team came up with the idea of Paolumu attacking with its balled-up tail, and we tied that in with how it preys on land-coral eggs. (*Tokuda*)

We wanted to add a new style of floating gameplay to the monster, and we did that with how it changes shape by blowing up like a balloon. On the planning side, we made it harder on ourselves by covering it in fur and trying to make it as adorable as possible. Unfortunately, contrary to how it appears in silhouette, its facial features make it look like a rodent and its eyes are a bit creepy. [laughs] As for how it attacks with its tail, the planning and design teams worked on that together. In order for the tail to be tough when balled up and flexible when flat, we went with a rubber-based approach. (*Fujioka*)

Fanged Wyvern
Great Girros

MONSTER DATA

▶ Full length: approx. 1053.15 cm
▶ Full height: approx. 273.04 cm
▶ Foot size: approx. 109 cm
▶ Known habitat: Rotten Vale

A Wincing Surveyor

*I was work-k-king the Rotten V-Vale when a
G-G-Great Girros z-z-zapped me from behind.
I g-got out in one piece, but I'm still all t-t-
tingly... Finish the j-j-job for me? P-please!*

INTRODUCTION

This agile Fanged Wyvern lives in the Rotten Vale and typically leads a pack of Girros. As one might gather from a glimpse at its sizable fangs, they're deadly weapons that can inject victims with a paralytic toxin. Its main source of food is the bodies of monsters that have fallen into the Vale from the Coral Highlands. Known for leading a small patrol of Girros, a Great Girros prowls the effluvium-filled reaches of the Rotten Vale searching for carrion to devour. When hunting live prey in packs, Great Girros will take the lead and attempt to paralyze a target, allowing the Girros to take it down. On the other hand, a Great Girros can also recognize when it has met its match and will retreat with discerning haste upon encountering superior monsters.

GREAT GIRROS

| ECOLOGY |
■ A Unique Adaptation for Wading Through Effluvium

Whenever a monster falls into the Rotten Vale from the Coral Highlands or an Elder Dragon possessing massive energy dies, the concentration of effluvium in the Vale increases. While Great Girros typically breathes through its mouth or nose, whenever the effluvium concentration increases, Great Girros makes use of a set of gills that function as respiratory organs. These gills are an evolutionary adaptation lined with cilia that filter the air by eliminating effluvium and allowing the Great Girros to live in this harsh environment.

Leading its pack, the Great Girros patrols its effluvium-covered territory. Its gills allow it to spend a great deal of time in the dangerous region.

ECOLOGY

■Hunting Prey with Paralyzing Fangs

The Great Girros's upper fangs are certainly one of its most striking features. These venomous fangs are connected to powerful toxin-secreting glands. Through its venomous bite, Great Girros can inject a target with large quantities of the toxin while in conflict. If enough paralytic agent is injected into a target, it will fall down paralyzed, becoming the Great Girros's next meal.

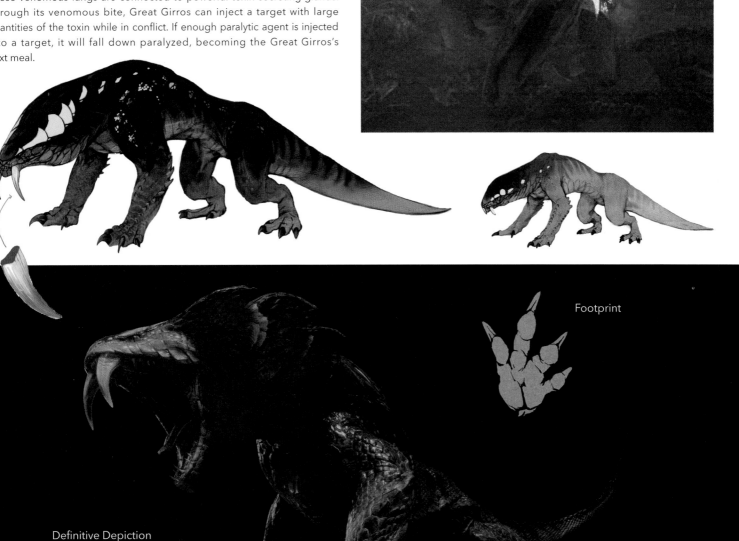

Footprint

Definitive Depiction

■A Born Leader at Finding Carcasses

Analysis

Many monsters of the Rotten Vale feed on the bodies of creatures that have fallen from the Coral Highlands. Great Girros is no different, and it often crosses paths with other monsters while scavenging for food. In such cases, the Great Girros often avoids conflict by retreating of its own volition. This behavior of avoiding reckless conflict is believed to be rooted in the Great Girros's ability to discern the threat a monster presents. This seemingly meek trait could simply be due to the high frequency of plummeting carcasses and the inefficiency of fighting over a single carcass with such abundant prey available. No matter the reason, don't consider for even a moment that a Great Girros avoids conflict out of concern for the safety of its Girros subordinates. (*From a researcher's notes*)

ECOLOGY
■ Calling Girros with Its Gills

Living in such a harsh environment means that Great Girros must move efficiently in packs to ensure successful hunts. After spotting prey, a Great Girros will bear down on a target and vibrate its gills to produce a call. Hearing this command, the Girros pack members will simultaneously join the fray. To finish things off, the Great Girros bites into its prey, putting an end to the struggle and completing the hunt. The Great Girros's high-pitched call can be heard from a great distance and will even gather Girros from outside its own pack that happen to be prowling in the area. The military-like efficiency with which a Great Girros's hunts are carried out is worth seeing at least once, but we do suggest you watch out for that call...if you're what they happen to be hunting.

Girros surround their prey and cut off any chance of escape. When signaled by the Great Girros, they will lunge at their prey in unison.

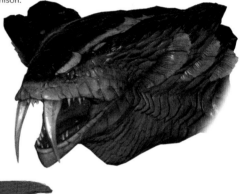

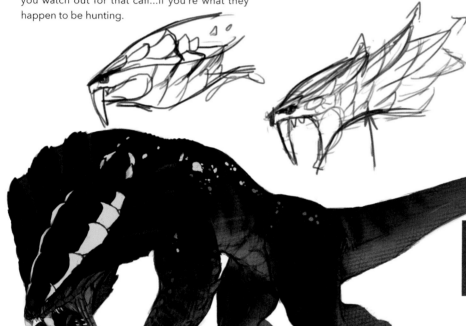

Production Backstory

PRODUCTION NOTES

Prowling Leader of the Rotten Vale Armed with a Pack and Paralytic Venom

Great Girros and Odogaron break down the carcasses that have fallen from the Coral Highlands. Only Great Girros leads a pack, and in that sense it's kind of like a hyena. While the Great Girros may be the weakest Rotten Vale monster, it needs to be tough to survive, so that's why we gave it paralytic venom. Take Pukei-Pukei's poison or Tzitzi-Ya-Ku's flash—by giving negative status effect abilities to weaker monsters, we're encouraging players to hunt and ultimately utilize their abilities for dealing with more challenging monsters. By facilitating defeating an easy opponent like Great Girros, the level design allows the player to gain a strategic advantage later on by making a paralytic weapon. (*Tokuda*)

It's a rather simple monster design. The gameplay involves a pack that takes commands, so we came up with the vibratory, organ concept. We already had the design for the Girros, so we simply brought the Girros up to the "great" level. It has a very strong immune system and therefore is not affected by the effluvium. (*Fujioka*)

ECOLOGY
■ Vibratory-Organ Use in Courtship

The sound emitted from a Great Girros's gills originates in a specialized organ. These organs are very well developed, and females will choose a mate based on the appeal of courtship calls made with said organ. Males that fight each other will often target the gills, which is why a male Great Girros's gills are almost always covered in fresh wounds.

Brute Wyvern
Radobaan

INTRODUCTION

Some call the Brute Wyvern Radobaan "Bone Gyre Brute" because of how it uses its large jaw to smash its enemies. Radobaans feed on the bones of carcasses scattered throughout the Rotten Vale and can almost always be seen covered in the bones of other creatures. The bones serve both defensive and offensive purposes and are an important part of this monster's unusual behavior. Due to not having any organs to filter effluvium, Radobaans may often be found in the upper reaches of the Rotten Vale. The Radobaan is a large, sluggish monster, but after curling its body into a ball, it can roll great distances in a short period of time. Some argue that the narrow paths in the upper regions of the Rotten Vale were carved out by the Radobaan. Despite appearances, Radobaans are actually extremely gentle and pay no mind to creatures that don't harm them; they don't even seem to hold grudges.

MONSTER DATA

▶ Full length: approx. 1803.47 cm
▶ Full height: approx. 899.52 cm
▶ Foot size: approx. 194 cm
▶ Known habitat: Rotten Vale

ECOLOGY

■ Devouring Bones and Making Them into Armor

Covered with the carrion of countless bodies, the Rotten Vale is overrunning with bacteria. Investigative research from recent years has led to the discovery of new forms of rare bacteria that break down monsters' inorganic material. These same studies have revealed that the bone-eating Radobaan obtains the majority of its nutrition from these bacteria and soft bone tissue.

RADOBAAN

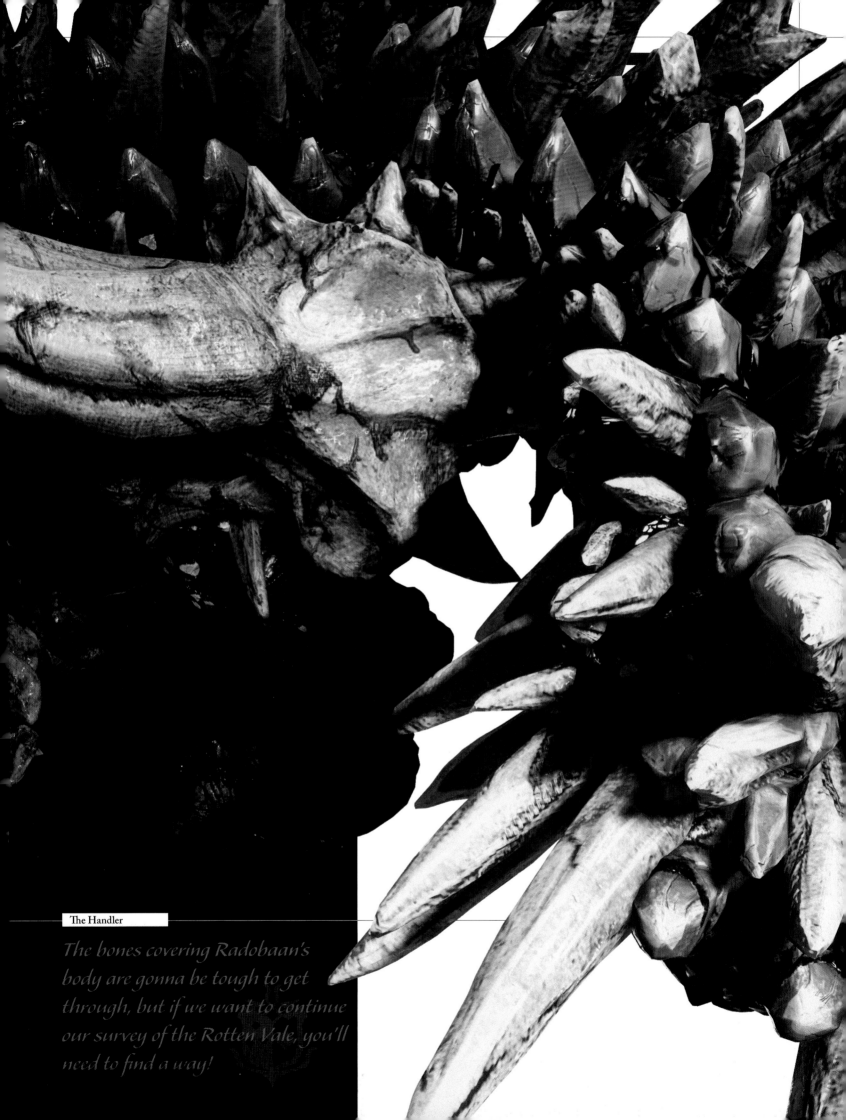

The Handler

The bones covering Radobaan's body are gonna be tough to get through, but if we want to continue our survey of the Rotten Vale, you'll need to find a way!

ECOLOGY

■ Adhering Bone to Skin with Tar

Radobaan's most striking form is when it is covered in a hard layer of bones, but the monster's actual skin has a soft, dentin-like quality. The pliability of its skin is what allows Radobaan to wheel about the Vale. In order to protect this soft skin, the Radobaan covers its body in tar before armoring itself by rolling about in a sea of bones. Not only an important form of defense against belligerent intruders, the careful arrangement of bones on a Radobaan seems to play a role in how it attracts copulation partners.

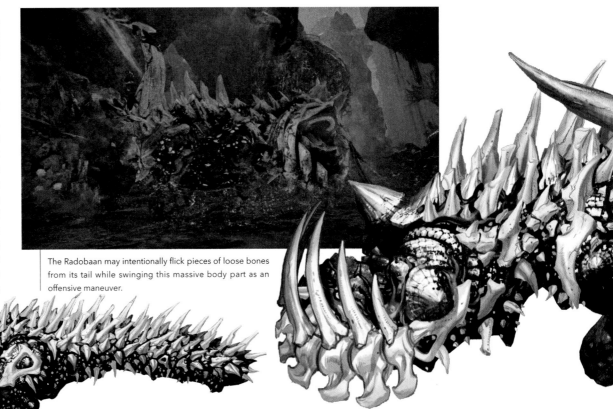

The Radobaan may intentionally flick pieces of loose bones from its tail while swinging this massive body part as an offensive maneuver.

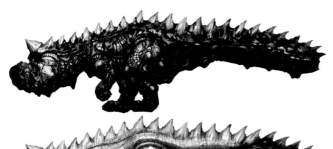

Radobaan may travel great distances quickly by rolling. Rarely, while moving about in such a fashion the bones and tar may rub off.

ECOLOGY

■ Utilizing Large Bones for Bold and Clever Rolling

One of the many uses for the Radobaan's bone coating is controlling its movement while rolling. Radobaan's rolling speed is much faster than its bipedal movement, yet it maintains fine control of its movement through traction gained by its spikelike bone armor. Note the exceptionally large horns adhered to the base of its legs. When rolling, Radobaan drives these bones deep into the ground to maintain balance while making hairpin turns. This is why Radobaan specifically chooses large, sturdy bones to adhere to its legs.

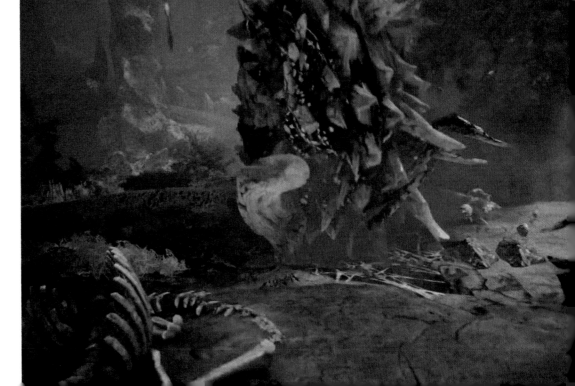

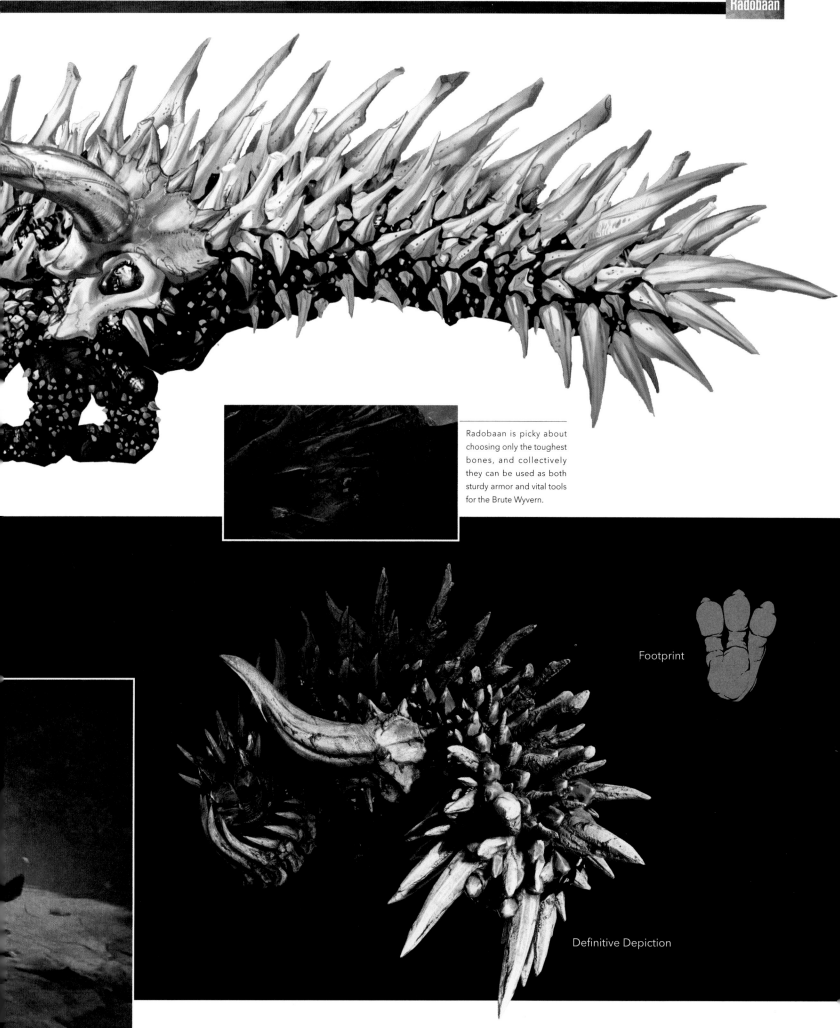

Radobaan is picky about choosing only the toughest bones, and collectively they can be used as both sturdy armor and vital tools for the Brute Wyvern.

Footprint

Definitive Depiction

261

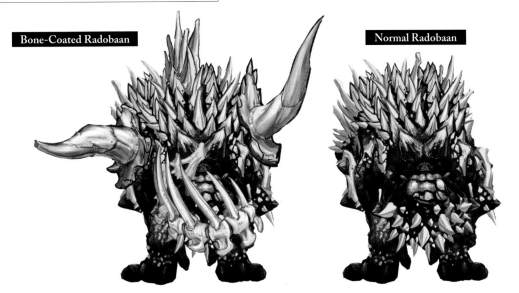

Bone-Coated Radobaan

Normal Radobaan

ECOLOGY

■ Roles for Each Region of Adhered Bones

Just as the bones at the base of its legs have a specific purpose, the bones in each region of Radobaan's body serve a specific role. The spiked bones along Radobaan's back allow it to roll straight. The bones located around its jaw increase the range of Radobaan's smashing jaw attacks. While at first glance it might seem that the Radobaan attaches bones to itself at random, that's simply not the case. Each and every bone is chosen and placed with instinctual intent.

ECOLOGY

■ Using Bacterially Generated Sleeping Gas

During digestion, the bacteria and the soft tissue of bones ingested by Radobaan react to create a gas with sleep-inducing properties. If severely wounded in a conflict, the Radobaan will expel this gas as a last resort to put its assailant to sleep.

Radobaan aren't usually seen fighting with other monsters of the Rotten Vale. Perhaps this is because they're one of the largest monsters in the region or maybe it's because they're comparatively docile creatures, but their sleeping gas is their secret weapon should they find themselves involved in a conflict.

Pathways for releasing sleeping gas are located around the Radobaan's abdomen. Stimulating these pathways by pushing its abdomen into the ground disperses a cloud of the gas in all directions.

■ Radobaan's Relation to Uragaan

Analysis

Most Research Commission members from the Old World have noted traces of Uragaan in their studies of the Radobaan. The ecological similarities between them are undeniable: both eat extremely hard substances (one eats bones, the other machalite), both move about by rolling, and of course they strongly resemble each other. While the precise relationship between these monsters has not been entirely uncovered, we believe that they share a common ancestor. Although both monsters live in the New World, only the Uragaan lives in the Old World, which leads us to believe that Radobaan is the result of an evolutionary response to its life in the Rotten Vale...or at least that's what we think for now. We don't believe it's any stretch of the imagination to suggest that the innumerable bones of the Rotten Vale made some contribution to the development of the Radobaan. (*Excerpt from the book* Theory of Monster Evolution)

ECOLOGY
■ The State of Radobaan's Bone-Grinding Teeth

Radobaan's teeth are all roughly the same shape and size. Note how their teeth grow together tightly without any trace of gaps between them. This evolutionary trait makes it easy for the Radobaan to chew, grind, and consume bones. Further aiding this process is the Radobaan's brawny club-like jawbone, which is used for smashing and breaking down bones that it then eats or adheres to itself.

Radobaan feeds once or twice a day on the bones of carcasses that have fallen into the Rotten Vale from the Coral Highlands. Thanks to its well-developed jaw and teeth, Radobaan has no problem masticating hard substances for sustenance.

Radobaan will choose a region of the Rotten Vale overflowing with bones for its nest. Even if Radobaan's bone armor is weakened or destroyed in conflict, it simply needs to return home and go swimming in a sea of bones to reattach an entirely new coat of armor.

ECOLOGY
■ Hatched from Tar Pits

During the reproductive season, Radobaan bury their eggs in the ground before leaving them to hatch on their own. The friction and pressure exerted by the movement of Radobaan through the Rotten Vale results in thermal decomposition of vegetation and decaying matter, leaving behind a layer of tar. From the very first time a young Radobaan emerges from the earth, it is already acclimated to a coating of tar and bones. As they mature they become capable of coating themselves with more tar and heavier bones, but as the adults do not rear their young, it's difficult to spot juvenile Radobaan, and their growth is still a mystery.

Production Backstory

PRODUCTION NOTES
Using Bones to Gain Power and Speed

The Rotten Vale has three main areas, and the topmost of them includes a bone-covered region, so we wondered if we could have a monster that made use of them by attaching them to its body. The Rotten Vale itself has hellish imagery going for it, so I wanted the Radobaan to be kind of like that fire wheel *yokai* that gets around by rolling. [laughs] We already had the Uragaan, so it felt realistic to have the Radobaan be a closely related but evolutionarily different relative in the New World. At first, we weren't even planning on having Uragaan make an appearance, so that's all thanks to the development of Radobaan. (*Tokuda*)

Something we wanted to do was to create a looped pathway. We thought it would be a good fit to have a rolling monster that could speed through the region. When we used Uragaan as a basic model for tweaking, we considered the fact that bones aren't as tough as machalite, which might make the Radobaan look weaker, so we just started heaping mounds of bones on it. What came out of that was this monster, who looks way fiercer than Uragaan ever did. [laughs] (*Fujioka*)

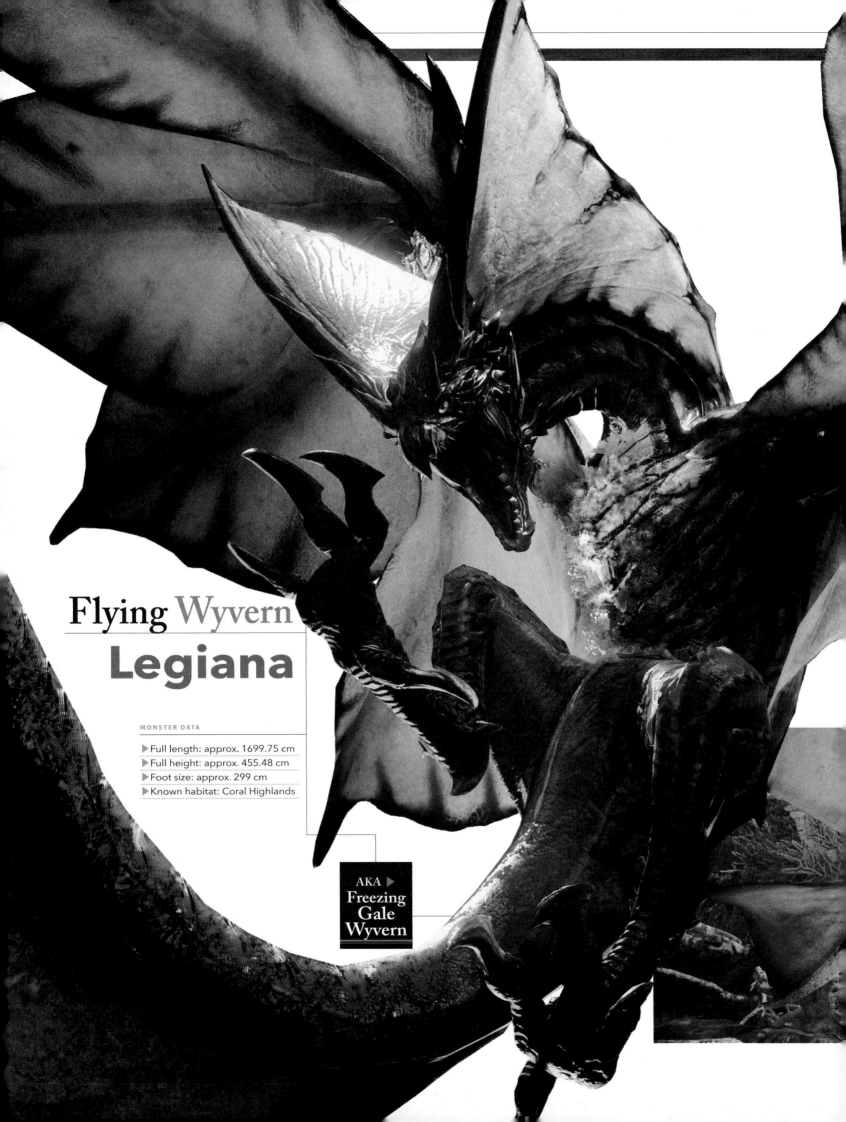

Flying Wyvern
Legiana

MONSTER DATA

▶ Full length: approx. 1699.75 cm
▶ Full height: approx. 455.48 cm
▶ Foot size: approx. 299 cm
▶ Known habitat: Coral Highlands

AKA ▶
Freezing
Gale
Wyvern

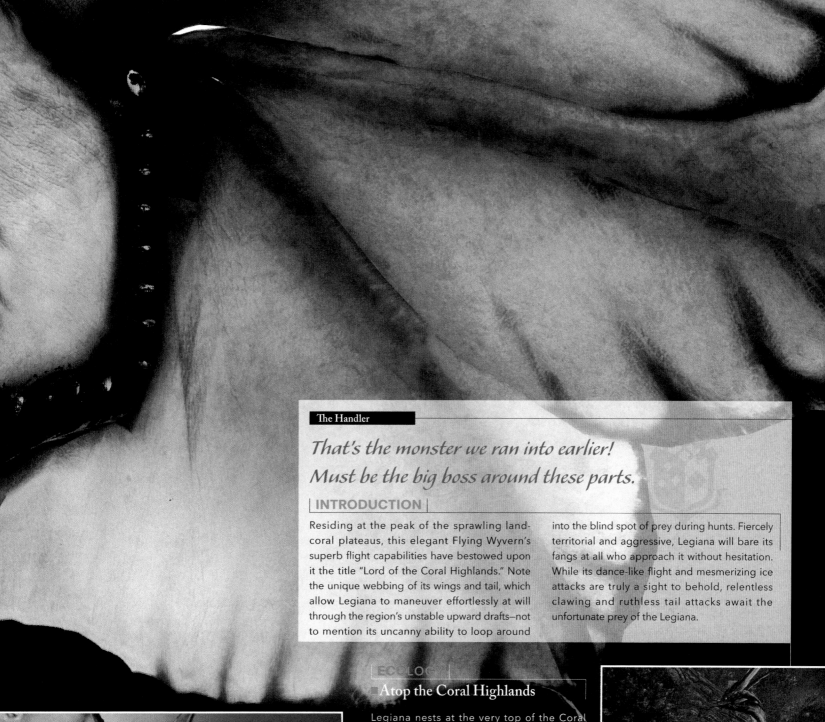

The Handler

That's the monster we ran into earlier!
Must be the big boss around these parts.

INTRODUCTION

Residing at the peak of the sprawling land-coral plateaus, this elegant Flying Wyvern's superb flight capabilities have bestowed upon it the title "Lord of the Coral Highlands." Note the unique webbing of its wings and tail, which allow Legiana to maneuver effortlessly at will through the region's unstable upward drafts—not to mention its uncanny ability to loop around into the blind spot of prey during hunts. Fiercely territorial and aggressive, Legiana will bare its fangs at all who approach it without hesitation. While its dance-like flight and mesmerizing ice attacks are truly a sight to behold, relentless clawing and ruthless tail attacks await the unfortunate prey of the Legiana.

ECOLOGY

Atop the Coral Highlands

Legiana nests at the very top of the Coral Highlands and considers most of the upper regions its territory. Spending most of its waking hours patrolling its territory for prey or intruders, Legiana only rarely visits the lower plateaus. Known for being highly territorial, Legiana will deal with any intruder by making an extremely aggressive display. Note the Legiana's ear-piercing cry, which is a message to would-be invaders both near and far. The high-pitched nature of the scream allows it to travel great distances through the Highlands.

Vigilant of its surroundings, the Legiana flits through its territory on the lookout. Its aggressive behavior toward any and all potential invaders seems fitting for the pride of this region.

LEGIANA

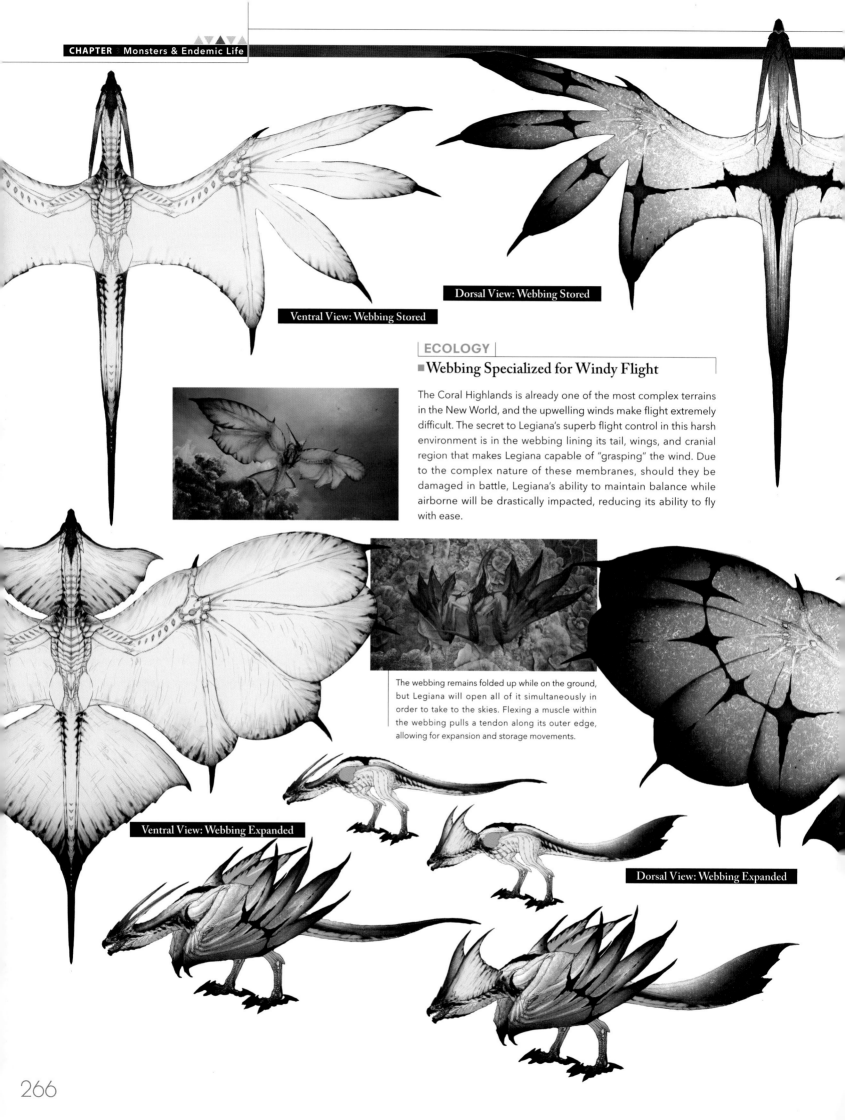

Dorsal View: Webbing Stored

Ventral View: Webbing Stored

ECOLOGY

■ Webbing Specialized for Windy Flight

The Coral Highlands is already one of the most complex terrains in the New World, and the upwelling winds make flight extremely difficult. The secret to Legiana's superb flight control in this harsh environment is in the webbing lining its tail, wings, and cranial region that makes Legiana capable of "grasping" the wind. Due to the complex nature of these membranes, should they be damaged in battle, Legiana's ability to maintain balance while airborne will be drastically impacted, reducing its ability to fly with ease.

The webbing remains folded up while on the ground, but Legiana will open all of it simultaneously in order to take to the skies. Flexing a muscle within the webbing pulls a tendon along its outer edge, allowing for expansion and storage movements.

Ventral View: Webbing Expanded

Dorsal View: Webbing Expanded

266

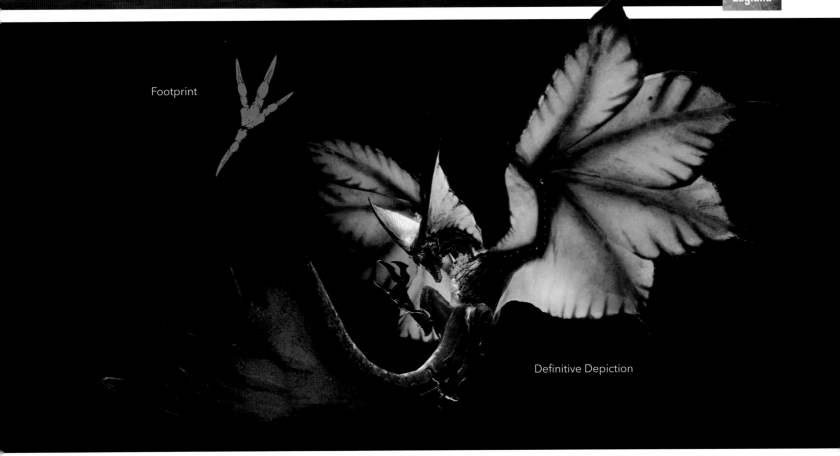

Footprint

Definitive Depiction

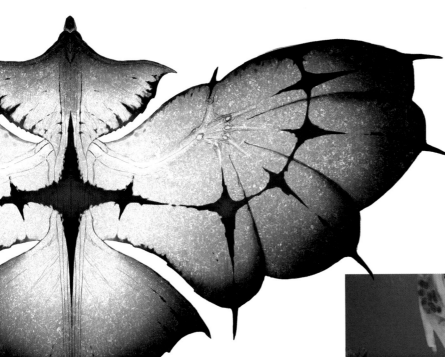

ECOLOGY

■ Capturing Enemies with Sharp Claws

Legiana's leg bones and claws are specialized for clutching. Legiana will always attempt to remain above its enemy or airborne—hence its well-developed legs and claws, which are ideal for attacking a target. Legiana's claws are also essential for hunting, so while patrolling the monster will sharpen its claws on the ground or land coral. This sharpening activity also marks the Legiana's territory and occurs upwards of dozens of times in a single day.

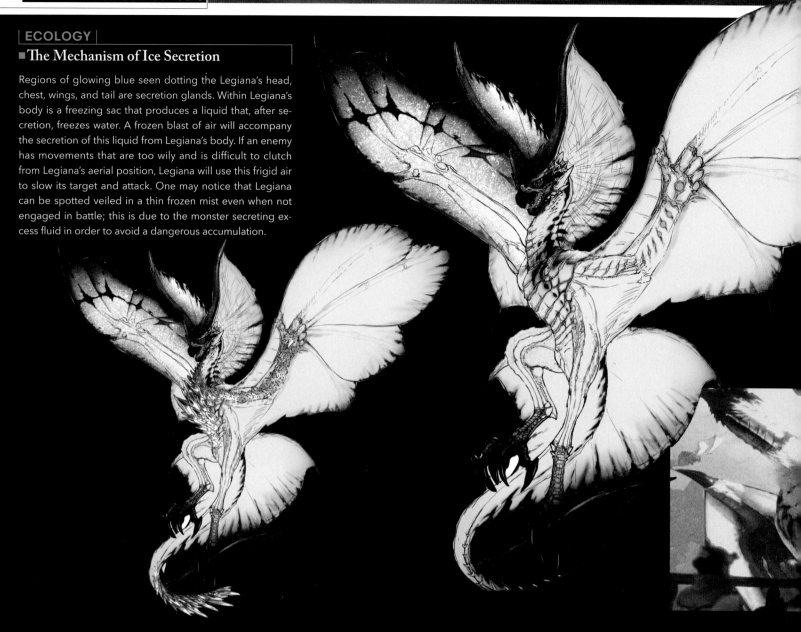

ECOLOGY

■ The Mechanism of Ice Secretion

Regions of glowing blue seen dotting the Legiana's head, chest, wings, and tail are secretion glands. Within Legiana's body is a freezing sac that produces a liquid that, after secretion, freezes water. A frozen blast of air will accompany the secretion of this liquid from Legiana's body. If an enemy has movements that are too wily and is difficult to clutch from Legiana's aerial position, Legiana will use this frigid air to slow its target and attack. One may notice that Legiana can be spotted veiled in a thin frozen mist even when not engaged in battle; this is due to the monster secreting excess fluid in order to avoid a dangerous accumulation.

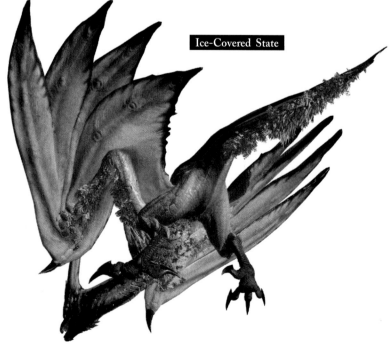

Ice-Covered State

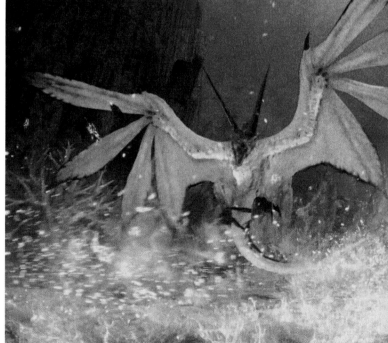

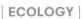

ECOLOGY
■ Preying on Raphinos While Airborne for Sustenance

As the undisputed ruler of the Coral Highland's skies, it shouldn't come as a surprise that Legiana hunts while airborne. Upon spotting a Raphinos, Legiana will fly straight up above the target into its blind spot before nose-diving straight for it. Tightly clamping down on its prey, Legiana will devour the Raphinos while airborne. If the target proves too difficult to catch, Legiana will use super cooled air to slow the prey enough for a lethal approach. Legiana appears to hunt mostly in the morning hours and is often known to feed only once per day, spending the rest of its time surveying its territory. One of the reasons for its limited feeding habits is so that it may maintain a relatively constant body weight, such that its speed and agility remain unaffected.

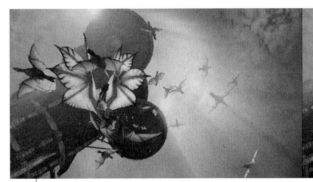

In order to increase their chances of a successful hunt, Legianas often target flocking Raphinos. When it comes to the New World, it seems doubtful that many other creatures can match the Legiana's graceful aerial techniques.

Analysis
■ The Usefulness of Poison Against Legiana

Legiana's resistance to poison is markedly weak. Weapons and tools that induce poison are highly recommended for subjugating Legiana. Poison will slightly dull the Legiana's sense of equilibrium, significantly reducing its flight capabilities. Incidentally, while suffering the effects of poison, Legiana's physical strength takes a nosedive. (*From a biologist's notes*)

Production Backstory
PRODUCTION NOTES
Fighter Jet-like Movement and Speeds

The three things we wanted to accomplish with this monster were introducing the standard difficulty level, establishing a tempo, and providing gameplay where both the monster and player could use updraft currents for battle. In terms of how to accomplish that, from the ecological side we wanted to use ice and from the action side we wanted to be able to corner the player—and Legiana fit both of those aspects really well. By the way, if you wait for the right moment, you can take advantage of its turf war with Paolumu. (*Tokuda*)

The first thing we discussed for this monster was how to make a Flying Wyvern that's agile and has powerful claws. But when it comes to quick aerial monsters, there's a bit of a hurdle. Eventually we were able to get those concepts across through some of its tricky maneuvers like nose-diving and holding a stable position in midair, which is why it's similar to a jet fighter, down to its webbing acting like wing flaps. The end result was less imposing than Rathalos, with a streamlined body and a compact face. We also wanted to express that this incredibly powerful monster can fall subject to predation, which is why we had it play a role in the Rotten Vale. (*Fujioka*)

UNIDENTIFIED

Extended World Gallery
Unidentified Creatures Log [III]

Here's a small mountain of unconfirmed material related to Paolumu, Legiana, and Great Girros. The research regarding monsters in the Coral Highlands and Rotten Vale was conducted mainly by the Third Fleet. Most of the illustrations found here are renditions that were based on speculative analysis, but seasoned researchers have said they've witnessed some of these creatures with their own eyes, making this material difficult to dismiss without further investigation.

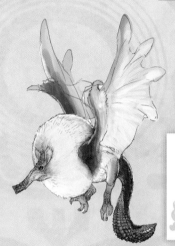
■Flying Wyvern ①

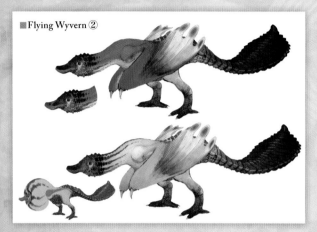
■Flying Wyvern ②

THE TRUNK EXPANDS IN SIZE WHEN EXPELLING AIR, BUT THE TIP ALWAYS REMAINS THE SAME SIZE.

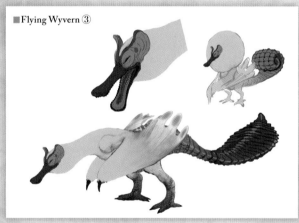
■Flying Wyvern ③

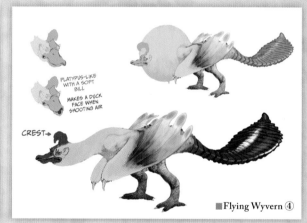

PLATYPUS-LIKE WITH A SOFT BILL

MAKES A DUCK FACE WHEN SHOOTING AIR

CREST→

■Flying Wyvern ④

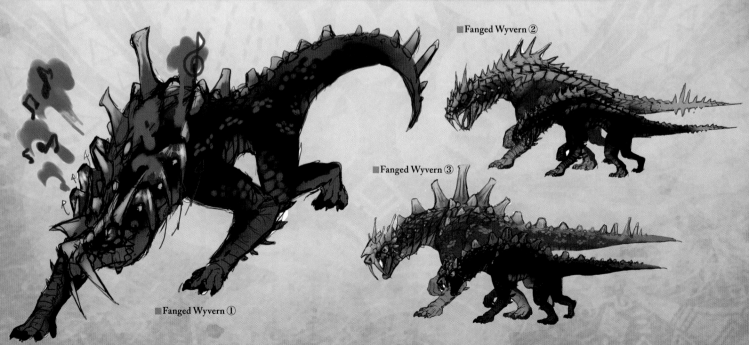
■Fanged Wyvern ②

■Fanged Wyvern ③

■Fanged Wyvern ①

CREATURES LOG

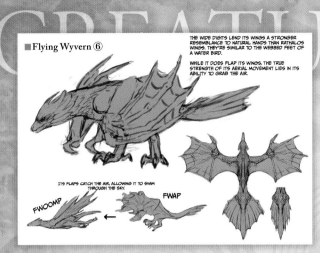

■ Flying Wyvern ⑥

THE WIDE DIGITS LEND ITS WINGS A STRONGER RESEMBLANCE TO NATURAL HANDS THAN RATHALOS WINGS. THEY'RE SIMILAR TO THE WEBBED FEET OF A WATER BIRD.

WHILE IT DOES FLAP ITS WINGS, THE TRUE STRENGTH OF ITS AERIAL MOVEMENT LIES IN ITS ABILITY TO GRAB THE AIR.

ITS FLAPS CATCH THE AIR, ALLOWING IT TO SWIM THROUGH THE SKY.

FWOOMP FWAP

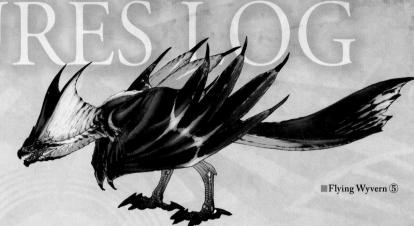

■ Flying Wyvern ⑤

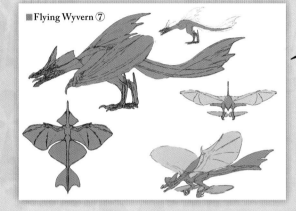

■ Flying Wyvern ⑦

■ Flying Wyvern ⑧

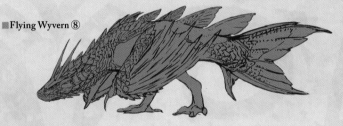

❖ Similar to "Floating Wyvern"

Flying Wyvern #1: The inflatable neck and tail suitable for bludgeoning closely resemble a genuine Paolumu's, however, the facial features, particularly the long snout, suggest otherwise.

Flying Wyverns #2-4: Here are several cases where the Paolumu-like creatures are depicted with elongated beaks. While their heads and necks have a rounded look to them, the beaks and noses—even the one mentioned above—look out of place. It's hard to accept that these are simply phenotypic differences between males and females.

❖ Similar to "Freezing Gale Wyvern"

Flying Wyvern #6: This creature displays a raptor-like appearance with a sturdy skeletal frame. The wings consist of long and thick-fingered wings that appear similar to webbed feet. While there are elements of it that appear similar to Legiana, the tip of its tail is quite different.

Flying Wyvern #7: To assist in low-speed flying airlift, a set of membranes connected from its second and fifth toes to its shins act as a second pair of wings.

❖ Similar to "Paralyzing Scavenger"

Fanged Wyvern #1: Like a Great Girros emitting some kind of sound. In this mechanism, gas is emitted from tubes jutting out from its gills, producing a specific sound.

Fanged Wyvern #4: Here's a depiction of an individual with an organ for creating sound in its tail. Looking at the overall form of the creature, its most outstanding characteristics are its crest stretching down its back and a set of retractable fangs. It doesn't seem too outlandish to consider the possibility that this beast exists somewhere out there.

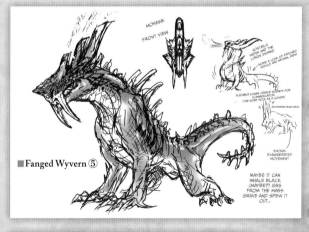

■ Fanged Wyvern ⑤

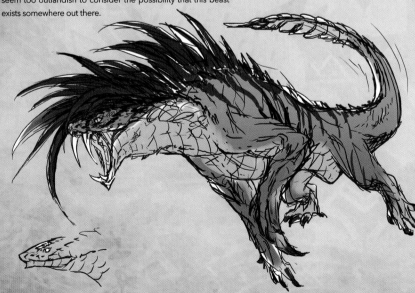

■ Fanged Wyvern ④

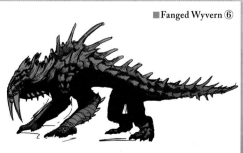

■ Fanged Wyvern ⑥

Excerpt from *The Monster Field Guide*

A terrifying monster that scours the Rotten Vale for carrion. Its highly aggressive nature means that anything, be it monster or man, is a potential meal.

INTRODUCTION

Of all the monsters inhabiting the Rotten Vale, this Fanged Wyvern is one of the most dangerous. It's no exaggeration to say that Odogaron's sinewy flexibility and lethal claws are among the highest class in the New World. The personality of this carrion feeder, whose body resembles that of a skinless beast, is probably much as you might expect from first sight—it is ferocious, warlike, and relentless, acting entirely on raw instinct towards any opponent. Using its novel claws, Odogaron plucks meat from the bones of its prey, which has earned it the nickname, "Cruel Claw." Odogaron's main territory is located in the Rotten Vale's lower caverns, where one may find the monster's den— a veritable storehouse of scavenged meat and monster bodies.

ECOLOGY

■ Searching Far and Wide for Carrion

There's barely any fat on the Odogaron, but in order to maintain the energy for its lithe movements it must always be on the hunt for meat. This constant need for energy is why Odogaron often travels with a carcass clenched in its jaws. While many corpses often fall into the Rotten Vale, the Odogaron sometimes tires of simply dragging around carrion and is known to wander all the way up into the Coral Highlands. Even the Radobaan, which is several times larger than the Odogaron, can't hold a candle to it in battle.

In terms of ferocity, it's difficult to argue that Odogaron comes in second place to any monster. At the very least, it can easily overwhelm the majority of monsters residing in the Rotten Vale and Coral Highlands.

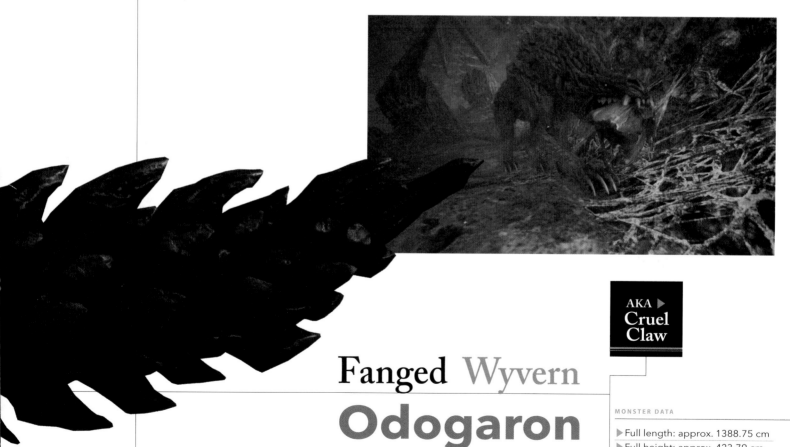

AKA ▶
Cruel Claw

Fanged Wyvern
Odogaron

MONSTER DATA

▶ Full length: approx. 1388.75 cm
▶ Full height: approx. 423.79 cm
▶ Foot size: approx. 104 cm
 (When enraged: approx. 146 cm)
▶ Known habitats: Coral Highlands,
 Rotten Vale

273

ECOLOGY

■Habitually Bringing Carrion Back to the Nest

To survive the effluvium-filled wastes of the Rotten Vale, Odogaron habitually drags the spoils of its hunt or scavenging back to its nest for storage. For example, with its unusually powerful jaws and overall body strength, an Odogaron is capable of dragging a full Legiana corpse all the way down to its den. Incidentally, it has been said that Odogaron may be a bit of a meat connoisseur, as it partakes of carrion that has been dried and aged during storage as something of a delicacy.

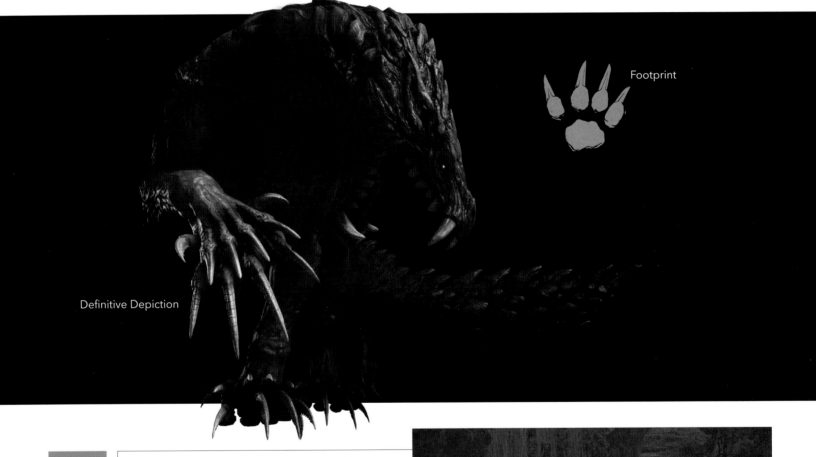

Footprint

Definitive Depiction

Analysis

■Odogaron Controls the Hollows Dotting the Rotten Vale

Note the cavities dotting the walls in the lower regions of the Rotten Vale. The Odogaron uses these tunnels when dragging carrion back to its den. Of particular interest is how these holes are just large enough to fit an Odogaron dragging a carcass the size of a Legiana. While it's possible that the Odogaron made these holes itself, it's just as likely that Odogaron considers the tunnels an important part of its territory and dissuades intruders to ensure its own exclusive use of them. As so many creatures of the Rotten Vale find sustenance through carrion, Odogaron maintains these routes as pathways for safe and effective transport of its bounty through the Vale. (*Excerpt from the book* Theories on New World Ecology)

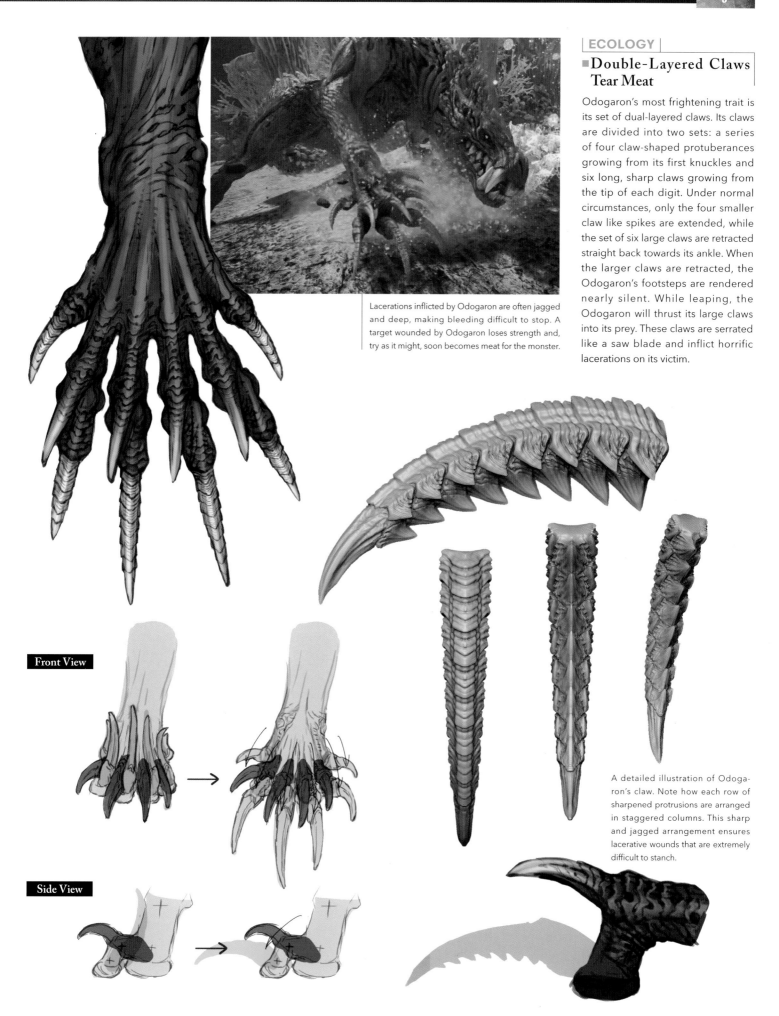

Lacerations inflicted by Odogaron are often jagged and deep, making bleeding difficult to stop. A target wounded by Odogaron loses strength and, try as it might, soon becomes meat for the monster.

■Double-Layered Claws Tear Meat

Odogaron's most frightening trait is its set of dual-layered claws. Its claws are divided into two sets: a series of four claw-shaped protuberances growing from its first knuckles and six long, sharp claws growing from the tip of each digit. Under normal circumstances, only the four smaller claw like spikes are extended, while the set of six large claws are retracted straight back towards its ankle. When the larger claws are retracted, the Odogaron's footsteps are rendered nearly silent. While leaping, the Odogaron will thrust its large claws into its prey. These claws are serrated like a saw blade and inflict horrific lacerations on its victim.

Front View

Side View

A detailed illustration of Odogaron's claw. Note how each row of sharpened protrusions are arranged in staggered columns. This sharp and jagged arrangement ensures lacerative wounds that are extremely difficult to stanch.

275

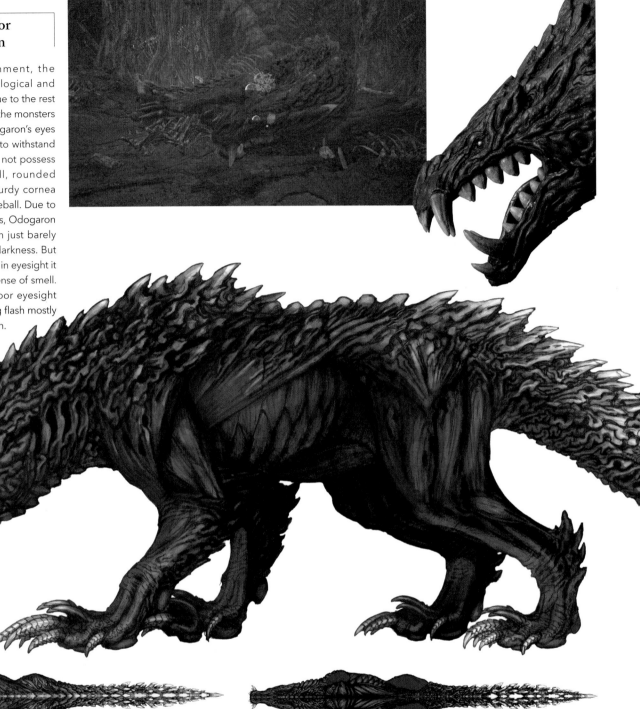

ECOLOGY

■ Eyes That Adapted for Effluvium Protection

Already a harsh environment, the Rotten Vale possesses ecological and evolutionary properties unique to the rest of the New World. As one of the monsters living in this region, the Odogaron's eyes have evolved over the ages to withstand effluvium. Although they do not possess eyelids, Odogaron's small, rounded eyes are protected by a sturdy cornea encompassing the entire eyeball. Due to the thickness of their corneas, Odogaron have poor eyesight and can just barely discern between light and darkness. But whatever an Odogaron lacks in eyesight it makes up for with its keen sense of smell. Incidentally, Odogaron's poor eyesight renders Tzitzi-Ya-Ku's blinding flash mostly useless against the Odogaron.

ECOLOGY

■ The Mechanism for Its Full-Body Flush

After a feast of carrion, Odogaron's body will flush a deep-red color and begin to expel steam from its mouth. It's believed that this alteration may be attributed to a sharp rise in body temperature that occurs when an Odogaron feeds after a period of fasting. While in this state, an Odogaron's physical capabilities and aggressiveness reach their peak, suggesting an Odogaron's reserves are also intended for a burst of energy when it's fatigued or senses mortal danger. On the other hand, this change in physical ability could be rooted in the monster's excitement over consuming what Odogaron considers high-quality meat.

ECOLOGY
■ A Keen Sense of Smell for Relentlessly Hunting

The Rotten Vale's topography makes it difficult for sunlight to penetrate its depths, leaving much of the region dimly illuminated. The Odogaron's vision is already poor to begin with, which is why it almost exclusively relies on its sense of smell for hunting. By widening its nostrils, an Odogaron can catch even the faintest of scents, granting it knowledge of its prey's location from afar. Odogaron can also use its sense of smell to follow trails of blood left behind by victims of its lacerating attacks. This method of tracking has led some to call this monster "Hunter of the Rotten Vale." Additionally, Odogaron's keen olfactory perception often leads it to fresh carrion in the Rotten Vale before other creatures even have a chance to happen upon it.

The Odogaron is unrelenting in pursuit of prey and will hunt down a fleeing target with its superb sense of smell.

ECOLOGY
■ The Hardened Skin of Its Tail

Note the innumerable protrusions on the Odogaron's tail. These are actually hardened skin. When examining a young Odogaron's tail, only a few protrusions may be observed; it's only as the monster matures that the upper epithelial cells harden and turn white. What's more, even if broken, an Odoragon's tail will eventually regain its length as new skin grows in.

Production Backstory

PRODUCTION NOTES
A Flesh-Powered Contender for Top Spot in the Rotten Vale

In contrast to the Radobaan, Odogaron is quite small. Despite that, it is one of the strongest monsters in the Rotten Vale. Its speedy combo-spamming, bleed-inducing trick claws, and even how it powers up with carcasses, makes this an unfair fight for the player. To balance that out, we made sure that its individual hits didn't land too hard. (*Tokuda*)

I wasn't really sure why it got stronger when eating raw meat, but Tokuda just dug his heels in and said, "It just does," so... [laughs] I mean, I designed it so that was possible, but lately the players are really good at handling Odogaron, so it never really gets the chance to show its full potential. [laughs] If I look at it from another perspective, that means I did my job well as a game designer, but still... Overall, Odogaron's form is simplistic, so we gave it some individuality with the retractable claws. Basing it somewhat on a real-life creature, what you assume are Odogaron's claws are actually just smaller spikes, an interesting gimmick. (*Fujioka*)

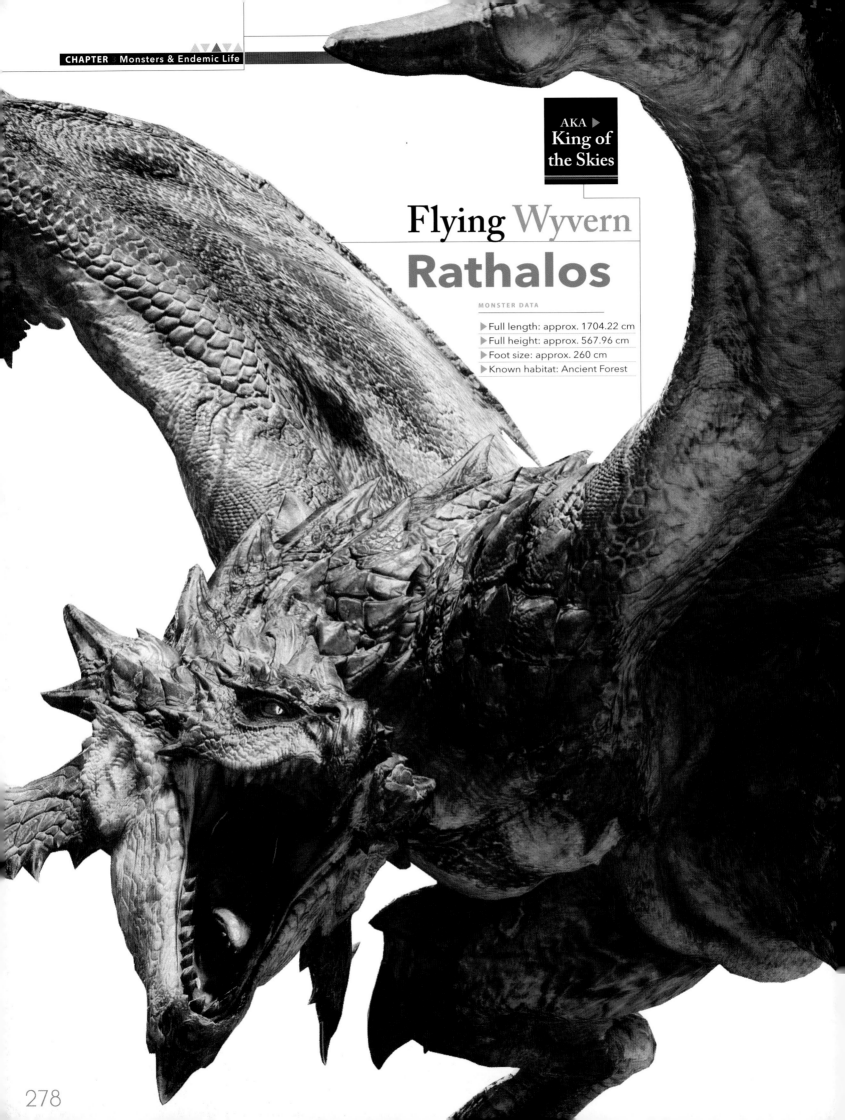

AKA ▶
**King of
the Skies**

Flying Wyvern
Rathalos

MONSTER DATA

▶ Full length: approx. 1704.22 cm
▶ Full height: approx. 567.96 cm
▶ Foot size: approx. 260 cm
▶ Known habitat: Ancient Forest

Excerpt from *The Monster Field Guide*

The apex monster of the Ancient Forest, also known as the "King of the Skies." A terrible wyvern that descends upon invaders, attacking with poison claws and fiery breath.

INTRODUCTION

The so-called King of the Skies, Rathalos is a red-shelled Flying Wyvern with rare airborne talent capable of overwhelming most living creatures with his vicious aerial assaults and fiery breath. Rathalos's command of the heavens gave birth to his title "King of the Skies." These individuals populating the New World make their nests at the very top of the Ancient Forest and drift regally through the skies, surveying the land as if aware of their superiority over every other creature in the forest. The ancient and wise First Wyverians had a name for the New World Rathalos of old: "Lord of the Forest." While the Rathalos is famous for pairing with a single mate in the Old World, New World Rathalos will mate with several Rathians and choose only the most eminent Rathian to nest alongside him in the Ancient Forest. Should this Rathian come under attack, the Rathalos will speed to her side and fight alongside his mate.

ECOLOGY

■Controlling Others with a Scorching Flame

True to its reputation, the Rathalos has fiery breath that originates from an internal organ called a flame sac that produces fine flammable particles. Rathalos can release his flames at will with a variety of attacks focused on pinning down enemies, such as firing flaming projectiles from the air or releasing a widespread inferno as he takes off from the ground.

RATHALOS

279

ECOLOGY

■ Differences in Evolution from Old World Rathalos

We believe that ancestors of New World Rathalos came to the New World from outside the continent and evolved somewhat differently from their Old World relatives. The first notable difference is in the bone structure of their wings, which possess an additional bone for wing-flap support. This evolutionary adaptation helps Rathalos maintain flexibility while flapping his wings among the dense vegetation. Next are his thigh muscles, whose considerable girth allow for easy takeoffs. It's believed that such adaptations are what allowed the Rathalos to wrest control of the upper canopy from Pukei-Pukei.

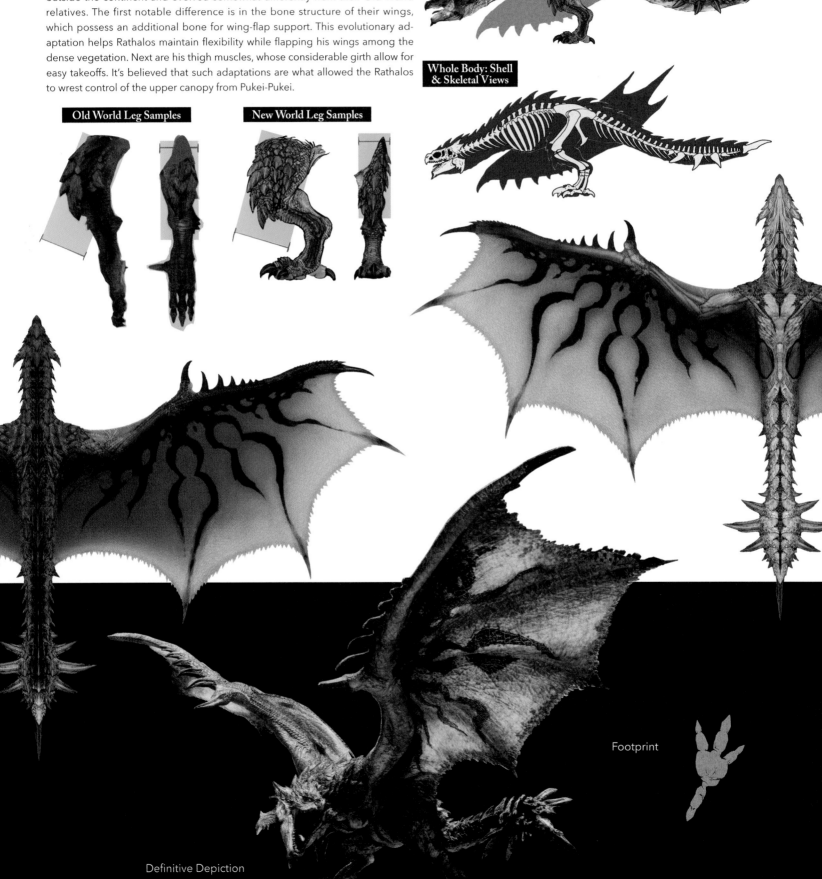

Whole Body: Shell & Skeletal Views

Old World Leg Samples

New World Leg Samples

Footprint

Definitive Depiction

ECOLOGY

■ The Structure of Shell and Skin That Allows Free Flight

The secret of the Rathalos's ability to fly so well rests literally on his shoulders, or at least within them. A hard shell that is divided into various plates spreads across Rathalos's body. Small scales fill the spaces between these plates, allowing the skin to maintain complete flexibility and full range of motion when beating his wings. These physical traits are the only reason a monster the size of Rathalos can fly in such confined spaces.

Wing: Skeletal View

Middle Back with Shell

An illustration of the Rathalos's middle back. While the shell is hard and mostly rigid, the fine scales growing in the gaps between the shell (the green region depicted on the right) grant the wings a full range of movement and flexibility.

Upper Body: While Beating Wings

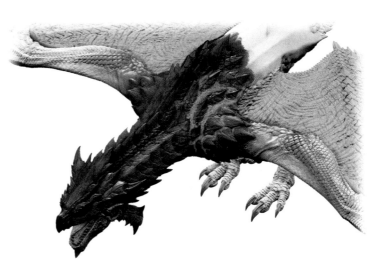

ECOLOGY

■ Altered Toes Enable Bipedal Movement

Rathalos of the New World are skilled at clutching prey with their sharp claws that hook into the flesh of their targets. They've even been known to lift an Anjanath completely off of the ground and into the sky. Their elongated toes—the first digit facing backward with the remaining three facing forward—are well suited for grasping objects. However, these same elongated toes would normally prove troublesome for bipedal movement on the ground if not for an interesting adaptation of the Rathalos's toes. While grounded, a Rathalos may bend his toe joints backwards, allowing him to fold up his toes for stable walking. Additionally, as with Old World individuals, New World Rathalos secrete poison from their claws, allowing for poisonous aerial strikes during conflict that rob their targets of strength. A Rathalos may also utilize poison during a hunt to finish off prey before consuming it.

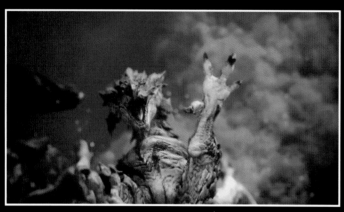

When Taking Off

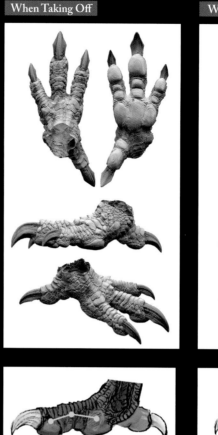

While Walking

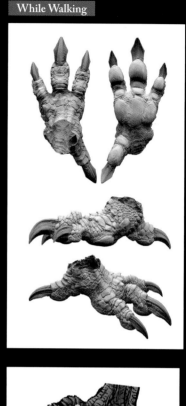

ECOLOGY

■ Standing at the Pinnacle of the Ancient Forest

In addition to being fiercely territorial, the Rathalos exhibits a hawkish nature and considers anyone or anything he faces to be an intruder and will engage this intruder without a moment's hesitation. The fact that he nests at the highest point of the Ancient Forest is more than enough to prove that this monster is truly "Lord of the Forest." He travels far and wide through the forest on a daily basis,

sharpening his talons and leaving deep claw marks behind as proof of his presence throughout the region, the entirety of which Rathalos considers his own territory. As far as raising his offspring is concerned, Rathalos will leave hunting for the young to his Rathian mate while he protects the nest with an unerring diligence.

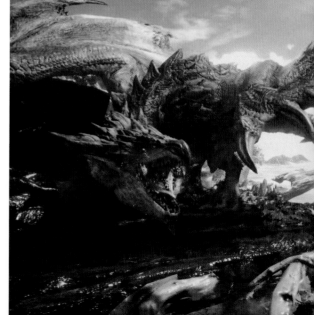

When a creature from the Ancient Forest spots a Rathalos—even a large monster—it will attempt to flee. Such behavior only encourages the Rathalos to pursue the creature with even greater vigor until he's satisfied that the creature has received his message loud and clear.

Analysis

■A Rathalos's Daily Routine

While investigating, I spent time following its daily routine. First, its nest was in Area 16, and I witnessed the Rathalos sharpening his talons in Areas 14 and 15. During one investigation, a Rathalos preyed on Aptonoth exclusively in Area 8, but on a different day I saw him hunting on the wide-open ground of Area 1. This suggests to me that Rathalos makes hunting choices based on factors such as weather and the movement of prey. A hunter should be able to come up with a plan of attack by observing how the Rathalos hunts. After several cycles of claw sharpening, predation, and resting, the Rathalos simply flew off, far away from the forest. It's uncertain why he simply left his mate behind, but I get the feeling that further investigation should uncover some new developments. (*From a researcher's notes*)

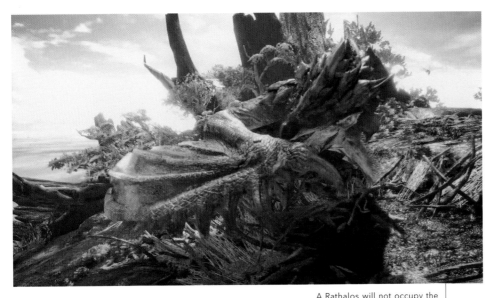

A Rathalos will not occupy the same habitat as Rathian with whom he is not paired, and Rathalos have not yet been spotted in the Wildspire Waste. They spend most of their time around their nests, taking in the sun while remaining ever vigilant.

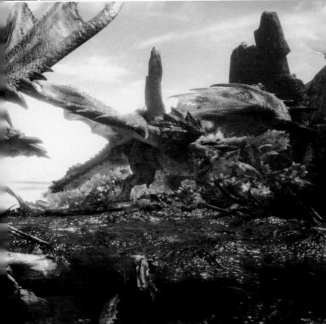

| ECOLOGY |

■Rathalos's Role in Rearing Hatchlings

Rathalos will rush to side of their Rathian nesting mate should she ever come under attack. After their eggs have hatched, Rathians will hunt for food and Rathalos will survey and protect the nest from the skies. The Rathalos is perhaps most dangerous while guarding his Rathian mate as she rests in their nest. At such times the Rathalos is extremely sensitive to any potential threats and should be considered highly dangerous.

| ECOLOGY |

■Polygamous Behavior and Hatchling Care

The Rathalos of the New World will mate with several Rathians but only choose one individual to be their nesting mate in their self-proclaimed territory of the Ancient Forest. In the Old World, fierce battles rage between Rathians over a Rathalos mate. One such conflict is said to have leveled an entire forest to cinders.

The spikelike growth on a Rathalos's lower jaw is used for nest construction. As breeding season approaches, it grows more prominent, at which point the Rathalos may use it for digging a nest. While the Rathalos will partake in parenting duties, he leaves incubating the eggs to his mate.

Production Backstory

Refining the King of the Skies

If you can memorize his route, he can help you with other monsters. It's a bit dangerous, but you can use him as the most devastating trap in the game. It's a different concept than using the terrain to your advantage. It's a technique for high-level players that tests their ability to learn and to use that knowledge. Early on I was testing a night battle with Anjanath in the Ancient Forest when suddenly the moonlight was blocked out by the wings of a Rathalos. They began a turf battle, and I remember being so pleased with the team as I thought to myself, "So this is why they call him 'Lord.'" (*Tokuda*)

Rathalos is up there with Great Jagras and Anjanath as one of the first monsters we worked on. Since he's well-known, our goal was to make sure he wouldn't easily lose to the new cast. Beyond cosmetic differences, we refined him by changing his skeletal and wing structure, which gave us some impressive results. He became the quality baseline for the remakes of all the classic monsters in the franchise. (*Fujioka*)

DIABLO

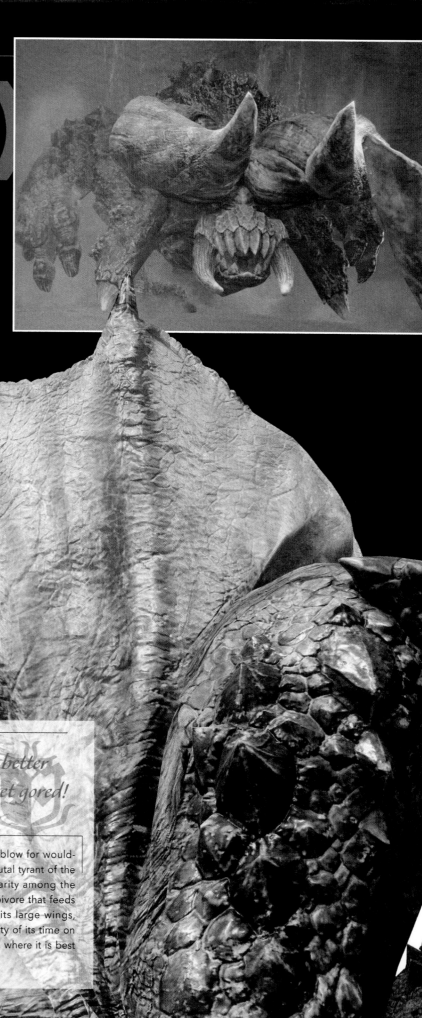

ECOLOGY

■Living Underground and Suddenly Attacking from Quicksand

In the sands of the Wildspire Waste hides a giant cave that the Diablos claims as its own. Only leaving its territory on rare occasions, Diablos attacks all intruders who enter its domain. As it spends most of its time moving about underground, its eyesight is poorly developed, but it boasts a superb sense of hearing. So pinpoint accurate is its hearing that it can follow the sound of a target from underground and thrust itself straight up into the intruder without any visual confirmation. Incidentally, this remarkable hearing is also what causes Diablos to spend so much time secluded in its cave, as it dislikes loud sounds and noises. Its impressive musculature is what allows it to travel through the ground with surprising fluidity and speed.

The Handler

Whoa, look at the horns on that thing! You better hope your armor holds up or you're gonna get gored!

INTRODUCTION

Based on its raw strength, the First Wyverians called this Flying Wyvern "Lord of the Wildspire Waste." Its cry will split your eardrums, just one swing of its tail can send a whole group of hunters hurtling through the air, and its twisted horns have the power to change the landscape itself. It's almost as if every simple action taken by this overwhelmingly powerful monster is a hunt-ending blow for would-be hunters. Although a brutal tyrant of the sands, Diablos is also a rarity among the Flying Wyverns as an herbivore that feeds mainly on cacti. Despite its large wings, Diablos spends the majority of its time on or underneath the ground, where it is best adapted to living.

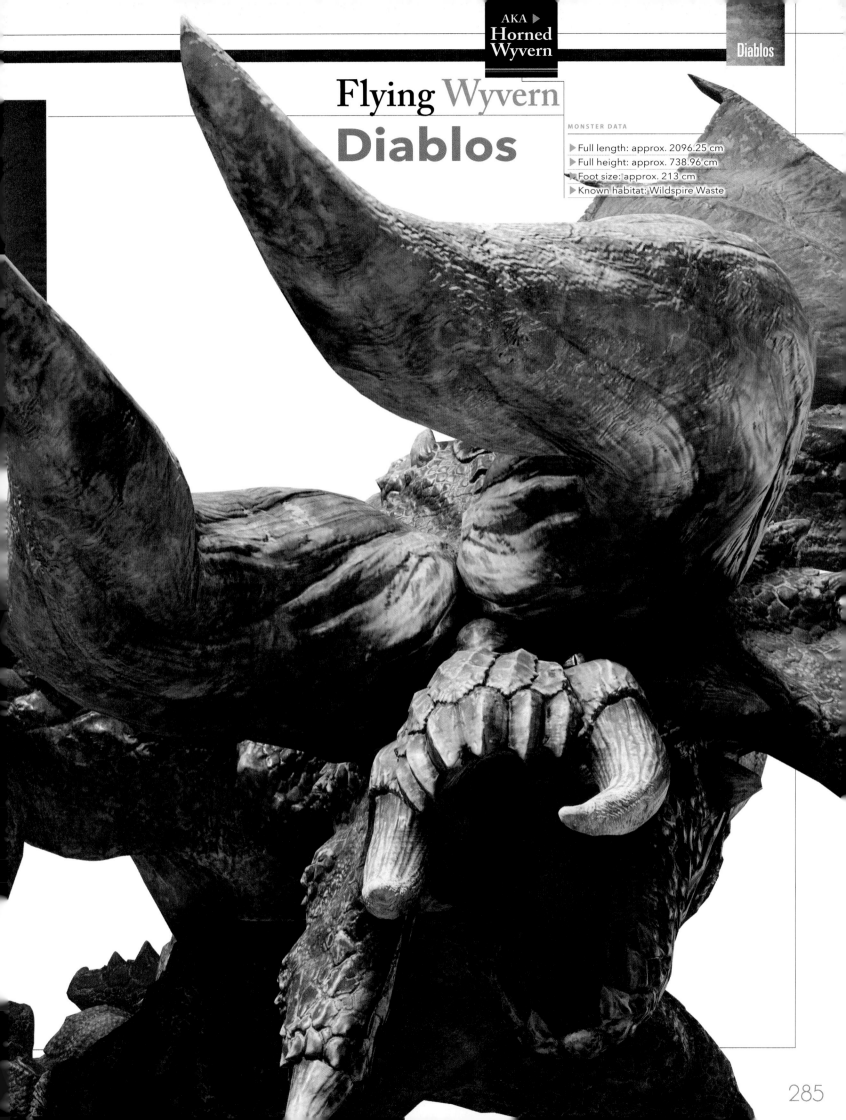

Flying Wyvern
Diablos

MONSTER DATA

▶ Full length: approx. 2096.25 cm
▶ Full height: approx. 738.96 cm
▶ Foot size: approx. 213 cm
▶ Known habitat: Wildspire Waste

An underground view of a hole opened up by a Diablos. The capability to open a hole of this size despite the ten-meter height of the roof is what makes Diablos a tyrant worthy of ruling this region.

Changing the Landscape with Charges from Its Horn

The Diablos's greatest weapon is its giant pair of horns, but their curved shape also makes them ideal for clearing an underground path through sand. In the heat of battle, a Diablos can move with speed unfitting its bulky size, as it charges enemies and attempts to flip them with its horns. The sheer power of this charge is enough to take down the resilient Barroth in one strike. Annoyed by the calls of Noios, Diablos are known to attack them by rearing up from their lairs, dotting the desert with holes that become treacherous quicksand traps and changing the very face of the landscape in which they reside.

Analysis

The Silent War over Cacti

The cactus-eating Diablos rises head and shoulders above its peers in terms of aggression. Even among common Diablos, the New World Diablos are in a special class of their own. To protect food sources, a Diablos will monopolize vast tracts of land conducive to cactus growth by forcing out other Diablos or Apceros. What's more, from time to time cacti growth is known to suffer, and during such stretches the Diablos will seek to expand its territory even farther. The reason for such poor cactus growth is due to the Wildspire Waste's Carrier Ants feeding on cactus nutrients, causing the cacti to wither. Fortunately, Diablos is not aware of the ants' reliance on cacti—otherwise it's possible the monster would be even more pugilistic than it already is. (*Excerpt from a researcher's notes on hunting*)

Conspecific Turf War

Territorial conflicts can even erupt between the male standard Diablos and the female black-bodied subspecies. What we commonly call the subspecies Diablos is in fact a pregnant female standard Diablos during the breeding season. Normally paired Diablos occupy the same territory, but during the mating and spawning seasons the extraordinarily aggressive Black Diablos will consider even her own mate as an intruder and aggressively chase the male out of her territory. Leading up to this, the two Diablos will square off and bash their horns in a battle of strength. Such conflicts may cause irreparable damage to an individual's horn or horns, making the daily life of that Diablos extremely challenging.

They do not take well to intruders. Diablos boasts the power to handily defeat most of the Waste's largest monsters with a single strike from its mighty horns.

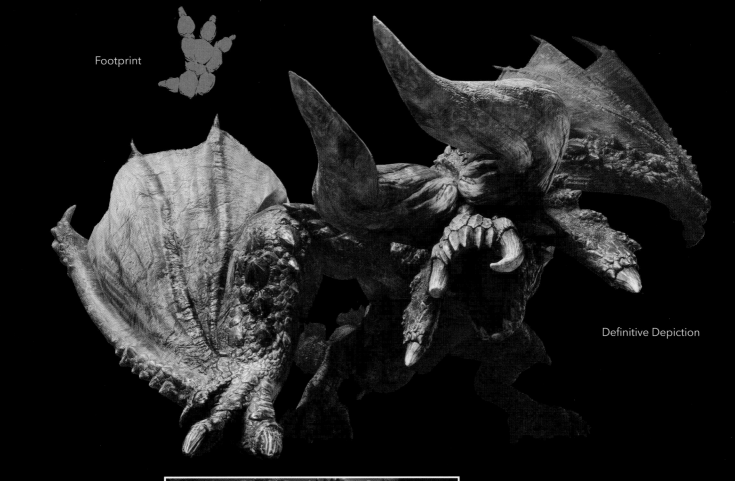

Footprint

Definitive Depiction

A Diablos will always feed at the same location. This may be because it favors cacti that contain the greatest hydration, but it's possible that the routine could simply be rooted in a preference of taste.

ECOLOGY

■Staying Hydrated with Its Staple Food

Cacti provide both nutrition and hydration for the Diablos, eliminating the need for them to travel to inconveniently located water sources. Its pointed fangs are well suited to gnashing a cactus's hard skin to bits for easy consumption. The Diablos leaves its cave for feeding, and it will cross the desert to feed upwards of five to six times a day in order to maintain its size.

Production Backstory

PRODUCTION NOTES
Power and the Food Chain

We could have created a new monster, but when considering what both new and old players should encounter as the master of the sands, there just wasn't a better option than Diablos. Diablos have always had a heavy charge attack that's tough to dodge. We kept those aspects, but balanced it out with the effectiveness of sound traps and how you can use Diablos itself to defeat other monsters. (*Tokuda*)

Depending on the situation, you might bump into a Rathalos butting heads with another monster, but Diablos is a monster that doesn't leave its territory. This forces the player to pull Diablos out of its cave to use it as a trap for other monsters. You can still use it like Rathalos, but I wanted there to be a clear difference. I think I might have caused some problems for the development team coming up with that massive quicksand hazard, but I was inspired by Tokuda's request for "a terrain effect on par with the Ancient Forest's waterfall hazard." [laughs] The dynamic factor of Diablos appearing combines with everything else to make a really enjoyable experience. (*Fujioka*)

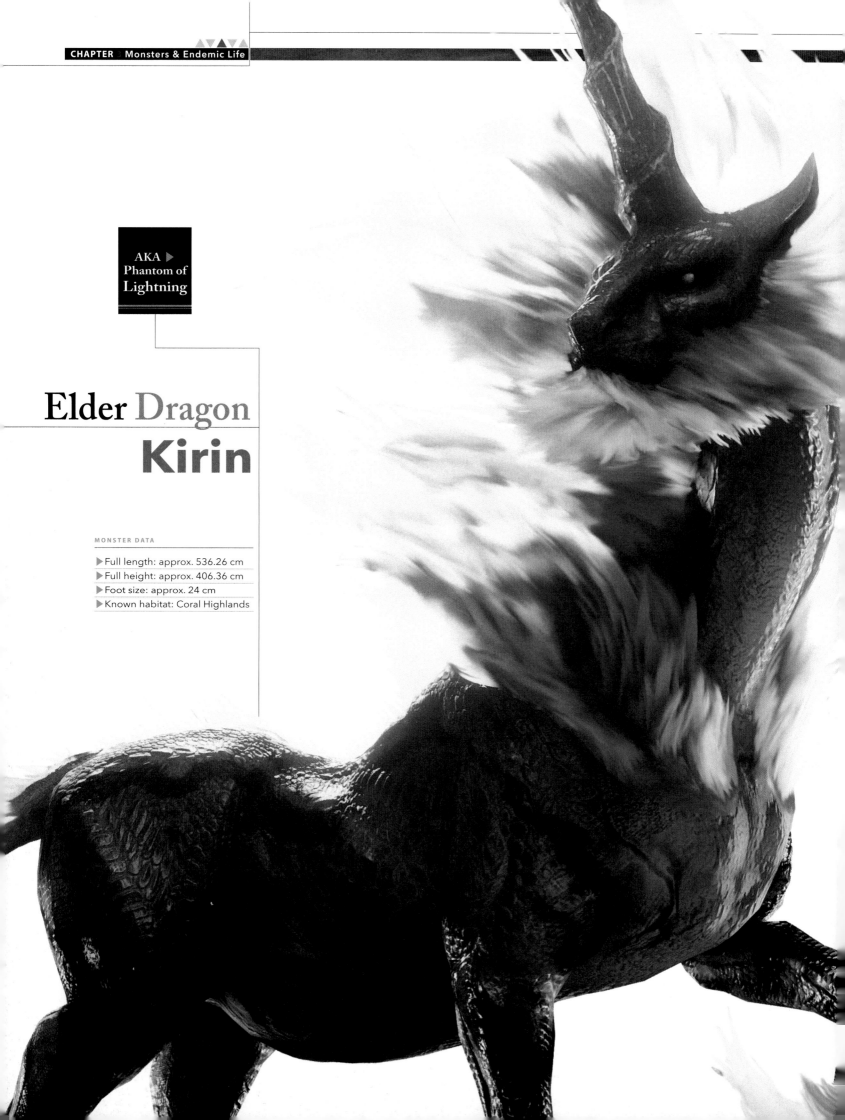

AKA ▶
Phantom of
Lightning

Elder Dragon
Kirin

MONSTER DATA

▶ Full length: approx. 536.26 cm
▶ Full height: approx. 406.36 cm
▶ Foot size: approx. 24 cm
▶ Known habitat: Coral Highlands

But don't you worry, we already know what it is. We followed the thunderclaps—and the hoofbeats!—right to the source. We're dealing with a Kirin! To think we'd find one here in the New World!

INTRODUCTION

Blue lightning and thunderclouds herald the arrival of the Elder Dragon Kirin. The divine shimmer of this noble monster's white-silver coat makes it the desire of many a hunter. Normally, sightings of the elusive Kirin are just as rare as the monster itself—appropriate for a monster with the nickname "Phantom of Lightning." Some people go their entire lives without so much as a glimpse of a Kirin.

This smallest of the logic-defying Elder Dragons is just as dangerous as its larger peers thanks to Kirin's control over lightning, a feat that instills fear and awe in those who stand in its way. Fortunately, recent sightings in the highest areas of the Coral Highlands have led to Kirin investigations in the New World that are already solving a number of ecological mysteries.

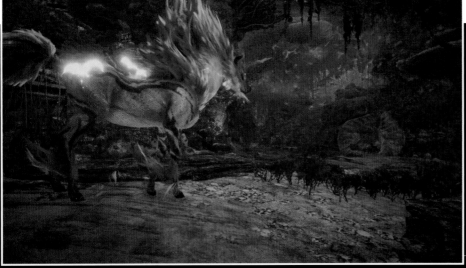

ECOLOGY
▪A Lonely Elder Dragon Inhabiting the Coral Highlands

Many of the New World Elder Dragons inhabit not only the Everstream-energy-rich caverns of the Elder's Recess, but other regions as well. Kirin, however, has only ever been spotted in the Coral Highlands. We have reason to believe that it resides in a secret location the Commission has not yet been able to uncover. Kirin's willingness to venture as close to the Commission enclave as it has might be due to Zorah Magadaros's crossing and its influence on the ecosystem and flow of energy in the New World.

Smaller monsters of the plateaus will scatter in the blink of an eye when they notice Kirin.

ECOLOGY
▪Deft Lightning Manipulation

The reason Kirin is classified as an Elder Dragon is because of the impact it has on its environment. They say that Kirin brings dark clouds with it, changing sunny skies into thundering gloom in a matter of moments and raining bolts of lightning at will. This ability to cause such phenomena is what earned the Kirin its Elder Dragon title, placing it among a group of peers often called "natural disasters."

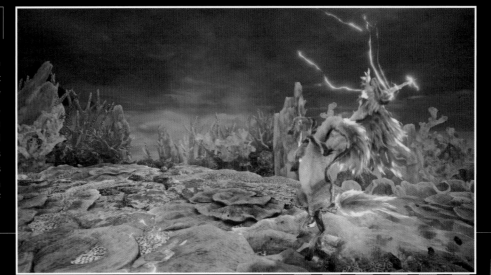

ECOLOGY

■Strengthening Itself with Lightning

Anyone foolish enough to capture its ire will send this Elder Dragon into a surging electrical rage. Storing this impressive amount of electrical energy internally causes lightning to seep from its body, cloaking it in a pale blue light. Not only does this potential energy grant Kirin the ability to unleash a devastating electrical discharge, the energy flowing through its body dramatically tempers the monster's muscles. While in this state, Kirin should be considered a major threat, as only high-class weapons stand any chance of damaging it.

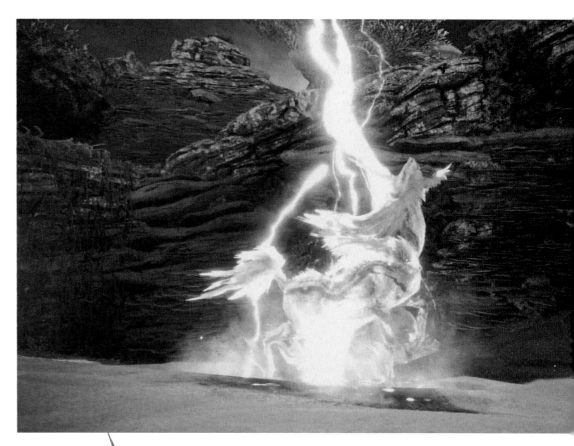

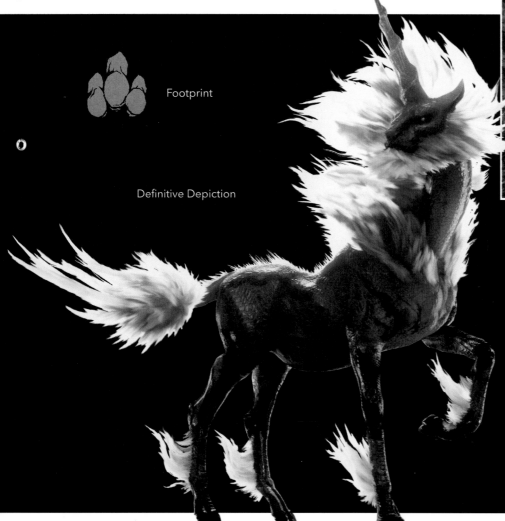

Footprint

Definitive Depiction

ECOLOGY

■A Surprising Level of Physical Strength

Kirin is known for making dramatic displays of its terrible strength. Adapted for launching itself from the ground with tremendous force, a Kirin has legs and hooves that are ideally shaped for jumping and running. Able to leap up and over smaller cliffs as if they were minor obstructions, it can even bound straight up the face of crags multiple times its own height as easily as if it were running across a flat plain. We think this is because Kirin can control the electrical signals running through its muscles, making them capable of accomplishing extraordinary feats.

Analysis

■ Regarding the Eating Habits of Kirin

The Kirin we observed in the higher plateaus would lap water droplets from the surface of plants. Since we already speculated that Kirin isn't carnivorous based on its oral structure and we weren't able to witness the Kirin hydrating itself at any significant water sources, we tentatively believe that Kirin can break down very small amounts of water in order to generate electricity. We also noticed that the Kirin shed some of its coat each time it lapped up water. We're not certain of the connection between these behaviors, but we should certainly question the mechanism by which Kirin can create energy from such a small amount of water. (*From a researcher's notes*)

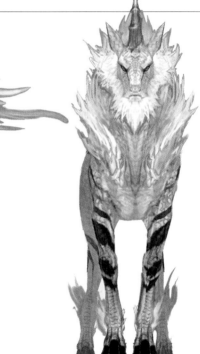

ECOLOGY

■ An Attack Unique to New World Individuals

Accounts of Kirin sightings have described an electrical phenomenon unique to New World individuals. One such report suggested Kirin can "shoot lightning parallel to the ground." This lightning covers far more ground than usual and is extremely dangerous. While it's possible that the New World's weather conditions make such a phenomenon possible, we cannot ignore the possibility that the ability is an environmental adaptation by Kirin.

Strength alone won't save anyone from the ruinous power of an electrical bolt tearing across the ground at the speed of light. Note how the ground will light up just before the lightning hits. This phenomenon occurs due to minerals in the ground reacting to a powerful electrical presence.

Secrets of Production

A Reward Befitting an Investigation of Fantastic Proportions

We knew from the start that we wanted our Elder Dragons from the Elder's Recess to appear in regions outside the Recess. We had Teostra in the Wildspire Waste, Kushala Daora in the Ancient Forest, and Vaal Hazak in the Rotten Vale. But the Coral Highlands didn't have an Elder Dragon, so we thought about what kind of Elder Dragon would live there. We decided on Kirin mainly because we wanted to add some balance and attribute changes, but also because Kirin armor and equipment has been really popular with players. So we wanted to see how it would look with high-end graphics. (*Tokuda*)

The reason why Kirin is the only Elder Dragon you can attempt from a low rank is because we wanted players to go along with the theme of a research commission carrying out capture investigations. Kirin was our way of rewarding diligent players who took a break from the path of the main story to round up some monsters. And after taking down Kirin—if players make the proper gear—they'll have a much easier time dealing with the Tempered Kirin quest required to raise their Hunter Rank. (*Fujioka*)

291

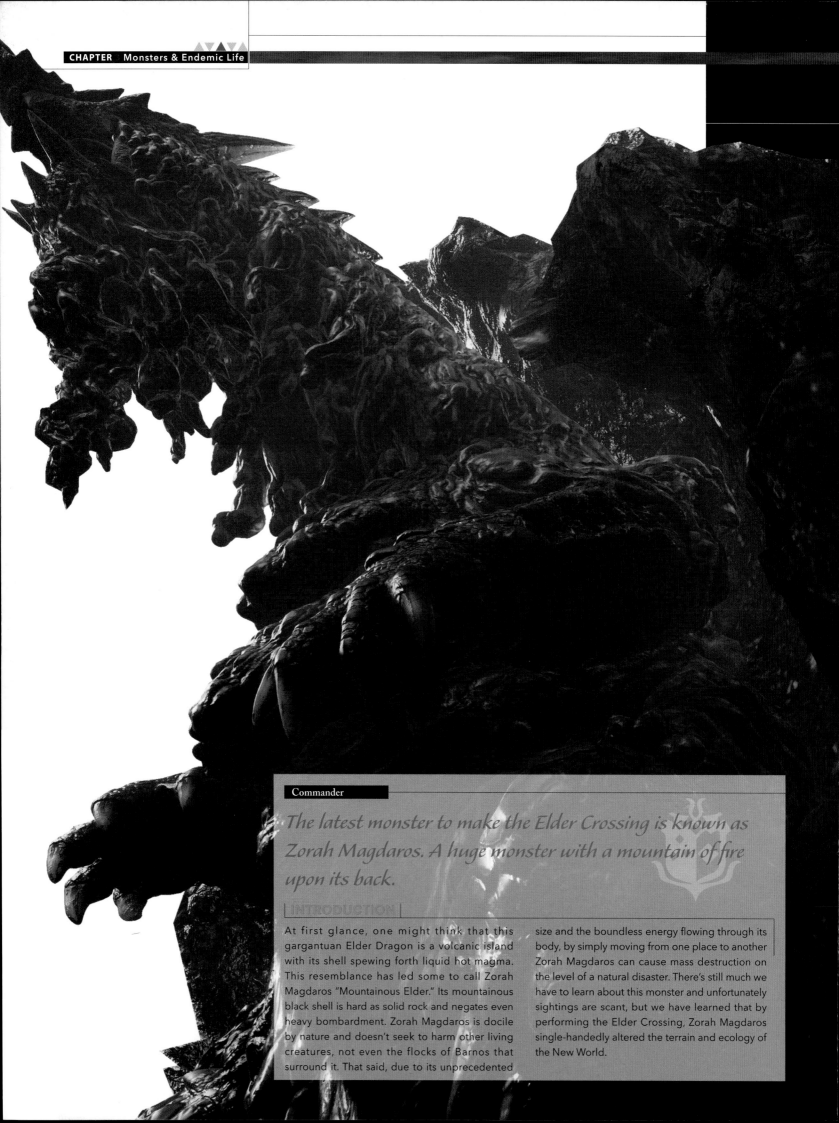

Commander

The latest monster to make the Elder Crossing is known as Zorah Magdaros. A huge monster with a mountain of fire upon its back.

INTRODUCTION

At first glance, one might think that this gargantuan Elder Dragon is a volcanic island with its shell spewing forth liquid hot magma. This resemblance has led some to call Zorah Magdaros "Mountainous Elder." Its mountainous black shell is hard as solid rock and negates even heavy bombardment. Zorah Magdaros is docile by nature and doesn't seek to harm other living creatures, not even the flocks of Barnos that surround it. That said, due to its unprecedented size and the boundless energy flowing through its body, by simply moving from one place to another Zorah Magdaros can cause mass destruction on the level of a natural disaster. There's still much we have to learn about this monster and unfortunately sightings are scant, but we have learned that by performing the Elder Crossing, Zorah Magdaros single-handedly altered the terrain and ecology of the New World.

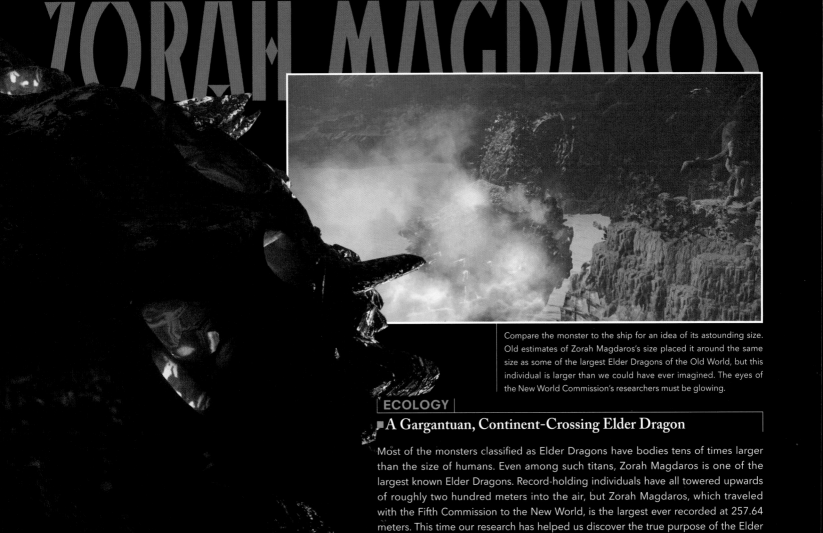

ZORAH MAGDAROS

Compare the monster to the ship for an idea of its astounding size. Old estimates of Zorah Magdaros's size placed it around the same size as some of the largest Elder Dragons of the Old World, but this individual is larger than we could have ever imagined. The eyes of the New World Commission's researchers must be glowing.

ECOLOGY

◼A Gargantuan, Continent-Crossing Elder Dragon

Most of the monsters classified as Elder Dragons have bodies tens of times larger than the size of humans. Even among such titans, Zorah Magdaros is one of the largest known Elder Dragons. Record-holding individuals have all towered upwards of roughly two hundred meters into the air, but Zorah Magdaros, which traveled with the Fifth Commission to the New World, is the largest ever recorded at 257.64 meters. This time our research has helped us discover the true purpose of the Elder

■Only Two Legs Support This Unprecedented Giant

During the crossing, Zorah Magdaros was witnessed walking both bipedally and on all fours. In order to properly disperse its weight, Zorah Magdaros frequently walks on four limbs. If its progression is obstructed by an obstacle, however, Zorah Magdaros can switch to walking on its hind legs. In order to support its impossibly heavy weight, its hind legs are considerably larger and more muscular than its front legs.

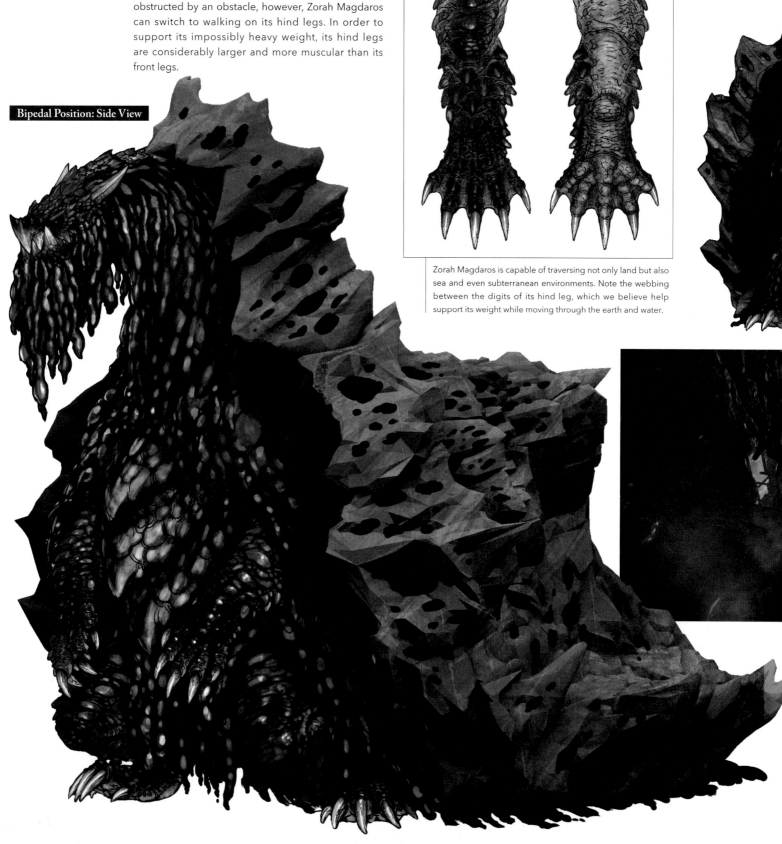

Hind Legs

Zorah Magdaros is capable of traversing not only land but also sea and even subterranean environments. Note the webbing between the digits of its hind leg, which we believe help support its weight while moving through the earth and water.

Bipedal Position: Side View

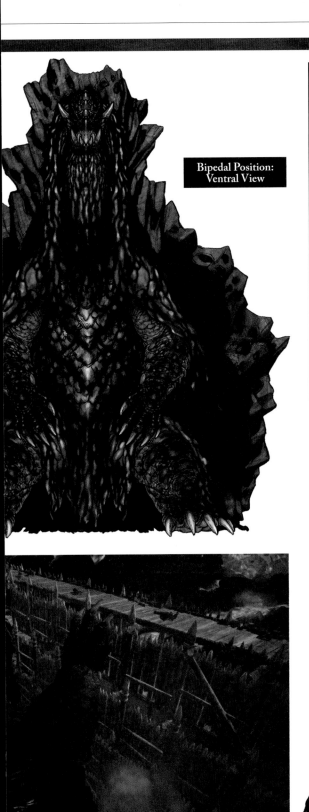

**Bipedal Position:
Ventral View**

This was during the Zorah Magdaros lure operation at the Everstream. Here, Zorah Magdaros was attempting to destroy the Commission's barrier wall. Note the astounding size of its forelegs.

ECOLOGY

■ A Shell as Strong as a Volcano

Zorah Magdaros carries on its back a tremendous volcano, which is actually formed from its own tissue. When the molten discharge from its body comes in contact with air, it cools and hardens, becoming a part of the Elder Dragon's shell. Even an aggressive bombardment of cannon and ballista fire is unlikely to feel like more than insect bites to the lumbering monster. The magma seeping from cracks and crevices in the shell is actually composed of indigestible materials consumed by the monster during feeding. Over time, as the expelled material hardens, it creates a shell that looks strikingly similar to a real volcano. Thanks to this process, it is possible to estimate the approximate age of Zorah Magdaros by measuring the shell layers it has accumulated. If research is carried out properly by the Commission, we may be able to discover more about its life span.

Over months and years, the layers of shell accumulate, toughening and growing ever larger. Occasionally bits and pieces of the shell will be shed, but even these tiny chunks are many times the size of a human.

**Quadrupedal Position:
Dorsal View**

**Quadrupedal Position:
Side View**

ECOLOGY

■Feeding on Explosive Materials

Zorah Magdaros feeds on minerals containing explosive matter to extract pure energy from them, which is then sent to its inner core. The unabsorbed waste material is expelled from its body as magma, which in turn becomes Zorah Magdaros's shell. The efficacy of Zorah Magdaros's internal combustion seems to increase as it matures. The ailing individual who recently performed the Elder Crossing was supposed to rest for eternity in the Rotten Vale but found itself lost near the Everstream, an event we believe was precipitated by the presence of other Elder Dragons.

Due to its size, Zorah Magdaros occasionally causes alterations to the earth itself. When it created a large fissure in the Great Ravine, many creatures gained access to previously inaccessible regions. What's more, this opened up a safe passage through the area for members of the Commission.

Zorah Magdaros releases its life energy in a single burst at the moment of its death. Had this most recent individual breathed its final breath at the Everstream, rather than at the bottom of the ocean, the New World would have been engulfed in flames.

ECOLOGY

■Vast Amounts of Energy Affecting the Ecosystems of the New Continent

Elder Dragons performing the Elder Crossing are known for changing the very ecosystems of the environments they pass through. The tremendous energy inside Zorah Magdaros dramatically affected the New World. The aged beast stimulated the energy cycle of the New World, enticing well-conditioned subspecies and monsters to populate the region. If the recently encountered Zorah Magdaros had unleashed its core energy while aground in the New World, the resulting explosion could have been a tragedy of unheard-of proportions.

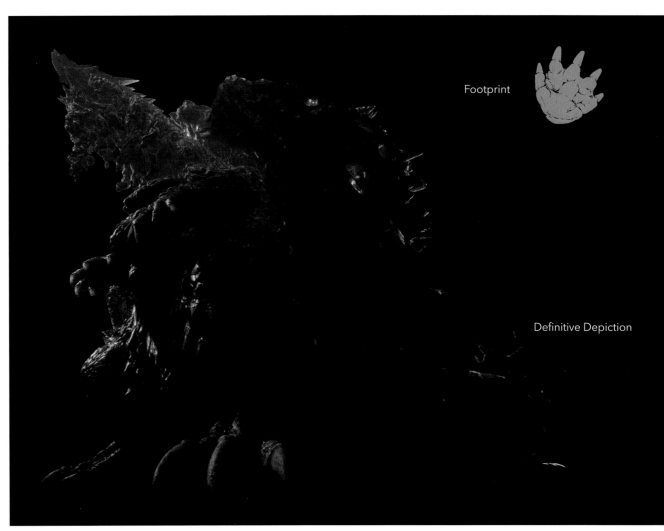

Footprint

Definitive Depiction

Note the magmacores dotting Zorah Magdaros's body. Occasionally magma will spout from these vents, aiding the monster with body temperature management.

ECOLOGY

■ Erupting Magmacores

Magmacores may be seen jutting from various locations around Zorah Magdaros's shell. The steady stream of scorching molten material from these spouts provide the Elder Dragon with body temperature maintenance. While the magmacores themselves might look like towering rocky crags, they're actually exposed internal organs and are thereby comparatively more delicate than the shell itself. Destroying these magmacores not only damages the well-guarded body of Zorah Magdaros, but also impedes its ability to manage body temperature, robbing it of strength and slowing down the monster.

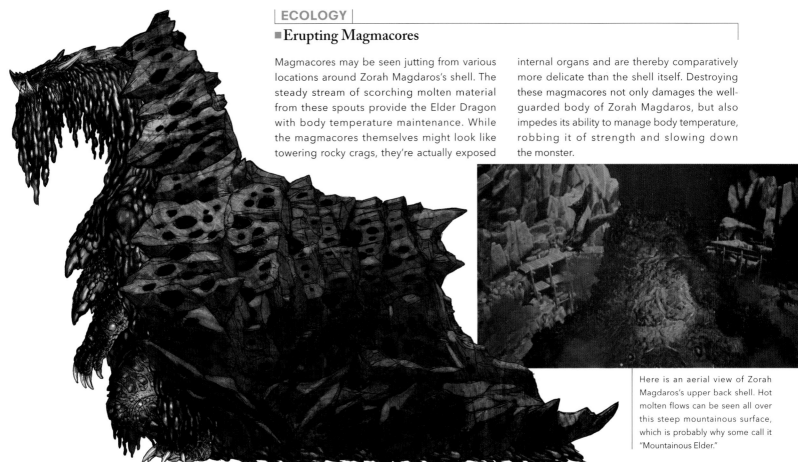

Here is an aerial view of Zorah Magdaros's upper back shell. Hot molten flows can be seen all over this steep mountainous surface, which is probably why some call it "Mountainous Elder."

297

ECOLOGY

■Winglike Arms to Support Its Burdensome Shell

Although difficult to see due to their location, Zorah Magdaros actually has two winglike arms on its shoulders, concealed within its shell. More similar to tree trunks than actual wings, they do not move with ease, but they support the weight of Zorah Magdaros's shell at its thickest (tallest) point. In fact, the shape of the middle back shell is due to the magma accumulations around its arms, which wraps them in a mountainous spire.

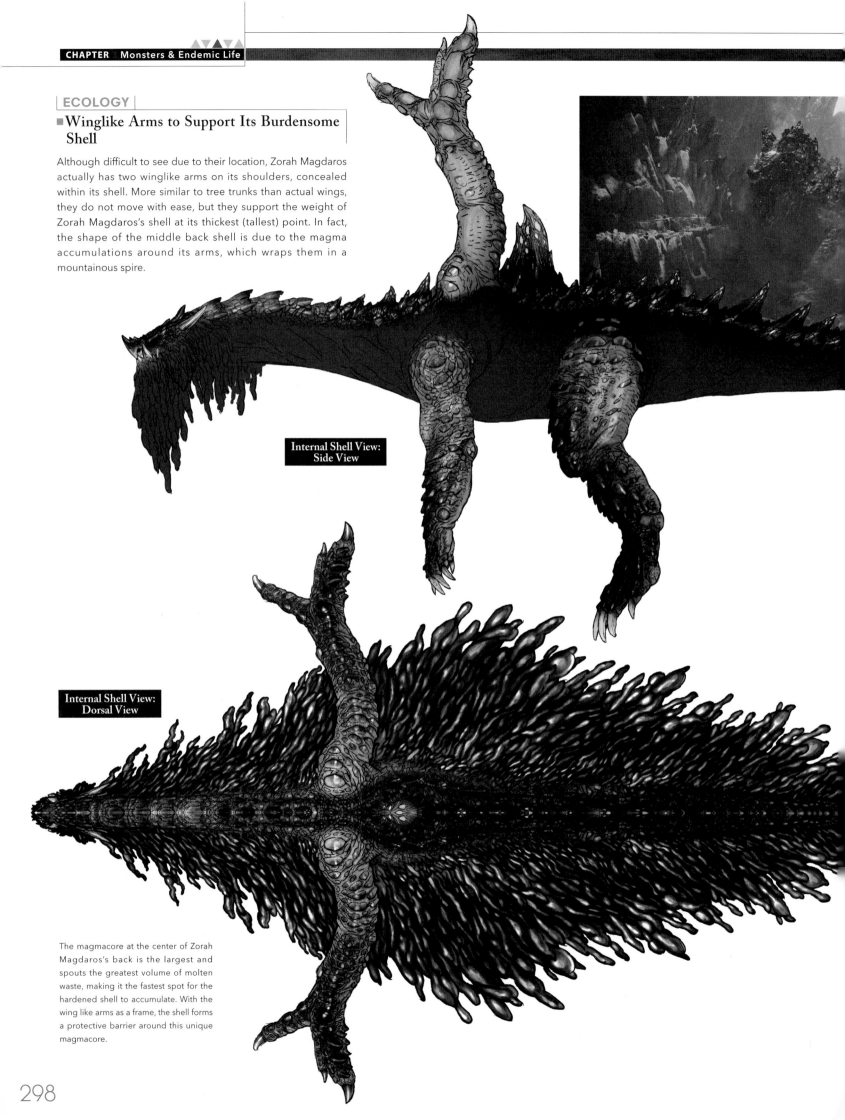

**Internal Shell View:
Side View**

**Internal Shell View:
Dorsal View**

The magmacore at the center of Zorah Magdaros's back is the largest and spouts the greatest volume of molten waste, making it the fastest spot for the hardened shell to accumulate. With the wing like arms as a frame, the shell forms a protective barrier around this unique magmacore.

A cropped side view of Zorah Magdaros standing on its hind legs. While standing, the powerful arms on its back are essential to supporting Zorah Magdaros's shell, which is about the same size as its own body but far denser.

ECOLOGY

■ The Ecology of Juvenile Individuals Without Shells

There are only a few existing records of juvenile Zorah Magdaros, but rare sightings and knowledge of the mature form's ecology have shed some light on their life cycle development. Newborn Zorah Magdaros do not possess a shell or a developed core for amplifying energy. They do not move from where they are born, growing by taking in minerals and building up their strength bit by bit. Once its core has developed, the juvenile will finally begin to move in search of sustenance. While its need for vital energy will increase as it matures, Zorah Magdaros's effectiveness at filtering energy from numerous minerals increases at a rate relative to its growth. However, this results in a large amount of waste material being released as magma. This process explains why Zorah Magdaros continually increases with size as it grows older and older. Despite having these clues to the ecological mysteries of the juvenile form, we have no data whatsoever on Zorah Magdaros's reproductive ecology, and we are still trying to determine whether separate male and female forms even exist.

Barnos are frequently spotted alongside Zorah Magdaros. Barnos typically roost around volcanic or tropical regions, explaining their attraction to the heat generated by Zorah Magdaros.

Analysis

■ On the Whereabouts of Zorah Magdaros in the Old World

Thanks to the individual who performed the Elder Crossing, we've learned much about Zorah Magdaros, but sightings of them in the Old World from whence they hail are scant at best. While it's true that they spend great periods of time hidden underground and underwater, why is it that sightings of these gargantuan organisms are so rare? Let's turn that question on its head. We know that young Zorah Magdaros stay stationary for great periods of time. Is it possible that due to its unlikely size, what we haven't considered to be a living organism is in fact a Zorah Magdaros? In other words, could what we think is a natural volcano actually be...Zorah Magdaros's shell? (*From an Elder Dragon scholar's notes*)

Production Backstory

PRODUCTION NOTES

Using a Giant Elder Dragon to Fuse Gameplay and Story

The story is based around the Commission attempting to bring order to a chaotic triangular relationship between Zorah Magdaros traveling to its final resting ground, Xeno'jiiva taking advantage of Zorah's journey, and Nergigante trying to devour Zorah. If a volcanic Elder Dragon like Zorah Magdaros were to perish on land in the New World, it would cover the region in magma. Zorah's physical presence allows players to experience gameplay on top of a volcano on the back of a gigantic moving landmass. Our goal was creating a monster that made both story and gameplay equally exciting experiences. (*Tokuda*)

We experimented with how the topography of its shell would change or interlock between its standing and grounded forms, as well as how players could interact with its core. Of course, we also needed to consider how other monsters would fit in, so a lot of factors needed to coincide. It might look similar to another four-legged Elder Dragon, Lao-Shan Lung, but it has arms inside its shell. By design, Zorah Magdaros can change its stance without losing balance because of how well those arms support that shell. (*Fujioka*)

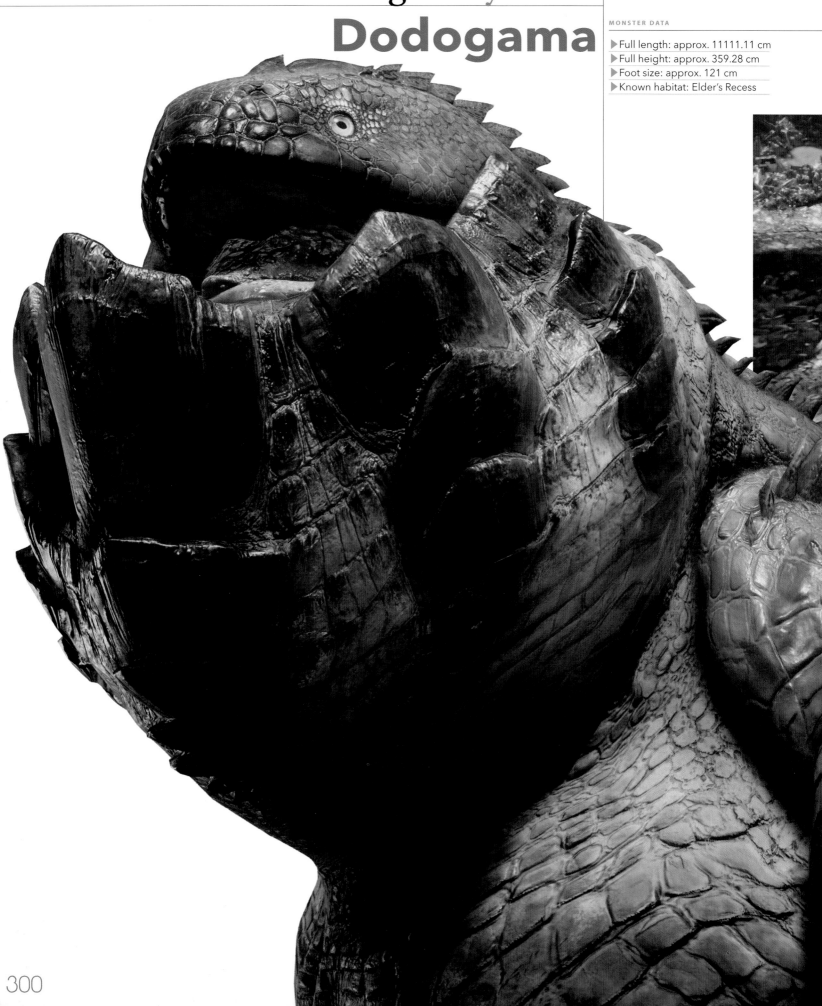

AKA ▶
Rock Gorging Glutton

Fanged Wyvern
Dodogama

MONSTER DATA

▶ Full length: approx. 11111.11 cm
▶ Full height: approx. 359.28 cm
▶ Foot size: approx. 121 cm
▶ Known habitat: Elder's Recess

DODOGAMA

ECOLOGY
■ A Mouth of Exploding Rocks

Dodogama feed on rocks and display a high preference for dragon crystals. Perhaps "feed" isn't the best term, as they don't really "eat" rocks. Rather, they process rocks into the basic form of dragon-crystal-producing energy, which they then absorb. The gritty remains of this process are then orally expelled by the Dodogama. When engaging an intruder, Dodogama will heave explosive rocks at its assailant to defend itself. The combustible nature of these otherwise normal rocks is the result of mixing dragon crystals with Dodogama's saliva. These highly unstable rocks can detonate if jostled, and if this occurs while they're inside a Dodogama's mouth...well, the Dodogama won't be very happy.

The rocks that Dodogama feeds on are made explosive through a combination of its saliva and dragon crystals, and they detonate on impact.

Excerpt from *The Monster Field Guide*

A monster that devours rocks as its primary diet. The crystals it devours mix with its saliva to produce explosive minerals that it can spit at its enemies.

INTRODUCTION

This Fanged Wyvern was first discovered in the Elder's Recess, where it feeds on its staple food, dragon crystals. Dodogama will habitually scoop up rubble with its sturdy jaw and store the cache in its mouth. While storing this material, Dodogama creates explosive rocks, which it may use defensively and offensively to discourage approaching enemies. As Dodogama waddles through its subterranean dragon-crystal-rich territory munching on rocks, it might seem frog-like and harmless, but looks can be deceiving. Dodogama will aggressively attack enemies with its brute strength, not to mention the explosive repertoire of short-range and long-range attacks that it employs against any approaching threats. Be certain never to let your guard down around this formidable opponent.

ECOLOGY

■ Expanding the Stomach to Release Body Heat

The chemical process by which a Dodogama produces explosive material with its saliva generates significant heat. We've learned that in order to maintain the most effective conditions for this process, Dodogama's normal body temperature is somewhat elevated compared to other organisms. As Dodogama lacks thermoregulatory organs, overheating would be a life-threatening problem if not for its elastic abdomen. By increasing the surface area of the portion of its body that comes in contact with the ground, Dodogama is able to effectively transfer heat energy into the ground. Also note that dragon crystals or rocks that have been processed in its throat may be sent to its stomach, where they are further processed for nourishment.

Front View

Dorsal View

Side View

Dodogama is seen here dragging its stomach along the ground as it moves about its territory. When not sleeping or eating, the monster tries to stay in constant motion in order to release excess body heat.

Definitive Depiction

Footprint

ECOLOGY

■ A Resilient and Hefty Jaw with Tremendous Clamping Power

From its delicate skill at carving dragon crystals to it raw resilience against explosions, Dodogama's jaw is a biological wonder. The prominent lower mandible features a powerful muscle that allows it to pluck dragon crystals straight out of the ground. A heat-resistant shell lines the jaw, allowing it to slice through volcanic rock with ease. By itself, this jaw of wonders accounts for a whopping 30 percent of Dodogama's body weight. The only reason the monster can move at all is thanks to its bulky neck and muscular forelegs.

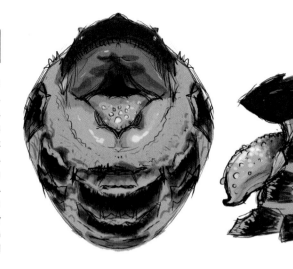

Dodogama's jaw is well suited to swallowing entire mouthfuls of earth. Note the complete lack of teeth for chewing.

Analysis

■ On the Relationship Between Dodogama and Toad Species

We believe that the Elder's Recess is Dodogama's natural habitat. With the exception of Nergigante, this differentiates Dodogama from the majority of the wyverns and Elder Dragons active in the region that were called there by Everstream energy. As for its origin, based on bone structure, one of the most prominent theories is that Dodogama is a relative of the Jagras that evolved to favor dragon-crystal consumption. However, even as I write this a bold group of researchers are developing a hypothesis based on the isolated nature of the Elder's Recess. They suggest that Dodogama's ancestors are in fact a species of gaseous toad that obtained energy from dragon crystals.

It's true that unlike other "glutton wyverns," Dodogama do not form packs. An observation that certainly lends credence to the hypothesis of their possible toad ancestry.

Its jaw is also a weapon used for oppressive bum-rush and explosive attacks.

ECOLOGY

■ A Shape-Changing, Rock-Storing Jaw

Note how the Dodogama's flexible skin is uniformly dotted with sections of hard shell; depending on whether the monster is storing rocks, the actual structure of its shell will change. On an empty stomach, Dodogama's elastic skin retracts and joins the shell plates, granting it a seamless hard shell. When storing rocks, Dodogama's skin expands and exposes soft gaps between the shell plates.

In this state, due to the exothermic reaction of chemically processing rocks, the rubble heats up and causes its lower jaw to glow red. While it may seem unnatural, the straight lines in which its shell plates are arranged are the best of both worlds for the Dodogama; it has enough elasticity to expand for rubble intake with enough resilience to withstand explosions.

Normal State

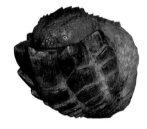

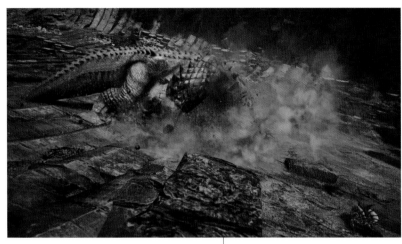

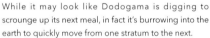

While it may look like Dodogama is digging to scrounge up its next meal, in fact it's burrowing into the earth to quickly move from one stratum to the next.

ECOLOGY

■ Standing Ground by Spitting Rocks at Enemies

The bountiful energy at the center of the Elder's Recess is what entices some of the New World's most powerful monsters to such a harsh environment. While Dodogama are certainly a force to be reckoned with, frankly speaking, compared to the other monsters of the Elder's Recess, they're at a severe competitive disadvantage. They pay no mind to creatures smaller than themselves, but don't mistake that apathy for a lack of vigilance. When encountering a large-bodied monster, Dodogama will respond with a barrage of explosive rocks in an attempt to surprise and drive away the individual. Even when not engaged in conflict, Dodogama may frequently be spotted with their mouths full, ready to unleash a wave of explosions at an enemy. As for their skill with these explosive projectiles, they've demonstrated the complex ability to accurately strike aerial targets. However, should their initial display of explosive force fail to deter an enemy, Dodogama will reveal their timid nature and retreat with haste.

With regard to sleeping habits, a Dodogama will dig a ditch and conceal the majority of its body when dozing. This habit allows it to blend in with its surroundings while protecting its jaw and vulnerable stomach.

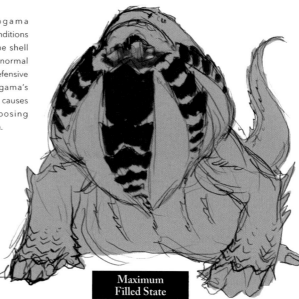

Depictions of Dodogama displaying the various conditions of its jowls. Note how the shell plates form a line in its normal state to create a single defensive layer protecting Dodogama's head. Filling up on rocks causes the jaw to jut out, exposing potentially vulnerable skin.

Filled State

Maximum Filled State

ECOLOGY

■ Differing from Other Bandit Wyverns by Traveling Alone

One of the defining differences between Dodogama and other "glutton wyverns" is their reluctance to travel in packs. The biggest reason for this is believed to be their mineral-based diets. This type of diet diminishes the benefits of a pack-based lifestyle.

Another possible explanation for the lack of pack behavior among Dodogama is that besides Wingdrakes—who can fly away to safety in a pinch—smaller monsters like Jagras or Girros find it exceedingly difficult to live in the Elder's Recess.

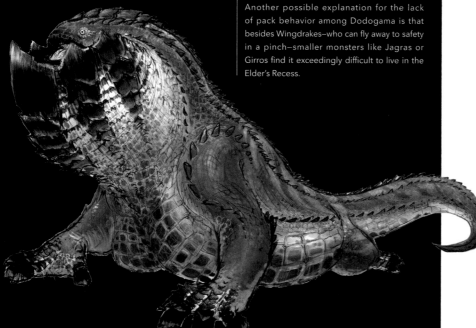

Production Backstory

PRODUCTION NOTES

A Welcome Face

After tiptoeing through the gauntlet of Elder Dragons in the Elder's Recess, when the player comes across the Dodogama we wanted them to think, "Okay, I can take on this one!" [laughs] If you just have a region full of nothing but Elder Dragons, not only is it way too tough, but it also feels off from an ecological perspective. We also wanted a monster that could net the player some good gear in order to make their progression a bit easier. To add a little flair to that, we came up with the explosive attacks and balanced them by making it possible to detonate the rocks while they're in Dodogama's mouth. (*Tokuda*)

The Great Jagras has a "full" state and a "sleek" state, and its two forms made it a resource-heavy monster early on in the project. We put a lot of work into the idea and we were able to use the skeletal structure of the "full" state as a basis for Dodogama. As for design, it thrives on minerals, so instead of crunching its food we have it grind ore with its tongue like a file. It lives in a harsh environment, but because hardly any other creatures feed on dragon crystals, it has a monopoly on the ore. [laughs] (*Fujioka*)

Extended **World Gallery**
Unidentified Creatures Log [IV]

The existence of Elder Dragon Zorah Magdaros was confirmed long ago, but up until now the only information we've had in our possession were incomplete or sensationalist accounts. Here are a few illustrated examples of those accounts that were based on solid conjecture. In addition, we've included some more recent documentation covering monsters possibly related to Odogaron and Dodogama. Some of this work seems to come from some very dedicated researchers with truly wild imaginations.

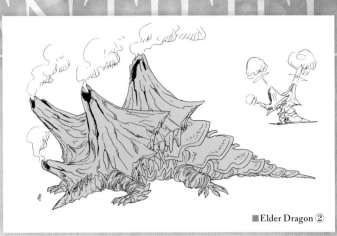

■ Elder Dragon ②

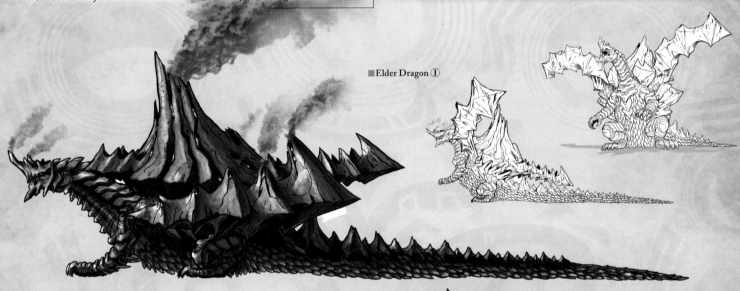

■ Elder Dragon ①

❖ Similar to "Mountainous Elder"

Elder Dragon #1: Zorah Magdaros is mostly viewed as a moving volcano. One journal seemed to imply that its eruptions made it appear like a floating island. We're not sure who created this depiction of Zorah Magdaros opening its wings.
Elder Dragon #5: It was thought that Zorah Magdaros had a red-hot mass of rock on its back.

❖ Similar to "Cruel Claw"

Fanged Wyvern #2: Note the distinct skin folds on its head and nostril, which is hollow in the middle. Cutaneous horns run from its back down to its tail.
Fanged Wyvern #3: The long-clawed first and fourth digits fold, crossing behind each leg, concealed in its coat. This suggests that the bristles of its legs and tail gather into bundles of spikes.

❖ Similar to "Rock Gorging Glutton"

Fanged Wyvern #5: A creature with a strong exoskeletal jaw that scoops earth. While storing rocks or defending itself, it closes its mouth tightly, using it as a shield-like mask.
Fanged Wyvern #9: This creature's broad, tough, and mollusk-like mouth is efficient at absorbing energy from rocks and ore. The striped channels on the outer layer may be indentations left by its movements.

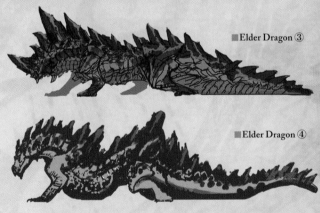

■ Elder Dragon ③

■ Elder Dragon ④

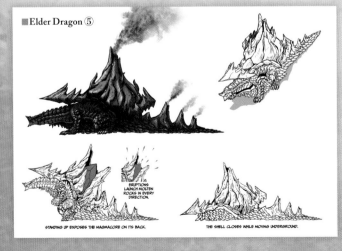

■ Elder Dragon ⑤

ERUPTIONS LAUNCH MOLTEN ROCKS IN EVERY DIRECTION.

STANDING UP EXPOSES THE MAGMACORE ON ITS BACK.

THE SHELL CLOSES WHILE MOVING UNDERGROUND.

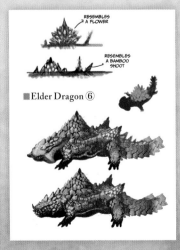

RESEMBLES A FLOWER

RESEMBLES A BAMBOO SHOOT

■ Elder Dragon ⑥

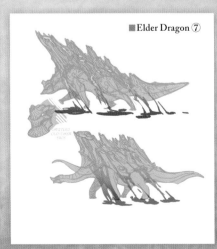

■ Elder Dragon ⑦

CREATURES LOG

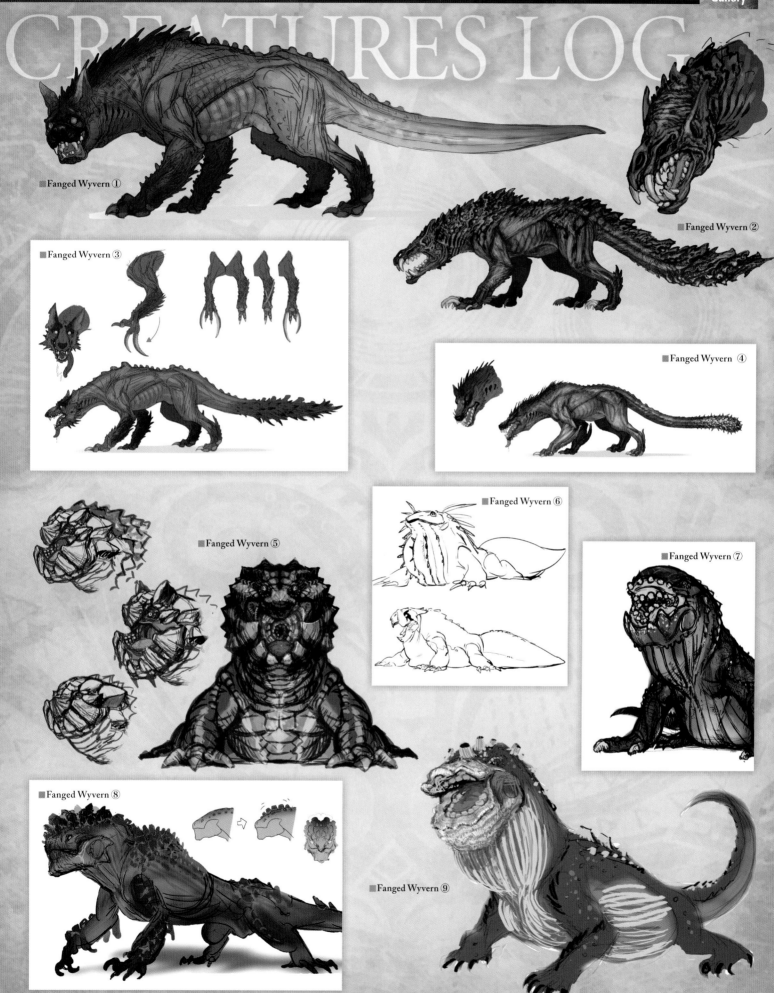

- Fanged Wyvern ①
- Fanged Wyvern ②
- Fanged Wyvern ③
- Fanged Wyvern ④
- Fanged Wyvern ⑤
- Fanged Wyvern ⑥
- Fanged Wyvern ⑦
- Fanged Wyvern ⑧
- Fanged Wyvern ⑨

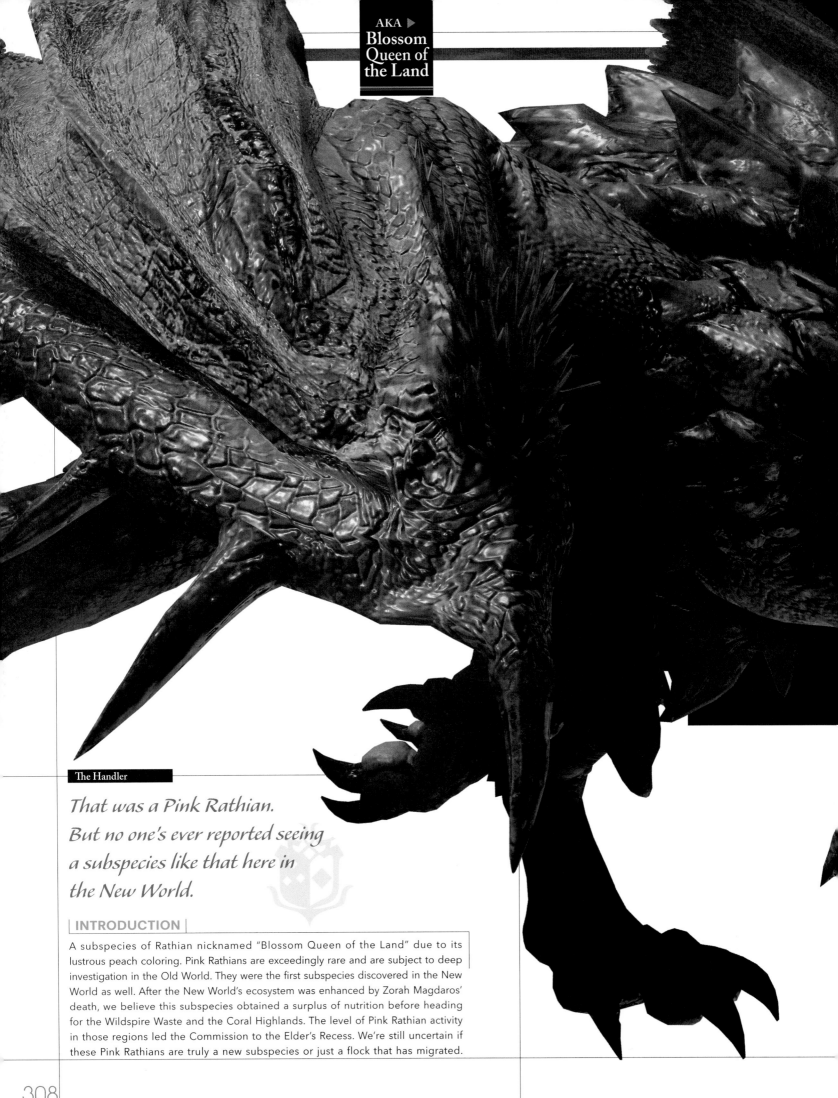

The Handler

*That was a Pink Rathian.
But no one's ever reported seeing
a subspecies like that here in
the New World.*

INTRODUCTION

A subspecies of Rathian nicknamed "Blossom Queen of the Land" due to its lustrous peach coloring. Pink Rathians are exceedingly rare and are subject to deep investigation in the Old World. They were the first subspecies discovered in the New World as well. After the New World's ecosystem was enhanced by Zorah Magdaros' death, we believe this subspecies obtained a surplus of nutrition before heading for the Wildspire Waste and the Coral Highlands. The level of Pink Rathian activity in those regions led the Commission to the Elder's Recess. We're still uncertain if these Pink Rathians are truly a new subspecies or just a flock that has migrated.

PINK RATHIAN

Don't expect weapons that work on a Rathian to lay a scratch on a Pink Rathian. Its pink shell isn't just for show; it's also proof of having survived many fierce battles.

ECOLOGY

■Tougher and More Flexible than Usual

Perhaps the biggest difference between Rathian types is in coloration. After the Everstream's activation, this subspecies of Rathians began to express changes in coloration, shell, and muscular properties as a direct result of a nutritional boost. Their shells have grown harder, while their scales and skin have become more pliable. As this difference is a nuanced one, it took some time to properly identify traces found in the Wildspire Waste as remnants of Pink Rathians.

Flying Wyvern
Pink Rathian

MONSTER DATA

▶ Full length: approx. 1754.37 cm
▶ Full height: approx. 577.22 cm
▶ Foot size: approx. 260 cm
▶ Known habitats: Wildspire Waste, Coral Highlands

309

ECOLOGY

■A Relentless and Aggressive Nature

Contrary to her elegant appearance, the Pink Rathian boasts a ferocious personality. She will utilize her full repertoire on any who approach, even those significantly smaller than herself and standard Rathians. In the Wildspire Waste, where the habitats overlap, Pink Rathians have been witnessed displaying threatening behavior towards Rathians, sometimes even attacking them. Generally surpassing standard Rathians, this subspecies is more efficient at chasing down and attacking its enemies, usually with a fierce barrage of biting attacks. Bipedal movement is the one area in which Pink Rathians meet but do not exceed their already powerful relatives. The Pink Rathian effortlessly takes to the sky and will chase down her enemies to finish them—almost dismissively—with her venomous tail.

Aside from the difference in body color, there are no other significant phenotypic differences between the standard species and the subspecies, but judging this book by its cover—or should we say color—would not be prudent.

In addition to its strong land attacks, Pink Rathians often attack from the air, making it a great threat to ground-based foes.

ECOLOGY

■Hitting Hard with a Mercurial Tail

Studying how the Pink Rathian utilizes her powerful venomous tail reveals yet another difference between her and the standard breed. Pink Rathians can perform the whiplike area-clearing attack famous among the standard breed, but they also display a unique offensive tail maneuver. A Pink Rathian's superior aerial maneuverability allows her to swing her tail while spiraling, an attack that can purge entire groups of enemies in an instant. What's more, her tail spikes contain an even higher concentration of venom than the standard breed. Even rampaging Bazelgeuse have been known to slink off licking their wounds once afflicted by her deadly venom.

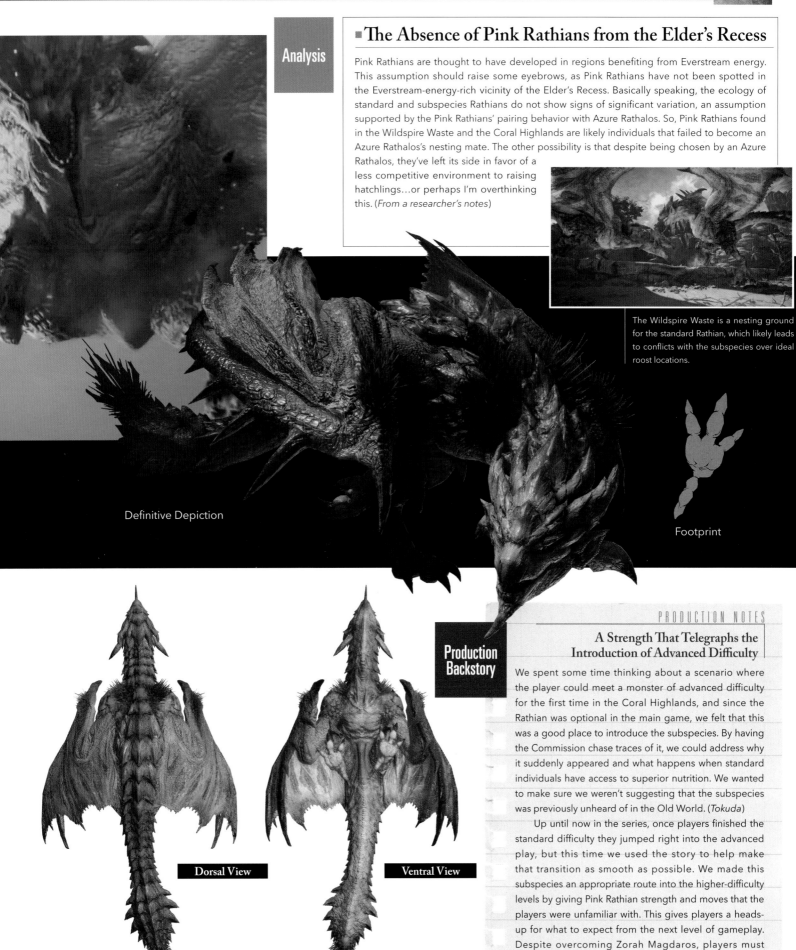

■ The Absence of Pink Rathians from the Elder's Recess

Analysis

Pink Rathians are thought to have developed in regions benefiting from Everstream energy. This assumption should raise some eyebrows, as Pink Rathians have not been spotted in the Everstream-energy-rich vicinity of the Elder's Recess. Basically speaking, the ecology of standard and subspecies Rathians do not show signs of significant variation, an assumption supported by the Pink Rathians' pairing behavior with Azure Rathalos. So, Pink Rathians found in the Wildspire Waste and the Coral Highlands are likely individuals that failed to become an Azure Rathalos's nesting mate. The other possibility is that despite being chosen by an Azure Rathalos, they've left its side in favor of a less competitive environment to raising hatchlings…or perhaps I'm overthinking this. (*From a researcher's notes*)

The Wildspire Waste is a nesting ground for the standard Rathian, which likely leads to conflicts with the subspecies over ideal roost locations.

Definitive Depiction

Footprint

Dorsal View

Ventral View

Production Backstory

PRODUCTION NOTES

A Strength That Telegraphs the Introduction of Advanced Difficulty

We spent some time thinking about a scenario where the player could meet a monster of advanced difficulty for the first time in the Coral Highlands, and since the Rathian was optional in the main game, we felt that this was a good place to introduce the subspecies. By having the Commission chase traces of it, we could address why it suddenly appeared and what happens when standard individuals have access to superior nutrition. We wanted to make sure we weren't suggesting that the subspecies was previously unheard of in the Old World. (*Tokuda*)

Up until now in the series, once players finished the standard difficulty they jumped right into the advanced play, but this time we used the story to help make that transition as smooth as possible. We made this subspecies an appropriate route into the higher-difficulty levels by giving Pink Rathian strength and moves that the players were unfamiliar with. This gives players a heads-up for what to expect from the next level of gameplay. Despite overcoming Zorah Magdaros, players must face monsters they've grown used to that, thanks to the Everstream, have become more powerful, forming the ladder between lower and higher difficulties. (*Fujioka*)

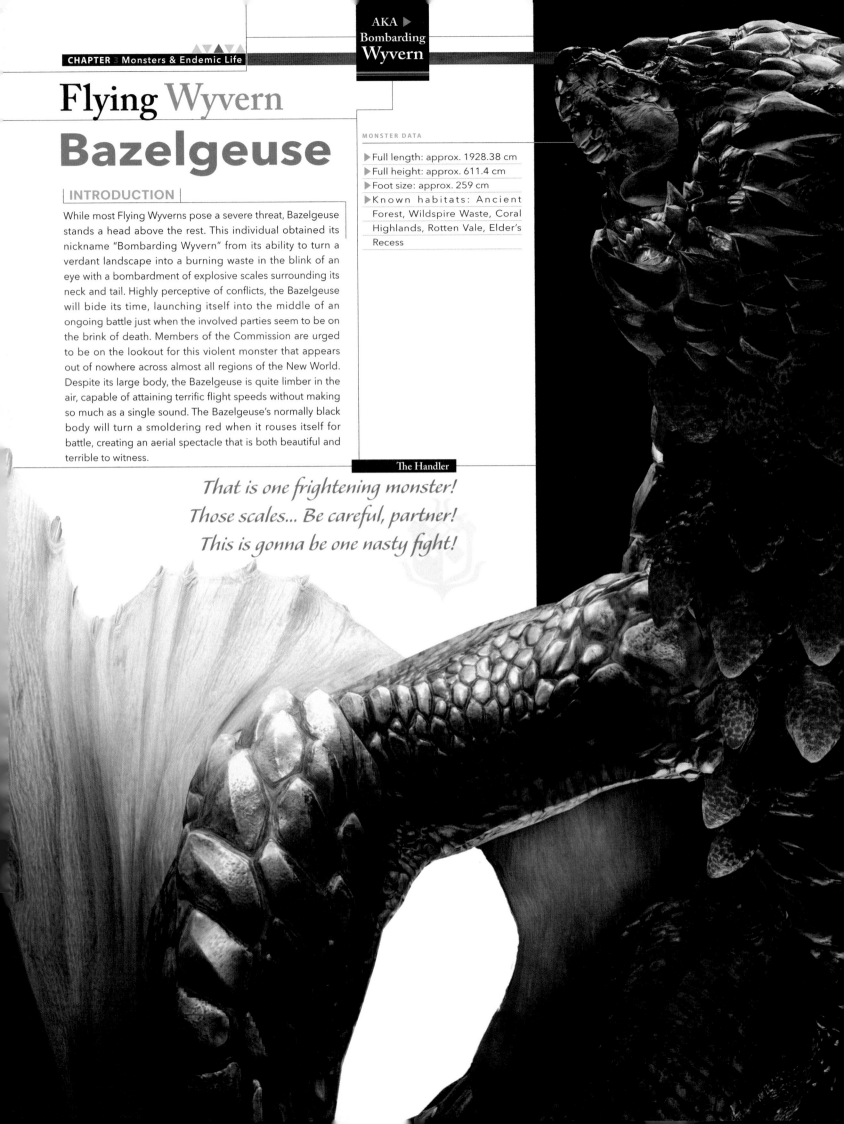

Flying Wyvern
Bazelgeuse

INTRODUCTION

While most Flying Wyverns pose a severe threat, Bazelgeuse stands a head above the rest. This individual obtained its nickname "Bombarding Wyvern" from its ability to turn a verdant landscape into a burning waste in the blink of an eye with a bombardment of explosive scales surrounding its neck and tail. Highly perceptive of conflicts, the Bazelgeuse will bide its time, launching itself into the middle of an ongoing battle just when the involved parties seem to be on the brink of death. Members of the Commission are urged to be on the lookout for this violent monster that appears out of nowhere across almost all regions of the New World. Despite its large body, the Bazelgeuse is quite limber in the air, capable of attaining terrific flight speeds without making so much as a single sound. The Bazelgeuse's normally black body will turn a smoldering red when it rouses itself for battle, creating an aerial spectacle that is both beautiful and terrible to witness.

MONSTER DATA

▶ Full length: approx. 1928.38 cm
▶ Full height: approx. 611.4 cm
▶ Foot size: approx. 259 cm
▶ Known habitats: Ancient Forest, Wildspire Waste, Coral Highlands, Rotten Vale, Elder's Recess

The Handler

That is one frightening monster!
Those scales... Be careful, partner!
This is gonna be one nasty fight!

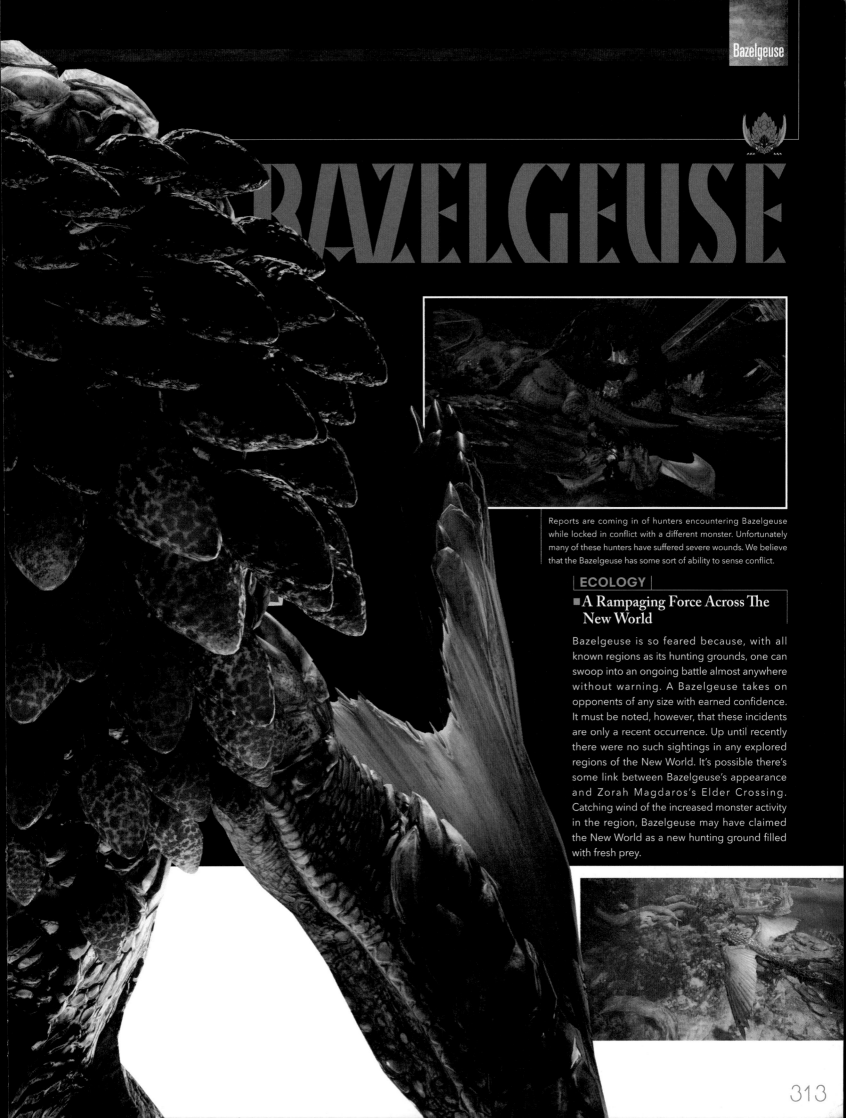

BAZELGEUSE

Reports are coming in of hunters encountering Bazelgeuse while locked in conflict with a different monster. Unfortunately many of these hunters have suffered severe wounds. We believe that the Bazelgeuse has some sort of ability to sense conflict.

ECOLOGY

■ A Rampaging Force Across The New World

Bazelgeuse is so feared because, with all known regions as its hunting grounds, one can swoop into an ongoing battle almost anywhere without warning. A Bazelgeuse takes on opponents of any size with earned confidence. It must be noted, however, that these incidents are only a recent occurrence. Up until recently there were no such sightings in any explored regions of the New World. It's possible there's some link between Bazelgeuse's appearance and Zorah Magdaros's Elder Crossing. Catching wind of the increased monster activity in the region, Bazelgeuse may have claimed the New World as a new hunting ground filled with fresh prey.

ECOLOGY

■ Approaching Prey by Gliding

One notable difference between the flight of a Bazelgeuse and other flying monsters is its reliance on gliding. Its wide and sleek wings cut silently through the wind so it can swoop in on its prey unannounced. Before long, the explosive scales have already done their job and the Bazelgeuse can settle in for a leisurely meal. It's also worth mentioning that Bazelgeuse's wings retain some of their function as arms, making this Flying Wyvern unique.

Dorsal View

Ventral View

For all their bark, Bazelgeuse literally lack a strong bite. Their teeth are poor at breaking down thick skin, bones, and joints, which is why they pepper their meals with explosions to break down their meat before they consume it.

ECOLOGY

■ The Formation of Its Explosive Scales

The unusually shaped "blasting scales" on Bazelgeuse's neck and tail are remarkable. Although we call them scales, they're not actually cutaneous. Bazelgeuse's body is covered in numerous glands that secrete a unique fluid that hardens, expanding the outermost layer of the gland's membrane so that it becomes a blasting scale. These scales will naturally drop away as it moves. If firmly jostled or exposed to the air for a certain amount of time, these biological bombs explode. When engaging an enemy, a Bazelgeuse uses these bombs to its advantage. For example, after showering an enemy's vicinity with scales, the Bazelgeuse will then charge or glide directly into them, detonating the scales with its own body for a massive explosion.

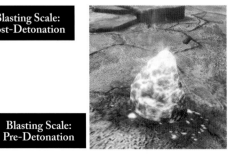

Blasting Scale: Post-Detonation

Blasting Scale: Pre-Detonation

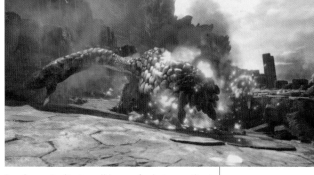

Bazelgeuse's skin is well-known for being resilient against both shock and fire from explosions, therefore rendering it immune to explosions from its own scales.

Analysis

■ On the Origin of Bazelgeuse Habits

Recently, Bazelgeuse have begun to appear everywhere, but where did they come from? Consider that their main form of aerial mobility is low-altitude gliding. This leads us to believe that Bazelgeuse are born in an area of high elevation—perhaps even the highest known to the Commission, the Elder's Recess. From such lofty heights, they would be able to survey the entirety of the New World.

If this hypothesis is correct, it would also explain why Bazelgeuse started appearing throughout Commission territories after the Elder Crossing drastically altered the ecology of various regions. They may be trying to wrest control from each region's apex monster in an attempt to make the territory their own. (*Excerpt from the book* Theories on New World Ecology)

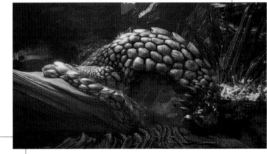

Here Bazelgeuse is seen rubbing its blasting scales against the ground. This behavior is only displayed by Bazelgeuse in the Elder's Recess and may be a form of territorial marking. Perhaps this act is only performed here due to the Recess's proximity to their original habitat.

Scale Formation After Blasting

Scale Formation Before Blasting

Glands in Bazelgeuse's neck and tail release an explosive substance that hardens to form a unique "scale." This substance is continuously secreted by the monster, and even after its scales are dropped, its reserves are soon replenished.

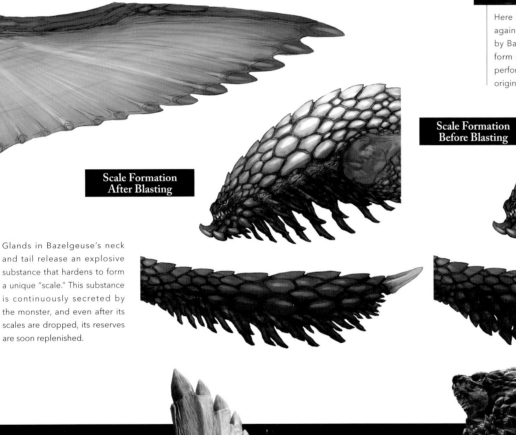

Definitive Depiction

Footprint

ECOLOGY

■ Activating Blasting Scales with Its Red-Hot State

When locked in conflict with large monsters or when hunting prey, the area around a Bazelgeuse's scales may display a smoldering red glow. This is what we call a Bazelgeuse's "enraged" state. It occurs when the monster's blood pressure rises sharply, which increases its body temperature. The root of this excitement is the monster's own berserker-like battle thrill. This state causes Bazelgeuse's blasting scales to become extremely volatile, exploding immediately on impact with the ground. While in this state, the monster's metabolism spikes, allowing Bazelgeuse to almost instantaneously replenish any depleted blasting scales. What's more, the Bazelgeuse seems to willfully induce this state. Outside of battle this state benefits Bazelgeuse during hunts. Enraged blasting scales make quick work of otherwise small and wily monsters.

An enraged Bazelgeuse's body temperature rises, causing its scales and certain crevices to glow red-hot.

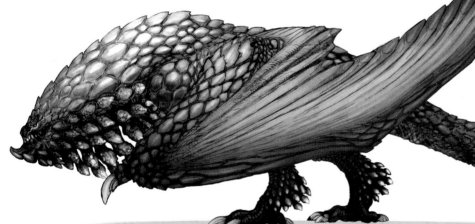

Enraged State: Side View

Enraged State: Front View

Blasting scales are replenished almost instantly while a Bazelgeuse is enraged, so watch out for a veritable shower of explosions.

Blasting Scale Formation and Enraged State Process

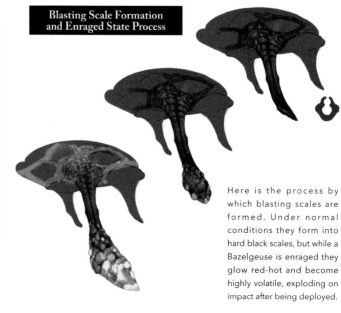

Here is the process by which blasting scales are formed. Under normal conditions they form into hard black scales, but while a Bazelgeuse is enraged they glow red-hot and become highly volatile, exploding on impact after being deployed.

| ECOLOGY |

■A Desire for Ecological Monopoly Leading to Eliminating All Annoyances

Bazelgeuse considers all regions of the New World to be its territory and defends them as such with an unshakable tenacity. After spotting an intruder, a Bazelgeuse launches a swift assault that ends only when the intruder is chased away or its life is ended. The Bazelgeuse's single-minded hostility towards other large monsters in its territory is rooted in its urge to definitively eliminate any source of potential predation by other monsters of its own prey. Such behavioral traits have led to particularly fierce territorial conflicts between Bazelgeuse and another monster recently confirmed to be inhabiting the New World named Deviljho. Similar to Bazelgeuse, Deviljho traverses the entirety of the known New World in constant search of prey to satiate its appetite. As they are equally matched in both temperament and strength, it comes as

no surprise that there have been sightings of these two rampaging monsters locked in mortal combat across the New World. Ironically, their battles over hunting rights send their prey scurrying for safety, potentially robbing both monsters of a meal.

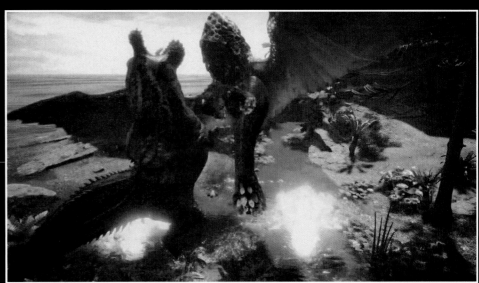

A Deviljho will attack a Bazelgeuse by clamping its viselike jaws onto its opponent and thrashing about. In return, the Bazelgeuse will commonly respond by releasing all of its blasting scales at once. It's no exaggeration to say their battles rank among the fiercest in all of the New World.

| ECOLOGY |

■How Bazelgeuse Detonates Blasting Scales with Fiery Breath

Occasionally a Bazelgeuse will expel flames from its mouth for the purpose of detonating its blasting scales. While oxidation due to aeration or strong shocks cause the scales to detonate, exposure to extreme heat has the same effect. Unlike other fire-breathing wyverns like Rathalos, Bazelgeuse do not have a flame-sac organ.

Production Backstory

PRODUCTION NOTES
An Explosive Interruption

As players head into harder battles, they're still seeing the same maps, so we wanted to change things up a bit. We thought up a monster that would fight over its prey, which led us to the concept of a Flying Wyvern that wreaks havoc by bombarding the playing field. That was the creation of Bazelgeuse. We heard that it gained a lot of attention from overseas gamers who were experiencing the series for the first time and, for better or for worse, we're glad it made such an impact. [laughs] (*Tokuda*)

Deviljho is famous for being a troublemaker, but since we're in the New World, you'd want a new monster, right? Explosive bombardment was in our heads almost from the start, and the design incorporates burning, regeneration, and awkward, seagull-like wings. Its ventral side conceals the secretory organs, so we made his dorsal side very simple. You know, we tend to focus on Bazelgeuse's explosive nature, but his face is so well proportioned that I think he's pretty handsome. (*Fujioka*)

Piscine Wyvern
Lavasioth

MONSTER DATA

▸ Full length: app.1797.24 cm
▸ Full height: approx. 669.71 cm
▸ Foot size: approx. 229 cm
▸ Known habitat: Elder's Recess

Excerpt from *The Monster Field Guide*

*A vicious Piscine Wyvern that swims
in lava and uses hardened magma
as armor.*

INTRODUCTION

A denizen of volcanic regions, Lavasioth
is a Piscine Wyvern that swims through
searing lava as easily as if through water.
It has made a home for itself in the New
World by inhabiting the lava pits of the
Elder's Recess, where it showers intruders
with lava. In terms of physical prowess, a
Lavasioth can walk bipedally on specially
adapted fins, swim at high speeds through
lava, and leap tens of meters into the
air. It shares an aggressive rivalry with its
neighbor Uragaan.

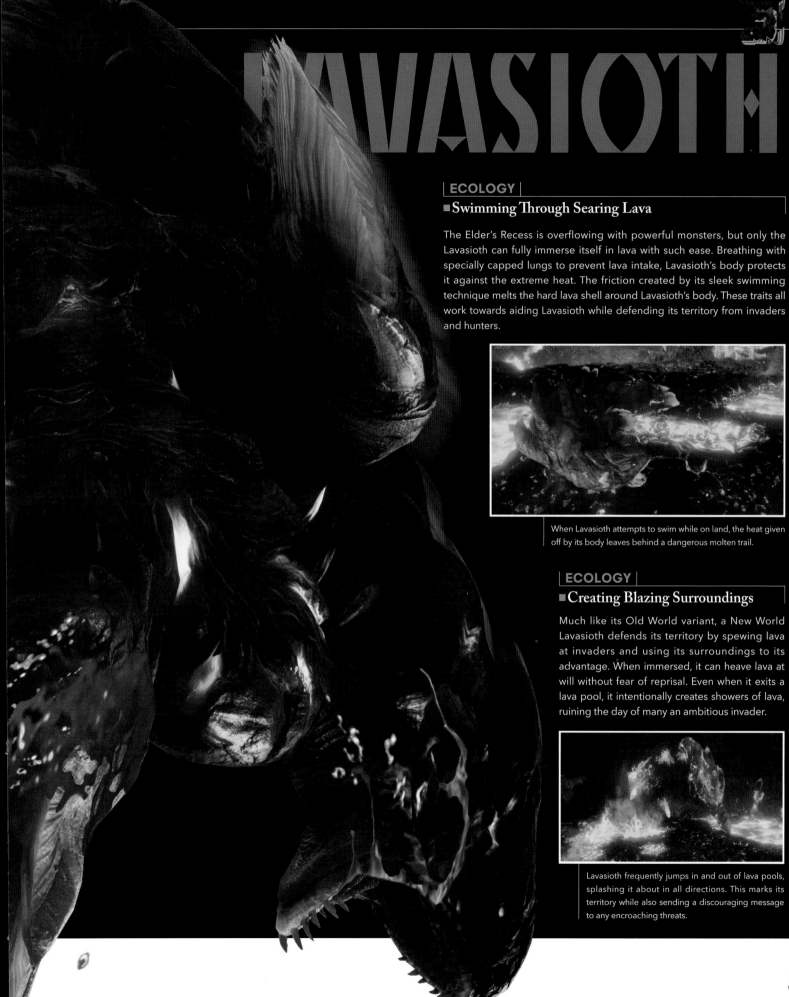

LAVASIOTH

ECOLOGY

■ Swimming Through Searing Lava

The Elder's Recess is overflowing with powerful monsters, but only the Lavasioth can fully immerse itself in lava with such ease. Breathing with specially capped lungs to prevent lava intake, Lavasioth's body protects it against the extreme heat. The friction created by its sleek swimming technique melts the hard lava shell around Lavasioth's body. These traits all work towards aiding Lavasioth while defending its territory from invaders and hunters.

When Lavasioth attempts to swim while on land, the heat given off by its body leaves behind a dangerous molten trail.

ECOLOGY

■ Creating Blazing Surroundings

Much like its Old World variant, a New World Lavasioth defends its territory by spewing lava at invaders and using its surroundings to its advantage. When immersed, it can heave lava at will without fear of reprisal. Even when it exits a lava pool, it intentionally creates showers of lava, ruining the day of many an ambitious invader.

Lavasioth frequently jumps in and out of lava pools, splashing it about in all directions. This marks its territory while also sending a discouraging message to any encroaching threats.

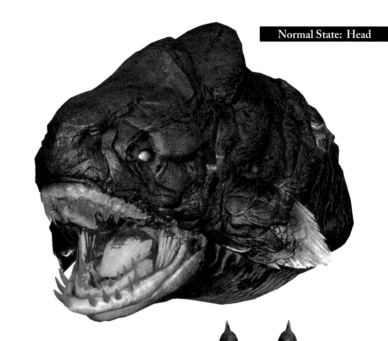

Normal State: Head

ECOLOGY

■ Enveloped in Tough Lava Armor

The thick black "skin" enveloping Lavasioth's body is actually lava that has accumulated on the monster during swimming and which—after hardening—becomes a thick layer of natural armor. When a Lavasioth exits a lava pool, the coating hardens over time. Upon returning to the lava, this armor will melt down, exposing its skin once again. For this reason, Torch Pods for the Slinger or flaming ammo is of great use during Lavasioth encounters. Like Jyuratodus, Lavasioth is capable of bipedal movement but boasts an even more powerful frame than the "Mud Piscine" to accommodate its weighty armor.

Normal State: Side View

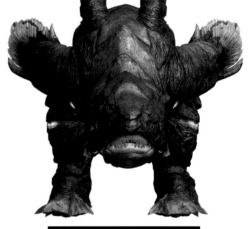

Normal State: Front View

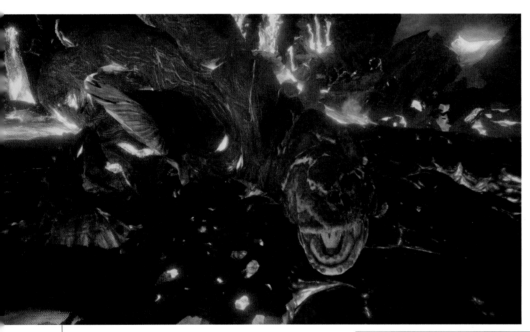

If a Lavasioth's lava armor is chipped during battle, you may catch a glimpse of the golden-scaled skin underneath its weighty defense.

Sometimes the Lavasioth is witnessed drinking lava from a lava pool. This routine helps Lavasioth maintain its internal body temperature.

Analysis

■ Regarding Lavasioth's Relationship with Jyuratodus

One may note various similarities between the appearance and ecology of Lavasioth and Jyuratodus. Jyuratodus were first discovered in the New World, but even among Piscine Wyverns, their skeletal structure is extremely primitive. As such, it's natural to hypothesize that Lavasioth are a Piscine Wyvern species that branched off from Jyuratodus and adapted to a lava-rich habitat. This requires us to consider which continent they originated from. Did Lavasioth evolve from Jyuratodus in the New World and migrate to the Old World? Or perhaps Jyuratodus migrated to the Old World and evolved into Lavasioth? With the existence of Jyuratodus in the Old World remaining unconfirmed, the subject of its potential role as the ancestor of modern Piscine Wyverns is of great interest to us. (*Excerpt from the book* Theory of Monster Evolution)

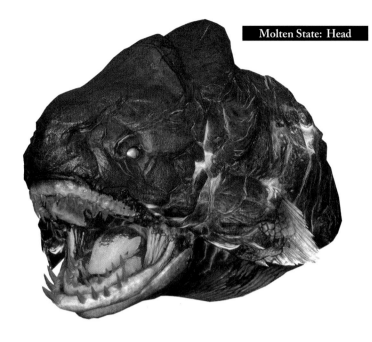

Molten State: Head

New World Lavasioth have been found to expel greater quantities of high-pressure lava at targets than their Old World counterparts. Lava fired at such high pressure splatters easily on impact, causing widespread damage.

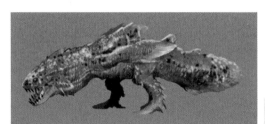

Molten State: Side View

Molten State: Front View

Definitive Depiction

Footprint

Production Backstory

PRODUCTION NOTES

A Monster That Thrives in the Lava Zone of the Elder's Recess

While preparing for Teostra's involvement, we developed a lava area in the Elder's Recess, which in turn made us want to add another monster. It had to be a monster that would be just below an Elder Dragon in terms of difficulty and continue to pull the player into the local ecology. Lavasioth was perfect for both requirements but hasn't been very popular with the players… We're not sure if that's because Lavasioth isn't a big part of the main story, but in any case, it's the reason we decided our first-anniversary quest would star Lavasioth. Whenever Lavasioth thrashes around, it drops jewels left and right, so I think fans will finally try to go after this monster. [laughs] (*Tokuda*)

Lavasioth is infamous for having powerful area-of-effect lava attacks and resorts to some repetitive gimmicks in battle, but if you know how to deal with them you can have some fun. There's some Slinger Torch ammo around there that will actually soften up Lavasioth, changing how to play against him. Not many people fight Lavasioth, so maybe they just didn't know, but I highly suggest giving it a shot. [laughs] (*Fujioka*)

Brute Wyvern

Uragaan

Excerpt from The Monster Field Guide

A monster that uses its enormous jaw to crush ore for consumption.

MONSTER DATA

▶ Full length: approx. 2058.63 cm
▶ Full height: approx. 750.53 cm
▶ Foot size: approx. 195 cm
▶ Known habitat: Elder's Recess

INTRODUCTION

Uragaan is a Brute Wyvern that nests in rocky and mineral-rich volcanic regions. Its presence in the New World has been confirmed in the Everstream-energy-rich Elder's Recess. One of the heaviest large-sized monsters, Uragaan can wrap its body into a wheel and roll between the rocky and volcanic areas of the Elder's Recess with astounding speed. However, we strongly advise against being distracted by this monster's vexing locomotion. Even if one stands safely clear of Uragaan's destructive path, the explosive rocks it drops are just as likely to bring about a premature demise.

ECOLOGY

■ Producing Explosive Rocks to Aid in Rock Digestion and Absorption

Uragaan usually sleeps on a bed of natural tar, leaving the monster covered in—as one might imagine—tar. The Uragaan uses this tar to adhere rocks to its abdomen and tail. Surprisingly, this behavior aids in feeding, a somewhat unlikely vital purpose. Once it has adhered Everstream-energy-rich rocks to its body, Uragaan will release a natural gas that grants these rocks explosive properties. The Uragaan can digest and absorb these altered rocks more quickly and efficiently than normal unaltered samples. Incidentally, these rocks aren't simply a portable food supply—they're also used by Uragaan to threaten its enemies.

ECOLOGY

■ Feeding on the Rocks of the Elder's Recess and Releasing Gas

Uragaan prefers to feast on the Everstream-energy-rich rocks of the Elder's Recess. When these rocks are broken down by bacteria in the Uragaan's stomach, a natural gas byproduct is generated. Located on the Uragaan's ventral belly are several unique glands that periodically release this gas when it builds up. The gas has a sleep-inducing effect on other creatures. Uragaan is instinctively aware of this and will intentionally use it to protect itself against opponents and threats.

An Uragaan will use its explosive rocks to their full potential locked in conflict with an enemy. It peppers the ground with the and, with a quick slam of its jaw or spin of its body, detonates the

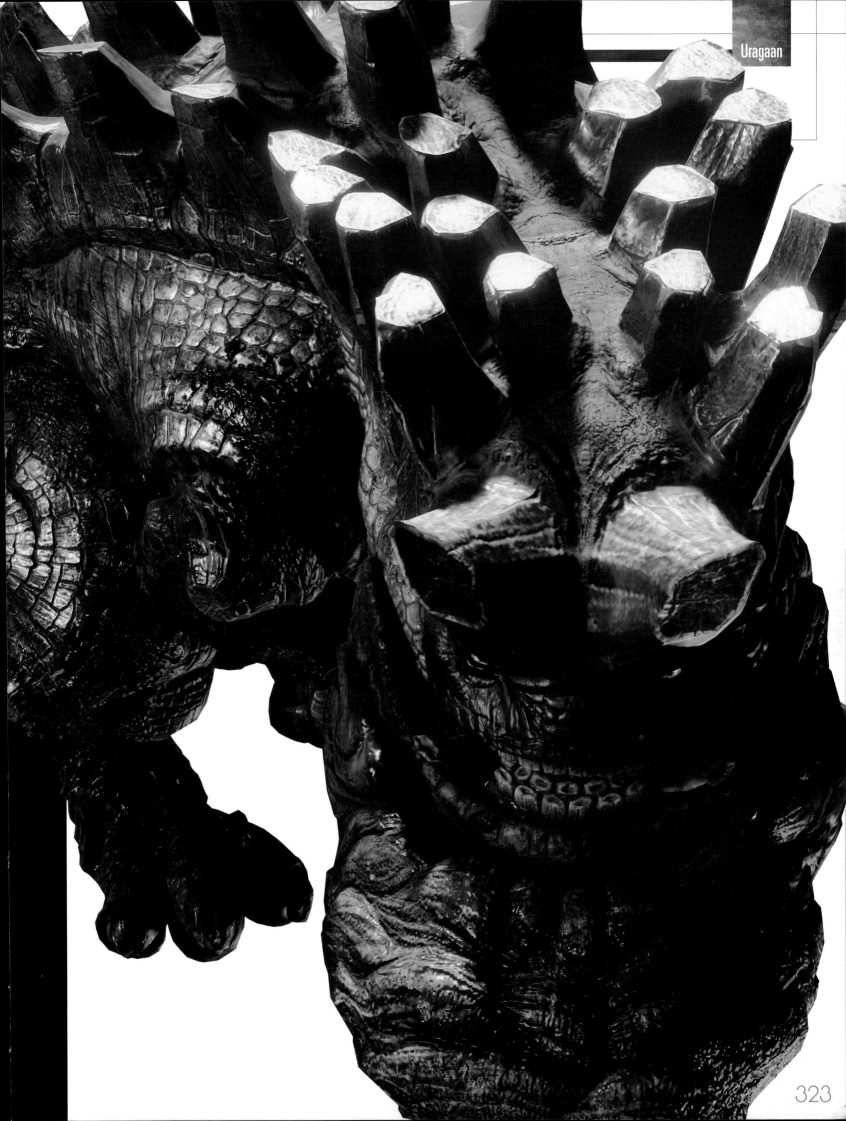

ECOLOGY

■Using the Projections on Its Back for Speedy Movement

The countless projections jutting from Uragaan's back are cutaneous nail-like growths that continue to grow throughout its life. These projections increase Uragaan's traction while rolling, allowing it to maintain its balance, control its direction, and come to a complete stop. The act of rolling keeps these projections well trimmed and glossy, which is more important to Uragaan than one might think. If these projections grow too long, an Uragaan will find rolling difficult. Uragaan is not known for being nimble on its feet due to its tremendous weight, and loss of rolling mobility would negatively impact the monster's ecology.

Profile View

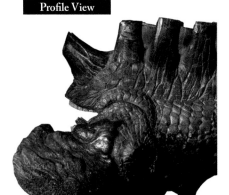

Uragaan's chin is coated in melted ore. Note the clear delineation between Uragaan's natural skin tone and the color of its lower jaw.

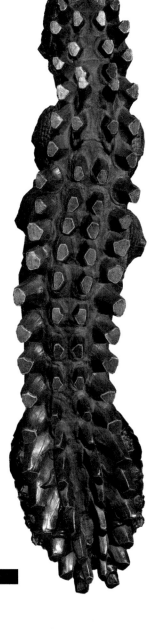

Dorsal View

Uragaan's sleep-inducing gas is also flammable, and if the monster is enraged while emitting said gas, its body temperature may ignite it, resulting in a fiery eruption.

ECOLOGY

■Rampantly Smashing with Its Powerful Jaw

Uragaan's most eye-catching feature is its unusually prominent lower jaw, which it utilizes like a hammer to break rocks into a size appropriate for manageable consumption. This jaw grows in size as an Uragaan matures, and to augment the jaw's already impressive crushing strength, the monster will coat it in molten ore. Individuals with the largest jaws have a greater advantage in not only territorial conflicts but also mate selection. Uragaan supports all of its weight with only two legs, but when rolling, the jaw becomes its center of gravity. These are all reasons why Uragaan takes meticulous care of its jaw's size and shape.

Uragaan's lower jaw is its greatest defensive weapon against opponents. Putting its full body weight into each smash sends shock waves in all directions.

Analysis

▪Are New World Uragaans Strategists?

While New World Uragaans display very little ecological variation from their Old World cousins, only New World Uragaans utilize their surroundings during conflict. According to one report, when a Uragaan was chased through its habitat in the crater-shaped area of the Elder's Recess, it simply rolled about at will, using the walls to its advantage and confounding the hunter. A separate account suggests that in a different area, one found enough speed to roll up a wall and push off it in an attempt to land on a hunter headfirst. (*Excerpt from a report on the New World*)

Definitive Depiction

Footprint

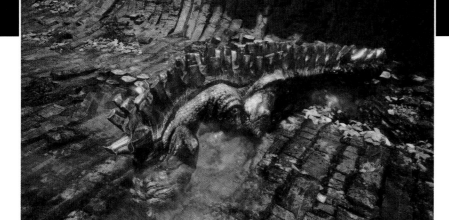

Production Backstory

PRODUCTION NOTES

Rampaging in the Gaps Left By Elder Dragons Helps Guide the Player

Kushala Daora takes the high ground and Teostra has the low ground in the Elder's Recess, but we needed a monster that could link those areas. So we liked the idea of a monster that lives in the upper stratum but travels down below when it needs to eat ore. We also wanted to introduce the sleep status effect, and Uragaan checked all of those boxes for us. It's intentional that Uragaan is a monster who travels on the ground and doesn't take to the air. Uragaan's role here is actually quite similar to how Kulu-Ya-Ku links Jyuratodus and the other Wildspire Waste monsters, but since this is the Elder's Recess it's on a whole different power scale. [laughs] (*Tokuda*)

Elder Dragons aren't the type to closely guard their territory. You don't need to worry about them coming across you, you need to worry about what happens if you come across them. Uragaan is a monster whose movement throughout the region gives the player an easy opportunity to stumble into an Elder Dragon. It's a pretty powerful monster in its own right, so the fact that Uragaan plays such a small role in the Elder's Recess really makes you think about how crazy the region is. [laughs] (*Fujioka*)

| ECOLOGY |

▪On Ecology and Territoriality During Mating Season

Male and female Uragaans are generally difficult to discern from one another, but during the short duration of their mating season, males will attempt to appeal to females by decorating their bodies with shiny ore. The properties of the ore directly affect the hardness and appearance of their bodies, and so during this period the males show a preference toward sturdy and lustrous ore for sustenance. Juveniles survive mainly on plant matter, but during their growth spurt their diet changes exclusively to rocks. This period is when they develop glands for expelling the gas that forms when they digest rocks. Dorsal protrusions are not fully developed in juvenile individuals, so they practice rolling about on smooth, flat surfaces. Please be aware that this information is based on Old World research and has not been confirmed with respect to New World individuals.

Uragaans require great quantities of rock as sustenance to support their large frame and are therefore inclined toward aggressiveness. Be on the lookout for Uragaan's reaction to Lavasioth. Their territories slightly overlap, and they've been known to threaten each other.

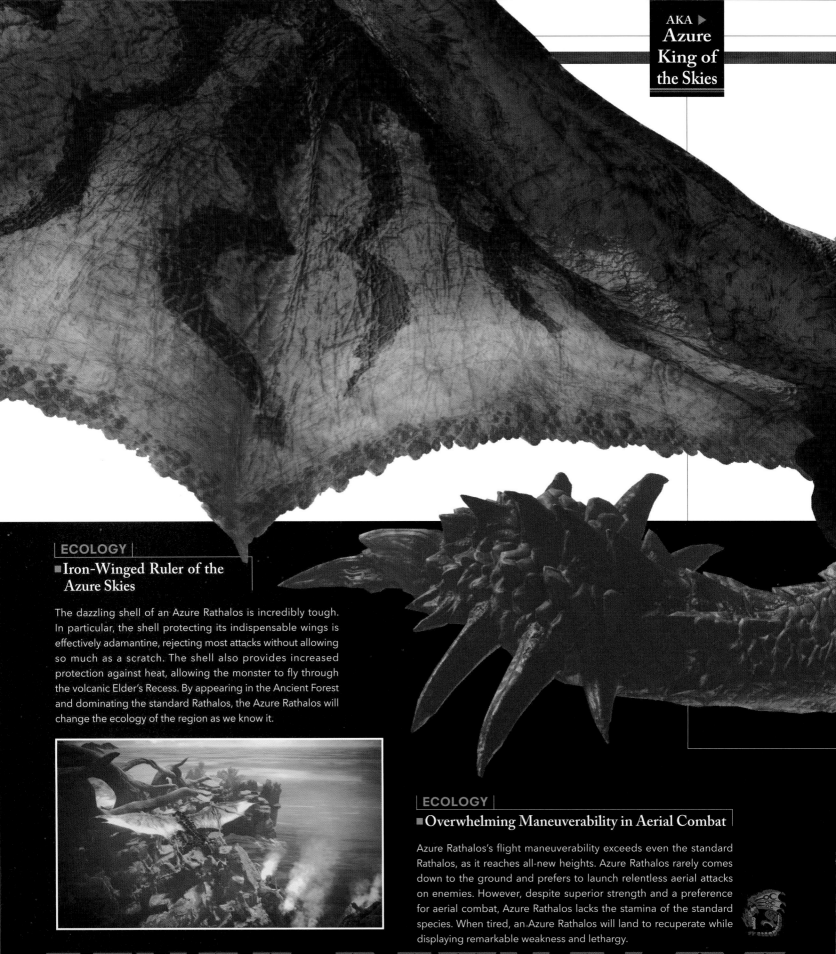

ECOLOGY

■ Iron-Winged Ruler of the Azure Skies

The dazzling shell of an Azure Rathalos is incredibly tough. In particular, the shell protecting its indispensable wings is effectively adamantine, rejecting most attacks without allowing so much as a scratch. The shell also provides increased protection against heat, allowing the monster to fly through the volcanic Elder's Recess. By appearing in the Ancient Forest and dominating the standard Rathalos, the Azure Rathalos will change the ecology of the region as we know it.

ECOLOGY

■ Overwhelming Maneuverability in Aerial Combat

Azure Rathalos's flight maneuverability exceeds even the standard Rathalos, as it reaches all-new heights. Azure Rathalos rarely comes down to the ground and prefers to launch relentless aerial attacks on enemies. However, despite superior strength and a preference for aerial combat, Azure Rathalos lacks the stamina of the standard species. When tired, an Azure Rathalos will land to recuperate while displaying remarkable weakness and lethargy.

AZURE RATHALOS

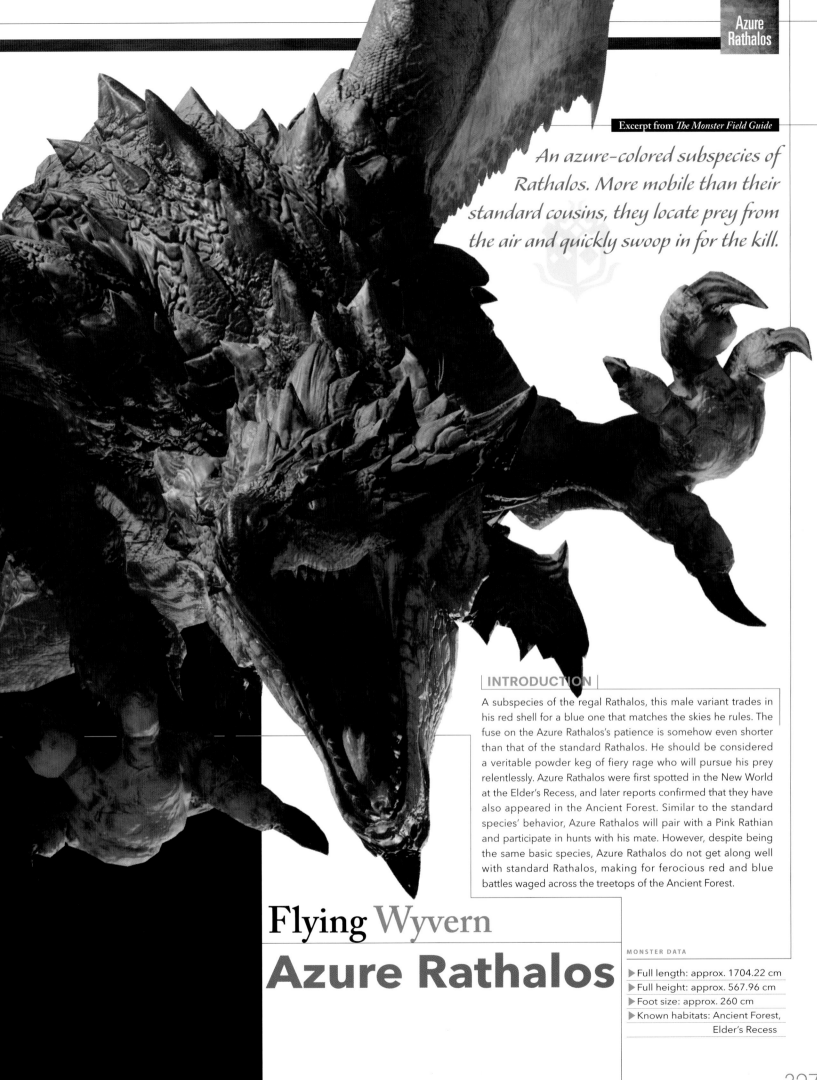

Excerpt from The Monster Field Guide

*An azure-colored subspecies of
Rathalos. More mobile than their
standard cousins, they locate prey from
the air and quickly swoop in for the kill.*

INTRODUCTION

A subspecies of the regal Rathalos, this male variant trades in
his red shell for a blue one that matches the skies he rules. The
fuse on the Azure Rathalos's patience is somehow even shorter
than that of the standard Rathalos. He should be considered
a veritable powder keg of fiery rage who will pursue his prey
relentlessly. Azure Rathalos were first spotted in the New World
at the Elder's Recess, and later reports confirmed that they have
also appeared in the Ancient Forest. Similar to the standard
species' behavior, Azure Rathalos will pair with a Pink Rathian
and participate in hunts with his mate. However, despite being
the same basic species, Azure Rathalos do not get along well
with standard Rathalos, making for ferocious red and blue
battles waged across the treetops of the Ancient Forest.

Flying Wyvern
Azure Rathalos

MONSTER DATA

- ▶ Full length: approx. 1704.22 cm
- ▶ Full height: approx. 567.96 cm
- ▶ Foot size: approx. 260 cm
- ▶ Known habitats: Ancient Forest,
 Elder's Recess

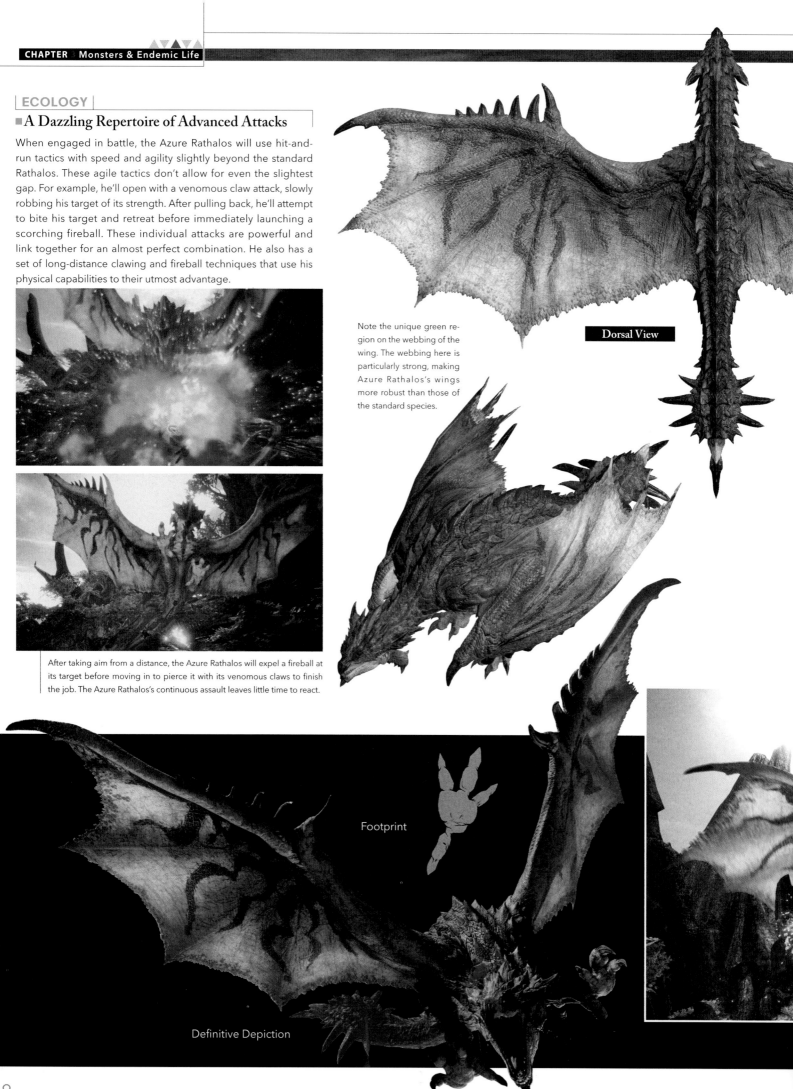

ECOLOGY

■ A Dazzling Repertoire of Advanced Attacks

When engaged in battle, the Azure Rathalos will use hit-and-run tactics with speed and agility slightly beyond the standard Rathalos. These agile tactics don't allow for even the slightest gap. For example, he'll open with a venomous claw attack, slowly robbing his target of its strength. After pulling back, he'll attempt to bite his target and retreat before immediately launching a scorching fireball. These individual attacks are powerful and link together for an almost perfect combination. He also has a set of long-distance clawing and fireball techniques that use his physical capabilities to their utmost advantage.

Note the unique green region on the webbing of the wing. The webbing here is particularly strong, making Azure Rathalos's wings more robust than those of the standard species.

Dorsal View

After taking aim from a distance, the Azure Rathalos will expel a fireball at its target before moving in to pierce it with its venomous claws to finish the job. The Azure Rathalos's continuous assault leaves little time to react.

Footprint

Definitive Depiction

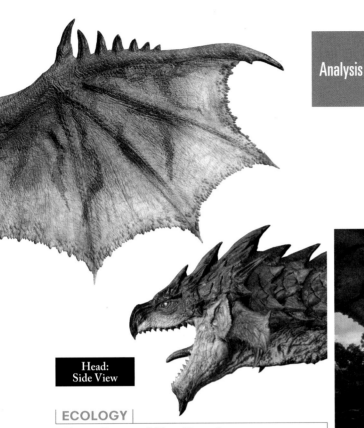

Analysis

■The Existence and Habitat of the Subspecies

Two popular explanations for the presence of Azure Rathalos in the New World have emerged. One suggests that a number of standard Rathalos settled in the Elder's Recess and were altered by the region's energy. The other popular hypothesis is that they migrated from the Old World. So why are we seeing them in the Ancient Forest?

While Azure Rathalos are naturally suited to the sweltering conditions of the Elder's Recess, the severity of the region does not make it opportune for raising hatchlings. This is why we believe that Azure Rathalos travel to the Ancient Forest during mating season. (*Excerpt from a Third Fleet scholar's notes*)

**Head:
Side View**

Whether shooting fireballs on the move or after dodging backwards, the Azure Rathalos has truly made this assortment of fire attacks his own.

| ECOLOGY |

■Rage-Powered Fire Breathing

Azure Rathalos can produce fireballs so wild and incendiary that his attacks are likely to burn down entire fields along with his prey. The angrier an Azure Rathalos becomes, the greater the intensity of his flames, almost as if the fire itself shares his rage. In addition to causing an increase in temperature and combustion efficiency, the anger of an Azure Rathalos will bolster its lungs, allowing him to spit flames far and wide.

**Production
Backstory**

PRODUCTION NOTES
Strengthening Rathalos's Flight and the Ultimate Form of Player-Controlled Difficulty

We brought Azure Rathalos to the Elder's Recess because we wanted a Flying Wyvern that wasn't an Elder Dragon. Basically he's not too different from a regular Rathalos other than that he's a much stronger flier and the player has greater control over his difficulty, depending on how they approach him. (*Tokuda*)

From a game-design standpoint, we made it easy to understand how to manipulate the standard Rathalos's flight abilities through combat. We wanted to add more to him, like Slinger-specific reactions or the ability to break his wings, but when he first appears in the game it's still a little bit early for all of that. Enter the Azure Rathalos, who represents what we originally wanted to do with Rathalos in this title. If you don't figure out how to handle him, it can be difficult to deal with his aerial abilities. I think he left a lot of people yelling at their screens, "Why won't he come down?!" So to everyone out there who felt that way, I suggest you take a step back and consider a new strategy. (*Fujioka*)

The Azure Rathalos's powerful lungs shoot fireballs with enough force to spread scorching flames over wide areas, lighting the ground itself on fire. Wise hunters would avoid these remnant flames as they're capable of inflicting significant burns.

Flying Wyvern
Black Diablos

MONSTER DATA

▶ Full length: approx. 2096.25 cm
▶ Full height: approx. 738.96 cm
▶ Foot size: approx. 213 cm
▶ Known habitat: Wildspire Waste

BLACK DIABLOS

ECOLOGY

■ Toying with Prey by Varying Charging Speed

While Black Diablos attacks in largely the same way as normal Diablos, she displays a more diverse way of carrying herself. The most significant difference is how she takes her time circling a target and searching for an opening. When she finds one, she'll charge her target at full speed, but don't mistake this for reckless behavior. The Black Diablos also excels at following indications of an intruder's presence and will accurately course correct—even during a charge—to follow her target.

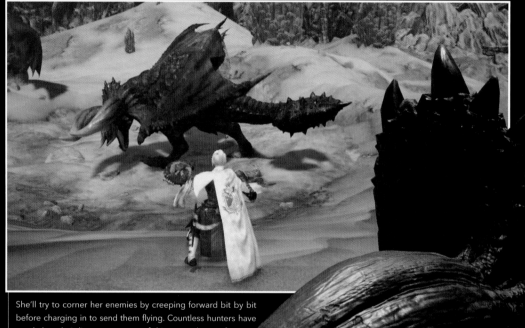

She'll try to corner her enemies by creeping forward bit by bit before charging in to send them flying. Countless hunters have nearly lost their lives on account of this unusual tactic from Black Diablos.

Excerpt from *The Monster Field Guide*

These black-shelled Diablos are actually female Diablos in heat. The color signals their aggressiveness and heightened hostility to other creatures in their habitat.

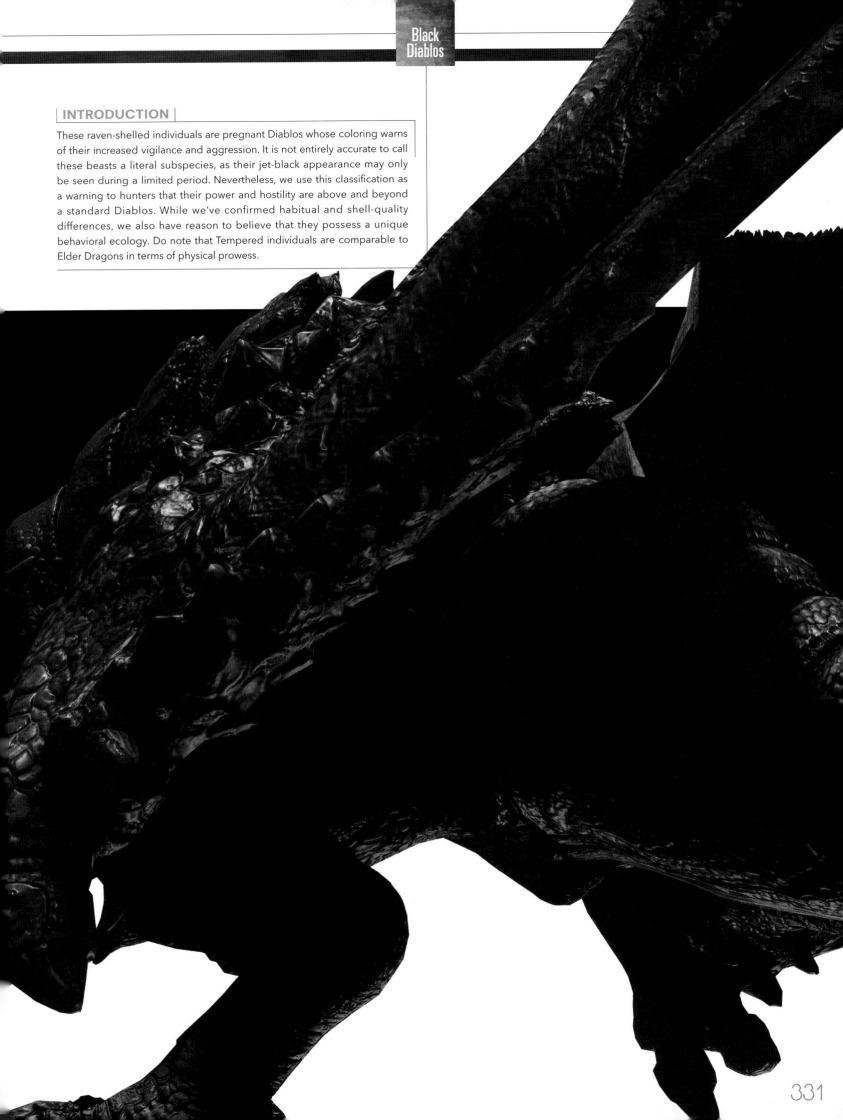

INTRODUCTION

These raven-shelled individuals are pregnant Diablos whose coloring warns of their increased vigilance and aggression. It is not entirely accurate to call these beasts a literal subspecies, as their jet-black appearance may only be seen during a limited period. Nevertheless, we use this classification as a warning to hunters that their power and hostility are above and beyond a standard Diablos. While we've confirmed habitual and shell-quality differences, we also have reason to believe that they possess a unique behavioral ecology. Do note that Tempered individuals are comparable to Elder Dragons in terms of physical prowess.

ECOLOGY

■ Evicting Their Own Mates Due to Strong Territoriality

Pregnancy in many female organisms will usher in a host of hormonal changes that cause a number of atypical behaviors, such as increased stress and a strong sense of instinctual preservation. As for the naturally territorial Diablos, the dramatic effects of such changes are reason alone to classify pregnant females as their own subspecies. Within their natural habitat of the Wildspire Waste, coupled Diablos may be spotted. However, unlike Rathians and Rathalos, there are no confirmed sightings of coupled Diablos cooperating with each other. On the contrary, if the female spots a male, she will brandish her horns and engage him in a fierce battle the same as any intruder. We believe this behavior could be the driving force behind why brood rearing is not a shared responsibility between Diablos parents. In fact, we cannot deny the possibility that female Black Diablos may not raise their own hatchlings.

A turf battle between a standard Diablos and Black Diablos. Such a test of abilities may result in a Diablos losing one of its indispensable horns.

Her jet-black shell conveys to other male Diablos that she is spoken for while conveying a warning sign to everyone else. We believe it might also aid her in absorbing sunlight in order to naturally raise her body temperature during pregnancy.

A Black Diablos's charge puts the standard Diablos to shame. Even sturdy anthills can be obliterated by one mighty strike without even a break in her pace.

ECOLOGY

■ Dominating the Wastes with Overwhelming Power and Ferocity

Perhaps due in part to the breeding season, Black Diablos spend most of their days in the deepest part of underground desert caves, separate from standard Diablos. They remain vigilant within their territory and don't usually encounter large monsters of other species; however, they may frequently happen upon other Diablos, as their territories tend to overlap. They only leave their cave to feed, and if they should cross paths with an unfortunate creature during this time, they will attack without hesitation. In the Wildspire Waste, none can match the power or ferocity displayed by a Black Diablos. Even the destructive Deviljho fears her strength and won't stay around long enough for more than a taste.

Analysis

■Dietary Differences Between Diablos and Black Diablos

A staple food of the Diablos are the cacti growing in the desert—typically cacti with high concentrations of stored water. This preference tends to lead many Diablos to the same cacti, but a hunter's recent testimony shed some new light on their preferred variety of cacti. Differing from the standard breed, Black Diablos seem to favor more nutritionally enriched cacti, which aid in the safe development of a brood. (*Excerpt from a report on the New World*)

Definitive Depiction

Footprint

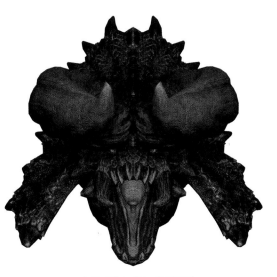

Head: Front View

From shell to horns, their coloration is a phenomenon that occurs from the start of a successful pregnancy until brooding season. The parts of Black Diablos collected during hunts are enriched with elements that differ from those of the standard species.

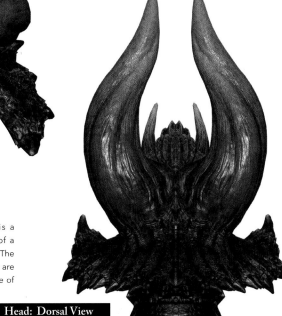

Head: Dorsal View

Production Backstory

PRODUCTION NOTES

Survival of the Fittest Through Brute Strength

Black Diablos is the only subspecies you don't need to clear the story to fight, and we added her because we were looking for a tough variant-type monster to add to the Wildspire Waste. Her territoriality adds a conspecific turf battle among Diablos that doesn't occur with the standard species. Because she's carrying eggs, she's quick to anger and sees everything as an enemy. She'll even attack her own mate, which is something we based on a real living creature that attacks its mate immediately after copulating. (*Tokuda*)

Compared to the other subspecies, she's a bit different since we designed her from the start to be a standard Diablos that happens to be pregnant. If you think about it, it's a bit sad to attack her when she's carrying eggs, but she attacks as the aggressor in the first place because she's thinking of her survival. However, she's not necessary for the player to clear the game, and there aren't many opportunities to hunt her. I guess you could say she's winning that whole "survival of the fittest" thing. [laughs] She's good at making comebacks too, so we've noticed that a lot of players just break her horns and retreat. (*Fujioka*)

Extended **World Gallery**

Know Your New World Monsters
Monster Types

Here we shall indulge in a brief explanation of the different monster classes that exist in the New World. At present, the Old World's Tree of Life is undergoing massive revisions, and we are expecting the announcement of some new discoveries, but the guild has limited the release of that information at this time. We will release the completed version at a later opportunity. In the meantime, we ask your patience as we work through the investigation process.

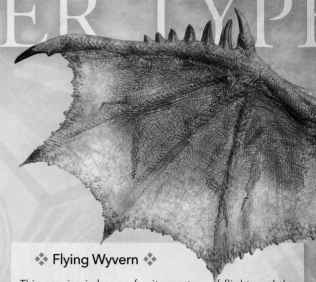

❖ Bird Wyvern ❖

A species whose features are strongly reminiscent of birds. Two main body types of Bird Wyverns have been described, one being the wingless sleek-bodied individuals like Kulu-Ya-Ku and the other being flight-capable individuals similar to Pukei-Pukei. Individuals belonging to the former classification often display complex ornamental or functional crests. Many Bird Wyverns considered to be medium-sized monsters display bipedal movement via their strong hind legs. Unsurprisingly, they're capable of performing powerful jumps.

❖ Flying Wyvern ❖

This species is known for its mastery of flight, and the classification "Flying Wyvern" is almost synonymous with the mighty Rathalos. The majority of these monsters are strong fliers with forelimbs that have evolved into their characteristic wings. Note that the basic structure of most Flying Wyvern's wings is webbing stretched over skeletal extensions of their former forelimb phalanges. There are some Flying Wyverns whose strong forelimbs are well adapted to quadrupedal mobility, but such individuals have not yet been confirmed in the New World. Incidentally, there are also some other winged monsters—like certain Bird Wyverns—who are sometimes casually referred to as Flying Wyverns.

❖ Fanged Wyvern ❖

This species shares a similar ancestor with Bird and Flying Wyverns, but their forelimbs are generally best suited for quadrupedal movement. Although only recently discovered in the Old World, Fanged Wyverns have long existed in the New World. Individuals such as Jagras and Great Jagras are still being discovered and are under investigation.

■ Kulu-Ya-Ku

■ Great Jagras

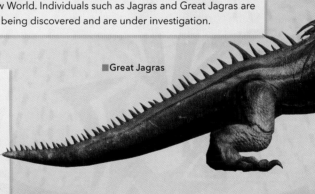

❖ Piscine Wyvern ❖

Piscine Wyverns usually inhabit regions with abundant water sources and have fins. Large individuals, such as Jyuratodus, rely entirely on their hind legs for balance, giving them a sluggish tendency when bipedal. We've discovered that they share an evolutionary branch with the Flying Wyverns and despite their many differences, their respiratory systems remain unchanged from those of their free-flying relatives.

■ Jyuratodus

TOPIC — On Subspecies

The Guild defines a subspecies as a population of monsters in which environmental factors or adaptive evolution have caused a change or mutation in individuals of a known standard species. Most subspecies differ in color from the standard variety and tend to be markedly more aggressive. For some New World populations of subspecies, such as the Rathians, the activated Everstream energy seems to have helped foster their growth. Do keep in mind that exceptions to this definition exist, such as the Black Diablos, which is simply a female Diablos during mating season.

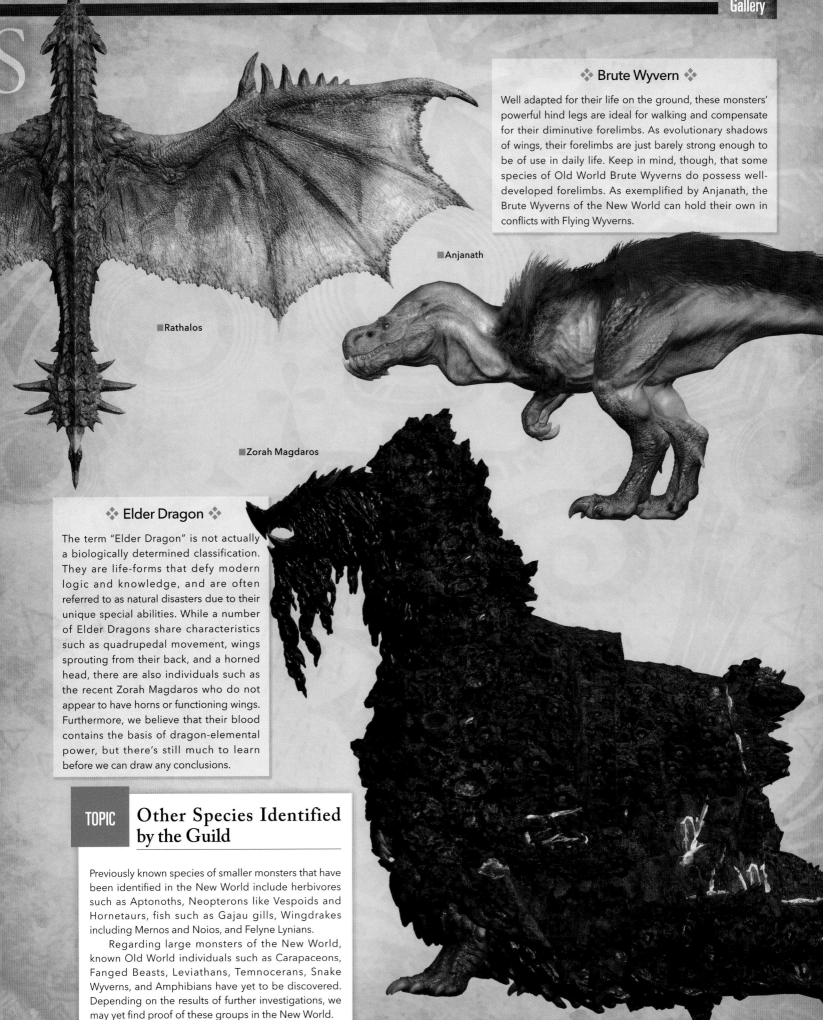

❖ Brute Wyvern ❖

Well adapted for their life on the ground, these monsters' powerful hind legs are ideal for walking and compensate for their diminutive forelimbs. As evolutionary shadows of wings, their forelimbs are just barely strong enough to be of use in daily life. Keep in mind, though, that some species of Old World Brute Wyverns do possess well-developed forelimbs. As exemplified by Anjanath, the Brute Wyverns of the New World can hold their own in conflicts with Flying Wyverns.

■Anjanath

■Rathalos

■Zorah Magdaros

❖ Elder Dragon ❖

The term "Elder Dragon" is not actually a biologically determined classification. They are life-forms that defy modern logic and knowledge, and are often referred to as natural disasters due to their unique special abilities. While a number of Elder Dragons share characteristics such as quadrupedal movement, wings sprouting from their back, and a horned head, there are also individuals such as the recent Zorah Magdaros who do not appear to have horns or functioning wings. Furthermore, we believe that their blood contains the basis of dragon-elemental power, but there's still much to learn before we can draw any conclusions.

TOPIC | **Other Species Identified by the Guild**

Previously known species of smaller monsters that have been identified in the New World include herbivores such as Aptonoths, Neopterons like Vespoids and Hornetaurs, fish such as Gajau gills, Wingdrakes including Mernos and Noios, and Felyne Lynians.

Regarding large monsters of the New World, known Old World individuals such as Carapaceons, Fanged Beasts, Leviathans, Temnocerans, Snake Wyverns, and Amphibians have yet to be discovered. Depending on the results of further investigations, we may yet find proof of these groups in the New World.

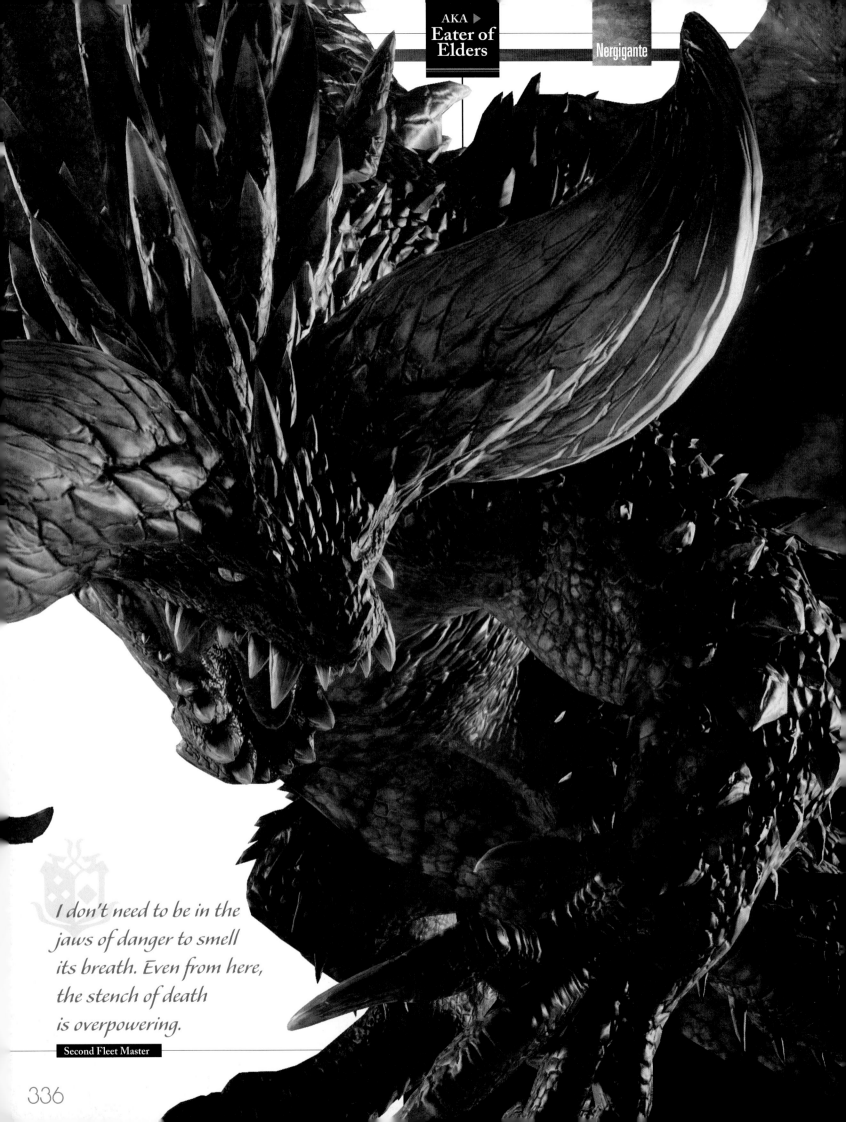

I don't need to be in the jaws of danger to smell its breath. Even from here, the stench of death is overpowering.

Second Fleet Master

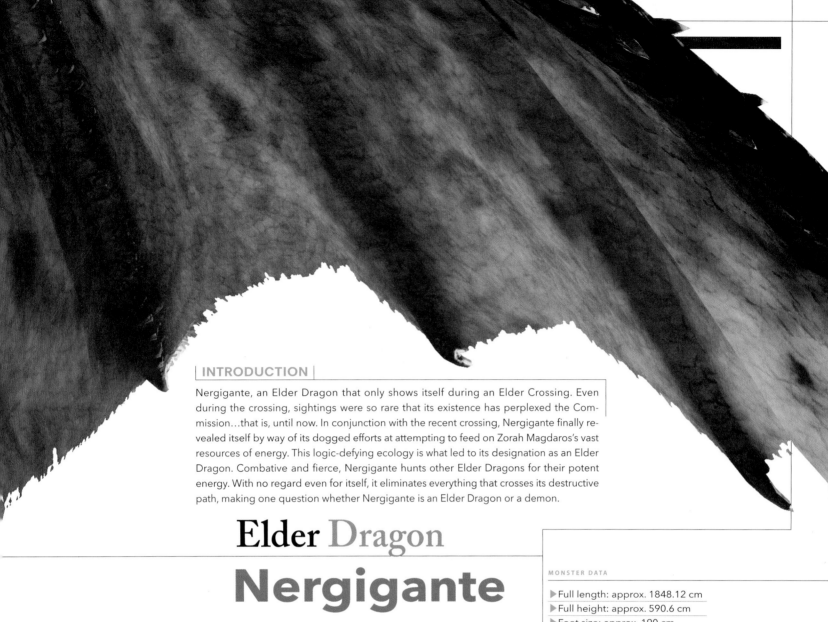

INTRODUCTION

Nergigante, an Elder Dragon that only shows itself during an Elder Crossing. Even during the crossing, sightings were so rare that its existence has perplexed the Commission…that is, until now. In conjunction with the recent crossing, Nergigante finally revealed itself by way of its dogged efforts at attempting to feed on Zorah Magdaros's vast resources of energy. This logic-defying ecology is what led to its designation as an Elder Dragon. Combative and fierce, Nergigante hunts other Elder Dragons for their potent energy. With no regard even for itself, it eliminates everything that crosses its destructive path, making one question whether Nergigante is an Elder Dragon or a demon.

Elder Dragon
Nergigante

MONSTER DATA

▶ Full length: approx. 1848.12 cm
▶ Full height: approx. 590.6 cm
▶ Foot size: approx. 190 cm
▶ Known habitat: Elder's Recess

ECOLOGY

■ An Elder Dragon That Eats Elder Dragons

By following traces of Nergigante's battles and feeding activity, Ecological Research has been able to determine that Nergigante preys on Elder Dragons, but not exclusively. In fact, all living creatures are prey to a Nergigante. In order to maintain its impressive regenerative capabilities, Nergigante requires vast sources of energy and remains ever vigilant for monsters that conceal pure energy within their bodies. And so it was–beckoned by the lifetime of energy welling up within the dying Zorah Magdaros–that Nergigante came to the New World.

Nergigante doggedly targeted Zorah Magdaros for its energy, which was higher in purity and strength than that of the other Elder Dragons.

ECOLOGY

■Super-Regenerative Power in the Jet-Black Spikes Covering Its Body

Even if destroyed, the tough black spikes covering Nergigante's body can reform within moments thanks to its regenerative capabilities. Newly regenerated spikes are milky white, pliable, and considerably susceptible to breaking. However, should these spikes be allowed to harden through prolonged oxidation, they will prove to be even tougher to break than the previous set of spikes in an endless cycle of destruction and regrowth. The recently defeated Nergigante was found to have approximately 1,800 spikes adorning its body. The regenerative process for these spikes—not to mention hardening them once they've regrown—requires an extraordinary amount of energy.

Within seconds of losing its spikes, Nergigante will sprout a new set. Initially white colored and several dozen centimeters long, these new spikes will continue to grow over time and blacken as they harden.

Normal State

Regrowth State

A comparison of Nergigante with new spikes and Nergigante with hardened spikes. A fully hardened set of elongated spikes can sometimes make it difficult for Nergigante to move, so it will occasionally adjust its spikes by intentionally breaking them.

Hardened State

Normal State: Dorsal View

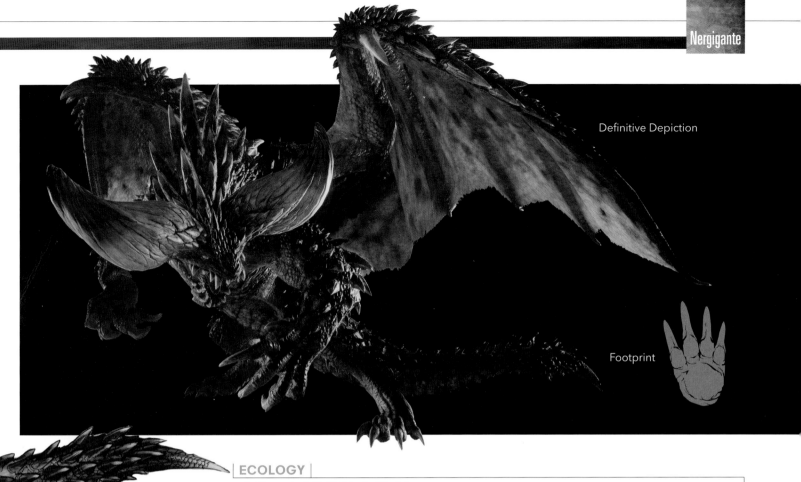

Definitive Depiction

Footprint

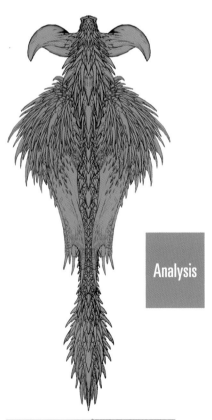

Regrowth State: Dorsal View

Analysis

| ECOLOGY |

■A Frenzied Full-Body Tackle

Once a certain number of spikes have completely hardened, Nergigante displays the terrifying ability to instantly harden all of its spikes. While Nergigante can only temporarily maintain this steeled form, it literally throws its entire being into ending the life of its prey by way of a full-body tackle. Compared to Nergigante's other attacks, the destructive power of this blitz is in a different league. The impact alone is strong enough to rend Nergigante's hardened spikes from its body, sending them flying in all directions. The destructive power of this attack is why the people of Astera call the beast "Eater of Elders."

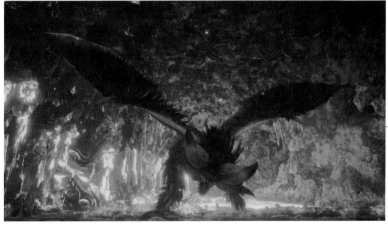

Nergigante's ear splitting roar frightens prey before it launches an air-to-ground attack. This attack also helps Nergigante manage its sometimes restrictive spikes. It unleashes this assault when over half of its spikes have hardened.

■A Hypothesis on the Reproductive Methods of Nergigante

Much of Nergigante remains mysterious. For instance, when researchers exposed a spike to nutrients, not only did the spike show strong signs of life for a brief moment, but egg cells within it began to divide. For this reason, the Ecological Research Center has proposed that Nergigante may in fact be born from...spikes.

Researchers now suggest that spikes may utilize a surplus of energy by changing into reproductive cells that create a genetic clone of the parent. While this might seem implausible, one need only consider the most recent Nergigante for persuasive evidence. This particular Nergigante displayed a strong attachment to Zorah Magdaros, despite there being many monsters around. If Nergigante was simply searching for energy to promote spike regrowth, its choices were not limited to preying solely on Zorah Magdaros. But if it was following Zorah Magdaros because it needed vast amounts of pure energy, it becomes clear why it focused solely on the gargantuan Elder Dragon. (*From a researcher's notes*)

ECOLOGY

■The Mechanism for Spike Regrowth and Hardening

After a spike is destroyed, cells begin to divide at an astounding speed, replacing the broken spike. When elements on the spike's surface are exposed to oxygen, they create a black enamel-like layer over the spike. A Nergigante will eventually choose to disperse hardened spikes or lose them when crashing into the ground. By repeating this process, Nergigante continually improves the efficacy of its armor.

Points of Spike Regrowth: Front View

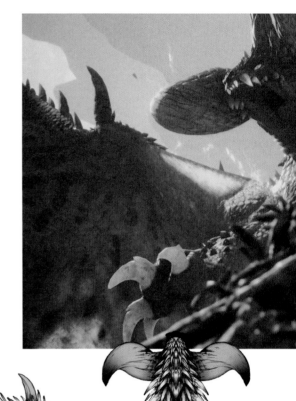

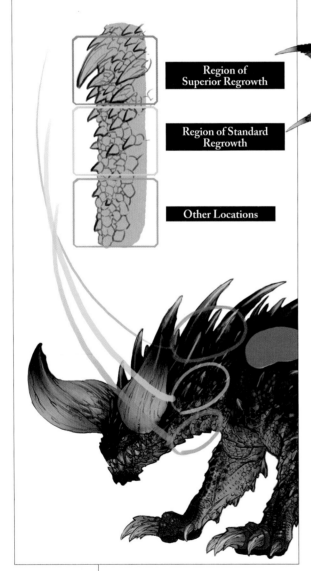

Region of Superior Regrowth

Region of Standard Regrowth

Other Locations

Points of Spike Regrowth: Dorsal View

Note how spike growth is localized around the neck, wing bends, back, and tail end. More than for protection, these spikes grow in locations that are likely to inflict as much damage as possible on targets.

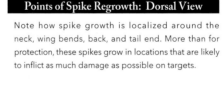

Normal Scale Forming a Spike

Scale Grouping Forming a Spike

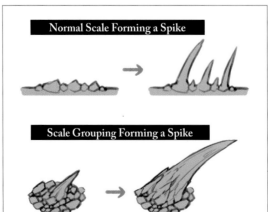

The underside of Nergigante's neck suggests that the region is devoid of spikes, but there are scales in the region capable of growing into full spikes. However, in order to remain agile and conserve energy, the majority of these do not grow.

Nergigante's spikes grow from the scales that cover its body. When multiple scales grow and merge into one, a spike is made.

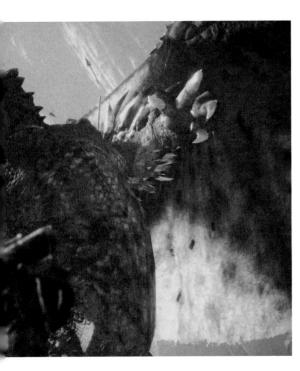

ECOLOGY

■ Exhibiting Increased Aggression when Troubled

We've learned that after exhausting its stamina in a prolonged battle, Nergigante will somehow become noticeably more aggressive. Despite the exhaustion, it will fight with even more furious intensity and tact, displaying crushing aerial attacks and gap-closing strikes. Throughout this assault, Nergigante thrashes its powerful forelimbs like a demon bent on destruction. Finally, sensing that its life is in danger, Nergigante unleashes a guttural roar and spreads its shield-like wings, taking to the sky for a heedless and devastating attack. Unlocking all of the energy stored in its body, the power of Nergigante's Elder Dragon prey is circulated throughout its body in a single burst, elevating its physical abilities. Based on how it fights without any concern for its own safety, people have called these energy-guzzling tactics Nergigante's "Ruinous Impulse."

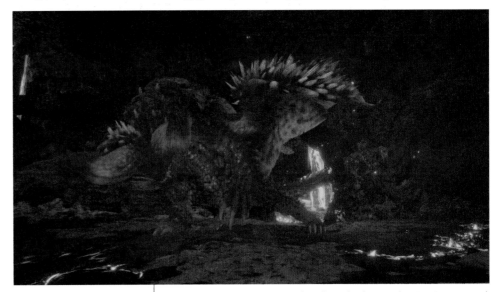

Nergigante can unleash a barrage of smaller spikes by spreading its wings—an attack that actually damages the monster itself. The wounds, however, might just as well be paper cuts for all the mind Nergigante pays them while trying to eviscerate its opponent.

ECOLOGY

■ The Connection Between the Gajalaka and Nergigante's Arrival

Not originally hailing from the New World, Nergigante crossed the ocean to reach the continent. Proof of this lies with the Lynian tribe of Gajalaka inhabiting the Elder's Recess. According to a Lynian researcher who established contact with a Gajalaka tribe, the area currently being used by Nergigante for sleeping was originally inhabited by Gajalaka. Drawn in by the presence of Elder Dragons, the Nergigante robbed the Gajalakas of their land, which is why Gajalakas may often be seen in the area's surrounding vicinity. One will find that some Gajalakas of the region hold a grudge against Nergigante and may be invaluable allies in the subjugation or a survey of the monster.

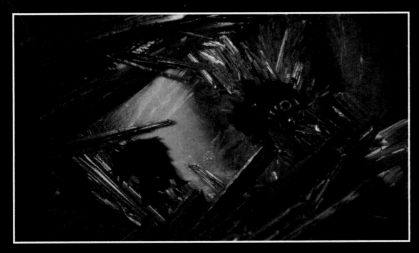

Production Backstory

PRODUCTION NOTES

A True Battle with the Non-Elemental Main Monster

Zorah Magdaros and Xeno'jiiva are main components of the story, but they're strongly tied to certain events, and they're also part of the mystery of the New World, so it's tough for either of them to be the main monster. That's why we came up with this new Elder Dragon that's always a part of the experience. Kushala Daora and the others were already set, so we didn't want it to have elemental powers. Instead, we wanted to focus on making an Elder Dragon that engages the player in a knock-down, drag-out battle. This is how we came up with the key phrase "destruction and rebirth," which encapsulates the two sides of the same coin embodied in our main monster. (*Tokuda*)

There were a number of twists and turns before the final design. Our designers got caught up in "destruction and rebirth" and churned out some creepy designs, like monsters with multiple faces. [laughs] We pulled it together with the relatively simple concept of "spikes." When these spikes regrow, Nergigante's attack power increases. Every aspect of the creature is bound by the concept of "destruction and rebirth," from the gameplay to the idea of asexual reproduction from the spikes. (*Fujioka*)

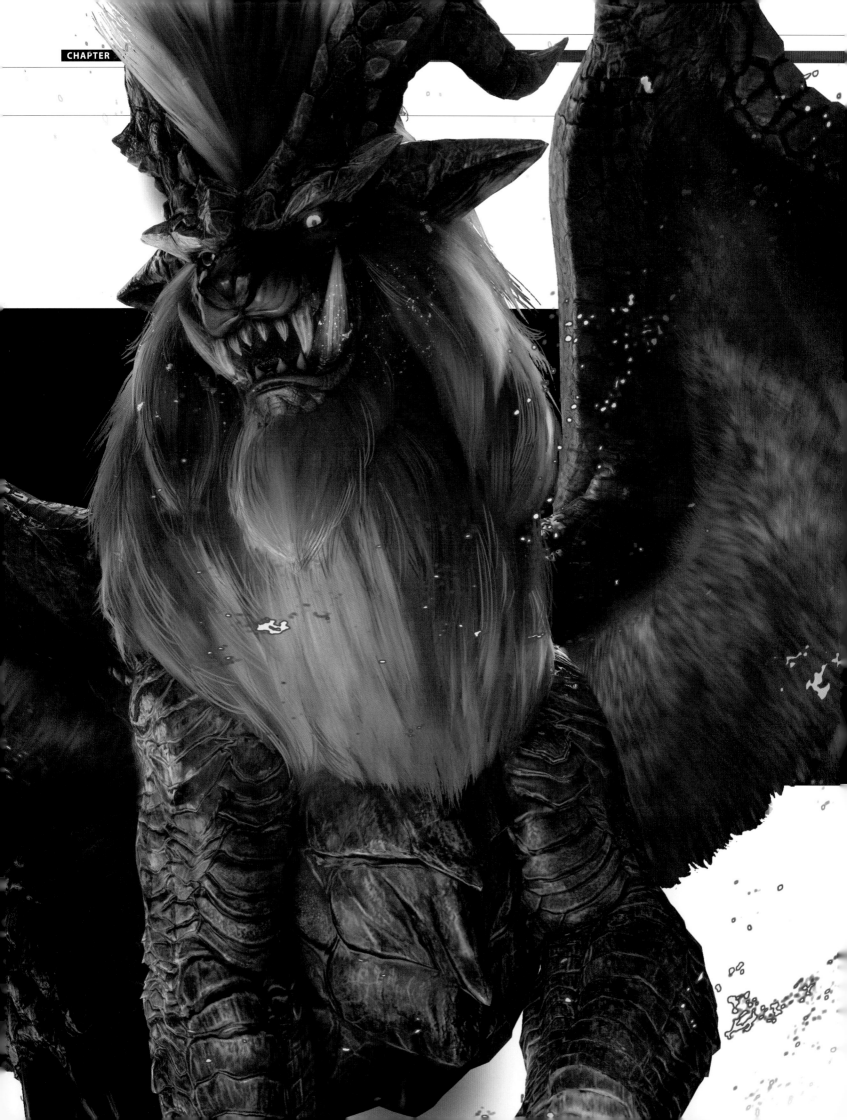

Elder Dragon
Teostra

MONSTER DATA

▶ Full length: approx. 1790.15 cm
▶ Full height: approx. 622.18 cm
▶ Foot size: approx. 112 cm
▶ Known habitat: Wildspire Waste,
 Elder's Recess

TEOSTRA

ECOLOGY

A Diet of Flammable Ore and Gunpowder

In order to maintain his blazing body, Teostra sustains himself on a diet of minerals that contain flammable ingredients and usually makes his home in ore-rich volcanic regions. While searching for ore and other explosive nourishment rich in heat energy, sometimes Teostra will follow traces of gunpowder back to their source, unintentionally wandering near human settlements.

Unfortunately, there was a case where a Teostra searching for gunpowder found his way into the Special Arena in the Great Ravine. He was observed attempting to consume ore and in doing so created a flammable gas. Long story short, it was a hot mess.

INTRODUCTION

This male Elder Dragon overwhelms all who stand in his way with fire and flame. Reports of sightings and disturbances are few and far between, but that's due to Teostra's preference for territory in far-removed deserts and secluded volcanic regions. Teostra is known for being as fierce as the flames it wields. There exists a legend in the Old World about a Teostra who painted the entirety of a vast desert with flame in a single night. A closely related Elder Dragon is Lunastra, a female. While Teostra originally inhabited the deep volcanic regions of the Elder's Recess, after Xeno'jiiva's activation of the New World's energy, they have also appeared in the Wildspire Waste.

Chief Ecologist

Its name is Teostra, and it's as violent as they come. They call it the Emperor of Flame and "Peerless One."

343

ECOLOGY

■ Wrapping His Body in Flame to Burn Assailants

When describing Teostra, there are two aspects of the Elder Dragon that must not be neglected: his control of flame and powder particles. Teostra can spray a radial wave of fire from his mouth. Not only does he expel this fire, he may also coat his body in the flame, scorching enemies. In addition, Teostra can control what region of his body receives this fire coating. He can emit a terrible wave of fire from his entire body in a single burst. The wind pressure created by this release creates a natural barrier against not only the Slinger, but also bowgun bolts and arrows, casting most of them harmlessly to the side. One might say Teostra bears a bona fide armor of flame, and despite its ruthless nature, the shimmering haze emitted by this blazing armor bestows an air of elegance to the monster.

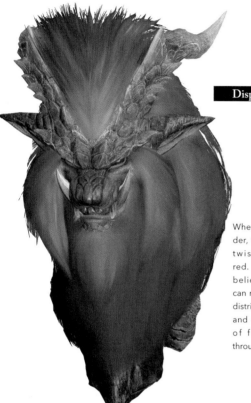

Dispersion State

When covered in powder, the tip of Teostra's twisted horns glow red. Based on this, it's believed that Teostra can manipulate powder distribution, explosions, and even the direction of flame dispersal through these horns.

Normal State

ECOLOGY

■ Controlling a Flammable Powder That Creates a Unique Flame

Why is it that among all the monsters capable of controlling flame, Teostra is the Emperor of Flame? It's because of his ability to disperse a flammable powder in order to cover his body. Reserves of this powder are typically stored in tiny hairs growing underneath Teostra's wings. After being sharply shaken by limb or wing movements, these powder particles disperse. Simply by gnashing his teeth, Teostra can create a spark that ignites the powder, causing an explosion over a wide area. Using flame and powder, Teostra manipulates both burning and explosive energy. The powder itself is actually leftover debris from Teostra's own body that has peeled off. Outside of combat or feeding, Teostra have been known to cover themselves in this powder for purposes of burning off excess waste.

While clad in his flaming armor, flickering flames appear to be attached to Teostra's body and his footfalls will scorch solid ground, leaving behind small patches of fire.

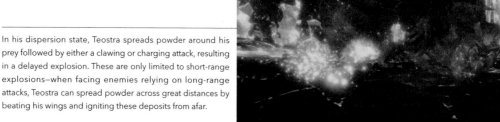

In his dispersion state, Teostra spreads powder around his prey followed by either a clawing or charging attack, resulting in a delayed explosion. These are only limited to short-range explosions—when facing enemies relying on long-range attacks, Teostra can spread powder across great distances by beating his wings and igniting these deposits from afar.

This is Teostra's strongest and largest attack, which may only be performed when its body is fully covered in flames and powder. Teostra takes to the air, condensing all of its combustion energy before releasing it at once in a massive explosion. We call this attack "Supernova" for its resemblance to the catastrophic astronomical event. Do not be caught within range of this devastating explosion.

Perhaps due to its habit of eating gunpowder, Teostra's body temperature is notably high and can even affect the temperature in certain regions by bringing a wave of thermal energy with him. By just appearing in the Wildspire Waste, Teostra caused a blazing heat wave, sending the region's temperature skyrocketing and other monsters fleeing for safety.

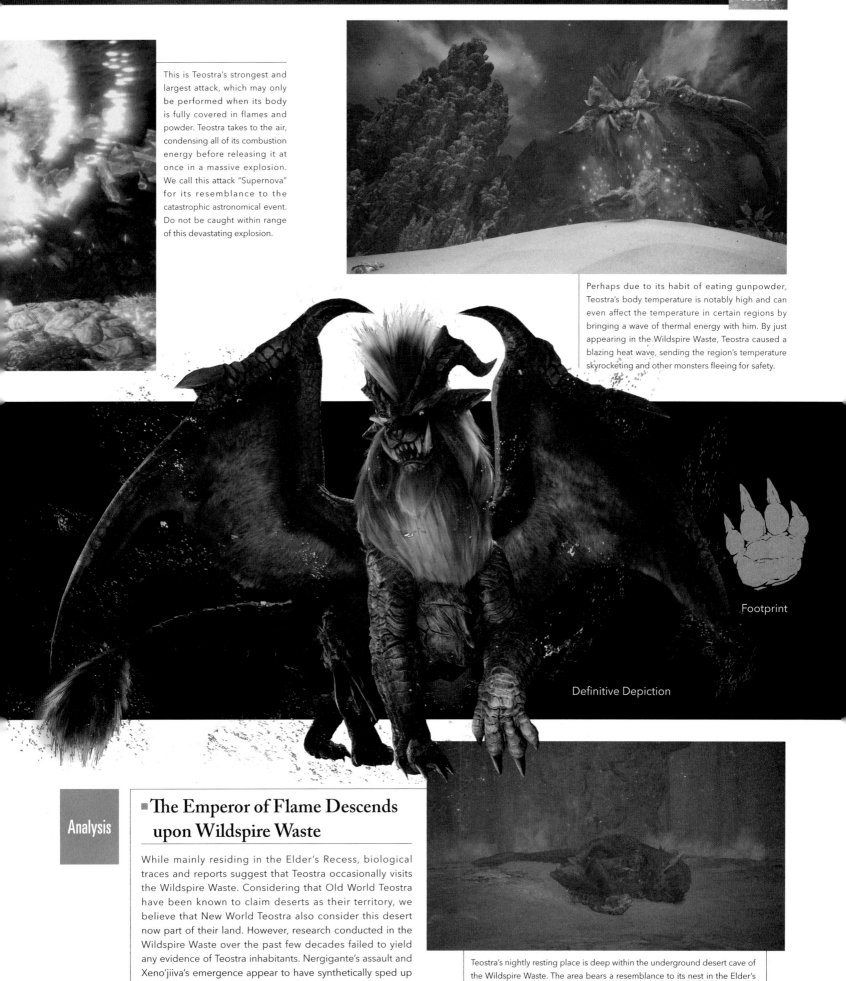

Footprint

Definitive Depiction

Teostra's nightly resting place is deep within the underground desert cave of the Wildspire Waste. The area bears a resemblance to its nest in the Elder's Recess, suggesting that it may feel comfortable here.

Analysis

■ The Emperor of Flame Descends upon Wildspire Waste

While mainly residing in the Elder's Recess, biological traces and reports suggest that Teostra occasionally visits the Wildspire Waste. Considering that Old World Teostra have been known to claim deserts as their territory, we believe that New World Teostra also consider this desert now part of their land. However, research conducted in the Wildspire Waste over the past few decades failed to yield any evidence of Teostra inhabitants. Nergigante's assault and Xeno'jiiva's emergence appear to have synthetically sped up the activity of Elder Dragons, the effects of which we might be seeing through Teostra's expansion of their territory. (*From a researcher's notes*)

ECOLOGY

■ Dashing About on All Fours

For its imposing size, Teostra is surprisingly agile and easily sprints across burning surfaces as it claws at prey with ease. This agility is largely possible thanks to the combination of Teostra's well-developed limbs for power, claws for traction, and wings that cut down air resistance. In fact, researchers of the Old World long believed that Teostra's wings had lost their functionality for prolonged flight until New World individuals were witnessed flying between areas and participating in aerial conflict. Since they are highly skilled fliers, aerial maneuverability is also part of their offensive repertoire, and they often fire on their targets from the skies.

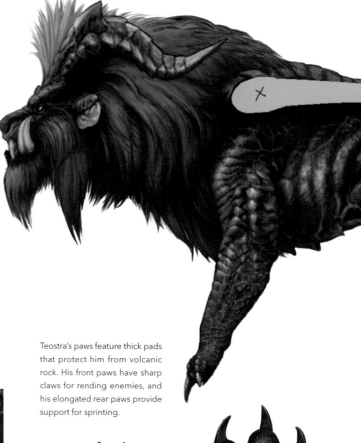

Unlike Old World individuals, New World Teostra are skilled fliers and can remain airborne for long spans of time.

Teostra's paws feature thick pads that protect him from volcanic rock. His front paws have sharp claws for rending enemies, and his elongated rear paws provide support for sprinting.

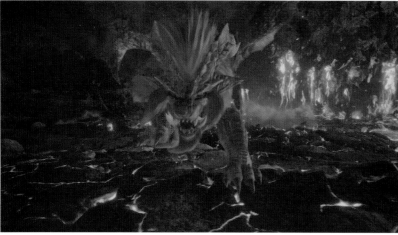

Front Paw: Underside

Rear Paw: Underside

ECOLOGY

■ Creating a Home with Explosions from Powder

Teostra's abode may be found at the farthest reaches of the Elder's Recess, normally obscured by an impenetrable wall of lava. The nest itself is a flat rocky base surrounded almost entirely by lava. Teostra makes its nest by blasting apart a rocky crag with its explosive powder and fashioning it into a stage spacious enough for the immense monster. However, as one might imagine, being surrounded by an ocean of lava makes this platform somewhat unstable. When angered by an intruder in its nest, Teostra's rising body temperature affects the surrounding area, causing lava to erupt from the ground.

More than just a place to rest, we believe that a Teostra's nest is also essential to attracting a Lunastra mate. A Lunastra probably selects her Teostra mate based on whose nest is the widest and has the best access to ore for sustenance.

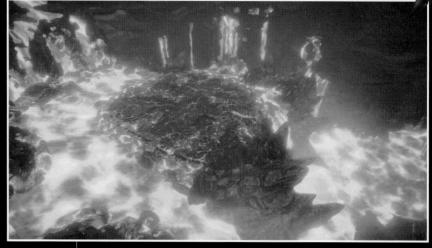

A panoramic view of the Teostra's berth. Carving out a mountain with explosions just to make a nest somehow seems appropriate for this master of flames. Some say that this behavior once caused a volcanic eruption.

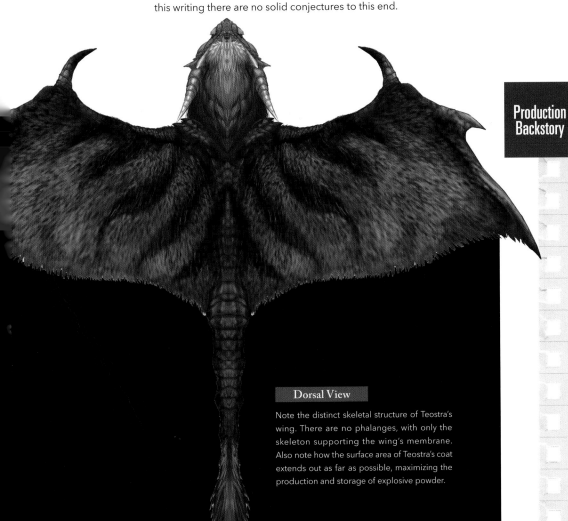

ECOLOGY

■ A Mane with Superior Heat Resistance and Durability

Teostra's regal mane is a symbol of its prowess but also serves important ecological functions. Although soft in appearance, the hairs of the mane are actually quite hard and protect its neck by deflecting blades of standard quality. The mane even aids in the production and storage of Teostra's explosive powder. The mane is what allows Teostra to stay hot enough to manipulate flames with ease. New World individuals display thicker manes than Old World individuals, with hairlines extending all the way to the base of their necks. The fullness of manes may even play a role in attracting partners. Some suggest that it's related to mating rather than courtship. Unfortunately, as of this writing there are no solid conjectures to this end.

Once a Teostra's flame and powder coatings reach a certain degree, the center of his mane will light up like a lantern due to heat accumulation.

Dorsal View

Note the distinct skeletal structure of Teostra's wing. There are no phalanges, with only the skeleton supporting the wing's membrane. Also note how the surface area of Teostra's coat extends out as far as possible, maximizing the production and storage of explosive powder.

Production Backstory

PRODUCTION NOTES

Planned from the Very Start, Bringing Out the One and Only Emperor of Flame

The New World is a continent where Elder Dragons gather, so we needed to populate it with individuals that carry a certain flair. From the very beginning of development, we already knew two Elder Dragons we just had to use, Teostra and Kushala Daora. We felt very strongly that from an action standpoint–for both old and new fans–we could refine these monsters enough to be crowd-pleasers. That was our starting place for developing the lava region of the Elder's Recess. It also fits our story in a believable way as the basis for the Everstream. Both gameplay and setting combined to help make Teostra a standout monster. (*Tokuda*)

We were trying to express how our Elder Dragons are strong enough to directly affect their surrounding environment, which is why Teostra causes lava eruptions whenever he rages. Since we were developing for high-end platforms, we were able to use fire in new ways, and I think that helped us make Teostra stand out like never before. Even from just an elemental perspective, Kushala Daora's ice abilities complement Teostra's fire quite well, and they make a good pair. (*Fujioka*)

Elder Dragon
Kushala Daora

MONSTER DATA

▶ Full length: approx. 1913.13 cm
▶ Full height: approx. 689.1 cm
▶ Foot size: approx. 103 cm
▶ Known habitats: Ancient Forest
　　　　　　　　Elder's Recess

Chief Ecologist

The Elder Dragon's name is Kushala Daora.
That's right, the Tempest of the Wind!

KUSHALA DAORA

ECOLOGY

■A Metallic Shell That Deflects Assailants

A dark-gray metallic shell covers Kushala Daora's body, which is also an exoskeleton that supports this proud monster's massive frame. This steel-like plating is where the monster gets its title, "Wings of Steel." More than any other region of its body, the plating of its wings and back—both crucial for flight—are said to be impervious to any blade ever forged. But even the toughest steel can be melted, and that is Kushala Daora's weakness. Although an inhabitant of the Elder's Recess, it will not enter the region's volcanic areas of its own volition. As Kushala Daora matures, its old plating begins to rust and new plating bursts through, causing the monster to molt, in a sense. While in the process of molting, the new plating is comparatively softer than its old plating, and during this period Kushala Daora is especially guarded and belligerent.

Due to Kushala Daora's massive weight, it doesn't get swept away when engulfed in floods or landslides in the Ancient Forest.

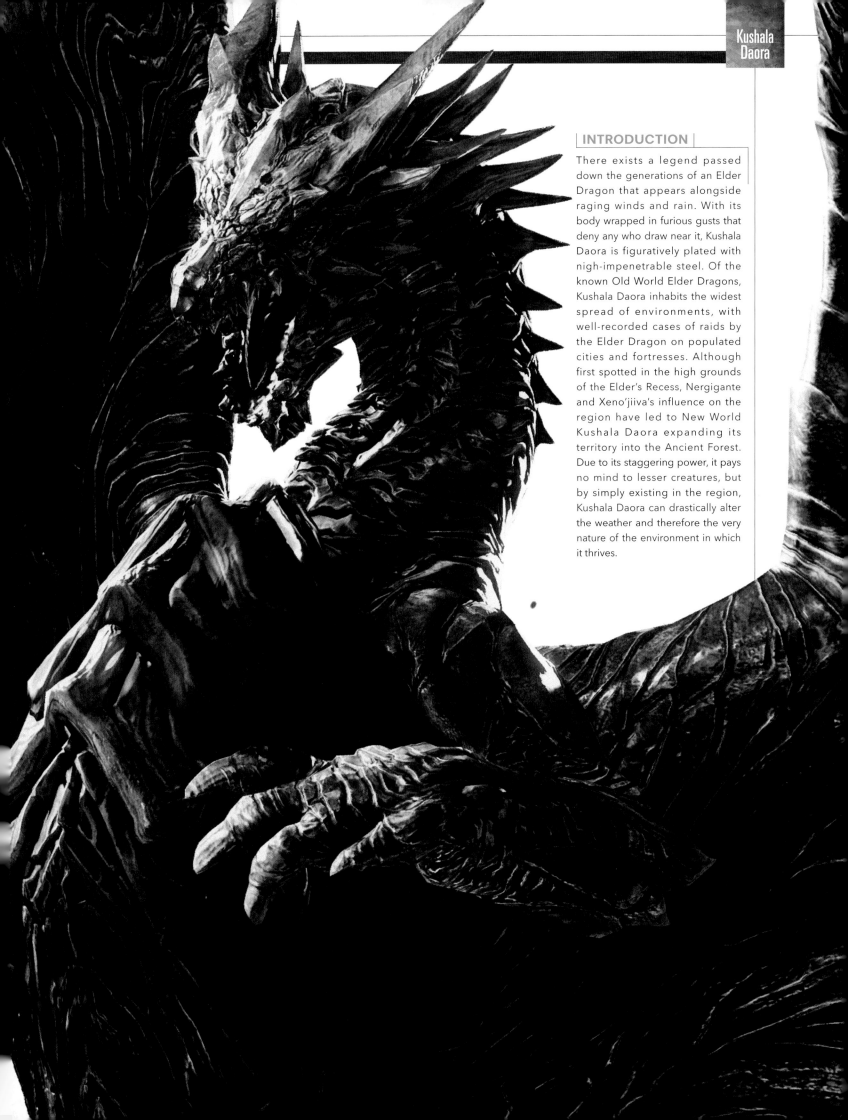

INTRODUCTION

There exists a legend passed down the generations of an Elder Dragon that appears alongside raging winds and rain. With its body wrapped in furious gusts that deny any who draw near it, Kushala Daora is figuratively plated with nigh-impenetrable steel. Of the known Old World Elder Dragons, Kushala Daora inhabits the widest spread of environments, with well-recorded cases of raids by the Elder Dragon on populated cities and fortresses. Although first spotted in the high grounds of the Elder's Recess, Nergigante and Xeno'jiiva's influence on the region have led to New World Kushala Daora expanding its territory into the Ancient Forest. Due to its staggering power, it pays no mind to lesser creatures, but by simply existing in the region, Kushala Daora can drastically alter the weather and therefore the very nature of the environment in which it thrives.

Dorsal View

Notice how Kushala Daora's wings and body are covered in layers of metallic plating. These layers make up a steel-like shell that can expand and contract, allowing it to easily flap its wings.

It's a wonder Kushala Daora can get off the ground, let alone fly. We believe that Kushala Daora's flight is made possible by self-generated updraft winds that aid its unnaturally large and muscular wings. As for maintaining balance while airborne, Kushala Daora's lengthy tail allows it to change its center of gravity with ease and precise control.

Ventral View

Rear View

Here's a look at Kushala Daora from the front and rear. Supporting its massive body are four limbs that are markedly well developed compared to the size of its trunk.

Front View

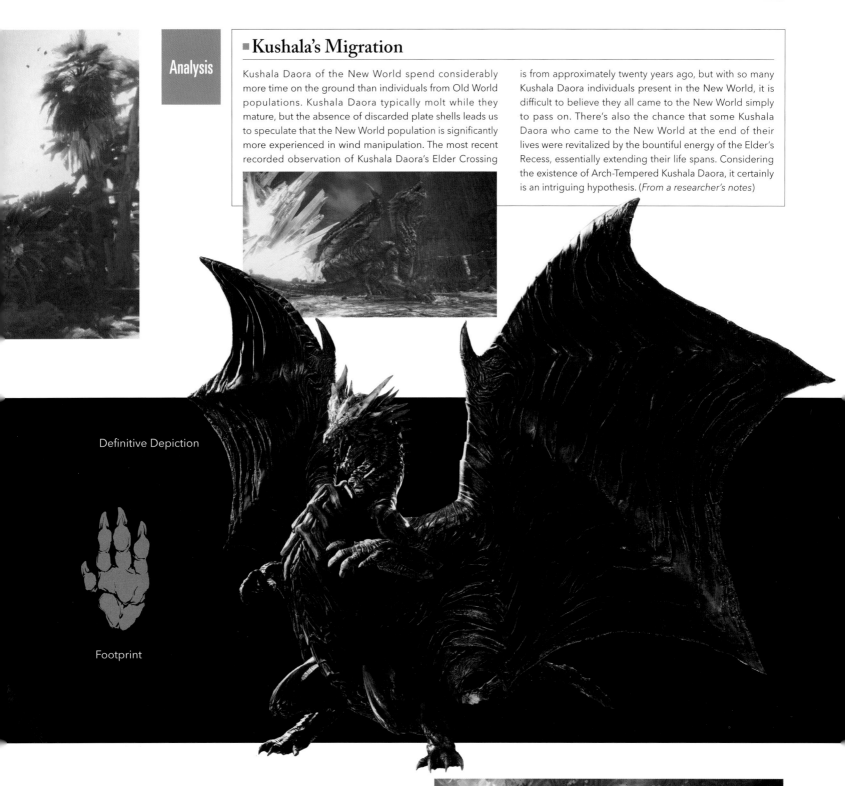

Analysis

■ Kushala's Migration

Kushala Daora of the New World spend considerably more time on the ground than individuals from Old World populations. Kushala Daora typically molt while they mature, but the absence of discarded plate shells leads us to speculate that the New World population is significantly more experienced in wind manipulation. The most recent recorded observation of Kushala Daora's Elder Crossing is from approximately twenty years ago, but with so many Kushala Daora individuals present in the New World, it is difficult to believe they all came to the New World simply to pass on. There's also the chance that some Kushala Daora who came to the New World at the end of their lives were revitalized by the bountiful energy of the Elder's Recess, essentially extending their life spans. Considering the existence of Arch-Tempered Kushala Daora, it certainly is an intriguing hypothesis. (*From a researcher's notes*)

Definitive Depiction

Footprint

ECOLOGY

■ Manipulating Unnatural Winds, an Unbeatable Armor

Just as the tale goes, Kushala Daora does indeed appear alongside a raging storm. This is no coincidence, as the gales surrounding this Elder Dragon are of its own creation. These furious winds transform into an armor of absolute defense, capable of deflecting arrows and all forms of ammunition. When gravely injured, Kushala Daora will return to its nest and unleash a fury of tornadoes to protect itself. Not only does the monster's uncanny ability to create gusts of wind increase on the verge of death, but the atmospheric conditions around its nest augment this power. These violent storms are how Kushala Daora gained the nickname "Tempest of the Wind."

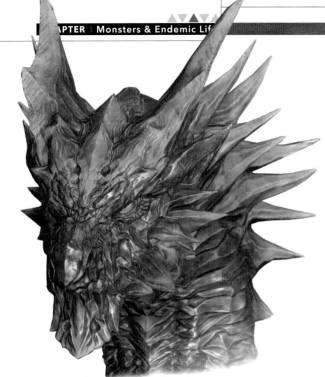

ECOLOGY

■ Controlling Wind with Its Horns

Kushala Daora generates wind from a specialized internal organ. This wind may be utilized for one of two purposes: encircling its body for defense or being fired from its mouth as an attack. While we have yet to unravel the secrets of this wind-producing organ, we have deduced that these winds are controlled by the pair of short horns on Kushala Daora's crown. Several testimonies have proven that a Kushala Daora will lose its ability to manipulate wind speed, power, and direction if its horns are damaged. Current hypotheses contend that based on the horn's metallic properties, Kushala Daora are able to control their wind through electromagnetic waves.

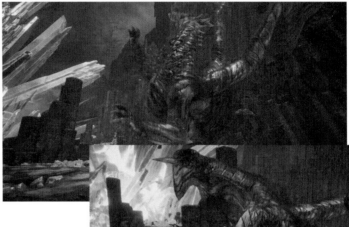

Kushala Daora's horns are the most sensitive and delicate part of the monster, despite its metallic plating. This region is one of the most susceptible on the monster's body and if they suffer any significant impact, try as it might, Kushala Daora will lose the ability to control twisters.

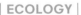

ECOLOGY

■ Wind Breath That Changes with the Strength of Its Wind Armor

Kushala Daora can store and compress gales in its mouth before releasing them at a target. A hunter who survived a Kushala Daora encounter described the devastating blast as, "...like being shot by a huge cannon." The potency of this blast depends entirely on the strength of the wind encompassing Kushala Daora's body. When covered in weak winds, Kushala Daora's projected gale will only travel a short distance before dispersing. This is nothing compared to when Kushala Daora lets loose while its body is enveloped in its most powerful winds. The surrounding zephyrs will boost the blast, sending slicing winds at its target much faster and farther than a normal shot. No amount of preparation will help the target withstand Kushala Daora's indomitable wind pressure.

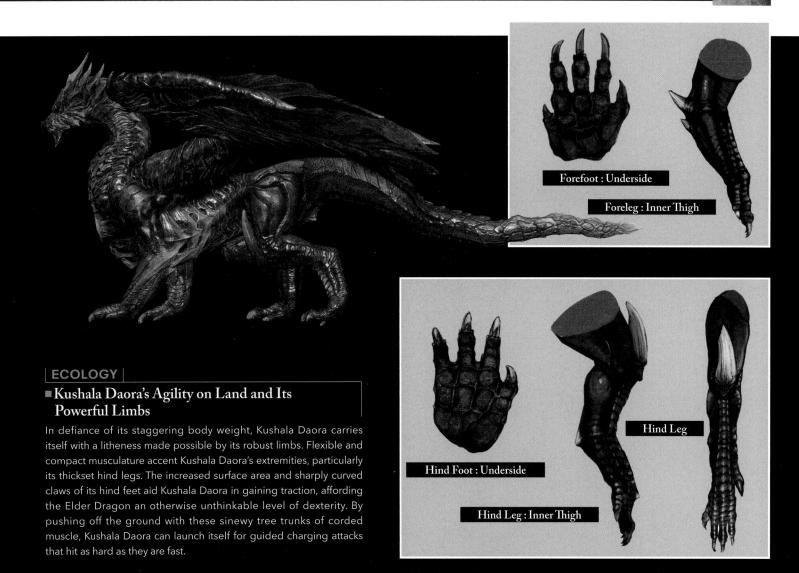

Forefoot : Underside

Foreleg : Inner Thigh

Hind Leg

Hind Foot : Underside

Hind Leg : Inner Thigh

ECOLOGY

■ Kushala Daora's Agility on Land and Its Powerful Limbs

In defiance of its staggering body weight, Kushala Daora carries itself with a litheness made possible by its robust limbs. Flexible and compact musculature accent Kushala Daora's extremities, particularly its thickset hind legs. The increased surface area and sharply curved claws of its hind feet aid Kushala Daora in gaining traction, affording the Elder Dragon an otherwise unthinkable level of dexterity. By pushing off the ground with these sinewy tree trunks of corded muscle, Kushala Daora can launch itself for guided charging attacks that hit as hard as they are fast.

Here Kushala Daora is creating a massive vortex simply by flapping its wings as it spirals up and into the sky. The extraordinary wind pressure temporarily anchors this dusty tornado to a stationary position, robbing Kushala Daora's targets of their sight.

Oral Cavity

Note how Kushala Daora's relatively small fangs are aligned in two rows. This aerodynamic structure reduces wind drag, allowing Kushala Daora to fire blasts of air smoothly as if through the barrel of a cannon.

Production Backstory

PRODUCTION NOTES

An Elder Dragon and Its Troublesome Tornados

Just like Teostra, Kushala Daora is an Elder Dragon that we simply couldn't leave out of a place like the New World, with all of its Elder Dragons. Kushala Daora inhabits the region's highlands, which helped us express how these monsters carve out their own territories. The leader of the graphics team did such a bang-up job on these two that I was dead set on coming up with gameplay that matched how great they looked. As a result of that, we have players who like or dislike certain Elder Dragons for reasons that are unique and varied. I think maintaining a balance of challenging play with a variety of play styles makes for a highly polished product. (*Tokuda*)

The twisters were always a challenge for players, and this time we made them even bigger. But beyond their size, we thought about how to improve the player's experience. We challenged ourselves by devising different kinds of damage that could occur when tornadoes make contact with specific objects like crystals, or how the twisters could affect the surrounding area. Weapons like the lance work well against Kushala Daora until about halfway through the fight, but if you have to go up to the nest...good luck! [laughs] (*Fujioka*)

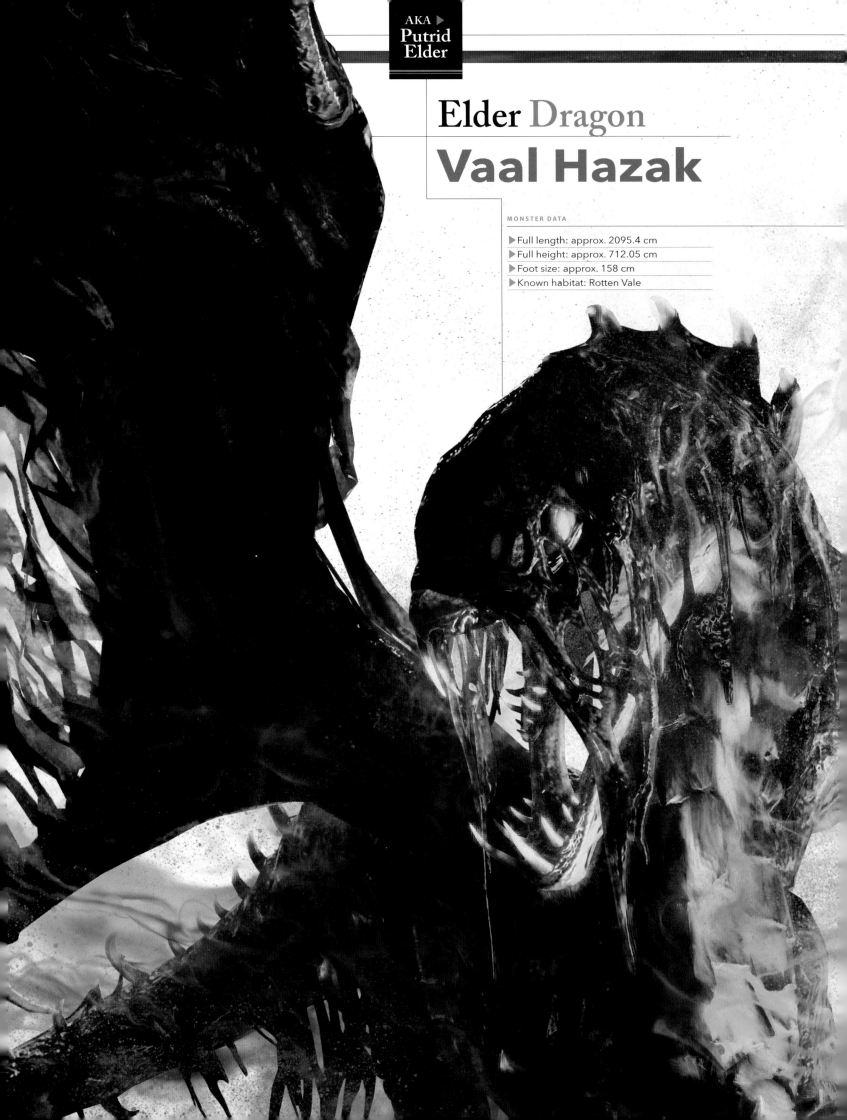

Elder Dragon
Vaal Hazak

MONSTER DATA

▶ Full length: approx. 2095.4 cm
▶ Full height: approx. 712.05 cm
▶ Foot size: approx. 158 cm
▶ Known habitat: Rotten Vale

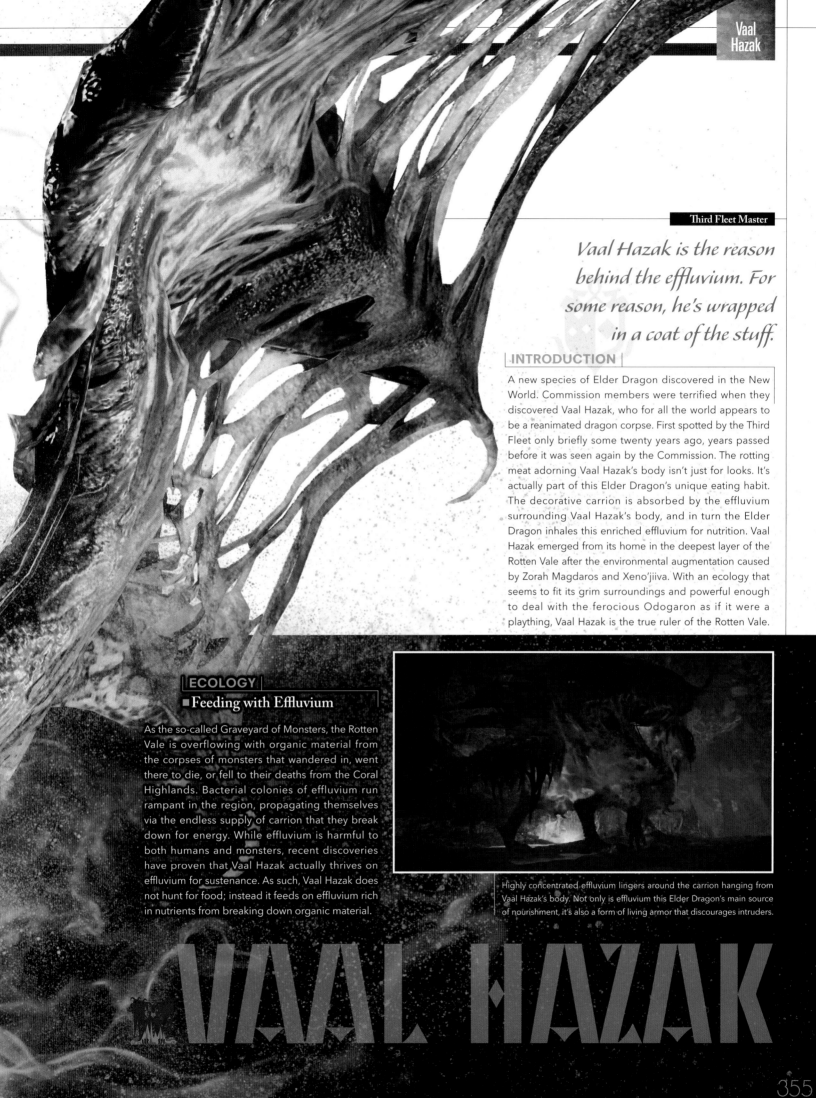

Third Fleet Master

Vaal Hazak is the reason behind the effluvium. For some reason, he's wrapped in a coat of the stuff.

INTRODUCTION

A new species of Elder Dragon discovered in the New World. Commission members were terrified when they discovered Vaal Hazak, who for all the world appears to be a reanimated dragon corpse. First spotted by the Third Fleet only briefly some twenty years ago, years passed before it was seen again by the Commission. The rotting meat adorning Vaal Hazak's body isn't just for looks. It's actually part of this Elder Dragon's unique eating habit. The decorative carrion is absorbed by the effluvium surrounding Vaal Hazak's body, and in turn the Elder Dragon inhales this enriched effluvium for nutrition. Vaal Hazak emerged from its home in the deepest layer of the Rotten Vale after the environmental augmentation caused by Zorah Magdaros and Xeno'jiiva. With an ecology that seems to fit its grim surroundings and powerful enough to deal with the ferocious Odogaron as if it were a plaything, Vaal Hazak is the true ruler of the Rotten Vale.

ECOLOGY

■ Feeding with Effluvium

As the so-called Graveyard of Monsters, the Rotten Vale is overflowing with organic material from the corpses of monsters that wandered in, went there to die, or fell to their deaths from the Coral Highlands. Bacterial colonies of effluvium run rampant in the region, propagating themselves via the endless supply of carrion that they break down for energy. While effluvium is harmful to both humans and monsters, recent discoveries have proven that Vaal Hazak actually thrives on effluvium for sustenance. As such, Vaal Hazak does not hunt for food; instead it feeds on effluvium rich in nutrients from breaking down organic material.

Highly concentrated effluvium lingers around the carrion hanging from Vaal Hazak's body. Not only is effluvium this Elder Dragon's main source of nourishment, it's also a form of living armor that discourages intruders.

VAAL HAZAK

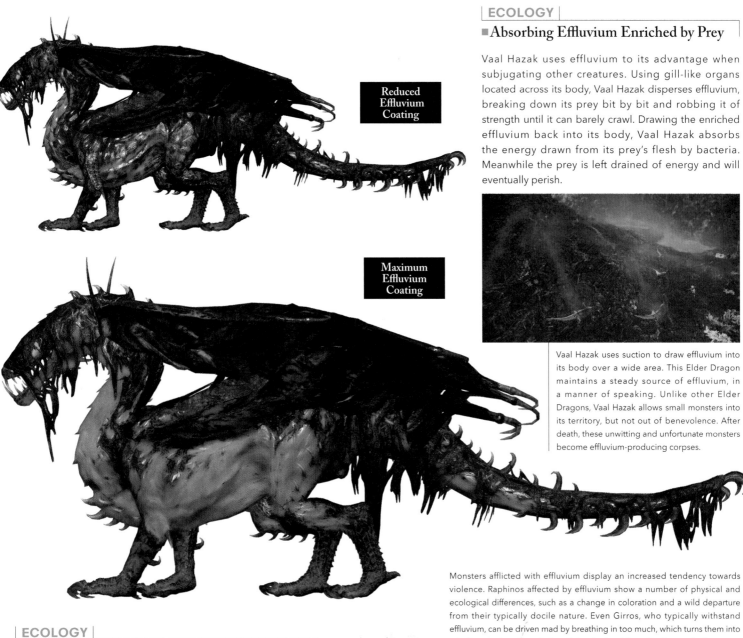

Reduced
Effluvium
Coating

Maximum
Effluvium
Coating

ECOLOGY

■ Absorbing Effluvium Enriched by Prey

Vaal Hazak uses effluvium to its advantage when subjugating other creatures. Using gill-like organs located across its body, Vaal Hazak disperses effluvium, breaking down its prey bit by bit and robbing it of strength until it can barely crawl. Drawing the enriched effluvium back into its body, Vaal Hazak absorbs the energy drawn from its prey's flesh by bacteria. Meanwhile the prey is left drained of energy and will eventually perish.

Vaal Hazak uses suction to draw effluvium into its body over a wide area. This Elder Dragon maintains a steady source of effluvium, in a manner of speaking. Unlike other Elder Dragons, Vaal Hazak allows small monsters into its territory, but not out of benevolence. After death, these unwitting and unfortunate monsters become effluvium-producing corpses.

Monsters afflicted with effluvium display an increased tendency towards violence. Raphinos affected by effluvium show a number of physical and ecological differences, such as a change in coloration and a wild departure from their typically docile nature. Even Girros, who typically withstand effluvium, can be driven mad by breathing in too much, which turns them into mindless creatures wandering aimlessly about the valley in search of prey.

ECOLOGY

■ Less Effluvium Means More Agility

While Vaal Hazak can manipulate effluvium, it does not actually produce this bacteria. Every time it releases effluvium around prey, the covering of effluvium encasing Vaal Hazak's body decreases. When Vaal Hazak loses its effluvium coating in its entirety, whether of its own volition or in battle, Vaal Hazak becomes agile and aggressive. That is to say, a Vaal Hazak's effluvium coating actually robs the Elder Dragon of its natural dexterity.

Effluvium lies nestled within the carrion encompassing Vaal Hazak's body. Plan well before attacking Vaal Hazak, as disturbing this meat could promote an explosive release of effluvium.

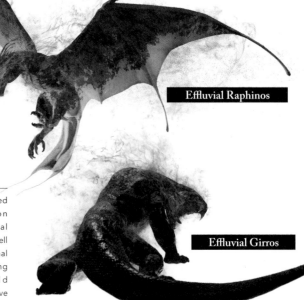

Effluvial Raphinos

Effluvial Girros

■ The Dominating Power of Effluvium

Analysis

The tendency of smaller monsters to run for cover when they sense the unnatural aura of an Elder Dragon is an ecological fact, or at least it was until now. Raphinos and Girros have been spotted gathering around Vaal Hazak and acting as its minions. Raphinos normally avoid Kirin out of fear, and Girros only follow the commands of Great Girros, so what compels these monsters to follow Vaal Hazak? The answer to this query may be a simple one: Effluvium. The monsters following Vaal Hazak are in a state of being eaten away by effluvium, which leads us to believe the Elder Dragon may be able to manipulate the smaller monsters' free will via the bacteria. If that's true, I daresay no other known monster has such a mystifying ability. (*From a researcher's notes*)

Many hunters have suffered disabling attacks from Vaal Hazak's minions that directly contributed to defeat at the Elder Dragon's claws. Some reported being rammed by Raphinos, others were paralyzed by Girros. Vaal Hazak manipulates them like toy soldiers and when the need arises, uses them like living emergency rations.

| ECOLOGY |

■ Protecting the Valley's Ecology Through Effluvium

Normally, effluvium levels are relatively stable within the middle layers of the Rotten Vale unless an unusually high number of corpses fall from the Coral Highlands in quick succession, causing a locally contained effluvium surge. The increased effluvium destabilizes the local area and causes oxygen deprivation through excessive decomposition. When deprived of oxygen, effluvium colonies will turn on themselves and begin consuming one another, leading to sharp decreases in effluvium levels. Luckily the Vaal Hazak assists in preventing this potentially calamitous event. When effluvium concentration is too high, Vaal Hazak draws excess effluvium into its body for consumption. Contrarily, in the event of low effluvium concentration, the meat adorning Vaal Hazak's body makes it a walking effluvium farm. Vaal Hazak's very existence is what holds the endlessly intriguing ecology of the Rotten Vale together.

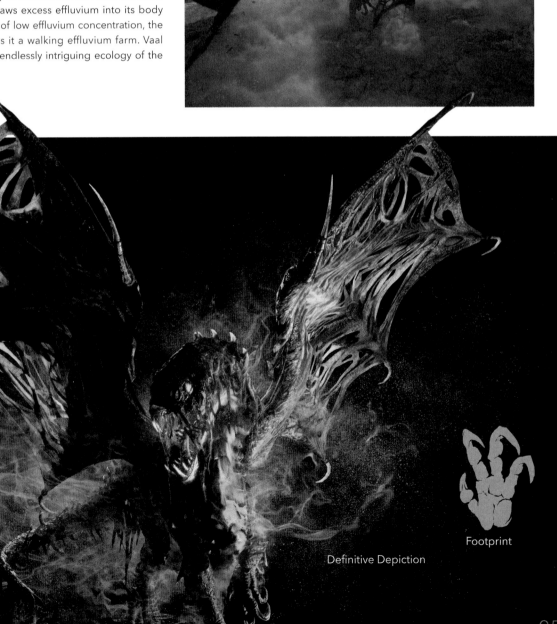

Footprint

Definitive Depiction

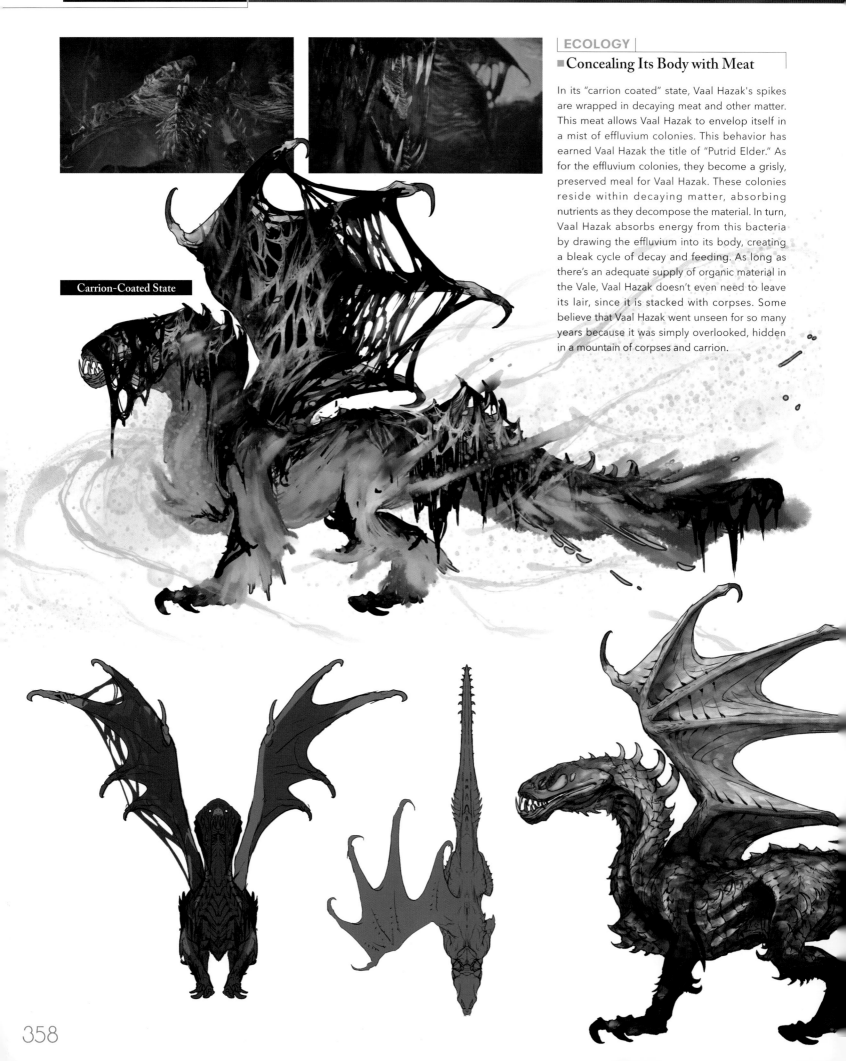

Carrion-Coated State

ECOLOGY

■Concealing Its Body with Meat

In its "carrion coated" state, Vaal Hazak's spikes are wrapped in decaying meat and other matter. This meat allows Vaal Hazak to envelop itself in a mist of effluvium colonies. This behavior has earned Vaal Hazak the title of "Putrid Elder." As for the effluvium colonies, they become a grisly, preserved meal for Vaal Hazak. These colonies reside within decaying matter, absorbing nutrients as they decompose the material. In turn, Vaal Hazak absorbs energy from this bacteria by drawing the effluvium into its body, creating a bleak cycle of decay and feeding. As long as there's an adequate supply of organic material in the Vale, Vaal Hazak doesn't even need to leave its lair, since it is stacked with corpses. Some believe that Vaal Hazak went unseen for so many years because it was simply overlooked, hidden in a mountain of corpses and carrion.

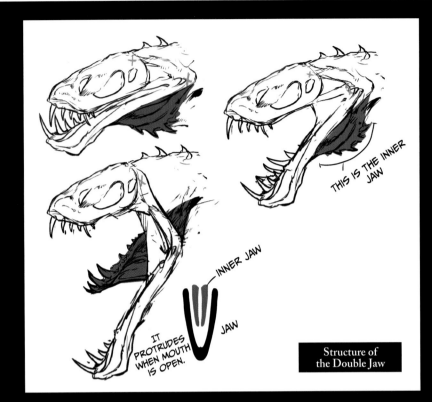

THIS IS THE INNER JAW

INNER JAW

IT PROTRUDES WHEN MOUTH IS OPEN.

JAW

Structure of the Double Jaw

ECOLOGY

■ The Structure of Its Jaw Used for Grasping Prey and Spreading Effluvium

Here is the structurally unique—yet altogether unnerving—double jaw of Vaal Hazak. Aside from its prominent outer jaw, there is also a hidden internal jaw that is unsuited to chewing meat but is superb at holding and restraining its prey. Gaining energy from effluvium, Vaal Hazak doesn't need to swallow its meals. It instead uses the sharp fangs of its outer jaw to seize prey, which it then draws to the back of its throat with the inner jaw. Next, Vaal Hazak coats the prey in effluvium, ending its struggles. Eaten away by bacteria, the corpse becomes a new breeding ground for effluvium, which the Vaal Hazak will eventually feast upon.

The unique structure of the outer jaw's joints allows it a wide range of movement, perfect for clamping down on prey of any size. When locked onto its prey, Vaal Hazak releases a cloud of effluvium from its bowels, showering the helpless creature.

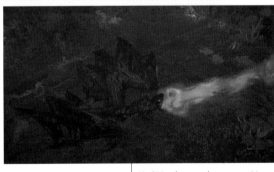

Vaal Hazak stores large quantities of effluvium within its body that it uses to rob foes of their energy for its own sustenance.

Carrion-Free State

When free of carrion and effluvium, Vaal Hazak's pale-blue plating resembles fish scales. The spikes covering Vaal Hazak, which grow contrary to its contour, easily catch on decaying matter. Briefly dipping its body into a mountain of corpses will leave the Elder Dragon coated in rotten flesh when it rises.

Production Backstory

PRODUCTION NOTES

An Elder Dragon That Makes the Most of Living with the Otherworldly Effluvium

I believe the Rotten Vale, as a key element in the overall ecology of the New World, deserves an Elder Dragon that can utilize the environment to its fullest extent. That's more important than just adding a Flying Wyvern for the heck of it. Since it uses effluvium, Vaal Hazak has a number of advantages over the player compared to other Elder Dragons, which limits how the player can approach it. We built it to be a monster that requires the player to strategize by thinking about how to best utilize their skill set, their equipment, and even nulberries. (*Tokuda*)

Vaal Hazak thrives on caloric intake obtained from effluvium, so under normal circumstances it wouldn't swallow anything with the intention of digesting it. That means it probably couldn't live in the outside world without effluvium. It has these gill-like organs all over its body that it uses to draw in or expel effluvium, but when Vaal Hazak coats its body in effluvium, that's not some kind of courtship behavior or camouflage—it's part of its basic needs for survival. That's one of the reasons that Vaal Hazak is kind of like a living extension of the Rotten Vale itself. (*Fujioka*)

UNIDENTIFIED

Extended **World Gallery**
Unidentified Creatures Log [V]

New species of monsters are appearing one after the other in the New World. This time we'll take a look at three samples of species currently under close investigation—monsters that seem to be affecting the very ecology of the continent in their own unique ways. First, Bazelgeuse, a monster who hunts creatures of every known region. Next, Nergigante, who preys on Elder Dragons making the Elder Crossing. And finally, the ruler of the Rotten Vale—which some call the very foundation of the New World—Vaal Hazak. Here and now, we stand poised to open the door to an exciting new realm of ecological research.

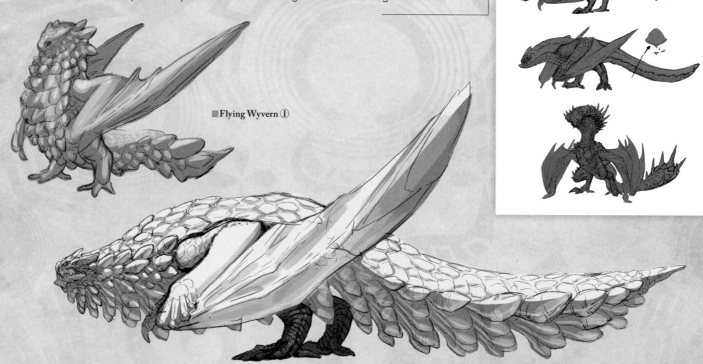

■Flying Wyvern ②

■Flying Wyvern ①

❖ Similar to "Bombarding Wyvern"
Flying Wyvern #1: Seeing the monster depicted here with tubular blaster scales on its stomach but missing them from its legs suggests that this came from early descriptions of Bazelgeuse. The researcher appears to have mistaken its facial features and wing structure for that of a standard Flying Wyvern.

Flying Wyvern #2: It seems a bit outrageous to consider this bestial-looking sample or even the snakelike individual as even closely related to Bazelgeuse.

❖ Similar to "Eater of Elders"
Elder Dragon #1: One notices almost immediately how it appears that this is a winged Brute Wyvern with features similar to well-documented monsters. Perhaps they simply assumed that eating other Elder Dragons meant that it would resemble a Deviljho.

Elder Dragon #3: This variant seems to transcend the very concept of an Elder Dragon. After flipping its prey into the air with its nose horn, the monster jumps up to meet the panicking prey, grasping it in its claws and devouring it after landing. Well, now this just sounds absurd.

❖ Similar to "Putrid Elder"
Elder Dragon #7: A depiction of what appears to be Vaal Hazak, though it's difficult to imagine that being the case as the blue and brown carrion almost adds a hint of beauty to the monster. While the skeletal structure of the wings is different and the double jaw appears to be absent, that sinister smile certainly resembles Vaal Hazak's.

Elder Dragon #9: As Vaal Hazak takes effluvium bacteria into its body, it stands to reason that effluvium is flowing throughout its body.

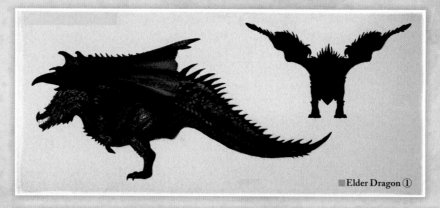

■Elder Dragon ①

■Elder Dragon ②

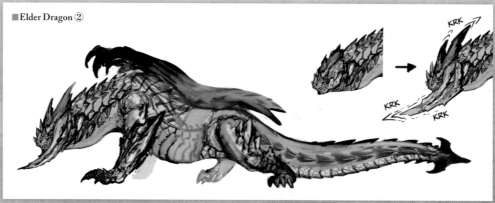

CREATURES LOG

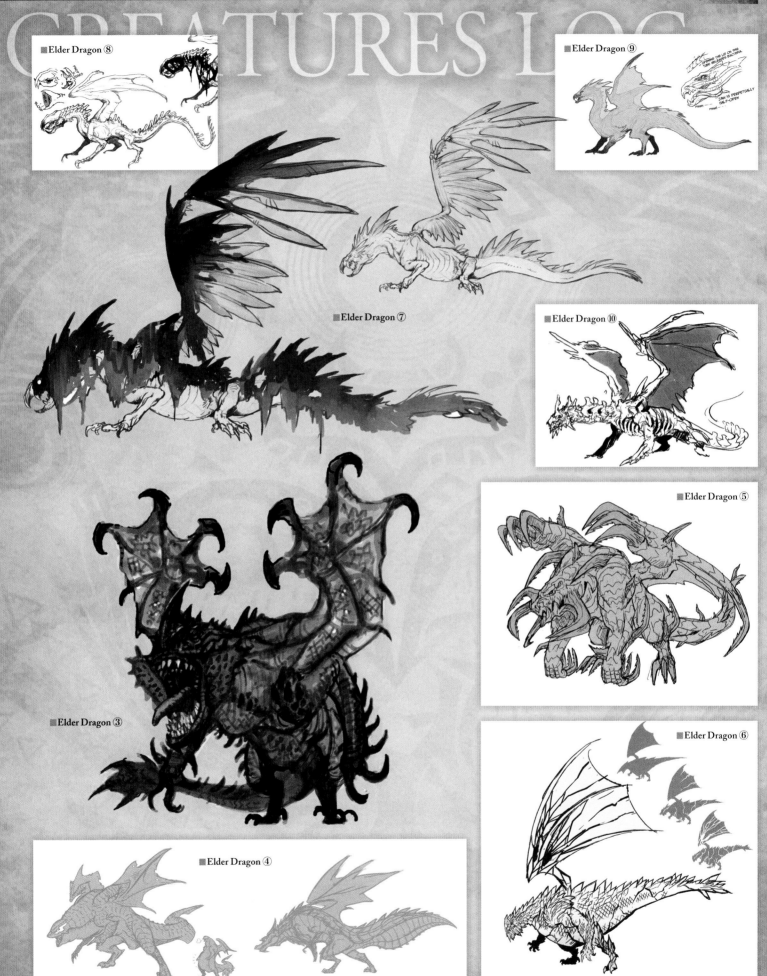

■ Elder Dragon ⑧

■ Elder Dragon ⑨

■ Elder Dragon ⑦

■ Elder Dragon ⑩

■ Elder Dragon ⑤

■ Elder Dragon ③

■ Elder Dragon ⑥

■ Elder Dragon ④

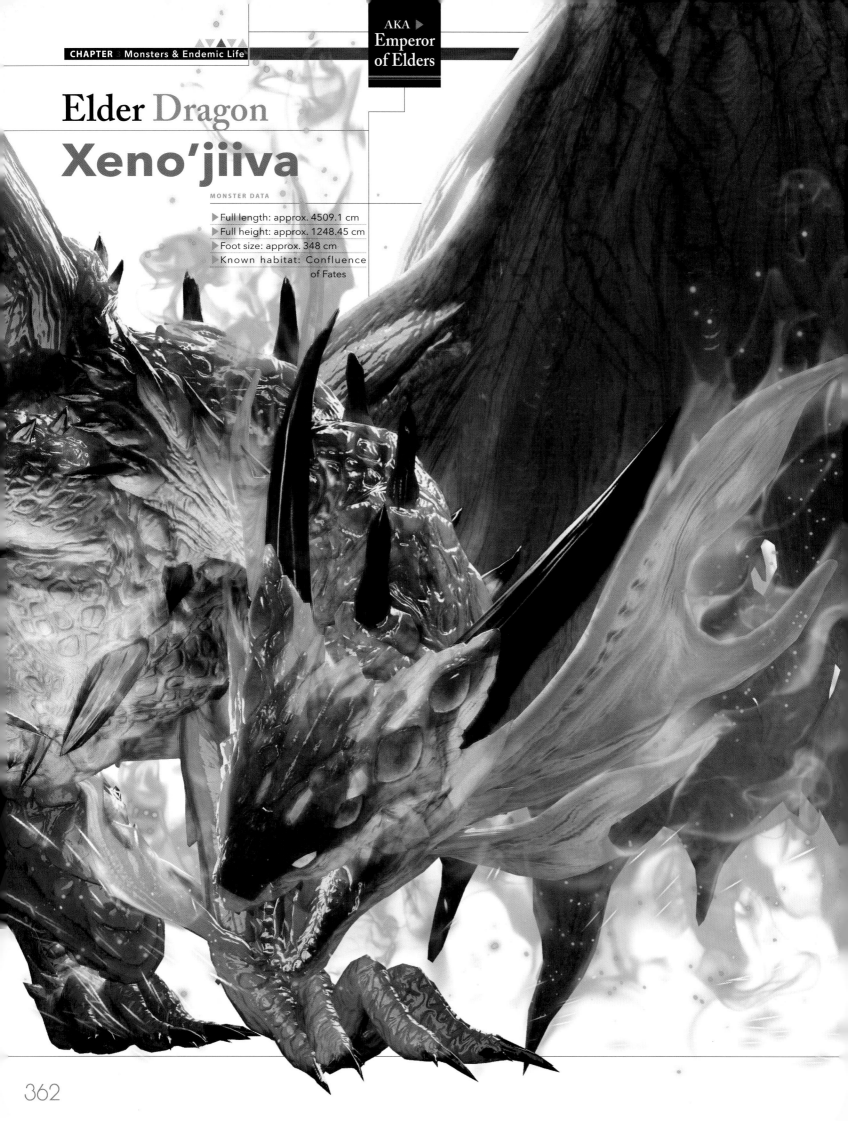

AKA ▶
Emperor of Elders

Elder Dragon
Xeno'jiiva

MONSTER DATA

▶ Full length: approx. 4509.1 cm
▶ Full height: approx. 1248.45 cm
▶ Foot size: approx. 348 cm
▶ Known habitat: Confluence of Fates

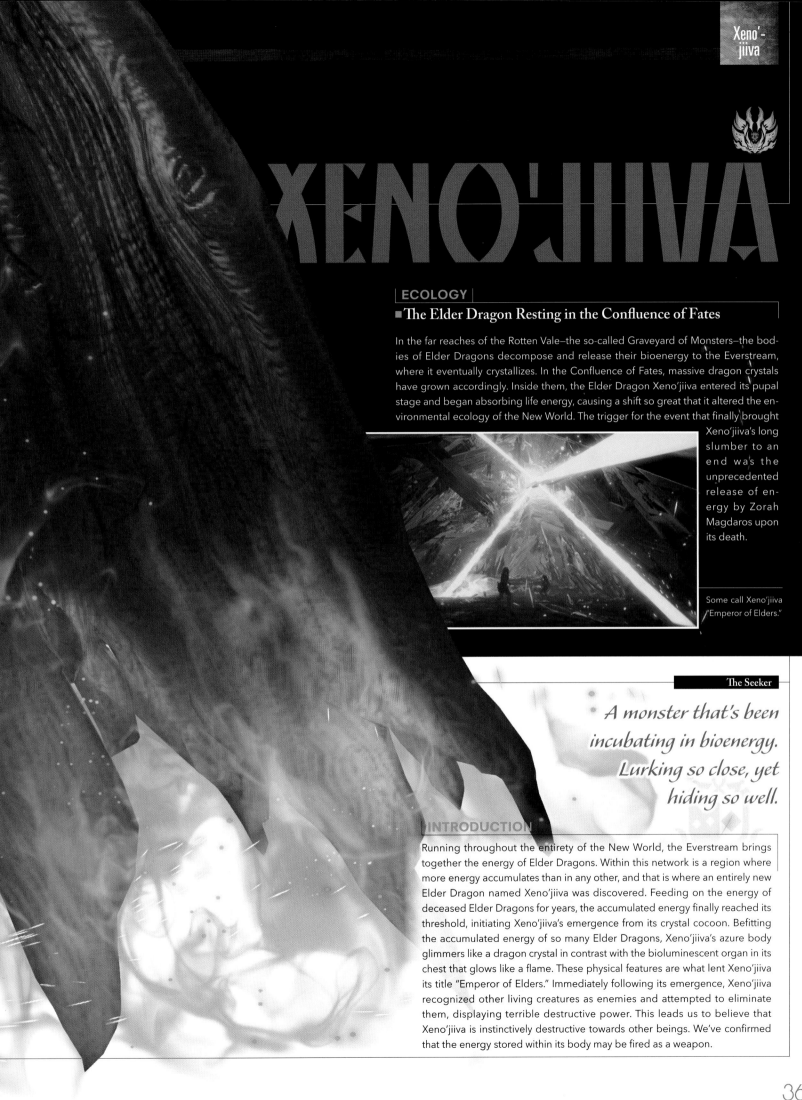

XENO'JIIVA

ECOLOGY

▪ The Elder Dragon Resting in the Confluence of Fates

In the far reaches of the Rotten Vale—the so-called Graveyard of Monsters—the bodies of Elder Dragons decompose and release their bioenergy to the Everstream, where it eventually crystallizes. In the Confluence of Fates, massive dragon crystals have grown accordingly. Inside them, the Elder Dragon Xeno'jiiva entered its pupal stage and began absorbing life energy, causing a shift so great that it altered the environmental ecology of the New World. The trigger for the event that finally brought Xeno'jiiva's long slumber to an end was the unprecedented release of energy by Zorah Magdaros upon its death.

Some call Xeno'jiiva "Emperor of Elders."

The Seeker

A monster that's been incubating in bioenergy. Lurking so close, yet hiding so well.

INTRODUCTION

Running throughout the entirety of the New World, the Everstream brings together the energy of Elder Dragons. Within this network is a region where more energy accumulates than in any other, and that is where an entirely new Elder Dragon named Xeno'jiiva was discovered. Feeding on the energy of deceased Elder Dragons for years, the accumulated energy finally reached its threshold, initiating Xeno'jiiva's emergence from its crystal cocoon. Befitting the accumulated energy of so many Elder Dragons, Xeno'jiiva's azure body glimmers like a dragon crystal in contrast with the bioluminescent organ in its chest that glows like a flame. These physical features are what lent Xeno'jiiva its title "Emperor of Elders." Immediately following its emergence, Xeno'jiiva recognized other living creatures as enemies and attempted to eliminate them, displaying terrible destructive power. This leads us to believe that Xeno'jiiva is instinctively destructive towards other beings. We've confirmed that the energy stored within its body may be fired as a weapon.

ECOLOGY

■ A Translucent Body After Emergence

After emerging from its pupal stage, Xeno'jiiva's glistening body is in a delicate state, and its internal veins are visible to the naked eye. Its wings also take time to fully spread and smooth out after being folded during its pupal state. Possessing both wings and four limbs is a classic Elder Dragon skeletal structure, but Xeno'jiiva stands out from its peers in terms of raw potential. Almost immediately following its emergence—while still not yet fully formed—Xeno'jiiva displayed violent behavior with energy coursing through its body.

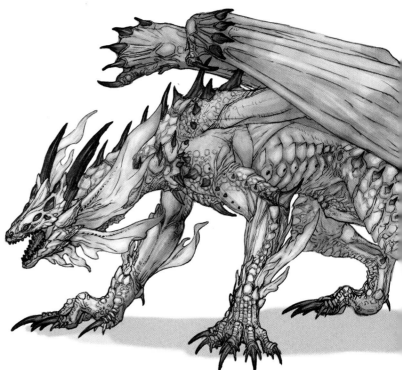

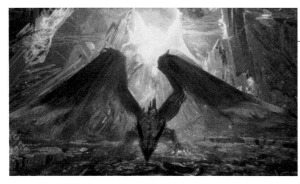

Following its emergence, Xeno'jiiva's wings were not fully stabilized and were therefore unsuitable for flight, but after only a short while energy began flowing to them, unlocking their full potential.

ECOLOGY

■ Controlling the Circulation of Energy Through Its Body

Taking advantage of an opportunity to observe Xeno'jiiva's venous structures while it was causing havoc, we noticed that energy tends to accumulate in its head, forelimbs, and tail. The Elder Dragon is weaponizing this energy by allocating it to specific regions where it is then compressed before being discharged all at once. However, Xeno'jiiva was not yet able to fully control the vast stores of energy at its disposal in this underdeveloped state. The thought of what might have transpired if this Xeno'jiiva had not been discovered so soon after emergence and allowed to gain full control over its power is frightening. Theoretically, given enough time, Xeno'jiiva may even be able to establish a loop of perpetual energy generation for itself.

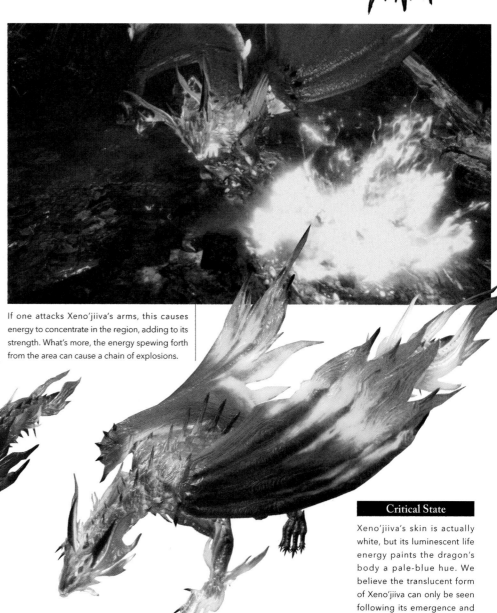

If one attacks Xeno'jiiva's arms, this causes energy to concentrate in the region, adding to its strength. What's more, the energy spewing forth from the area can cause a chain of explosions.

Normal State

Critical State

Xeno'jiiva's skin is actually white, but its luminescent life energy paints the dragon's body a pale-blue hue. We believe the translucent form of Xeno'jiiva can only be seen following its emergence and that a mature Xeno'jiiva loses this appearance.

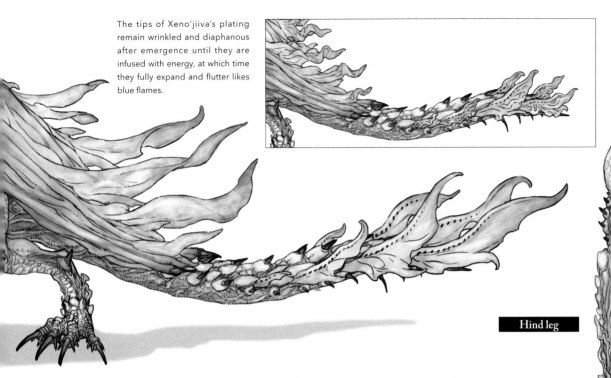

The tips of Xeno'jiiva's plating remain wrinkled and diaphanous after emergence until they are infused with energy, at which time they fully expand and flutter likes blue flames.

Forelimb

Hind leg

Here we see Xeno'jiiva's five-fingered forearm and four-toed hind leg. Note the clawed phalangeal protrusion from the wrist and heel. The sturdy musculature of Xeno'jiiva's hind legs fully supports its impressive frame when rearing up.

Analysis

▪What if Xeno'jiiva Wasn't Targeting a Crossing Elder Dragon?

A certain scholar has brought forth a novel hypothesis regarding Xeno'jiiva ecology. Xeno'jiiva primarily feeds on the energy of other monsters, which it accomplishes by drawing powerful monsters to its vicinity with pheromones. By making its home in the New World, a place that naturally draws Elder Dragons at the end of their life cycle,

Xeno'jiiva's presence may have augmented the Elder Dragons' natural attraction to the region. If this hypothesis stands, it would explain not only the increased Elder Crossing activity but also how Xeno'jiiva gained enough power to earn the title "Emperor of Elders." *(Excerpt from a Third Fleet scholar's writings)*

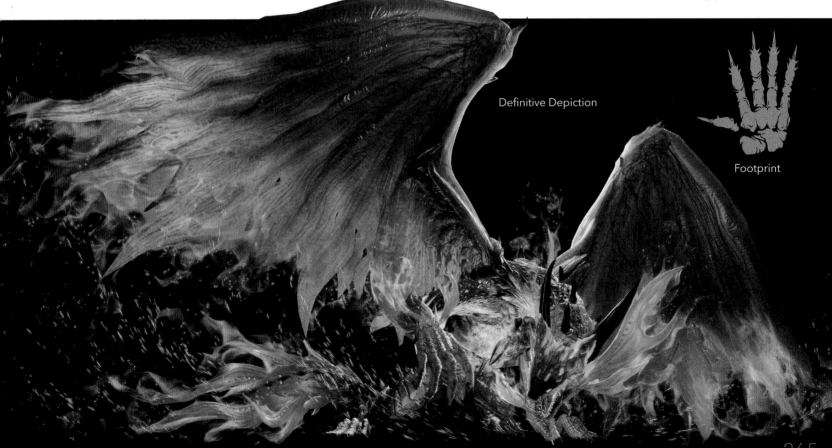

Definitive Depiction

Footprint

ECOLOGY

■ The Glowing-Red Energy-Gathering Organ in Its Chest

The crimson-glowing structure located within Xeno'jiiva's chest is the central point of its venous system and manages the flow of energy throughout its body. Just as it can distribute energy, this organ can stop the flow of energy and store it. Once a certain threshold of energy has been reached, its entire body seems to explode with light as if literally overflowing with energy. Every movement the monster makes in this state is potentially devastating to nearby organisms. Currently we believe that a mature Xeno'jiiva does not "feed" on prey for nourishment in the traditional sense, but gains energy directly from the stock generated in this centrally located organ.

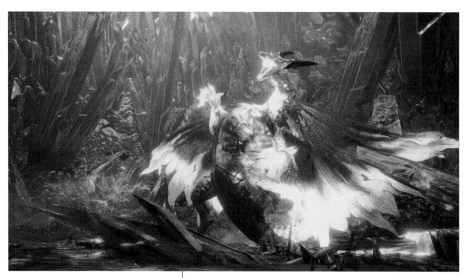

Upon entering a critical state, a flaring light bursts from Xeno'jiiva's body, illuminating the entirety of its trunk from its chest organ. While in this state, Xeno'jiiva's physical capabilities increase dramatically.

Critical State: Ventral View

Critical State

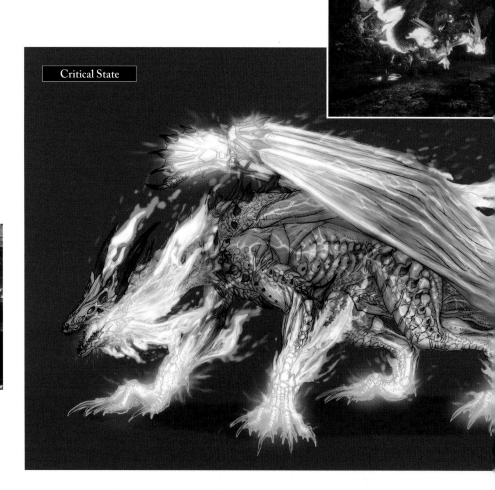

In the Confluence of Fates, even the Everstream itself responds to Xeno'jiiva's critical state, causing large-scale eruptions of energy.

ECOLOGY

■ Releasing Volatile Energy as Critical Ray Breath

Xeno'jiiva can gather energy in different regions of its body with varying effects, but perhaps the most alarming behavior comes when it stores energy in its head. Under this condition, Xeno'jiiva can spew concentrated energy in the form of a searing beam. Curiously, despite the monster's inherently rash nature, the purpose of this beam isn't just to cause havoc and destruction. Even Xeno'jiiva can only contain a limited amount of energy before it loses control. And so, Xeno'jiiva periodically releases energy like this to manage its internal energy levels. This activity exhausts the Elder Dragon, leaving it vulnerable for a few moments. When the immature Xeno'jiiva fired this beam, its critical state ended, but we believe a fully mature Xeno'jiiva can maintain the state.

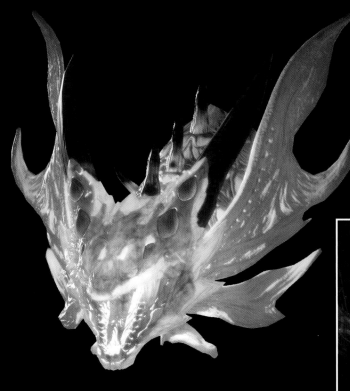

Twisting its body as it rears up, Xeno'jiiva fires an area-clearing burning attack. Incidentally, this beam can melt the ground beneath the Elder Dragon, making it unstable. Under such conditions, the full weight of the Elder Dragon may cause the ground to cave in.

While in its critical state, each physical aspect of Xeno'jiiva operates at peak performance and its attacks can create small craters in the ground. When this occurs, there's a chance for a perfect storm of energy collision to occur. Should Xeno'jiiva's bioenergy fuse with Everstream energy leaking from the ground…well, you should probably run.

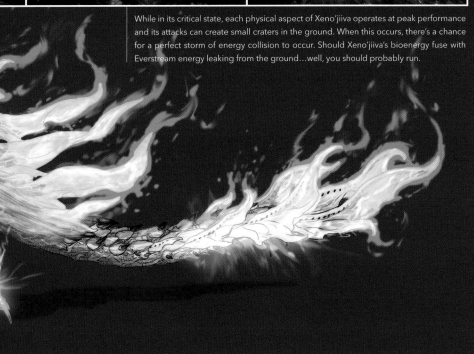

Production Backstory

PRODUCTION NOTES

The Emperor of Elders

Basically the only reason you can win this fight against the Emperor of Elders is because it was just born. The concept of it as the Emperor of the Elder Dragons is something we wanted to carry over into the gameplay. It's fearsome, how it gathers energy and has all of these attacks with laser beam-like breath. I've always wanted to make the kind of laser attack where a bead is drawn on the ground and everything stops for a second before the beam pierces the location. These new techniques were made possible through Xeno'jiiva. (*Tokuda*)

I wanted there to be an element of gameplay involving a monster that could control energy flowing throughout its body. The glowing organ in its chest can control energy flow by dedicating it to strengthening the monster, or it can stop the energy flow entirely and stock it up for an explosion. This strengthening and stocking is a cycle the monster repeats. It can use energy recklessly like this because of internal biological heating constructs. Basically, it never needs to feed because it has an infinite source of energy. If it ever matured and got out to the New World, it would be a real troublemaker. It might look like its skin is glowing but it's actually glowing from the inside out, kind of like how your insides look on an X-ray. (*Fujioka*)

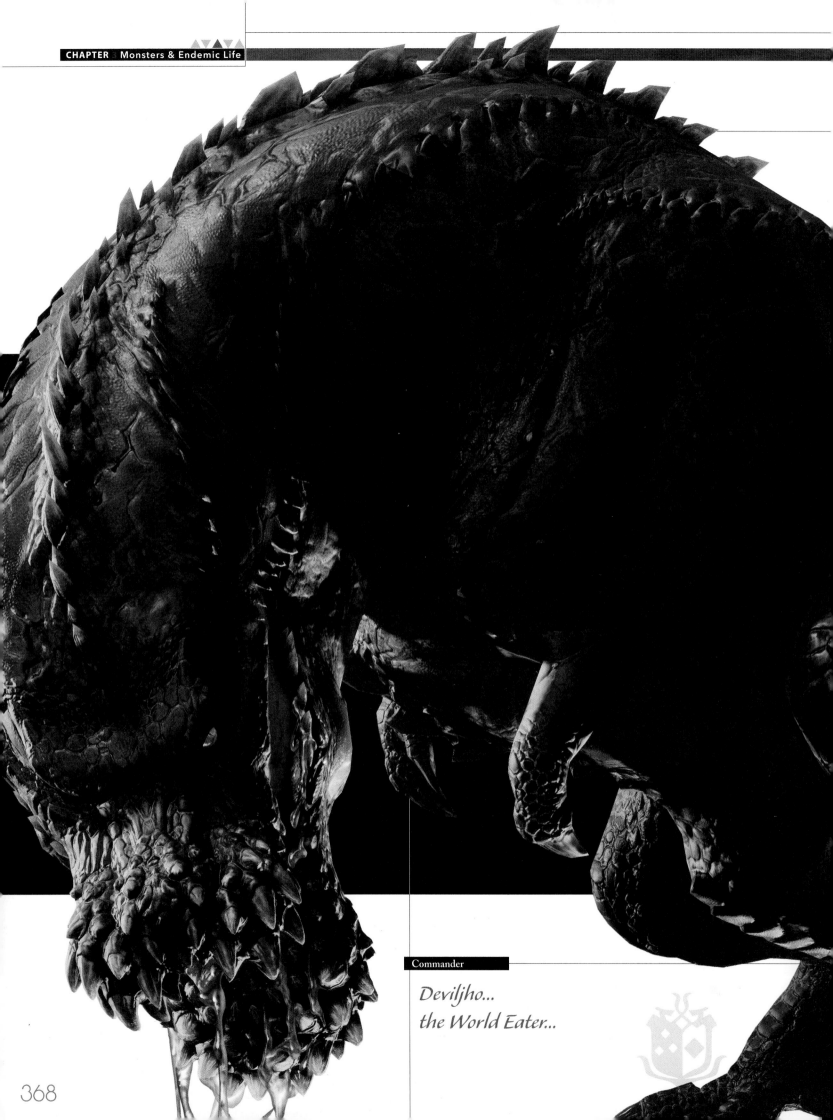

Commander

Deviljho...
the World Eater...

Brute Wyvern
Deviljho

MONSTER DATA

▶ Full length: approx. 2063.82 cm
▶ Full height: approx. 723.49 cm
▶ Foot size: approx. 146 cm
▶ Known habitats: Ancient Forest, Wildspire Waste, Coral Highlands, Rotten Vale

DEVILJHO

DEVILJHO

INTRODUCTION

A primal and ravenous impulse to feed fuels the Deviljho, devourer of all who stand before it. Said to have driven a certain region of the Old World to the point of total environmental destruction, the Guild has seen fit to deem this Brute Wyvern a special target on par with Elder Dragons. Whether a creature is small, large, or even an Elder Dragon, Deviljho will attempt to consume any living creature, going so far as to cannibalize members of its own species. While it does pose a threat to all forms of life, fortunately Deviljho's insatiable cravings and out-of-control metabolism grant it a short life span. Perhaps that is why, until recently, there hadn't been Deviljho sightings in the New World in forty years.

Here Deviljho may be seen sunbathing in a Rathalos nest...or perhaps it's simply waiting for the nest's owner to come back so it can enjoy an easy meal.

ECOLOGY
■ Seeking Prey Everywhere

Deviljho is a rarity among monsters in that it doesn't have any territory to call its own because it must stay in a perpetual state of roaming. Its metabolism is far more demanding than most other creatures', and maintaining its body temperature requires digesting a constant stream of prey. If Deviljho were to stay in one area, it would almost certainly deplete the entire region of animal life in no time. Tracking by scent, Deviljho approaches its prey and attempts to swallow it whole. Equally disturbing is Deviljho's uncanny ability to adapt to its surrounding environment, with hazards such as effluvium or lava leaving the monster wholly undaunted. This brute's sadistic desire for food can be seen in how it tramples through Rathalos nests in the Ancient Forest or Diablos dens in the Wildspire Waste.

ECOLOGY

▪A Recklessness That Leads It into Direct Conflict with Large Flying Wyverns

Each region of the New World has one monster that resides at the top of the local ecology. For the Ancient Forest that would be Rathalos, and for the Coral Highlands, Legiana. Usually only Flying Wyverns display the capacity for flight, and as such, they tend to have the clear advantage against wingless monsters. Enter Deviljho, who not only stands its ground against Flying Wyverns, but launches preemptive attacks at them, roaring crazily all the way. Should airborne monsters try to make aerial strikes, Deviljho fights back with all its might by clasping them between its powerful jaws and hurling them away. This fearless behavior and daunting strength are why some in the Old World call Deviljho "Gluttonous Demon." What's more, even when it is not hungry, Deviljho may attack smaller monsters for no particular reason whatsoever, a cruel trait that puts Deviljho in a class of its own.

Here–after dodging the Deviljho's breath attack–a Rathalos sank his claws into the Brute Wyvern's back, but the enraged Deviljho simply shook him off with its superior strength. Even the King of the Skies is a mere peasant before the Gluttonous Demon.

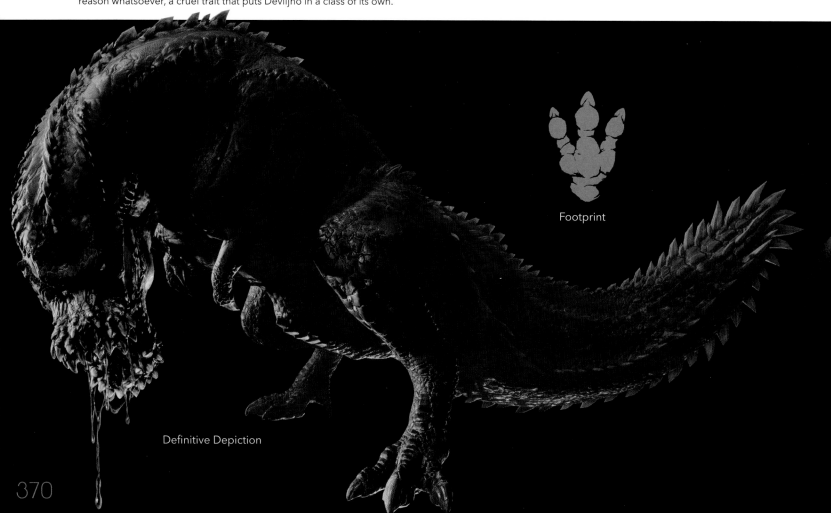

Footprint

Definitive Depiction

ECOLOGY

■ Acidic Saliva That Corrodes Its Prey's Plating

Deviljho's overactive metabolism leaves it in an almost constant state of craving sustenance. The sight of this monster with acidic saliva drooling from its mouth is enough to leave other creatures transfixed with fear. This saliva is used mainly for rapidly dissolving Aptonoth shells or large monsters' plating, but it's strong enough to eat away at the steel plating of a hunter's armor.

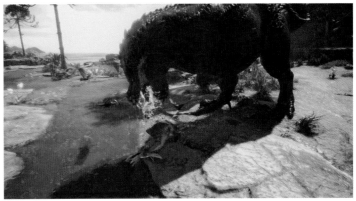

ECOLOGY

■ Throttling Prey with Its Powerful Jaws

Already blessed with magnificent musculature, the crown jewel of Deviljho's strength is its indomitable maw. Once its prey is locked between its mandibles, Deviljho will throttle the creature without restraint, often ending the prey's life then and there. Deviljho has been known to leave the site of a struggle with prey locked in its mouth, carrying the corpse around like a portable meal. Should a Deviljho spot another suitable walking meal while its fresh prey is still sitting in its mouth, Deviljho may display some darkly humorous behavior. Overcome with excitement, the Deviljho has been known to forget that it already has a meal in its mouth and assault the new prey with its former victim by smacking it or even throwing the unfortunate corpse like a projectile weapon. The spikes you see lining its mouth here are actually full-grown teeth. Deviljho will remove damaged teeth by rubbing them against the ground and tearing them out, and new teeth will grow in to replace them.

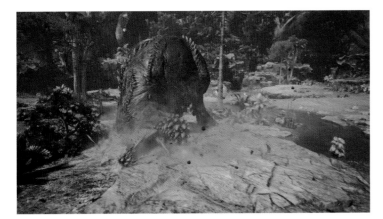

Cranial Region

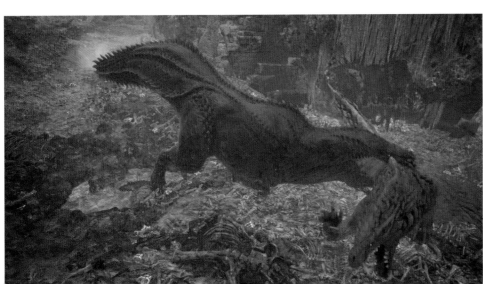

Even the mighty Odogaron, capable of easily overwhelming many other monsters, is reduced to a light snack for Deviljho.

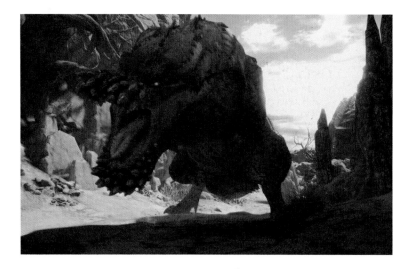

■How Deviljho Evaded New World Surveys

In the forty years since the Commission first came to the New World, Deviljho individuals have never been spotted. Why are they appearing after all this time? Some suggest that they made the long journey to the New World, while others posit that a monster making the Elder Crossing unwittingly carried eggs with it. In either case, Deviljho's ability to thrive in any environment strongly suggests that this individual inhabited the far reaches of the New World in a region that remains undiscovered by the Commission. (*Excerpt from the diary of a certain researcher*)

ECOLOGY

■Augmenting Muscles with Rage

Deviljho is known to be overcome with rage when facing strong opponents, at which time the muscles around its neck and back will cause its naturally black skin to flush crimson. Any given strike by a muscle-bound Deviljho in this "mighty" state can be fatal. Deviljho becomes focused solely on obtaining its prey at any cost and loses itself in the pursuit. However, this state is a high-risk, high-return gamble, as Deviljho's swollen muscles expose sensitive muscle fibers, leaving them wide open to severely damaging attacks.

Mighty State

Improved blood flow during excitement strengthens Deviljho's muscle tissue, a double-edged sword for the monster. While it does obtain demonic strength, its swollen chest muscles expose old wounds.

Here we see a fierce dragon-element breath attack by a Deviljho. This element surges through Deviljho when angered. Even when caught in pitfall traps, raging Deviljho are known to fire this breath while struggling to free themselves.

Normal State

ECOLOGY

■ Deviljho's Even More Powerful Upper Body

The chests of the New World Deviljho appear more lean, but their necks and jaws are considerably more bulky and muscular. Overall their upper body is clearly more brawny than Old World individuals. With this strength Deviljho can trap heavy-class monsters like Dodogama in its jaws and walk around with such prey as if it weighed almost nothing. What's more, Deviljho can wield the monsters trapped in its jaws like a weapon by thrashing its head. As Deviljho are able to adapt to diverse environments better than any other monster, we believe that this increase in muscle mass is part of their natural adaptation to the New World. There is a documented case in the Old World of an elderly Deviljho that could not suppress its primal instincts, continuing to grow more and more hostile. Eventually the individual was producing so much dragon-element-derived strength that not only was it destroying the local environment, it was literally killing itself. Researchers are invested in determining whether such an individual exists here in the New World.

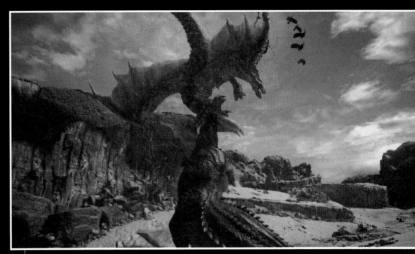

Here we see a Deviljho intercepting a Diablos charge and turning the tables by lifting it up and off the ground like a plaything.

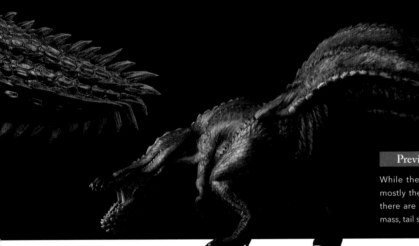

Previously Identified Individual

While the unsettling jet skin and claws are mostly the same as the Old World Deviljho, there are clearly some differences in muscle mass, tail shape, and number of spikes.

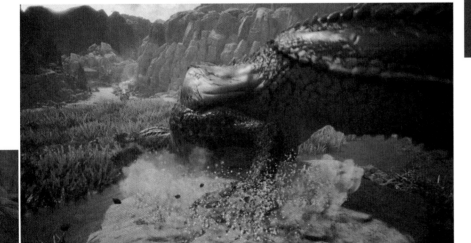

Despite their lean appearance, Deviljho's legs are quite strong, easily supporting their large bodies. By stomping the ground, they can cause a tremor severe enough to disable faraway enemies.

Production Backstory

PRODUCTION NOTES
The Tyrannical Brute and Its Duality with Bazelgeuse

Bazelgeuse is a chaotic element from the sky, and Deviljho fulfills that same role from the ground. Deviljho is a destroyer of environmental ecology, so with environment being at the forefront of the game it was a natural fit. We wanted Deviljho to be available from the start, but all said and done, it was decided that adding it to the mix later would have a bigger impact, which is why we released Deviljho with an update. Most turf wars have monsters clashing and then going their separate ways, but we gave Deviljho the ability to use monsters as weapons or even walk around with them, which matched its violent personality… (*Tokuda*)

Having Deviljho walk around with other monsters in its mouth was so natural, but since it has a small head the variety of monsters it can carry around are actually limited. [laughs] We started with Great Jagras and went in order, figuring out which monsters fit. We aimed to make sure that Deviljho could hold at least one variety of monster from each field. If we couldn't at least do that, we knew that Bazelgeuse would overshadow Deviljho, which would have disappointed a lot of the Deviljho fans out there. (*Fujioka*)

Elder Dragon
Kulve Taroth

MONSTER DATA

▶ Full length: approx. 4573.25 cm
▶ Full height: approx. 1219.32 cm
▶ Foot size: approx. 321 cm
▶ Known habitat: Caverns of
 El Dorado

Admiral

*Kulve Taroth, or the "Mother Goddess of Gold."
It's gotta ring to it, right? Ha!*

KULVE TAROTH

ECOLOGY

■ Lady of the Subterranean City of Gold

In the Caverns of El Dorado lie deposits of precious metals as big as boulders, and this is where Kulve Taroth makes her lair while adorned in a dazzling shell created from pure gold. Parts of her shell naturally fall off and scatter, a trait that has seeded the caverns with gold, giving rise to their name. Being comfortable in her underground stronghold with no desire to reach the surface allowed her to remain undiscovered for forty years.

Glittering gold can be seen decorating almost every surface in Kulve Taroth's home, the Caverns of El Dorado. These tempting hunks of fortune are portions of her shell that have fallen off during her travels through the caverns.

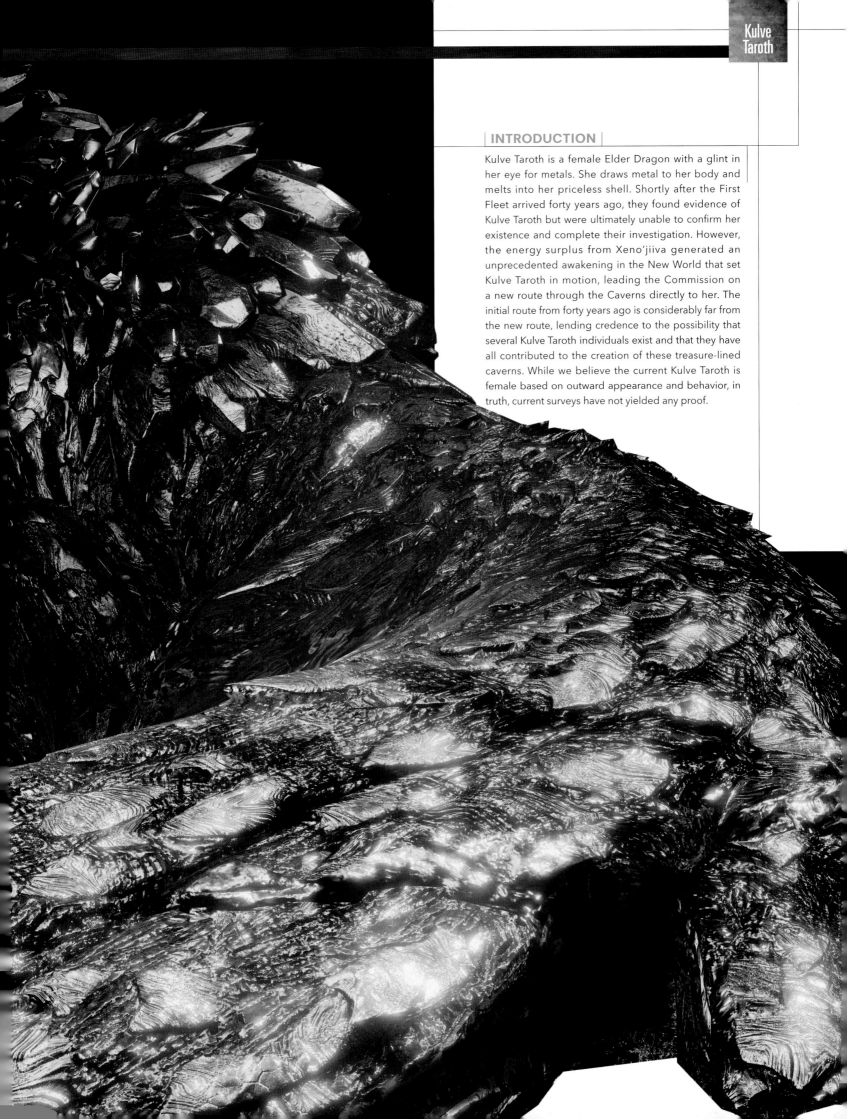

INTRODUCTION

Kulve Taroth is a female Elder Dragon with a glint in her eye for metals. She draws metal to her body and melts into her priceless shell. Shortly after the First Fleet arrived forty years ago, they found evidence of Kulve Taroth but were ultimately unable to confirm her existence and complete their investigation. However, the energy surplus from Xeno'jiiva generated an unprecedented awakening in the New World that set Kulve Taroth in motion, leading the Commission on a new route through the Caverns directly to her. The initial route from forty years ago is considerably far from the new route, lending credence to the possibility that several Kulve Taroth individuals exist and that they have all contributed to the creation of these treasure-lined caverns. While we believe the current Kulve Taroth is female based on outward appearance and behavior, in truth, current surveys have not yielded any proof.

■ Golden Armor for Attracting Metals

Displaying behavior appropriate for the so-called Golden Elder, Kulve Taroth can draw all manner of metals from surrounding rocks and strata to her body. Her furnace-hot temperature melts these precious metals to her body. They cool over time, bestowing her with a gift of brilliant golden armor. As the quantity of stored metals varies between individuals, controlled repeat surveys of a single individual are recommended. Also, be on the lookout for man-made weapons wedged into the shell. These weapons are from Kulve Taroth's previous encounters with humans and may have been combined with gold, granting them unique properties.

This full-body metal plating is extraordinarily resilient but also cumbersome. Since it serves as heavily reinforced armor, Kulve Taroth won't so much as notice most heavy impacts on its shell.

Gold-Plated State

Once merged into Kulve Taroth's shell, the refined gold shines brilliantly. Some of her scales also contain many precious metals. If a hunter managed to snatch just one of them, they could surely amass a great fortune.

Melding State

As Kulve Taroth's body temperature rises, the metals across her body emit a reddish glow as they start to melt. While in this softened state, sections of metal may fall off if struck with a powerful impact.

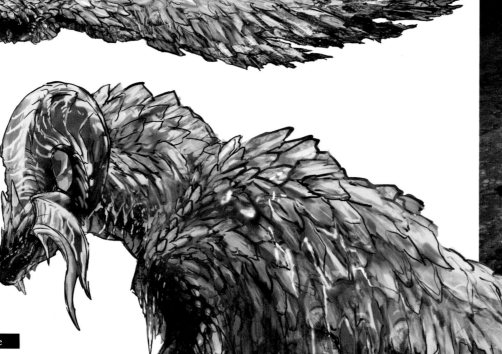

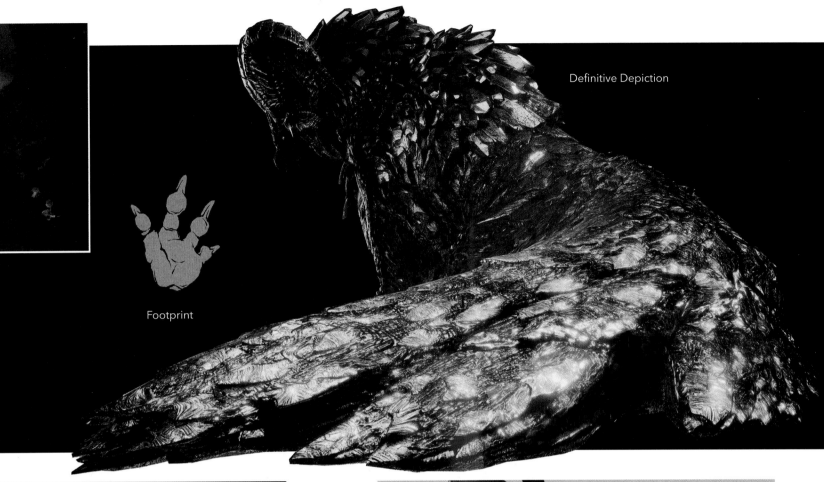

Definitive Depiction

Footprint

While in her melding state, Kulve Taroth's chest—the control center for her body temperature—appears to glow bright red. If we assume that she was only covered in pure gold, her body temperature could be over 1,400 degrees Celsius.

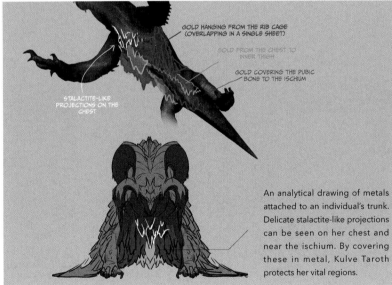

GOLD HANGING FROM THE RIB CAGE
(OVERLAPPING IN A SINGLE SHEET)

GOLD FROM THE CHEST TO
INNER THIGH

GOLD COVERING THE PUBIC
BONE TO THE ISCHIUM

STALACTITE-LIKE
PROJECTIONS ON THE
CHEST

An analytical drawing of metals attached to an individual's trunk. Delicate stalactite-like projections can be seen on her chest and near the ischium. By covering these in metal, Kulve Taroth protects her vital regions.

ECOLOGY

■ Melding and Heat Release from Her Sudden Increase in Body Temperature

An organ crucial to Kulve Taroth's body temperature maintenance rests in her chest. Though normally passive, if her gold plating is severely damaged, she will react in anger and her body temperature will rise sharply. Along with the change in body temperature, her metal plating may begin to melt and her entire body will glow red. In this melding state, Kulve Taroth will become more aggressive towards intruders and periodically release her accumulated body heat on her unfortunate victims. She'll also head underground in an attempt to replenish her lost metal plating from the surrounding strata. In addition to using the gold for combat purposes, Kulve Taroth seems driven to coat herself in gold for aesthetic reasons.

377

Analysis

■What Impact Does Kulve Taroth Have?

Hidden within the Everstream's Caverns of El Dorado are Gold Helmcrabs and Copper Calappas that feed on metal-infused organic material, much of which is produced by Kulve Taroth. In addition, Gold Scalebats can easily blend in with their surroundings. Members of the Golden Tribe are always on the lookout for gold to incorporate into their weapons or ensemble, and the mythical Tsuchinko was even confirmed for the first time ever here.

Incidentally, we believe the secret of Kulve Taroth's ability to attract metals and ore to her body rests in her giant horns. They probably contain some kind of powerful magnetic element or compound. We're looking forward to studying a sample for ourselves. (*Excerpt from Third Fleet research records*)

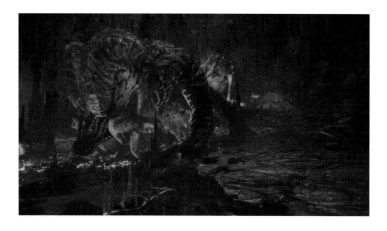

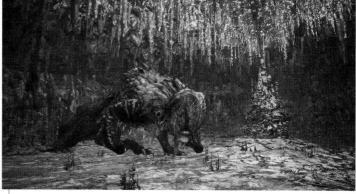

In order to defeat her enemies, Kulve Taroth removes her metallic coat of armor and prepares for battle. She lures would-be invaders to her lair, which is a literal and figurative gold mine, as well as a battleground where Kulve Taroth fights with home field advantage.

ECOLOGY

■Powerful Limbs Hide Beneath Her Sparkling Golden Armor

Kulve Taroth will only show her true prowess in battle if intruders manage to knock off the majority of her armor. Spurred on by rage, she removes all the metal from her body and reveals her natural form. While covered in armor she might have a brutish appearance, but her actual limbs are quite lean, and without the golden burden she demonstrates fantastic agility. Razor-sharp bites, area-clearing arm sweeps, and crushing blows with her facial spikes are just a few of the spectacular moves she displays in battle.

Unconcealed Kulve Taroth

Kulve Taroth's powerful limbs are capable of supporting not only her large frame but also the burden of her gold armor. She is also somewhat unique for her lack of wings, a phenotypic characteristic that matches her underground territory.

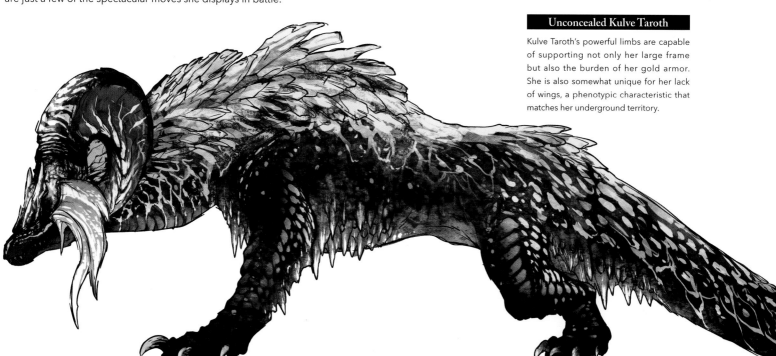

A Kulve Taroth that no longer has her golden coating displays pale-white stalactite-like spikes and a giant pair of horns. The horns exude a beguiling aura of beauty as their color shifts between blue and green, depending on the angle they're viewed from.

THE GOLD BEARD FOLLOWS THE JAWLINE.

As is the case with many Elder Dragons, we believe that Kulve Taroth's horns possess unique abilities. Obtaining a sample of her horns is a matter of the utmost importance and should take priority in Kulve Taroth surveys.

ECOLOGY

■ Exhaling Searing Breath to Manage Body Temperature

Aside from Kulve Taroth's golden coating, she's also known for having versatile control of her body temperature, which allows her to melt down the metals that come in contact with her body and form armor as it cools. Kulve Taroth can release bursts of superheated air to lower her body temperature and to dissuade assailants. Incidentally, these expulsions are not actually flames, but furnace-hot waves—or bursts—capable of melting metals, bedrocks, and of course, hunters.

While she typically uses her facial spikes to carve out a new tunnel, occasionally she will be confronted with resilient ground or walls of solid gold. Kulve Taroth then uses her furnace-like breath to soften the material, allowing her to dig through it with relative ease.

Normally she adjusts her breath to a temperature that won't affect her golden coating, but when a Kulve Taroth is angered, her body temperature rises rapidly and she loses control of her breath. In this reckless state, she's been known to ruin the gold coating of her lair by expelling large quantities of unmanaged breath.

Production Backstory

PRODUCTION NOTES

Unique Sixteen-Player Online Gameplay

The Kulve Taroth survey combines a cooperative event mission with straightforward head-to-head action. Our inspiration was the image of a dragon covered in riches, something Fujioka has wanted to do for a long time now. We aimed for gameplay that fits this concept, and we wanted it to feel like a lottery with a chance to win treasure. Actually, that's why we released it through an update. Since the reward system is built around a concept that differs from the main hunts, it made more sense to implement it as postgame content. (Tokuda)

Hunters pursuing a treasure-loving subterranean dragon find themselves becoming the hunted—their own weapons eventually adding to the armor of the very creature they pursued. That basic image of a dragon has such an Arthurian appeal, and that's what I tried to create with Kulve Taroth. We happened to be looking for online gameplay that required tight cooperation among players, so the timing was perfect. I'm quite pleased that we were able to bring all of these elements together for a new experience that includes simultaneous sixteen-player gameplay. (Fujioka)

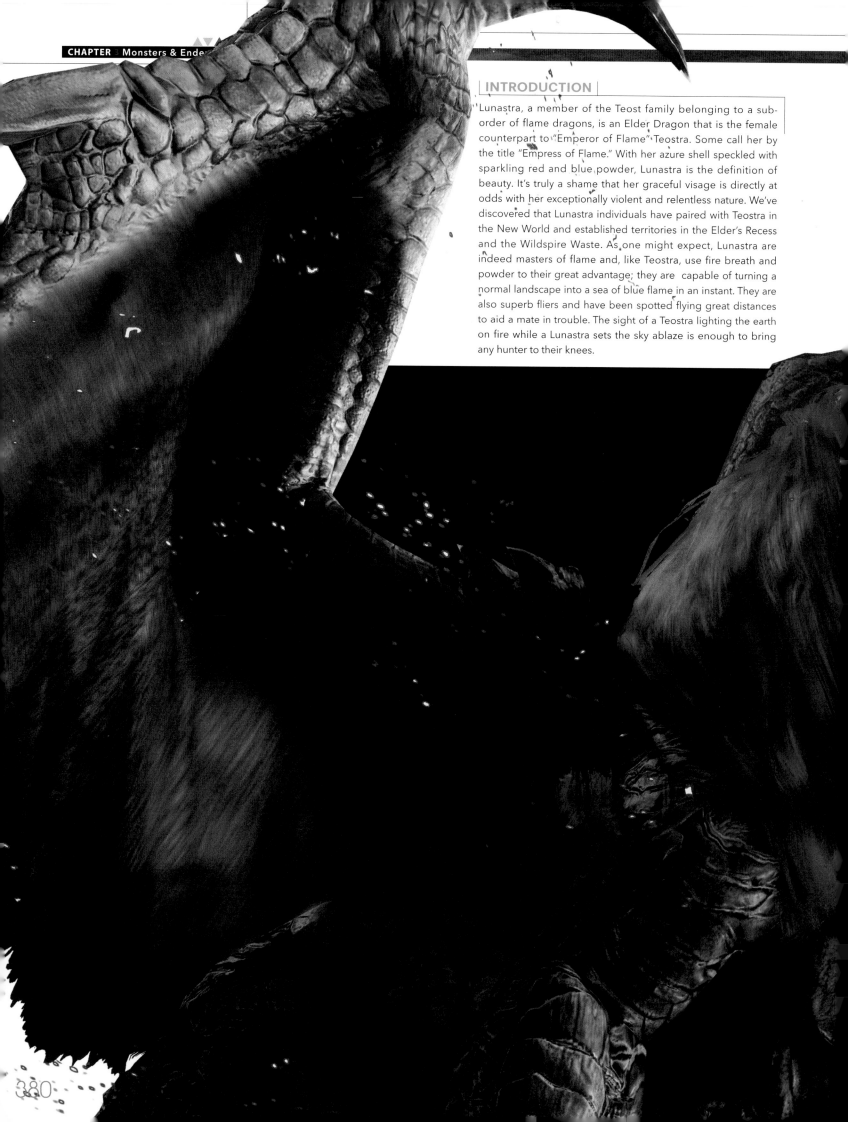

INTRODUCTION

Lunastra, a member of the Teost family belonging to a sub-order of flame dragons, is an Elder Dragon that is the female counterpart to "Emperor of Flame" Teostra. Some call her by the title "Empress of Flame." With her azure shell speckled with sparkling red and blue powder, Lunastra is the definition of beauty. It's truly a shame that her graceful visage is directly at odds with her exceptionally violent and relentless nature. We've discovered that Lunastra individuals have paired with Teostra in the New World and established territories in the Elder's Recess and the Wildspire Waste. As one might expect, Lunastra are indeed masters of flame and, like Teostra, use fire breath and powder to their great advantage; they are capable of turning a normal landscape into a sea of blue flame in an instant. They are also superb fliers and have been spotted flying great distances to aid a mate in trouble. The sight of a Teostra lighting the earth on fire while a Lunastra sets the sky ablaze is enough to bring any hunter to their knees.

Elder Dragon
Lunastra

MONSTER DATA

▶ Full length: approx. 1828.68 cm
▶ Full height: approx. 627.56 cm
▶ Foot size: approx. 112 cm
▶ Known habitats: Wildspire Waste, Elder's Recess

ECOLOGY

■ Wearing a Cloak of Blue Flame

By keeping herself constantly veiled in flame, Lunastra maintains a high body temperature. It is common knowledge that blue flames burn at higher temperatures than red, and this holds true for Lunastra and Teostra. Her flames are markedly hotter than Teostra's, as any hunter who has tried to approach her may attest, and she can set off powerful blasts by releasing blue powder from her wings and tail. Upon making contact with her hard shell, the powder sparks and explodes.

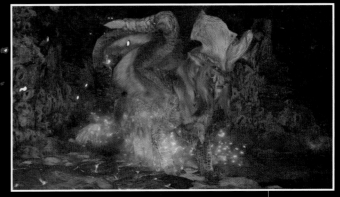

Lunastra is known for her perpetual vigilance. Notice how she wraps herself in flame even when not being threatened. She is unwilling to let anything besides her own species get even remotely close to her.

LUNASTRA

Commander

Is that a...Lunastra?!
She must be that Teostra's mate!

ECOLOGY

■High Vigilance and Strong Aggression

Lunastra are known for vigilance and are not easily spotted in the wild. Sending a group to conduct a Lunastra survey almost always ended with the Lunastra fleeing, which is why surveys have heretofore been carried out as solo missions. Curiously, the Lunastra encountered in the New World does not display such behavior. In contrast to Teostra's lackadaisical attitude toward harmless organisms, if Lunastra has reason to believe her territory is being breached by any forms of life, she will immediately raise her claws and begin a preemptive strike.

Before these hunters can so much as unsheath their weapons, Lunastra has already begun her vicious assault.

Definitive Depiction

Footprint

ECOLOGY

■Burning with Blue Flame and Detonating Powder

When ignited, Lunastra's highly flammable powder sends out an explosive wave of fire that burns so exquisitely hot it sets solid volcanic rock ablaze. This unnatural wildfire dramatically raises the ambient temperature and drains the life of any who are near. Lunastra is aware of the danger these flames pose and will persistently coat the field with her powder, igniting it with her flame breath or by simply cracking her tail. In other words, Lunastra intentionally attempts to consume her enemies in a sea of fire.

Here, a Lunastra is deliberately stoking her flames by piling on powder and creating an expanding field of fire that almost seems to be stoking itself.

ECOLOGY

■ Crown-Like Horns Fit for an Empress

Although physically similar to Teostra's, Lunastra's broad horns are actually strikingly different. These crown-like horns exude an air of regality, as fitting for an entity with her title. As for their function, we believe that they are somehow connected to her manipulation of explosive powder. Lunastra's hair may also be more well developed than Teostra's, giving her better control of powder storage. In any case, her voluminous mane is certainly a sight to behold. Individually these physical traits of Lunastra convey her fiery disposition and ferocity, but few could disagree that together, they also grant her a sense of majesty.

Displaying manes and tails with more volume than Old World individuals, these adaptations in New World Lunastra may aid them in protecting vital regions, but there is also a chance that they may be involved in mating behavior.

Instead of using her fangs to ignite the powder like Teostra, Lunastra slaps the spikes of her wings together to cause sparks that light sweeping wildfires.

ECOLOGY

■ Special Powder Spread in High-Temperature Conditions That Lead to the Hell Flare Phenomenon

Lunastra's endless coating of powder creates a dense pocket of air around her. This pocket retains heat and raises her temperature over time. Once it rises above a certain threshold, she disperses a unique powder. When lit, it sets off a truly spectacular explosion. The explosion is called a "Hell Flare," a name which properly conveys the threat it poses.

Taking to the skies, the Empress of Flame unleashes her most powerful attack—a massive ball of azure flame, punishing anyone foolish enough to step foot in her territory.

ECOLOGY

■ Forging Bonds Through Fire— Regarding Courtship

Teostra and Lunastra exhibit exemplary cooperation in conflict. As Lunastra spreads her powder, Teostra ignites it with his fire breath, leaving their opponents no time to respond. But nothing compares to what they are capable of when they combine "Hell Flare" and "Supernova." These chaotic displays are actually one form of courtship, and are commonly called "the Empress of Flame's Bond" and "the Emperor of Flame's Bond."

After the explosion, Teostra's flames stoke Lunastra's spreading conflagration, increasing their severity and robbing all living creatures of their strength, temporarily giving control of the field to the Elder Dragon pair.

Analysis

■ A Means of Extinguishing Lunastra's Blaze

Lunastra's extraordinary wildfires make the environment extremely unsuitable for their enemies. These infernos can actually be extinguished if caught early on. Experienced hunters suggest using "small barrel bombs or Crystalburst to wipe out the flames when they're still small. Use slinger ammo or weapons that have water properties to lower the temperature."

We would be remiss in failing to note that these fires can spread as long as Lunastra is surrounded by powder, which can make it difficult for a solo hunter. Lunastra will stand her ground in the presence of multiple hunters, so ambitious parties should assign one hunter to fire-extinguishing duty. (*From a researcher's notes*)

ECOLOGY

■ Why Lunastra Appeared in the New World

During a recent survey, Teostra was observed being attacked by the vicious Nergigante. Teostra appeared to be having trouble until Lunastra appeared and the two began cooperating to deter Nergigante. Their display of concern confirmed suspicions of their partnership, distinguishing this as the first-ever observed case of a couple. This leads us to the irrefutable conclusion that her appearance in the New World is due to her urge to produce offspring. During the breeding season, Lunastra's heightened vigilance and aggression are beyond anything we've seen displayed in Old World individuals.

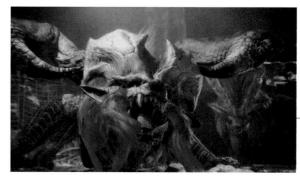

After attacking Teostra, Nergigante was successfully repelled by Lunastra.

Carried by winds, Lunastra and Teostra's powders seem to fuse as they dance into the sky, initiating a chain of explosions. It is a truly mystical sight—one that we suggest you witness from a considerable distance.

Teostra and Lunastra observed taking what appears to be a pleasant stroll in the Wildspire Waste—a rare sight indeed.

Production Backstory

PRODUCTION NOTES

An Elder Dragon Couple That Scorches The Earth

This is Lunastra's first time back after a long absence on consoles. As for why we chose her, sure, part of it's because she's a crowd-pleaser. But the biggest reason is that we weren't limited by hardware that could display only one Elder Dragon at a time. We started thinking about how to change up turf wars and wondered what would happen if we turned the tables on the players and had two Elder Dragons actively cooperating to defeat them. At first, we were worried about the difficulties players might face in dealing with two Elder Dragons at once, but releasing her as an update let us design a confrontation suited to players who'd spent some serious time learning the gameplay. (*Tokuda*)

We emphasized the differences between this Elder Dragon couple by highlighting Teostra's flames and Lunastra's powder. In previous titles their abilities were basically the same, so we had to decide what would justify bringing both of them onto the field at the same time. Their relationship is the result of that. Basically, the more we worked on Lunastra, the more she became like an overprotective wife that nobody wants to mess with. [laughs] Lunastra's mane is modest compared to Teostra's, but her coat covers more of her body even all the way down to her tail. Having all of this fur is how she stores so much flammable powder. (*Fujioka*)

Extended **World Gallery**
On the Existence of Tempered Monsters

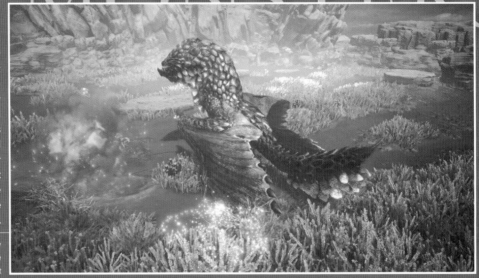

When an Elder Dragon has completed its Crossing and passes away in the Rotten Vale, the bioenergy within it is released into the Everstream and spreads throughout the New World. Recent discoveries have shown that this event affects monsters throughout the continent. Monsters that have fed on this energy for extended periods are carefully surveyed by the Guild. Monsters that outperform others in both strength and aggression are called "Tempered Monsters," identifiable by their lustrous sheen. Here, we've compiled a list of confirmed Tempered Monsters, but we do not recommend attempting to challenge any of them unless you are fully prepared.

Scoutflies respond to Tempered Monsters by emitting an azure glow, identical to their response to Elder Dragons. This luminous display is a silent sign of the threat posed by Tempered Monsters.

Monsters with Tempered Forms

Threat Level 1

 Barroth

 Pukei-Pukei

 Paolumu

 Tobi-Kadachi

 Jyuratodus

 Anjanath

 Radobaan

 Rathian

Threat Level 2

 Rathalos

 Azure Rathalos

 Pink Rathian

 Legiana

 Uragaan

 Lavasioth

 Bazelgeuse

 Diablos

 Black Diablos

 Odogaron

Threat Level 3

 Teostra

 Kushala Daora

 Nergigante

 Vaal Hazak

 Kirin

 Deviljho

Lunastra

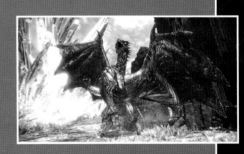

■ Streamstone and Its Many Uses

Within each Tempered and Arch-Tempered Monster's body resides a crystallized form of Everstream energy that we refer to as "Streamstones." The more a Tempered Monster overcomes deadly battles, the larger their Streamstone grows. The larger the Streamstone, the more dangerous the monster. Streamstones allow hunters to maximize the potential of gear and unlock abilities, and their usefulness in charms melded by First Wyverians is currently being tested. These gifts from the bountiful Everstream are truly a blessing for the people of Astera.

■Arch-Tempered Individuals

There exists a class of monsters so terrible that they surpass even the mighty Tempered Monsters. These abominations send shock waves not only through the Guild, but throughout all of Astera. We call them "Arch-Tempered Monsters." In the case of an Arch-Tempered Monster, an influx of Everstream energy pushes the monster's abilities beyond its limits. The massive stock of energy grants a sublime lustrous sheen to the monster's body, proof of its tremendous power. It's hard to imagine that anyone could possibly possess the power to overcome these supreme titans.

Monsters with Arch-Tempered Forms

 Kirin　　　　 **Vaal Hazak**

Teostra　　　　 **Kushala Daora**

Lunastra　　　　 **Zorah Magdaros**

Xeno'jiiva　　　　 **Kulve Taroth**

Nergigante

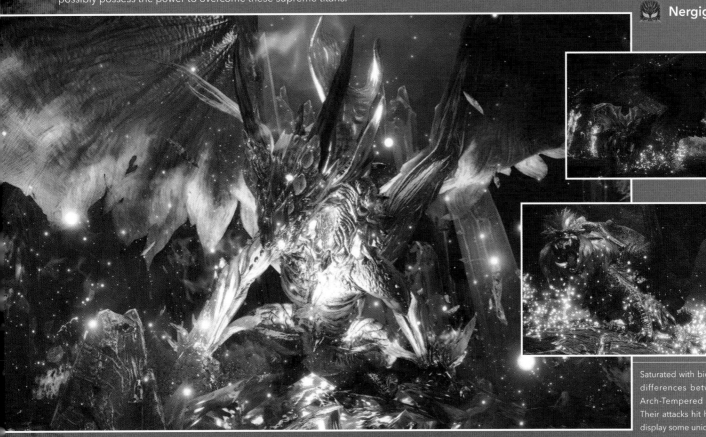

Saturated with bioenergy, the physical differences between standard and Arch-Tempered Monsters are clear. Their attacks hit harder, and they may display some unique techniques.

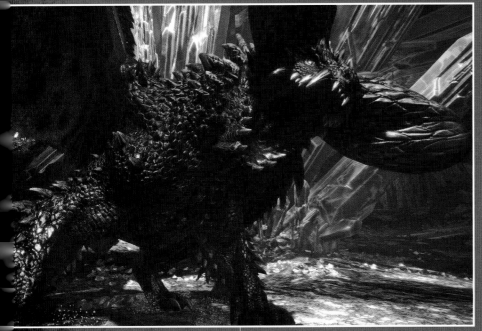

The gap of strength between the mighty Tempered and the insurmountable Arch-Tempered Monsters is vast. Even superior strength aside, Arch-Tempered Monsters' ability to shrug off the effects of Flash Pod ammo makes hunting them a challenge unlike any other.

Extended **World Gallery**
Unidentified Creatures Log [VI]

First, we examine the "Emperor of Elders," Xeno'jiiva, responsible for sending ripples through the Everstream, speeding up the Elder Crossing, and changing the ecology of the New World as we knew it. Second, we'll take a look at Kulve Taroth, an Elder Dragon that constructed the Caverns of El Dorado. Our studies of these individuals are still in the early stages. We will continue to update this data as we receive more detailed information.

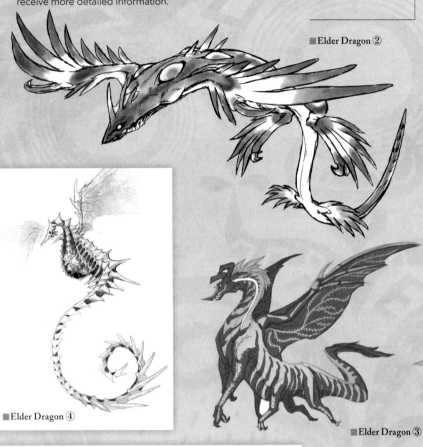

■ Elder Dragon ②

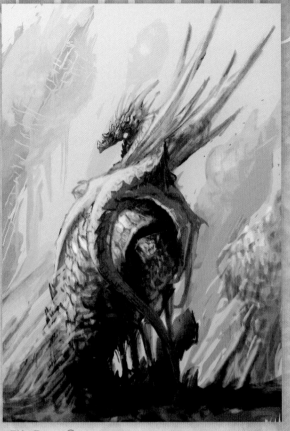

■ Elder Dragon ①

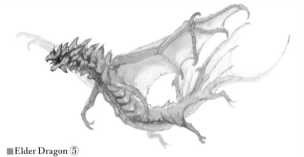

■ Elder Dragon ④

■ Elder Dragon ③

■ Elder Dragon ⑧

■ Elder Dragon ⑤

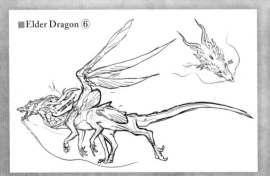

■ Elder Dragon ⑥

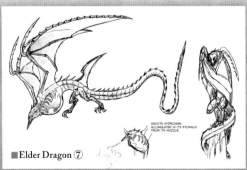

SHOOTS HYDROGEN ACCUMULATED IN ITS STOMACH FROM ITS MUZZLE.

■ Elder Dragon ⑦

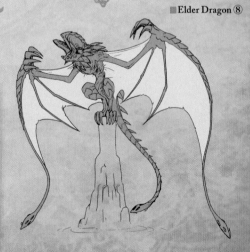

CREATURES LOG

■ Elder Dragon ⑨

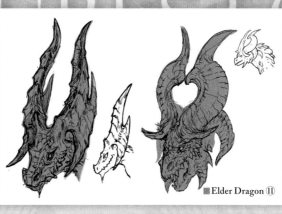

■ Elder Dragon ⑪

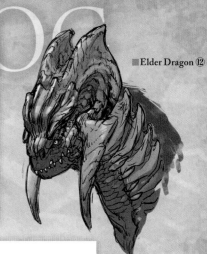

■ Elder Dragon ⑫

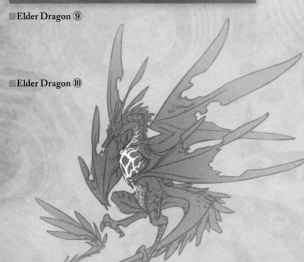

■ Elder Dragon ⑩

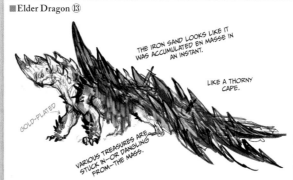

■ Elder Dragon ⑬

THE IRON SAND LOOKS LIKE IT WAS ACCUMULATED EN MASSE IN AN INSTANT.

LIKE A THORNY CAPE.

GOLD-PLATED

VARIOUS TREASURES ARE STUCK IN—OR DANGLING FROM—THE MASS.

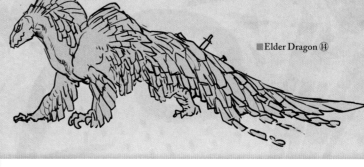

■ Elder Dragon ⑭

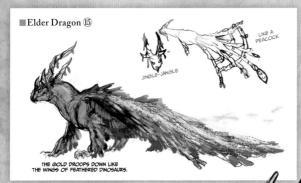

■ Elder Dragon ⑮

LIKE A PEACOCK

JINGLE-JANGLE

THE GOLD DROOPS DOWN LIKE THE WINGS OF FEATHERED DINOSAURS.

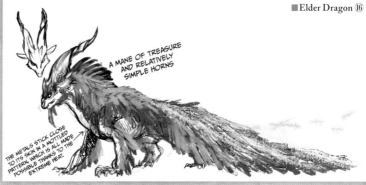

■ Elder Dragon ⑯

A MANE OF TREASURE AND RELATIVELY SIMPLE HORNS

THE METALS STICK CLOSE TO ITS SKIN IN A MOTTLED PATTERN WHICH IS ALL MADE POSSIBLE THANKS TO THE EXTREME HEAT.

■ Elder Dragon ⑰

❖ Similar to "Emperor of Elders"

Elder Dragon #3: The light is due to electricity and the dark spots to a coating of hardened iron sand. We have little reason to trust this, as it describes a "skeleton floating through the midnight sky."

Elder Dragons #4-8: Reports describe a myriad of unique characteristics. Some accounts suggest it has four arms, while others—perhaps as a result of its translucent body—suggest a shell-like exoskeleton.

Elder Dragon #10: This depiction evokes the image of a flower riding the wind but clashes with the sense of dread an Elder Dragon evokes.

❖ Similar to "Mother Goddess"

Elder Dragons #11-17: Reports presenting contradictory descriptions have led us to believe there may be more than one individual. These conflicting observations may be due to a sexual difference, however, as these may be male. Differences in their metallic armor are also seen.

389

Herbivore
Aptonoth

▶ Known Habitat: Ancient Forest

Gentle herbivores that live in herds; known for stampeding when attacked or sensing danger. Aptonoths are susceptible to heavy predation due to their palatable and nutritious meat.

APTONOTH

APCEROS

Herbivore
Apceros

▶ Known Habitat: Wildspire Waste

Their thick shells protect them from attacks, and when they huddle in groups they create a barrier. Apceros are also wary of the whereabouts of their eggs and are quick to defend them.

Herbivore
Kestodon

▶ Known Habitats: Ancient Forest, Wildspire Waste

Herds work together to defend themselves from invaders. The females are perpetually vigilant and will alert the males of any danger. The aggressive males use their knobbed heads to drive off intruders with a charging headbutt.

KESTODON

Herbivore
Gastodon

▶ Known Habitat: Elder's Recess

These territorial herbivores live in herds and display menacing behavior before boldly charging any invader, even large monsters.

GASTODON

ECOLOGY

■ Learning About the Ecological Environment from Herbivores

Aptonoths and the majority of herbivores are prone to predation by large monsters. Finding their remains in the wild indicates that the area might be a hunting ground. By patiently following herds and listening to their cries, one can determine when large monsters arrive.

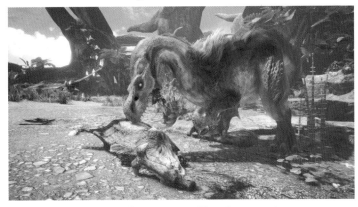

■ An Aptonoth being targeted by a large carnivorous monster.

ECOLOGY

■ Protecting Themselves from Attack with Their Shells

When facing a threat, herbivores will usually attempt to flee or drive off their assailant. However, for New World Apceros, their shell is a magnificent form of defense against predators. Three individuals will arrange themselves in a circle, using their shells like shields. Incidentally, a certain Commission member was saved from certain death at the claws of a large monster by entering a ring of defensive Apceros during an investigation.

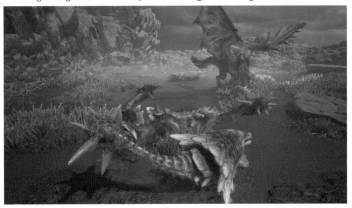

■ Apceros joined in a defensive huddle.

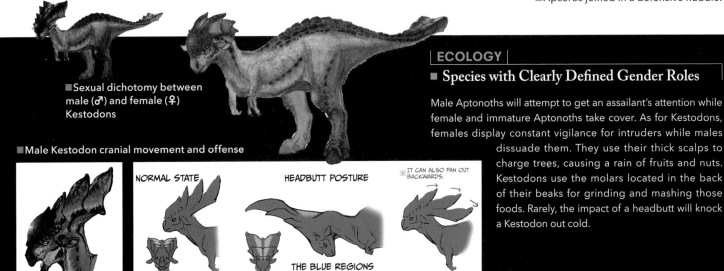

■ Sexual dichotomy between male (♂) and female (♀) Kestodons

■ Male Kestodon cranial movement and offense

NORMAL STATE

HEADBUTT POSTURE

※ IT CAN ALSO FAN OUT BACKWARDS.

THE BLUE REGIONS BECOMES VISIBLE.

ECOLOGY

■ Species with Clearly Defined Gender Roles

Male Aptonoths will attempt to get an assailant's attention while female and immature Aptonoths take cover. As for Kestodons, females display constant vigilance for intruders while males dissuade them. They use their thick scalps to charge trees, causing a rain of fruits and nuts. Kestodons use the molars located in the back of their beaks for grinding and mashing those foods. Rarely, the impact of a headbutt will knock a Kestodon out cold.

ECOLOGY

■ How a Gastodon Communicates Through Anger

Gastodons display fierce territorial behavior. Gastodon herds plant themselves in one location, remaining as a single unit. Should an invader disturb them, Gastodons will act in unison to drive away the threat. In a particularly drawn-out struggle, a Gastodon seeing red may lose itself and chase a target beyond its own territory. Despite the beasts' tenacity, if a herd is thinned by an assailant, the remaining members may flee.

■ This flush-red coloration is the sign of an angered Gastodon.

■ Gastodons may be angered by the sight of flame.

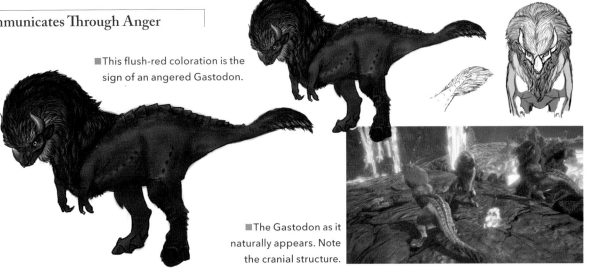

■ The Gastodon as it naturally appears. Note the cranial structure.

ECOLOGY

A Humane Method of Horn Gathering

Kelbi furs are a safe trade item, but their popularity pales in comparison to the demand for Kelbi horns. As the base ingredient in a myriad of curatives, Kelbi horns are extremely popular. In the wild, the appearance of large monsters will send Kelbi sprinting for safety, but Commission members do not seem to spook the beasts. On the other hand, Vespoid and Hornetaur carapaces are fragile and cannot withstand strong blows; if damaged, they lose their market value. To avoid this we suggest afflicting them with poison using the comparatively delicate slinger as an effective means of gathering their carapaces fully intact.

A Kelbi individual without its horns.

An intact insect carapace ready for harvesting.

ECOLOGY

How Mosswine Reveal Rare Mushrooms Through Their Eating Habits

Where there are Mosswine, there are mushrooms. Sniffing and snorting as they root about here and there in search of their favorite fungi, a Mosswine's actions reveal the location of mushrooms that are otherwise difficult to find. They do not form herds, and they lead solitary lives, establishing their territory based on mushroom preference. Reports suggest that spooking Mosswine will cause them to flee to a secret refuge, and sometimes this hideaway may be home to a mother lode of mushrooms. Even the Mosswine can't help but display elation upon discovering these rare fungi.

This Mosswine looks happy when discovering mushrooms.

ECOLOGY

Insects' Swarming Vigilance

Insects are somewhat similar to smaller monsters in how they establish territories in groups or swarms. While they will attack intruders, generally speaking insects shouldn't pose much of a threat. However, insects can be fiercely territorial in response to large monsters. Upon spotting a monster, insects will swarm and wait. When the monster draws near, the swarm will assault the intruder in a flurry, attempting to drive it away. This behavior suggests that insects do not fear the presence of Commission members as much as they do monsters.

ECOLOGY

Understanding Their Attraction to Flame and Light

Phototaxis is the movement of an organism either towards or away from light—a shared trait in insects, as they are all drawn toward light sources. Taking advantage of this and compelling Hornetaurs or Vespoids to one convenient location for elimination is a technique from the Old World. In the New World, ammo such as Torch Pods or Brightmoss are especially useful. Detonating Brightmoss in close proximity to an insect will shock it, sending the victim rolling over onto its ventral side, rendering it defenseless.

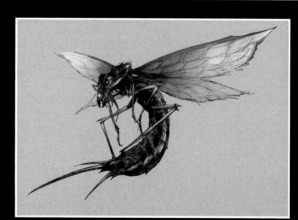

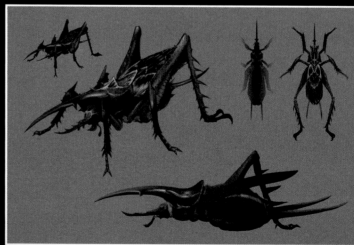

Vespoids (above) and Hornetaurs (below) are known for keeping vigilance in swarms.

Gathering near a light source is classic insect behavior.

Herbivore
Kelbi

▶ Known Habitats: Wildspire Waste, Coral Highlands

Small, docile beasts that display sexual dimorphism in coloration and in the shape of their ears and horns, which contain medicinal properties. New World Kelbi are more robust than Old World individuals.

KELBI

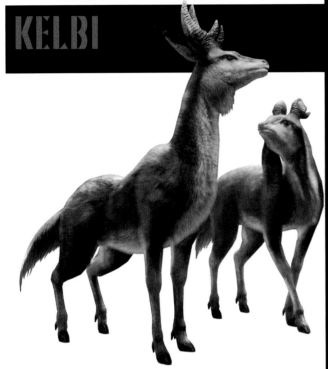

MOSSWINE

Herbivore
Mosswine

▶ Known Habitats: Ancient Forest, Wildspire Waste, Rotten Vale

Small herbivorous beasts with a superb sense of smell, Mosswine like to wander about in search of their favorite food, mushrooms. Known for their gentle demeanor, these charming beasts are easily identifiable by their elongated snouts and hard domed skulls. Patches of moss from their local habitat grow freely on their backs.

Neopteron
Vespoid

▶ Known Habitats: Ancient Forest, Wildspire Waste, Coral Highlands, Rotten Vale, Elder's Recess

Vespoids are insects with powerful jaws for biting and an abdominally located stinger containing paralytic venom. They are best known for their range of flight and adaptability.

VESPOID

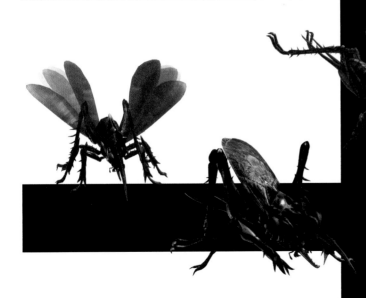

Neopteron
Hornetaur

▶ Known Habitat: Rotten Vale

Ground-dwelling and warlike insects, Hornetaurs do not take kindly to invaders and will charge them with their sharp horns. In the Rotten Vale, Hornetaurs thrive on the abundant supply of carrion.

HORNETAUR

Fanged Wyvern
Jagras

▶Known Habitat: Ancient Forest

Small Fanged Wyverns with a nearly insatiable appetite, lean muscular bodies, coloration well suited to forest camouflage, and large spikes growing along their spine.

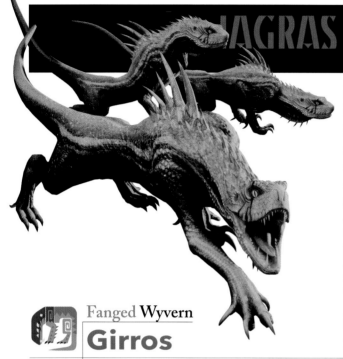

Fanged Wyvern
Girros

▶Known Habitats: Rotten Vale, Coral Highlands

Girros are small but stocky Fanged Wyverns with fangs that contain a paralytic venom. Girros follow the orders of a Great Girros and move in packs as they waddle about the Vale in search of carrion. Individuals afflicted with effluvium should be considered more dangerous than usual.

Fish
Gajau

▶Known Habitats: Ancient Forest, Wildspire Waste

Approaching a Gajau's relentless snapping maw, even from the safety of land, might not be in one's best interest, as they can leap out of the water.

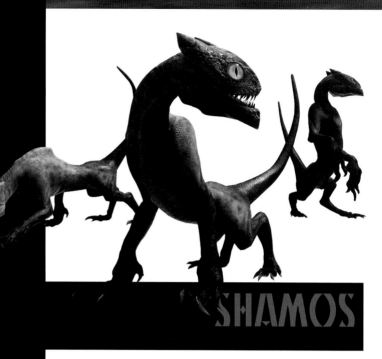

Fanged Wyvern
Shamos

▶Known Habitat: Coral Highlands

Shamos are small Fanged Wyverns. Thriving on carrion, Shamos are extremely fierce and will not retreat from a conflict even if a number of their pack members are killed. Their most striking features are their large eyes and the dark coloration of their lithe bodies, which allows them to slink unnoticed through the night.

off

ECOLOGY

■Closing in Aggressively On Enemies as a Pack

More often than we'd like to admit, Commission members who've failed to show proper respect for the danger posed by these smaller monsters have met with unfortunate circumstances. The Fanged Wyverns have an instinctual drive to win by sheer numbers, and thinning their numbers will cause the pack to retreat. In the case of Jagras, a well-aimed Scatternut can spook the entire pack. Starting a fire and dropping some raw meat can create a distraction in a pinch.

■Jagras (above) and Girros (below)

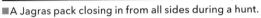
■A Jagras pack closing in from all sides during a hunt.

■Gajau display similar behavior and surround their target.

ECOLOGY

■How Small Monsters Display Vigilance and Aggressiveness Toward Large Monsters

While smaller Fanged Wyverns aren't the bravest of monsters, Jagras behavior in particular is the very definition of cowardice. If or when an intruding monster is somehow incapacitated—be it caught in a trap or simply collapsed due to exhaustion—the pack will seize this opportunity and climb down to attack in force. Even in the presence of their Great Jagras alpha, the smaller Jagras will instinctively follow this, shall we say, "prudent" behavior.

■Jagras observing the proceedings of a hunt from the treetops.

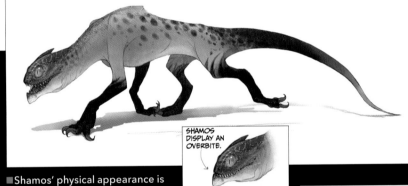
■Shamos' physical appearance is unique even among fanged wyverns.

SHAMOS DISPLAY AN OVERBITE.

■Pupils contracting in the presence of strong light.

ECOLOGY

■Weak Against Light, Shamos Prefer the Dark

Shamos are Fanged Wyverns that rest in the shade during the day and stalk the Coral Highlands after sunset. Their nocturnal nature is clearly apparent after an examination of their eyes. Note their large pupils, which are ideal for picking up small traces of light but leave them at a severe disadvantage against strong sources of light. The slinger's Torch and Flash Pods are very useful, but Brightmoss seems to elicit a particularly strong reaction from these wyverns. Shamos have an antagonistic relationship with the light-producing Tzitzi-Ya-Ku and frequently fight it.

■Even in the dark, Shamos are easy to identify by their vibrant-red facial coloration.

ECOLOGY

■Fanged Wyverns' Tendency to Act at the Behest of an Alpha

Jagras and Girros display different behavior in how they interact with their alpha. Jagras will only involve themselves in a fight if a Great Jagras becomes enraged or shows signs of being in serious danger. On the other hand, Girros will take an active part in attacking intruders alongside their Great Girros alpha from the start. However, in the absence of an alpha, both Jagras and Girros will surround it from a distance and attack as one.

■A Great Girros prowls the Vale with its Girros minions.

ECOLOGY
■ On Flying with Mernos

Mernos are timid and spend most of their time pruning and feeding on nuts and berries. The sight of a large monster will send them flying, but even a well-placed warning shot from the slinger is enough to scare off a Mernos. Mernos carry out their daily lives in pairs or small groups of three, but occasionally flock in large groups as needed. They can learn to adjust to the presence of humans, a trait that the Commission has utilized to their great advantage. Grappling an in-flight Mernos's foot with the slinger has become an essential method of aerial transportation for New World Commission members. Mernos travel exceptionally long distances, even for Wingdrakes, and their overall flying capabilities are noteworthy.

■Mernos flying in formation.

ECOLOGY
■ Noios Flock to Carrion, Letting Out a Piercing Cry

The Noios of the Wildspire Waste are relatively gentle Wingdrakes, but they do show a preference for meat, especially carrion. Upon spotting a corpse from the air, Noios will circle down to the source and begin feasting. In defiance of their otherwise calm nature, Noios have a tendency to wildly overreact to unexpected disturbances. If surprised while airborne, Noios will lose control of their bodies and plummet to the earth, shrieking all the way. This shrieking is how they alert their flock of approaching danger. Their characteristic features include birdlike beaks and dewlaps.

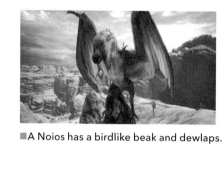
■A Noios has a birdlike beak and dewlaps.

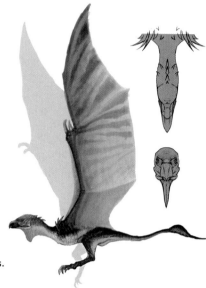

ECOLOGY
■ Ecological Behavior of Giant Raphinos Flocks

The Raphinos of the Coral Highlands display intriguing behavior by uniting several smaller units to form a single giant Raphinos flock. This may be witnessed as the land coral prepare to lay their eggs. When the egg-laying begins, this sizable flock will gather under a certain giant pink coral. The sight of dozens of Raphinos feasting on land-coral eggs is a breathtaking and memorable experience. Upon sensing danger, a Raphinos will fly about making a ruckus to warn its nearby flock. After fleeing an enemy, Raphinos flocks may merge with other flocks once they reach safety.

■The streamlined profile of a Raphinos, ideal for catching the wind.

ECOLOGY
■ On the Aggressive Nature of Barnos and Their Acidic Spray

The ill-tempered Barnos is known for doggedly pursuing intruders and dissuading invaders with a corrosive acidic expulsion. A vicious and wild Wingdrake, it spews this fluid at invaders of all sizes. The scent of this fluid drives entire Barnos flocks to attack the source of the smell. Catching a ride on Barnos with the Slinger is possible if the Commission member takes them by surprise or if they're severely weakened. In the latter case, the Barnos will always return to its flock's territory.

■Note the hook-like shape of Barnos's claws.

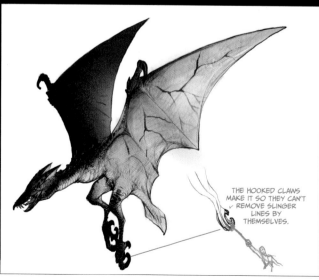

THE HOOKED CLAWS MAKE IT SO THEY CAN'T REMOVE SLINGER LINES BY THEMSELVES.

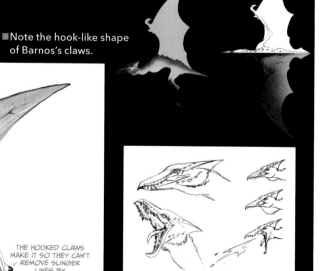
■How a Barnos expels acid.

Wingdrake
Mernos

▶ Known Habitats: Ancient Forest, Wildspire Waste

Wingdrakes known for their love of arboreal fruits and nuts, particularly Scatternuts. Mernos can be grappled by their feet as a natural and convenient means of transportation.

MERNOS

Wingdrake
Noios

▶ Known Habitat: Wildspire Waste

Noios have a characteristic shriek comparable to the noise produced by Screamer Pods. They prefer carrion but will flock to seek fresh prey. One might be able to grapple them, but Noios will not leave their own territory.

NOIOS

Wingdrake
Raphinos

▶ Known Habitats: Coral Highlands, Rotten Vale

Raphinos are flocking Wingdrakes of the Coral Highlands that feed on the eggs of land coral. Their supple and flavorful meat makes them popular targets of predation. Violent individuals afflicted with effluvium have also been spotted.

RAPHINOS

Wingdrake
Barnos

▶ Known Habitat: Elder's Recess

Barnos are fierce Wingdrakes that are highly protective of their territory. Barnos will assault almost any approaching life-form with aerial raids in flocks. They spew an acidic spray to weaken their target.

BARNOS

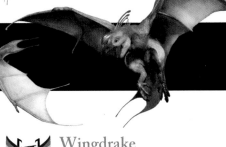

Extended **World Gallery**
Unidentified Creatures Log [VII]

This is just a small sampling of material that has not yet been properly sorted and edited. These sketches and ecological conjectures are based on incomplete data, and we request your understanding that this information may become obsolete. That said, if we are able to catch a glimpse of any of these creatures in the wild, we would eagerly seize the opportunity to study their ecology.

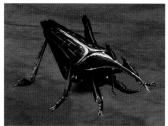
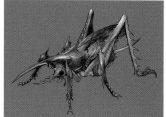

■ Insects

■ Fanged Wyverns ①

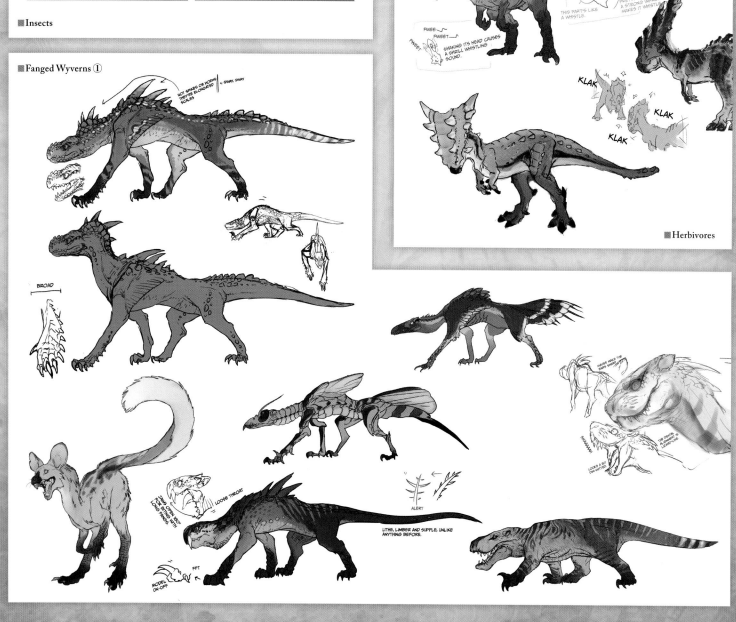

■ Herbivores

CREATURES LOG

■ Fanged Wyverns ②

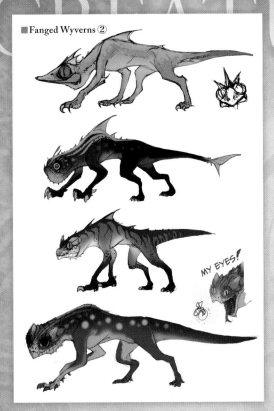

MY EYES!

■ Wingdrakes ①

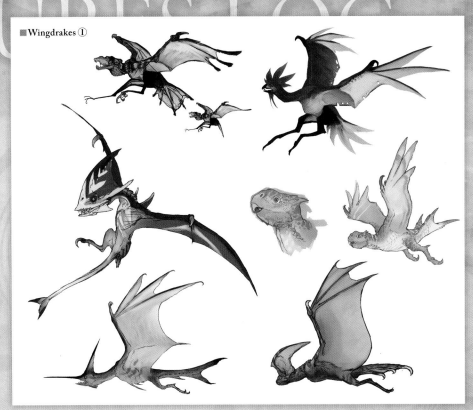

❖ Similar to Herbivores

Each report on Kestodon ecology seems to mention their unique cranial structure. There are a variety of descriptions, such as these individuals with mortar-like shapes well suited to scooping up fruits, nuts, or rocks. Others have flutelike structures for producing sound and some even have drumlike scalps that make noise when struck with force.

❖ Similar to Fanged Wyverns

Fanged Wyvern #1: Here are some sketches related to the Jagras. One is beast-like with a full coat of fur. Another resembles an insect with a full exoskeleton.

Fanged Wyvern #2: Most of the individuals described in Shamos-related material seem well suited to amphibious lifestyles.

❖ Similar to Wingdrakes

Wingdrakes #1: Various sketches of Mernos research. The bony wings spread while hovering and fold while gliding. The triangular beak is used for directing their flock and also serves as a weight and rudder.

Wingdrakes #2: These sketches tucked in with Raphinos data all follow an aquatic theme.

Wingdrakes #3: Along with some thoughts on their method of expelling acid, we found these sketches of atypical wingdrakes alongside Barnos research.

■ Wingdrakes ②

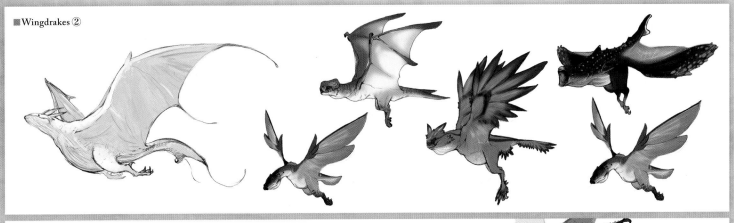

■ Wingdrakes ③

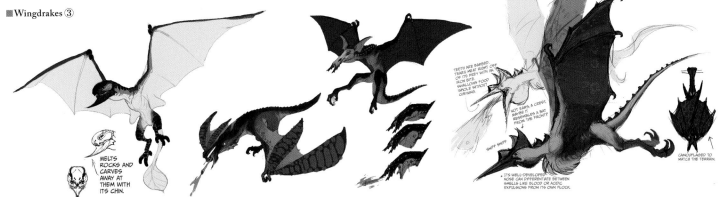

MELTS ROCKS AND CARVES AWAY AT THEM WITH ITS CHIN.

TEETH ARE BARBED. TEARS MEAT RIGHT OFF OF ITS PREY WITH AN IRON BITE. SWALLOWS FOOD WHOLE WITHOUT CHEWING.

NOT EARS. A CREST. MAYBE IT RESEMBLES A BAT FROM THE FRONT?

SNIFF SNIFF

ITS WELL-DEVELOPED NOSE CAN DIFFERENTIATE BETWEEN SMELLS LIKE BLOOD OR ACIDIC EXPULSIONS FROM ITS OWN FLOCK.

CAMOUFLAGED TO MATCH THE TERRAIN.

The Endemic Life of the New World

Of the many unique creatures found in the bountiful New World, one category is a myriad of life-forms we refer to as "endemic life." Here, we have compiled records on the over sixty forms of endemic life discovered thus far throughout Astera, including sketches by our handlers.

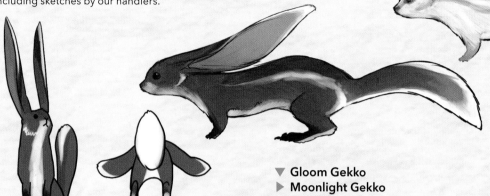

◀ **Shepherd Hare**
▲ **Pilot Hare**

Shepherd and Pilot Hares are easily distinguished by their coats. The Shepherd Hare's white-streaked taupe coat is unlikely to be confused for the red-eyed Pilot Hare's white coat streaked with twinges of pink. Using their long hind legs, they move about by hopping from place to place. If surprised, they will stand upright and search for the origin of the disturbance with their large ears, striking a pose that is decidedly adorable.

▼ **Gloom Gekko**
▶ **Moonlight Gekko**

The Gloom Gekko's striking coloration suggests that the creature wields poison as a defense mechanism. Meanwhile, the Moonlight Gekko is able to alter its coloration through luminescence. Their ability to cling to walls is made possible by the fine hairs growing from their digits.

Terrestrial Life

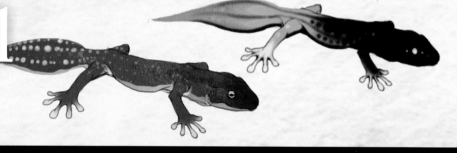

Shepherd Hare

A small animal with large ears for pinpointing the origin of delicate sounds. They tend to flee through narrow passages. Known habitats: Ancient Forest, Wildspire Waste

Forest Gekko

A tree-dwelling lizard. Feeding on insects attracted to light, the Forest Gekko may often be found in the vicinity of Brightmoss. Known habitat: Ancient Forest

Wildspire Gekko

A lizard that feeds mainly on Carrier Ants. They are known to gather in great numbers around the massive Wildspire. Known habitat: Wildspire Waste

Pilot Hare (Rare)

A rare species with a strong resemblance to Shepherd Hares. Perhaps their fondness of sunbeams is why they're only seen on sunny days. Known habitats: Ancient Forest, Wildspire Waste

Gloom Gekko

A lizard that prefers living in murky caves and similar locations. The Gloom Gekko's coloration helps it avoid predation. Known habitats: Rotten Vale, Elder's Recess

Moonlight Gekko (Rare)

A rare lizard whose tail glows due to substances contained within Brightmoss. This gekko's tail attracts prey directly to its vicinity. Known habitats: Rotten Vale, Elder's Recess

◄ Blissbill
▼ Revolture

The Revolture is a helpful sign of large monsters. These scavenger birds will swoop in to pick at a fresh kill even if the monster is still in the vicinity. Blissbills, on the other hand, are herbivores.

▲ Vaporonid ► Scavantula

At first glance, both of these spiders might seem dangerous, but Vaporonids will flee when their webs are disturbed, and Scavantulas simply gather near carrion or bones. Neither species is considered harmful.

◄ Dung Beetle
► Bomb Beetle

Finding a Dung Beetle means there's monster dung nearby. Their dung balls can be utilized as Dung Pods for the slinger. A slightly less pungent option would be the volatile rocks rolled by Bomb Beetles. These explosive rocks can be formed into Bomb Pods for the slinger.

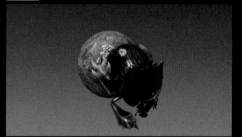

Vaporonid

Small eight-legged arthropods. These spiders are known for spinning sticky webs and tricky traps with their silk. Known habitats: Ancient Forest, Wildspire Waste

Revolture

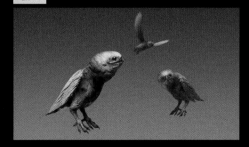

Small scavenger birds. Ever in search of leftovers, Revoltures are often spotted circling above large monsters. Known habitats: most regions of the New World excluding the Coral Highlands

Dung Beetle

Small arthropods known for rolling monster dung into almost perfect balls by walking backwards while performing a handstand-like pose. Known habitat: Wildspire Waste

Scavantula

Small carnivorous arthropods. Known for making clusters around carrion and bones, these spiders will scatter at the first sign of an intruder. Known habitat: Rotten Vale

Blissbill

Meek birds who have been known to acclimate to humans. They feed mostly on fruits and seeds. Known habitats: Ancient Forest, Wildspire Waste

Bomb Beetle

A small arthropod that makes for an unusual sight as it rolls explosive rocks. Bomb Beetles will abandon their load to flee danger. Known habitat: Elder's Recess

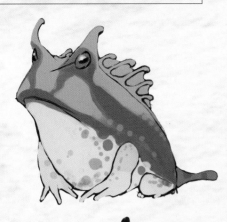

▼ Wiggler
▶ Wiggler Queen

Wigglers are known for slipping underground at the first sign of an intruder. Using their tiny webbed feet, Wigglers push their heads up as far as they can in order to feed on land-coral eggs carried by the wind.

◀ Sleeptoad
▼ Nitrotoad

When attacked, Gas Toads release a specific kind of gas as a defense mechanism. The explosion caused by a Nitrotoad is volatile enough to melt a Lavasioth's hardened lava armor.

Terrestrial Life

TOPIC In Search of Endemic Life ①

Most forms of endemic life will flee for safety upon sensing an intruder. Although crouching is one effective way to approach smaller creatures, the only surefire way to make a stealthy approach is by using the Ghillie Mantle.

Paratoad

A small toad that stores and releases a paralytic agent. It often remains immobile, and when it does move it's quite sluggish. Known habitats: most regions of the New World

Nitrotoad

Nitrotoads store an explosive substance within their bodies. If ignited, the resulting explosion can shock even large monsters. Known habitat: Elder's Recess

Wiggler Queen (Rare)

A rare Wiggler that only comes out on the night of a full moon. Some call her "Moonlight Queen." Known habitat: Coral Highlands

Sleeptoad

A toad with a specialized organ for developing sleeping gas. It hardly ever moves. Known habitat: Coral Highlands

Wiggler

A small creature with a long and thin body. Wigglers can be found in groups, their elongated bodies swaying together in the wind. Known habitat: Coral Highlands

Carrier Ant

These small arthropods form long lines as they transport bits and pieces of monster remains for consumption. Known habitats: Ancient Forest, Wildspire Waste, Rotten Vale

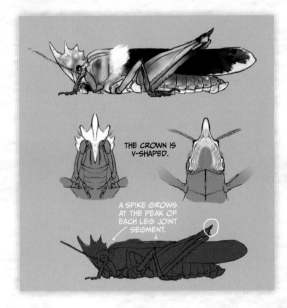

THE CROWN IS V-SHAPED.

A SPIKE GROWS AT THE PEAK OF EACH LEG JOINT SEGMENT.

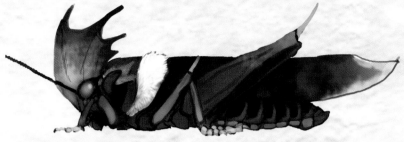

◀ **Emperor Hopper** ▲ **Tyrant Hopper**

The Emperor Hopper's noble name comes from not only its crown-like crest but also the coloration of its wings, which—topped off by white hairs—can almost be mistaken for a timeworn royal robe. The similar but decidedly more sinister shading and shape of the Tyrant Hopper is the origin of its name as well.

◀ **Iron Helmcrab** ▲ **Soldier Helmcrab**
▼ **Emerald Helmcrab**

A Helmcrab's shell hides the creature's many legs, which it uses for motility and grasping. Iron Helmcrabs can usually be found holding Piercing Pods while Soldier Helmcrabs often carry Slinger Thorns around with them. The coloration of their eyes will change when they stand at attention and monitor their surroundings.

CHANGES IN EYE COLORATION

VIGILANT STATE

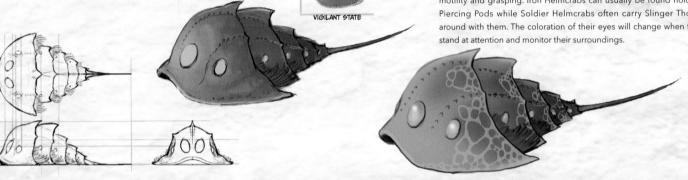

 # Emperor Hopper

Large grasshoppers that inhabit flatlands and grassy regions. If approached, they will hop away. Known habitats: Ancient Forest, Wildspire Waste

 # Tyrant Hopper

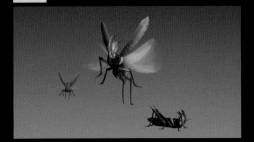

A relative of the Emperor Hopper. Its tendency towards violent behavior might be a side effect of effluvium. Watch out—they bite. Known habitat: Rotten Vale

 # Iron Helmcrab

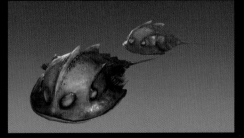

An arthropod with a spikelike tail whose entire body is covered in a broad shell. It has a tendency to carry around hard objects. Known habitat: Wildspire Waste

 # Soldier Helmcrab

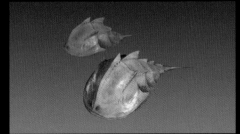

These small arthropods live in clusters and hold on to Slinger Thorns. It's unknown why they carry the thorns. Known habitat: Rotten Vale

 # Emerald Helmcrab (Rare)

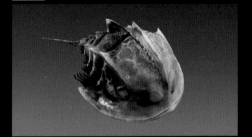

A rare form of helmcrab with an intricately colored shell. Often appears during inclement weather. Known habitats: Wildspire Waste, Rotten Vale

 # Gold Helmcrab
Shiny Gold Helmcrab (Rare)

Rare golden helmcrabs and their subspecies that inhabit the Caverns of El Dorado have taken on a golden appearance due to their eating habits. They also have a tendency to gather Dragon Pods.

Aquatic Life

▼ **Andangler**

Yet another example of a fish with limb-like fins. Its physique is similar to that of a toad. The luminous regions seem to blink in response to the presence of large monsters.

▲ **Climbing Joyperch**

The Climbing Joyperch's limb-like fins and anterior luminescent regions are its standout features. The largest luminous region only opens wide when the joyperch makes its call.

TOPIC

In Search of Endemic Life ②

There are a variety of endemic life-forms that may be kept within one's living quarters after capture. One might hear the call of the Climbing Joyperch or witness a Vigorwasp preparing its nectar sac. Such sights are sure to soothe one's spirit while instilling a burning passion for further research. By upgrading their living quarters, one may gain access to aquariums or even ponds in order to accommodate an even wider variety of endemic life.

Here we observe a Nitrotoad inflating its throat in order to release an incredibly explosive substance.

One may witness the production of a fragile nectar sac from the comfort of one's living quarters' garden.

 ## Copper Calappa

Copper Calappas gather around traces of gold. Should they discover golden nuggets hidden in their food, they will carry the priceless bits back to their homes. Known habitat: Caverns of El Dorado

 ## Tsuchinoko (Rare)

A creature so rare that some believe it only exists in myth. A Tsuchinoko squirms about using the fins located at the base of its tail. Known habitat: Caverns of El Dorado

 ## Pink Parexus

A fish that has retained the classic features of ancient piscine species. The spikes along its back help it avoid predators. Known habitats: most regions of the New World

 ## Gold Calappa (Rare)

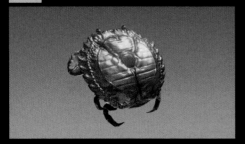

These are believed to be aged Copper Calappas. Their size allows them to carry large chunks of gold back to their homes. Known habitat: Caverns of El Dorado

 ## Climbing Joyperch

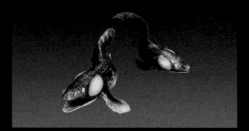

Suited to terrestrial and aquatic life, the Climbing Joyperch is believed to be one of the first amphibians. Known habitats: Ancient Forest, Wildspire Waste

 ## Burst Arowana

These fish display a preference for gathering in weedy shallows. Their scales contain a combustible chemical substance. Known habitats: most regions of the New World

▶ Petricanths

Although thought to be long extinct, the discovery of a Petricanths in the New World sent shock waves through the ecological research community. The luminous spots around its body lend an air of magic and mystery to the fish's appearance.

▼ Whetfish

The Whetfish's dorsal fins and scales—seen here arranged in a staggered pattern—are ideal for sharpening dull weapons, while its ventral scales make excellent files.

▼ Gastronome Tuna

Note the jutting lower jaw dotted with a smattering of teeth. Such anatomical form and function suggests that rather than being a fierce hunter, this tuna doesn't want to afford its meals a chance to escape its jaws.

Bomb Arowana

This fish's scales contain an explosive chemical component like a Burst Arowana. They are extremely sensitive to movement. Known habitats: most regions of the New World

Hopguppy

Fish that move in schools and jump through the surface. By spreading their large ventral fins, they can glide. Known habitats: Ancient Forest, Wildspire Waste, Coral Highlands

Whetfish

A small fish with a surprisingly hard dorsal fin. They seem to prefer the deepest regions of various bodies of water. Known habitats: most regions of the New World

Andangler

A fish that one could mistake for an amphibian due to its ability to remain on land. The light attracts Flying Medusos to eat. Known habitat: Coral Highlands

Petricanths (Rare)

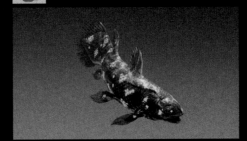

A legendary fish previously thought to be extinct. Some call it a living fossil. Known habitats: Rotten Vale, Elder's Recess

Gastronome Tuna

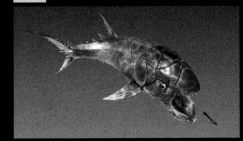

A very large fish known for devouring anything. Cutting open their stomachs sometimes reveals their prey almost entirely intact. Known habitats: most regions other than the Coral Highlands

[Aquatic Life] Photo Gallery

A Collection of the Biggest Catches from Around the New World

Great Pink Parexus

Great Whetfish

Great Burst Arowana

Great Bomb Arowana

Great Gastronome Tuna

❖ Different Reactions to Bait

Jiggling one's bait is an excellent way to attract a variety of fish to a lure. Speaking strictly of great size fish, Great Pink Parexus, Great Whetfish, Great Gastronome Tuna, Great King Marlins, Great Sushifish, and Great Gunpowderfish are all attracted to "energetic" bait.

❖ Great King Marlin

❖ Great Goldenfish

❖ Great Platinumfish

❖ **Baitbugs Are a Feast Fit for Fish!**

Avid fans of fishing refer to the common Baitbug as "feastbugs" due to their broad appeal to the palates of our piscine friends, even the great size variety!

❖ Great Goldenfry

❖ Great Sushifish

❖ Great Gunpowderfish

Hauling in a huge, "great size" fish is the dream of every angler. Great size forms of many fish species inhabit the waters of our world, and managing to catch even one is considered a status symbol in the fishing community. Here, we've assembled the fishing records of a well-seasoned Commission member who traveled the New World in pursuit of his dream to reel in every last whopper. Have you ever experienced a yearning when you spot a shadow skimming just below the surface? The endless potential of the cast of your line? The heart-pounding anticipation as you wait for the bite? It's in that instant, the very second your line pulls taut as the bait is snatched, that the true battle begins. That moment is what this man and anglers the world over live for.

We offer our thanks to all fish, nay, every form of life, this day and every day henceforth, for as long as this living legend continues to cast his line.

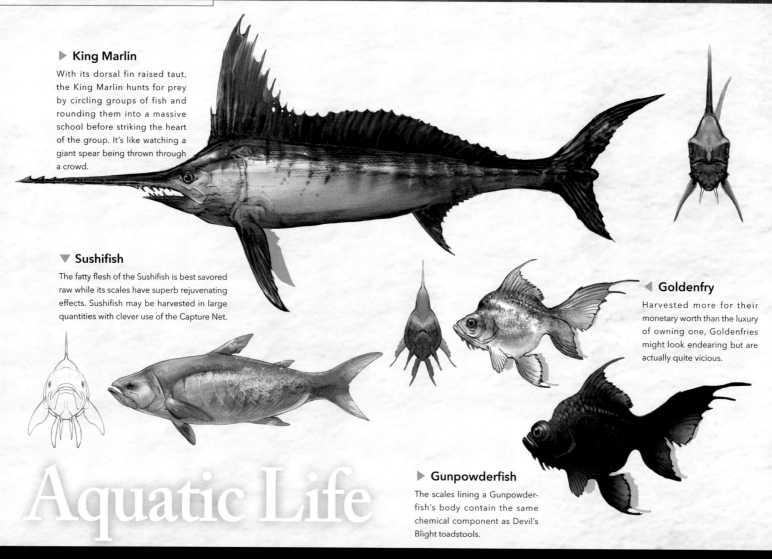

▶ King Marlin

With its dorsal fin raised taut, the King Marlin hunts for prey by circling groups of fish and rounding them into a massive school before striking the heart of the group. It's like watching a giant spear being thrown through a crowd.

▼ Sushifish

The fatty flesh of the Sushifish is best savored raw while its scales have superb rejuvenating effects. Sushifish may be harvested in large quantities with clever use of the Capture Net.

◀ Goldenfry

Harvested more for their monetary worth than the luxury of owning one, Goldenfries might look endearing but are actually quite vicious.

▶ Gunpowderfish

The scales lining a Gunpowderfish's body contain the same chemical component as Devil's Blight toadstools.

Aquatic Life

King Marlin (Rare)

A fish with a swordlike upper jaw. It spends nights in warm open waters and comes in bayside by day to prey on small schools of fish. Known habitat: Ancient Forest

Platinumfish

An uncommon fish whose scales shine as if they were forged from pure platinum. Much like Goldenfish, these fish are extremely cautious of predators. Known habitat: Elder's Recess

Sushifish

A fish not only popular for its use in delicacies but also for its nutrient-rich and restorative scales. Known habitat: most regions of the New World

Goldenfish

As its name would suggest, the rarely glimpsed cavern-dwelling Goldenfish is coated in dazzling golden scales. Known habitats: Coral Highlands, Rotten Vale, Elder's Recess

Goldenfry

They live in pools within caverns, their shimmering bodies contrasting with their surroundings. Their scales are worth as much as golden coins. Known habitat: most regions of the New World

Gunpowderfish

Take one whiff and you'll know how it got its name. The chemical substance within its scales is used for explosives. Known habitats: Coral Highlands, Rotten Vale, Elder's Recess

Airborne Life

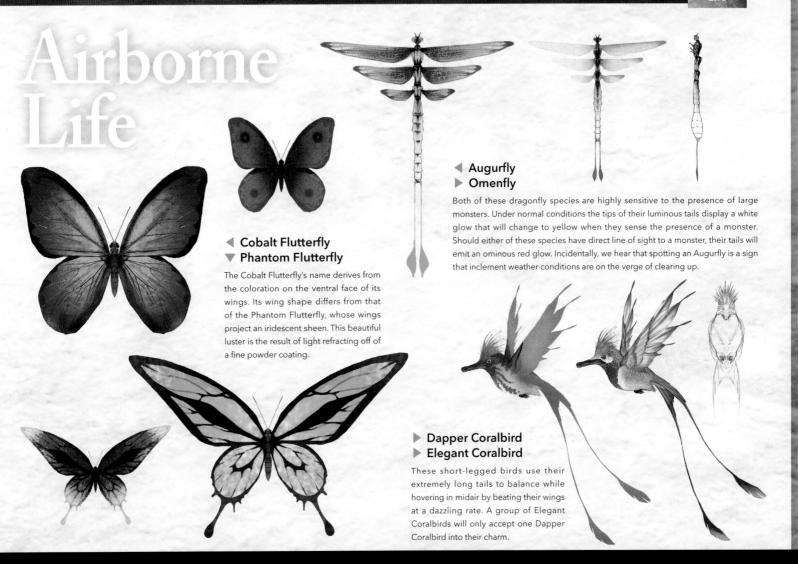

◀ **Cobalt Flutterfly**
▼ **Phantom Flutterfly**

The Cobalt Flutterfly's name derives from the coloration on the ventral face of its wings. Its wing shape differs from that of the Phantom Flutterfly, whose wings project an iridescent sheen. This beautiful luster is the result of light refracting off of a fine powder coating.

◀ **Augurfly**
▶ **Omenfly**

Both of these dragonfly species are highly sensitive to the presence of large monsters. Under normal conditions the tips of their luminous tails display a white glow that will change to yellow when they sense the presence of a monster. Should either of these species have direct line of sight to a monster, their tails will emit an ominous red glow. Incidentally, we hear that spotting an Augurfly is a sign that inclement weather conditions are on the verge of clearing up.

▶ **Dapper Coralbird**
▶ **Elegant Coralbird**

These short-legged birds use their extremely long tails to balance while hovering in midair by beating their wings at a dazzling rate. A group of Elegant Coralbirds will only accept one Dapper Coralbird into their charm.

Cobalt Flutterfly

An elegant cobalt-winged flutterfly whose wings are often mistaken for flowers. Known habitat: Ancient Forest

Omenfly

An insect whose terminal abdomen produces a luminous glow. This soft white glow becomes a foreboding red when monsters are near. Known habitat: most regions of the New World

Elegant Coralbird

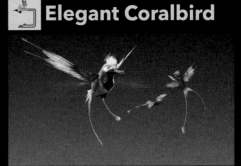

A female coralbird with stunning pink coloration made possible by its diet of land coral. Known habitat: Coral Highlands

Phantom Flutterfly (Rare)

A fairy-tale-like flutterfly with dazzling rainbow-colored wings. Although rare, they appear most active on sunny days. Known habitat: Ancient Forest

Augurfly (Rare)

A rare insect believed to appear during rainy weather. Known habitat: most regions of the New World

Dapper Coralbird (Rare)

The male coralbird. It's not known whether the males of the species exist in small numbers or are simply difficult to spot in the wild. Known habitat: Coral Highlands

Airborne Life

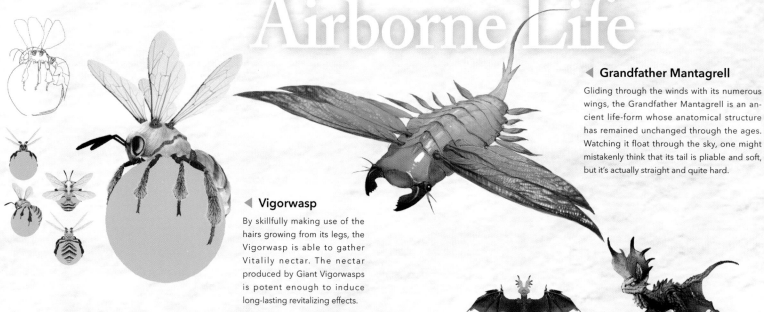

◀ Grandfather Mantagrell

Gliding through the winds with its numerous wings, the Grandfather Mantagrell is an ancient life-form whose anatomical structure has remained unchanged through the ages. Watching it float through the sky, one might mistakenly think that its tail is pliable and soft, but it's actually straight and quite hard.

◀ Vigorwasp

By skillfully making use of the hairs growing from its legs, the Vigorwasp is able to gather Vitalily nectar. The nectar produced by Giant Vigorwasps is potent enough to induce long-lasting revitalizing effects.

▶ Flying Meduso

Jellyfish-like life-forms that follow the winds to gather in blooms. Their limited mobility is made possible by adjusting their anteriorly located umbrella-like structure to catch the wind.

▲ Scalebat

Subtle signs of their Flying Wyvern ancestry remain in the Scalebat's appearance such as its sharp claw-thumb and the webbing that spreads down to its legs. Scalebat legs are useless for walking but do allow them to hang upside down.

Vigorwasp

An insect that stores Vitalily nectar. A light disturbance is enough to release its revitalizing bounty. Known habitats: Ancient Forest, Wildspire Waste, Coral Highlands

Flying Meduso

An organism that inhabits the Coral Highlands. They are usually found in windy regions and follow strong gusts from place to place. Known habitat: Coral Highlands

Grandfather Mantagrell

Grandfather Mantagrells float high in the skies of the Highlands. They're fragile, and the slightest physical disturbance can knock them from the air. Known habitat: Coral Highlands

Giant Vigorwasp

An insect that gathers an extremely potent form of Vitalily nectar. Being coated in this nectar leaves one with a long-lasting revitalizing effect. Known habitat: Ancient Forest

Flashfly

Insects with a glow that intensifies when they swarm and can temporarily blind large monsters. Known habitat: most regions of the New World

Scalebat

Flying Wyverns that have evolved to a miniscule size and resemble bats due to living in caverns. Known habitats: most regions of the New World excluding the Coral Highlands

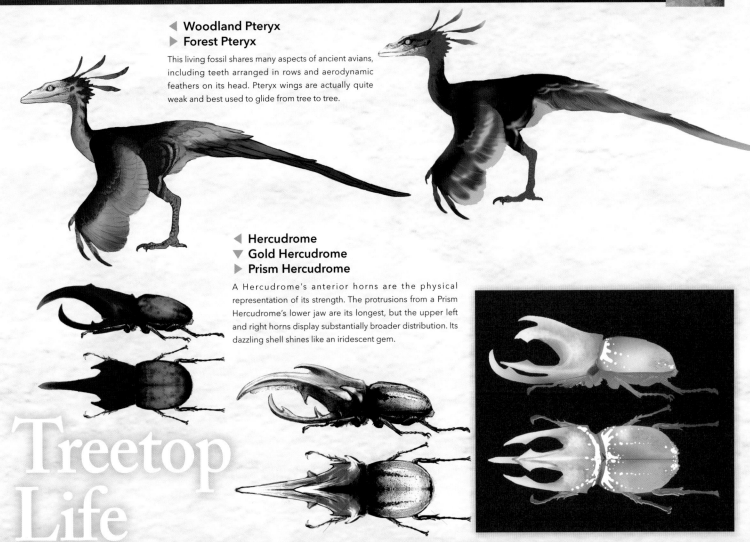

◄ Woodland Pteryx
► Forest Pteryx

This living fossil shares many aspects of ancient avians, including teeth arranged in rows and aerodynamic feathers on its head. Pteryx wings are actually quite weak and best used to glide from tree to tree.

◄ Hercudrome
▼ Gold Hercudrome
► Prism Hercudrome

A Hercudrome's anterior horns are the physical representation of its strength. The protrusions from a Prism Hercudrome's lower jaw are its longest, but the upper left and right horns display substantially broader distribution. Its dazzling shell shines like an iridescent gem.

Treetop Life

Gold Scalebat
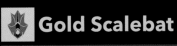

A relative of the Scalebat, this cavern-dwelling hunter developed a shiny coat as a result of inhabiting the gold-rich underground caverns. Known habitat: Caverns of El Dorado

Forest Pteryx (Rare)

Compared to the fossils of their ancient relatives, the anatomical structure of modern Forest Pteryx is basically identical. Known habitat: Ancient Forest

Gold Hercudrome (Rare)

A glistening golden beetle thought to bring good fortune. It only appears at night. Known habitats: Ancient Forest, Wildspire Waste

Woodland Pteryx

A creature that inhabits wooded areas. Its resemblance to the bone structure and plumage of its ancestors' fossils is uncanny. Known habitat: Ancient Forest

Hercudrome

A large beetle sporting magnificent anterior horns. Known habitat: Ancient Forest

Prism Hercudrome (Rare)

The ultimate rarity, this horned beetle with a sparkling rainbow shell only appears briefly at the break of dawn and again at sunset. Known habitat: most regions of the New World

◀ **Downy Crake**
▼ **Bristly Crake**

Downy and Bristly Crakes ride along the back of their symbiotic partners. Their long legs are normally bent backwards on themselves and concealed beneath their voluminous plumage. If startled by the presence of a potential predator, they will flee with utmost speed.

Unclassified

Downy Crake (Rare)

An exceptionally rare bird. The touch of their down is rumored to be sublime. Known habitats: Ancient Forest, Wildspire Waste, Coral Highlands

Bristly Crake (Rare)

Yet another exceptionally rare bird. In contrast to the fluffy variation of the species, the feel of a Bristly Crake's down is said to be rigid beyond description. Known habitats: Rotten Vale, Elder's Recess

TOPIC

In Search of Endemic Life ③

The rarest of the rare are the Downy and Bristly Crakes. These species have only been spotted riding the backs of certain small monsters. Their characteristic cheeps and chirps are a sign of their presence, but only the stealthiest of approaches is appropriate. At the slightest sense of an approaching presence, crakes will escape with lightning speed. Should one be lucky enough to come across them, it would be wise to use the Ghillie Mantle.

In addition to traveling on the backs of Aptonoths and Apceros, Downy Crakes have also been spotted hitching lofty rides on Grandfather Mantagrells.

Bristly Crakes form small flocks on the backs of Mosswine and Gastodons and eat small parasites, establishing a symbiotic relationship with their hosts.

Scatternut

The fallen fruit of Scatternut trees may be used as ammo. When a monster is positioned directly beneath a cluster of fruit, one may attempt to shake the Scatternut fruit from their branches and onto the unsuspecting monster to inflict some damage.

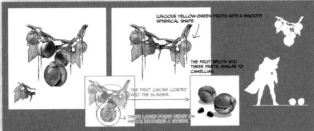

LUSCIOUS YELLOW-GREEN FRUITS WITH A SMOOTH SPHERICAL SHAPE.

THE FRUIT SPLITS INTO THREE PARTS, SIMILAR TO CAMELLIAS.

THE FRUIT CAN BE LOADED INTO THE SLINGER.

THE RED FRUIT GROWING ON THESE PLANTS CAN BE HARVESTED FOR USE WITH THE SLINGER. HARVESTING A PLANT WILL YIELD SEVERAL PIECES OF FRUIT.

▲ Redpit

▶ Wiggly Litchi

These edible insects might look like standard worms, but they have a fruity taste and promote stamina enhancement. A tasty and helpful snack for Commission members on the go.

AFTER BEING HARVESTED, BRIGHTMOSS PATCHES LOSE MOST OF THEIR GLOW.

▲ Brightmoss

Plants and Assorted Life

VITALILY FLOWERS PRODUCE A FORM OF NECTAR WITH RESTORATIVE PROPERTIES. ONE CAN SPOT VITALILIES WITH AN ABUNDANCE OF NECTAR BY HOW THEY DROOP. WHEN PHYSICALLY DISRUPTED, THE VITALILIES WILL RELEASE A SHOWER OF THE NECTAR AND RETURN TO THEIR ORIGINAL UPWARD-FACING FORM. VIGORWASPS OFTEN CARRY THIS NECTAR AROUND WITH THEM.

▲ Vitalily

SPORES ACCUMULATE ON THE HEAD OF THIS PLANT, FORMING A SPHERICAL FLUFF.

SPORE LAYER

▲ Sporepuff

🔺 Wedge Beetle

THE VERSATILE POISONCUP CAN BE FOUND GROWING ALONG THE GROUND OR CREEPING UP THE WALLS OF NATURAL BARRIERS. THEY STORE A NATURAL POISON THAT THEY RELEASE WHEN PHYSICALLY DISTURBED. WHEN EMPTIED, THEIR POISON SACKS SHRIVEL UP BEFORE EVENTUALLY REFILLING WITH LIQUID BANE.

▲ Poisoncup

The inside of a Wedge Beetle's thick segmented shell is luminous. Although they cannot be captured, they're extremely useful as grappling points.

NO IMAGE Scoutflies

TOPIC

On the Nature of the Scoutfly's Coloration

Since the Elder Crossing, Scoutfly populations have been booming. They respond to specific stimuli by swarming and altering their color. While they normally glow green, we have also noticed red and blue. The former is a warning of aggressive monsters, and the latter indicates Elder Dragon-level power.

Tiny insects with a pale green glow that swarm around specific scents and substances. They're extremely useful when tracking many things.

Extended World Gallery
Unidentified Creatures Log [VIII]

UNIDENTIFIED

There are scholars and then there are endemic life scholars. The hearts of these dedicated researchers burn with a passion to unlock the secrets of the world's endemic life. While their main goal is to better understand the endemic life in our world today, they also strive to predict what lies ahead for various forms of endemic life by combining their creativity and knowledge to devise conceptual depictions of where evolution will carry these creatures. The following sketches are based on the results of such studies and represent just a small sample of their extensive and curious work.

■ Sushifish Variant

■ Revolture Variants

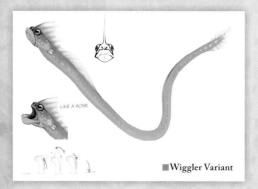

■ Wiggler Variant

LIKE A HOSE

■ Paratoad Variants

INFLATED STATE

NATURAL STATE

DORSAL VIEW

SIDE VIEW

■ Carrier Ant Variants

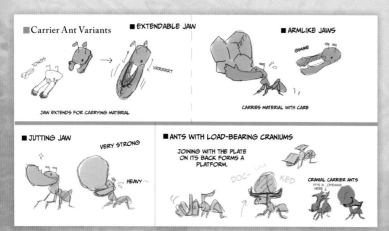

■ EXTENDABLE JAW

VRRRRRT

■ ARMLIKE JAWS

GIMME

JAW EXTENDS FOR CARRYING MATERIAL

CARRIES MATERIAL WITH CARE

■ JUTTING JAW

VERY STRONG

HEAVY~

■ ANTS WITH LOAD-BEARING CRANIUMS

JOINING WITH THE PLATE ON ITS BACK FORMS A PLATFORM.

DOC- KED

CRANIAL CARRIER ANTS FITS IN OPENING

❖ **Regarding Revoltures**

The modern Revolture is thought to have evolved from the Woodland Pteryx. The pteryx is known for displaying both reptilian and avian traits. Note the clawed digits located at the anterior bend in a Revolture's wings; surely these are remnants of its pteryx lineage. In the future, Revoltures may lose these ancient phenotypic traits and develop specialized wings similar to what we see here.

❖ **Regarding Carrier Ants**

Upon seeing the giant Wildspire, scholars were convinced that a species of ant with carrying capacities exceeding the common Carrier Ant must have been responsible. These sketches are a few of the concepts they considered for species that could have constructed the towering anthill. In reality, this monolithic anthill was determined to have been made possible by the Everstream activation, which was in turn one of the effects of the Elder Crossing. Even now the construction of the Wildspire still holds many mysteries that scholars are racing to unlock.

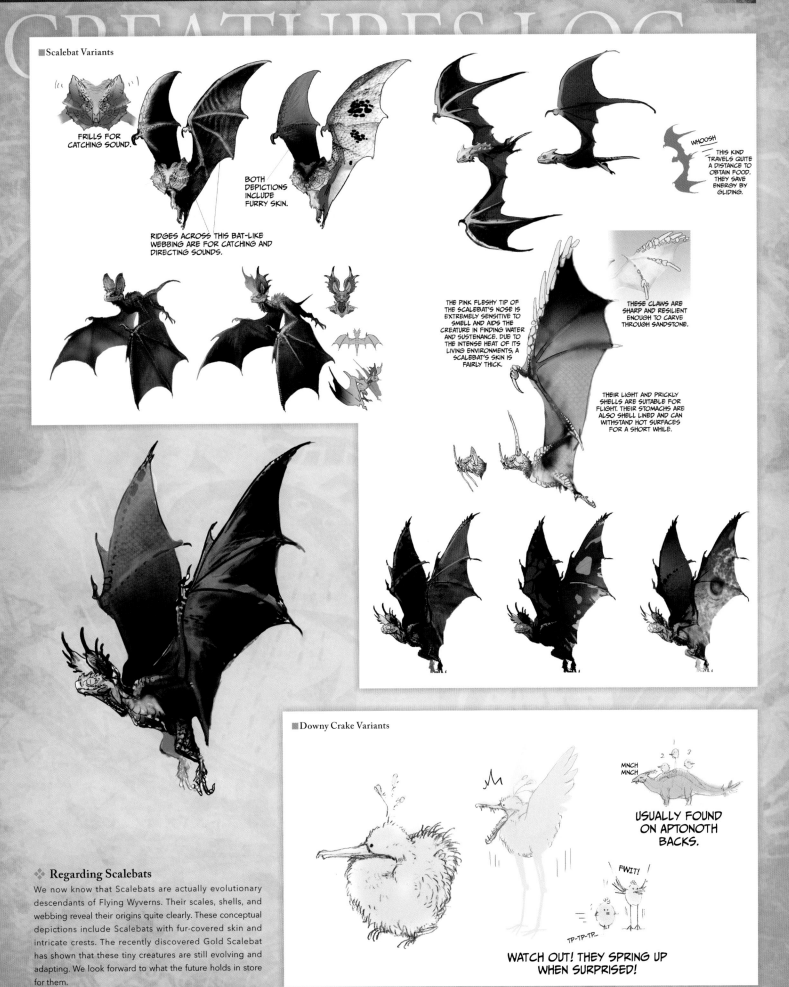

CREATURES LOG

■ Scalebat Variants

FRILLS FOR CATCHING SOUND.

BOTH DEPICTIONS INCLUDE FURRY SKIN.

RIDGES ACROSS THIS BAT-LIKE WEBBING ARE FOR CATCHING AND DIRECTING SOUNDS.

WHOOSH

THIS KIND TRAVELS QUITE A DISTANCE TO OBTAIN FOOD. THEY SAVE ENERGY BY GLIDING.

THE PINK FLESHY TIP OF THE SCALEBAT'S NOSE IS EXTREMELY SENSITIVE TO SMELL AND AIDS THE CREATURE IN FINDING WATER AND SUSTENANCE. DUE TO THE INTENSE HEAT OF ITS LIVING ENVIRONMENTS, A SCALEBAT'S SKIN IS FAIRLY THICK.

THESE CLAWS ARE SHARP AND RESILIENT ENOUGH TO CARVE THROUGH SANDSTONE.

THEIR LIGHT AND PRICKLY SHELLS ARE SUITABLE FOR FLIGHT. THEIR STOMACHS ARE ALSO SHELL LINED AND CAN WITHSTAND HOT SURFACES FOR A SHORT WHILE.

◆ Regarding Scalebats

We now know that Scalebats are actually evolutionary descendants of Flying Wyverns. Their scales, shells, and webbing reveal their origins quite clearly. These conceptual depictions include Scalebats with fur-covered skin and intricate crests. The recently discovered Gold Scalebat has shown that these tiny creatures are still evolving and adapting. We look forward to what the future holds in store for them.

■ Downy Crake Variants

MNCH MNCH

USUALLY FOUND ON APTONOTH BACKS.

FWIT!

TP-TP-TP...

WATCH OUT! THEY SPRING UP WHEN SURPRISED!

CHAPTER 4
Weapons & Armor

We have obtained the designs of what could be called the blueprints of the weapons and armor that are made in Astera and have compiled some of them in this chapter. We are including as much of the material as possible, but not all of it, as much of it was created in the early stages of the conception of the game, so differences from the equipment that was actually put into use in *Monster Hunter: World* will be evident. Please keep this in mind as you enjoy this chapter.

Sometimes it saves one's life,

sometimes it takes the life of one's quarry.

Innovation in crafting techniques and technology in recent years has been remarkable,

and many weapons and armor have been born from the hands of the artisans in the workshops.

Here in Astera, the unflagging research and refinement day after day produces those results.

However, full-scale investigations of the New World have only just begun.

As new breeds of monsters are discovered one after the next, even more research into the

application of the materials harvested from them is needed.

Great Jagras Equipment

Weapons and armor made from Great Jagras material. The material is easily collected and crafting it doesn't take much effort, so it's popular not just with hunters, but with artisans as well. Artisans who come to Astera start with the Great Jagras to get used to monster materials.

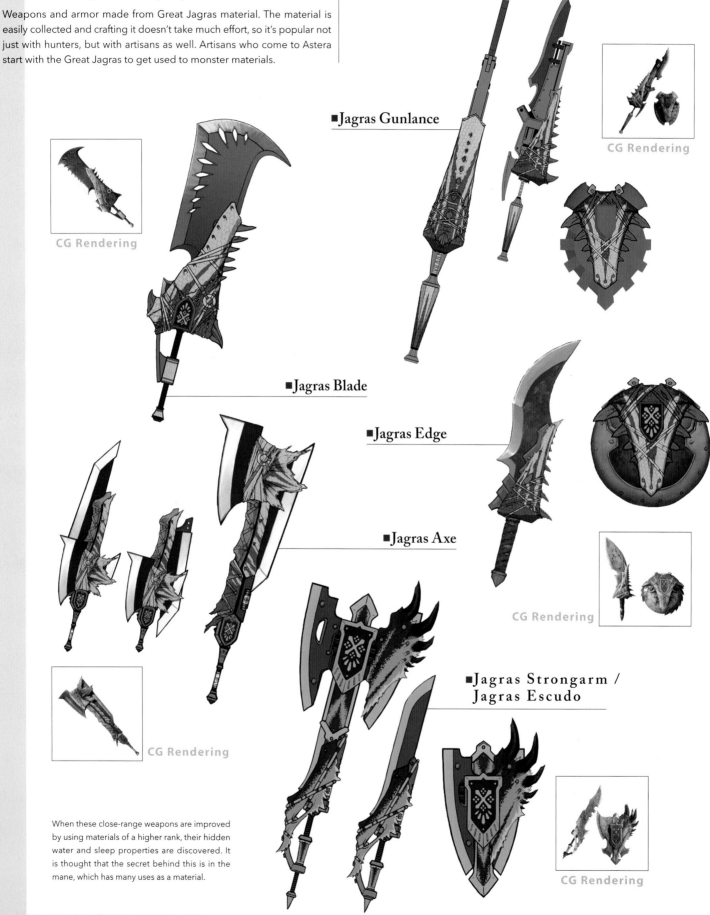

CG Rendering

■Jagras Gunlance

CG Rendering

■Jagras Blade

■Jagras Edge

■Jagras Axe

CG Rendering

■Jagras Strongarm / Jagras Escudo

CG Rendering

CG Rendering

When these close-range weapons are improved by using materials of a higher rank, their hidden water and sleep properties are discovered. It is thought that the secret behind this is in the mane, which has many uses as a material.

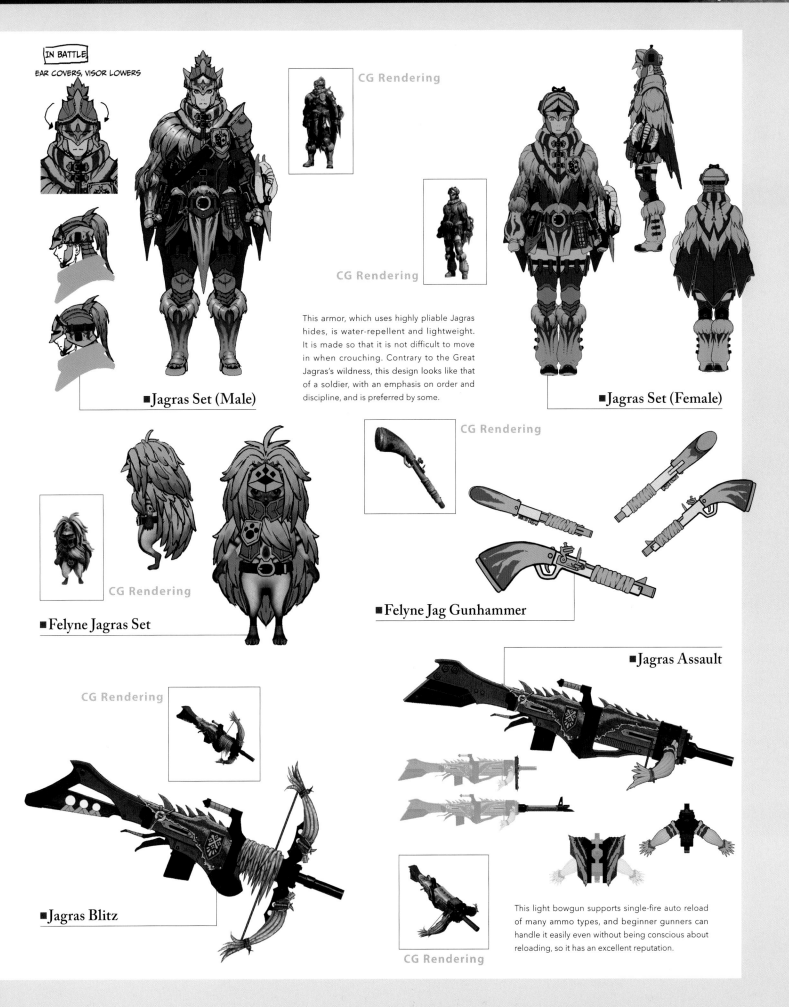

IN BATTLE

EAR COVERS, VISOR LOWERS

CG Rendering

CG Rendering

This armor, which uses highly pliable Jagras hides, is water-repellent and lightweight. It is made so that it is not difficult to move in when crouching. Contrary to the Great Jagras's wildness, this design looks like that of a soldier, with an emphasis on order and discipline, and is preferred by some.

■Jagras Set (Male)

■Jagras Set (Female)

CG Rendering

■Felyne Jagras Set

■Felyne Jag Gunhammer

■Jagras Assault

CG Rendering

■Jagras Blitz

This light bowgun supports single-fire auto reload of many ammo types, and beginner gunners can handle it easily even without being conscious about reloading, so it has an excellent reputation.

CG Rendering

Kulu-Ya-Ku Equipment

Weapons and armor made from Kulu-Ya-Ku material. The brightly colored feathers growing on the forelegs of the Kulu-Ya-Ku are frequently used as ornamentation by the artisans who design this equipment, to the point of obsession. The armor, which glows in lively vermillion and orange colors, has an exotic air about it.

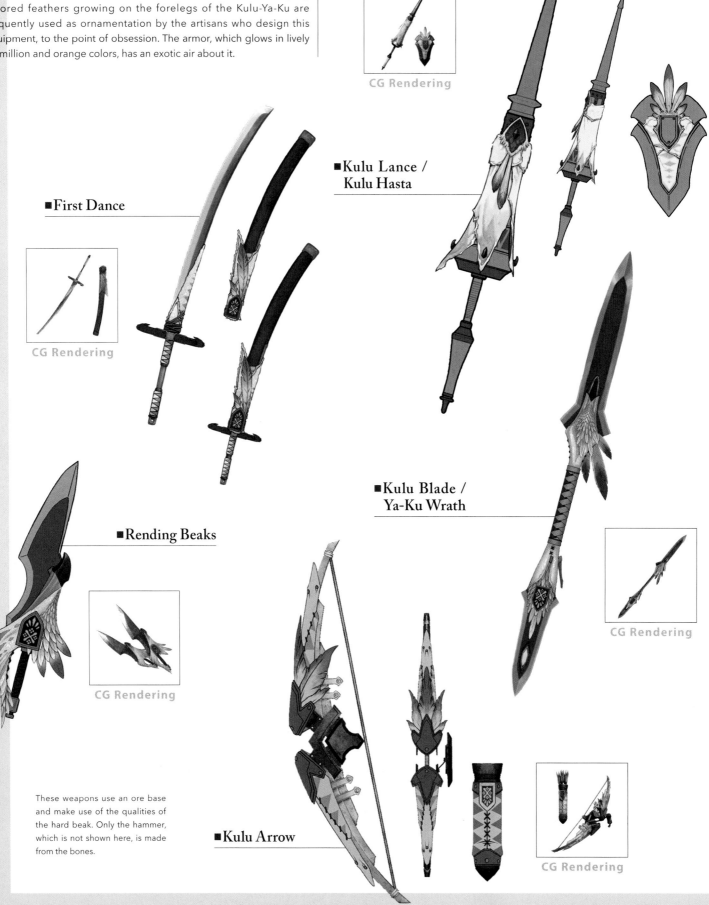

CG Rendering

■Kulu Lance /
Kulu Hasta

■First Dance

CG Rendering

■Kulu Blade /
Ya-Ku Wrath

■Rending Beaks

CG Rendering

CG Rendering

These weapons use an ore base and make use of the qualities of the hard beak. Only the hammer, which is not shown here, is made from the bones.

■Kulu Arrow

CG Rendering

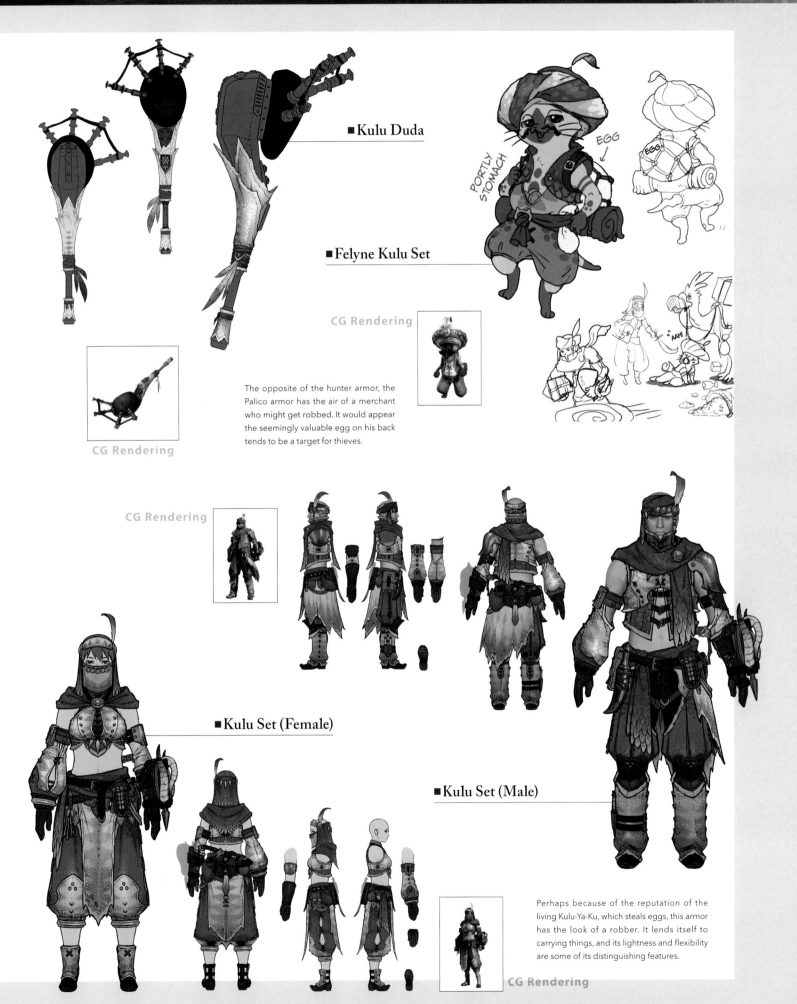

■ Kulu Duda

■ Felyne Kulu Set

PORTLY STOMACH

EGG

EGG

AAH!

CG Rendering

CG Rendering

The opposite of the hunter armor, the Palico armor has the air of a merchant who might get robbed. It would appear the seemingly valuable egg on his back tends to be a target for thieves.

CG Rendering

■ Kulu Set (Female)

■ Kulu Set (Male)

Perhaps because of the reputation of the living Kulu-Ya-Ku, which steals eggs, this armor has the look of a robber. It lends itself to carrying things, and its lightness and flexibility are some of its distinguishing features.

CG Rendering

Pukei-Pukei Equipment

Weapons and armor made from Pukei-Pukei material. Its green scales and shell are used in abundance, and its venom-soaked down can be combined with weapons to make them highly poisonous. It's hide comes in a wide variety of types, allowing for many different types of armor to be made.

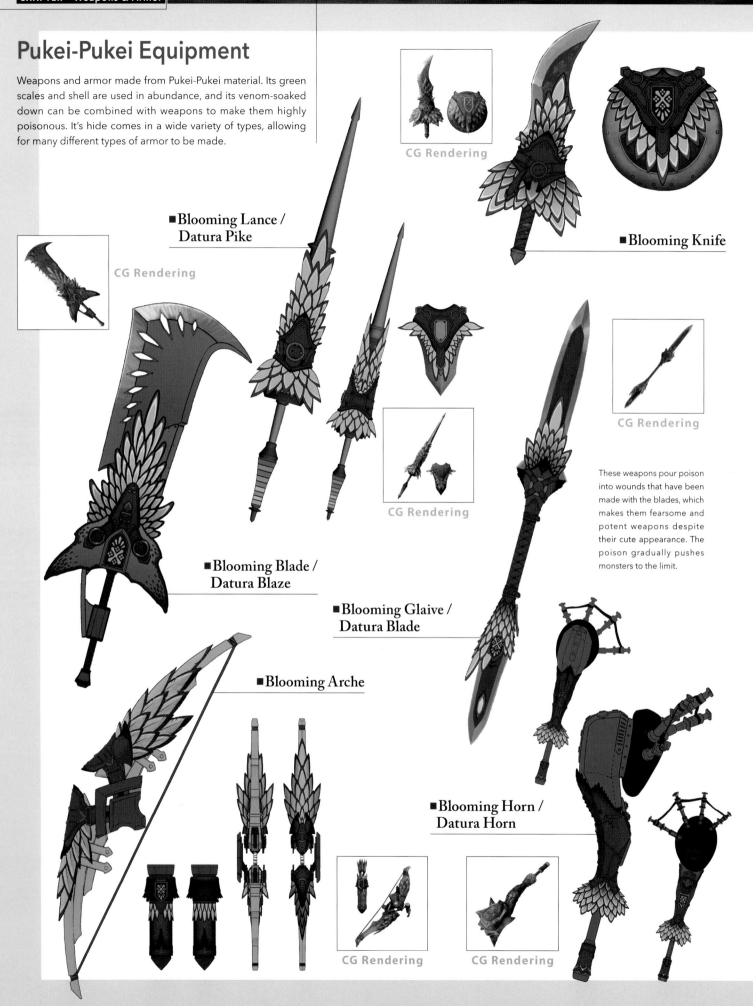

CG Rendering

■ Blooming Lance /
Datura Pike

CG Rendering

■ Blooming Knife

CG Rendering

CG Rendering

These weapons pour poison into wounds that have been made with the blades, which makes them fearsome and potent weapons despite their cute appearance. The poison gradually pushes monsters to the limit.

■ Blooming Blade /
Datura Blaze

■ Blooming Glaive /
Datura Blade

■ Blooming Arche

■ Blooming Horn /
Datura Horn

CG Rendering

CG Rendering

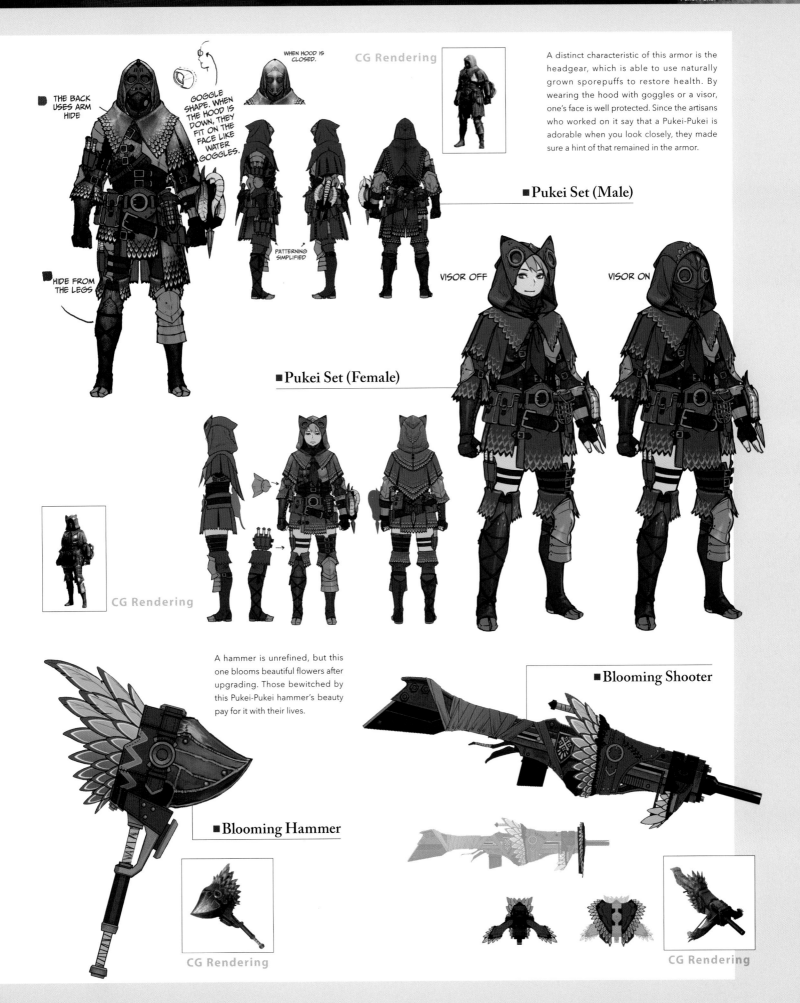

THE BACK USES ARM HIDE

WHEN HOOD IS CLOSED.

GOGGLE SHAPE. WHEN THE HOOD IS DOWN, THEY FIT ON THE FACE LIKE WATER GOGGLES.

CG Rendering

A distinct characteristic of this armor is the headgear, which is able to use naturally grown sporepuffs to restore health. By wearing the hood with goggles or a visor, one's face is well protected. Since the artisans who worked on it say that a Pukei-Pukei is adorable when you look closely, they made sure a hint of that remained in the armor.

HIDE FROM THE LEGS

PATTERNING SIMPLIFIED

■ Pukei Set (Male)

VISOR OFF

VISOR ON

■ Pukei Set (Female)

CG Rendering

A hammer is unrefined, but this one blooms beautiful flowers after upgrading. Those bewitched by this Pukei-Pukei hammer's beauty pay for it with their lives.

■ Blooming Shooter

■ Blooming Hammer

CG Rendering

CG Rendering

Jyuratodus Equipment

Weapons and armor made from Jyuratodus material. The artisanship shines through in this beautiful armor that makes use of the Jyuratodus's soft scales and features contoured shapes. Its material contains hard mud, which coats and hardens the armor. Its external appearance takes on the characteristics of the Jyuratodus's reddish scales and fins.

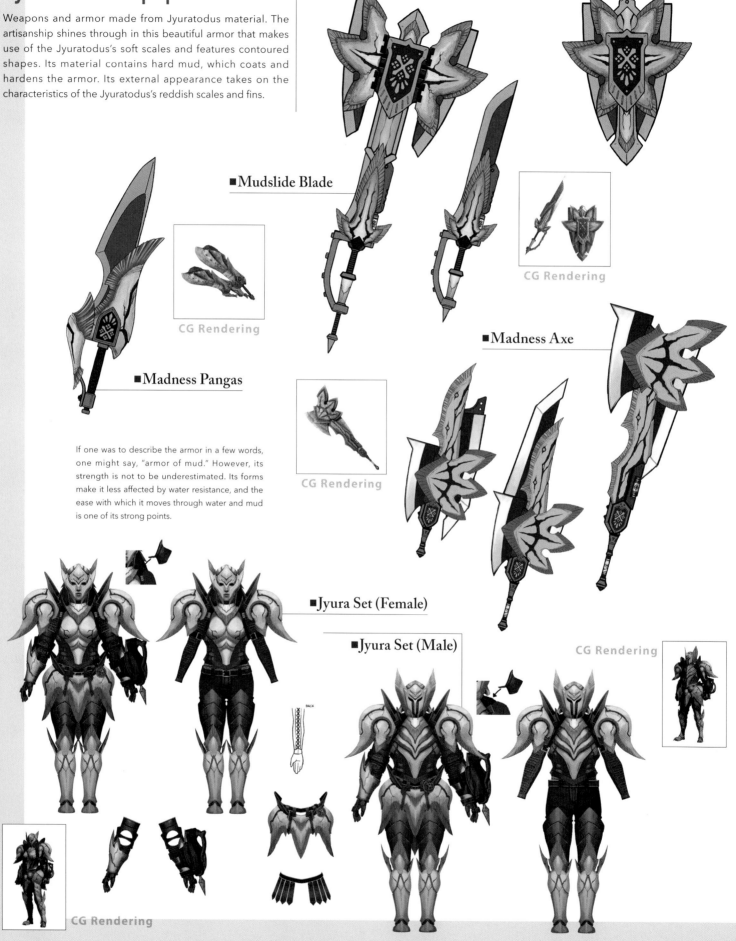

■Mudslide Blade

CG Rendering

CG Rendering

■Madness Pangas

CG Rendering

■Madness Axe

If one was to describe the armor in a few words, one might say, "armor of mud." However, its strength is not to be underestimated. Its forms make it less affected by water resistance, and the ease with which it moves through water and mud is one of its strong points.

■Jyura Set (Female)

■Jyura Set (Male)

CG Rendering

CG Rendering

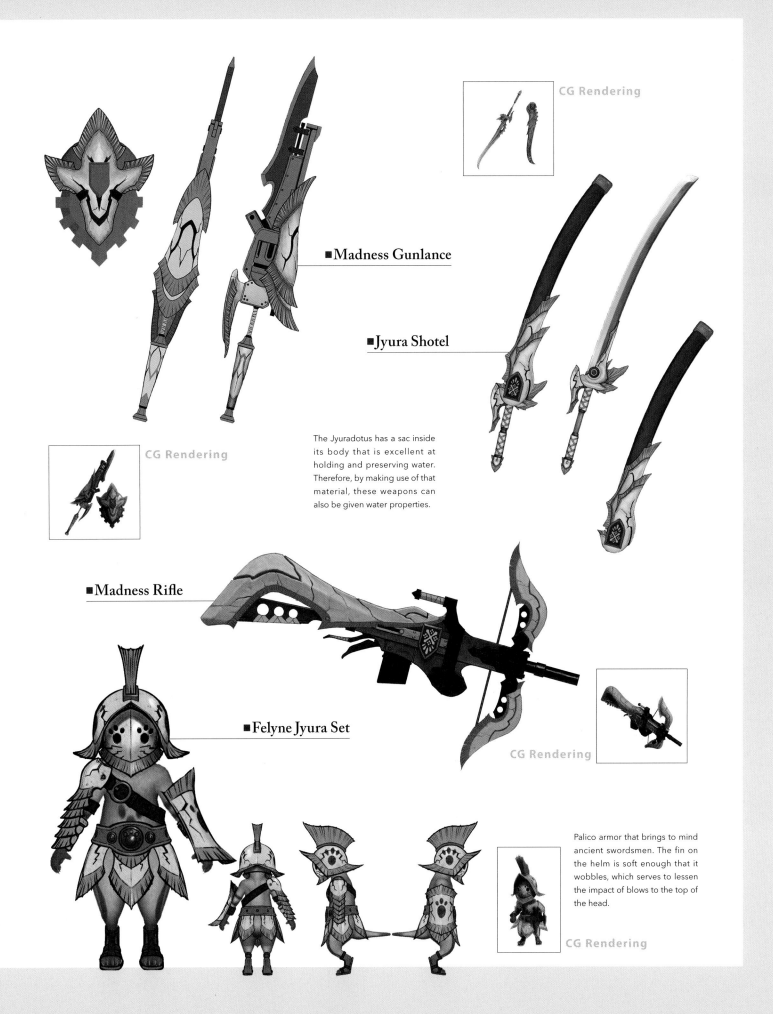

■Madness Gunlance

■Jyura Shotel

The Jyuradotus has a sac inside its body that is excellent at holding and preserving water. Therefore, by making use of that material, these weapons can also be given water properties.

■Madness Rifle

■Felyne Jyura Set

Palico armor that brings to mind ancient swordsmen. The fin on the helm is soft enough that it wobbles, which serves to lessen the impact of blows to the top of the head.

Tobi-Kadachi Equipment

Weapons and armor made from Tobi-Kadachi material. The fine and soft fur stores static electricity and needs to be handled with sensitive technical expertise when it is used for crafting. The Tobi-Kadachi's physical appearance is brought to life in the design work, and the contrast between its white fur and vibrant blue scales is beautiful.

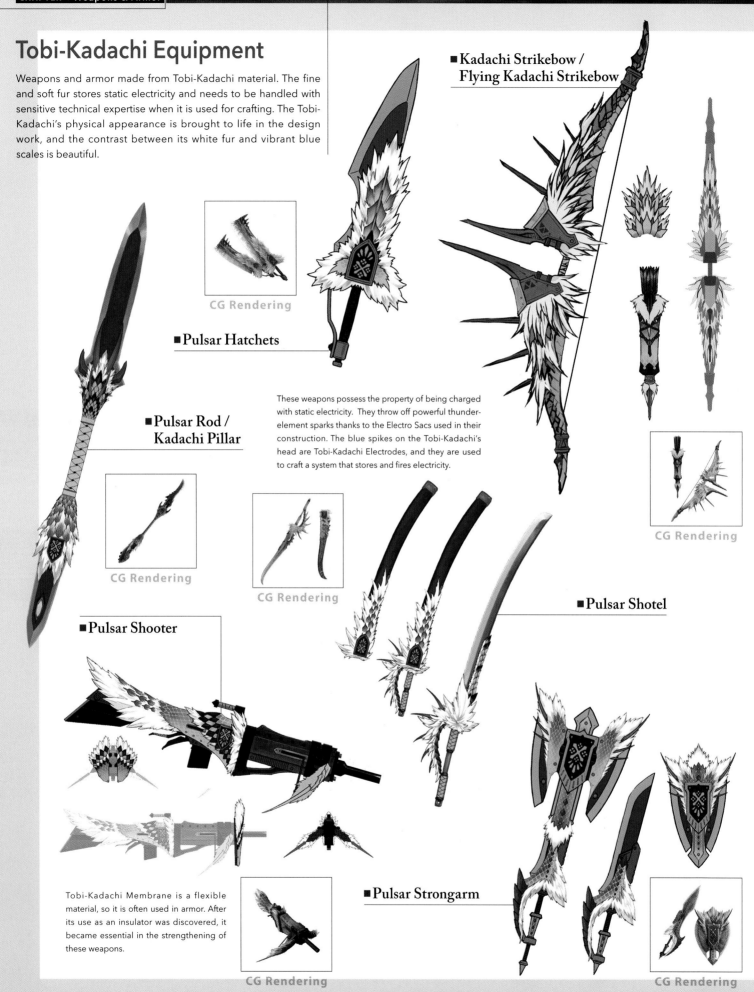

■ Kadachi Strikebow /
Flying Kadachi Strikebow

CG Rendering

■ Pulsar Hatchets

■ Pulsar Rod /
Kadachi Pillar

These weapons possess the property of being charged with static electricity. They throw off powerful thunder-element sparks thanks to the Electro Sacs used in their construction. The blue spikes on the Tobi-Kadachi's head are Tobi-Kadachi Electrodes, and they are used to craft a system that stores and fires electricity.

CG Rendering

CG Rendering

CG Rendering

■ Pulsar Shotel

■ Pulsar Shooter

Tobi-Kadachi Membrane is a flexible material, so it is often used in armor. After its use as an insulator was discovered, it became essential in the strengthening of these weapons.

■ Pulsar Strongarm

CG Rendering

CG Rendering

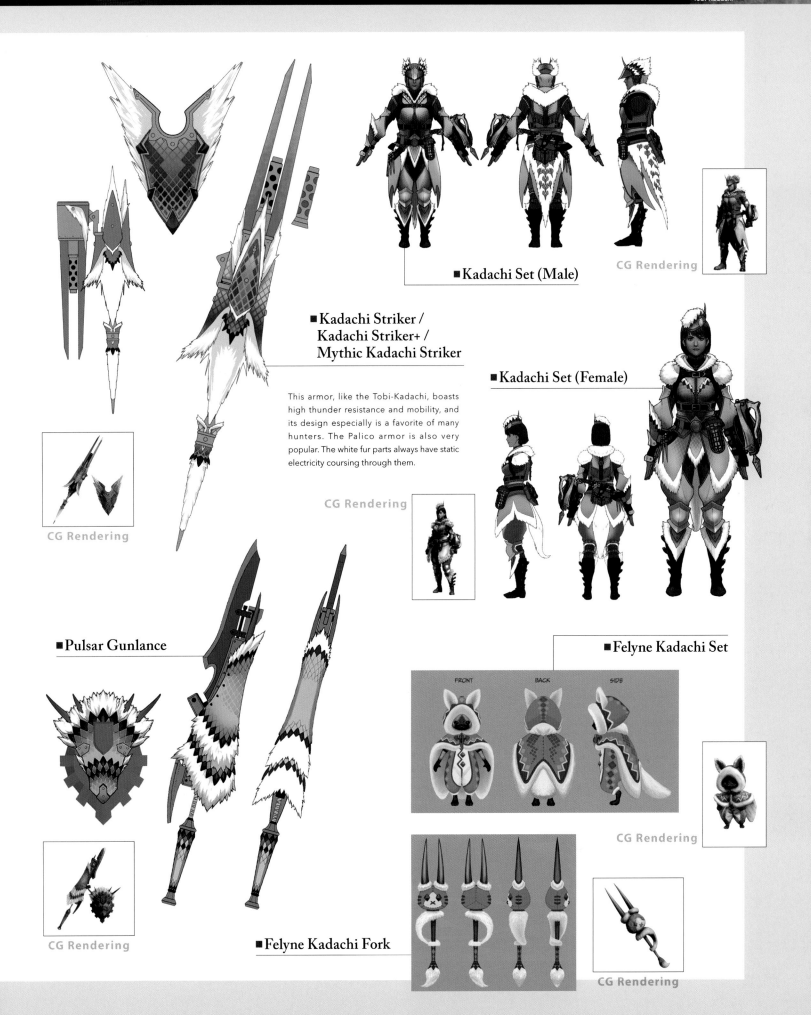

■Kadachi Set (Male)

CG Rendering

■Kadachi Striker /
Kadachi Striker+ /
Mythic Kadachi Striker

This armor, like the Tobi-Kadachi, boasts high thunder resistance and mobility, and its design especially is a favorite of many hunters. The Palico armor is also very popular. The white fur parts always have static electricity coursing through them.

CG Rendering

CG Rendering

■Kadachi Set (Female)

CG Rendering

■Pulsar Gunlance

■Felyne Kadachi Set

FRONT BACK SIDE

CG Rendering

CG Rendering

■Felyne Kadachi Fork

CG Rendering

427

Anjanath Equipment

Weapons and armor made from Anjanath material. The harsh design of this material calls to mind savage tribes, and the hunters, whose livelihood is hunting, have a kind of reverence for it. The armor is modeled after a certain tribe's hunting garb, and those motifs also attract attention.

■ **Flammenkaefer / Flammenkaefer+ / Gnashing Flammenkaefer**

■ **Blazing Shotel**

CG Rendering

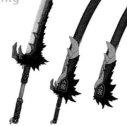

CG Rendering

■ **Flammenzahn / Flammenzahn+ / Gnashing Flammenzahn**

The Anjanath Pelt is especially tough and is useful as a material with high heat resistance. By wrapping it around weapons, it not only increases their strength but also gives them a fire element attribute.

CG Rendering

■ **Anja Striker**

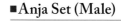

■ **Anja Set (Male)**

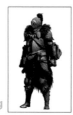

CG Rendering

FIFTH FLEET EMBLEM

UNDER THE ACCESSORIES

NOT TOO STYLISH, ORTHODOX ARMOR

FULL GEAR

This spirit-elevating design is proof of one's valor, and the hide's ornamentation acts as a prayer for good crops. The armguards with their finely detailed structure are proof of wisdom, and their imposing construction is a prayer for protection. The solid workmanship is proof of a determined fighting spirit. Each piece of the armor is imbued with the thoughts of the unknown tribe.

UNDER THE MEDAL ON THE CHEST, THE NECKPIECE IS TIED WITH LEATHER STRAPS

■ **Anja Set (Female)**

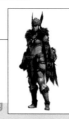

CG Rendering

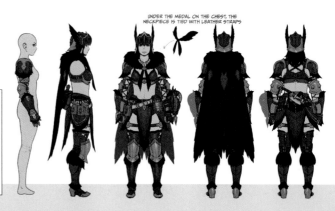

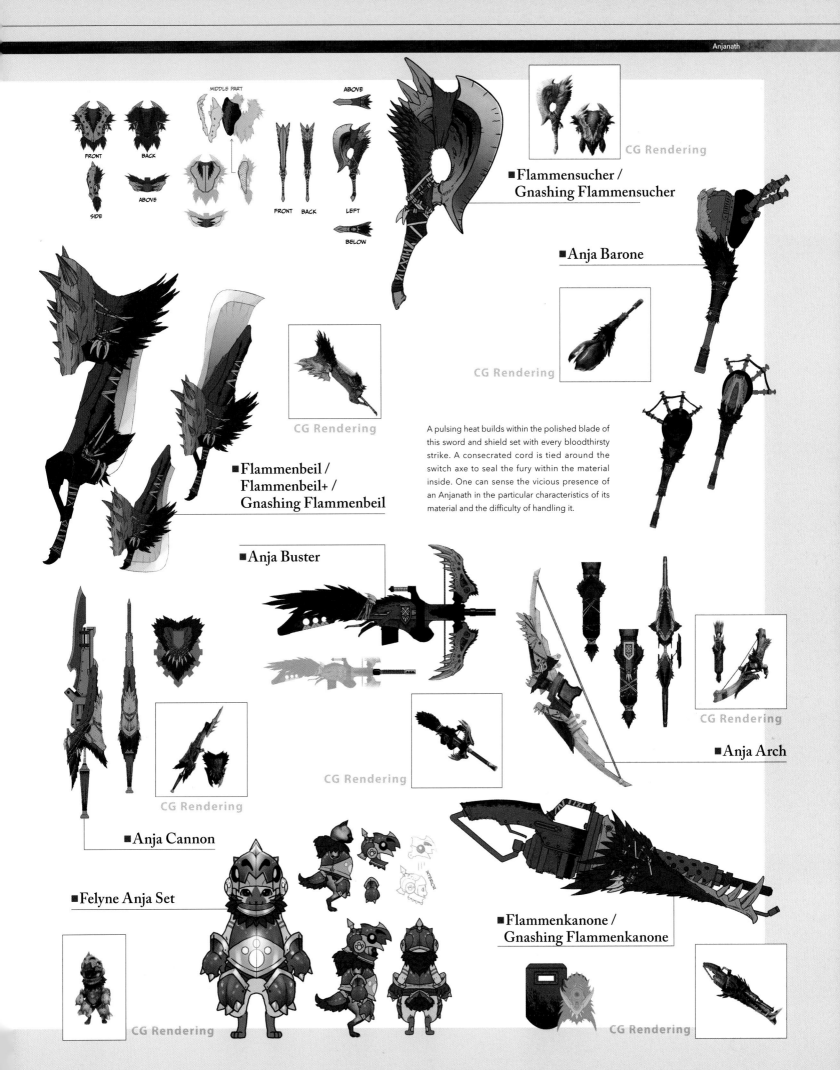

**Flammensucher /
Gnashing Flammensucher**

CG Rendering

Anja Barone

CG Rendering

**Flammenbeil /
Flammenbeil+ /
Gnashing Flammenbeil**

CG Rendering

A pulsing heat builds within the polished blade of this sword and shield set with every bloodthirsty strike. A consecrated cord is tied around the switch axe to seal the fury within the material inside. One can sense the vicious presence of an Anjanath in the particular characteristics of its material and the difficulty of handling it.

Anja Buster

Anja Cannon

CG Rendering

CG Rendering

Anja Arch

CG Rendering

Felyne Anja Set

**Flammenkanone /
Gnashing Flammenkanone**

CG Rendering

CG Rendering

429

Extended World Gallery
Fascinating Kinsect Specimens

Kinsects can be controlled when using an insect glaive. There are roughly twenty classifications of them and their stages of growth. Two species of Kinsects were brought from the Old World, and they have evolved to meet the environment here in the New World for more than ten years so far. Now, it has reached the point where they can be used for special biological attacks using Kinsect Powder. Have a look at these precious Kinsect specimens. They display growth unique to the New World depending on how they are nurtured.

Kinsect Tree Types and Their Ability to Change with Nurturing

The first Kinsects that one is able to purchase are the Culldrone and Mauldrone. The former has a head like small scissors and can make severing attacks. The latter's head is small and pointed and makes blunt-type attacks. Characteristics such as their power, healing, and speed can be improved by nurturing them. Insect glaives with Kinsect Bonus effects can bring out even more of their abilities.

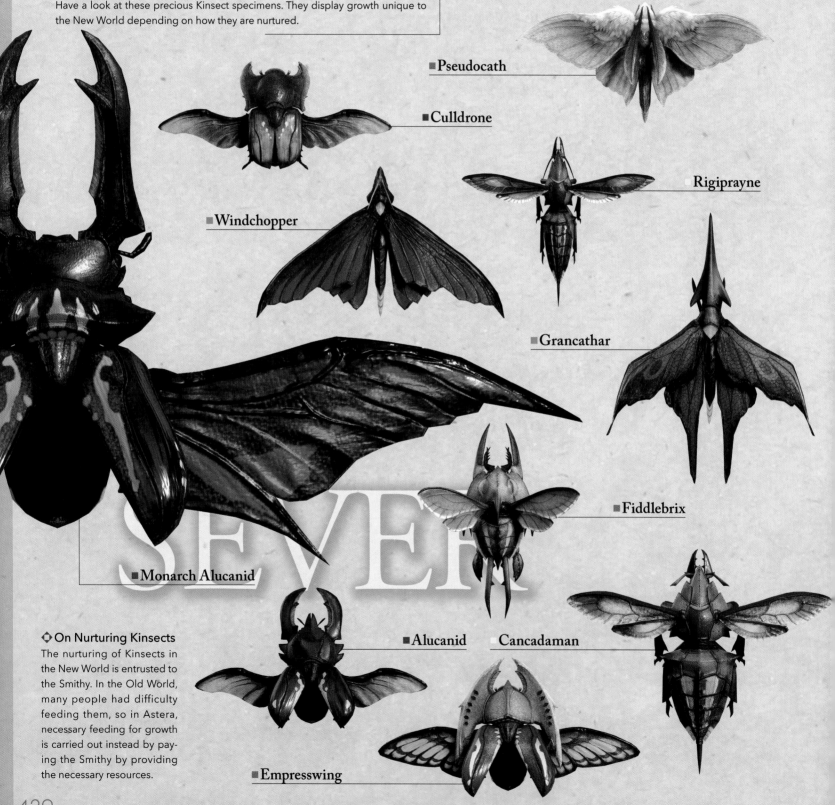

■Pseudocath

■Culldrone

Rigiprayne

■Windchopper

■Grancathar

■Fiddlebrix

■Monarch Alucanid

◇ On Nurturing Kinsects
The nurturing of Kinsects in the New World is entrusted to the Smithy. In the Old World, many people had difficulty feeding them, so in Astera, necessary feeding for growth is carried out instead by paying the Smithy by providing the necessary resources.

■Alucanid Cancadaman

■Empresswing

TOPIC The Relationship Between Kinsect Powder Attributes and Ability Inclinations

One of the characteristics of Kinsects is their Kinsect Powder ability. When a hunter hits a monster's body part with Mark Target, the Kinsect will release Kinsect Powder there. When the affected area is struck by an impact, the powder will produce the specified effect. That effect may be an abnormal status effect on a monster or healing for the hunter depending on the Kinsect. Mainly, power-inclined Kinsects have poison-effect powder, healing-inclined Kinsects have paralysis-effect powder, and speed-inclined Kinsects have healing-effect powder, but some of Kinsects will have the blast element regardless of their ability inclination. Influenced by the Kinsect Bonuses on insect glaives, these abilities can also be made even more effective.

[Kinsect Powder Elements]
■ Poison ■ Recover ☐ Paralysis ■ Blast

The color of the ■ accompanying the names of the Kinsect specimens indicates which Kinsect Powder type it is. It is interesting that Kinsect Powder reacts to Screamer Pods and Flash Pods as well.

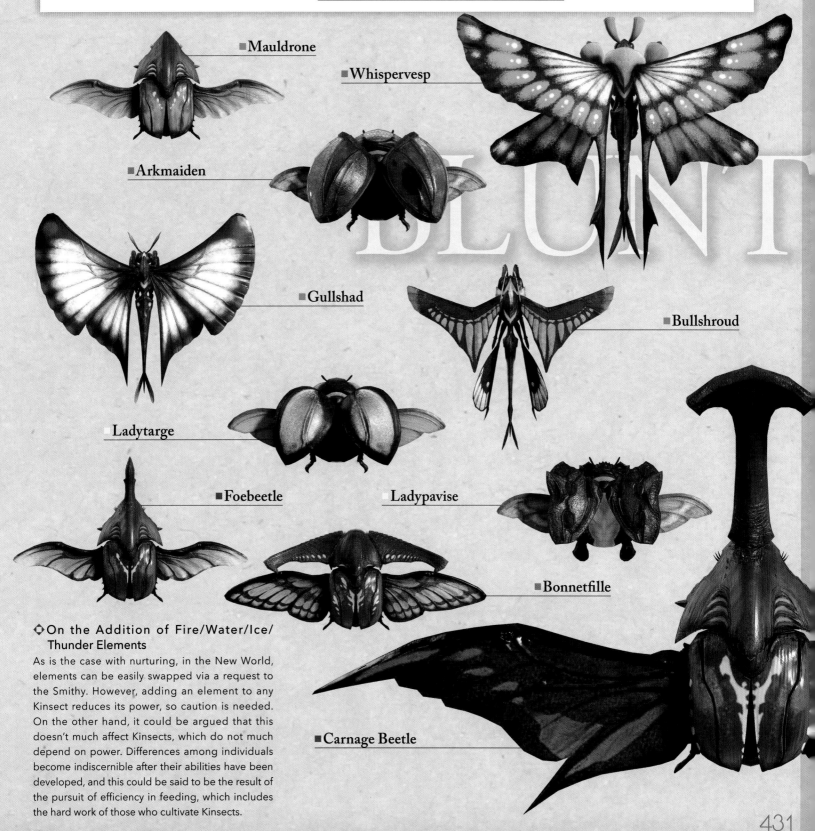

- ■ Mauldrone
- ■ Whispervesp
- ■ Arkmaiden
- ■ Gullshad
- ■ Bullshroud
- ☐ Ladytarge
- ■ Foebeetle
- ■ Ladypavise
- ■ Bonnetfille
- ■ Carnage Beetle

◇ On the Addition of Fire/Water/Ice/Thunder Elements

As is the case with nurturing, in the New World, elements can be easily swapped via a request to the Smithy. However, adding an element to any Kinsect reduces its power, so caution is needed. On the other hand, it could be argued that this doesn't much affect Kinsects, which do not much depend on power. Differences among individuals become indiscernible after their abilities have been developed, and this could be said to be the result of the pursuit of efficiency in feeding, which includes the hard work of those who cultivate Kinsects.

Rathian Equipment

Weapons and armor made from Rathian material. This armor is based around traditional armor. By using material of high fire resistance, its endurance against flames is heightened, and it is said that those who wear it gain the refined power of a queen. The male and female gear have a brilliance overflowing with strength and elegance.

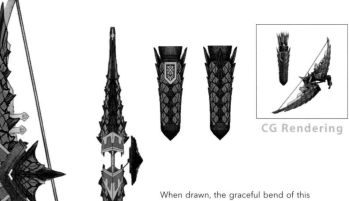

CG Rendering

TOPIC

The Rathian Gear Worn by the Huntsman

The gear worn by the Huntsman is called the Rathian set, but his equipment was made in the Old World, and he has continued using it and repairing it as necessary. It is said to be for the use of general blademasters, so in terms of functionality it is not ideal for use by gunners. Therefore, it differs in design from the Rathian sets built in the New World.

■**Princess Arrow**

When drawn, the graceful bend of this bow resembles the beautiful back of a queen, and a user of it shows a nobility too. However, who was it that said, "The beautiful bow has a poison coating"?

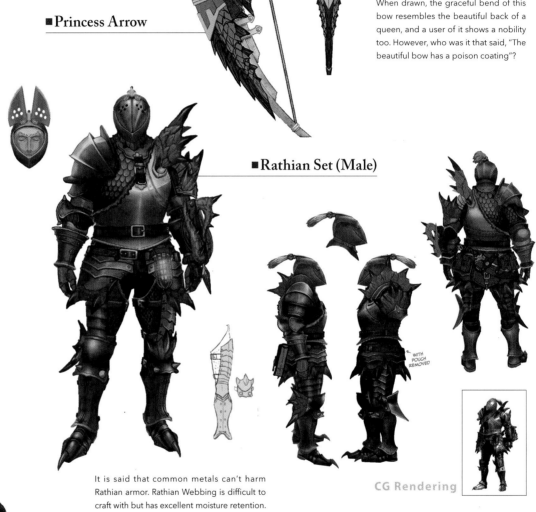

■**Rathian Set (Male)**

WITH POUCH REMOVED

CG Rendering

It is said that common metals can't harm Rathian armor. Rathian Webbing is difficult to craft with but has excellent moisture retention. It has been adopted for inner wear.

■**Rathian Set (Female)**

CG Rendering

Tzitzi-Ya-Ku Equipment

Weapons and armor made from Tzitzi-Ya-Ku material. Their luster and markings are beautiful, and the armor, with its bold glamorousness, has many devotees. The material receives light and refracts it back out. Perhaps because of this, it reflects and diffuses the light around it, and is recognized for softening the light that shines into the eyes of its wearer.

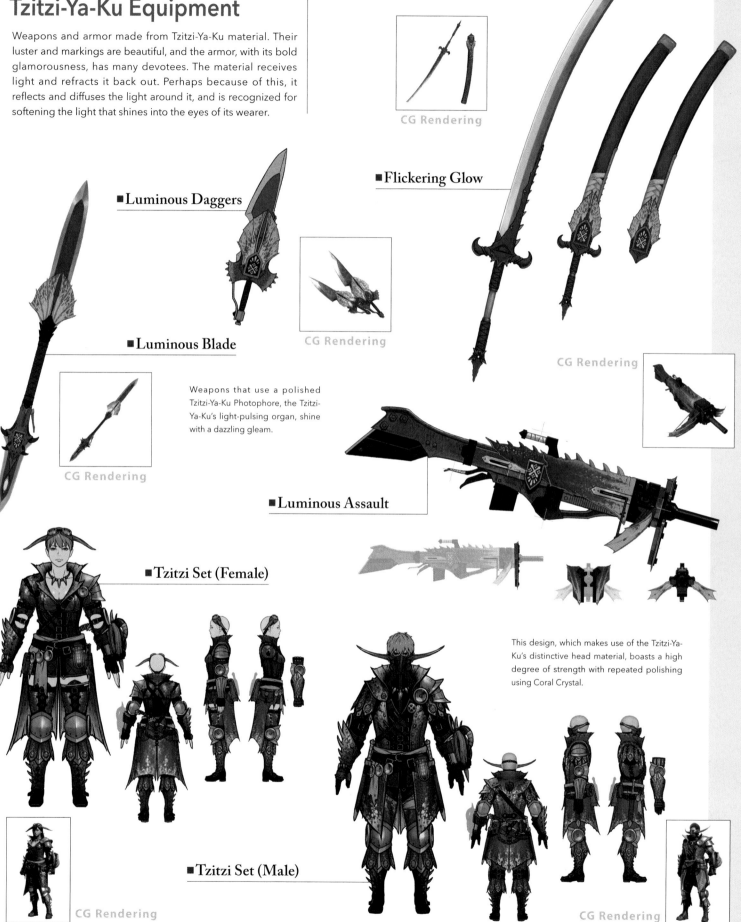

CG Rendering

■ **Flickering Glow**

■ **Luminous Daggers**

CG Rendering

■ **Luminous Blade**

CG Rendering

Weapons that use a polished Tzitzi-Ya-Ku Photophore, the Tzitzi-Ya-Ku's light-pulsing organ, shine with a dazzling gleam.

CG Rendering

■ **Luminous Assault**

■ **Tzitzi Set (Female)**

This design, which makes use of the Tzitzi-Ya-Ku's distinctive head material, boasts a high degree of strength with repeated polishing using Coral Crystal.

■ **Tzitzi Set (Male)**

CG Rendering

CG Rendering

433

Paolumu Equipment

Weapons and armor made from Paolumu material. This is highly fashionable gear lavished in rich, lustrous Paolumu hide, and an exceptional set of items. With careful considerations about its functionality as well, it is a matter of pride for its artisans. For those who wear a complete set of armor in particular, it has a kind of therapeutic effect.

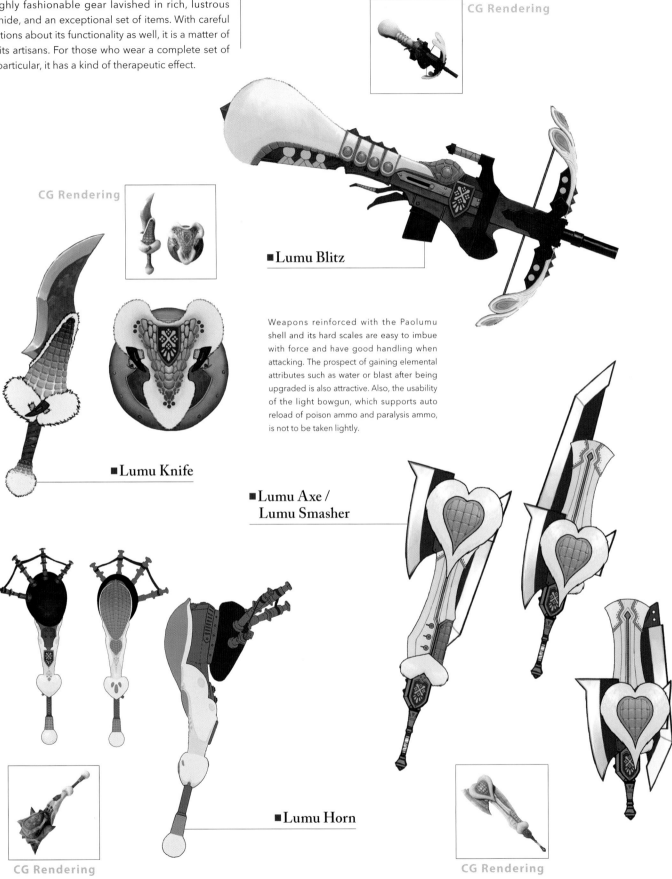

CG Rendering

CG Rendering

■ Lumu Blitz

Weapons reinforced with the Paolumu shell and its hard scales are easy to imbue with force and have good handling when attacking. The prospect of gaining elemental attributes such as water or blast after being upgraded is also attractive. Also, the usability of the light bowgun, which supports auto reload of poison ammo and paralysis ammo, is not to be taken lightly.

■ Lumu Knife

■ Lumu Axe /
Lumu Smasher

■ Lumu Horn

CG Rendering

CG Rendering

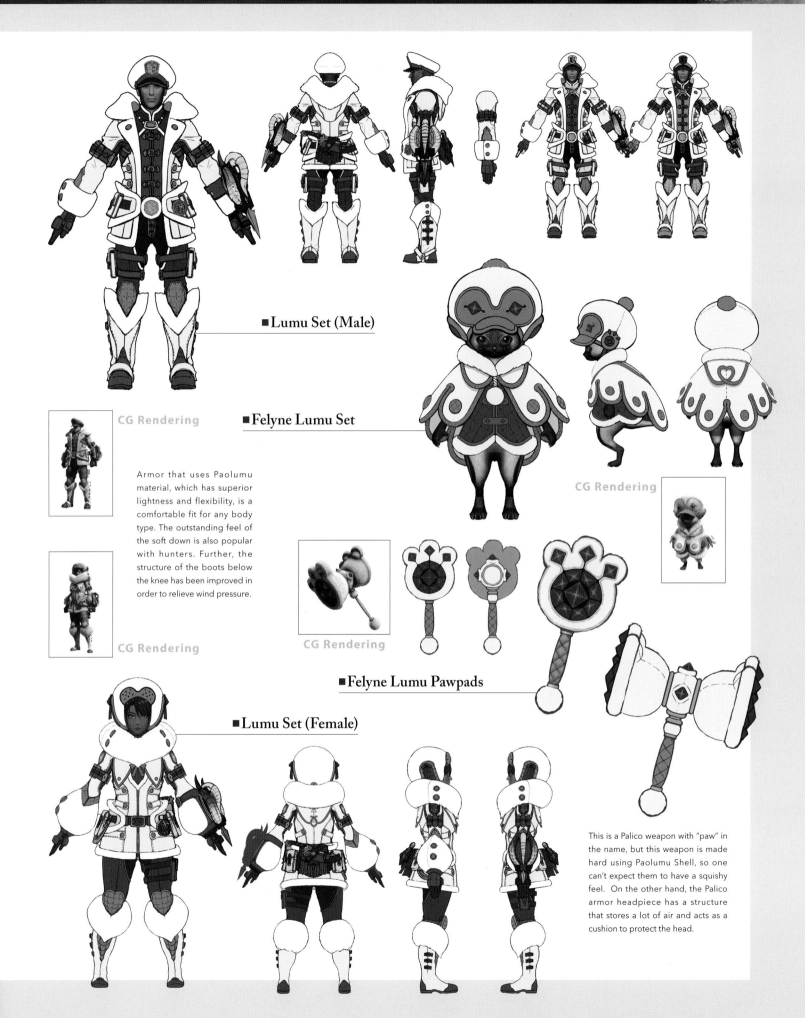

■Lumu Set (Male)

CG Rendering

■Felyne Lumu Set

Armor that uses Paolumu material, which has superior lightness and flexibility, is a comfortable fit for any body type. The outstanding feel of the soft down is also popular with hunters. Further, the structure of the boots below the knee has been improved in order to relieve wind pressure.

CG Rendering

CG Rendering

CG Rendering

■Felyne Lumu Pawpads

■Lumu Set (Female)

This is a Palico weapon with "paw" in the name, but this weapon is made hard using Paolumu Shell, so one can't expect them to have a squishy feel. On the other hand, the Palico armor headpiece has a structure that stores a lot of air and acts as a cushion to protect the head.

435

Barroth Equipment

Weapons and armor made from Barroth material. Gear that uses this tough material boasts an extraordinary degree of strength, can crush rock, and won't crack even if trampled on by a dragon. Armor made from it makes its wearer look like a fortress. Thanks to the thorough removal of all moisture, it is also thunder resistant.

■**Barroth Shredder**

Recommended to be used in combination with strong Kestodon material for reinforcement. By doing so, these weapons and armor can be made all the stronger.

CG Rendering

■**Carapace Sledge**

■**Barroth Grinder**

■**Carapace Cannon**

Weapons that include Barroth material gain a crude powerfulness that can carve new scars into the earth. When their abilities are awakened, they create impacts that hinder the actions of their prey.

CG Rendering

CG Rendering

CG Rendering

■**Carapace Lance**

CG Rendering

■**Carapace Edge**

CG Rendering

■**Carapace Rifle**

CG Rendering

■**Barroth Set (Female)**

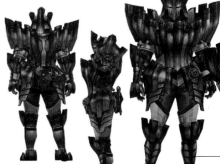

■**Barroth Set (Male)**

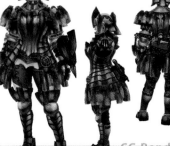

CG Rendering

CG Rendering

Diablos Equipment

Weapons and armor made from Diablos material. They boast an overwhelmingly intimidating air and fearsome strength. Wearing this gear is proof that one is the supreme ruler of the sands. The material brings robustness to the armor, a swelling power in those who equip it, and a menacing destructive force to the weapons, which can shatter a hunter's quarry.

■ Diablos Hatchets

CG Rendering

■ Diablos Wall

■ Diablos Axe

The Diablos's emblematic two horns and the case of its tail are valuable as materials and are used for a wide range of purposes.

CG Rendering

CG Rendering

■ Diablos Rod

■ Diablos Sledge

■ Diablos Bow

CG Rendering

CG Rendering

CG Rendering

■ Diablos Set (Male)

■ Diablos Set (Female)

The styling one sees on the armor resembles the desert tyrant itself. The armor is extremely heavy, so only some are able to use it, but this is a small price to pay for its strength, which is unperturbed by fierce attacks or tremors.

CG Rendering

CG Rendering

437

Great Girros Equipment

Weapons and armor made from Great Girros material. Has the power to paralyze quarry or the power to resist paralysis. It is said that these abilities sow brutality in the users of the gear. Perhaps this is only to be expected, because one's quarry is made to feel fear while immobile but still completely conscious.

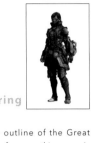

CG Rendering

■Girros Set (Female)

■Girros Blade

CG Rendering

Using the outline of the Great Girros as reference, this armor is made with the material of its pliable hide designed to fit the wearer's body, and it exhibits adaptability in the special environment of the Rotten Vale. The mask and waist piece make use of specially processed Great Girros Hoods.

CG Rendering

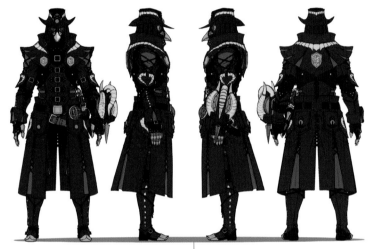

■Girros Set (Male)

The many weapons which have been made to exploit the effects of Great Girros Fang material to the fullest. Thanks to their keen sharpness, a single fierce slash injects a paralyzing agent into the body through the wound.

■Malady's Fist

■Girros Gunlance

■Girros Strongarm

CG Rendering

CG Rendering

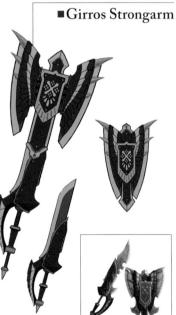

■Girros Knife

CG Rendering

CG Rendering

Dodogama Equipment

Weapons and armor made from Dodogama material. Perhaps it was inevitable that the artisans would be moved by its visual impact and incorporate its uniquely shaped jaw in the equipment's design. One can also see the reproduction of the patterning spread across the Dodogama's back and legs. When using high-rank materials, excellent performance is guaranteed too.

CG Rendering

■ Gama Pilebunker

■ Gama Cane

■ Gama Horn

CG Rendering

The Dodogama chews up crystals and turns them into explosive minerals. After the components of its saliva were studied, the fact that weapons soaked in its saliva acquire explosive properties was discovered.

CG Rendering

■ Gama Cannon

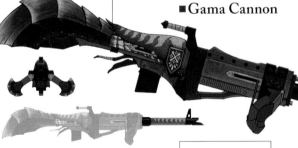

CG Rendering

■ Dodogama α Set (Male)

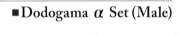
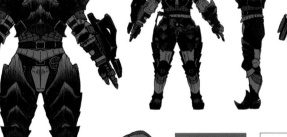

CG Rendering

■ Dodogama α Set (Female)

CG Rendering

Hides and shells are polished till they glisten and layered over each other to make this blue armor. It promises strength and more maneuverability than it would appear to have at first sight, and the properties of the material increase its effectiveness against various explosives.

439

Radobaan Equipment

Weapons and armor made from Radobaan material. By using the bone and plating material, which boasts a high density since it's used to flick out hard rocks, expert artisans have created this armor, which is superheavy and unfaltering, whatever the impact. These artisans gave their all to create these weapons and armor.

By making use of the Sleep Sac found among the Radobaan's internal organs, the sleep attribute has been successfully added to these weapons. As with the armor, it increases the wearer's resistance to sleep and weapon effectiveness.

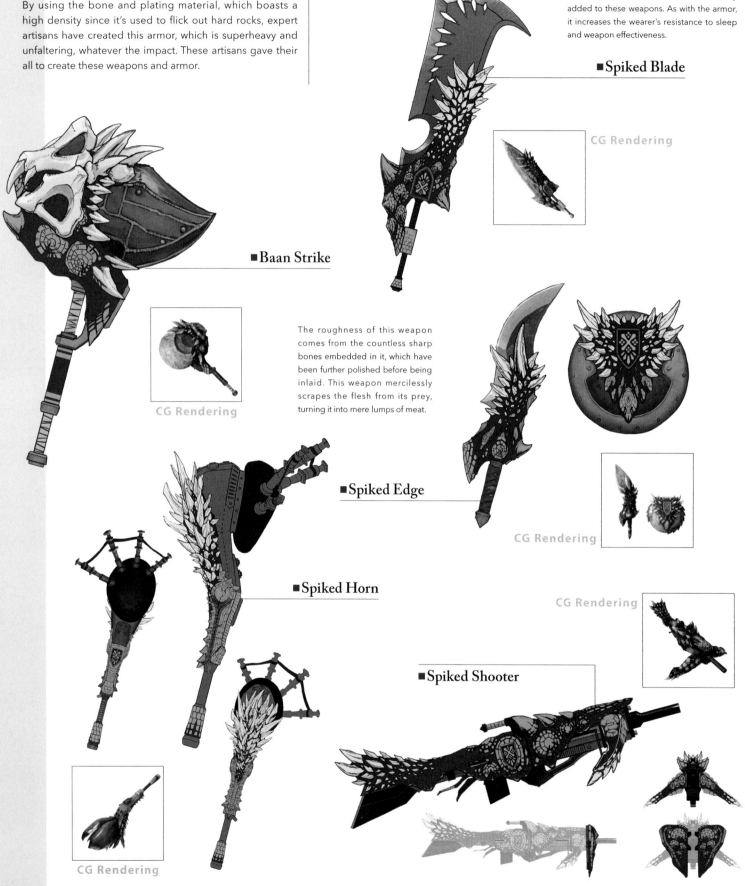

■Spiked Blade

CG Rendering

■Baan Strike

CG Rendering

The roughness of this weapon comes from the countless sharp bones embedded in it, which have been further polished before being inlaid. This weapon mercilessly scrapes the flesh from its prey, turning it into mere lumps of meat.

■Spiked Edge

CG Rendering

■Spiked Horn

CG Rendering

■Spiked Shooter

CG Rendering

CG Rendering

440

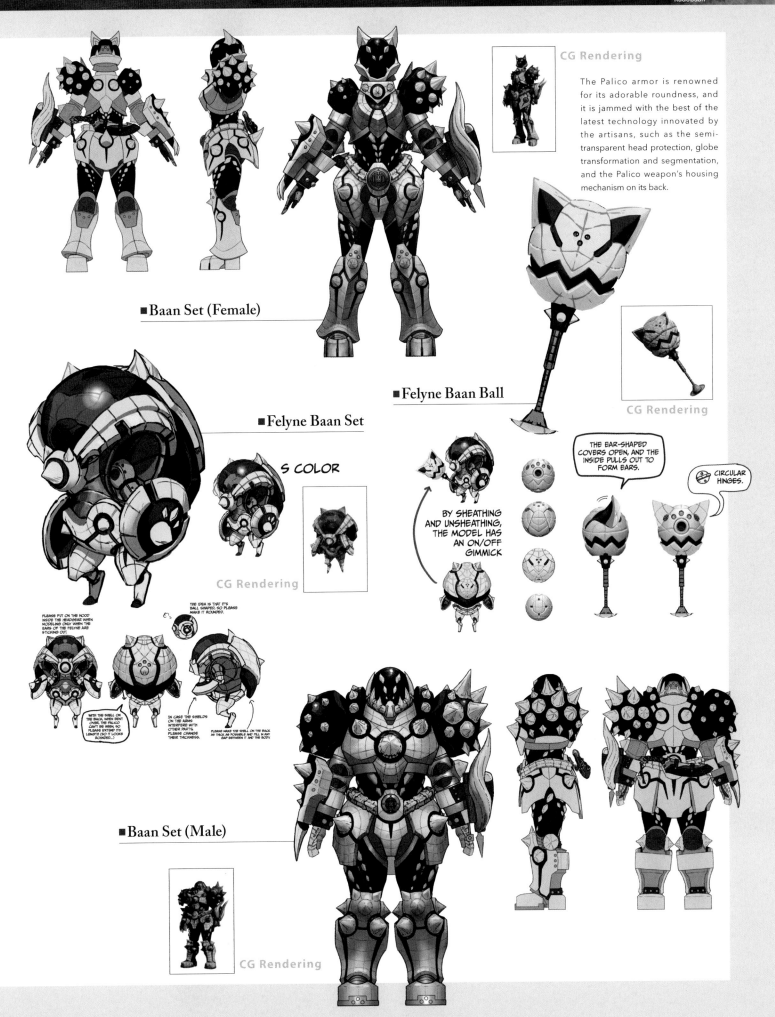

■ Baan Set (Female)

■ Felyne Baan Set

■ Felyne Baan Ball

■ Baan Set (Male)

S COLOR

CG Rendering

CG Rendering
The Palico armor is renowned for its adorable roundness, and it is jammed with the best of the latest technology innovated by the artisans, such as the semi-transparent head protection, globe transformation and segmentation, and the Palico weapon's housing mechanism on its back.

THE EAR-SHAPED COVERS OPEN, AND THE INSIDE PULLS OUT TO FORM EARS.

CIRCULAR HINGES.

BY SHEATHING AND UNSHEATHING, THE MODEL HAS AN ON/OFF GIMMICK

MANTLES

Extended World Gallery
Mantle Collection

Mantles...these garments are worn over the torso and grant numerous divine protections to their wearers, a power born from the workings of the New World. With the progress of all of the ecological research in the New World, this is one of the outcomes, something given back to the Commission personnel. Here, the sixteen types of mantles are on display. They are on loan from a Fifth Fleet collector, so please look but do not touch.

■ Ghillie Mantle

A mantle that can conceal one from a monster's view temporarily. It makes one mimic a bush, of course, but does it also make one feel like a First Wyvernian?!

■ Glider Mantle

A mantle that extends one's airtime when jumping. In places with strong winds, one gains an ability to fly that reminds one of a Legiana.

■ Vitality Mantle

A mantle that absorbs a fixed amount of damage. There is a limit to the amount of damage it can absorb, but everyone knows about its versatility.

■ Bandit Mantle

This mantle causes large monsters to drop rare and valuable items when attacked. In that instant, it sparkles brightly.

■ Challenger Mantle

A mantle that prompts monsters to target a hunter more often. The ornamentation on the mantle wavers and reflects seven colors of light, which provokes their natural instincts.

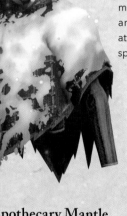

■ Apothecary Mantle

This mantle increases the likelihood of abnormal status attacks contributing to status buildup. It is the result of research on a variety of monsters.

■ Impact Mantle

This mantle adds or increases a stun effect to specific attacks. Its form is modeled after a Tempered monster, and it is very grim and wild in appearance.

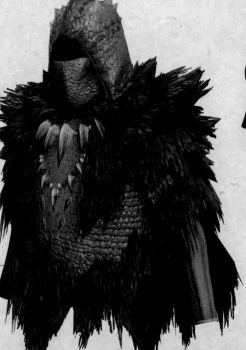

■ Immunity Mantle

This mantle removes and nullifies all abnormal status effects and elemental blights. It has undergone special detoxification and sterilization processes, and therefore has a pure feeling about it.

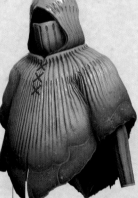

■ Evasion Mantle

This mantle lengthens one's invulnerability window while evading. The design yields lightness and also has the effect of giving an attack boost when one evades at the very last moment.

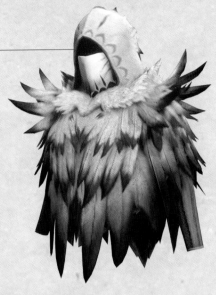

■ Iceproof Mantle

This mantle reduces ice damage and nullifies iceblight. It is warm and comfortable thanks to the use of Paolumu material.

■ Fireproof Mantle

This mantle reduces fire damage, nullifies fireblight and blastblight, and prevents damage from hot environments. Its fire resistance specs are unequaled.

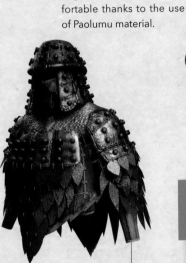

■ Rocksteady Mantle

A mantle that makes one undaunted by impacts. It gives protection against wind pressure, roars, and tremors, and even lessens damage. Incomparable and matchless.

■ Waterproof Mantle

This mantle reduces water damage and nullifies waterblight. Thanks to the blessing of high-quality Jyuratodus materials, this mantle makes muck and water easier to move through too.

■ Thunderproof Mantle

This mantle reduces thunder damage and nullifies thunderblight and paralysis. The Kirin material woven into it is what gives it these powers.

■ Temporal Mantle

This mantle nullifies damage from powerful attacks by automatically evading. When the lights covering the mantle detect an impact, it forces the body to react.

■ Dragonproof Mantle

This mantle reduces dragon damage and nullifies dragonblight. With its Vaal Hazak-like sinister aura, it also powers up your weapon's dragon properties.

TOPIC Mantle and Equipment Combinations

The use of support tools called "Boosters" alongside mantles is becoming widespread. The Health Booster restores health, the Cleanser Booster removes abnormal status effects, and the Affinity Booster increases affinity.

Also, simply by having an item called a "Charm" on one's person, one's skills are enhanced, so they are quite popular. There are various different designs for charms as well.

■ Booster

A tool that is set in the ground and that releases smoke into the area. They are effective for a limited time, but anyone who touches the smoke receives the effects.

Charm

The skills of the artisans is clearly evident in the luxurious designs of these items, which are worn around the wrist or neck. They are not a burden at all.

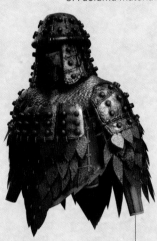

Legiana Equipment

Weapons and armor made from Legiana material. Reproducing the patterning that looks like beautiful flowing lines drawn on its huge wings, this gear is sharp and light, and also contains the cold of ice within it. It is said that by wearing this equipment, one can conquer, control, pacify, subdue, and rule over the wind.

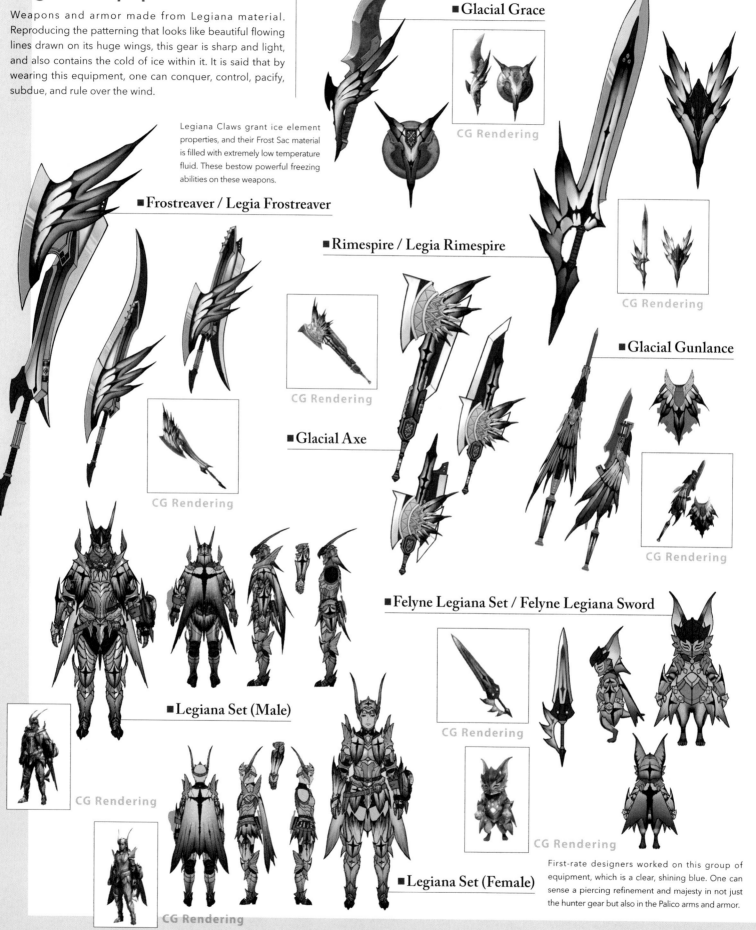

Legiana Claws grant ice element properties, and their Frost Sac material is filled with extremely low temperature fluid. These bestow powerful freezing abilities on these weapons.

■ **Glacial Grace**

CG Rendering

■ **Frostreaver / Legia Frostreaver**

■ **Rimespire / Legia Rimespire**

CG Rendering

CG Rendering

■ **Glacial Gunlance**

CG Rendering

■ **Glacial Axe**

CG Rendering

■ **Felyne Legiana Set / Felyne Legiana Sword**

CG Rendering

■ **Legiana Set (Male)**

CG Rendering

CG Rendering

■ **Legiana Set (Female)**

CG Rendering

First-rate designers worked on this group of equipment, which is a clear, shining blue. One can sense a piercing refinement and majesty in not just the hunter gear but also in the Palico arms and armor.

444

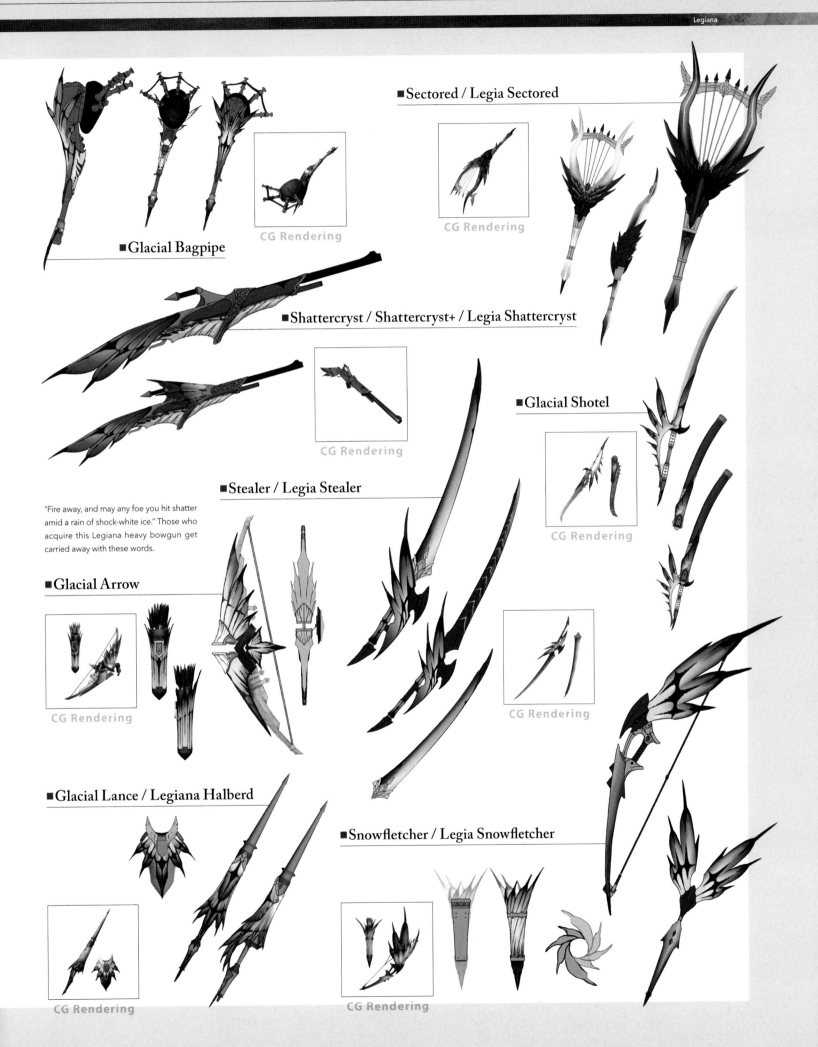

■Sectored / Legia Sectored

CG Rendering

■Glacial Bagpipe

CG Rendering

■Shattercryst / Shattercryst+ / Legia Shattercryst

CG Rendering

■Glacial Shotel

CG Rendering

■Stealer / Legia Stealer

"Fire away, and may any foe you hit shatter amid a rain of shock-white ice." Those who acquire this Legiana heavy bowgun get carried away with these words.

■Glacial Arrow

CG Rendering

CG Rendering

■Glacial Lance / Legiana Halberd

■Snowfletcher / Legia Snowfletcher

CG Rendering

CG Rendering

Odogaron Equipment

Weapons and armor made from Odogaron material. It seems to pulsate with the flesh and blood of countless prey torn apart by its claws, and some say that it is as if they are possessed by a hateful spirit. It is also said that if those who obtain this equipment have any weakness in their hearts at all, they will end up a prisoner to bloodlust.

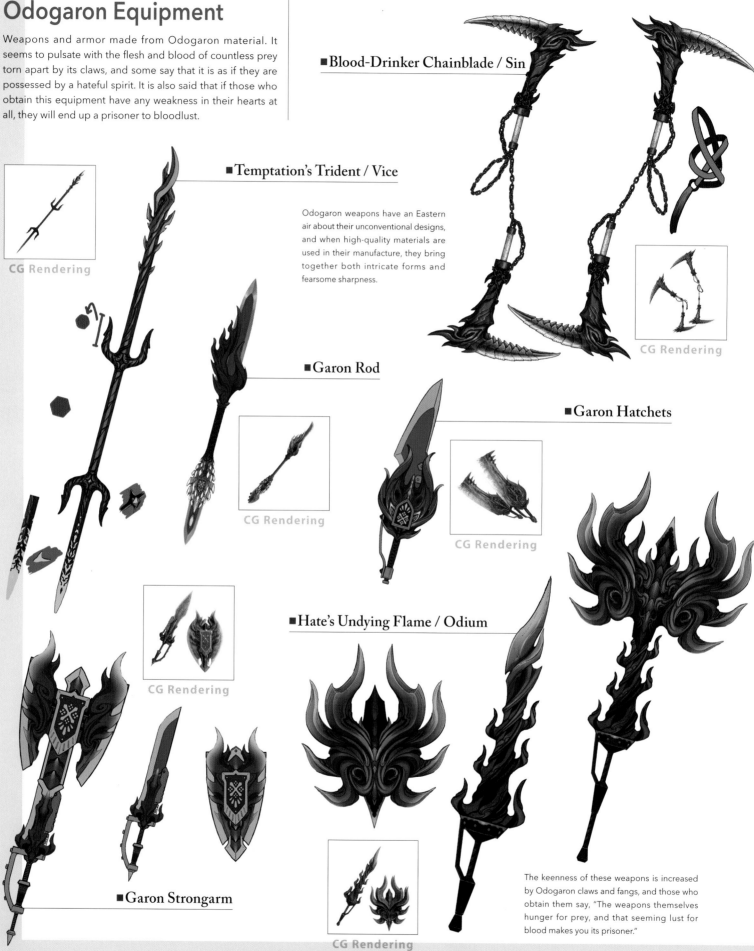

■Blood-Drinker Chainblade / Sin

■Temptation's Trident / Vice

Odogaron weapons have an Eastern air about their unconventional designs, and when high-quality materials are used in their manufacture, they bring together both intricate forms and fearsome sharpness.

CG Rendering

■Garon Rod

CG Rendering

■Garon Hatchets

CG Rendering

CG Rendering

CG Rendering

■Hate's Undying Flame / Odium

CG Rendering

■Garon Strongarm

CG Rendering

The keenness of these weapons is increased by Odogaron claws and fangs, and those who obtain them say, "The weapons themselves hunger for prey, and that seeming lust for blood makes you its prisoner."

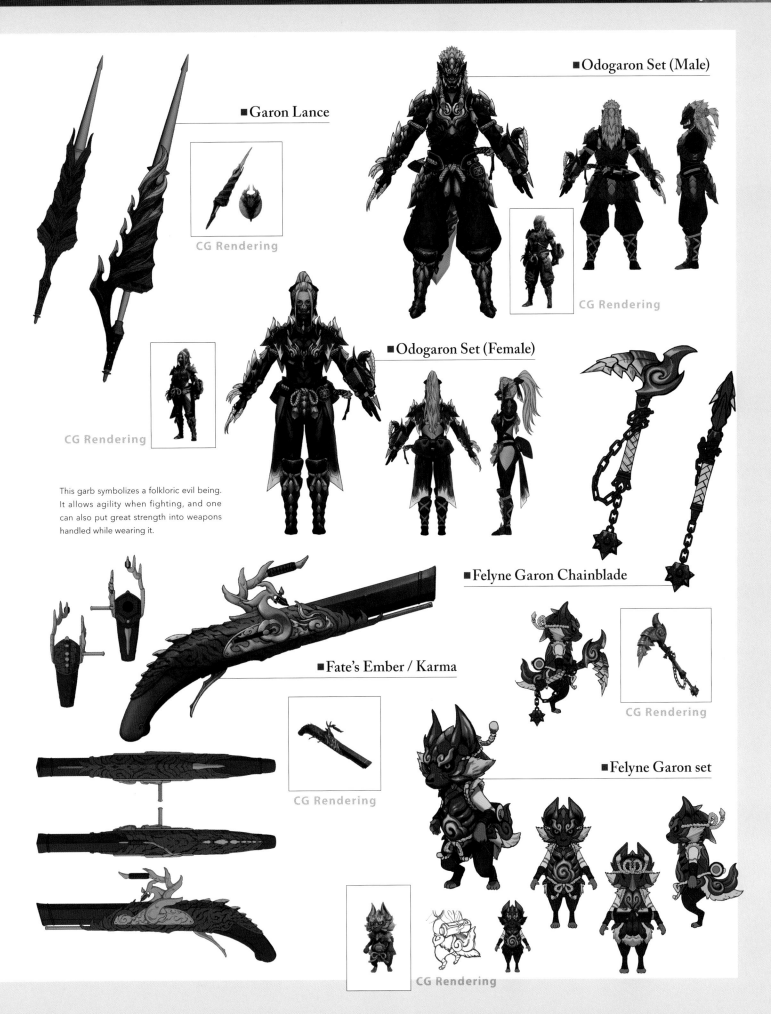

■Garon Lance

CG Rendering

■Odogaron Set (Male)

CG Rendering

■Odogaron Set (Female)

CG Rendering

This garb symbolizes a folkloric evil being. It allows agility when fighting, and one can also put great strength into weapons handled while wearing it.

■Felyne Garon Chainblade

CG Rendering

■Fate's Ember / Karma

CG Rendering

■Felyne Garon set

CG Rendering

Rathalos Equipment

Weapons and armor made from Rathalos material. Those who equip this gear are robed in ambition that lives up to the name of Rathalos, the Fire Wyvern and King of the Skies. No flames, no matter how intense, can get near it. A blow from these weapons is invested with a blazing heat, but this armor is capable of bringing forth the might of a Rathalos or even greater, esoteric special abilities.

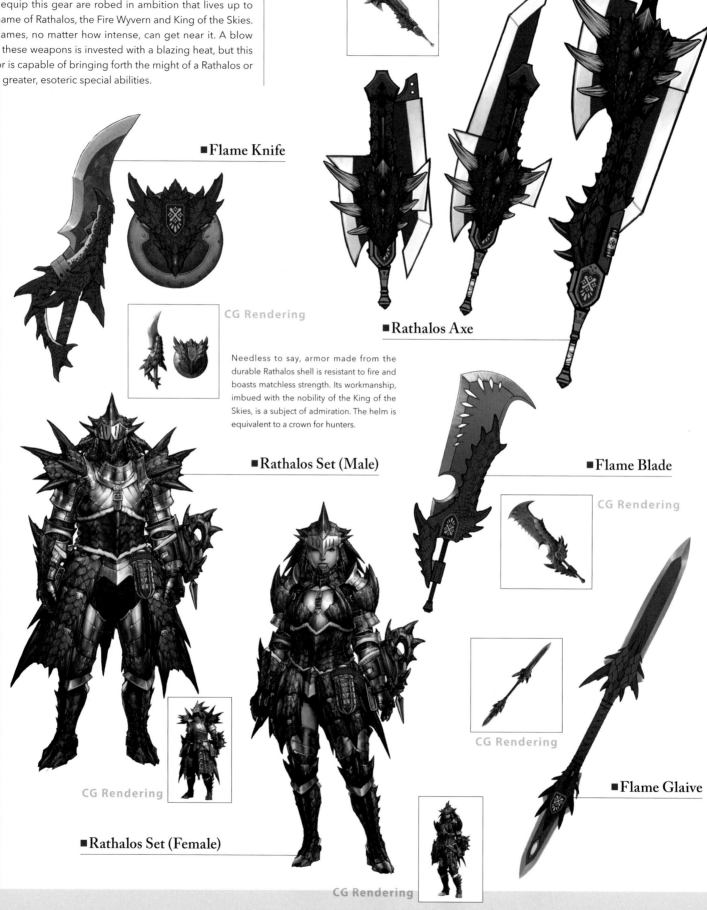

CG Rendering

■ Flame Knife

CG Rendering

■ Rathalos Axe

Needless to say, armor made from the durable Rathalos shell is resistant to fire and boasts matchless strength. Its workmanship, imbued with the nobility of the King of the Skies, is a subject of admiration. The helm is equivalent to a crown for hunters.

■ Rathalos Set (Male)

■ Flame Blade

CG Rendering

CG Rendering

■ Rathalos Set (Female)

CG Rendering

CG Rendering

■ Flame Glaive

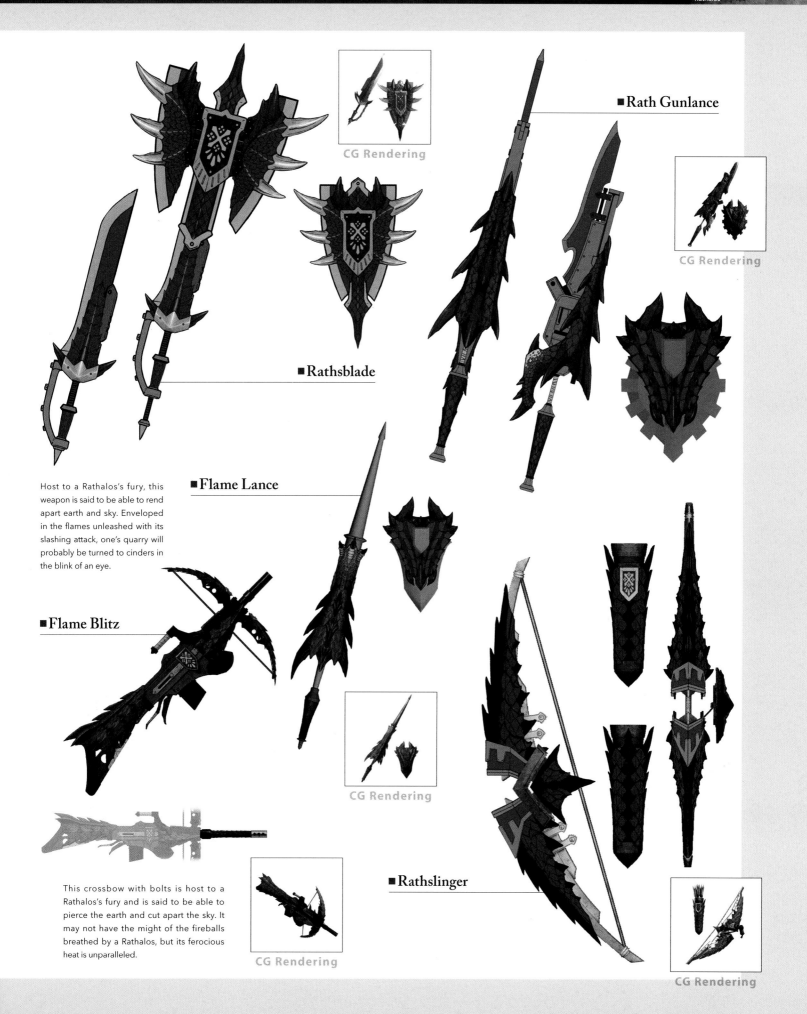

CG Rendering

■Rath Gunlance

CG Rendering

■Rathsblade

■Flame Lance

Host to a Rathalos's fury, this weapon is said to be able to rend apart earth and sky. Enveloped in the flames unleashed with its slashing attack, one's quarry will probably be turned to cinders in the blink of an eye.

■Flame Blitz

CG Rendering

■Rathslinger

This crossbow with bolts is host to a Rathalos's fury and is said to be able to pierce the earth and cut apart the sky. It may not have the might of the fireballs breathed by a Rathalos, but its ferocious heat is unparalleled.

CG Rendering

CG Rendering

449

Bazelgeuse Equipment

Weapons and armor made from Bazelgeuse material. These are masterpieces that make maximum use of the properties of the material. No matter the place or the opponent, the mind of the Bazelgeuse runs wild and everything that moves becomes prey, ready to fall victim to its explosive scales. All of this equipment has inherited that wild mind unfettered.

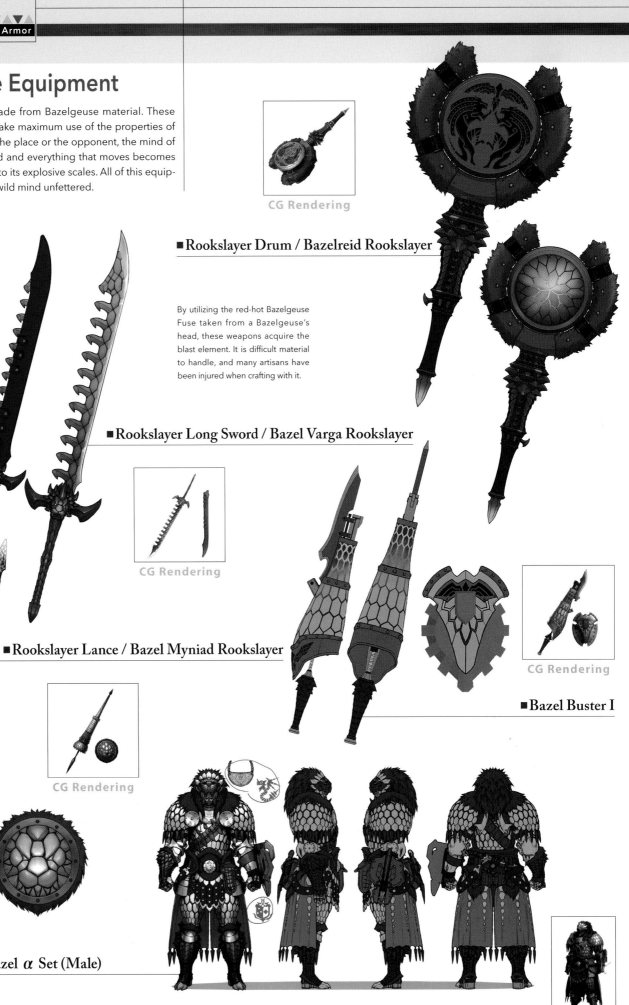

CG Rendering

■ Rookslayer Drum / Bazelreid Rookslayer

By utilizing the red-hot Bazelgeuse Fuse taken from a Bazelgeuse's head, these weapons acquire the blast element. It is difficult material to handle, and many artisans have been injured when crafting with it.

■ Rookslayer Long Sword / Bazel Varga Rookslayer

CG Rendering

■ Rookslayer Lance / Bazel Myniad Rookslayer

CG Rendering

■ Bazel Buster I

CG Rendering

■ Bazel α Set (Male)

CG Rendering

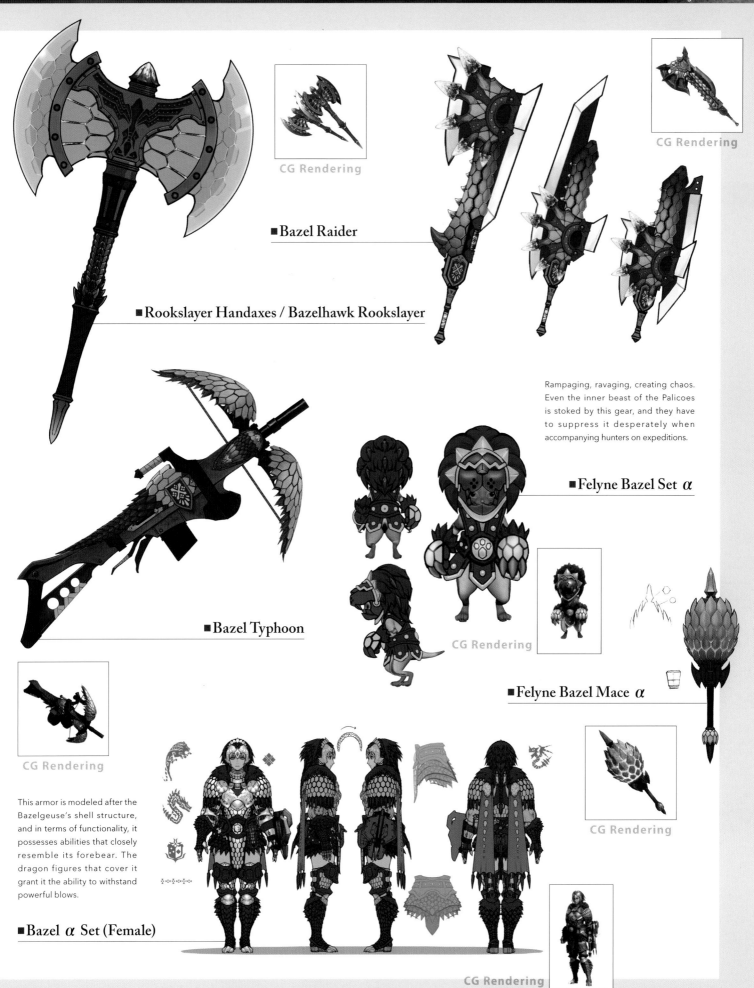

■Bazel Raider

CG Rendering

■Rookslayer Handaxes / Bazelhawk Rookslayer

Rampaging, ravaging, creating chaos. Even the inner beast of the Palicoes is stoked by this gear, and they have to suppress it desperately when accompanying hunters on expeditions.

■Felyne Bazel Set α

CG Rendering

■Bazel Typhoon

CG Rendering

■Felyne Bazel Mace α

CG Rendering

This armor is modeled after the Bazelgeuse's shell structure, and in terms of functionality, it possesses abilities that closely resemble its forebear. The dragon figures that cover it grant it the ability to withstand powerful blows.

■Bazel α Set (Female)

CG Rendering

Lavasioth Equipment

Weapons and armor made from Lavasioth material. Crafting with its shell, which is covered with lava that has cooled and hardened into a natural armor, requires an extremely high degree of discipline. Able to withstand the broiling heat of a volcano, this equipment has been manufactured to make use of that and is endowed with a toughness that incorporates rare minerals.

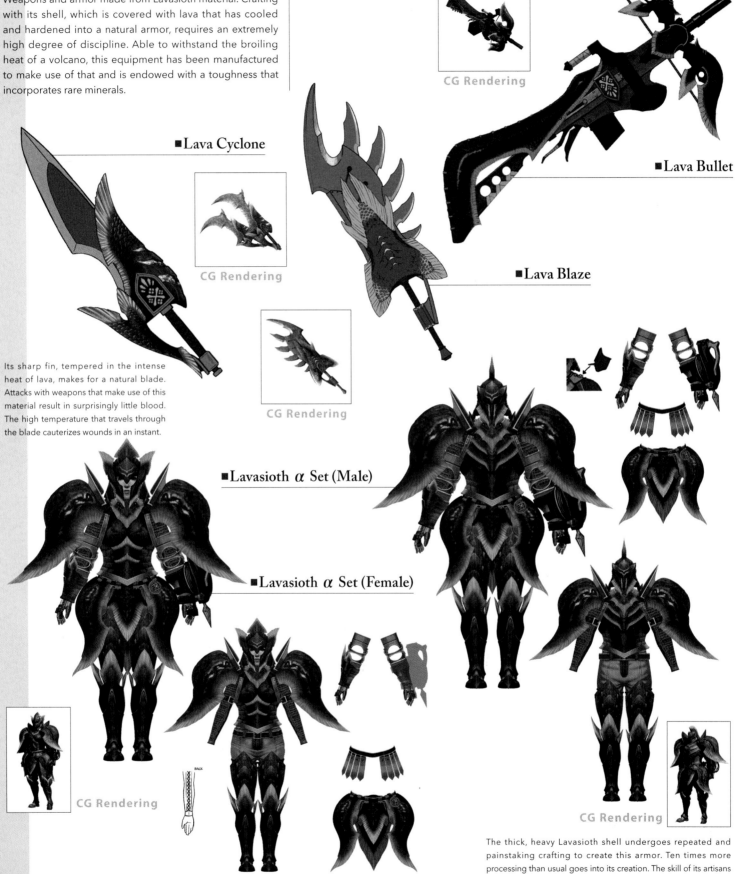

CG Rendering

■Lava Cyclone

CG Rendering

■Lava Bullet

■Lava Blaze

CG Rendering

Its sharp fin, tempered in the intense heat of lava, makes for a natural blade. Attacks with weapons that make use of this material result in surprisingly little blood. The high temperature that travels through the blade cauterizes wounds in an instant.

■Lavasioth α Set (Male)

■Lavasioth α Set (Female)

CG Rendering

BACK

CG Rendering

The thick, heavy Lavasioth shell undergoes repeated and painstaking crafting to create this armor. Ten times more processing than usual goes into its creation. The skill of its artisans shines through, and intense heat resides in some parts of it.

Uragaan Equipment

Weapons and armor made from Uragaan material. The material listed in this gear has a thick, heavy shell with a dull golden luster, and, with polishing during crafting, it can be made even more dazzling. It boasts a thermal resistance that can block the heat of lava and an overwhelming degree of strength, but on the other hand it is extremely heavy and difficult to handle.

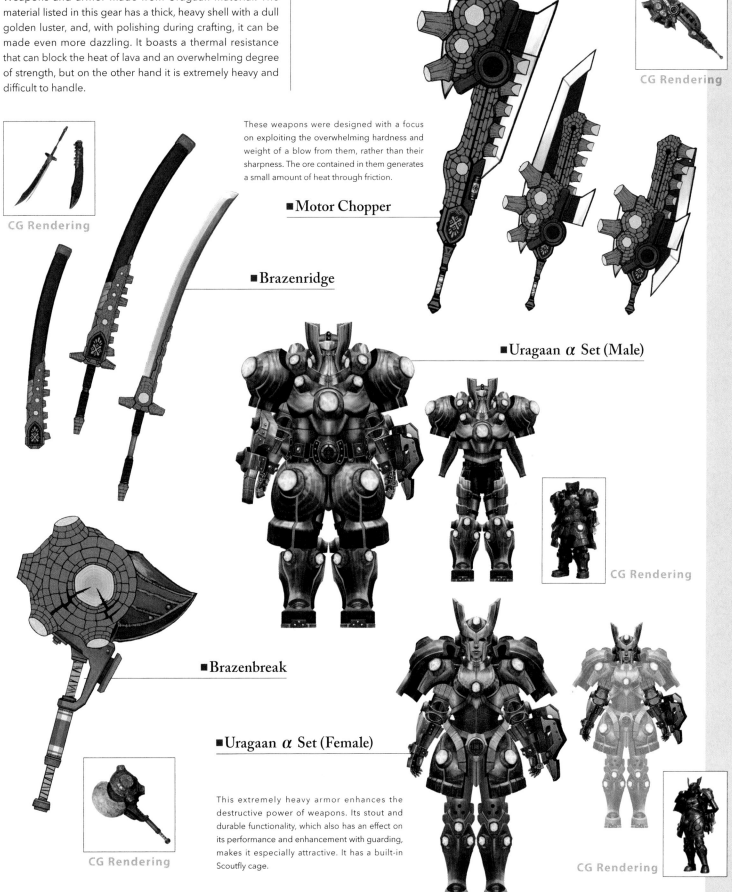

CG Rendering

These weapons were designed with a focus on exploiting the overwhelming hardness and weight of a blow from them, rather than their sharpness. The ore contained in them generates a small amount of heat through friction.

CG Rendering

■ Motor Chopper

■ Brazenridge

■ Uragaan α Set (Male)

CG Rendering

■ Brazenbreak

■ Uragaan α Set (Female)

This extremely heavy armor enhances the destructive power of weapons. Its stout and durable functionality, which also has an effect on its performance and enhancement with guarding, makes it especially attractive. It has a built-in Scoutfly cage.

CG Rendering

CG Rendering

Zorah Magdaros Equipment

Weapons and armor made from Zorah Magdaros material. Its jet-black shell is almost like volcanic rock that covers its extraordinarily massive frame, and it brings opponents to their knees with its overwhelming strength and explosive heat. When one wears this gear, a noble beauty can be sensed alongside the wearer's strength.

A single blow from these weapons, in which resides the power of the gods that rule over volcanoes, contains enough might to halt the flow of a river or turn a lake into steam. One who acquires them is burdened with fate.

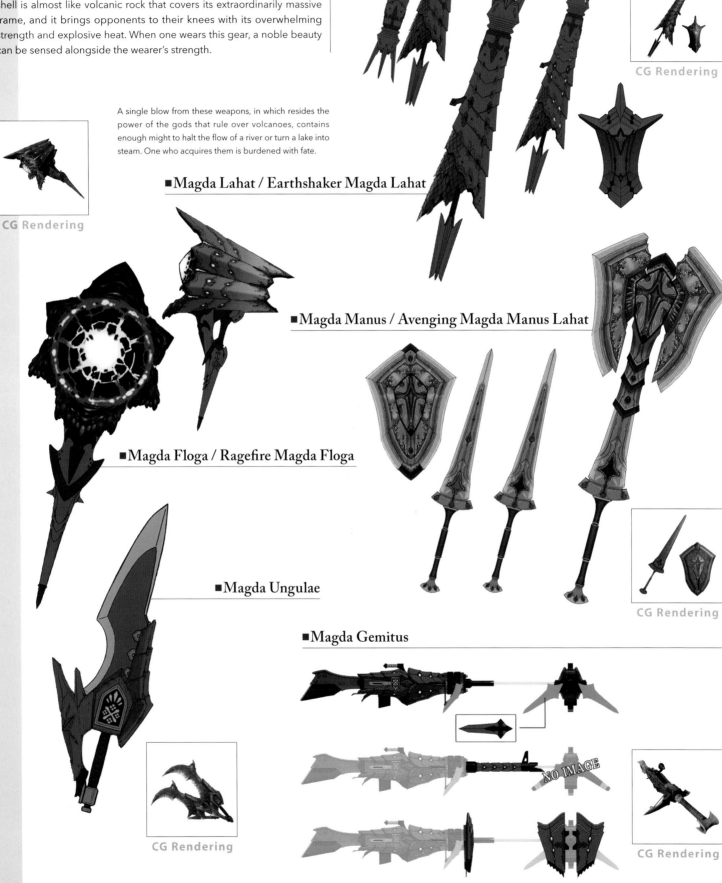

CG Rendering

CG Rendering

■Magda Lahat / Earthshaker Magda Lahat

■Magda Manus / Avenging Magda Manus Lahat

■Magda Floga / Ragefire Magda Floga

CG Rendering

■Magda Ungulae

■Magda Gemitus

NO IMAGE

CG Rendering

CG Rendering

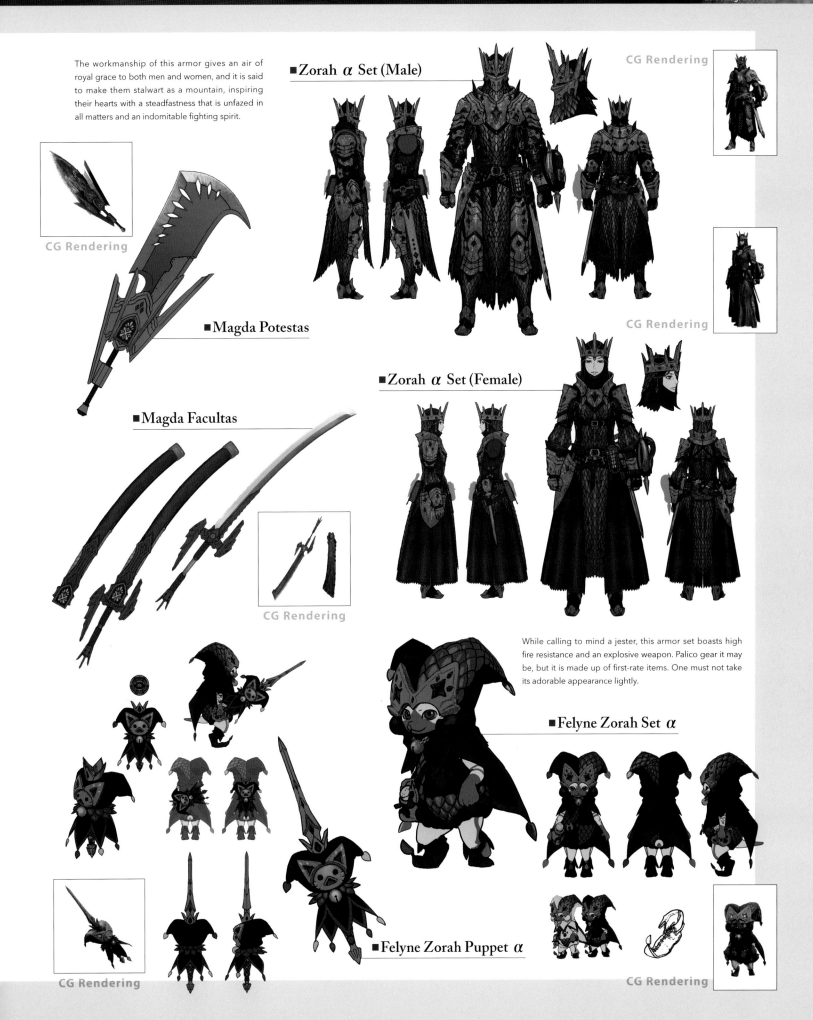

The workmanship of this armor gives an air of royal grace to both men and women, and it is said to make them stalwart as a mountain, inspiring their hearts with a steadfastness that is unfazed in all matters and an indomitable fighting spirit.

CG Rendering

■Magda Potestas

■Magda Facultas

CG Rendering

■Zorah α Set (Male)

CG Rendering

CG Rendering

■Zorah α Set (Female)

While calling to mind a jester, this armor set boasts high fire resistance and an explosive weapon. Palico gear it may be, but it is made up of first-rate items. One must not take its adorable appearance lightly.

■Felyne Zorah Set α

■Felyne Zorah Puppet α

CG Rendering

CG Rendering

Nergigante Equipment

Weapons and armor made from Nergigante material. Nergigante seeks Elder Dragons to turn into its own flesh and blood, and it wields a brutal power in doing so. Nergigante has sharp, wondrously hard spikes to protect its body, and these spikes have a frightening ability to regrow. The weapons made with Nergigante material can pierce and rend any opponent, and the armor can heal an injured body.

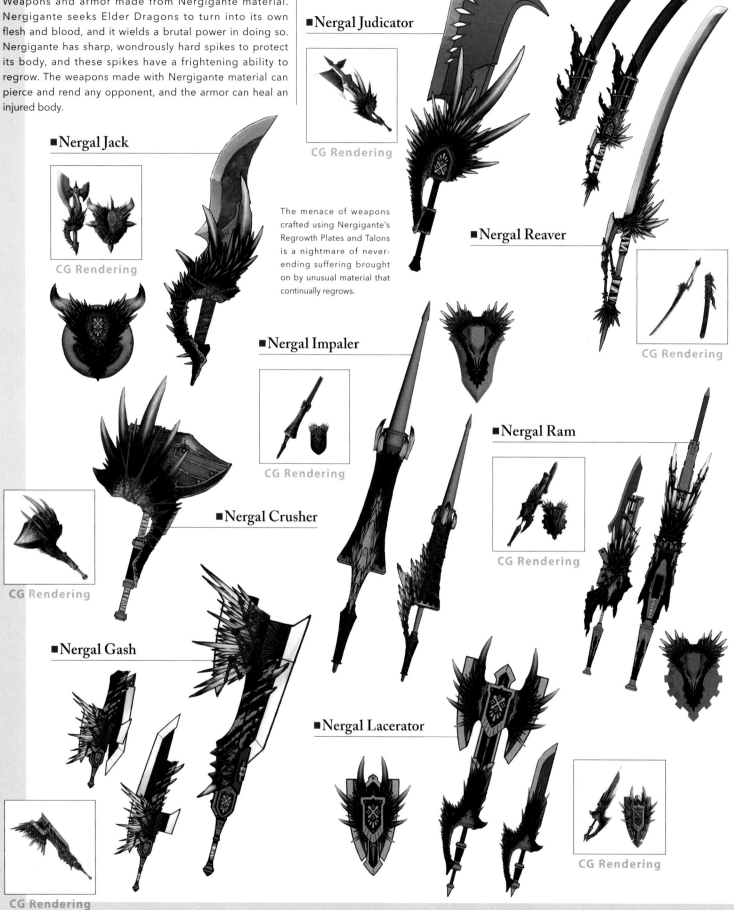

■Nergal Jack

CG Rendering

■Nergal Judicator

CG Rendering

The menace of weapons crafted using Nergigante's Regrowth Plates and Talons is a nightmare of never-ending suffering brought on by unusual material that continually regrows.

■Nergal Reaver

CG Rendering

■Nergal Impaler

CG Rendering

■Nergal Crusher

■Nergal Ram

CG Rendering

■Nergal Gash

■Nergal Lacerator

CG Rendering

CG Rendering

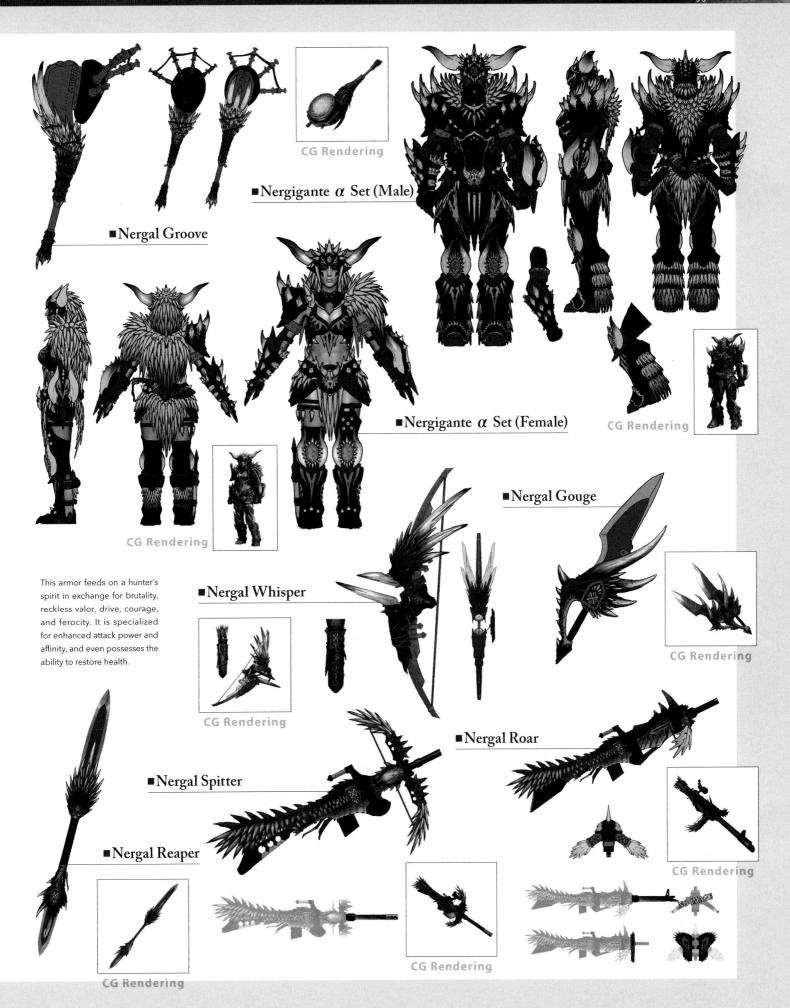

CG Rendering

■Nergigante α Set (Male)

■Nergal Groove

■Nergigante α Set (Female)

CG Rendering

CG Rendering

This armor feeds on a hunter's spirit in exchange for brutality, reckless valor, drive, courage, and ferocity. It is specialized for enhanced attack power and affinity, and even possesses the ability to restore health.

■Nergal Gouge

■Nergal Whisper

CG Rendering

CG Rendering

■Nergal Roar

■Nergal Spitter

■Nergal Reaper

CG Rendering

NO IMAGE

CG Rendering

CG Rendering

Nergigante Equipment

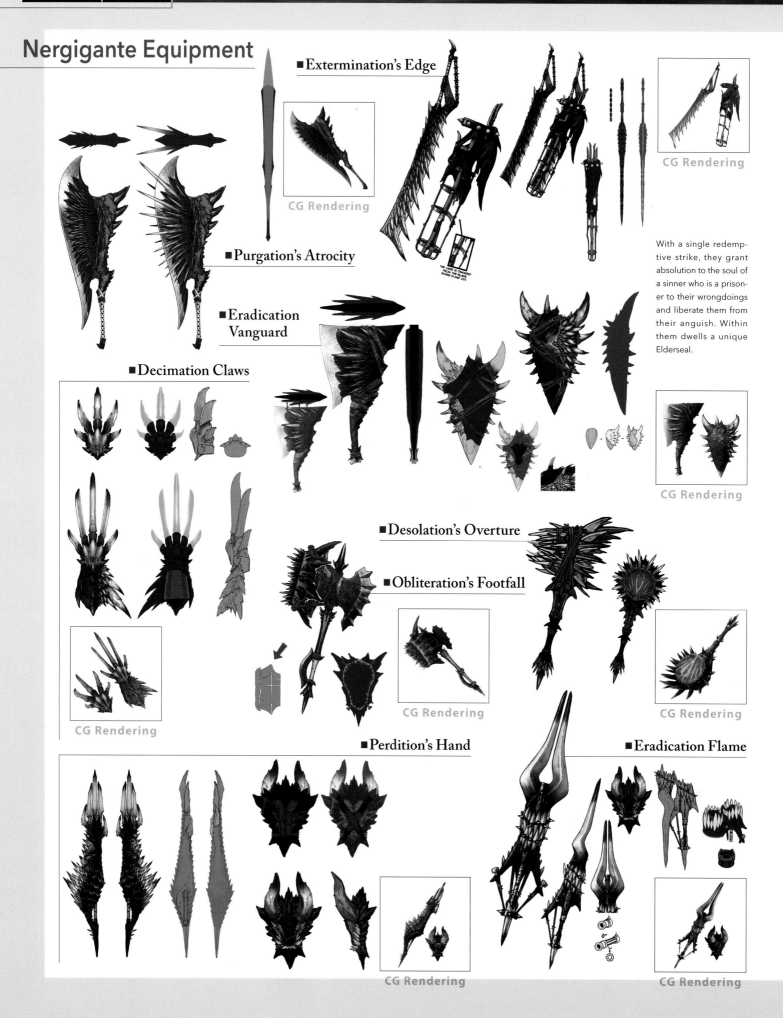

■ Extermination's Edge

CG Rendering

CG Rendering

■ Purgation's Atrocity

■ Eradication Vanguard

■ Decimation Claws

With a single redemptive strike, they grant absolution to the soul of a sinner who is a prisoner to their wrongdoings and liberate them from their anguish. Within them dwells a unique Elderseal.

CG Rendering

■ Desolation's Overture

■ Obliteration's Footfall

CG Rendering

CG Rendering

CG Rendering

■ Perdition's Hand

■ Eradication Flame

CG Rendering

CG Rendering

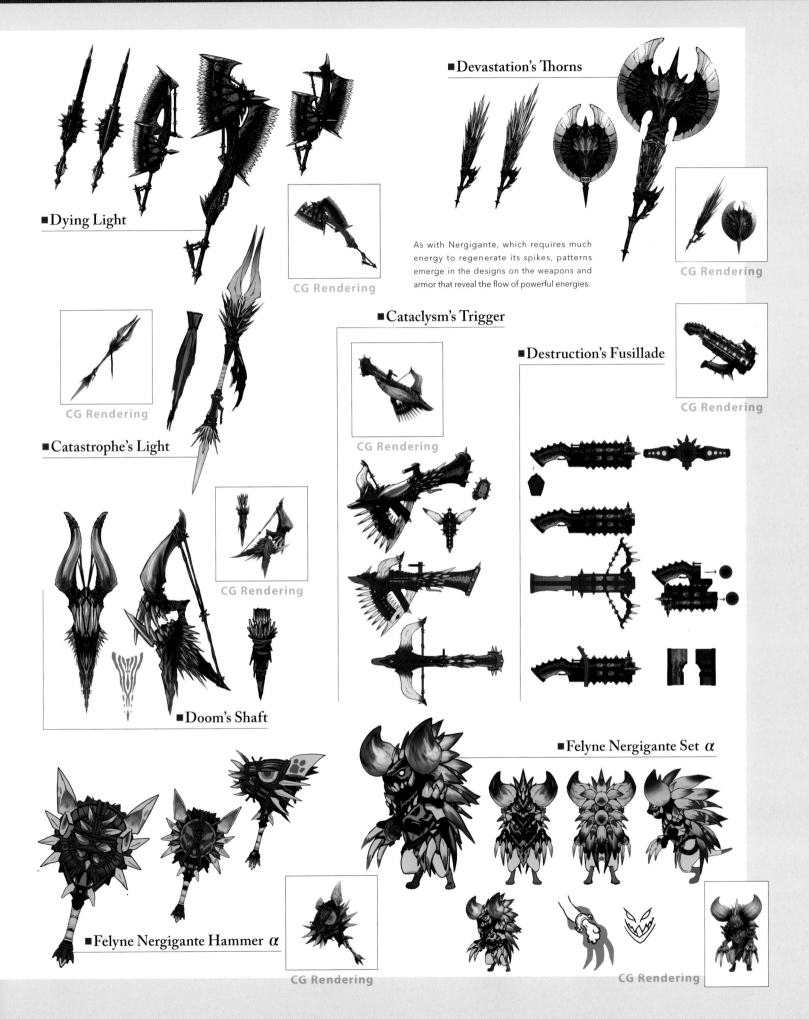

■Dying Light

CG Rendering

■Devastation's Thorns

CG Rendering

As with Nergigante, which requires much energy to regenerate its spikes, patterns emerge in the designs on the weapons and armor that reveal the flow of powerful energies.

CG Rendering

■Catastrophe's Light

CG Rendering

■Cataclysm's Trigger

CG Rendering

■Destruction's Fusillade

■Doom's Shaft

CG Rendering

■Felyne Nergigante Set α

■Felyne Nergigante Hammer α

CG Rendering

CG Rendering

459

Kirin Equipment

Weapons and armor made from Kirin material. The power of this Elder Dragon, with its fantastical form, in which one can sense the glory that comes with all the heavens' thunder, has been elevated into forms that can be worn on one's person thanks to the exceptional skills of the artisans. The pale-white attire defends against impact, and wielded weapons give off a majesty as if clad in lightning.

■Kirin Set (Male)

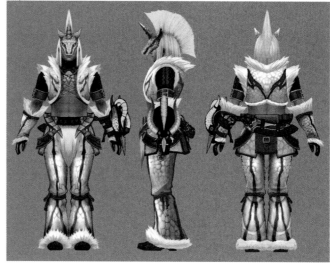

■Kirin Set (Female)

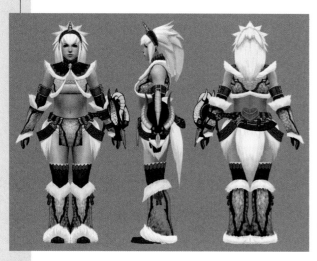

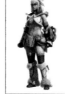
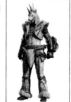

CG Rendering

CG Rendering

These weapons and armor are crafted with the beauty of the Kirin's Azure Horn and Mane still fully intact. Those who use them gain the power of thunder and also the divine protection of the spirits.

Kushala Daora Equipment

Weapons and armor made from Kushala Daora material. The benefit that the tough Kushala Daora material brings is not just a menacing level of hardness. These weapons are imbued with an icy bite, and they give one the power to defy gales. Their appearance calls to mind steel statues, and one is impressed by their stateliness.

■Kushala Alpha Set (Female)

This armor's majesty gives one the impression of an ancient deity come to life. The soul of Kushala Daora resides in the sharpness of the weapons, perhaps an effect of the gem used in the workmanship of the chest pieces.

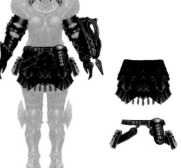

CG Rendering

■Kushala Alpha Set (Male)

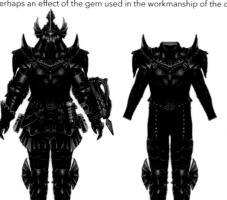
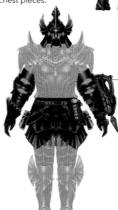
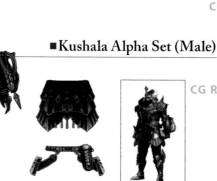
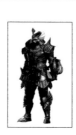

CG Rendering

Teostra Equipment

Weapons and armor made from Teostra material. The nobility of the imposing Emperor of Flame is revealed in these designs, and the Teostra's red flames are sealed within them thanks to the latest technology. As a result, the armor boasts a high resistance to heat in addition to its toughness, and attacks with these weapons are clad in its explosive powder.

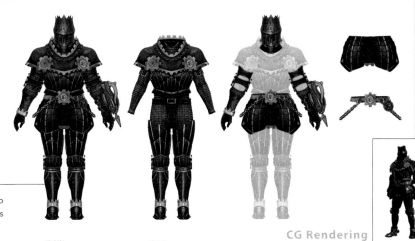

■ Teostra α Set (Male)

Those who equip this armor not only release latent power but are also able to learn martial arts to improve their ability to mitigate the sharpness of enemy weapons. This armor is considered to be exceptional.

CG Rendering

■ Teostra α Set (Female)

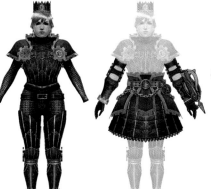

PLEASE ADD EARRINGS, WHICH CAN BE USED AS A SECOND PLACE FOR A COLOR ON THE HEAD.

CG Rendering

TOPIC

Armor Made from Tempered and Arch-Tempered Elder Dragons

As well as Tempered Elder Dragons, there are also Arch-Tempered Elder Dragons, which are in an even higher class. Those who have hunted them are awarded a special ticket as proof and receive special treatment at the Smithy. Gear forged with material from these Elder Dragons possesses capabilities that surpass all existing sets. And because the light they give off is so conspicuous, it's probably only natural that those around hunters using this gear must admit their superiority.

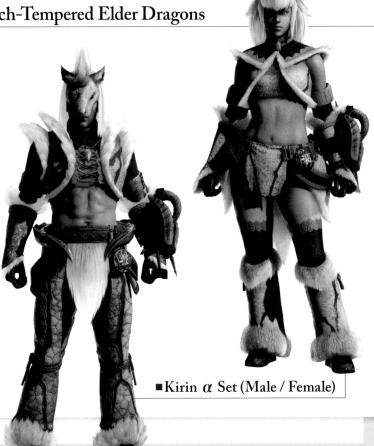

■ Kirin α Set (Male / Female)

Vaal Hazak Equipment

Weapons and armor made from Vaal Hazak material. Perhaps because it is modeled after an Elder Dragon whose source of power is rotting flesh and effluvium, this gear grants abilities befitting those who reap the lives of others. However, whispering voices resound in the heads of those who wear this attire. Ghostly voices tell the wearer to cut off their lingering attachments to life...

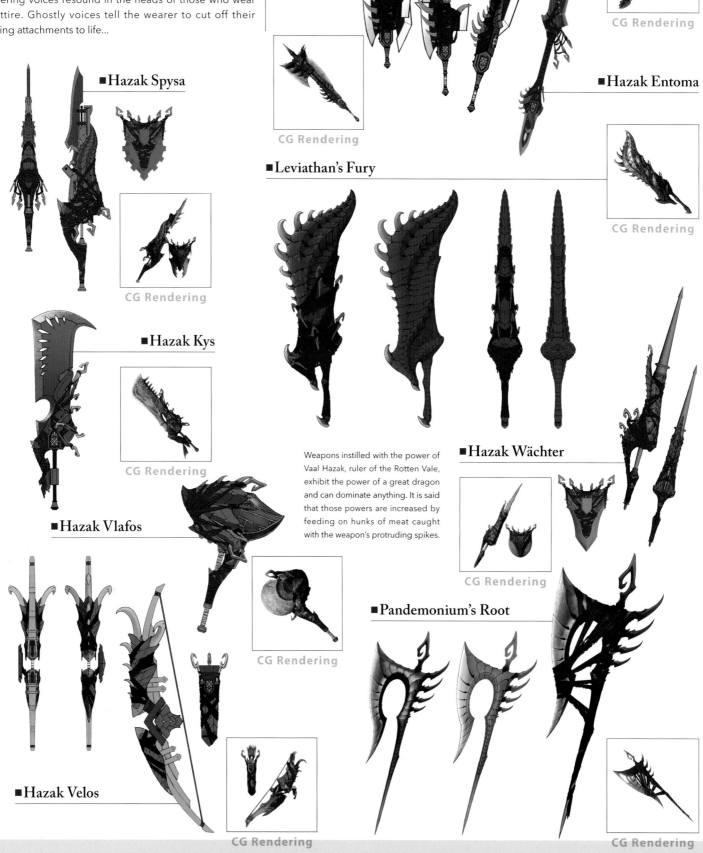

Hazak Demios

CG Rendering

Hazak Spysa

CG Rendering

Hazak Entoma

CG Rendering

Leviathan's Fury

Hazak Kys

CG Rendering

Weapons instilled with the power of Vaal Hazak, ruler of the Rotten Vale, exhibit the power of a great dragon and can dominate anything. It is said that those powers are increased by feeding on hunks of meat caught with the weapon's protruding spikes.

Hazak Wächter

CG Rendering

Hazak Vlafos

CG Rendering

Pandemonium's Root

Hazak Velos

CG Rendering

CG Rendering

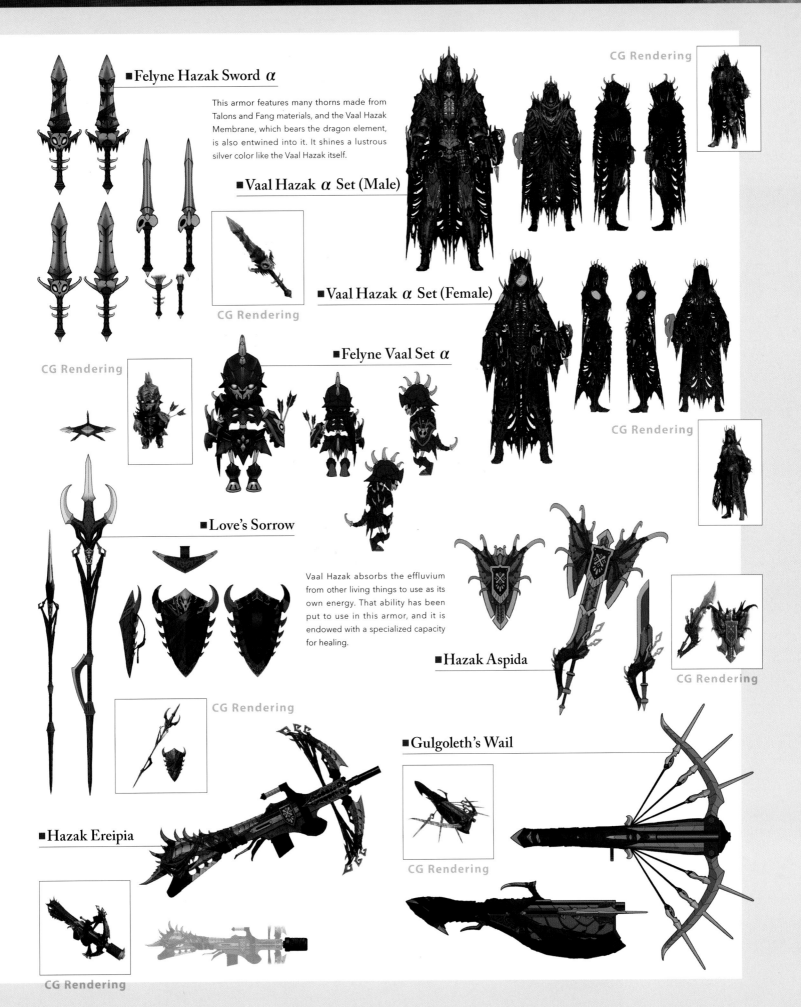

■ Felyne Hazak Sword α

This armor features many thorns made from Talons and Fang materials, and the Vaal Hazak Membrane, which bears the dragon element, is also entwined into it. It shines a lustrous silver color like the Vaal Hazak itself.

CG Rendering

■ Vaal Hazak α Set (Male)

CG Rendering

■ Vaal Hazak α Set (Female)

CG Rendering

CG Rendering

■ Felyne Vaal Set α

CG Rendering

■ Love's Sorrow

Vaal Hazak absorbs the effluvium from other living things to use as its own energy. That ability has been put to use in this armor, and it is endowed with a specialized capacity for healing.

■ Hazak Aspida

CG Rendering

CG Rendering

■ Gulgoleth's Wail

CG Rendering

■ Hazak Ereipia

CG Rendering

GADGETS
Extend World Gallery
Palico Gadget Laboratory

Palico weapons and armor demonstrate evidence of the exchange of friendship with the native inhabitants of the New World. Here we introduce the six types of Palico Gadgets. The more one uses them, the more convenient they are and the deeper one's experience of them becomes. We have also secretly acquired sketches for ideas that were rumored to exist and were original to Astera, so we've quietly published them here as well.

Brought to Life by the Wisdom of the Native Tribes

The Six Palico Gadgets

(1) Vigorwasp Spray
(2) Flashfly Cage
(3) Shieldspire
(4) Coral Orchestra
(5) Plunderblade
(6) Meowlotov Cocktail

MEDICINAL HERBS ARE TURNED INTO A POWDER, WATER IS ADDED, AND IT IS KNEADED INTO A PASTE.

AFTER USE

FSSS

MUCH LIKE A CAT ROCK

(1) A superb tool that summons Vigorwasps. The therapeutic spray is modeled after the cat-shaped rocks found in places inhabited by Felynes.

(2) A gift from the Bugtrappers. The cage can keep insects that emit light or paralyze. The Bugtrappers have also passed on the techniques for catching these insects.

(3) A gift from the Protectors. Made from hard bone, this sturdily built massive shield provokes monsters with its distinctively loud and rough design.

(4) A gift from the Troupers. This instrument boosts attack strength and status resistances. It is a combination horn and bongo that can play both subtle and bold tones.

(5) A gift from the Plunderers. With its claw-shaped blades, it can steal items from monsters. The right and left sides can also be joined together.

(6) A gift from the Gajalakas. It is a pot bomb for throwing, but it is also suitable for firing from a Palico slinger. With an emphasis on easy handling, it uses a moderate amount of gunpowder.

❖ Palico Gadget Analysis

Felyne Palicoes have taught us the secret of Vigorwasp Spray—medicinal herbs powdered, mixed with water, and kneaded into paste.

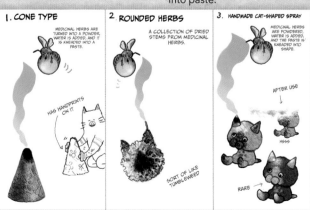

1. CONE TYPE
MEDICINAL HERBS TURNED INTO A POWDER, WATER IS ADDED, AND IT IS KNEADED INTO A PASTE.

HAS HANDPRINTS ON IT

2. ROUNDED HERBS
A COLLECTION OF DRIED STEMS FROM MEDICINAL HERBS.

SORT OF LIKE TUMBLEWEED

3. HANDMADE CAT-SHAPED SPRAY
MEDICINAL HERBS ARE POWDERED, WATER IS ADDED, AND THE PASTE IS KNEADED INTO SHAPE.

AFTER USE

FSSS

RARE

❖ Repeated Trial and Error

Trials to see whether medicinal herbs and leaves or stems should be used occured. Shapes tested included cones and dolls.

TOPIC
Two Types of Boomerangs for Throwing at Enemies at a Distance

When it comes to Palico Gadgets, boomerangs for long-range attacks are indispensable. There is the slashing-attack type carved from wood and the blunt-attack type made of bones put together in a cross. They can be swapped to match the Palico's other weapons. They always return, and they are so tough that they rarely break.

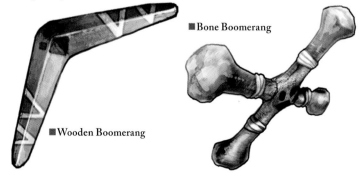

■ Bone Boomerang

■ Wooden Boomerang

They Actually Almost Used These? ▶▶▶

Numerous Idea Sketches

BEAST TECH SYSTEM: NEEDLES

BLOOD-SUCKING ITEMS

RECOVERY ATTACK

EXHAUST ATTACK

DASH ATTACK

Walks around with a giant medical implement containing liquids with various effects and injects them in the hunter as required. Perhaps hygiene was a concern?

The concept of packing potions for recovery into a beehive and using the potions as nutrients to raise medicinal herbs is a surprising one, but it did not end up being applied.

PALICO RECOVERY INSTALLATION ITEM PROPOSALS (NATURAL OBJECTS?)

A — MAYBE IT SHOULD BE GREEN AND FLICKERING TO MAKE IT EASY TO UNDERSTAND?

B — DROPS OF LIGHT COME OUT

RECOVERY BEEHIVE

THE SEEDLING GROWS INTO GLOWING LEAVES.

PALICO PLUNDER ITEM PROPOSALS

A — INSECT NET

B — FISHING ROD

C — STICKY NUNCHAKU HANDS

IDEAS USE EXISTING ITEMS

STATUS EFFECT ATTACKS: MEDICINE BOTTLES

POISON

BLAST

LOOKS LIKE A PICKLED WEAPON.

PARALYSIS

SLEEP

The idea here is that a Palico weapon would be soaked in an abnormal status effect liquid and would then gain the same effects as that liquid. That fact that if it broke it would invite disaster resulted in this idea being reconsidered.

PLUNDERING ART: ARABESQUE PATTERN WRAPPING CLOTH

IMPROVED PLUNDERING. THIEF VIBE.

GATHERING ART: CARGO WRAPPING CLOTH

RED

BLUE

GREEN

IMPROVE SPECIAL GATHERING

HIGH-SPEED GATHERING

YELLOW

GATHER FINDING SKILL

GATHERING FOCUS

This style employs simple cloth for plundering and harvesting. If one observes the variations in color patterning, it's quite obvious that the bags have specialized abilities.

OTHER VISUAL IDEAS

BUG GLASS

LOCATE ITEMS FOR GATHERING ANTIVIRUS, ETC.

SHIELD + HELM, MANTLE

SOUND PROTECTION, IMPROVED GUARD, WIND PROTECTION, IMPROVED PROTECTION AGAINST ABNORMAL CONDITIONS

HUGE SHIELD

IRON WALL SKILL *EVEN A HUNTER CAN HIDE BEHIND IT!

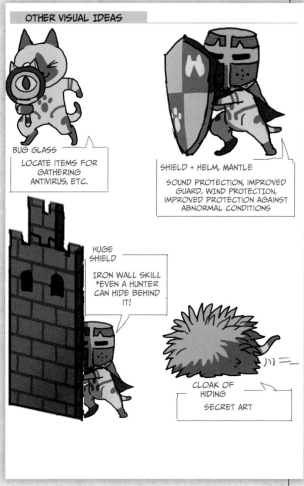

CLOAK OF HIDING

SECRET ART

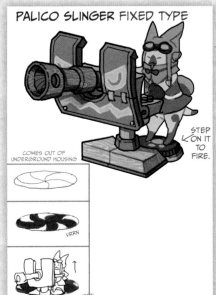

PALICO SLINGER FIXED TYPE

STEP ON IT TO FIRE.

COMES OUT OF UNDERGROUND HOUSING

VRRN

VWEEN

This fixed-type Palico slinger was also devised with base defense in mind. The specs would have been more powerful and durable compared to the mobile type.

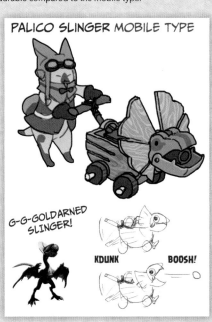

PALICO SLINGER MOBILE TYPE

G-G-GOLDARNED SLINGER!

KDUNK

BOOSH!

The mobile Palico slinger started with a prototype based on the motif of an Old World monster and was refined to be suitable for Meowlotov Cocktails.

Among the many Palico Gadgets designed, it seems the defense-enhancement side of things was a major topic. It is a godsend that the Shieldspire was acquired.

Xeno'jiiva Equipment

Weapons and armor made from Xeno'jiiva material. Parts of Xeno'jiiva's body were made by feeding on the pulsing energy from the veins of the earth, and that rushing power becomes a faint light that spills out, unleashing a brilliance that seems not of this world. Wearing this attire grants one a mysterious power.

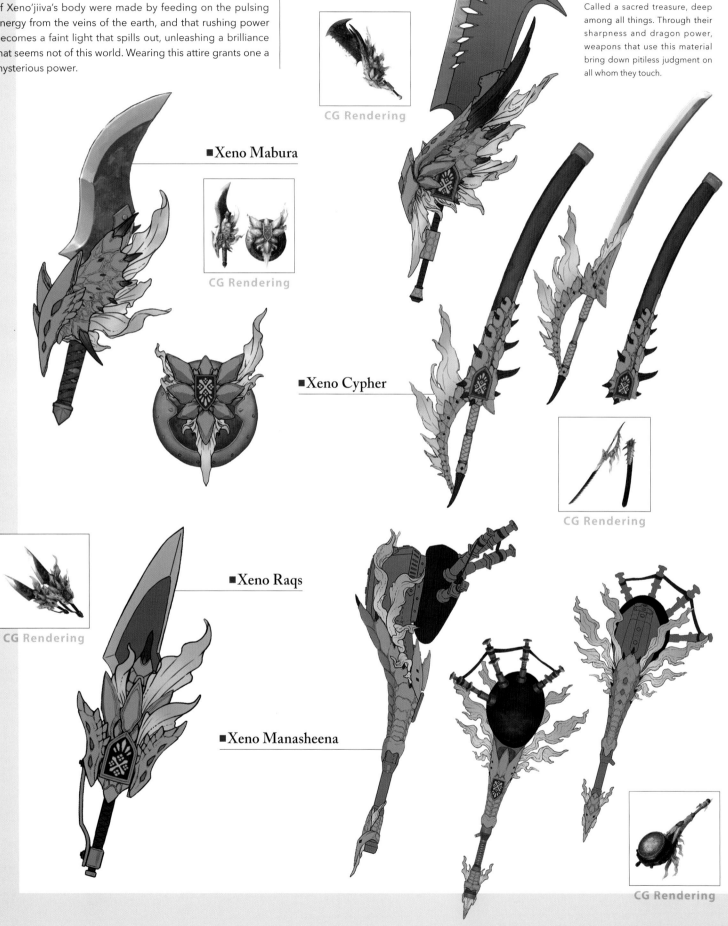

■Xeno Maliq

CG Rendering

Called a sacred treasure, deep among all things. Through their sharpness and dragon power, weapons that use this material bring down pitiless judgment on all whom they touch.

■Xeno Mabura

CG Rendering

■Xeno Cypher

CG Rendering

■Xeno Raqs

CG Rendering

■Xeno Manasheena

CG Rendering

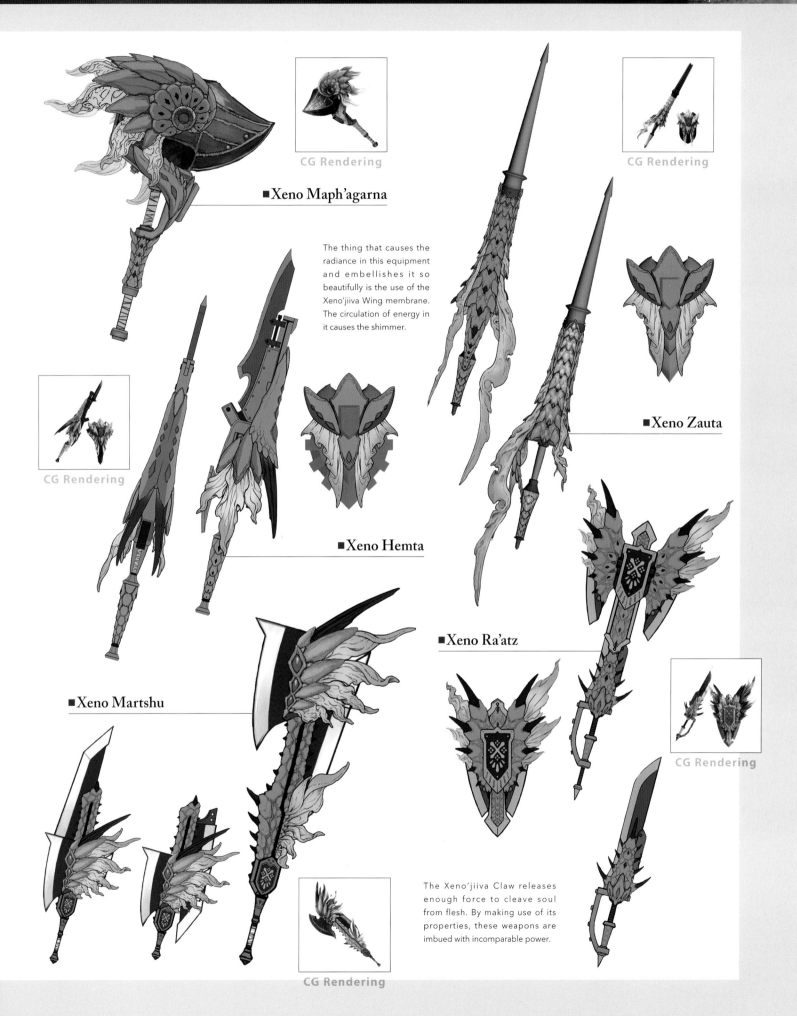

■Xeno Maph'agarna

CG Rendering

The thing that causes the radiance in this equipment and embellishes it so beautifully is the use of the Xeno'jiiva Wing membrane. The circulation of energy in it causes the shimmer.

CG Rendering

■Xeno Zauta

CG Rendering

■Xeno Hemta

■Xeno Ra'atz

■Xeno Martshu

The Xeno'jiiva Claw releases enough force to cleave soul from flesh. By making use of its properties, these weapons are imbued with incomparable power.

CG Rendering

467

Xeno'jiiva Equipment

It is as if this armor embodies the innocent souls making merry at an underworld revelry. By wearing it, one is blessed with the circulation of high energies within, and one's heart and mind are inspired to action.

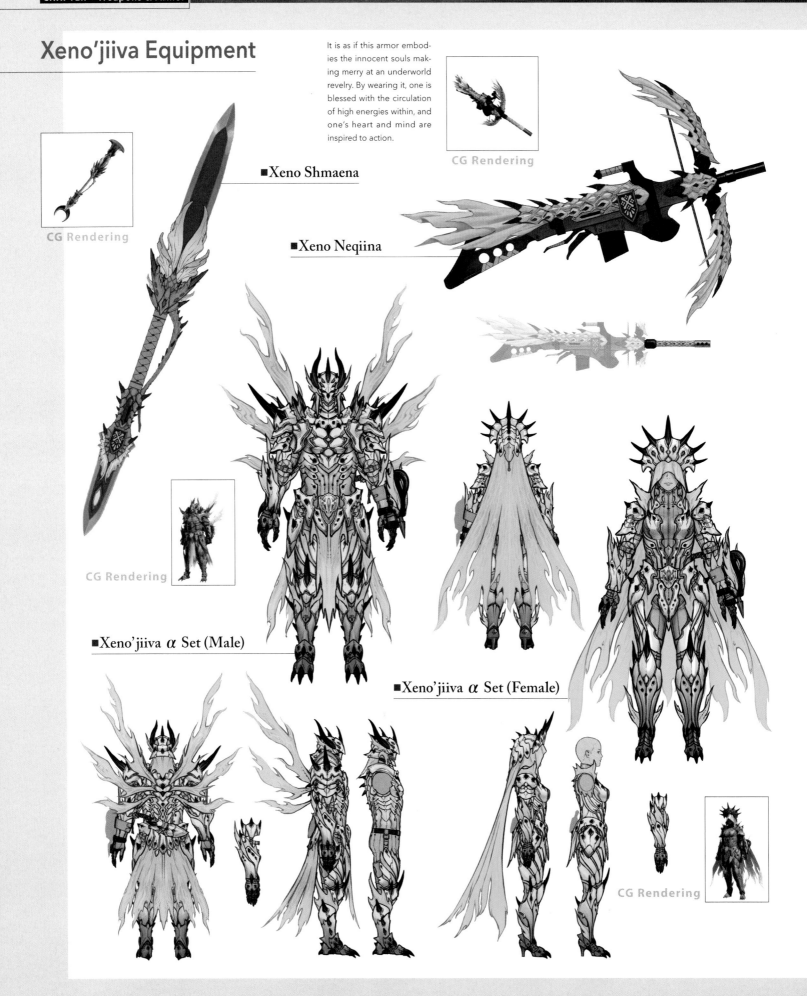

CG Rendering

■Xeno Shmaena

■Xeno Neqiina

CG Rendering

CG Rendering

■Xeno'jiiva α Set (Male)

■Xeno'jiiva α Set (Female)

CG Rendering

468

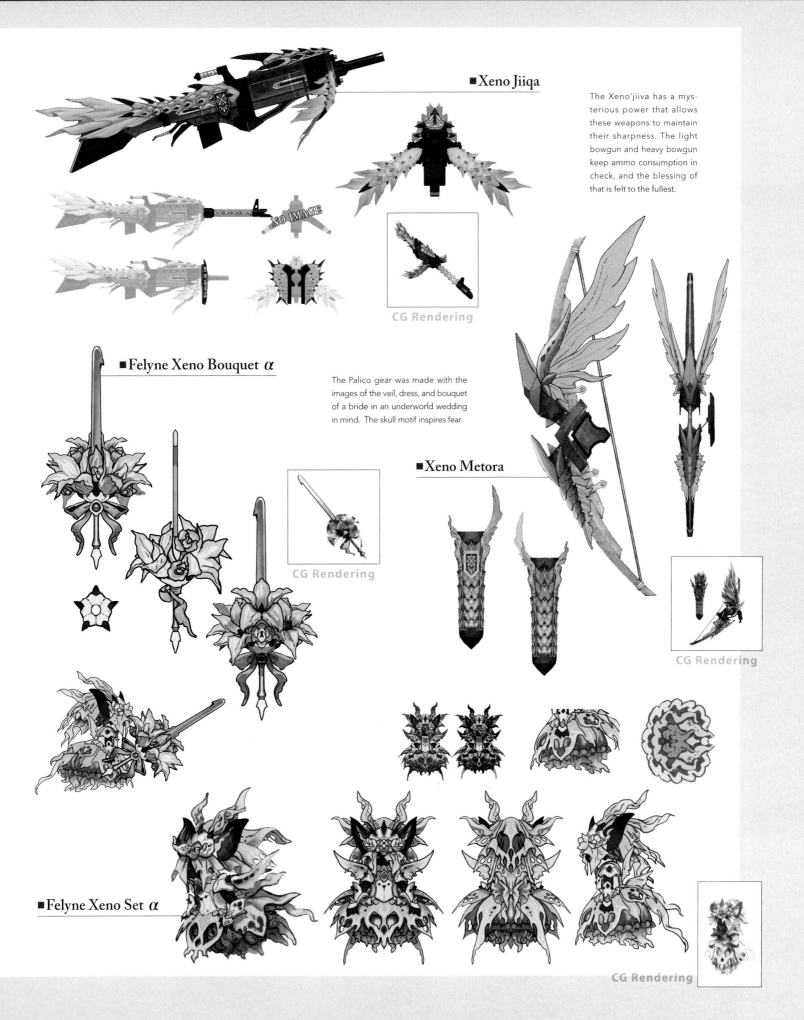

■Xeno Jiiqa

The Xeno'jiiva has a mysterious power that allows these weapons to maintain their sharpness. The light bowgun and heavy bowgun keep ammo consumption in check, and the blessing of that is felt to the fullest.

NO IMAGE

CG Rendering

■Felyne Xeno Bouquet α

The Palico gear was made with the images of the veil, dress, and bouquet of a bride in an underworld wedding in mind. The skull motif inspires fear.

CG Rendering

■Xeno Metora

CG Rendering

■Felyne Xeno Set α

CG Rendering

469

Deviljho Equipment

Weapons and armor made from Deviljho material. Deviljho eats as it pleases and is brutal to the limit. This equipment is proof one has bested a Deviljho, and if one acquires it, along with the Deviljho level of power one gains from it, one is driven by a dangerous urge to destroy.

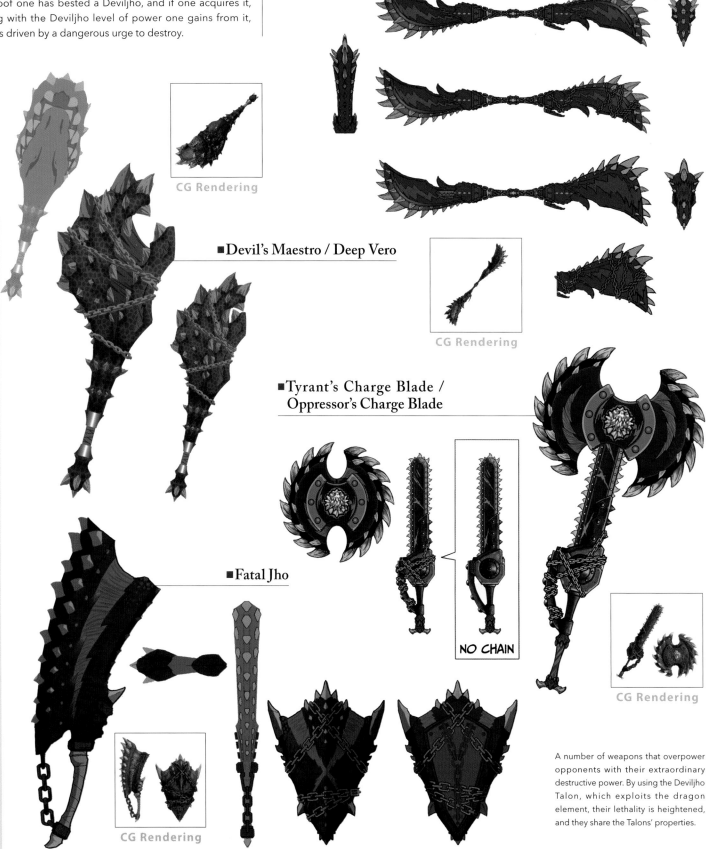

CG Rendering

■Bad Wing / Grunge Storm

■Devil's Maestro / Deep Vero

CG Rendering

■Tyrant's Charge Blade / Oppressor's Charge Blade

NO CHAIN

■Fatal Jho

CG Rendering

CG Rendering

CG Rendering

A number of weapons that overpower opponents with their extraordinary destructive power. By using the Deviljho Talon, which exploits the dragon element, their lethality is heightened, and they share the Talons' properties.

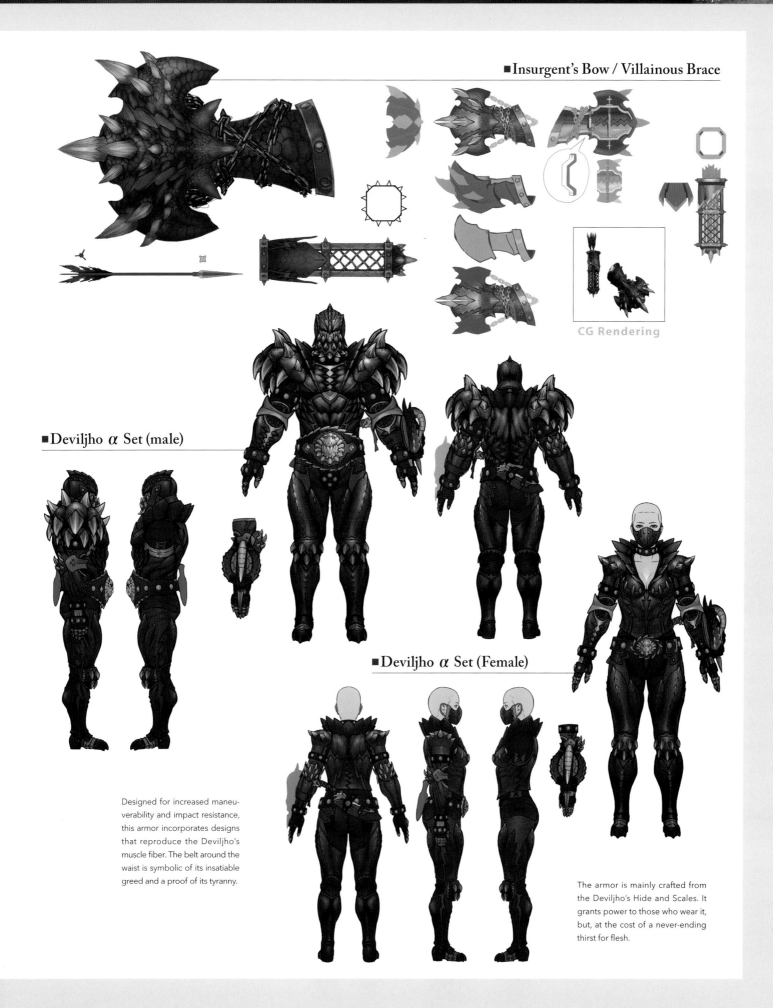

■Insurgent's Bow / Villainous Brace

CG Rendering

■Deviljho α Set (male)

Designed for increased maneuverability and impact resistance, this armor incorporates designs that reproduce the Deviljho's muscle fiber. The belt around the waist is symbolic of its insatiable greed and a proof of its tyranny.

■Deviljho α Set (Female)

The armor is mainly crafted from the Deviljho's Hide and Scales. It grants power to those who wear it, but, at the cost of a never-ending thirst for flesh.

Kulve Taroth Equipment

Weapons and armor made from Kulve Taroth material. The Elder Dragon, also called the Mother Goddess, is adorned in shining metal and has brought many blessings to Astera. Their value aside, the weapons possess various abilities, and the armor is resplendent with ornamentation, so many people are captivated by them.

■ **Kulve Taroth α Set (Male)**

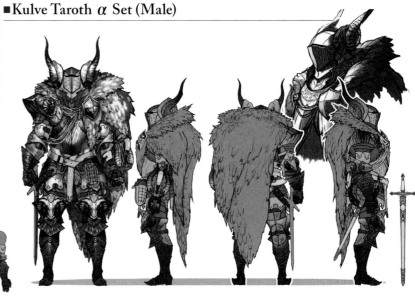

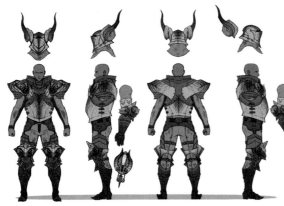

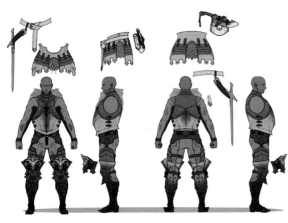

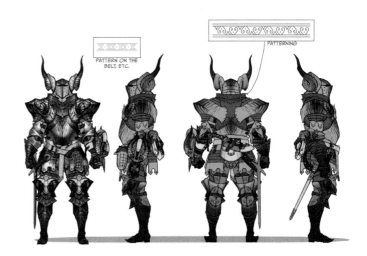

PATTERN ON THE BELT, ETC.

PATTERNING

■ **Kulve Taroth β Set (Male)**

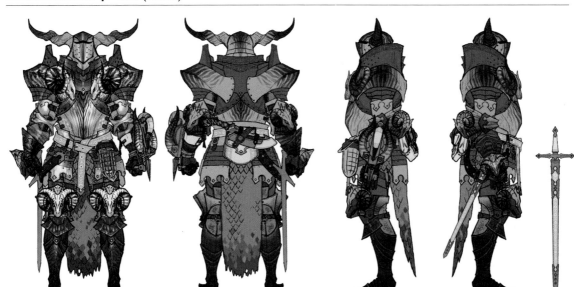

The armor has an outer layer of gold plating, and those who wear it gain the charisma and grandeur of a monarch who is full of fortitude and affection.

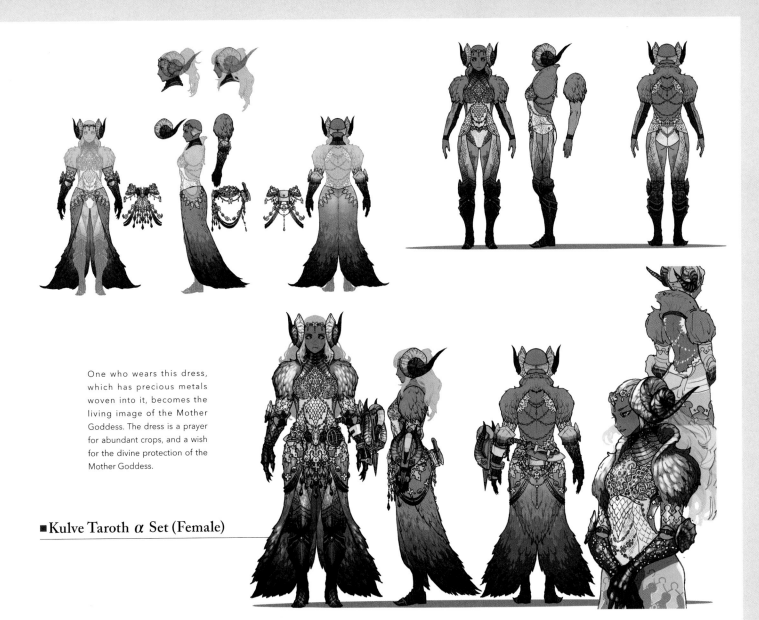

One who wears this dress, which has precious metals woven into it, becomes the living image of the Mother Goddess. The dress is a prayer for abundant crops, and a wish for the divine protection of the Mother Goddess.

■ Kulve Taroth α Set (Female)

■ Kulve Taroth β Set (Female)

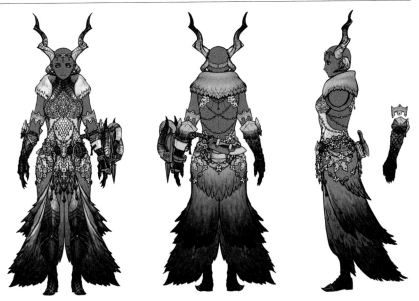

This armor possesses capabilities that demonstrate effectiveness in all facets of offense and defense, and with its gold everywhere, it demonstrates excellent conductivity of heat and electricity. The ornamentation on the head, which forms a spiral and apes the great horns of Kulve Taroth, contains within it the Mother Goddess's fury.

Kulve Taroth Equipment

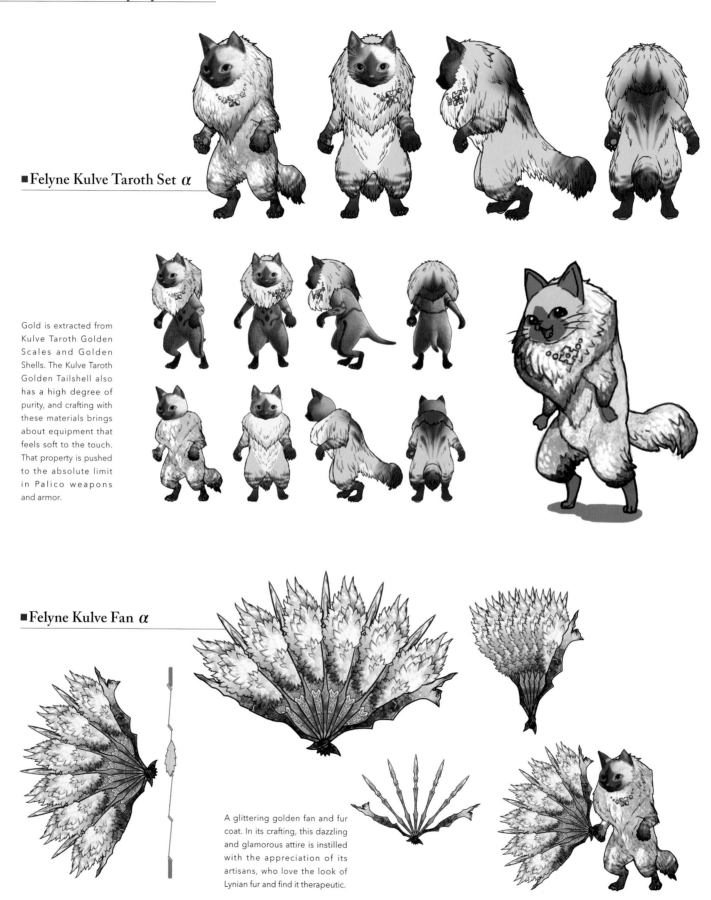

■Felyne Kulve Taroth Set α

Gold is extracted from Kulve Taroth Golden Scales and Golden Shells. The Kulve Taroth Golden Tailshell also has a high degree of purity, and crafting with these materials brings about equipment that feels soft to the touch. That property is pushed to the absolute limit in Palico weapons and armor.

■Felyne Kulve Fan α

A glittering golden fan and fur coat. In its crafting, this dazzling and glamorous attire is instilled with the appreciation of its artisans, who love the look of Lynian fur and find it therapeutic.

The Numerous Appraisal Weapons That Can Be Obtained from Kulve Taroth

The various weapons that have been melted and attached to Kulve Taroth's body are used as material in the completion of new weapons that bear the name of Kulve Taroth. When this happens, these higher-grade articles are known as Kulve Taroth Weapons. These weapons are mixed with gold and other materials, and they're attractive for their beauty and high performance. For the weapons on display here, we asked the artisans to do the impossible and restore those weapons that had been melted onto the beast.

(IRON-BASE GREAT SWORD 1) (IRON-BASE GREAT SWORD 2) (IRON-BASE GREAT SWORD 3)

(BONE-BASE GREAT SWORD 1) (BONE-BASE GREAT SWORD 2) (BONE-BASE GREAT SWORD 3)

CG Rendering

CG Rendering

Many of the weapons made in Astera are based around metal or bone crafted into sword blades and gun barrels, and they are enhanced with the addition of monster materials. One should consider that these restored weapons having undergone a similar process.

■Dissolved Weapon: Great Sword

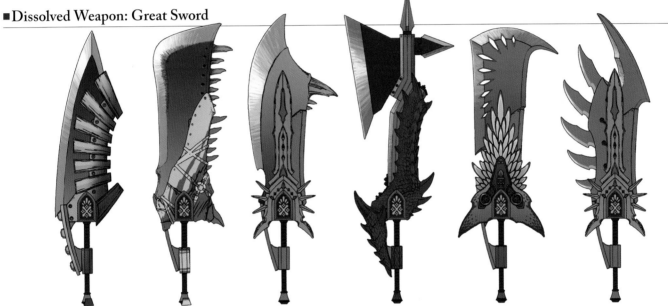

■Dissolved Weapon: Long Sword

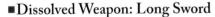

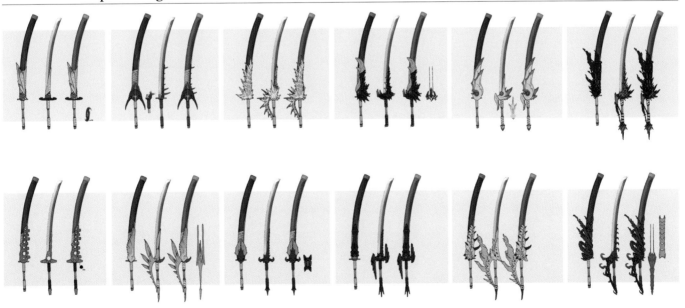

Kulve Taroth Equipment

■Dissolved Weapon: Sword and Shield

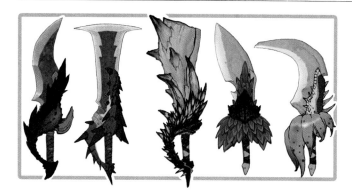

■Dissolved Weapon: Dual Blades

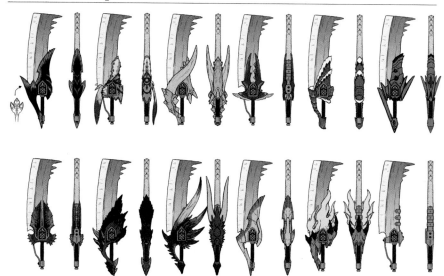

■Dissolved Weapon: Hammer

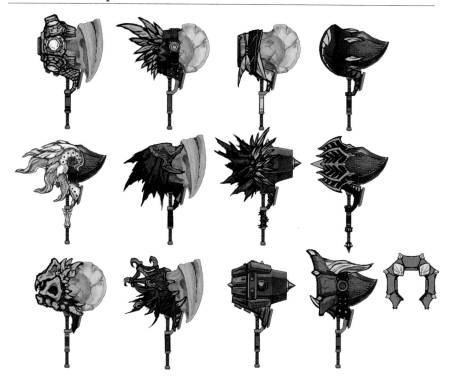

CG Rendering

CG Rendering

CG Rendering

CG Rendering

CG Rendering

476

■Dissolved Weapon: Hunting Horn

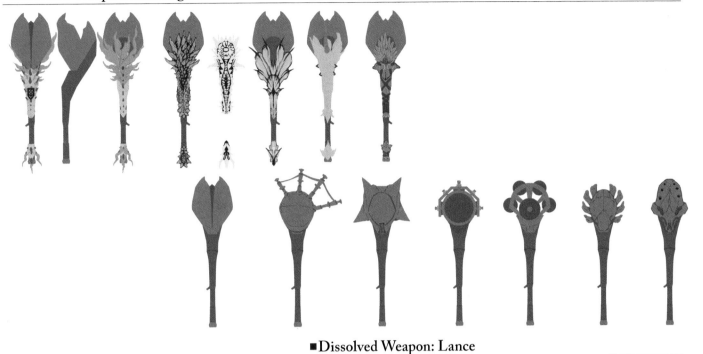

Of the weapons thought to have been created in Astera, the base components of only the gunlance, the two types of bowguns, and the bow have been discovered. Perhaps by examining the age of the weapons, we can clarify the ecological travel routes of Kulve Taroth in recent years.

■Dissolved Weapon: Lance

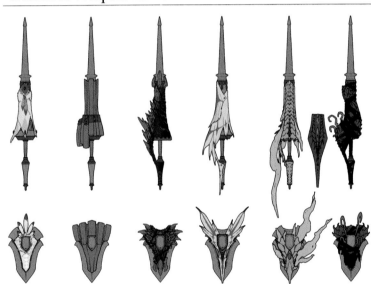

■Dissolved Weapon: Gunlance (Bayonet Part)

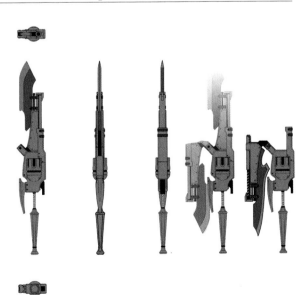

■Dissolved Weapon: Gunlance (Shield Part)

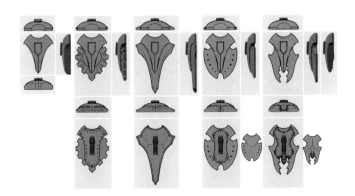

Kulve Taroth Equipment

■Dissolved Weapon: Charge Blade (Iron Base)

■Dissolved Weapon: Charge Blade (Bone Base)

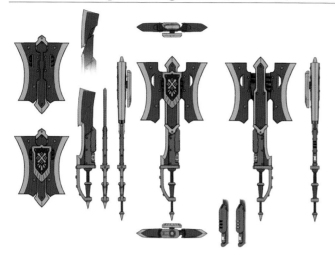

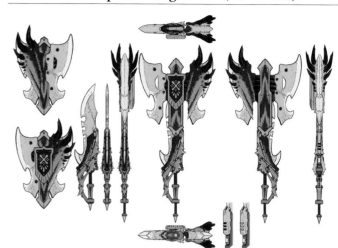

■Dissolved Weapon: Insect Glaive

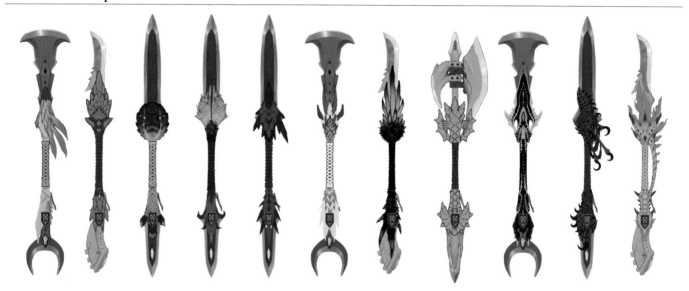

■Dissolved Weapon: Bow (iron base)

CG Rendering

CG Rendering

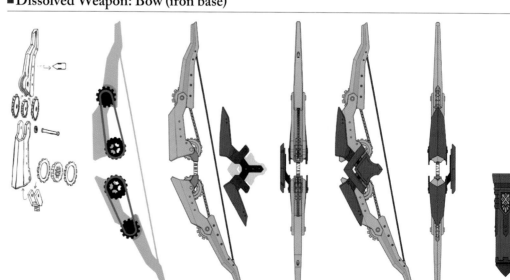

■Dissolved Weapon: Heavy Bowgun (Iron Base)

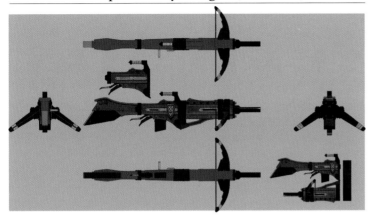

■Dissolved Weapon: Light Bowgun (Bone Base)

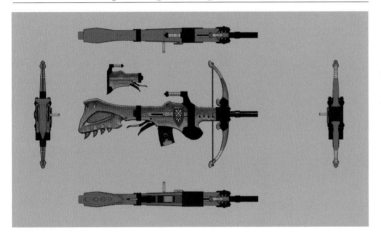

■Dissolved Weapon: Heavy Bowgun (Iron Base / Barrel)

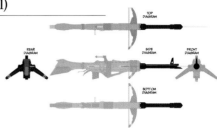

■Dissolved Weapon: Heavy Bowgun (Iron Base / Shield)

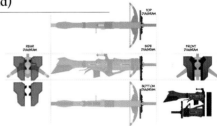

■Dissolved Weapon: Heavy Bowgun (Iron Base / Extension Parts)

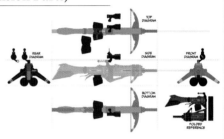

■Dissolved Weapon: Light Bowgun (Bone Base / Silencer)

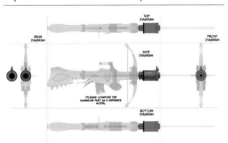

■Dissolved Weapon: Light Bowgun (Bone Base / Long Barrel)

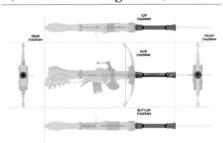

■Dissolved Weapon: Light Bowgun (Bone Base / Extension Parts)

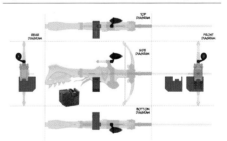

■Dissolved Weapon: Bow (Bone Base)

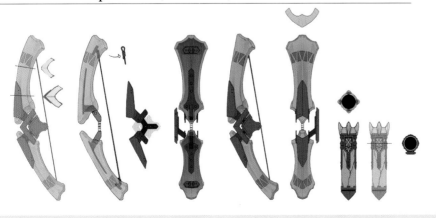

CG Rendering

CG Rendering

CG Rendering

Lunastra Equipment

Weapons and armor made from Lunastra material. As if in praise of the Empress of Flame, this armor is decorated in noble tones, bewitching the hearts of those who see it. The blue flames invoke fear of the fires of hell, and the weapons they produce grant their wielders peerless abilities.

CG Rendering

■Lunastra α Set (Male)

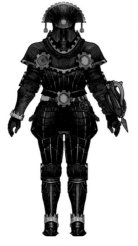

(Portions of the armor's color can be changed)

One senses the majesty of an immovable tower from this armor that has the blue flame of Lunastra sealed within. Also, it boasts an unwavering resistance to flame thanks to the properties of the Lunastra Mane.

CG Rendering

■Lunastra α Set (Female)

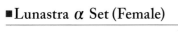

The armor color can be changed.

TOPIC The Special Powers Contained Within Weapons Produced Using Lunastra Materials

Inside these weapons, which give off Lunastra's blue light, dwell secret powers. The first is guarding their users from fatal blows. The second is healing their users' wounds. The third is increasing the durability of sword blades, bullets, and arrows.

These almost miraculous abilities manifest separately because Elder Dragon materials and Lunastra materials resonate with each other. These effects have been confirmed in all types, including the Charge Blades on the right.

Lunastra Tree
Weapon Skill: Guts

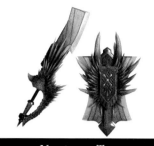

Nergigante Tree
Weapon Skill: Hasten Recovery

Xeno'jiiva Tree
Weapon Skill: Razor Sharp / Spare Shot

■Felyne Lunastra Set α

With a beautiful parasol in hand that exudes a noble dignity, this Palico armor is an elegant match for parkgoers. The style of the attire has been passed down by a family line from a faraway place.

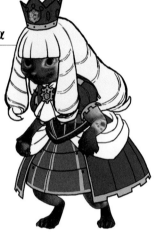
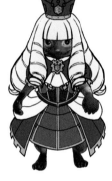

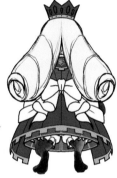

CG Rendering

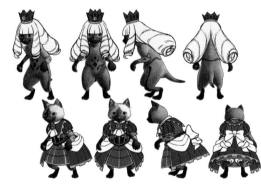

CG Rendering

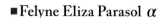

■Felyne Eliza Parasol α

Those who don Lunastra armor are all granted equal favor. The effect is the addition of a Stamina Cap Up for the wearer, and the further effect of Mind's Eye / Ballistics for weapons.

Astera Festival Memories

Extend **World Gallery**

Seasonal Events That Decorate the Celestial Pursuit Tavern in Splendor

Astera Fests Photo Memorial

Spring Blossom Fest

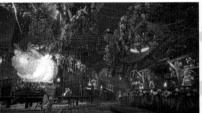

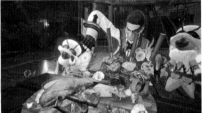

This event commemorates the season of blooming flowers, and there is a giant Poogie art object decorated with flowers of every color. On top of that, a Felyne seems to love tossing petals.

Summer Twilight Fest

A celebration to forget the heat and feel cool and refreshed for a while. Everyone wears uninhibited clothing, while the Felynes build a Rathalos ice sculpture that chills one's bones.

Autumn Harvest Fest

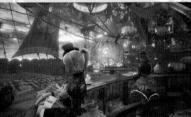

Celebrating the harvesting of the grains, costumed revelers pray that anything inauspicious that causes harm is driven away. There's a giant pumpkin sculpture in the shape of a Felyne.

Winter Star Fest

The purpose of this festival is to pray that the dead find rest and for the growth of new buds. Exquisite and beautiful illuminated glass paints the icy-cold nights with resplendence.

❖ Astera Fests

Following Old World customs, Astera Fests commemorate the changing of seasons. They are held four times a year and last for about twenty days. Hard work is put into decorating the Celestial Pursuit Gathering Hub, and there one is met by Felynes, unique meals, and the Celestial Pursuit staff in seasonal clothing. The bar counter handles event quests exclusive to the fest, and even many quests from the past, so it's more lively than usual. The sale of goods, daily bounties, and special items and gear associated with each of the seasons are also available, so whenever a festival is held it is bursting with excitement.

TOPIC

Poogie Is Decked Out in Flamboyant Special Costumes Too

When there's an Astera Fest, a Commission member with a forte for sewing creates seasonal and festival-appropriate costumes for Poogie, as shown here. Not only does Poogie not mind changing clothes, but the member has taken precise measurements of Poogie and seems to understand perfectly how to win over Poogie. The designs are based on the outfits worn by the Handler.

❖ **Spring Blossom Fest**
Buzzy Bee

❖ **Appreciation Fest**
Sparkling Party

The Appreciation Fest is a special event held to commemorate the one-year anniversary of the arrival of the Fifth Fleet. Poogie's costume is an especially happy outfit that fits the festive atmosphere.

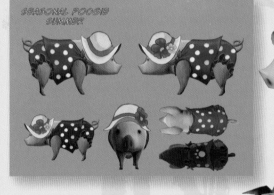

SEASONAL POOGIE
SUMMER

❖ **Summer Twilight Fest**
Seaside Sausage

❖ **Winter Star Fest**
Boa Bell Coat

❖ **Autumn Harvest Fest**
Pumpkin's Revenge

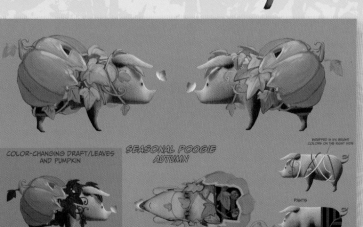

COLOR-CHANGING DRAFT/LEAVES
AND PUMPKIN

SEASONAL POOGIE
AUTUMN

WRAPPED IN MY BRIGHT
COLORS ON THE RIGHT SIDE

PANTS

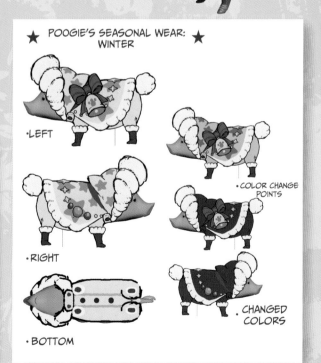

★ **POOGIE'S SEASONAL WEAR:** ★
WINTER

• LEFT

• COLOR CHANGE
POINTS

• RIGHT

• CHANGED
COLORS

• BOTTOM

Small Monsters Equipment

These are weapons and armor made from small monster material. Each organism has its own characteristic properties, and in many cases, only one part of the armor can made be made that exploits those properties. As with material from Neopterons, it can be said that the creation of a complete set of these weapons and armor is rare.

When it comes to Neopteron material, one can gather it and increase its density so it becomes harder than one would imagine. It has even been used in weapons and armor in the Old World for ages. Some hints were taken from the way the creatures huddle into a defensive formation, and it seems now only their vulnerability to fire has not been overcome.

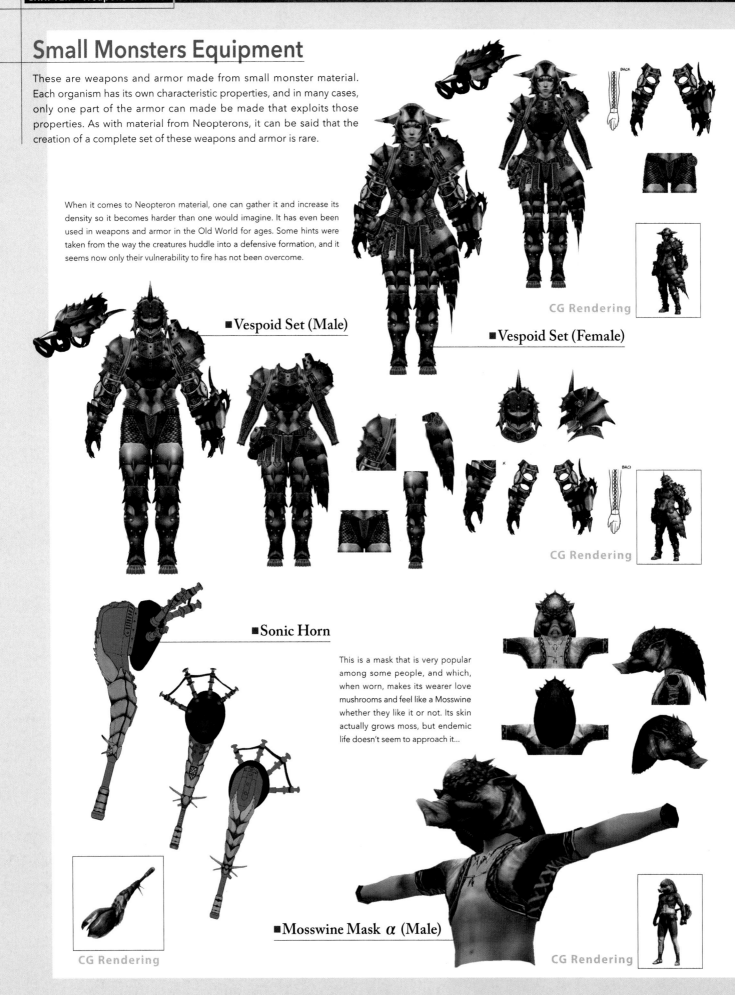

■Vespoid Set (Male)

■Vespoid Set (Female)

CG Rendering

CG Rendering

■Sonic Horn

■Mosswine Mask α (Male)

This is a mask that is very popular among some people, and which, when worn, makes its wearer love mushrooms and feel like a Mosswine whether they like it or not. Its skin actually grows moss, but endemic life doesn't seem to approach it...

CG Rendering

CG Rendering

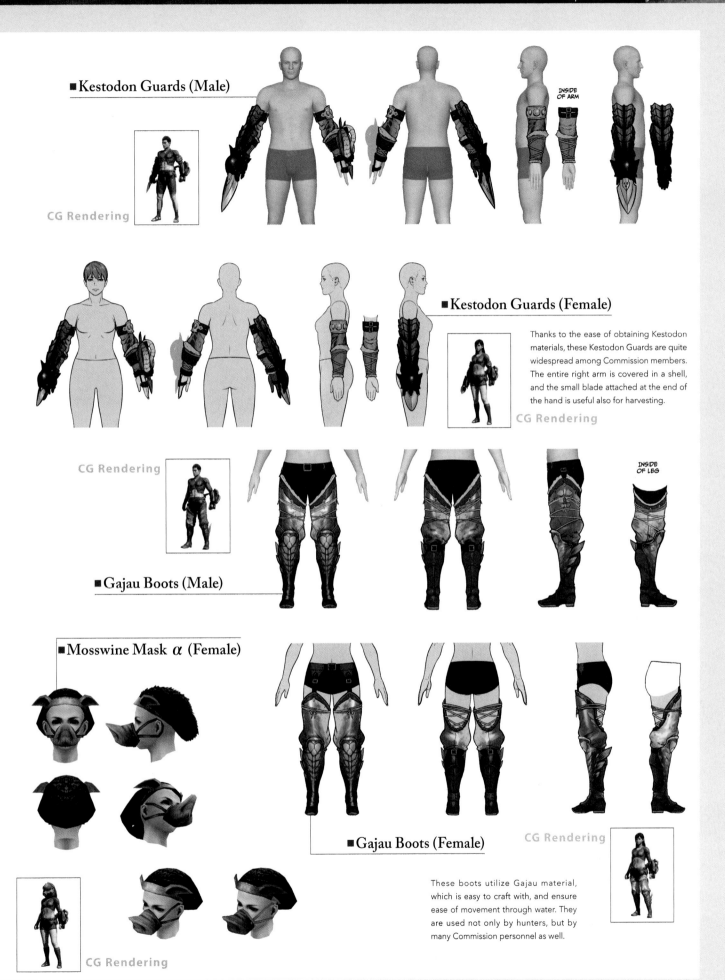

■Kestodon Guards (Male)

CG Rendering

INSIDE OF ARM

■Kestodon Guards (Female)

Thanks to the ease of obtaining Kestodon materials, these Kestodon Guards are quite widespread among Commission members. The entire right arm is covered in a shell, and the small blade attached at the end of the hand is useful also for harvesting.

CG Rendering

CG Rendering

INSIDE OF LEG

■Gajau Boots (Male)

■Mosswine Mask α (Female)

■Gajau Boots (Female)

CG Rendering

These boots utilize Gajau material, which is easy to craft with, and ensure ease of movement through water. They are used not only by hunters, but by many Commission personnel as well.

CG Rendering

485

Small Monsters Equipment

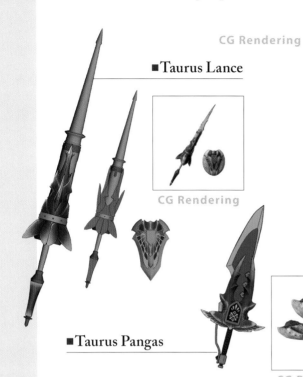

■Taurus Lance

CG Rendering

CG Rendering

■Taurus Pangas

CG Rendering

CG Rendering

CG Rendering

■Shamos Goggles (Male)

■Shamos Goggles (Female)

CG Rendering

■Gastodon Horn α (Male)

The goggles make it possible to have night vision like a Shamos. The thick, hard fur of the headdress, which is modeled after the head of a Gastodon, absorbs impacts. The jacket is made from Barnos hide that is carefully tanned and processed to be resistant to heat. Both are exceptionally practical.

CG Rendering

■Barnos Jacket α (Male)

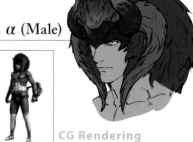

■Hornetaur Set (Male)

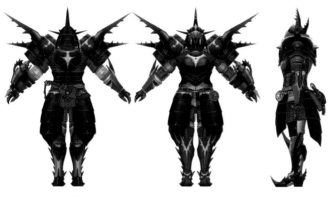

CG Rendering

CG Rendering

CG Rendering

CG Rendering

■Hornetaur Set (Female)

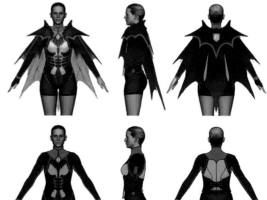

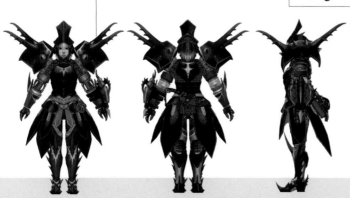

■Barnos Jacket α (Female)

Equipment from Other Materials

At this point, we feature gear that uses ore or bone as its main materials, and gear for which a special ticket is needed at the time of production. From articles that are easy to make to those that are difficult because their materials are extremely difficult to obtain, please have a look at these diverse weapons and armor.

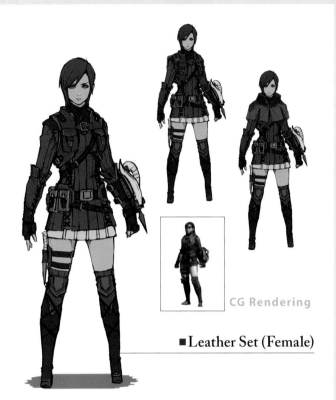

CG Rendering

■Leather Set (Female)

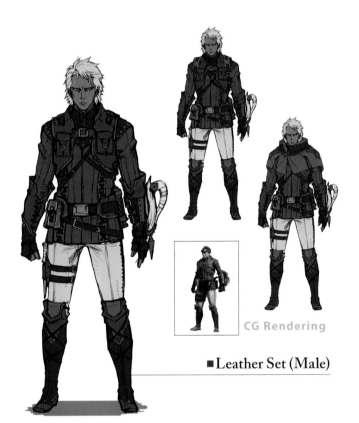

CG Rendering

■Leather Set (Male)

The Leather set uses pieces of processed monster hides. It is functional, supporting agile movement, and it is popular for its comfort. People tend to use it for a long time.

Lightweight and quite strong, the Leather sets are comfortable to use, and they are endorsed even by Palicoes. The Palico weapon is also used for farmwork.

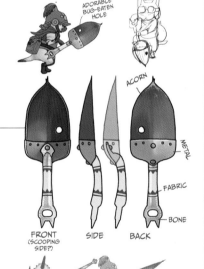

ADORABLE BUG-EATEN HOLE

ACORN

METAL

FABRIC

BONE

FRONT (SCOOPING SIDE?) SIDE BACK

■Felyne Acorn Spade

HEADGEAR

SOMEWHAT ACORN COLORED...

MAKE AS ROUND AS POSSIBLE

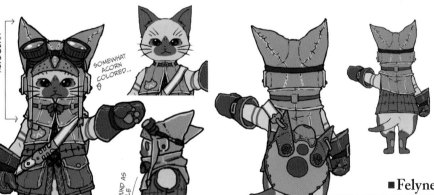

■Felyne Leather Set

FELYNE FLASK? BAG

CG Rendering

CG Rendering

Equipment from Other Materials

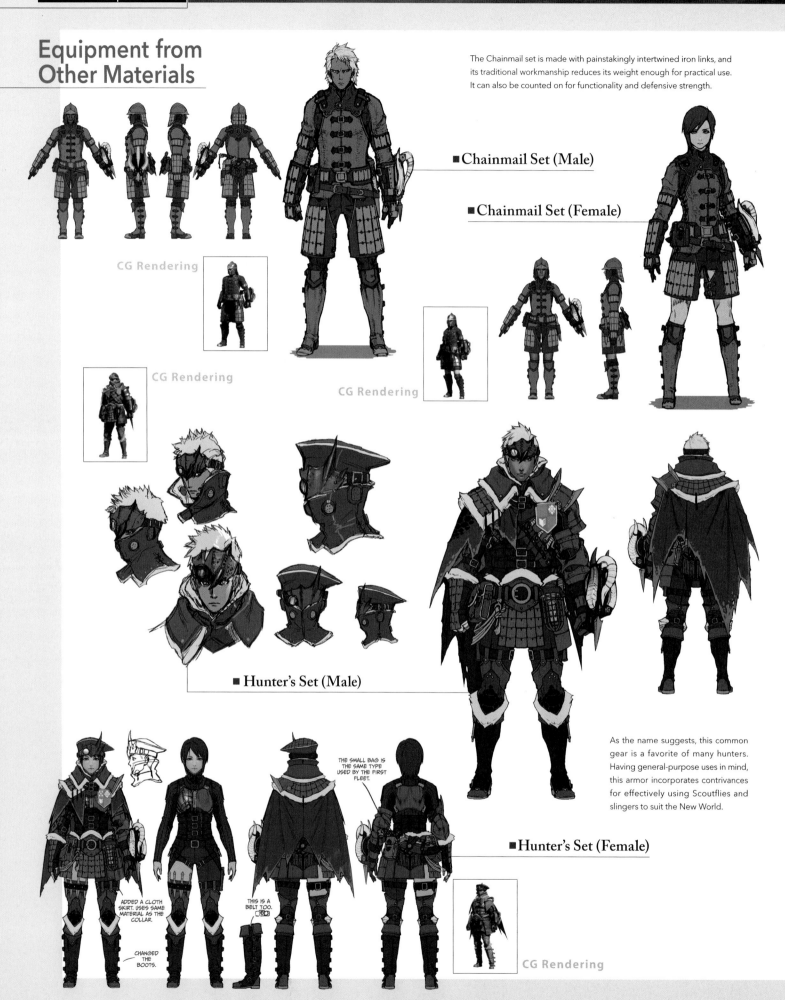

The Chainmail set is made with painstakingly intertwined iron links, and its traditional workmanship reduces its weight enough for practical use. It can also be counted on for functionality and defensive strength.

CG Rendering

■ Chainmail Set (Male)

■ Chainmail Set (Female)

CG Rendering

CG Rendering

■ Hunter's Set (Male)

As the name suggests, this common gear is a favorite of many hunters. Having general-purpose uses in mind, this armor incorporates contrivances for effectively using Scoutflies and slingers to suit the New World.

■ Hunter's Set (Female)

THE SMALL BAG IS THE SAME TYPE USED BY THE FIRST FLEET.

ADDED A CLOTH SKIRT. USES SAME MATERIAL AS THE COLLAR.

THIS IS A BELT TOO.

CHANGED THE BOOTS.

CG Rendering

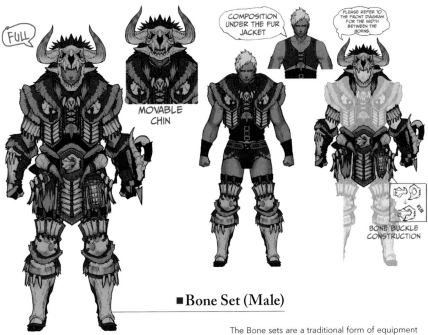

FULL

MOVABLE CHIN

COMPOSITION UNDER THE FUR JACKET

PLEASE REFER TO THE FRONT DIAGRAM FOR THE WIDTH BETWEEN THE HORNS.

BONE BUCKLE CONSTRUCTION

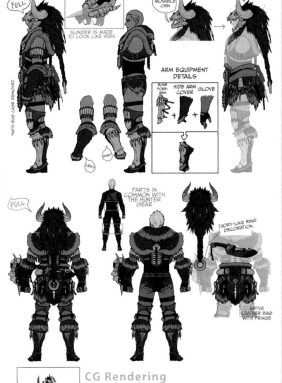

FULL

SLINGER IS MADE TO LOOK LIKE RIBS

MOVABLE CHIN

BLACK PARTS ARE FEATHER DECORATIONS

ARM EQUIPMENT DETAILS

BONE FORE-ARM + HIDE ARM COVER + GLOVE

*WITH BUG CAGE REMOVED

FULL

PARTS IN COMMON WITH THE HUNTER GEAR

IVORY-LIKE RING DECORATION

NATIVE LEATHER BAG WITH FRINGE

■ Bone Set (Male)

The Bone sets are a traditional form of equipment that make use of the bones of monsters. They are ferocious in appearance, but on the other hand their moisture retention has been well thought out, and the dedication of the artisans shines through in the detailed and decorative bone designs.

CG Rendering

NEW BONE SET (MALE) 5 COLOR CONCEPT
‣ 5 COLOR 1 — BONE
‣ 5 COLOR 2 — PELT (BLACK)

NEW BONE SET (FEMALE) 5 COLOR CONCEPT
‣ 5 COLOR 1 — BONE
‣ 5 COLOR 2 — PELT (BLACK)

CG Rendering

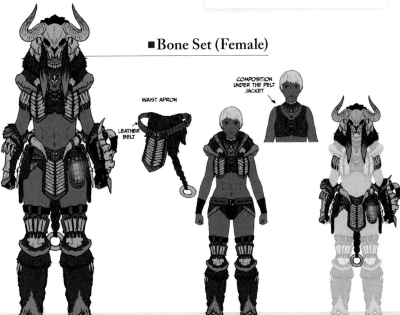

■ Bone Set (Female)

WAIST APRON

LEATHER BELT

COMPOSITION UNDER THE PELT JACKET

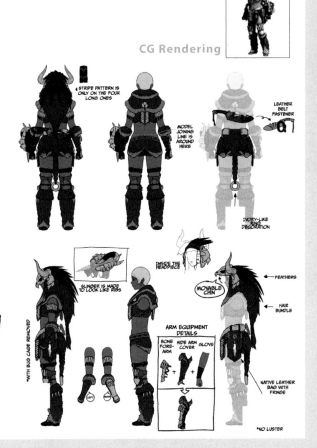

STRIPE PATTERN IS ONLY ON THE FOUR LONG ONES

LEATHER BELT FASTENER

MODEL JOINING LINE IS AROUND HERE

IVORY-LIKE DECORATION

SLINGER IS MADE TO LOOK LIKE RIBS

INSIDE THE HEADPIECE

MOVABLE CHIN

FEATHERS

HAIR BUNDLE

ARM EQUIPMENT DETAILS

BONE FORE-ARM + HIDE ARM COVER + GLOVE

*WITH BUG CAGE REMOVED

NATIVE LEATHER BAG WITH FRINGE

*NO LUSTER

Equipment from Other Materials

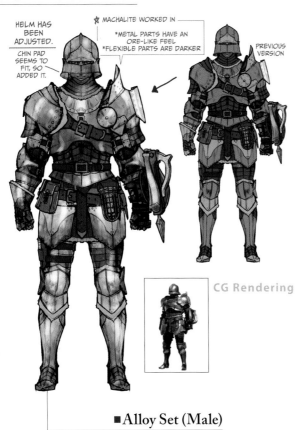

HELM HAS BEEN ADJUSTED.

CHIN PAD SEEMS TO FIT, SO ADDED IT.

★ MACHALITE WORKED IN

*METAL PARTS HAVE AN ORE-LIKE FEEL
*FLEXIBLE PARTS ARE DARKER

PREVIOUS VERSION

CG Rendering

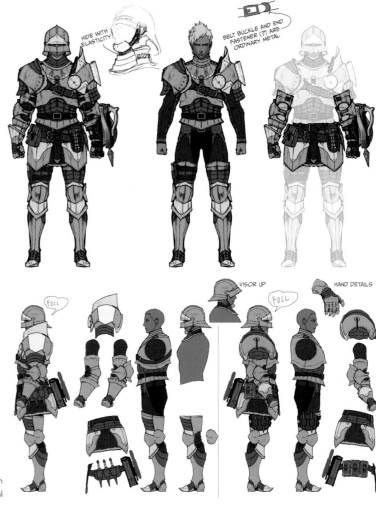

HIDE WITH ELASTICITY

BELT BUCKLE AND END FASTENER (?) ARE ORDINARY METAL

VISOR UP

HAND DETAILS

FULL

FULL

■ Alloy Set (Male)

The Alloy sets are notable examples of equipment made with good-quality machalite ore. In addition to the crafting of metal plates that boast strength, the structure ensures mobility.

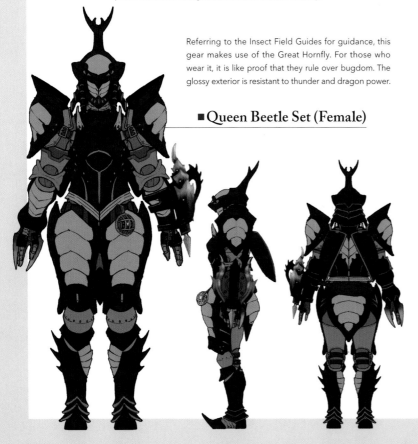

Referring to the Insect Field Guides for guidance, this gear makes use of the Great Hornfly. For those who wear it, it is like proof that they rule over bugdom. The glossy exterior is resistant to thunder and dragon power.

■ Queen Beetle Set (Female)

■ King Beetle Set (Male)

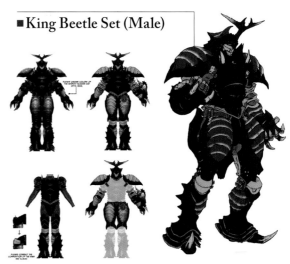

CG Rendering

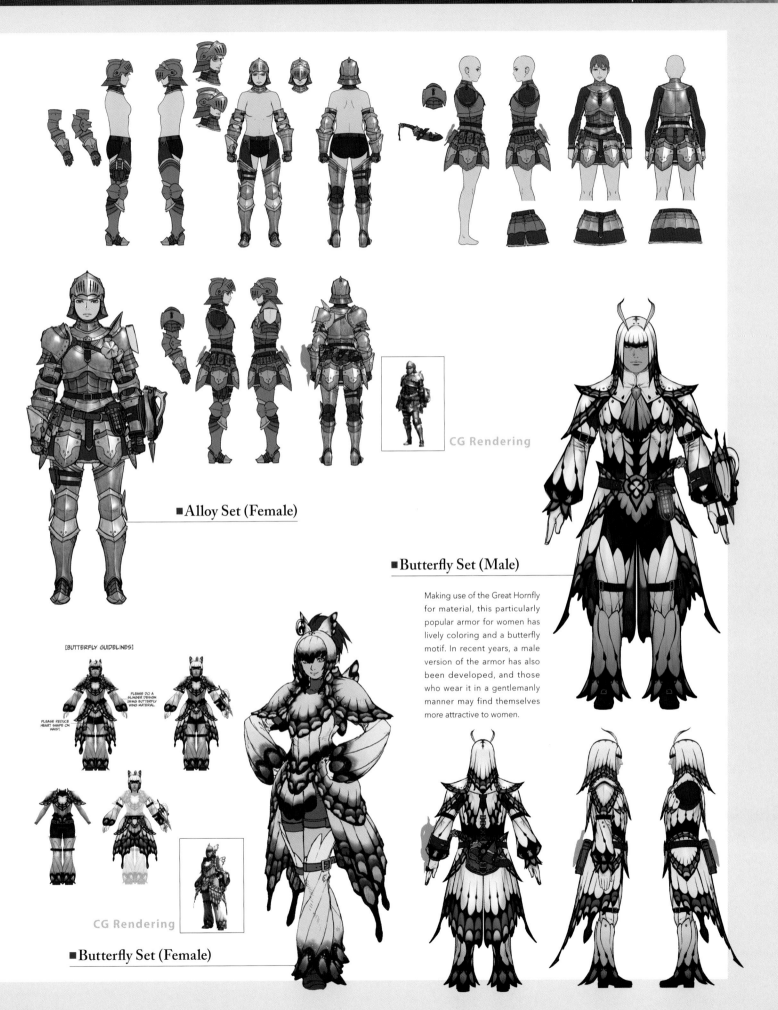

CG Rendering

■ **Alloy Set (Female)**

[BUTTERFLY GUIDELINES]

PLEASE DO A
SLINDER DESIGN
USING BUTTERFLY
WING MATERIAL.

PLEASE REDUCE
HEART SHAPE ON
WAIST.

CG Rendering

■ **Butterfly Set (Female)**

■ **Butterfly Set (Male)**

Making use of the Great Hornfly
for material, this particularly
popular armor for women has
lively coloring and a butterfly
motif. In recent years, a male
version of the armor has also
been developed, and those
who wear it in a gentlemanly
manner may find themselves
more attractive to women.

Equipment from Other Materials

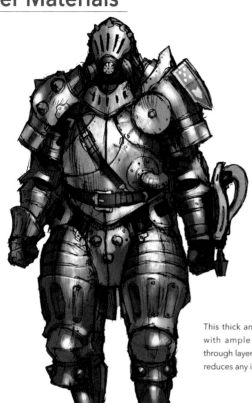

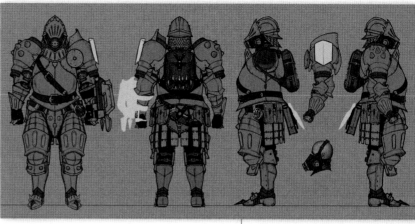

CG Rendering

■High Metal Set (Male)

■High Metal Set (Female)

This thick and heavy armor made with ample ore is made sturdy through layering. Its rounded shape reduces any impacts it receives.

CG Rendering

TOPIC Hoisting High the Determination to Challenge the Unknown Continent

In the distant past, five of the dragons that lived among humanity created the land, mountains, lakes, rain, forests, and a star of sapphire blue upon the foundations of their own bodies. A lone youth asked the dragons why. Some time passed and he returned with no answers, but he had received scales from five dragons—and with them the power to create a new continent.

This story was passed down through the ages, and the entirety of it can be read in the Chamber of the Five in the First Fleet's ship. The Commission emblem was designed with the five ancestor dragons in mind, and the First Fleet insignia underneath it depicts a star. It could be the sapphire star created by the dragons, or maybe it is the youth who guides people to the new continent. It represents the bravery needed to meet the challenges in the New World and the hope of new discoveries. It is a guiding light to lead all across the murky seas. The Commission lance gives physical form to the desire to hold aloft such ideals and is an anchor of their aspirations, so to speak.

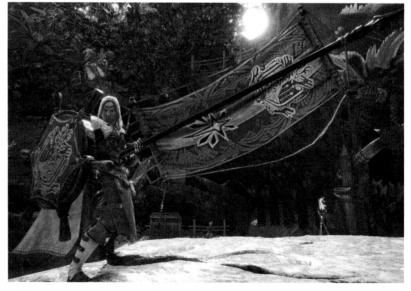

■Shooting Star Lance / Sapphire Star Lance

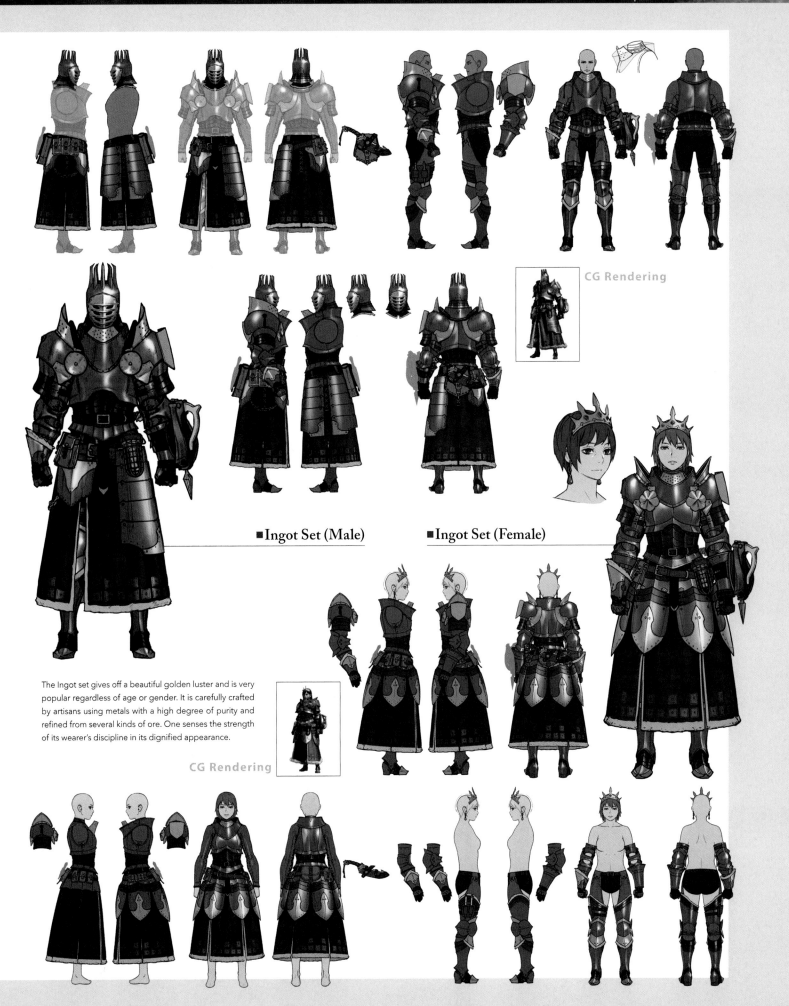

■Ingot Set (Male)　■Ingot Set (Female)

CG Rendering

The Ingot set gives off a beautiful golden luster and is very popular regardless of age or gender. It is carefully crafted by artisans using metals with a high degree of purity and refined from several kinds of ore. One senses the strength of its wearer's discipline in its dignified appearance.

CG Rendering

Equipment from Other Materials

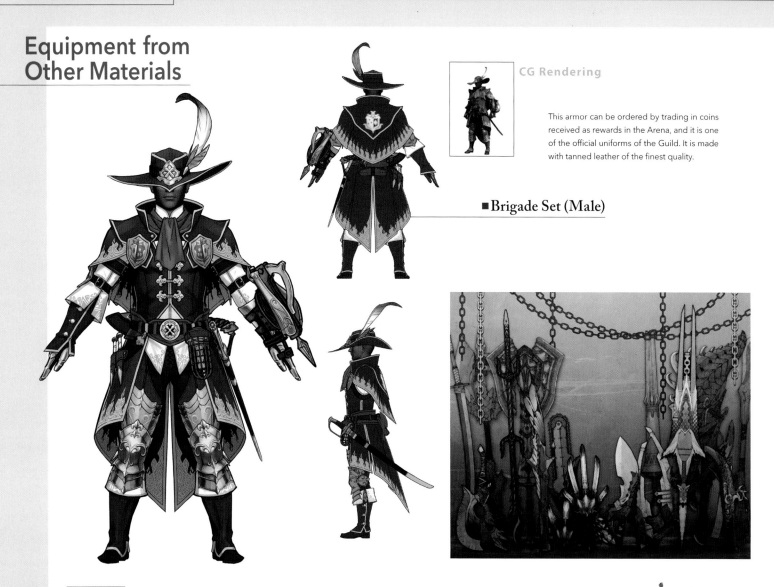

CG Rendering

This armor can be ordered by trading in coins received as rewards in the Arena, and it is one of the official uniforms of the Guild. It is made with tanned leather of the finest quality.

■ Brigade Set (Male)

TOPIC

Because They Love That Certain Feel...

Someone asked if the hair dropped when the rare endemic life-form known as Downy Crake molts could be utilized in equipment. After more than half a year of work, the Endemic Life Researcher and the others completed the Downy Crake Brooms—a pair of dual blades in which the male is held in the right hand and the female in the right. When struck by this weapon with its generously applied top-quality, fluffy down, rather than feeling pain, one succumbs to a comfortable drowsiness. The client was greatly happy about this.

Another hammer was modeled after the Bristly Crake, which is even more rare than the Downy Crake. The hammer part, which looks like a pincushion from a sewing kit, uses top-quality bristly fur and has an added poison effect. It fills the eyes of its user with an ominous light. This was not the work of its artisans, so people wonder if they become possessed by the soul of a Bristly Crake that was turned into a poison weapon. Perhaps they are not wrong.

BEAK STICK
EYES ARE BUTTONS AND BEADS

■ Bristly Pincushion / Bristly Grudge

■ Downy Crake Brooms / Downy Crake Love

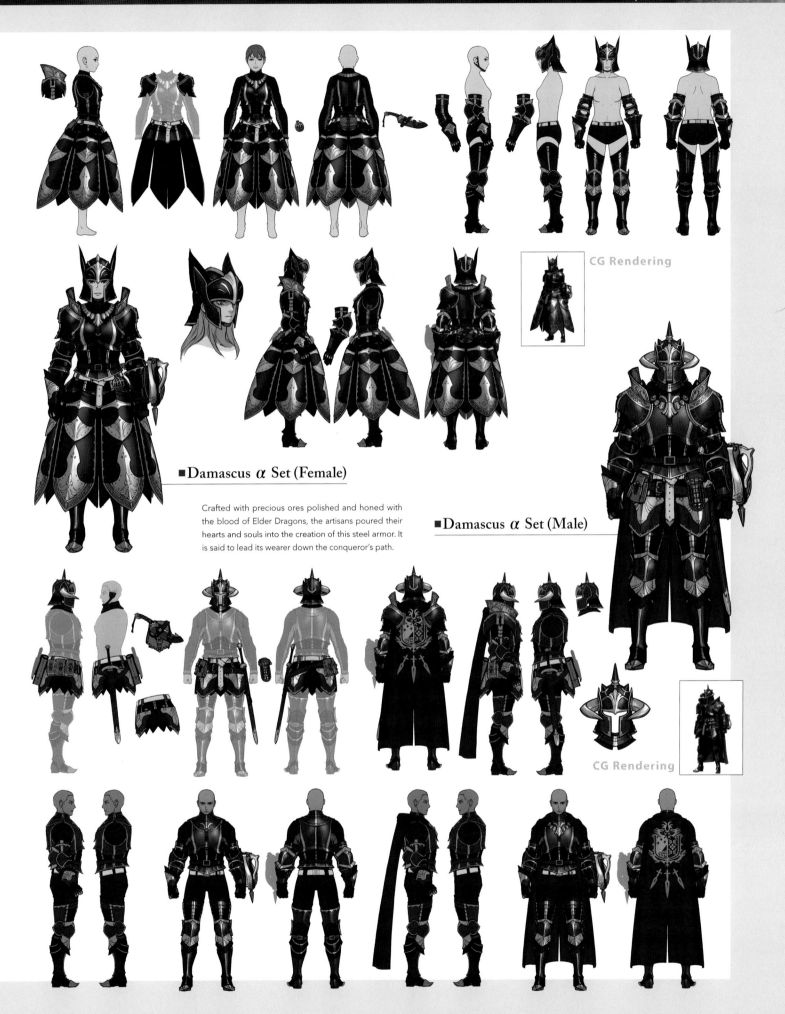

■ Damascus α Set (Female)

Crafted with precious ores polished and honed with the blood of Elder Dragons, the artisans poured their hearts and souls into the creation of this steel armor. It is said to lead its wearer down the conqueror's path.

■ Damascus α Set (Male)

CG Rendering

CG Rendering

Equipment from Other Materials

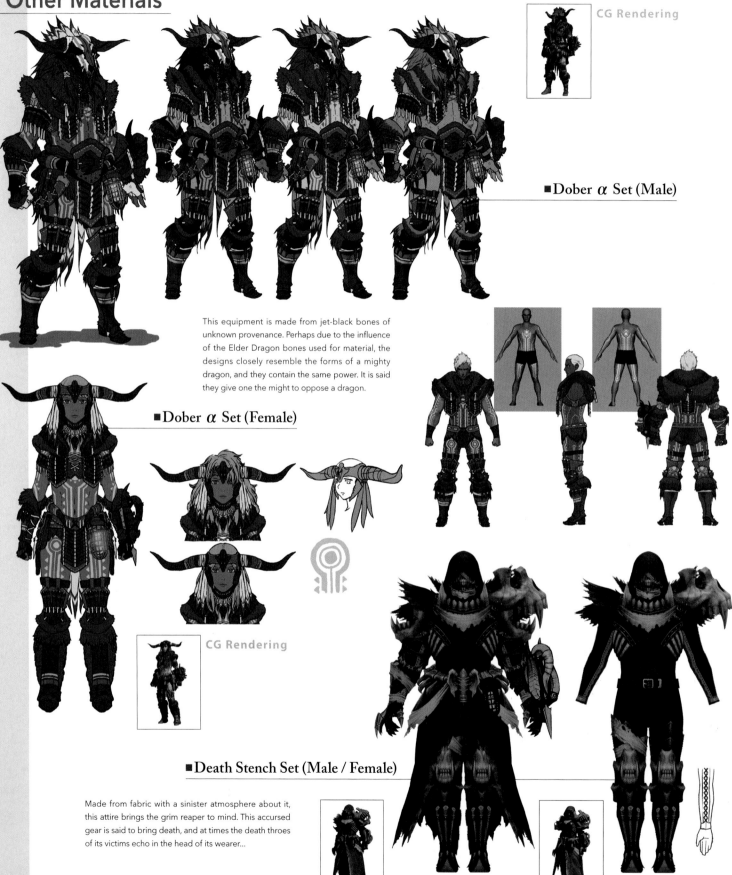

CG Rendering

■Dober α Set (Male)

This equipment is made from jet-black bones of unknown provenance. Perhaps due to the influence of the Elder Dragon bones used for material, the designs closely resemble the forms of a mighty dragon, and they contain the same power. It is said they give one the might to oppose a dragon.

■Dober α Set (Female)

CG Rendering

■Death Stench Set (Male / Female)

Made from fabric with a sinister atmosphere about it, this attire brings the grim reaper to mind. This accursed gear is said to bring death, and at times the death throes of its victims echo in the head of its wearer...

CG Rendering

CG Rendering

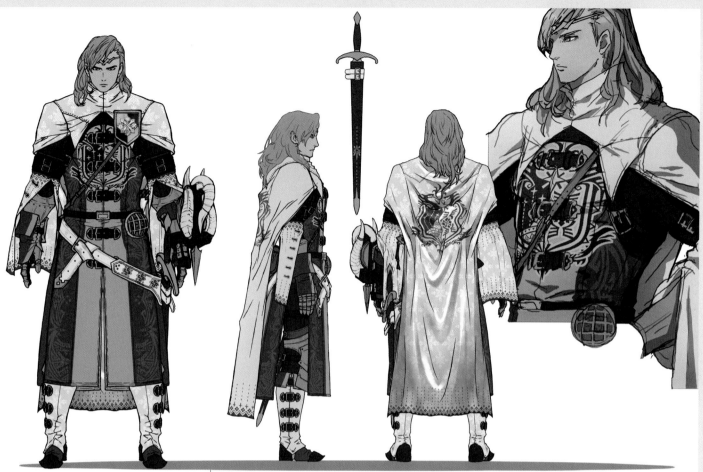

CG Rendering

■ Guild Cross Set (Male)

■ Guild Cross Set (Female)

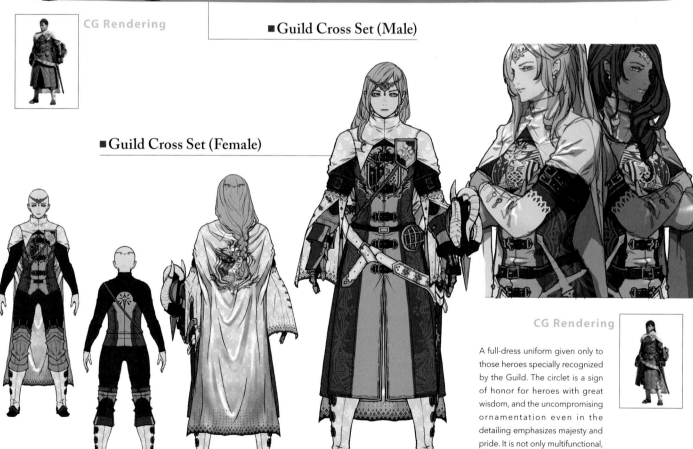

CG Rendering

A full-dress uniform given only to those heroes specially recognized by the Guild. The circlet is a sign of honor for heroes with great wisdom, and the uncompromising ornamentation even in the detailing emphasizes majesty and pride. It is not only multifunctional, but also brings good fortune to those who don it.

Equipment from Other Materials

CG Rendering

This gear uses the motifs of armor that has been passed down from a foreign country in the east. Using subtle techniques, the reproduction of the helmet, armor, and sleeves that cover the shoulders and upper arms are all superb.

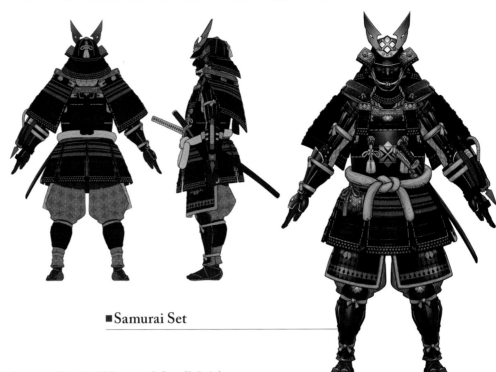

■Samurai Set

■Layered Armor: Bushi "Homare" Set (Male)

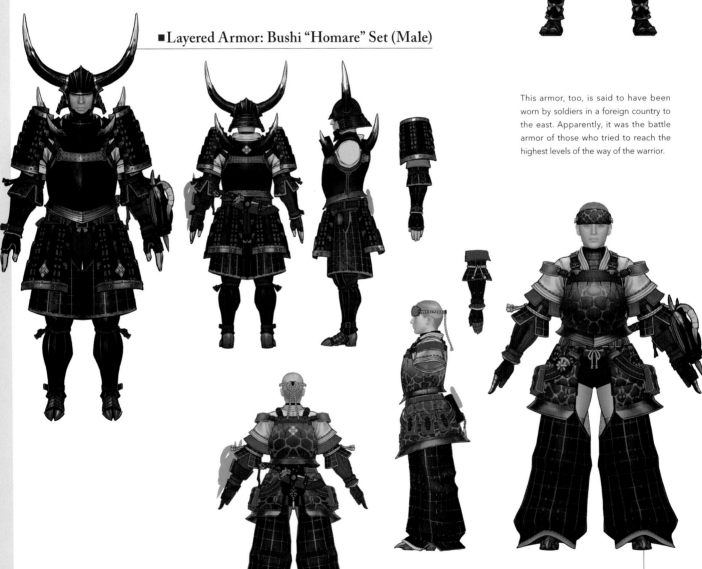

This armor, too, is said to have been worn by soldiers in a foreign country to the east. Apparently, it was the battle armor of those who tried to reach the highest levels of the way of the warrior.

■Layered Armor: Bushi "Sabi" Set (Female)

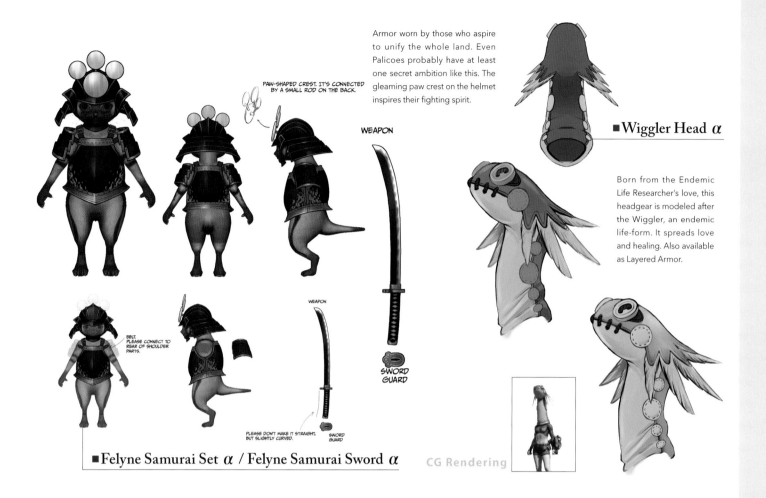

Armor worn by those who aspire to unify the whole land. Even Palicoes probably have at least one secret ambition like this. The gleaming paw crest on the helmet inspires their fighting spirit.

PAW-SHAPED CREST. IT'S CONNECTED BY A SMALL ROD ON THE BACK.

WEAPON

SWORD GUARD

BBLT. PLEASE CONNECT TO RBAR OF SHOULDER PARTS.

WEAPON

PLEASE DON'T MAKE IT STRAIGHT, BUT SLIGHTLY CURVED.

SWORD GUARD

■Felyne Samurai Set α / Felyne Samurai Sword α

CG Rendering

■Wiggler Head α

Born from the Endemic Life Researcher's love, this headgear is modeled after the Wiggler, an endemic life-form. It spreads love and healing. Also available as Layered Armor.

TOPIC

On the Visual Influence of Lao-Shan Lung in the Bushi Set

■Lao-Shan Lung

When the Bushi "Sabi" and "Homare" sets were produced and crafted, reference was made to Auroros and Borealis, equipment from the Old World. That equipment was built upon material from a type of Elder Dragon boasting a frame even bigger than Kulve Taroth. It was called Lao-Shan Lung or "Old Mountain Dragon." These monsters have existed since ancient times, and they have lived on in countless folk stories and in people's hearts. Also, it might not be that unusual if some of them had appeared in the New World after an Elder Crossing in the past and lived out their lives here.

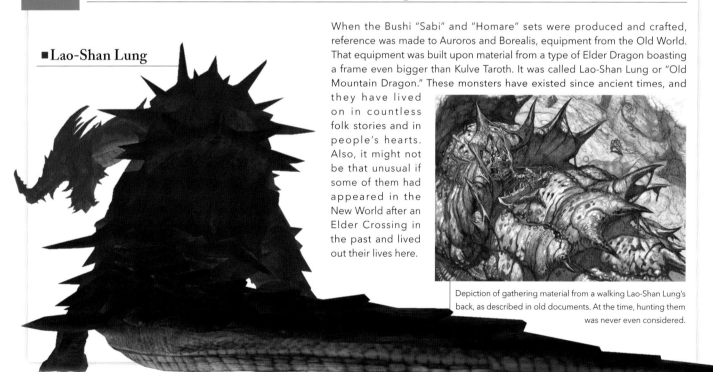

Depiction of gathering material from a walking Lao-Shan Lung's back, as described in old documents. At the time, hunting them was never even considered.

※ Image from Monster Hunter.

499

Astera Fest Outfits

Here we focus attention on the gear that can be produced in exchange for the tickets distributed during Astera Fests. From the fancy to the eccentric, they help boost the festival atmosphere, and there are quite a few masterpieces from enthusiastic artisans.

■Blossom α Set (Female)

■Blossom α Set (Male)

This outfit lends splendid colors to the Spring Blossom Fest with its flower motif and smart, clean design. The corsage on the chest is a touch of refinement for both ladies and gentlemen.

This Palico outfit is modeled after butterflies that dance in the warm spring weather. It may look adorable, but the Palico weapon sprinkles paralyzing insect scales.

■Felyne Butterfly Set

■Felyne Butterfly Wand

■Diver α Set (Male)

An outfit for the Summer Twilight Fest. Form fitting, it has excellent thermal insulation and water repellency. It is perhaps inevitable that its wearer is struck by an urge to jump into the sea.

■Diver α Set (Female)

■Felyne Aloha Set

■Felyne Aloha Ukulele

This outfit creates the image of an everlasting summer vacation. With the airy attire and musical instrument in hand, it truly does have a cheerful atmosphere about it. There's also a little fish accessory for the wrist.

Astera Fest Outfits

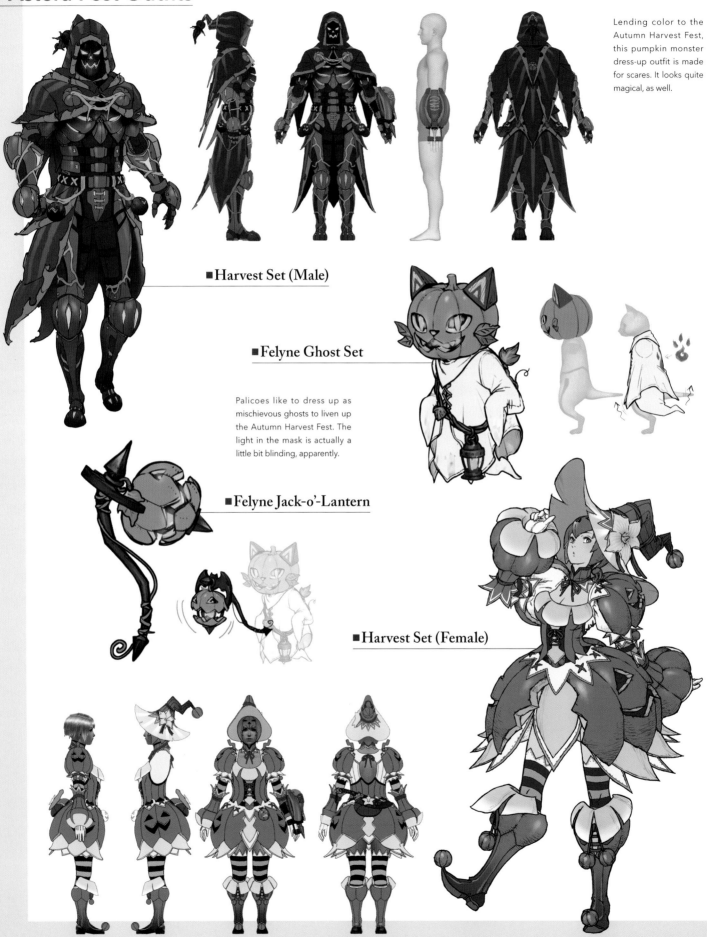

Lending color to the Autumn Harvest Fest, this pumpkin monster dress-up outfit is made for scares. It looks quite magical, as well.

■ Harvest Set (Male)

■ Felyne Ghost Set

Palicoes like to dress up as mischievous ghosts to liven up the Autumn Harvest Fest. The light in the mask is actually a little bit blinding, apparently.

■ Felyne Jack-o'-Lantern

■ Harvest Set (Female)

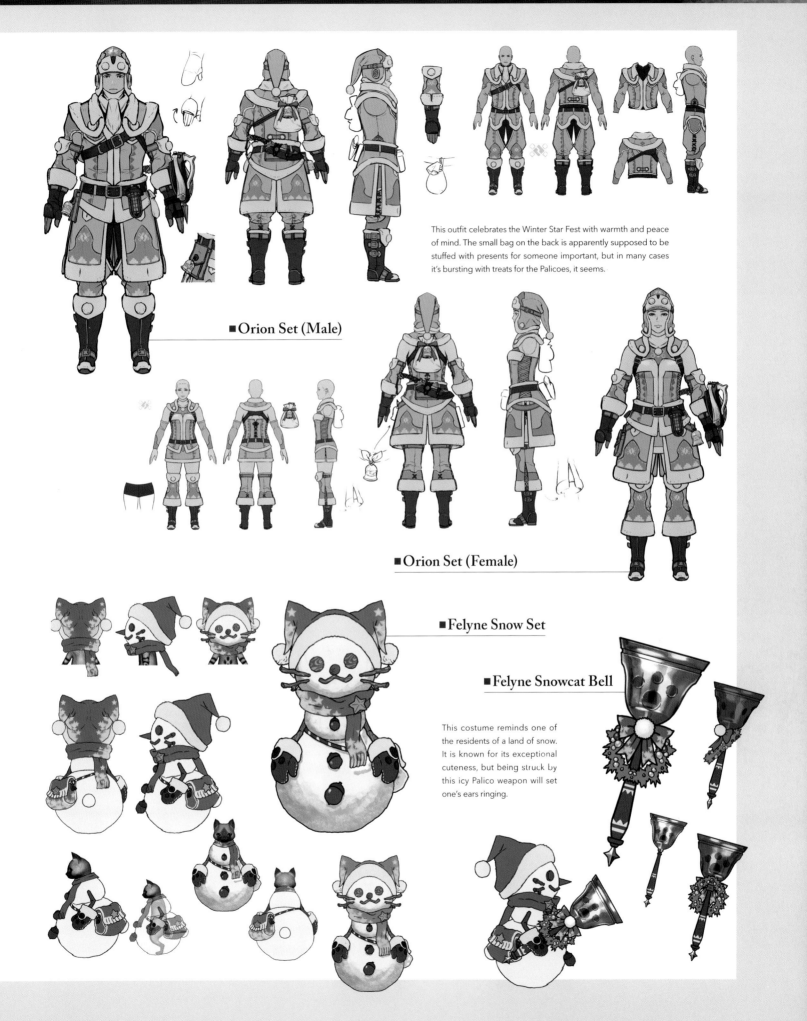

This outfit celebrates the Winter Star Fest with warmth and peace of mind. The small bag on the back is apparently supposed to be stuffed with presents for someone important, but in many cases it's bursting with treats for the Palicoes, it seems.

■Orion Set (Male)

■Orion Set (Female)

■Felyne Snow Set

■Felyne Snowcat Bell

This costume reminds one of the residents of a land of snow. It is known for its exceptional cuteness, but being struck by this icy Palico weapon will set one's ears ringing.

Astera Fest Outfits

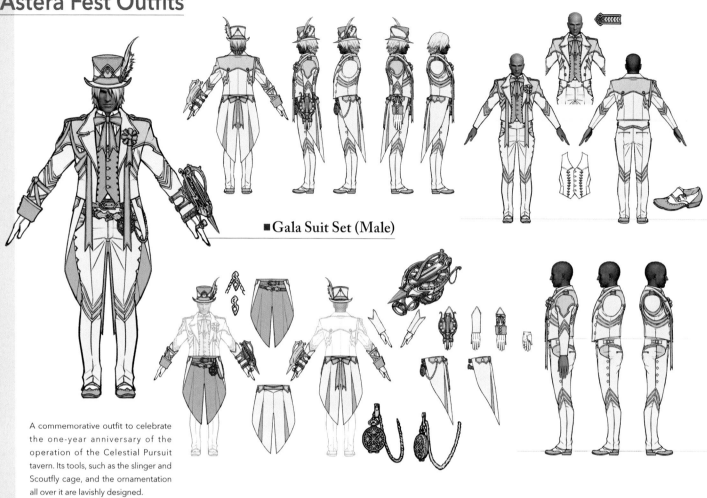

■Gala Suit Set (Male)

A commemorative outfit to celebrate the one-year anniversary of the operation of the Celestial Pursuit tavern. Its tools, such as the slinger and Scoutfly cage, and the ornamentation all over it are lavishly designed.

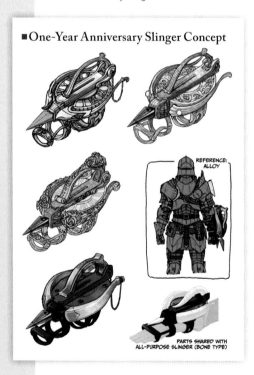

■One-Year Anniversary Slinger Concept

REFERENCE: ALLOY

PARTS SHARED WITH ALL-PURPOSE SLINGER (BONE TYPE)

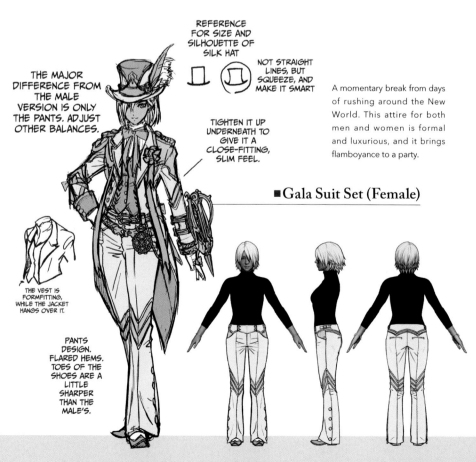

THE MAJOR DIFFERENCE FROM THE MALE VERSION IS ONLY THE PANTS. ADJUST OTHER BALANCES.

REFERENCE FOR SIZE AND SILHOUETTE OF SILK HAT

NOT STRAIGHT LINES, BUT SQUEEZE, AND MAKE IT SMART

TIGHTEN IT UP UNDERNEATH TO GIVE IT A CLOSE-FITTING, SLIM FEEL.

A momentary break from days of rushing around the New World. This attire for both men and women is formal and luxurious, and it brings flamboyance to a party.

■Gala Suit Set (Female)

THE VEST IS FORMFITTING, WHILE THE JACKET HANGS OVER IT.

PANTS DESIGN. FLARED HEMS. TOES OF THE SHOES ARE A LITTLE SHARPER THAN THE MALE'S.

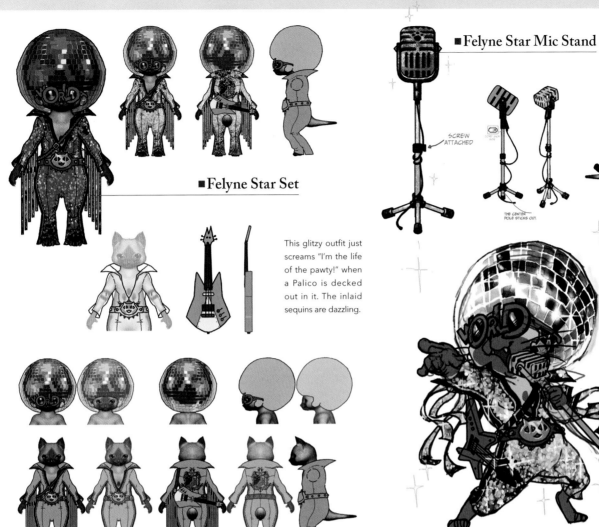

■ Felyne Star Mic Stand

SCREW ATTACHED

THE CENTER POLE STICKS OUT.

■ Felyne Star Set

This glitzy outfit just screams "I'm the life of the pawty!" when a Palico is decked out in it. The inlaid sequins are dazzling.

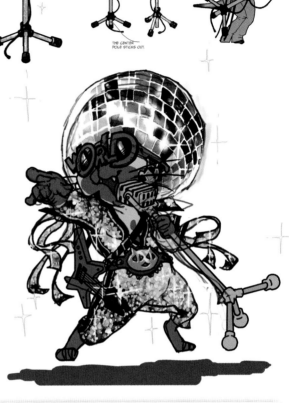

TOPIC: The Creative Design for a Great Sword Made a Master Craftsman of a Hunter

This design was drawn in front of the Second Fleet Master by a certain hunter. It incorporated an innovative idea. Seeking to achieve the ultimate strike from a great sword, it had a mechanism built into it to accelerate slashing attacks. The Second Fleet Master had to admit, "At a glance, I can feel the force of it in my arms," and the weapon was given the name Wyvern Ignition.

Its high offensive strength, fire element property, keen sharpness, and upgradability make this weapon a dream for any great sword user.

■ Wyvern Ignition

CG Rendering

NORMAL
EVEN NORMALLY IT'S HOT AND THE BACK SIDE IS LIT UP (PLANNING TO PROCESS IN MODELING.)

BUILDUP 1
SPARKS COMING FROM ALL VERNIERS (6 OF THEM).

BUILDUP 2
THE BACK TWO VERNIER SHIELDS SLIDE AND ALL SPARKS GET BIGGER.

BUILDUP 3
THE BIGGEST VERNIER SHIELD OPENS AND THE MESH PART SLIDES TO THE BACK. LARGE FLAMES COME OUT, AND THE FOUR FIRES ON TOP LOOK LIKE ONE BIG ONE.

Extend **World Gallery**

Livening Up Astera Fests
The Handler's Seasonal Outfits

Astera Fests mark the changing of the seasons. The Handler busily spends her days accompanying the hunter on expeditions and recording information, and this is the one time she dons flashy outfits and recharges her batteries. Here we present her four different outfits for the Astera Fests, along with their design drawings. We hope this is a chance for audiences to discover or rediscover why they like her.

Rough Sketch

Rough Sketch

EACH OF THE SHELL ACCESSORIES REFLECTS AND SHINES IN RAINBOW COLORS

TUR-QUOISE

SHELL EARRINGS

SUNGLASSES. THEIR BONE FRAME HAS THE SAME DECORATIVE CARVING PATTERN AS THE BIKINI.

TRANS-LUCENT

IMAGE OF FLOWERS ON VARIOUS PARTS

BACK OF BRACELET

BARRETTE

WOODEN

SUNGLASSES DOWN

TRANS-LUCENT

PAREO BUCKLE (WOOD)

SHELL ANKLET (RIGHT FOOT ONLY)

ORNAMENTATION FOR ATTACHING BOOKS

FLOWER HERE

SWIMSUIT PATTERN

❖ **Busy Bee Dress**

This outfit for the Spring Blossom Fest has a bee motif. There is delicate patterning on the wing-shaped cape, and the Handler quite likes the bug-shaped Scoutfly cage and honeycomb-patterned tights.

❖ **Sunshine Pareu**

This fetching Summer Twilight Fest outfit consists of a bold swimsuit and a somewhat translucent pareu. She appears a bit shy about the exposed belly button, and seeing her bashful is perhaps something new.

Astera's Party Costumes

TOPIC

Let Me Be Your Pal on an Expedition

The Appreciation Fest is held to commemorate the one-year anniversary of the Fifth Fleet's research activities, and this is the Handler trying on the Friendly Felyne costume for the event. If she begged you to buy it, you couldn't turn her down, could you?!

Rough Sketch

Rough Sketch

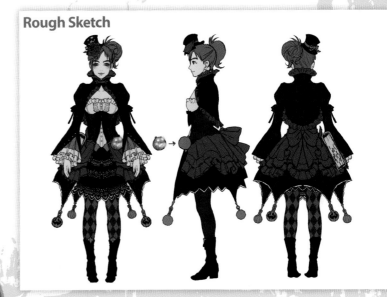

❖ **Mischievous Dress**

This outfit for the Autumn Harvest Fest reminds one of a spell-casting witch. It has a spooky vibe about it, but on the other hand, the cute ribbons, frills, and corset make her happy.

❖ **Winter Spirit Coat**

This outfit is for the Winter Star Fest, the purpose of which is to pray that the souls of the dead find rest and that new buds grow. The fluffy parts are warm, and the wearer gets a feeling of satisfaction, as if one has eaten one's fill.

Rough Sketch

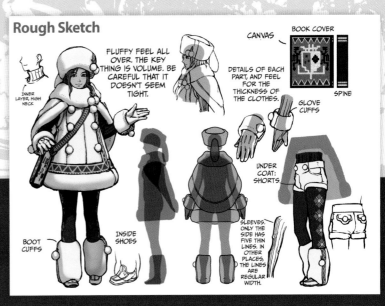

FLUFFY FEEL ALL OVER. THE KEY THING IS VOLUME. BE CAREFUL THAT IT DOESN'T SEEM TIGHT.

INNER LAYER, HIGH NECK

CANVAS

BOOK COVER

DETAILS OF EACH PART, AND FEEL FOR THE THICKNESS OF THE CLOTHES.

SPINE

GLOVE CUFFS

UNDER COAT: SHORTS

BOOT CUFFS

INSIDE SHOES

SLEEVES: ONLY THE SIDE HAS FIVE THIN LINES. IN OTHER PLACES, THE LINES ARE REGULAR WIDTH.

Extended **World Gallery**
Equipment Gallery

The production of gear that makes use of material from monsters newly discovered in the New World is possible thanks to the numerous designs conceived by Second Fleet members through time-consuming trial and error. Here we present some of the files provided by the Smithy, focusing on ones that were not actually adopted.

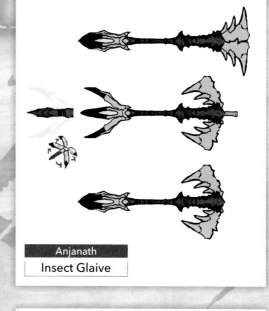

Anjanath
Insect Glaive

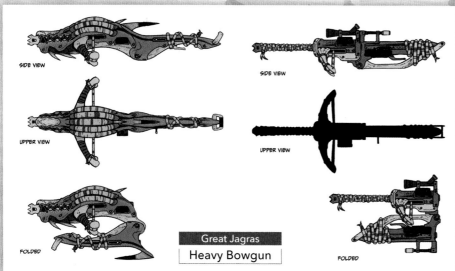
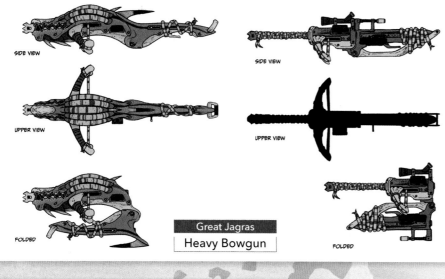

SIDE VIEW

SIDE VIEW

UPPER VIEW

UPPER VIEW

FOLDED

FOLDED

Great Jagras
Heavy Bowgun

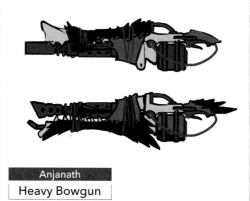

Anjanath
Heavy Bowgun

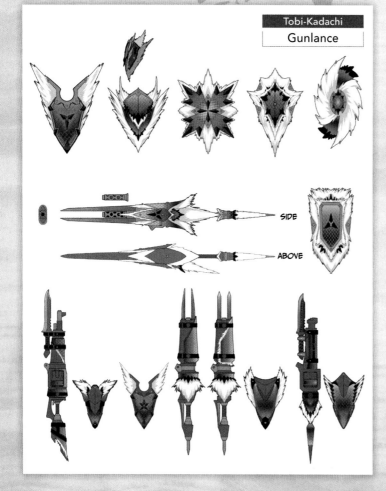

Tobi-Kadachi
Gunlance

SIDE

ABOVE

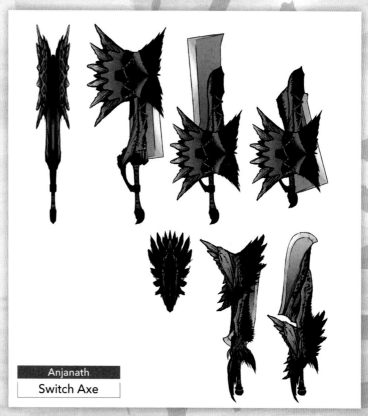

Anjanath
Switch Axe

Legiana
Sword and Shield

Legiana
Bow

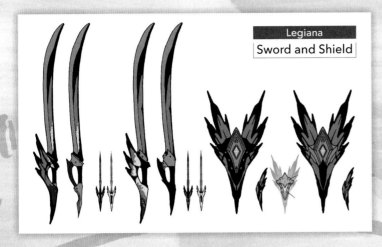
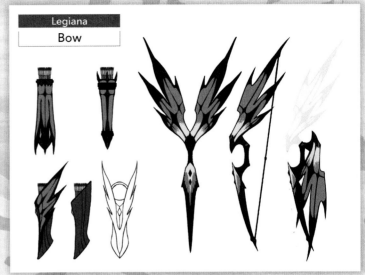

Legiana
Switch Axe

Legiana
Long Sword

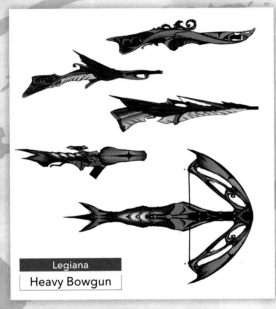
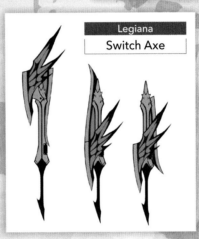
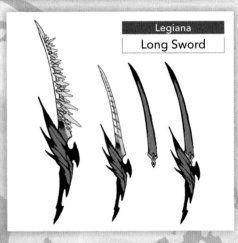

Legiana
Heavy Bowgun

Odogaron
Charge Blade

Odogaron
Insect Glaive

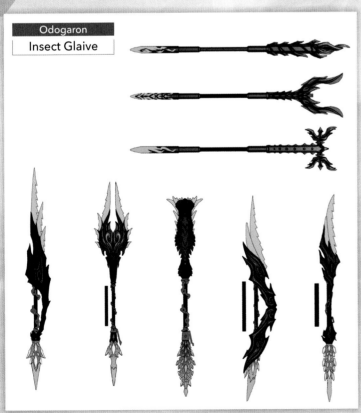
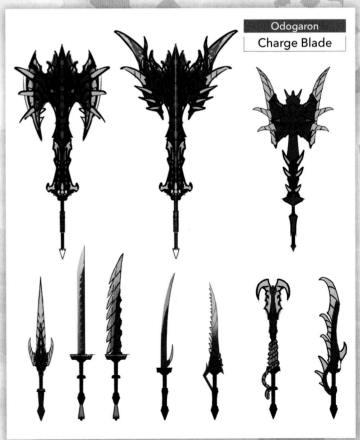

Bazelgeuse
Dual Blades

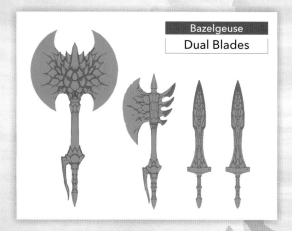

Bazelgeuse
Hunting Horn

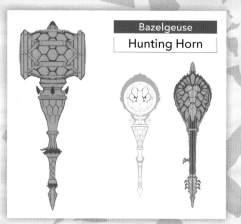

Zorah Magdaros
Gunlance

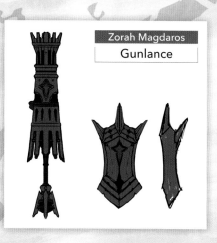

Zorah Magdaros
Charge Blade

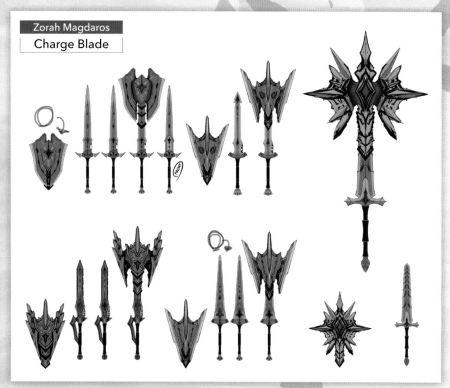

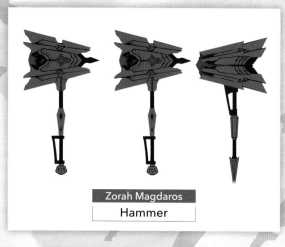

Zorah Magdaros
Hammer

SYMMETRICAL
VERSION

ASYMMETRICAL
VERSION

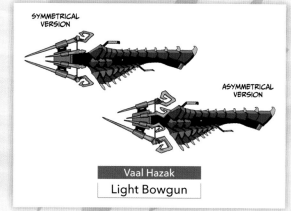

Vaal Hazak
Light Bowgun

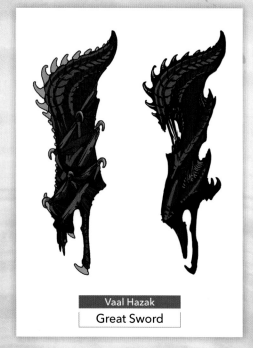

Vaal Hazak
Great Sword

Vaal Hazak
Lance

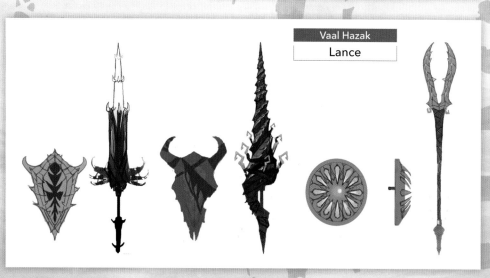

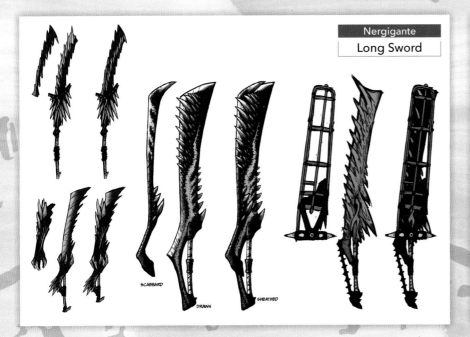

Nergigante
Long Sword

SCABBARD DRAWN SHEATHED

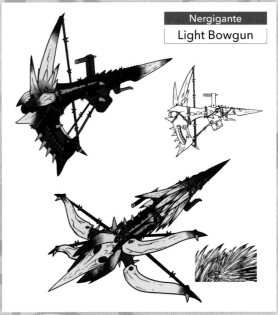

Nergigante
Light Bowgun

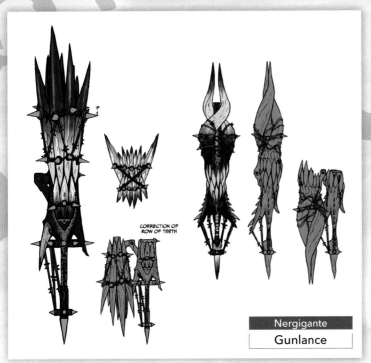

CORRECTION OF ROW OF TEETH

Nergigante
Gunlance

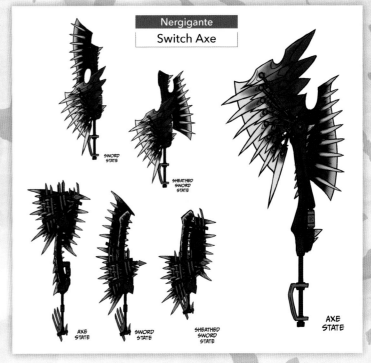

Nergigante
Switch Axe

SWORD STATE

SHEATHED SWORD STATE

AXE STATE

SWORD STATE

SHEATHED SWORD STATE

AXE STATE

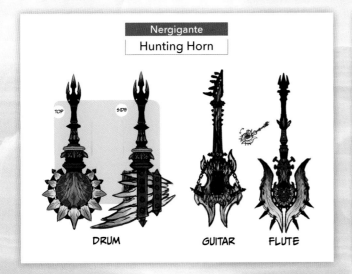

Nergigante
Hunting Horn

TOP SIDE

DRUM GUITAR FLUTE

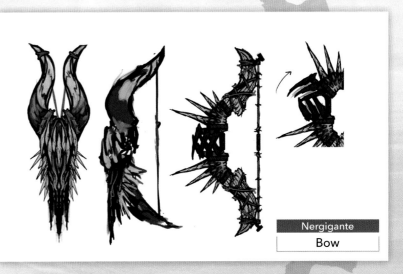

Nergigante
Bow

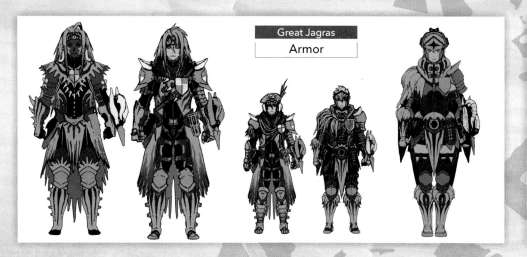

Great Jagras
Armor

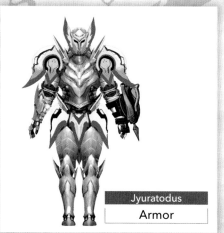

Jyuratodus
Armor

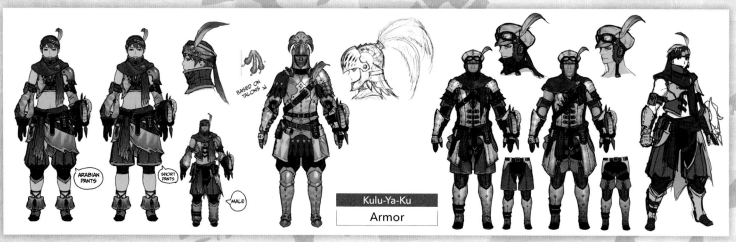

ARABIAN PANTS

SHORT PANTS

BASED ON TALONS

MALE

Kulu-Ya-Ku
Armor

Tobi-Kadachi
Armor

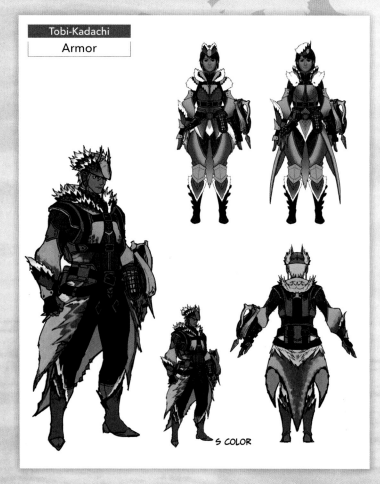

S COLOR

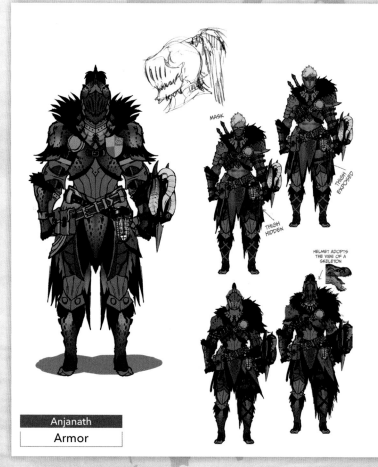

MASK

THIGH EXPOSED

THIGH HIDDEN

HELMET ADOPTS THE VIBE OF A SKELETON

Anjanath
Armor

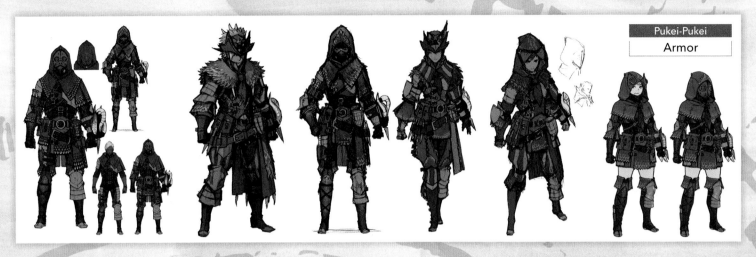

Pukei-Pukei
Armor

Great Girros
Armor

S1.
S2.

THIS TYPE OF IDEA

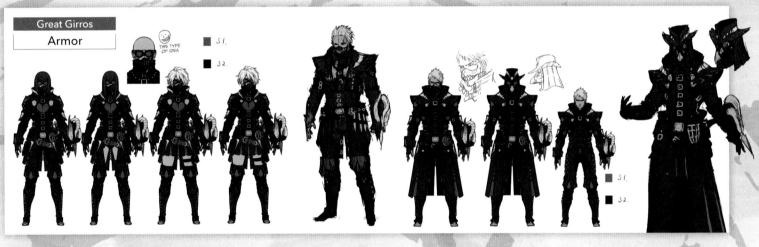

S1.
S2.

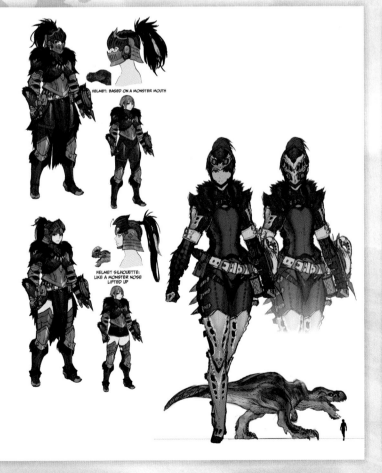

HELMET: BASED ON A MONSTER MOUTH

HELMET SILHOUETTE: LIKE A MONSTER NOSE LIFTED UP

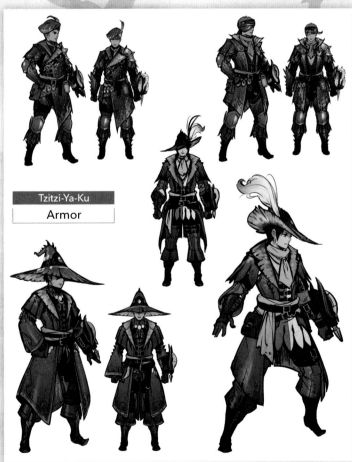

Tzitzi-Ya-Ku
Armor

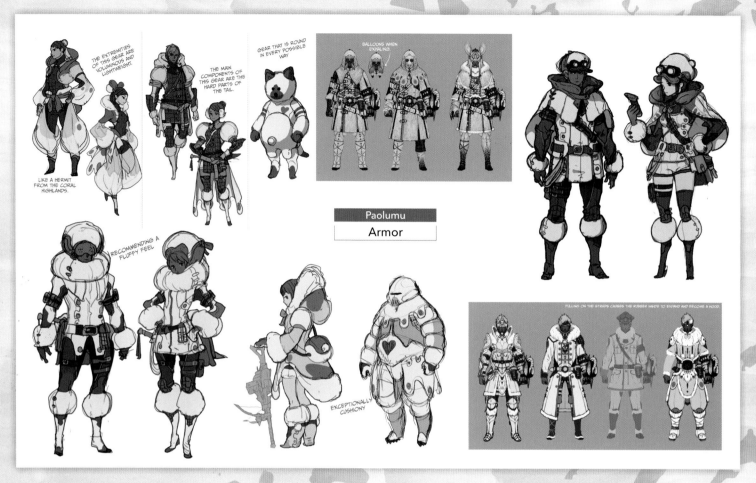

THE EXTREMITIES OF THIS GEAR ARE VOLUMINOUS AND LIGHTWEIGHT.

LIKE A HERMIT FROM THE CORAL HIGHLANDS.

THE MAIN COMPONENTS OF THIS GEAR ARE THE HARD PARTS OF THE TAIL.

GEAR THAT IS ROUND IN EVERY POSSIBLE WAY

BALLOONS WHEN EXHALING.

Paolumu

Armor

RECOMMENDING A FLUFFY FEEL

EXCEPTIONALLY CUSHIONY

PULLING ON THE STRAPS CAUSES THE RUBBER INSIDE TO EXPAND AND BECOME A HOOD.

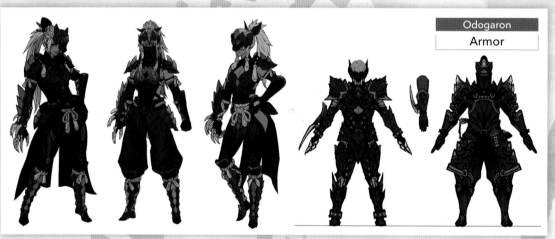

Odogaron

Armor

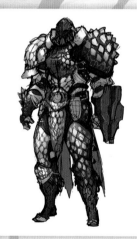

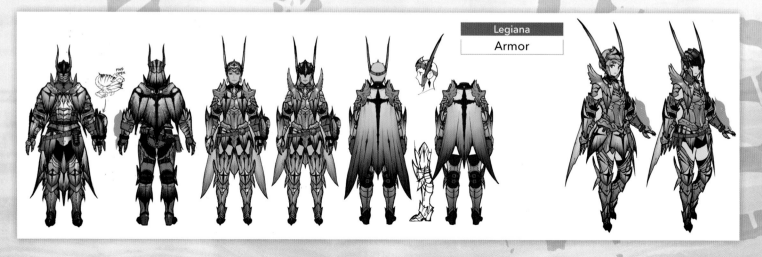

FINS OPEN

Legiana

Armor

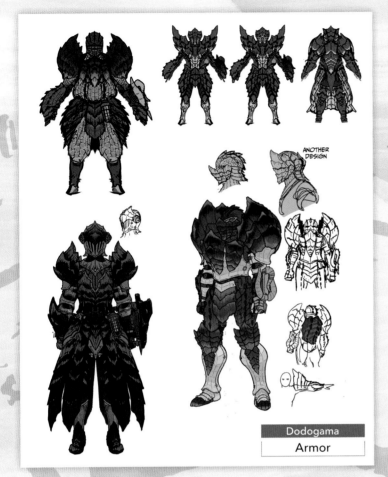

Dodogama

Armor

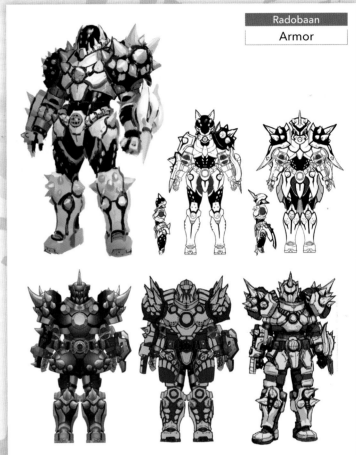

Radobaan

Armor

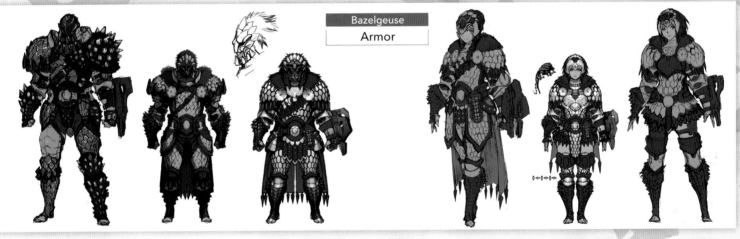

Bazelgeuse

Armor

Rathalos

Armor

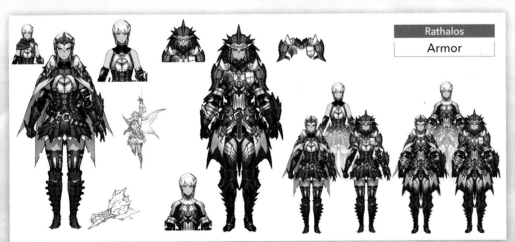

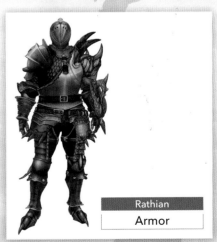

Rathian

Armor

Zorah Magdaros
Armor

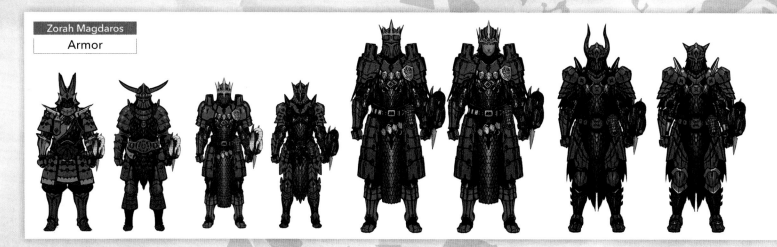

Nergigante
Armor

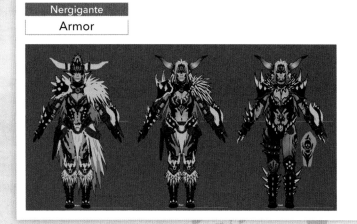

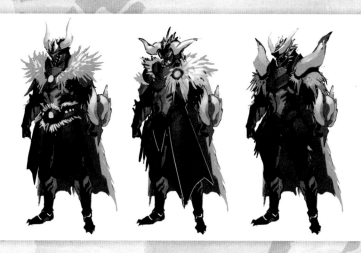

Vaal Hazak
Armor

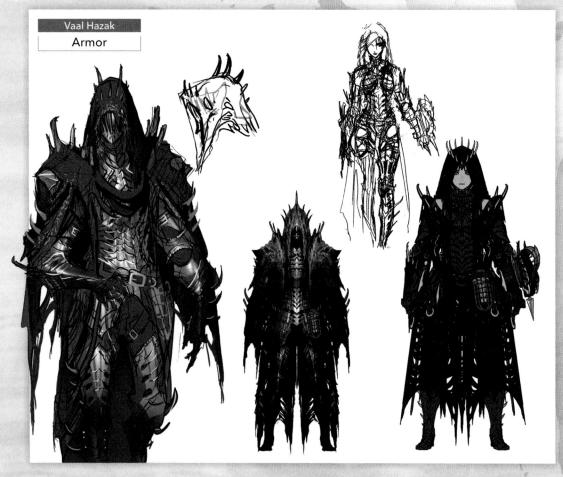

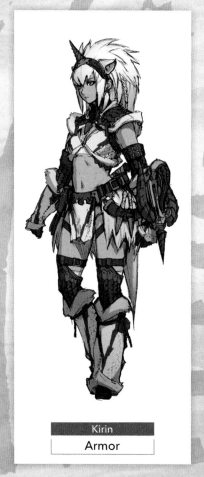

Kirin
Armor

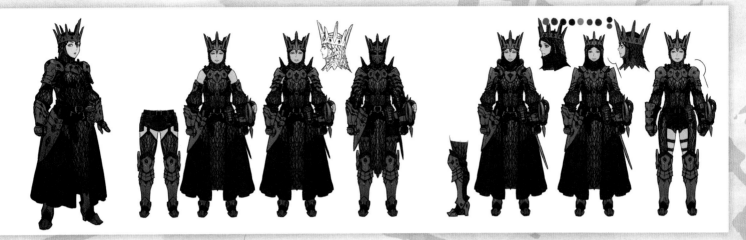

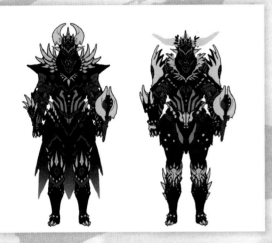

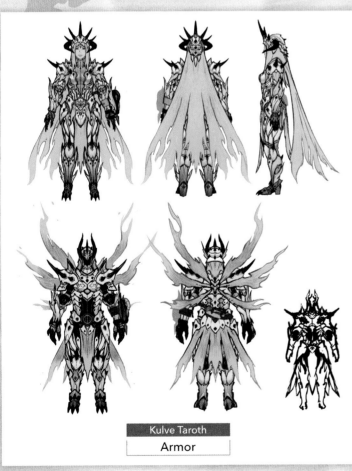

Kulve Taroth

Armor

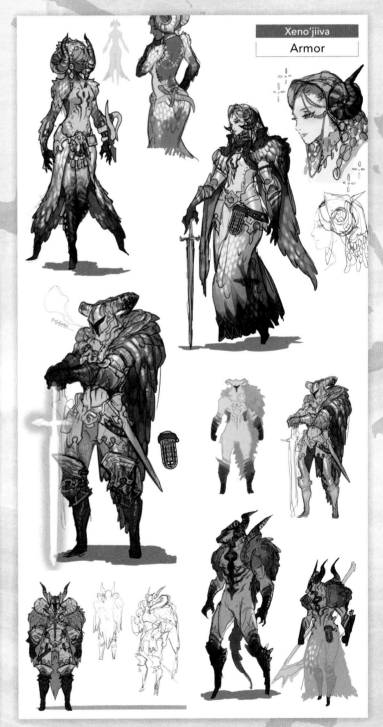

Xeno'jiiva

Armor

Great Jagras
Palico Arms and Armor

TURNS INTO A FUR BALL WHEN CROUCHING!

CRAWLING CHARGE!

WOHO

KIND OF LIKE HAVING A CAMP-FIRE

Kulu-Ya-Ku
Palico Arms and Armor

EEK! A-A-THIEF!!

HEH HEH...!

CREEP CREEP

Jyuratodus
Palico Arms and Armor

WHAT IS THE TRUE IDENTITY OF THE MYSTERIOUS WARRIOR...?

HAIL THE MEOWMPEROR

URGH

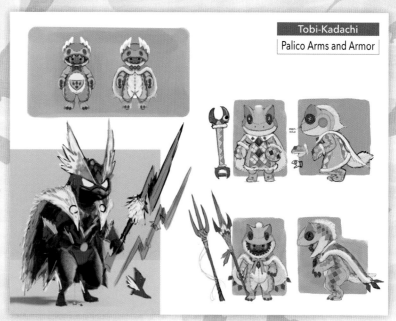

Tobi-Kadachi
Palico Arms and Armor

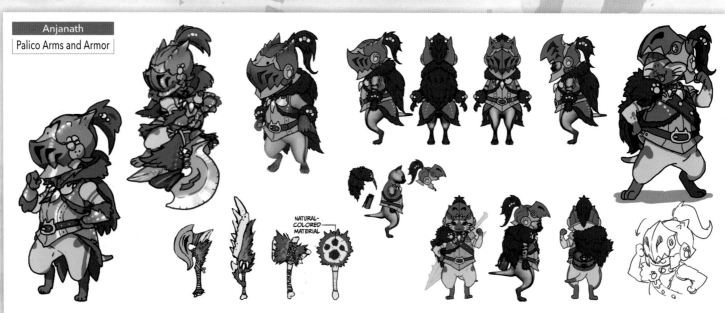

Anjanath
Palico Arms and Armor

NATURAL-COLORED MATERIAL

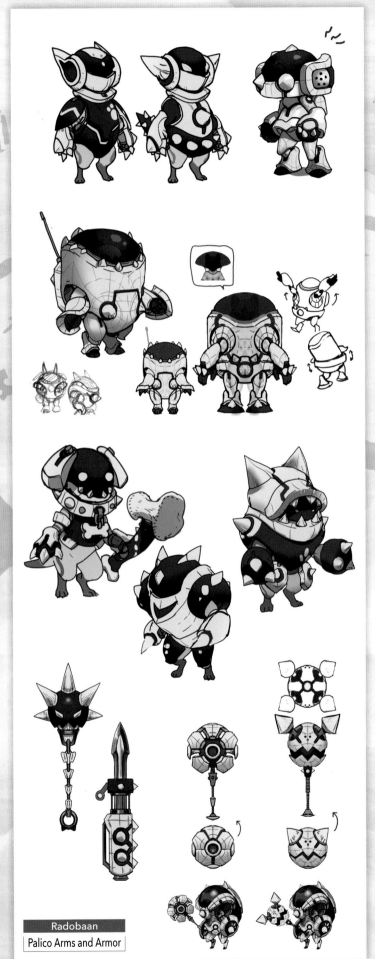

Radobaan
Palico Arms and Armor

Paolumu
Palico Arms and Armor

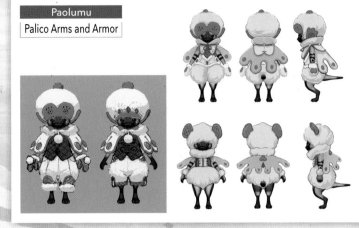

Odogaron
Palico Arms and Armor

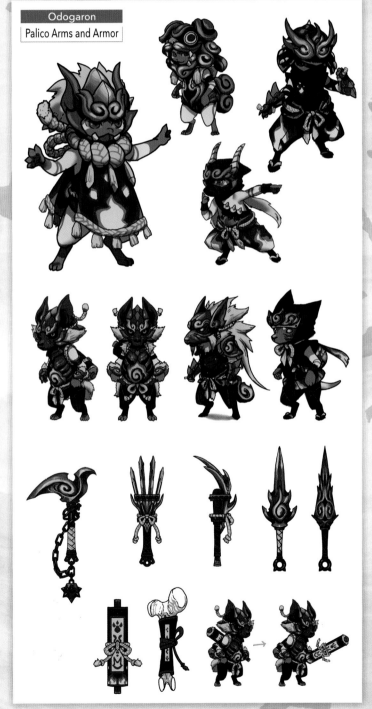

519

Bazelgeuse
Palico Arms and Armor

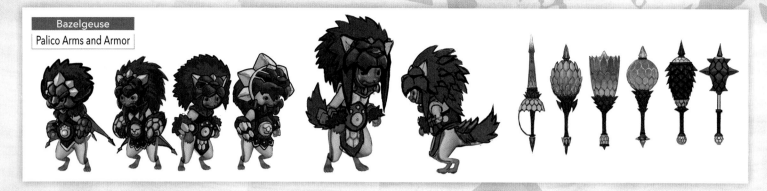

Zorah Magdaros
Palico Arms and Armor

Vaal Hazak
Palico Arms and Armor

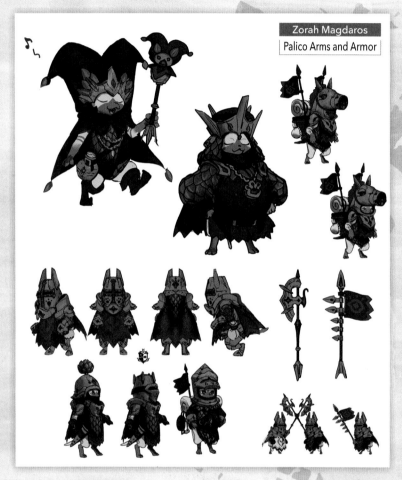

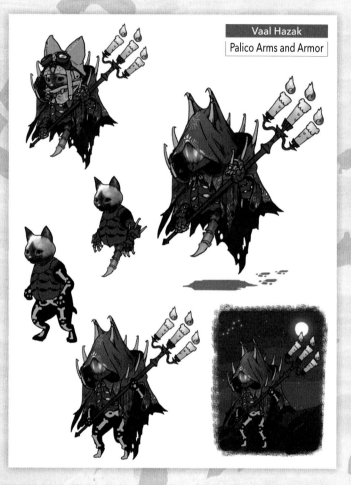

Nergigante
Palico Arms and Armor

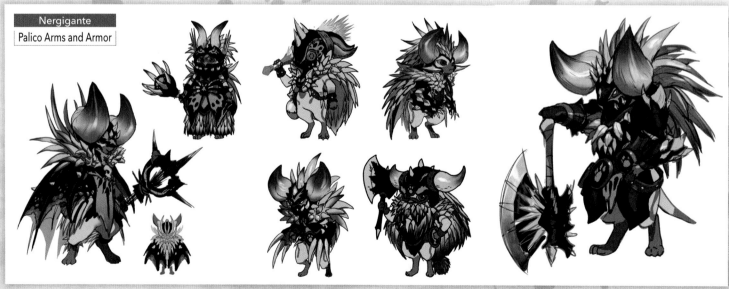

Xeno'jiiva
Palico Arms and Armor

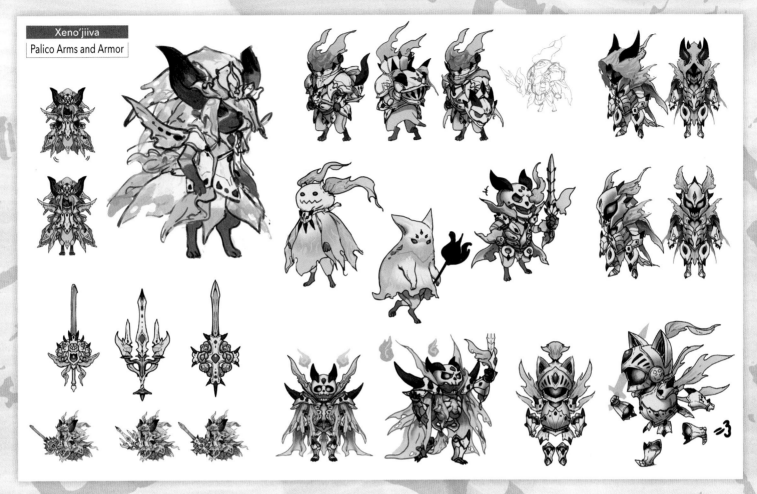

Kulve Taroth
Palico Arms and Armor

Y-YOU'RE SO VERY
BEAUTIFUL...!

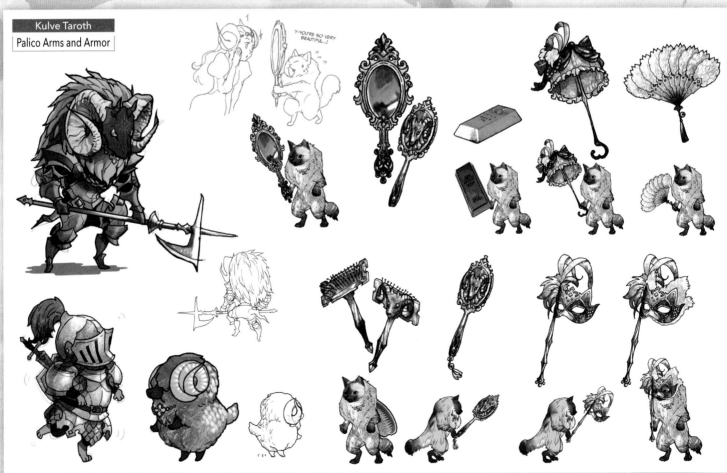

CHAPTER 5

History of the Fifth Fleet

This chapter talks about the Fifth Fleet's journey, from the moment they arrived in the New World until they fulfilled their mission of solving the mystery behind the Elder Crossing and were dismissed from duty. This is a record of how the Research Commission of the Old World traversed the New World.

※ We are using the latest data, since we have more detailed information from the members compared to when the Fifth Fleet first arrived in the New World.

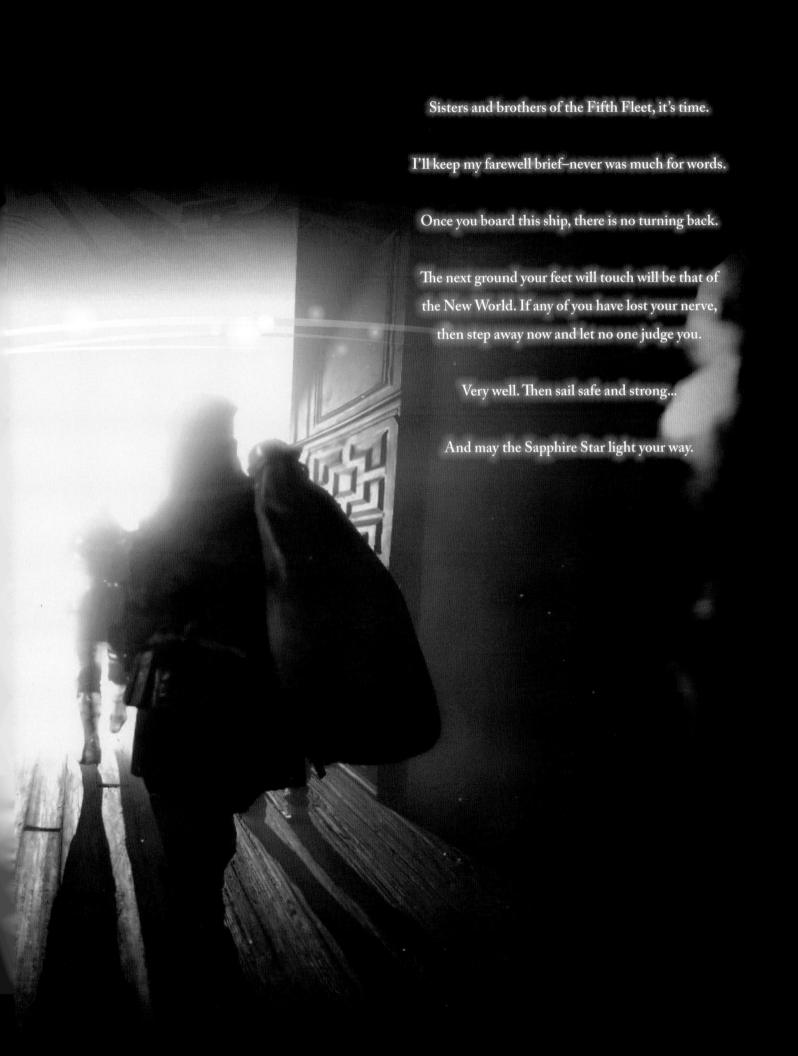

Sisters and brothers of the Fifth Fleet, it's time.

I'll keep my farewell brief—never was much for words.

Once you board this ship, there is no turning back.

The next ground your feet will touch will be that of
the New World. If any of you have lost your nerve,
then step away now and let no one judge you.

Very well. Then sail safe and strong...

And may the Sapphire Star light your way.

Once there was a world without time. The world was nothing but white light, inhabited only by people and five dragons.

In that world, there was only eternity, and a sun that burned without beginning or end.

And because there was only timeless eternity, nothing was ever lost...yet nothing was ever gained.

One day, the people began to wonder why their world had no beginning or end, so they asked the dragons. The dragons opened their mouths as if to answer, but from their mouths poured water instead of words. It rushed out in streams to create the sky and the oceans, and the dragons swam away.

The dragons swam to the center of the ocean, and there they began to transform into an island.

One dragon sank into the sea and became the land.

One dragon lifted its gaze to the sky and became the mountains.

One dragon stooped low and became the lakes, and scattered its scales to create the rain.

One dragon fell into a deep slumber and became the forests.

The last dragon climbed far into the sky to become a star of sapphire blue, shining brightly above the island.

The people could not understand why the dragons had left, or why they had transformed. Eventually, a lone youth decided to go to the island to seek the answers from the dragons themselves. He donned a simple cloak, climbed into a simple boat, and cast off alone into the murky seas.

At last, guided by the light of the Sapphire Star, he reached the Island of the Five.

Some time passed, and the youth returned. "Did you speak with the dragons?" the people asked.

"Yes, I spoke with them," he replied. And the people said, "Then tell us, why did they create the island?" But the youth did not answer. Instead, he reached into his cloak and pulled out five dragon scales, which he gave to the people. And then, before anyone realized, the youth disappeared. The people left their white world and sailed across the ocean. Using the five scales,

they created their own lands, their own mountains, their own lakes, and their own forests.

Last of all they created a bright moon...

...so that the Sapphire Star, which had guided the youth during his voyage to seek the dragons, would no longer shine alone

in the sky. The land grew large enough to obscure the sun, and day and night were born. The mountains, lakes, and forests breathed together, and the seasons were born. The moon cast its light on the ocean, and waves were born.

And thus time was also born.

Swept up in the almighty current of time, the people came to know death. But the people also came to know life.

Countless days and countless nights have passed since people first came to live on the lands they had created.

As time passed, they lost their memory of the Five Dragons, and even the memory of how time itself had been born. But deep in their hearts there dwelt a quiet knowledge of the Island of the Five, the most sacred place in the world, which to this day sleeps in the middle of the ocean, uninhabited by people, and unchanged even by the relentless flow of time.

In order to learn about the activities of the Research Commission and the Fifth Fleet, we must first give an account of how and why they were formed. This is a record of how each of the fleets were dispatched to the New World.

Milestone 1 「Elder Crossing」

This Commission is special—different from your past undertaking, if I had to take a guess. It's not about hunting down the Elder Dragons or punishing them for the damage they cause. The Commission seeks an understanding of their place in nature...and ours. That's the point. The Elder Dragons are nature, and it's as futile to try to punish nature as it is to run from it. But knowing nature... Now that's something we can do.

—Commander

↑The Elder Dragons heading out to sea have reminded the people of the grand and old story "The Tale of the Five."

Elder dragons have always been a mystery. There are even records from several hundred years ago that speak of a volcano-like Elder Dragon heading out to sea. Where it was headed and why had long been shrouded in mystery. Once an Elder Dragon appeared, the earth would shatter, forests would burn, towns would disappear...people had no time to wonder. It was only forty years ago that the Guild finally took interest in the movements of the Elder Dragons...

The Elder Dragons and Their Destination

Elder Dragons crossed the sea to an unknown destination. It occurred once every hundred years, then fifty, and then thirty. Now, we know that this phenomenon has been occurring in a fixed cycle of ten years for the last fifty years. Although details are unknown, there were Elder Dragons that traveled underwater too. The Guild named this phenomenon the "Elder Crossing" and organized the first Research Commission forty years ago.

And thus, the Research Commission was formed forty years ago to follow Kushala Daora, which had been showing signs of crossing over, by ship, discover where it was headed, and report back. How long would the journey be? How dangerous would it be if the destination turned out to be a huge Elder Dragon breeding ground? The journey was carried out by a small group of personnel who had agreed to sign a waiver that stated that this journey could cost them their lives. This group would later be known as the First Fleet of the Research Commission, a massive research campaign that spanned over the next half century.

The brave explorers set out on a single ship in search of the truth behind the Elder Crossing, just like that lone youth in "The Tale of the Five," hoping that the Sapphire Star would light their way.

What Are Elder Dragons?

Elder Dragons have existed since ancient times with traits beyond human understanding. They range from as large as an ordinary Flying Wyvern to the size of a small mountain. They will walk over anything in their way, changing the ecosystem of the places they pass through, and will even destroy human villages at times. Therefore, Elder Dragons have been feared as much as natural disasters, and their stories have been passed down for generations around the world as legends.

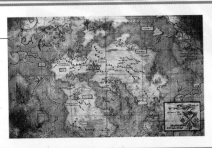

➜ The current world as surveyed by the Guild. Elder Dragons will crush everything in their way and will even change the ecosystem at times.

Pursuing the Elder Dragons: Arriving in the New World

Thus the First Fleet set sail and followed the flying Elder Dragon Kushala Daora. Sometime after leaving the Old World, they were met by a raging storm. Amid the raging wind and water, the Commission saw Kushala Daora fighting against another entity. The storm grew ever worse, and the ship was blown away by the flow of water...

Once the clash subsided, an unbelievable sight appeared. Their ship was stuck on the edge of a cliff overlooking the ocean to the south, but to the west was a deeply forested area, and to the east, a barren desert. As landscapes like that didn't exist in the Old World, it was a sign that they'd reached the New World. Further investigation confirmed that the other entity was an Elder Dragon that controlled water and prevented Kushala Daora from completing the crossing. (No sign of it landing was discovered.)

The New World's Celestial Pursuit

The X marks where the First Fleet ship landed and the location of Astera, the Research Commission headquarters. The ship that washed up on the cliff was named "Celestial Pursuit." The Chamber of the Five located at the stern of the ship later became a Gathering Hub for the hunters.

➜ A map of the area around the Research Commission headquarters in the New World. The weather in this area changes so rapidly that even monsters cannot approach it when the sea is stormy.

The Unique Ecosystem of the New World

The First Fleet immediately began to create the Research Commission headquarters out of the Celestial Pursuit. Only two members of the Commission were technicians, but luckily for them the cliff they landed on had a huge waterfall, so they had more than enough water, according to the Tech Chief as he recalled those days. They made splendid progress and succeeded in building a waterway along with a hydropower system. In a few years, they had secured a simple living environment as well as a large headquarters. Detailed records of sightings of Rathalos and Anjanath in the Ancient Forest and the shining spires in the desert to the east still remain from this era. Familiar creatures like the Aptonoth existed as well, but most of the discoveries were a surprises to the researchers.

For example, the flying lights they sighted, which the Commander named "Scoutflies," had the ability to pick up the scent of many things. This caught the interest of the Guild and researchers as a unique tool for exploration.

⬆ Wedge Beetle and Dung Beetle (top) and Shepherd Hare (bottom). New species were discovered in every report, which greatly fascinated the scholars.

⬆ In addition to the Scoutflies, Wingdrakes were something unique to the New World. The hunters of the New World would use their slingers to hitch on to the Wingdrakes to fly freely around the air while hunting.

For whatever reason, many of the beasts that make the Elder Crossing carry a vast amount of energy inside them. Of course, conversely, without that much energy, they probably wouldn't be able to make it across. It makes one wonder...

What sets these Elder Dragons apart from the others? Of course, I'm not actually asking you. Keep your head injuries for the field, dear Hunter!

I'm curious about your opinion. Do you think the Elder Dragons are more like people? At times, I sometimes wonder if they're not more similar to plants. Vast trees, if you will...

—Chief Ecologist

⬆ The Ancient Forest located to the west of the Research Commission headquarters. The Ancient Tree is a conglomeration of various plants and continues to grow today.

Dude...all the flowers, the monsters, and the little creatures, they all evolved differently here in the New World. Just when you think you've seen it all—bam!—some new creature scurries across your path. To tell you the truth, it can get a bit exhausting! Ha!

—Fun Fourth

Milestone 2 「Research Commission」

The Research Commission ranges from the First Fleet to the Fifth Fleet, and close to a thousand people have visited the New World on these expeditions. Each of the fleets served a different specific purpose. Learning about the fleets and their flags will help you understand the Commission as a whole. They are not just a group of hunters or scholars—they are challengers of the unknown.

Those Who Staked Their Lives on This Unknown Journey and the New World

I have written that there have been close to a thousand researchers, but a ship back to the Old World departed when the Fourth Fleet arrived, and the same thing happened when the Fifth Fleet arrived. Therefore, most of the First and Second Fleet hunters who spent thirty to forty years in the New World since their dispatch have returned home. When people who have returned to the Old World speak of the New World, they often say, "Those in the New World are geniuses, weirdos, and troublemakers," which clearly identifies the type of people who rejected the return order and remained in the New World. All the fleets beginning with the Second Fleet were composed of more than three ships, and it was traditional to keep two ships for the return trip and one other as a spare. The remaining ships were dismantled and used as precious material.

⬆ The emblem of the Research Commission. It is made up of the symbol of the Guild and dragons with symbols that represent "The Tale of the Five." It has been used since the First Fleet.

The latest monster to make the Elder Crossing is known as Zorah Magdaros, a huge monster with a mountain of fire upon its back. The Research Commission's job is to discover exactly why the Elder Dragons are migrating to the New World.

—Commander

First Fleet Flag

The symbol is a star, and the color of the banner is red. This fleet was dispatched roughly forty years ago to track Kushala Daora. The group had thirty specialists, and most of them were skilled hunters. They had trouble securing shelter since there were only two technicians. The Fleet Master resembled a Rajang and soon became the admiral of the Research Commission.

Second Fleet Flag

The symbol is fire, and the color of the banner is orange. This fleet was dispatched roughly thirty years ago. Of the ninety members in three ships who followed Teostra's crossing, 60 percent were technicians. As they arrived, they were attacked by a black thorned dragon. Despite lackluster resources, they refreshed the equipment standards and improved their qualify of life by creating waterwheels and slingers.

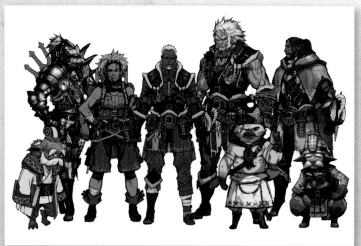

⬆ Starting from the left: the Chief Ecologist, the Huntsman, the Tracker, the Commander, the Admiral, the Meowscular Chef, the Seeker, and the Tech Chief. These were the names they used when the Fifth Fleet arrived, after most of the First Fleet members had already returned home.

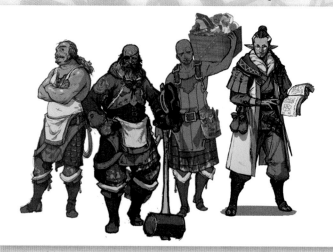

⬆ Members of the Second Fleet smithies. In the center is the Second Fleet Master, known as the Foreman. He lost sight in his right eye from staring too closely at fire while working on his numerous inventions. The man on the right is the Analytics Director.

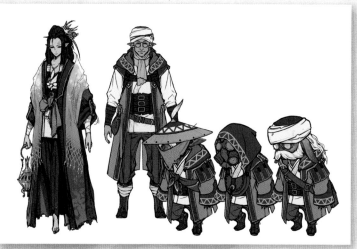

↑Main members of the Third Fleet. Many of them were Wyverians, who often make a life out of research. The woman on the left is the Third Fleet Master. She is the younger sister of the Analytics Director who came with the Second Fleet, and she too is Wyverian. On the right are the three scholars.

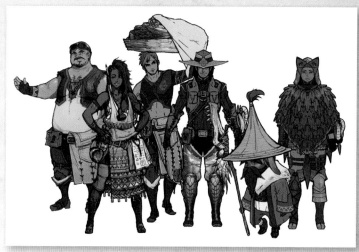

↑The Fourth Fleet not only had hunters and scholars but many merchants and traders as well. This shows that life in the New World had begun to prosper, and all kinds of supplies were being handled at the various facilities in Astera.

Third Fleet Flag

The symbol is a chalice, and the color of the banner is purple. The fleet mostly consisted of scholars and researchers and was dispatched twenty years ago. A total of 110 members headed for the New World on three ships during the Elder Crossing of Kushala Daora. They converted their main ship into an airship, flew off into the depths of unexplored territory, and went missing.

Fourth Fleet Flag

The symbol is a wheel, and the color of the banner is green. This fleet was dispatched ten years ago. The headquarters had already taken in more than two hundred people so merchants and those skilled in daily business were chosen for this journey. By this time, members of the earlier fleets were returning, so applicants greatly increased now that people knew it was not a one-way trip. A total of 270 people arrived with the Elder Crossing of Kirin.

Fifth Fleet Flag

The symbol is the wind, and the color of the banner is white. This Fleet featured nearly five hundred members, the largest ever, on six ships. They were going to head out to sea to follow the Elder Crossing of Zorah Magdaros, but a certain hunter didn't arrive until just before departure, so there was concern that the fleet would not leave as scheduled.

The Elites: Skilled Hunters and Handlers

Although the Commission encountered troubles, the quality and quantity of the members has continued to improve. The Fifth Fleet in particular is made up of almost the same number of members as all the previous fleets combined, which shows the great improvement in seafaring technology after forty years. Since such a long time has passed, second-generation Commission members—those whose parents and grandparents were members of previous fleets—have joined as well. There are even some new members who were born and raised in the New World. The current Field Team Leader is the grandson of the Commander and is bound to get attention due to his background.

Once Zorah Magdaros began to cross, the Guild began to recruit and send notice to the hunters, handlers, and candidates they had gathered beforehand to join the Commission. This was the beginning of the "teams of two" system originated by the Commander of the First Fleet, and many of these so-called A-Listers had met each other before the departure to get to know each other better. Preparations in the New World to accept the new Commission members were ready, and the hope of finally getting to the bottom of the Elder Crossing mystery was starting to rise.

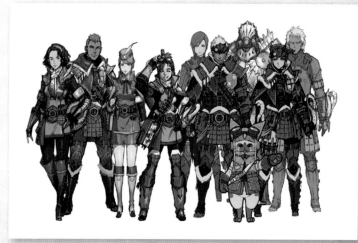

↑An image of the members of the Fifth Fleet. The Serious Handler and the Excitable A-Lister on the left were an especially noticeable duo. It is said that they successfully proved the effectiveness of working as a pair in numerous situations.

↑ The Fifth Fleet was organized under the orders of the Commander with hopes of boosting the research of the Elder Crossing. Never before have so many skilled elites been gathered.

Very well. Then sail safe and strong...

And may the Sapphire Star light your way.

After running the Research Commission for forty-odd years, the Guild's itching for an answer. They say the Fifth Fleet's got the best shot at cracking this case, and I agree!

—Excitable A-Lister

Listen to that. Getting rough out there... The waves are picking up. And that's gotta mean landfall!

—The Handler

↓ Zorah Magdaros appeared right amid the Fifth Fleet just as they were about to reach the New World. It was as if an underwater volcano had risen up.

It had been forty years since the dispatching of the First Fleet, a historic milestone. The hunters and handlers of the Fifth Fleet had gathered in a room and were waiting for departure time with determination and faith in their hearts. After a sudden silence, it felt as if a gust of wind blew through the room. That was the arrival of the hunter who later became known as the "Sapphire Star of the New World," fresh from another mission.

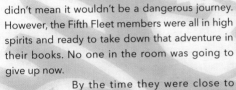

Driven by the Star

There were no sad farewells for those headed to the New World. The room was filled with ardor and anticipation for the adventures that awaited them. Stories about the New World were relatively common thanks to returnees, but that didn't mean it wouldn't be a dangerous journey. However, the Fifth Fleet members were all in high spirits and ready to take down that adventure in their books. No one in the room was going to give up now.

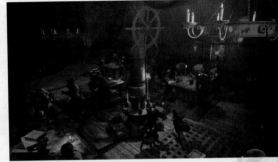

By the time they were close to arriving in the New World, the hunters had met their Guild-assigned partners, the handlers, and gotten to know them. There was one pair that still hadn't met each other yet, the same one that hadn't attended the briefing. In other words, the future Sapphire Star and their Guild-assigned handler.

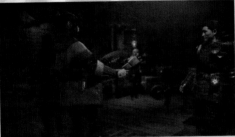

Meeting a Friend

Just as the Excitable A-Lister and the Serious Handler were talking over a drink with the hunter in question, waves began to rise around the fleet. The hunters who noticed quickly rose to their feet to look out of the porthole and climbed up on deck to see for themselves.

A shock suddenly came from right below them as the sea divided. One ship overturned, and another pointed its nose right up at the night sky. The Elder Dragon Zorah Magdaros, the Fifth Fleet's target, had suddenly risen up amid the fleet, as if it had decided to join the party or wanted to stop the noise.

Having the opportunity to see the monster right before their very eyes was something to be grateful for, but the Fifth Fleet members were in no position to enjoy it. Some were thrown out into the sea, some tried to keep sailing, and others desperately escaped from the sinking ship. The Fifth Fleet faced total chaos on the edge of the New World.

The Fifth Fleet members that managed to survive and were rescued by the Research Commission headquarters, Astera, all said, "Did you see the light falling from Zorah Magdaros?"

The New World Opens Up

A hunter and handler pair were thrown onto Zorah Magdaros's body after the ship sank. Luckily for them, they were near the New World, so they hitched a ride on a Wingdrake and managed to escape. A vast forest spread out below them under the morning sun before they fell at the edge of the Ancient Forest, west of Astera. Having lost their weapons in the chaos, they carefully dodged the fangs of the monsters and managed to meet up with the Field Team Leader, who had come running to their rescue.

The Fifth Fleet's Route

Just like the first four fleets, the Fifth Fleet was naturally heading for the Research Commission headquarters, Astera, by riding the currents near the New World. They did come in contact with Zorah Magdaros shortly before their landing, but that was a result of them successfully pursuing the creature by calculating its path.

➡ The red circle is the Research Commission headquarters in Astera. The two who were thrown off Zorah Magdaros headed east from a camp in the Ancient Forest.

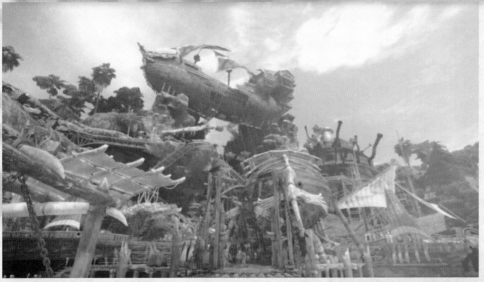

↑ Due to a series of coincidences, the pair escaped from Zorah Magdaros on Wingdrakes and enjoyed the scenery of the New World from above.

↑ The swarming Scoutflies. The hunter and the Handler used this to keep track of one another and succeeded in staying together in the deep forest until they were rescued.

↑ The Field Team Leader and the rescued pair encountered a rampaging Anjanath near the gates of Astera. It was a close call for them.

That old man in charge, my grandfather, was with the First. But that was a loooooong time ago.

Me? I'm not with any fleet. Born and bred right here. Never even been to the Old World.

—Field Team Leader

↑ Waterwheels powered by the river and waterfall are located all over Astera and used to power various facilities. It's also used as a mode of transport around Astera's many layers.

↑ A view of Astera from the west gate. It was built using the scarce materials the fleet members had, which lends a strange yet beautifully functional look to the place.

The Story of the New World, Or Possibly, Its Recollection

And so—the Fifth Fleet arrived in the New World and began their research on the Elder Crossing. This is the story of the hunters and handlers who traversed the uncharted lands in pursuit of Zorah Magdaros. Their mission became a journey to unravel the mystery behind the massive ecosystem of the New World.

The Foundation of the New World—Research Commission Headquarters, Astera

↑ The symbol of Astera with the starred ship at the top, the waterwheels and pulleys of the facilities, and the ocean and port before our very eyes.

We've got it all here...

We've got hunters to do all the exploring, scholars to do the research, technicians to keep them going...

This place is the beating heart of the Commission.

—Field Team Leader

Miraculously, the entire Fifth Fleet survived. They were a group of A-Listers and luck was on their side. The fleet had sunk near Astera, and Zorah Magdaros's heat raised the seawater to near-body temperature, which protected everyone from the cold. The last to arrive were also the last to arrive on the ship: an A-list hunter and their Handler. We will be following the trail of light they left behind in this recollection of the adventures in the New World.

Preparations

After the past four fleets, the HQ and the surrounding facilities had become quite a fortress. The Celestial Pursuit lies to the northeast with the smithies from the Second Fleet, waterwheel, lifts, and Tradeyard from the Fourth Fleet all spreading out radially from it. (The majority of the Third Fleet left soon after they arrived, so they have not provided notable contributions to the development of Astera.) To the south across the port is the residential area created from the ships of the Fourth Fleet which made it possible to accommodate the Fifth Fleet, the largest fleet ever.

↑ Smithy: The abode of the Foreman. Numerous pieces of equipment are created here around the clock.

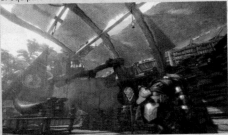

↑ Ecological Research: Countless documents have piled up during the search to study the ecology of the various creatures of the New World.

↑ Botanical Research: A part of the Ancient Tree has been brought back there with hopes of attempting to use its traits to grow other plants (such as fruits and grains).

↑ The Tradeyard was mainly built by the Fourth Fleet, and it's where members raise their voices to barter goods just like skilled artisans.

The Ancient Forest

After enjoying a hefty meal at the Canteen, the Fifth Fleet hunters headed out to the Ancient Forest. Due to the landing of Zorah Magdaros, the monsters around the area had become agitated, and even Kestodon, an herbivore, had begun to show signs of hostility.

The hunters grabbed the weapons created by the Foreman (he's the Second Fleet Master but everyone calls him the Foreman and it suits him) and entered the depths of the forest. The Scoutflies swarmed around the plants and monster tracks beautifully and brightly.

Targeted–Those Who Lurk in the Forest

After monsters like Kestodon, Jagras, and Great Jagras were discovered in the Ancient Forest, they were hunted until they became agitated and extremely hostile, just as the Commander predicted.

It came as a surprise that scholars were still carrying out their research. According to them, strange situations like this allowed their scholarship to truly thrive. Their research focused not only on the monsters at the top of the ecosystem but on all the endemic life, like small animals, bugs, fish, and even the Grimalkyne, a Lynian creature. With the Elder Crossing being the main pillar, other studies branched off it like the Ancient Tree. Occasionally, hunters discovered something to add to the menu at the Canteen. Small things like that made being a member of the Research Commission so pleasant.

In any case, they discovered tracks that seemed to belong to Zorah Magdaros, but a Pukei-Pukei roaming the area made things difficult. As a result, the Commission decided to prioritize rebuilding the camp that had been destroyed by Zorah Magdaros instead. Although a Kulu-Ya-Ku was raiding the campsite, the creature was no match for the Fifth Fleet hunters.

The New World's Rapidly Changing Geology

It is said, "A New World map becomes useless after every Elder Crossing." The Elder Dragons alter the geology and ecosystem like a natural disaster. When the Fifth Fleet arrived, numerous campsites were destroyed by Zorah Magdaros. The habitats of the various monsters changed as well, so the Commission had to redo their investigations.

↑ The researchers grieved that the wildlife map had to be created again due to how dangerous and powerful Elder Dragons are.

Incidents at Astera

- The Commander calls for the two who jumped off Zorah Magdaros to serve as the representatives of the Fifth Fleet.
- The Meowscular Chef asks for a supply of Gourmet Shroomcaps.
- To learn about the influence of Zorah Magdaros, the Chief Ecologist asks for a reinvestigation of monsters such as Kestodons and Jagras.

How old is it? That's what I want to know. I've done enough research to get a rough idea. Now I just need a way to find out if I'm right.

Once we capture it, I've put together a daunting but doable list of things we need to document.

Oh my! I'm going to need more space for books!

—Chief Ecologist

- The Foreman begins to create equipment for the Fifth Fleet.
- Airship Engineer has trouble developing an airship that is capable of crossing over the Great Ravine.

- All Fifth Fleet members are rescued from the shipwreck alive.
- The rebuilding of the Ancient Forest campsite is carried out.
- The Resource Center is opened for use to the Fifth Fleet.

- Living quarters are opened to the Fifth Fleet.
- The Fourth Fleet teaches newcomers how to hunt in the New World. Some of the hunters have difficulty with the slingers.

Fifth Fleet Quest Progression ❶

Jagras

◆ The fleet beings investigating Jagras's habitat.
◆ Rumor has it that the Fifth Fleet's ace has defeated seven of them in an instant.

Kestodon

◆ Changes in the habitat of Kestodon are confirmed. They come across a Great Jagras preying on a Kestodon during a quest with the Field Team Leader and decide to investigate that too.

Great Jagras

◆ Tracks that seem to belong to Zorah Magdaros are discovered for the first time since the investigation began. However a Pukei-Pukei is seen nearby, and further investigation has to be postponed.

Changes to the ecosystem of the Ancient Forest had been recorded, and the monsters were in a riled-up state. It was probably due to the influence of Zorah Magdaros appearing in the New World, so the Fifth Fleet began to take an active role in securing the safety of Astera.

Expedition to the Ancient Forest

◆ The fleet comes in contact with the Lynian Researcher, the Piscine Researcher, and the Endemic Life Researcher while traveling around various regions and obtains their knowledge.
◆ The fleet comes in contact with a Kulu-Ya-Ku raiding the campsite.

Kulu-Ya-Ku

◆ The Provisions Manager gives orders to hunt the Kulu-Ya-Ku so the raided campsite can be rebuilt. After restoring safety, the provisions team delivers the needed materials to successfully rebuild the camp in the depths of the forest.

Wildspire Waste

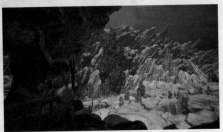

↑ The dark-looking thing among the sandstones is the Wildspire. It is unbelievably large and is still growing.

While I was out exploring the Wildspire Waste, I found something Zorah Magdaros left behind.

But I found some other weird tracks nearby, too. My Scoutflies were going CRAZY around 'em...

—Hotblooded Fourth

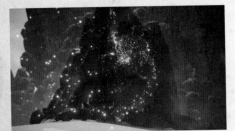

↑ The Scoutflies gathering around Zorah Magdaros's track and glowing blue. Remnants of strange energy unlike that of an ordinary life-form can be felt.

Hey, dude. I heard you found some kind of monster trail in the Wildspire Waste. Man, I remember hearing similar reports ten years ago...

Heh, I was so scrawny back then, but ten years of lugging boxes does a lot for your abs!

—Fun Fourth

Might I ask, are you tracking the monster that dropped that massive slag?

I am as well. It seems so easy... Follow the trail, find the truth...

—The Seeker

After hunting Pukei-Pukei, a full-scale investigation of Zorah Magdaros's tracks began. Tracks were discovered at the Wildspire Waste located to the east of Astera opposite the Ancient Forest, and strange thornlike tracks were also reported by field teams as well. The Forth Fleet members had seen the thorns before. The researchers—otherwise known as the three scholars—headed out to investigate the tracks at the Wildspire Waste, so the Commander asked the Shooting Star to go with them just in case there was any danger.

The Wind Blowing Across the Wildspire Waste

The Commander's biggest concern seemed to be an encounter with the monster that left thorns behind. That was avoided, but the investigation by the three scholars met a rocky road. They were chased by a Rathian and attacked by a Barroth. They would not have survived if the hunter had not been with them. Later on, it was discovered that the hunter had met the Seeker while missing in action, a Wyverian hunter who was once the Commander's right-hand man. That was met with quite a bit of surprise in Astera.

Fifth Fleet Quest Progression ❷

Pukei-Pukei

◆ An urgent quest is commissioned by the Commander. Pukei-Pukei is in a hostile state from having its territory invaded by another monster, and it needs to be hunted down for the fleet to investigate Zorah Magdaros's tracks.

Expedition to the Wildspire Waste

Barroth

◆ The fleet follows the three scholars who are headed down to the Wildspire Waste to investigate Zorah Magdaros's tracks. They encounter a Rathian on the way to the Waste.

◆ Zorah Magdaros's tracks are discovered at the Wildspire Waste. The group comes in contact with Barroth, which the hunter defeats.

A full-scale investigation in pursuit of Zorah Magdaros began. The investigation area was widened to include the large Wildspire Waste region. Meanwhile, the Fifth Fleet members were kept busy hunting and researching monsters, as well as protecting the scholars and handlers who were taking part in the investigation.

The Dragon That Rules the Forest

After investigating the tracks in various regions and connecting when the tracks were discovered, the Commission came to the conclusion that Zorah Magdaros was heading to the Great Ravine to the northeast. The Commander called for a council and proposed capturing the massive Elder Dragon. In order to do that, the Commission would have to make use of every bit of the manpower and provisions it had. However, the Commission needed to ensure the safety of Astera, which would be empty during that time from the tyrant of the forest, Anjanath. So an urgent quest to protect Astera was announced.

The Chief Botanist of Botanical Research wanted to hand out Ghillie Mantles, a specialized tool, to the hunters as protection, but a Tobi-Kadachi had begun living where the materials for the mantle could be gathered. The hunt for Tobi-Kadachi and the preparation of the tools became top priorities. In the end, as many specialized tools as possible were prepared.

Anjanath is the perfect example of monsters that have adapted to the environment of the New World. Anjanath was the fated enemy they met just after arriving in the New World, so this may have been the opportunity they were waiting for. With the issue of Astera's safety resolved, the Commission prepared to face Zorah Magdaros.

Jyuratodus

◆ The fleet embarks on a quest to search for the Ecological Research scholar who has gone missing in the Wildspire Waste. He is discovered at the swamp, but the hunter comes in contact with Jyuratodus and has to hunt it.
◆ Black thorns and strange tracks are discovered.

Tobi-Kadachi

◆ The Chief Botanist asks for Tobi-Kadachi to be hunted down at the Ancient Forest.

Anjanath

◆ An urgent quest is commissioned by the Commander—the hunt for the tyrant of the forest, Anjanath. This is to ensure Astera's safety during the operation to capture Zorah Magdaros.

Incidents at Astera

- The Seeker suddenly comes into contact with the Shooting Star in the Wildspire Waste.
- The Commander decides to capture the Elder Dragon.
- The Canteen is expanded.
- The Meowscular Chef asks for Gajau Liver, Bullion Meat, and Herbivore Egg.
- The Ecological Research team analyzes the substances found in Zorah Magdaros's tracks.

- The Smithy and Armory begin to prepare even more weapons and armor.
- The Analytics Director is frightened about reuniting with his sister, the Third Fleet Master.

Some ancient peoples believed misfortune would strike any who tried to possess an Elder Dragon.

Frankly, I'd like to witness such a catastrophe. It would make for marvelous research...ha ha! I jest! I would never hope for—oh, never mind.

—Analytics Director

- Thornlike tracks are discovered in the Wildspire Waste, possibly related to the mysterious black monster reported thirty years ago.

- The Chief Botanist suggests handing out Ghillie Mantles to all the hunters.
- Security is reinforced at the gate to Astera.
- The seed of the Ancient Tree sprouts and grows rapidly at Botanical Research.

Actually, I knew the tree would sprout by the time I got back. This isn't my first attempt.

But the other sprouts didn't grow very well. I could not tell you why.

Hopefully this new sprout will be an exception. I'd like to see it grow big and tall...

...so big that it SMASHES right through the roof of the lab! Wouldn't that be something?

—Chief Botanist

- An advance item is dispatched to the Wildspire Waste to rescue a scholar who has gone missing.
- A tour of the Chamber of the Five is popular. The symbol of the Commission, the Sapphire Star, reminds the tourists of the story behind it.

↑ Cannons and ballistae that are usually used for the protection of the headquarters were carried without rest to the Great Ravine.

All the same... How long has it been since the night filled me with such dread? Since I've wished this much for the morning not to come?

I've spent so long in the company of fire that I thought I'd lost my fear of darkness.

—Foreman

Zorah Magdaros will arrive at dawn... This all feels like something out of a fairy tale.

—Serious Handler

➡ The Scoutflies gave off a blue light and gathered at one point at the bottom of the Great Ravine. A moment later, Zorah Magdaros broke through the bedrock and appeared in the Great Ravine, lit red by the morning sun.

The Fifth Fleet's capture operation for Zorah Magdaros involved pursuing the monster, riding its back, and searching high and low for its tracks. Where did this giant come from? What does it eat? Why did it cross the ocean, and where is it headed to in the New World? Nothing about it is known. And it is also a mystery as to what the Commission will discover during this operation.

Yet the Commission worked together as one to fulfill what they came to do. The hunters, the handlers, the scholars, and the researchers—everyone—gathered at the moonlit ravine to stop Zorah Magdaros's progress, capture it, and research it.

 ## The Great Battle of the Ravine

The capture operation was finally executed. However, certain questions came to mind: What will we discover after capturing Zorah Magdaros? And capturing the Elder Dragon means it must be kept alive, so what will happen when it wakes up? According to the Chief Ecologist, once Zorah Magdaros is captured, once it is stopped and successfully chained down, they will extract a section of its outer skin. Then they will check if the Elder Dragon has any teeth, and if it does, what they look like. Once the Scoutflies had memorized the Elder Dragon's traits, the Commission would set it free. For a long time, the Chief Ecologist had wanted to study how old the Elder Dragon is, and it was thought that studying its growth process and the growth ring of its outer skin would help them discover that. Releasing the Elder Dragon to pursue it was part of the Commission's plan from the start.

The unprecedented operation to capture an Elder Dragon was put into action, and Scoutflies glowed blue and flew out of the pockets of the hunters who were hiding in the ravine. Just as we suspected, it appeared exactly at dawn—the Chief Ecologist, who calculated Zorah Magdaros's movements, must have shouted such, but we

Capturing an Elder Dragon

In the long history of monster hunting, it has been common knowledge that an Elder Dragon cannot be captured, so the Commander's plan came as a surprise to everyone. However, the Analytics Director argued that methods of capturing an Elder Dragon had been unknown because they were on a completely different level from other living creatures.

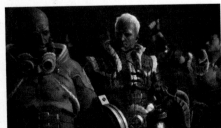

↑ The Commander who came up with the idea of capturing Zorah Magdaros and the Foreman who created all sorts of equipment for every possible situation.

↑ Elder Dragons like Zorah Magdaros are like natural disasters. The Great Ravine crumbled and shattered with every step.

⬅↑ Two barriers were built along Zorah Magdaros's path. After attacking with cannons and ballistae, the Commission attempted to capture the monster using a one-shot binder. After that failed, they climbed upon Zorah Magdaros to attack before attempting to restrain their target again in front of the second barrier.

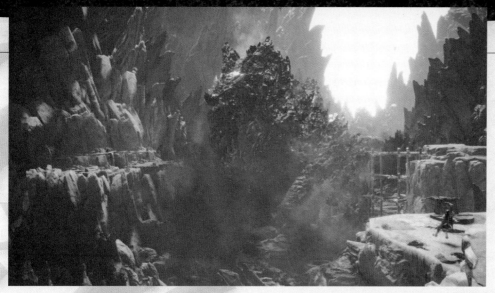

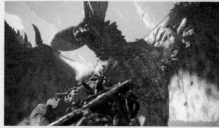

⬆ The mysterious black monster that flew right at Zorah Magdaros. It was extremely vicious, as you can tell from its brutal thorn-covered body.

Ayyy, Hunter! Heard you got a good look at that black meownster.

Years and years ago, my partner and I traded blows with it a few times...

Couldn't even put a dent in 'em! That's one nasty meownster, Hunter. You be careful.

—Meōwscular Chef

had no time to check...for the operation had now begun.

The Commission members began attacking with cannons, ballistae, catapults, and everything they had. But Zorah Magdaros continued and broke through the first barrier.

In order to stop it at the second barrier, the hunters climbed upon Zorah Magdaros's body and began to destroy its magmacores. Disliking that, Zorah Magdaros stood on its hind legs to shake the pesky animals off.

After it stood, a magmacore was discovered on its head, which was destroyed upon the Commander's order. After that, it took to all fours before reaching the second barrier (was it getting tired?). The Commission used this opportunity to fire one-shot binders. But just when the operation seemed to be a success, a monster flew onto Zorah Magdaros's back. It was a brutal-looking creature with countless black thorns on its body—the Huntsman rushed over to face it and swung his long sword at the thorns on its left arm, but the thorns immediately grew back in place.

This interruption gave Zorah Magdaros time to escape from the bind and start moving again.

That black monster...

We've encountered it in the past... Nergigante.

Nergigante's arrival and subsequent disappearance always coincided with a certain event.

That's right...the Elder Crossing. I had my suspicions, but this latest appearance proves there's a connection.

—Commander

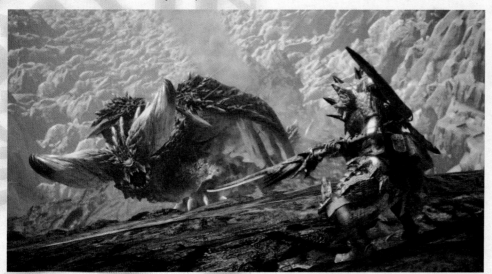

⬆ Zorah Magdaros took no notice of the fences propped up by the humans and advanced, shattering the ground and disappearing into the depths of the Great Ravine.

Fifth Fleet Quest Progression ③

The Fifth Fleet was the trump card of the capture operation, which the Commission had placed all their efforts into.

Zorah Magdaros

◆ The Commission awaits Zorah Magdaros at the Great Ravine and executes the capture operation.
◆ After the destruction of the first barrier, the hunters climb onto Zorah Magdaros and destroy the magmacores on its body.
◆ The operation ends in failure with the sudden appearance of Nergigante, a monster that the Fifth Fleet has not met before.

Nergigante

↑ On the other side of the Great Ravine is an area covered in colorful coral reefs, as if the seabed has suddenly appeared.

Now why would you pick there, of all places, to take a nap? If you needed a nap, you could've come back here.

It's not me you have to thank for carrying you out of the Rotten Vale and back here to safety.

That was someone else.

—Third Fleet Master

The full-scale capture operation failed. Zorah Magdaros's whereabouts were now unknown, and even if they managed to find it, they would be unable to execute another operation of the same scale since they had depleted most of their provisions.

Never before had the Research Commission been in such a tight spot, but the Commander remained undaunted. He entrusted the Captain with reporting the outcome and his desire to continue the operation back to the Guild in the Old World and ordered the hunters to pursue Zorah Magdaros. Luckily, Zorah Magdaros had created a crack in the ravine...

The Loneliness of Research: Meeting the Third Fleet

The Coral Highlands. Even before the hunters had a chance to enjoy the view, they were attacked by an unknown wyvern. Two partners fell down from the highland...deep below the forest of the coral reef.

When they came to, they awoke in a room filled with the complicated scent of incense. The light shining down from above told them that it was daytime.

"Oh, hello," a Wyverian woman called out to them. According to her, the Shooting Star and their partner smashed through the coral Highlands and had fallen underground to the bottom of the valley. They had miraculously survived, since the coral they fell through had cushioned their descent. Pure luck.

The hunter and the Third Fleet Master quickly exchanged information. The Third Fleet had left Astera twenty years before to cross the Great Ravine but had been attacked by a monster and crash-landed. The area around the Research Base is divided into an upper and lower tier, each with a very distinct and different ecosystem and environment. The upper tier being in the Coral Highlands, where they were, and the lower tier in the Rotten Vale, the place they had fallen down to. The members of the Third Fleet living in the airship were all scholars and were incapable of fieldwork, let alone hunting for monsters, so their research materials were brought to them by the Tracker.

Meanwhile, the Shooting Star shared information about the Fifth Fleet being dispatched to the New World ten years after the last Elder Crossing and explained how Zorah Magdaros had escaped their pursuit and disappeared to the other side of the ravine. After hearing about the situation, the Third Fleet Master decided that the present priority was to locate Zorah Magdaros.

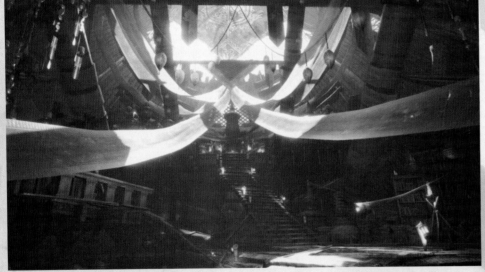

← Since the Fleet Master is Wyverian, eccentrics...I mean geniuses, have gathered at the Research Base, which has a different atmosphere compared to Astera. Since it was originally a ship, it is quite large inside.

The Land of Raining Life

The Coral Highlands is thought to be the source of life in the New World. When life ends there, the remains fall to the bottom layer and are decomposed into energy by the effluvia at the bottom of the Vale. I will talk about the importance of the Rotten Vale in the New World and the bearing it has on its ecosystem, but here I would like to praise the beauty of the coral. The spawning of the coral is truly a breath of life—an exceptional adventurer of the First Fleet described this as "raining life."

➡ A spawning scene at the Coral Highlands. Countless eggs have been spread throughout the air and they fall to the ground like snow. The abundant eggs will become food for the Raphinos and Paolumus that inhabit this area. Those that prey upon them will also be a part of this bloom of life.

The Gale That Dances Across the Highlands

Now that the Third Fleet Research Base had become accessible, the Airship Engineer and Field Team Leader met up with the Shooting Star at the Coral Highlands. The Third Fleet Master came to the conclusion that the Rotten Vale held the key to Zorah Magdaros's whereabouts and decided to raise the Third Fleet ship into the air to head for the Rotten Vale. The process was expedited, and it did not take long for the ship to take on the form of an airship using Paolumu material.

The airship went without a test flight, but it flew flawlessly. The Third Fleet ship, which was now a flying research base, searched for a location to land in the Rotten Vale. The Shooting Star and their partner slid down a pulley to the lower layer, where they were met with dangerous monsters such as Great Girros and Radobaan. They were also reunited with the Tracker from the First Fleet, who was both a hunter and a handler.

The Tracker and the Third Fleet Master used their experience and knowledge to deduce that Zorah Magdaros's tracks must be at the very bottom of the Vale, so the airship flew along the upper tier of the Rotten Vale to search for a place to fly down to the bottom. The area was covered in Raphinos, due to the strong air current blowing up from the ground, making it the perfect feeding ground for the wyverns. Suddenly, the monster that had crashed the Third Fleet airship when it flew across the Great Ravine and knocked the hunter and their partner to the bottom of the Vale appeared before them. The monster that stood at the top of the food chain in the Coral Highlands—Legiana.

Legiana, the ruler of the skies above the Coral Highlands, flew around freely and was a tough opponent, but the ace of the Fifth Fleet managed to defeat it. The airship was finally ready to land at the bottom of the Vale.

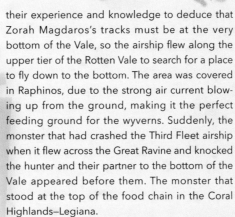

Fifth Fleet Quest Progression ④

New adventures and monsters awaited them as they continued in pursuit of Zorah Magdaros.

Expedition to the Coral Highlands

◆ The advance team goes through the crack in the Great Ravine and arrives at the Coral Highlands. They are attacked by a mysterious wyvern.
◆ The Third Fleet's Research Base is discovered and a route to Astera secured.

Tzitzi-Ya-Ku

◆ Tzitzi-Ya-Ku is discovered.

Paolumu

◆ The team investigates Paolumu under the orders of the Third Fleet Master and gathers materials to modify the Research Base into an airship.

Headed for Rotten Vale on the Airship

Great Girros Radobaan

◆ They descend from the Coral Highlands using a pulley. They encounter a Great Girros at the bottom and defeat it.
◆ They encounter a Radobaan in the Rotten Vale and defeat it.

Legiana

◆ They hunt the hunter of the sky, Legiana, at the Coral Highlands upon orders from the Third Fleet Master.

Incidents at Astera

- The Field Team Leader arrives at the Third Fleet Research Base.
- The Meowscular Chef requests a supply of Soulful Caviar and Marinated Carpaccio.
- The Tracker, while exploring the Rotten Vale, comes across two Commission members who have fallen from the Coral Highlands.

- The Foreman builds a Special Arena in the Great Ravine without rest.
- The Armory creates the Cleanser Booster.
- The Airship Engineer uses Paolumu material to modify the airship again.
- The Analytics Director seems a bit shaky.

- The members are surprised to hear that the Field Team Leader is the Commander's grandson.
- The Laid-Back Botanist requests expansion of the Harvest Box.
- The Elder Melder creates a charm via First Wyverian techniques.
- The three scholars investigate Paolumu ecology.

- The provisions team stocks new items for the Fifth Fleet, who will be crossing the Great Ravine.
- The Provisions Manager laments the huge loss of provisions.

So what do you think it's like on the other side? Do you think you'll find me anything weird or interesting for my stockpile?

Just thinking about the possibilities has got me excited.

Anyway, I am none too happy with our current supply situation...

Is it too much to ask for someone to swoop down from the sky and deliver the stuff we need? [sigh]

—Provisions Manager

- The Serious Handler becomes very excited about the unique area beyond the Great Ravine.
- One report at the time of the capture says, "Zorah Magdaros seemed to be burning more brightly than it was when it first arrived."

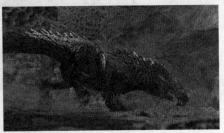

⬆ Odogaron shows the fearsome side of the Rotten Vale. Even the well-experienced Tracker will be in danger if she is taken off guard.

Since no tracks were discovered at the Coral Highlands is the upper tier of the Rotten Vale, the only place remaining for Zorah Magdaros was the bottom of the Rotten Vale. With the aid of the Tracker, a specialist in the Rotten Vale, the hunter and their partner headed out on their journey to the bottom of the Vale, which was filled with the rancid stench of death.

The Place Where Life Returns

The Rotten Vale is divided into three tiers. The upper tier catches the dead bodies that fall down from the Coral Highlands. If you look down from above, it looks like a giant dragon's skeleton. The carrion and bones decompose like leaves and then fall to the middle tier. The middle tier is dark and filled with effluvium, which breaks the meat and bones into even smaller fragments. The effluvium decomposes everything. The Rotten Vale is filled with death.

And at the very bottom are the glowing lakes of acid. It is as if the entire Vale is made to produce nutrition from death. It is like a stomach that digests the food inside it... Maybe that is the function of the Rotten Vale.

A place that gives a purpose to death... in other words, a place where life returns. A graveyard. That term came to our minds. We didn't even need to say it aloud. We could sense it. Above us, life both large and small thrived but...no, these aren't two different things. The life above and the carrion beneath our feet are one. They are connected. The dead bodies will fall into the Vale to become nutrition for the land that serves as the foundation of the New World. That energy will give birth to life, which will grow and die again.

The Coral Highlands and the Rotten Vale. Life and death and...the New World and the Elder Crossing!

The Tracker had reached that conclusion herself after seeing the Rotten Vale long ago. The Third Fleet Master must have come upon the same idea too. It was as if the Fifth Fleet was the last step in confirming that hypothesis. That is how I see it.

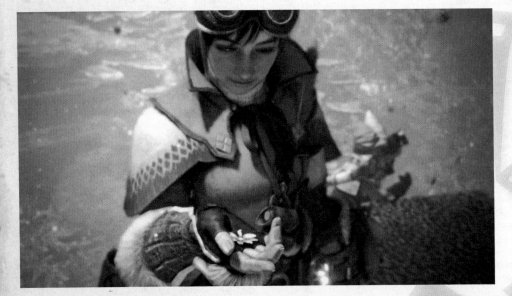

You're right. The Vale is where monsters come to rest.

They sense the end and make their way here. Their bodies become nutrients that feed the Coral Highlands. From death rises new life, which, after a cycle, returns to the Vale to die again.

It's an ecological marvel. One that easily dwarfs any I have ever seen.

—The Tracker

Ho-ho-hee! The Ancient Tree must also draw energy from Elder Dragon corpses! A fascinating fact, don't you think, young hunter? This explains the growth spurts every ten years too! Just when I thought trees couldn't get any more interesting...

From the smallest sapling to the tallest tree, every living thing has its purpose. Don't you agree, young hunter?

—Laid-Back Botanist

Those at the Top of the New World's Food Chain

As suspected, Zorah Magdaros's tracks were discovered at the bottom of the Rotten Vale. However, the creature in question was nowhere to be seen. Where had the massive monster disappeared to?

After receiving the reports, the Commander came to the conclusion that the Rotten Vale was an Elder Dragon graveyard and gave the order to keep looking for Zorah Magdaros. The ace of the Fifth Fleet and their partner headed for the top of the Ancient Tree and managed to meet the First Wyverian, who claimed that it knew the whereabouts of the dragon with a mountain of fire upon its back. But first, the hunter had to prove their worth by defeating two fearsome creatures: Rathalos and Diablos.

Any rookie hunter would have fled with tears in their eyes upon hearing the assignment, but the hunter who had defeated Legiana in the Coral Highlands and Odogaron in the Rotten Vale was not afraid of those monsters. The hunter bravely faced and successfully defeated them and earned an answer. According to the First Wyverian, Zorah Magdaros was attracted by the light of life and had wandered into the Everstream. What had lured Zorah Magdaros away? But if it died in the Vale, the explosive energy in its body might flow through the veins of the earth, causing the New World to go up in flames. It had to be stopped...but how?

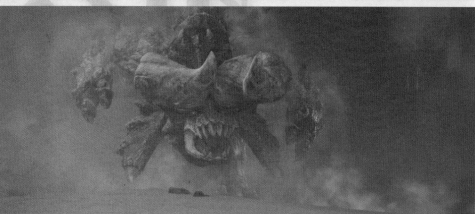

Zorah Magdaros's Life Burns Out

If Zorah Magdaros were to die near the Everstream, a massive flow of explosive energy would occur and reduce the New World to ashes. The Commission had to stop this.

You... You have ascended to the apex and proved yourself.

Now you may know the secret of the dragon that carries a mountain of fire on its back.

The dragon hovers on the brink of death, but the light of life is calling to it, drawing it away from its proper grave. It has wandered into the Everstream and lost its way.

Now it stands poised to perish there, brimming with fiery life-bringing energy.

— First Wyverian

♦ Zorah Magdaros is heading for the Everstream.

♦ Zorah Magdaros will unleash all the fiery energy it has stored at the moment of its death.

♦ The veins of the earth are connected to every bit of the New World, and if Zorah Magdaros dies there, the unleashed energy will engulf the New World in flames.

Zorah Magdaros must be lured out to sea to lighten the influence of its energy discharge.

If Zorah Magdaros's actions were in accordance with the laws of nature, then trying to stop it was a challenge against the New World.

We don't fight nature, and we don't run from it. We learn to understand it. That's what we all strive for.

That's the way of the New World hunter.

— Commander

Fifth Fleet Quest Progression ⑤

Expedition to the Rotten Vale

Odogaron

♦ Heading down to the bottom of the Rotten Vale in search of Zorah Magdaros's tracks, the hunter encounters Odogaron and defeats it.

What was the secret of the Rotten Vale, where life and death were intertwined? The hunter's battle grew ever fiercer in the search for the truth behind the Elder Crossing.

Rathalos

Expedition to the Ancient Forest and Wildspire Waste

♦ The hunter searches for the First Wyverian to learn about the whereabouts of Zorah Magdaros. The hunter fulfills the First Wyverian's request and defeats Rathalos and Diablos, the monsters at the top of the food chain in the Forest and Waste.`

A Colossal Task

↑ The anti-Elder Dragon weapon known as the Dragonator. A trump card for defense and driving away the Elder Dragons, the Dragonator appears in many records.

For as long as I've been watching the sea, the Guild has been looking for ways to improve its sailing technology. The folks here at the Commission aren't the only ones working hard.

— Captain

I was so desperate that when I saw the Captain arrive, with his silky locks—

*I mean we...WE were all desperate... Desperate for his supplies. G-good thing he arrived when he did. *Ahem**

— Provisions Stockpile

The Commission was filled with stress. Zorah Magdaros's whereabouts had been discovered, but the First Wyverian warned them that if the Elder Dragon were to head to the Everstream and die, the life force stored inside it would cause flames to erupt all over the New World, scorching the skies and burning the earth.

They would not be able to complete their investigation and couldn't possibly stay in the New World. Should they evacuate? But the Fifth Fleet presented a solution. They would lure Zorah Magdaros out to sea to lessen the impact of the energy release.

The Dragon with a Mountain of Fire on Its Back

The plans were set, but executing them was another problem. The Commission was still short on provisions after the previous capture operation and did not have enough supplies to stage a full-scale operation.

But thanks to divine luck—or as a result of the Commander's quick judgment—the Captain who had left the New World soon after the capture operation had returned with a fleet full of provisions just as they were holding the planning council.

News from the Captain revived the Commission's spirits. After receiving the report, the Guild had prepared even more provisions and weapons. One of them was a state-of-the-art ship equipped with the Dragonator, an anti-Elder Dragon weapon.

The Commission would put these new provisions to full use to lure Zorah Magdaros out to sea. The Commander swiftly commissioned an urgent quest. This was not an operation to hunt the Elder Dragon or an order to wait for the New World to go up in flames, but a request to find a way to live in harmony.

Now that they thought about it, Zorah Magdaros crossing to the New World and heading for the Everstream were natural things for the Elder Dragon and were probably nothing but small incidents in the New World's...no, the whole world's cycle. However, the hunters tried to change its course. I'm sure some would say that was a selfish act. It is only natural that people would feel that way. However, the answer is simple. The Commander and the other members of the Commission were all doing what they had to as living creatures that reside in the New World.

The operation was simple. The Commission would wait for Zorah Magdaros in the Everstream. Then they would strike it with the Dragonator to dampen its energy and drive it out to sea.

↑ A clash against the Elder Dragon at the Everstream, where the energy of the earth flows out as lava. If the energy stored inside Zorah Magdaros was released here, the surrounding areas would have all gone up in flames, bringing an end to the Research Commission's story.

To be brutally honest, ballista and cannon attacks won't stop Zorah Magdaros from getting where it wants to go. It simply isn't going to happen.

But! If we can convince it that detouring out to sea will be less of a headache than going through us, then our goal will be achieved.

— Analytics Director

The Sign of a Hero

The cannons and ballistae on the barrier and even the rocks on the ceiling were used as weapons. As expected, the black-thorned monster Nergigante appeared too, but the fleet was ready to face it after the experience they'd gained during the last capture operation.

Just as Zorah Magdaros approached the barrier, the Commander gave the order. The impact of the Dragonator piercing the Elder Dragon was so great that it felt as if the ship the weapon was mounted on was being pushed back. A single spear being thrust into the body of a huge Elder Dragon was clearly not enough

to fatally wound it, but it probably had never experienced such pain. The creature let out a roar, sank into the water, and turned towards the sea. The operation was a success. The Everstream corridor filled with cheers.

The Research Commission's goal of solving the mystery behind the Elder Crossing had come to an end. Elder Dragons headed for the Rotten Vale to face their deaths. The dead Elder Dragons became the foundation of the New World's rich nature, giving birth to more life.

But…why had Zorah Magdaros headed for the Everstream?

Why do ya think Zorah Magdaros bailed on its own grave? It came all this way to die. What's the point of makin' a big fuss now?

Betcha there's somethin' more to it...

—Meowscular Chef

⬇ The Commander and the Huntsman giving a sigh of relief. Forty years had passed since the First Fleet had landed in the New World, and they had finally gotten to the bottom of the Elder Crossing.

⬆ The Commission members are joyous after successfully pulling off the operation of a lifetime. The Fifth Fleet had become the driving force behind the Commission's research, just as everyone had anticipated.

Fifth Fleet Quest Progression ❻
The final battle against Zorah Magdaros was the end of the duties of the Fifth Fleet that had pursued the monster to the New World as well as the apex of the Research Commission's forty years of investigations.

Zorah Magdaros

◆ The Commission waits for Zorah Magdaros at the Everstream and executes the lure operation.
◆ The Commission uses every method possible to weaken Zorah Magdaros and destroy the magmacores on its body.
◆ The Commission manages to drive away Nergigante, which had broken into the operation, and the operation ends in success.

Nergigante

After the Lure Operation

Zorah Magdaros collapsed soon after reaching the sea. Its body will give birth to a new ecosystem someday. To many, it seemed a direct call back to "The Tale of the Five." But why had the Elder Dragon left the graveyard? What was there at the end of the Everstream that had lured it?

A Journey to the Next Life

⬆ Travelling by wingdrake to investigate allows the Fifth Fleet ace to avoid any trouble from Legiana.

⬆ A mysterious Pink Rathian chasing after the wingdrakes that entered its territory.

After the lure operation of Zorah Magdaros, the Commission was given some time off. The only people busy during this time were the scholars investigating Zorah Magdaros's tracks and the Commander, who was compiling a report for the Guild. A route connecting the Old World with the New World had been secured now that the Commission had a ship equipped with the Dragonator.

The Chamber of the Five in the Celestial Pursuit had been renovated into the living quarters for the Shooting Star of the Commission, the hunter from the Fifth Fleet, who was referred to as the Sapphire Star after all their incredible achievements.

Murmurs of the Beasts Inviting the Hunter to the Forbidden Land

The curious hunters and handlers who didn't need a break continued to explore and returned to Astera with a sense of discomfort. "We've seen usual monsters in unusual places." Not only that, but the monsters they had encountered were highly hostile and stronger than ever.

In order to confirm these rumors, the hunter known as the Sapphire Star and their partner headed down to the Wildspire Waste and found Pukei-Pukei, which usually inhabits the Ancient

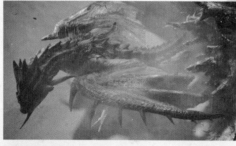

Forest, roaming about, and strange, Rathian-like tracks as well. After investigating, the Commission determined that the monster that had left the strange tracks was at the Coral Highlands. An urgent quest was immediately commissioned, and the hunter and their partner rushed out to investigate. While traveling on their Wingdrakes, they were attacked by a Pink Rathian, a subspecies that had not yet been seen in the New World.

The scholars raised their voices in surprise while they examined the Pink Rathian that had just been captured. At the same time, a cry rose from the western gate as well.

A hulk of a man far larger than the others walked into Astera holding a sack over his shoulder. The Commander smiled and jokingly punched the giant in his chest.

This was the First Fleet Master, whom the Fifth Fleet had not met yet—the man known to all as "Admiral."

The Shining Crystals

The duo hurried to the Everstream. The Admiral claimed that he had found tons of the mysterious crystals he had brought back to Astera where the Zorah Magdaros lure operation had been held. After pursuing Nergigante for the past thirty years, he had discovered a large open area at the rear of the Everstream.

The hunters walked through the narrow path in the Everstream created by the Elder Dragon and entered a strange place that seemed to be a mixture of underground and surface, covered in crystals and bubbling lava from the volcano.

Record has it that a strange sweet scent filled the area and a tingling sensation ran through the bodies of those touching a crystal.

It was clear that the energy that flowed through the veins of the earth from the Rotten Vale was seeping out like dew. The Admiral suggested that the powerful monsters that had suddenly appeared in the New World were heading for this area.

Discussing the Admiral

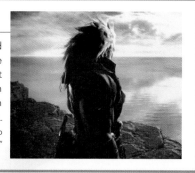

Out wandering more often than not. Wild and unpredictable. Appears like lightning, gone like the wind... People describe the Admiral in many different ways. The Fourth and Fifth Fleet members who saw him for the first time referred to him as a Rajang, or even cuckoo.

➡He left Astera in the hands of the Commander. The Admiral seems to act on impulse and do whatever he pleases, but "whatever he pleases" often turns out to be the right course of action.

Fifth Fleet Quest Progression ⑦

The hunters were investigating the powerful monsters that had begun appearing. The Admiral returned to Astera, and the investigation of the Elder Crossing entered a new phase.

Expedition to the Wildspire Waste

Pukei-Pukei

◆ The hunters discover strange tracks that were apparently left by a Rathian. They encounter a powerful Pukei-Pukei and investigate it.

Anjanath

◆ They receive a report from the Chief Ecologist and investigate the hostile Anjanath.

Pink Rathian

◆ They Investigate the numerous tracks seemingly left by a Rathian.

◆ They head for the Coral Highlands on orders from the Commander to discover and investigate the Pink Rathian.

Expedition to the Everstream and Elder's Recess

◆ They head for the depths of the Everstream and arrive at the Elder's Recess. During their exploration of the area, they encounter Dodogama, Lavasioth, and Uragaan.

Dodogama

Lavasioth

Uragaan

High-Rank Quests

- The Chief Ecologist analyzes the strange tracks.
- The Meowscular Chef expands the Canteen and begins to sell alcoholic beverages.
- The Meowscular Chef asks the Fifth Fleet for a supply of Tangy Tripe and Steeled Meat. A supply of Millionfold Cabbage is also secured.

Here in the New World, the Anjanath makes for a good baseline when conducting research. It has a medium-sized frame and exhibits relatively simple behavioral patterns.

—Chief Ecologist

- High-quality materials enable the development of new equipment.
- Development allows adding decorations to equipment.
- The Armory develops numerous specialized tools.

- The Elder Melder continues to devote time to studying new techniques.
- Numerous delivery requests produce items such as Demontater Brew, Wyvern Amber Ale, and Ratha Whiskey.

- The Provisions Stockpile stocks up new items.
- Materials from Kulu-Ya-Ku are used to create Choice Mushroom Substrate, a new fertilizer for cultivation.
- Materials from Jyuratodus are used to increase the size of the Harvest Box.
- Materials from Great Girros are used to create Ancient Catalyst, a new fertilizer for cultivation.

I saw plenty of rare subspecies back where I came from. That was just the nature of the work I was doing.

—Excitable A-Lister

At times like this, I remember the words of my wise handler mentor: "If you don't bother to look into what bothers you, you're in for a real bother." ...Yeah, she wasn't that poetic.

—The Handler

While the Admiral and others were exploring, new trouble had arisen. Sightings of numerous Elder Dragons were being reported all over the New World. These reports started after Zorah Magdaros disappeared and Nergigante returned to the Elder's Recess. Luckily, many of the hunters had experience sighting or facing an Elder Dragon, so they managed to deal with the situation without panicking. All the Elder Dragons were well-known and had been suspected of crossing to the New World, but why they suddenly appeared remained a mystery.

↑A forest of crystals located in the volcanic region in the depths of the Everstream. The Commission named this place the "Elder's Recess" and began their exploration.

After Zorah Magdaros vanished into the sea, Nergigante disappeared too. So I decided to track it down, and this is where it led me...

A gap in the earth that was probably wrenched open by Zorah.

—Admiral

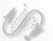 ## Beastly Fangs That Threaten the Elder Dragons

After the ecological research team analyzed the tracks and carcasses...they reached the conclusion that Nergigante was feeding on the Elder Dragons.

A monster that fed on Elder Dragons was out of the ordinary. But it made sense that the Elder Dragons in the New World had been stirred up at Nergigante's appearance in the Elder's Recess, where the Elder Dragons were settled.

The conclusion the Commission came to was as follows: Nergigante only appeared during the Elder Crossings because it targeted Elder Dragons that had lived long and had stored much energy. However, Zorah Magdaros, its primary target, had disappeared into the sea, so it had headed for the Elder's Recess to prey on other Elder Dragons.

Due to that, the Elder Dragons were now being spotted in other areas.

And so, all the clues pointed to Nergigante, a mysterious dragon that had been discovered thirty years before, had defeated the Admiral and the Meowscular Chef, and could not be pursued. If I used the words of the Chief Ecologist, the only way to classify this monster that cannot be classified is to toss it into the Elder Dragon pile. Like the Commission, it too targeted the Elder Dragons.

The Commander commissioned an investigation of Nergigante. The Commission had assumed that its defeat would put a stop to the restless Elder Dragons—however, they showed no signs of calming down.

Kushala Daora and Teostra...there seemed to be no end to the appearance of the Elder Dragons. In order to continue with the exploration of the Elder's Recess, these Elder Dragons were also commissioned to be investigated. Vaal Hazak, whose existence had remained unconfirmed for the previous twenty years, was also sighted in the Rotten Vale.

To everyone's surprise, all of these quests were completed by the "White Wind" of the Fifth Fleet.

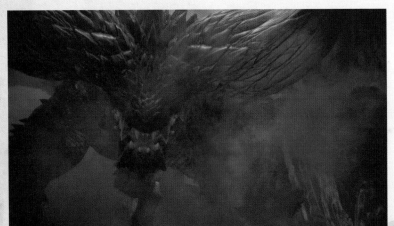

↑ Nergigante and the Fifth Fleet, who had long been pursuing Zorah Magdaros, come face-to-face.

Why did Nergigante go to Elder's Recess after failing to consume Zorah Magdaros?

Was it simply to feed on the Elder Dragons there? Or does it hunger for something else entirely?

On the brink of death, Zorah Magdaros fled the graveyard and made its way to Elder's Recess deeper into the corridor.

But why? What is there?

Whatever it is, it's enough to draw monsters that are both longing for death and craving for life...

—Commander

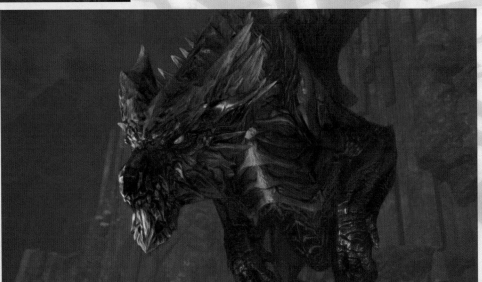

↑The Elder Dragon Kushala Daora, which conquered the pinnacles of the Elder's Recess. The Fifth Fleet members headed down with the Field Team Leader and were faced with a tough challenge against the winds the Elder Dragon created. Some people say Kushala Daora controls the weather.

Incidents at Astera

- The Huntsman becomes excited at the news that Teostra has been sighted and sets out for the Emperor of Flame.
- The Meowscular Chef asks for Aromaticelery, Boorish Yellowtail, Great Mutton, Fatty Tomato, Prismatic Paprika, and Millenary Crab.

Elder Dragons are walking calamities. And yet everyone has managed to stay calm. The Guild wasn't kidding when they said they'd send us their best veterans.

— Field Team Leader

- The Foreman wants the Admiral to use the slinger, but he refuses.
- The Armory continues to develop specialized tools like the Challenger Mantle, Affinity Booster, Fireproof Mantle, etc.

- The Elder Melder continues to study new techniques.
- Research into the Diablos and Black Diablos lead to the development of an Affinity Booster and Astera Beer.
- Numerous delivery requests help produce Goldenfish Brew.
- The three scholars locate the habitat of the flying monstrosity Bazelgeuse.

Once, when I was still back home, an Elder Dragon came around and messed up our supply route... We nearly starved! Allo, Fiver. You know, I don't know how to feel about all these Elder Dragons... On the one hand, they cause all this mess. Frankly, I have a headache thinking about how much they interfere with my operations...

—Provisions Manager

- Materials from Tzitzi-Ya-Ku are used to create Thick Summoner Jelly, a new fertilizer for cultivation.
- The Chief Botanist uses Rotten Vale soil to spark growth in the Ancient Tree...and ends up destroying the facility.

- The Feisty Fiver notices the reflection of light off of Kushala Daora's body. He's sure he's seen it before in the Old World.

If you ever feel lost, just pick a direction and run! Soon your troubles will vanish in the dust behind you.

—Admiral

Fifth Fleet Quest Progression ⑧

Incidents concerning Elder Dragons rapidly increased after the battle against Nergigante.

Nergigante

◆ The Commander commissions an urgent request. The Fifth Fleet successfully manages to defeat Nergigante, the Elder Dragon that had burst into the Zorah Magdaros capture-and-lure operations.

Teostra

Vaal Hazak

◆ The fleet gathers tracks at the Wildspire Waste and encounters Teostra at the Elder's Recess. The Fifth Fleet investigates this monster with the Huntsman.

◆ The team gathers tracks at the Ancient Forest and encounters Kushala Daora in the Elder's Recess. The Fifth Fleet investigates this monster with the Field Team Leader.

◆ They gather tracks at the Rotten Vale and encounter Vaal Hazak in the Vale. The Fifth Fleet successfully investigates under the orders of the Third Fleet Master.

Kushala Daora

And where do you think you're goin', Hunter? You will be coming back, yes?

—Tech Chief

↑ Those who are dying and those who crave life. What do both of them desire? The answer to that lies at the end of this river...

I take it you've seen the Elder Dragons' graveyard.

I have discovered that an abnormal amount of energy was flowing through the veins beneath the Vale and coursing through the whole continent. When we last spoke, I was still investigating the cause. But now I have located a place where all the energy seems to be gathering. It's at the end of this river.

I intend to go there and see this place. This is the end of everything. Together, let us find our ending.

—The Seeker

Why did Nergigante head for Elder's Recess after failing to feed on Zorah Magdaros? Was it after an Elder Dragon that lived there? Why did Zorah Magdaros leave the Rotten Vale, its chosen resting place? The Commission was gradually getting closer to the truth behind the Elder Crossing that led to the source of life in the New World.

The Admiral returned just when the Elder Dragon incidents finished. With a friend, he had discovered the reason the energy flow had suddenly increased. In addition, the Admiral had brought back a message from the Seeker. "I'll be waiting in the place beyond, where all things converge."

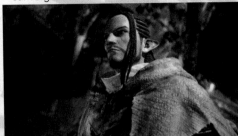

A Light upon the River's Gloom

The place was dark and quiet. A blue light reflected from the crystals dimly lit the area. It was filled with raw life energy, which made it feel strangely lifeless. A river flowed through it with a boat parked on the side.

The Wyverian was waiting for the hunter with an oar in his hand.

No one knew what awaited them. No one knew if they would be able to come back. The Handler was asked to wait by the shore so someone would be left to make the report. The Admiral, the Seeker, the Sapphire Star, and their Palico crossed the dark river together.

The Seeker had managed to find this river because Zorah Magdaros had changed the landscape. At the end of the river was where the energy had gathered. As past investigations had discovered, the deceased Elder Dragons decomposed in the Rotten Vale, flowed through

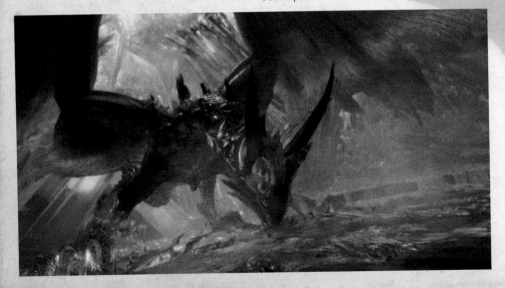

the earth, and were crystallized. The Elder's Recess was a culmination of the cycle of life in the New World. However, the Elder Crossing cycle had increased to once every ten years, and the Seeker had noticed that the energy flowing through the veins of the earth had rapidly increased. That was why he had been pursuing the source of the energy flow, which was not part of the Commission's research.

What awaited them at the place where the energy gathered? "Something is terribly amiss," said the Seeker. The Admiral's gut shouted that something was about to happen.

If the crystals were a crystallization of the Elder Dragons' energies, then the beast must be a regenerated entity of that energy. A dragon glowing with the same colored light as the crystals... Energy radiated out of that thing in the shape of a dragon as if it was celebrating its birth. Only one hunter was there to face it. The hunter who fought against the energy of the New World at the depths of the continent was the one and only Sapphire Star of the Fifth Fleet.

The Commander waiting in Astera ordered the hunter to return. "If you feel yourself slipping away, remember your partner," he said. That was a warning and a word of advice. Many of his old friends had been enchanted by the New World and had gone their own way, and as a result the Commission had had no choice but to take many detours in their investigations. That was why the Commander believed that the hunter and the Handler working together would broaden the horizons of New World exploration.

In the end, the Sapphire Star and their partner even managed to pacify "that thing," the mass of refined energy that had been stored in the New World.

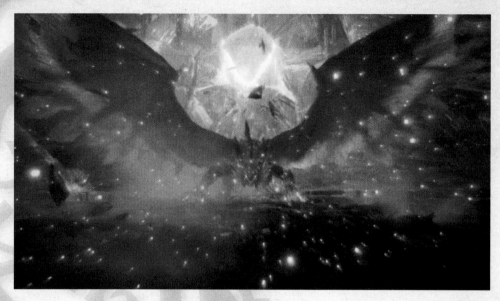

The White Wind of the New World

The Sapphire Star crossed the dark sea, crossed the river, fell off a dragon, fell out of the sky, fell underground, and came back to Astera once again.

A feast. What for? Was it because they had solved the mystery behind the Elder Crossing? During the great feast, they received a message from the Guild that praised them for solving the Elder Crossing, named the new Elder Dragon "Xeno'jiiva," and came with a request for the entire Commission to return to the Old World.

A feast? What for? For more research of the New World. The start of more hardship. But everyone's eyes are shining in hope and high expectations. Let's give a toast to the Research Commission and the Sapphire Star!

Remember when you talked to the First Wyverian and he said he'd reveal Zorah's secrets to whoever stood at the top of the food chain in the Forest and the Waste?

During this last study, you took out the monsters that were standing at the top of the food chain in those areas, right?

So does that make you the apex predator or something? If so...please don't eat me, OK?

—Eager Fourth

But you rose above them, like a star to the heavens. You created your own light instead of following others.

The Guild would like to honor your deeds with a special title. Henceforth, you shall be known as the Sapphire Star.

I believe now that calling you here to the New World will end up being my greatest achievement. I salute you, Sapphire Star.

—Commander

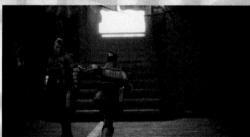

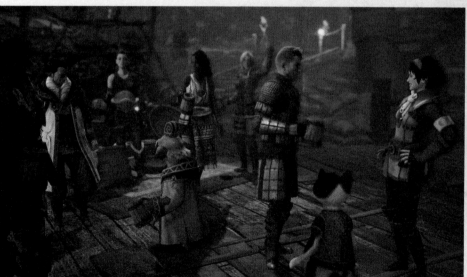

Fifth Fleet Quest Progression ⑨

Xeno'jiiva

They arrived in the depths of the New World and faced it not as their duty, but as their fate to challenge the unknown.

◆ The fleet heads down to the Confluence of Fates with the Seeker and the Admiral. They encounter an unknown monster and defeat it.
◆ The newly discovered Elder Dragon is named Xeno'jiiva by the Guild.
◆ The Guild announces the completion of the Research Commission's duties. Volunteers from each of the fleets decide to continue their research of the New World.

The New World is unbelievably vast. Even after all these years, I feel like I've only explored a fraction of what's out there.

There must be things lurking out there that we can't even imagine.

What do you think? Are you excited to discover them?

—The Tracker

The New World and Its Record

The story of the Research Commission's task to solve the mystery of the Elder Crossing has come to an end. However, everyone knows that research into the New World has only begun. I would like to organize the activities of the Commission for the past forty years at the end of this record. I hope this will be helpful to future scholars.

Driven by the Star: A Trajectory of the Research Commission

Most of the Commission's progress on the Elder Crossing research is concentrated after the Fifth Fleet arrived at the New World. It is as if the fleets previous to that were all building the foundation for the Fifth Fleet. Behind the illustrious activities of the Fifth Fleet are forty concentrated years of societal development and history.

The Commission arrived at an unknown continent on a single ship and barely had a place to live during the first ten years. The major activities of the First Fleet were to step foot into uncharted territory, explore the surrounding area, and to prepare a foundation to build their headquarters. Many of the fleet members enjoyed exploration and research, but they were unable to make much progress. I am sure they must have been filled with frustration every time they saw a monster or Elder Dragon-like shadow.

The flames of technology were brought to the New World with the arrival of the Second Fleet. More types of equipment became available, and the facilities around Astera expanded quickly. The Third Fleet's disappearance over the Great Ravine must have been a huge blow to the Commission and the Guild. They must have wanted to dispatch a search team right away, but they had no choice but to wait for the next Elder Crossing. And so, the members of the Fourth Fleet were gathered from a wide variety of people. The Guild succeeded in sending many people with actual hands-on work experience. As a result, Astera became a self-sustained town and began trade with the Old World. Residential areas were expanded for the upcoming Fifth Fleet as well.

The History of the Commission That Led to the Arrival of the Fifth Fleet

1 Roughly 40 Years Ago	2 Roughly 30 Years Ago	3 Roughly 20 Years Ago	4 Roughly 10 Years Ago	5
A guiding light to lead them across the jet-black sea.	**The source of life, and a symbol of their resolve, which they must never let die.**	**One filled with knowledge, its surface undisturbed by trouble.**	**One that moves with force and drives their research forward.**	**To push you toward your goal, and remind you to be light on your feet.**
• Just before arrival, their ship is thrown up on top of the cliff.	• Standardized equipment for the blademasters and gunners is set.	• The fleet sets sail in pursuit of Kushala Daora.	• A wide variety of people are recruited.	• The Fifth Fleet encounters Zorah Magdaros.
• They lose sight of Kushala Daora and encounter a water dragon.	• A prototype slinger is developed.	• They convert their ship into an airship to cross the Great Ravine.	• The Tradeyard is built and residential area enlarged.	• They successfully cross the Great Ravine to meet the Third Fleet.
• The ship on the cliff becomes Commission headquarters.	• Teostra attacked by Nergigante while making the crossing.	• The airship falls into the Coral Highlands after an attack by Legiana.	• The Provisions Manager joins with the Analytics Director (First Fleet) and Tech Chief (Second Fleet) to efficiently commission materials. The trio is nicknamed "the Leaders."	• Numerous investigations into monsters such as Legiana, Vaal Hazak, and Nergigante are carried out.
• The Commander comes across the Scoutflies and searches for a way to use them.	• The Admiral's Palico loses his weapon during the fight against Nergigante and becomes a chef.	• The Third Fleet discovers a valley filled with effluvium and a mysterious dragon named Vaal Hazak.	• The Elder Dragon making the crossing is suspected to be Kirin.	• The fleet finds the Elder's Recess and solves the mystery behind the Elder Crossing.
• They come across a glowing dragon and name it Kulve Taroth.		• The Third Fleet continues their research.		• Xeno'jiiva is discovered.
				• A regular shipping route to the Old World is secured.

Members of the Commission

It is impossible to document every member, but I have created a list of people who were especially important in recording the story behind the Research Commission.

The reason the Fifth Fleet did not have a Fleet Master is because a system of command already existed. It was common for the Fourth Fleet Field Team Leader to lead members during hunts and for the Commander to invite the representatives of the Fifth to councils. I must add that the Leaders who have control over the Tradeyard are also members of the First, Second, and Fourth Fleets. You may notice things you had not noticed until now if you recall the story of the Fifth Fleet with these details in mind. We must not forget the natives, such as the Grimalkynes and Gajalakas.

⬆ Even after his son returned to the Old World, the Commander and the Field Team Leader, who both stayed in the New World, have retained their grandfather and grandchild relationship.

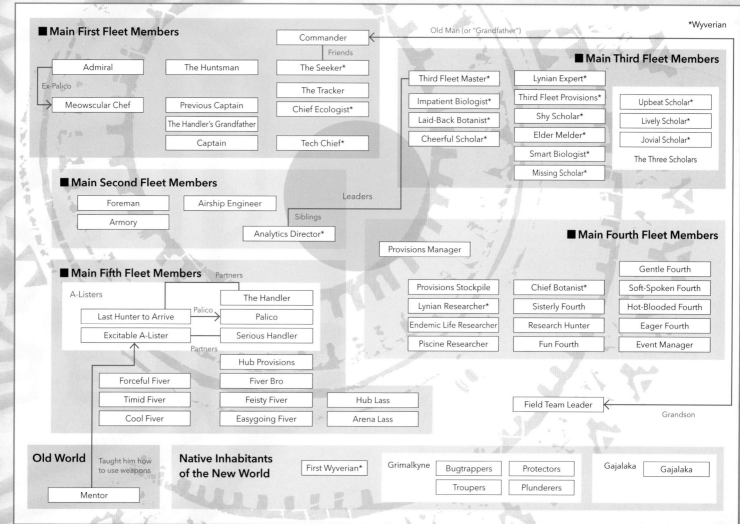

*Wyverian

■ Main First Fleet Members

- Admiral
- Ex-Palico
- Meowscular Chef
- The Huntsman
- Previous Captain
- The Handler's Grandfather
- Captain
- Commander
- Old Man (or "Grandfather")
- Friends
- The Seeker*
- The Tracker
- Chief Ecologist*
- Tech Chief*

■ Main Third Fleet Members

- Third Fleet Master*
- Impatient Biologist*
- Laid-Back Botanist*
- Cheerful Scholar*
- Lynian Expert*
- Third Fleet Provisions*
- Shy Scholar*
- Elder Melder*
- Smart Biologist*
- Missing Scholar*
- Upbeat Scholar*
- Lively Scholar*
- Jovial Scholar*
- The Three Scholars

■ Main Second Fleet Members

- Foreman
- Armory
- Airship Engineer
- Analytics Director*

Leaders
Siblings

- Provisions Manager

■ Main Fourth Fleet Members

- Provisions Stockpile
- Lynian Researcher*
- Endemic Life Researcher
- Piscine Researcher
- Chief Botanist*
- Sisterly Fourth
- Research Hunter
- Fun Fourth
- Gentle Fourth
- Soft-Spoken Fourth
- Hot-Blooded Fourth
- Eager Fourth
- Event Manager

■ Main Fifth Fleet Members

A-Listers
Partners

- Last Hunter to Arrive
- Palico
- Excitable A-Lister
- The Handler
- Palico
- Serious Handler

Partners

- Forceful Fiver
- Timid Fiver
- Cool Fiver
- Hub Provisions
- Fiver Bro
- Feisty Fiver
- Easygoing Fiver
- Hub Lass
- Arena Lass

- Field Team Leader
- Grandson

Old World

Taught him how to use weapons

- Mentor

Native Inhabitants of the New World

- First Wyverian*

Grimalkyne
- Bugtrappers
- Troupers
- Protectors
- Plunderers

Gajalaka
- Gajalaka

Overview of the Ecosystem of the New World

↑Forty years after the Celestial Pursuit arrived at the New World, the Commission succeeded in researching the ecosystems thanks to the work of the Fifth Fleet.

The investigation of the New World was a series of journeys that involved surviving numerous ecosystems. The chart below, "The Whereabouts of Zorah Magdaros and the Fifth Fleet's Progress," clearly shows that.

First, after arriving in the New World, the Fifth Fleet explored the Ancient Forest in search of tracks. They secured the safety of Astera (1) and spread their area of exploration to the Wildspire Waste, where they discovered tracks (2) left by Nergigante. The Zorah Magdaros capture operation ended in failure, but the Fifth Fleet crossed the Great Ravine (3) through the crack that had been created.

At this stage, the Fifth Fleet had only a simple understanding of the New World—it was full of large, vibrant creatures. It was as simple as that.

Survival of the Fittest and Further Research

After crossing the Great Ravine, the Fifth Fleet received aid from the Third Fleet to explore the Coral Highlands and Rotten Vale (4) and managed to lure Zorah Magdaros out to sea in front of the Everstream (5). The possibility of Zorah Magdaros's death resulting in the New World going up in flames was successfully avoided. This brought an end to the Commission's pursuit of Zorah Magdaros.

The Commission concluded that the Elder Crossing was the act of an Elder Dragon heading to meet its end, and it seemed like the Commission had achieved their goal.

As a result, they discovered that the New World was an ensemble of ecosystems that centered around the Coral Highlands and the Rotten Vale. However, there was a risk that if the balance was disrupted, the entire ecosystem would be destroyed.

In fact, something had changed after the disappearance of Zorah Magdaros. Powerful monsters and subspecies had appeared all over. The hunters were forced to run around the Ancient Forest and the Wildspire Waste once again (6), and would eventually step foot in the depths of the Everstream with the Admiral (7).

■ The Whereabouts of Zorah Magdaros and the Fifth Fleet's Progress

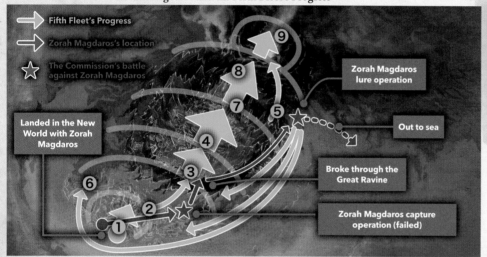

➡ Fifth Fleet's Progress

➡ Zorah Magdaros's location

★ The Commission's battle against Zorah Magdaros

Landed in the New World with Zorah Magdaros

Zorah Magdaros lure operation

Out to sea

Broke through the Great Ravine

Zorah Magdaros capture operation (failed)

■ Simplified Chart of the New World's Ecosystem

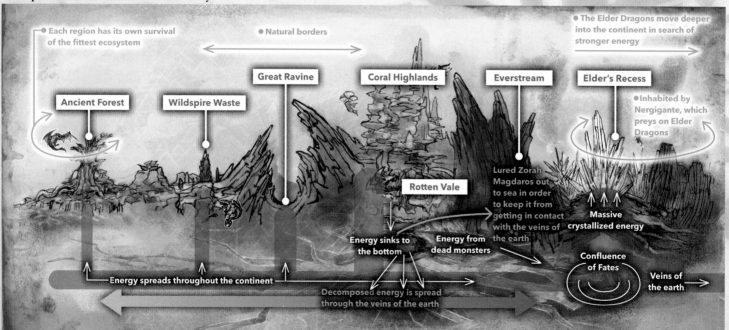

● Each region has its own survival of the fittest ecosystem

● Natural borders

● The Elder Dragons move deeper into the continent in search of stronger energy

Ancient Forest

Wildspire Waste

Great Ravine

Coral Highlands

Everstream

Elder's Recess

●Inhabited by Nergigante, which preys on Elder Dragons

Rotten Vale

Lured Zorah Magdaros out to sea in order to keep it from getting in contact with the veins of the earth

Massive crystallized energy

Energy sinks to the bottom

Energy from dead monsters

Confluence of Fates

Veins of the earth

Energy spreads throughout the continent

Decomposed energy is spread through the veins of the earth

In the depths of the Everstream was a totally different world from the natural scenery they had seen before. The Elder's Recess was completely different from the Forest, Waste, Highlands, and Vale, which were filled with life. That was where the Fifth Fleet encountered their fated opponent, Nergigante (8). And this was when they realized that the different ecosystems of the various regions in the New World were all connected together. See the "Simplified Chart of the New World's Ecosystem" on the previous page.

The keys to the New World's ecosystem are the Coral Highlands and the Rotten Vale, which are like the very beating heart of this continent. The monsters and their energy, which decompose in the Rotten Vale, spread across the continent through the veins of the earth to influence everything.

Everything…even the ancient trees and spires were a part of that. The fact that the Ancient Tree grew rapidly every ten years (the same cycle as the Elder Crossings) and a seed suddenly sprouted when they used Zorah Magdaros's carapace as fertilizer is clear proof of that. The Commander's friend, the Seeker, had noticed it earlier on, and that was why he had been following the veins of the earth. The Tracker, who single-handedly crossed the Great Ravine, and the Fleet Master and scholars of the Third Fleet all had some idea of this great cycle of life.

However, they needed solid proof to confirm their hypothesis, and that was where the hunter came in, and the arrival of the Fifth Fleet completed the long investigation.

The ecosystem and its fundamental system of the survival of the fittest… Just like how life plays out, the energy that gathered in this land passed through the Coral Highlands and the Rotten Vale, and went even deeper underground in the process of refining itself. In some ways, you can call it the concentration of energy. These masses of energy were concentrated over the long years, and eventually crystallized and shaped the Elder's Recess. And the hunters continue to challenge more refined ecosystems by facing the tougher tasks that stand before them.

Where was the hunter headed after defeating Rathalos, Diablos, Nergigante, Kushala Daora, Teostra, and even Vaal Hazak…?

The hunter was led to a mystic location, the core of where the energy of the New World had gathered, which the Seeker had noticed (9).

A light upon the river's gloom, the boat floats along. It is led by the faint light, the white wind blowing on its banner.

You shall discover, Sapphire Star…

That is the breath of life.

■ "The Tale of the Five" Relief

Final Words from the Nameless Handler

I look at the carving in the Chamber of the Five and feel déjà vu. "The Tale of the Five" seems to be the spitting image of the adventures in the New World.

Dragons crossing the sea, and at the end of their journey, those dragons became land, mountains, lakes, and forests. A young person led by the Sapphire Star cast off alone into the murky sea…

Everything seemed to fit "The Tale of the Five" to a T. Maybe I'm overthinking it?

I do not know what the act of taking Xeno'jiiva down means. The Forest, Highland, and Vale still exist, and the Coral Highlands are raining life down as always. There has not been any report of the monsters on the continent suddenly weakening. The only difference I can imagine is that the Elder Dragons would be able to head for the Rotten Vale safely for the time being. After all, the eerie glow of energy that had been luring them away has been stopped…

Many members, including those in the Fifth Fleet, have decided to remain in the New World to continue their research. This continent is huge, and the regions the Commission members have discovered may only be a fraction of its entirety. And who knows when the next Elder Crossing will be? Ten years later again? Or maybe a hundred years later? I just hope that this record will be of some help to any future hunter and handler.

Lastly, I would like to jot down a few personal words of my own as a handler. I believe that the new life-form named Xeno'jiiva was the Sapphire Star of the New World.

It was awaiting the arrival of the Commission—the "White Wind" that had been led there by the story of the Elder Crossing. After all, we too have now become part of the New World's ecosystem and will live and die in this cycle of life.

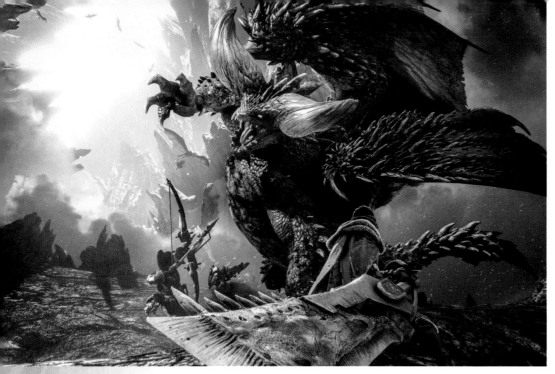

Kaname
Fujioka

Executive Art Director

Looking Back on *Monster Hunter: World*

Not only did *Monster Hunter World* (*MHW* for short) sell ten million copies worldwide, but it also received numerous awards, such as the Grand Prize at the Japan Game Awards 2018, to become the leading game of 2018. Now that a year has passed since it came out, how do the three key men involved–Ryozo Tsujimoto, the producer; Kaname Fujioka, the executive director; and Yuya Tokuda, the director–feel about it? What were their thoughts while working on it? We decided to hold an interview centered around the announcement of the game and the year after it came out, and we asked them to talk about the many challenges they faced during its development.

(Recorded at Capcom, Tokyo headquarters, in November 2018)

A Busy Year After Launch

Ryozo Tsujimoto: First, I'd like to thank everyone. To all the people who are enjoying *MHW*, the entire crew thanks you from the bottom of our hearts. Thank you very much for playing our game.

 Interviewer: It's been almost a year since it came out.

Tsujimoto: Yes. But to be honest, it feels like, "What? It's already been a year?" We've been holding championships since the game launched, so we have been endlessly busy.

Kaname Fujioka: I can't remember any *Monster Hunter* series that I have kept such a close eye on since it came out. This was the first time we kept developing new content and continued to add large updates to the game on a regular schedule. We ended up having a much stronger desire to do more for the players than we originally anticipated, so we had trouble deciding what not to do and spent a lot of time trying to do everything.

Yuya Tokuda: We were especially busy during the

first six months–dealing with bugs and balancing the game and whatnot. We were fixing things in areas that we had never had to fix before. And on top of that, we had to develop the new updates as well.

Fujioka: We'd be saying, "We're almost done with this update," but then we'd get news on the deadline of the next update before we finished the first update. We'd have consecutive meetings, and in the end we'd be so confused that we'd be saying, "Wait, which update are we talking about?" [*laughs*]

Tokuda: Until then, we'd had some sense of completion when we finished developing a game, but now we didn't even have that when the game was launched in stores. We'd prepare a patch to tweak the game balance, and then we'd have the updates to develop and then the bugs to fix...and that continued on, so I really didn't have time to stop for a moment and relax the whole year.

 Interviewer: Then when did that moment of relaxation come?

Fujioka: Probably after the championship, right?

Tsujimoto: Right. After Dream Match at the Tokyo

Game Show in 2018 ended. So, about September or so?

 Interviewer: But that's autumn!

Tsujimoto: It's quite recent, isn't it. [*laughs*]

Tokuda: We had to work on the collaboration events back in May and June when we were hosting a championship every week, and honestly speaking, I felt busier during that time than when I was working on the final touches to complete the game. There were even moments when I felt, "I think my mind's starting to slip away." [*laughs*]

A Two-Director System from the Very Beginning

 Interviewer: What was the reason behind assigning both Mr. Fujioka and Mr. Tokuda as directors?

Fujioka: I was the one who first asked to have two directors assigned for the development. I knew we'd have a lot to work on, so I wanted Tokuda to concentrate on the game design. Until then, I had been the only director, so I was only able to participate

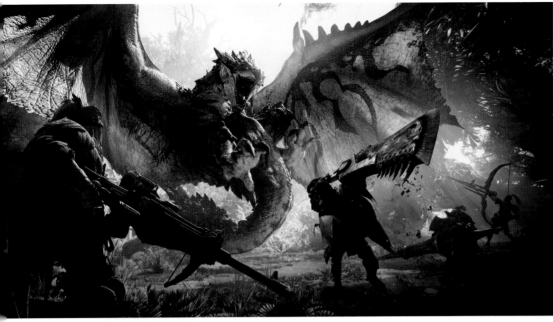

Ryozo
Tsujimoto

Producer

Yuya
Tokuda

Director

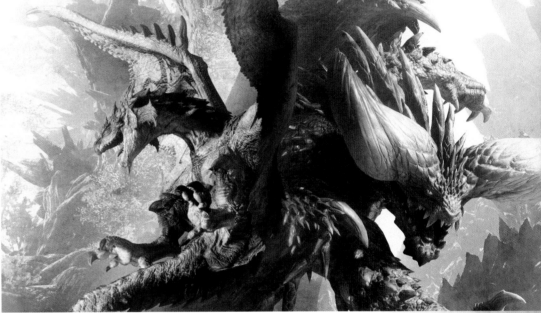

in the top-priority issues, whether it was developing the game or preparing an event, but this time either one of us was capable of hopping in to help out when the other director was busy, so it turned out to be a good idea.

Tokuda: We kept talking about it all the time. Like, "This would never have been possible with just one director."

Fujioka: Right. [*laughs*]

Tsujimoto: This was actually the first time we tried something like this.

Interviewer: How did you feel when you first heard about the double-director system, Mr. Tsujimoto?

Tsujimoto: I always thought it would be a good idea too. The burden on the director is too great with a game of this scale. I had felt that in the series previous to MHW, so I thought we'd need to assign several directors when working on the next-generation console games. I always wanted to split up the directors handling the art design and world design and the ones handling the game design, so I immediately gave him the go-ahead.

Fujioka: I was already starting to reach my limit when I began to be more conscious of making the game appealing to other countries when working on *Monster Hunter 4*. I had to be at the office to check up on the development and deal with any situations, but I also had to go overseas as well...and that was impossible to do if I was the only director. [*laughs*]

Tsujimoto: It has always been our method to use various events to communicate with the players about our games rather than just developing them in the office. So we needed to create an environment where we could split up the workload. It would be better if there was always someone around rather than no one. But we kept going overseas even in situations like that, so this helped us broaden our horizon towards a worldwide audience even more.

Fujioka: We'd always been thinking about making the game appeal to a worldwide audience, after all.

Tsujimoto: The other members of our team all like video games from other countries.

"My Head Went Blank from Anxiety and

Excitement at the Announcement"

Interviewer: You announced the game on June 13, 2017, at E3 in the United States. How did you feel when creating that teaser, and how did you prepare for that day?

Fujioka: I was very cautious about choosing what to show in the teaser, even though Tokuda and I already had a relatively solid concept in our heads. Our idea was that we wouldn't show any weapons so the audience would think "What game is this?" and then finish it by revealing that it was actually *MH*. But we kept getting complaints from everyone in the office, like, "I think you should show weapons being wielded" and "You need more action" and whatnot. [*laughs*] I clearly remember trying to convince the others by telling them, "No, this is meant to be a teaser! The important thing is to pique their interest!"

Tokuda: If we started out by telling them "This is *MH*!" and then moved on to action sequences using a variety weapons, it would make the game seem very shallow. Fujioka and I both shared the belief that we should show people things you could do in this game

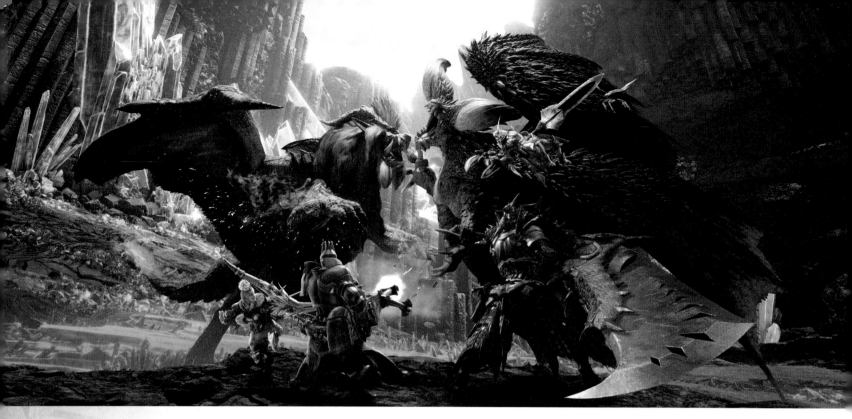

without using weapons.

Tsujimoto: We wanted to create a teaser that would give a hint to the people who were acquainted with the series. We wanted them to think "Maybe this is *MH*" in the beginning, and when Rathalos appeared, they'd know for certain. Come to think of it...the teaser was a lot longer at first, wasn't it?

Fujioka: Right. To be honest, we did want to show more, but we decided that it should be faster paced. In the beginning, the teaser was about ten minutes long with everything in it, but we trimmed it down to three or four minutes in the end.

Tokuda: We did a lot of work on it, but we still felt nervous about the announcement.

Fujioka: We sure did. We were only showing a teaser, but we actually went to E3 ourselves. We had been working on the teaser until the very last minute, so I was nervous to see how people would react to it.

Tokuda: I was so nervous that my head went blank! [*laughs*] A cheer rose for us, but I really didn't notice it at the time.

Fujioka: Right!

Tokuda: It was only later, when I looked at a video of it, that I realized people were cheering so much.

Fujioka: A member of our staff had recorded the announcement and told us, "It was really good." I saw in the video that people cheered when Rathalos appeared and gave another big cheer when the logo appeared. That was when we finally felt relieved that the teaser had been a success.

Tokuda: My heart was still beating fast even after the presentation.

Fujioka: Right. But we were already talking about what to do next after that.

Everyone: [*laughs*]

Tokuda: The day after the announcement, we had a closed live presentation at E3, and I believed that would be quite important too. It turned out that we were receiving very good reactions from everyone. I heard them cheering even when a Great Jagras swallowed an Aptonoth and spat it out.

Fujioka: We quarreled a lot about how to approach that live presentation too.

Tokuda: We did. Some said we should just play footage of the game. But we wanted to show people how the environment would change and what you could do with it. These people had taken the time to actually come down to E3, so I wanted them to have a unique experience. Of course, there was always a risk that we'd fail if we actually played the game in front of them during the presentation. But we were confident that we had developed a game that would be fun even if something unexpected were to occur. I recorded a playthrough beforehand to tell people, "We definitely need to show these features, and if you fail, here's the recovery plan you should execute." I had decided everything beforehand, and I handed out a detailed guide on what to do to all the staff who were in charge of playing the game.

Fujioka: I remember seeing Tokuda giving a Spartan gaming lesson to them. [*laughs*]

Tokuda: I was especially strict with them during E3.

Fujioka: Like, "Your gameplay sucks! You need to practice until you can play like this."

Everyone: [*laughs*]

Tsujimoto: Due to that, we took quite a lot of Japanese staff members overseas. We also took the interpreters who would explain the gameplay in English.

Fujioka: That was the first time we had taken so many people to an event overseas. But now that I look back on it, I always had the strong belief since the first *MH* that we were the only people who could properly present this game to others. I remember sending the developers to various events to present the game back in those days too.

Tsujimoto: And this time we were doing that overseas. I was asked, "Do you really need to take all these people on a business trip?" But this was something we really had to do. [*laughs*]

Interviewer: But as a result, you received a great reaction, right?

Tokuda: Yes, the response from the players was great.

That gave us confidence that we'd definitely be able to succeed if we did the same thing once we returned to Japan. But personally, I remember being super nervous at a livestreaming event in Akihabara.

Tsujimoto: Really?

Tokuda: That's right! After all, it was back in Japan. This time, I would be playing together with Mr. Tsujimoto and the others. E3 was a closed presentation, so some mistakes were okay, but a livestream is a onetime thing. And on top of that, I was nagging the staff at E3. I told the development team, "I want to present this scene to them, so could you do a better job about making it look good?" So if I ended up failing in my live playthrough, I'd be wasting everyone's hard work as well. I wanted to do my best, but Mr. Tsujimoto was also playing with me in multiplayer, and he always messes everything up! How could I not be nervous?!

Everyone: [*laughs*]

Interviewer: The people watching it have a lot of fun, though! [*laughs*]

Fujioka: Our live playthroughs tend to be very laid-back. After all, I think it's important to show that the developers and presenters are actually enjoying the game. But when we're presenting the game, the priority is showing a specific feature, so I'm sure Tokuda felt nervous.

Tokuda: Right. I'm glad I succeeded, and I even received a comment saying that it must be a good game since middle-aged men like Mr. Tsujimoto were enjoying themselves so much. [*laughs*]

Interviewer: Mr. Tsujimoto messes around in multiplayer because he knows it creates a positive image of the game, right?

Fujioka/Tokuda: No way.

Tsujimoto: That's right.

Everyone: [*laughs*]

Fujioka: He basically wants to touch everything in front of him. [*laughs*]

Tsujimoto: I get the urge to show more.

Tokuda: When that happens, I'll say something like, "Eh, please wait a minute," and my head will be spinning

around in confusion. [*laughs*]

Fujioka: Come to think of it, one thing I remember is…Tokuda wasn't the one playing, but there was a time when we needed to present the game to the CEO and the sales department. But Tsujimoto butted in and destroyed everything… We needed to show something good to the CEO, but it ended up being the worst presentation. [*laughs*]

Tokuda: We were in the busiest time of our development, and Mr. Tsujimoto said, "We don't want the developers to take on the whole burden, so the producers will take care of it for you." I was like, "Thank you very much."

Fujioka: Sounds cool, right?

Tokuda: But then that ended in utter failure, and Mr. Tsujimoto said, "You take care of everything next time." [*laughs*]

Tsujimoto: It was awful, wasn't it? I'm glad we got some laughs out of it when I said, "You never know what will happen in *MHW*. We'll have better players next time too," when I ended the presentation.

Everyone: [*laughs*]

Interviewer: And that game has now achieved the ten million mark, so that's amazing.

Fujioka: I'm very, very grateful for it.

Tokuda: Mr. Tsujimoto would call or text me every time we reached a certain goal, which made me really happy. I could tell that the producer was happy to see the game clearing one hurdle after another.

Tsujimoto: Of course. Honestly speaking, hardly anyone in the company believed that it would sell this well.

Fujioka: I don't think anyone imagined that it would sell this well as a stand-alone game. After all, it's not a sequel or anything.

Simultaneous Worldwide Release and Response

Interviewer: How did you feel on the day *MHW* was released?

Tokuda: To be honest, I was so busy that I don't remember. [*laughs*]

Tsujimoto: Tokuda and I were attending a game launch event in Shibuya, but Fujioka was in the United States.

Fujioka: Yes. [*laughs*] It was simultaneously released worldwide, so I was at an event in the United States. I signed autographs for the players who came to buy the game, but I managed to join in on the event in Japan too because they connected me using FaceTime.

Interviewer: How was the reaction in the U.S.?

Fujioka: I had imagined that stereotypical hard-core gamers would be there, but I turned out to be wrong. Casual gamers were there to buy the game too, and the staff at the shop told me that was quite rare. For example, apparently this wasn't the type of game women would usually buy. I was happy to get the chance to meet the American players.

Tsujimoto: We went straight to Taiwan after the event in Shibuya.

Tokuda: Right. We had a game launch even there too.

Interviewer: A simultaneous worldwide release is impressive.

Tsujimoto: Now that I think of it, it was very hard work to make adjustments for everything. There's not only the release date, but also what information we disclosed. It all needed to be the same. This country is whatever o'clock and that country is whatever o'clock right now and whatnot…so I was always thinking about the time difference.

Fujioka: In some ways, Japan ended up getting the short end of the stick because they'd get new information early in the morning or really late at night.

Tsujimoto: We can't do anything about that because that's just the order we have to announce things. [*laughs*]

Fujioka: But the hard work paid off, and everyone in the world received the same information, so I think it helped boost everyone's interest. More people are playing now, so you can easily match up with other players online. If you shoot up an SOS flare, an overseas player will come to your rescue. Quite a lot of overseas players will join you if you send up an SOS flare while playing a Universal Studios Japan collaboration quest.

Tokuda: I shot up an SOS flare once and played together with players from overseas, and they kept thanking me. I played together with a player from Korea and China and joined them for a few quests until they managed to craft new equipment. The Chinese player sent a message thanking me, but the Korean player was taking their time, so I was wondering what they were doing until I received a message in the Roman alphabet saying "Arigato gojaimasu" at the end. [*laughs*]

Interviewer: That's so nice.

Fujioka: *MHW* is actually the first game that lets you communicate with overseas players like this. I experienced connecting with people of different races, so this was a very good experience for us.

Tokuda: What I found interesting when I was reading through the *MHW* communities overseas was how they were reacting to the two Kirins quest that unlocks your hunter rank.

Fujioka: Everyone was screaming.

Tokuda: Some overseas players who had played the series before complained that *MHW* was too easy compared to past games, but others would say, "That's because you still haven't done the quest against two Kirins, right? Try that out first." [*laughs*]

Fujioka: Every time someone got stuck in that quest they'd say, "Welcome to *MHW*!" [*laughs*]

Tokuda: I was so glad they understood the game.

Interviewer: Reactions from overseas players like that can be refreshing.

Tokuda: Players who hadn't played the series before had a hard time beating the two Kirins quest.

Fujioka: Some players who had managed to smoothly beat the quests until that point weren't used to working together or considering elemental weaknesses, so they needed to keep using Lifepowder to stay alive.

Tokuda: We designed it so that you have to build up

your skills and make full use of specialized tools and Lifepowders. Our aim was for people who overcame that hardship to learn to care for the other people they were playing with. But we think we pushed it a bit too far, so we talked with the development staff who'd created Kirin. We said that everyone seemed to be having trouble, so let's try and help out on ten quests a day, and then we'd hop in whenever an overseas player shot up an SOS flare to help those players out during the night. [*laughs*]

Interviewer: That's another way for them to learn about cooperative multiplayer. [*laughs*]

Fujioka: I'm sure more people will realize how we want everyone to play this game if we keep going online like Tokuda to play with them for even a short while.

Tokuda: Of course, we're the ones setting the standard, but we wanted people to realize how the game should be played, and I was interested in finding out how everyone was playing this game. I especially wanted to know where the overseas players got stuck and where and how they'd clear that bar. There was a possibility that we would have to deal with the situation with an update, so I'd pay attention to those details while playing the game with them.

Interviewer: And that was how you got a feel that the game was gradually gaining popularity overseas?

Fujioka: We noticed that happening a lot overseas this time. For example, when our staff was working overseas, a local person told them, "I've been playing *MHW*." This was something we hadn't experienced often before. In Japan, we frequently heard from people inside and outside the gaming industry that they were fans of this series. But we'd only hear things like that from gamers in the industry overseas. So hearing "We're fans of the game" and "I've been playing the game" from people who weren't necessarily from the gaming industry gave us a better feel that the series was gaining worldwide acceptance. The social phenomenon that happened in Japan was gradually starting to happen overseas too.

Tsujimoto: Oh, that happened to me in San Francisco the other day. I was out walking, and someone said, "I've been playing *MHW*." I couldn't help saying "Ooh!" when I heard that.

Fujioka: You were just walking by? [*laughs*]

Tsujimoto: Right. The person came walking up to me all of a sudden, so I was caught by surprise. [*laughs*]

Fujioka: The event in Singapore I participated in with Tokuda was like that too. People from the Philippines, Indonesia, Malaysia, and other Southeast Asian countries told me that they were fans of the series. It really made me realize how much the fan base of the game had expanded.

Tokuda: A female reviewer who had played *MH* for the first time said something really great to me when I visited the United States this May. She said, "I had heard of the title before, but I had never played it. It was such an exciting experience. I never knew it was such a great game." She spent forty-five minutes trying to defeat Pink Rathian while running around the Coral Highlands and was really moved when she finally managed to defeat it. "The excitement of managing

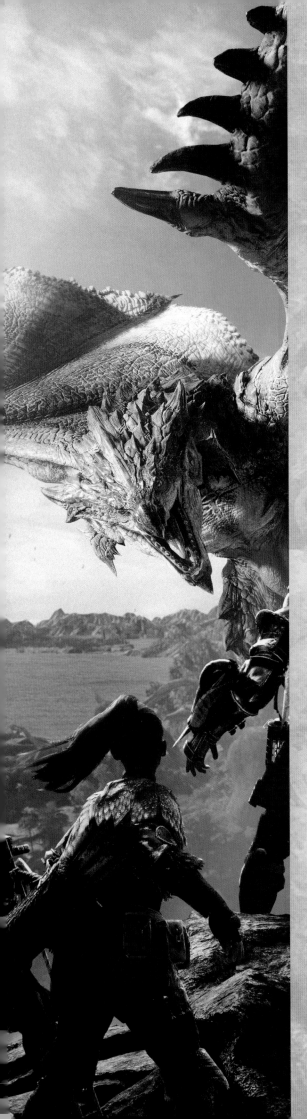

to beat the monster after using everything I could and running out of provisions was an experience I had never had before in other games," she said passionately. That was when I felt that we had been able to present an electrifying game that truly let you experience the ecosystem of *MH* for anyone playing the game for the first time. That was the feeling I had felt when I played the first *MH*, and I wanted everyone to experience that too. That was the moment I understood the increase in worldwide popularity.

Interviewer: When did you feel the increase in popularity overseas, Mr. Tsujimoto?

Tsujimoto: We held a championship overseas this time as well. And at the very end, we hosted an exhibition match at the Tokyo Game Show. Watching players from numerous countries communicating with each other gave me a satisfying feeling that our efforts to gain a worldwide audience had paid off.

Fujioka: On top of that, the players who participated in the championship apparently held a little party to celebrate afterwards. The players who could speak both Japanese and English took on the role of interpreters. I checked the streaming sites later on, and the streamers had invited those players as guests to play the game together. I really liked how those players had become somewhat like celebrities when they went back to their countries.

Tokuda: Some streams by Japanese players have English subtitles on them, and that also shows how worldwide it has become.

Tsujimoto: Right. I think *MHW* has become the most streamed game in the series both inside and outside of Japan.

Fujioka: I enjoy watching the streams of people hitting a wall but then taking on the challenge again after thinking about what they could improve.

Interviewer: How about the reaction in Japan? I'm sure you've received a lot of response to the game from players in the past year.

Fujioka: We've been updating the game regularly, so that seemed to excite the Japanese players a lot. Like, "The Behemoth is too strong—what are we supposed to do?" [*laughs*]

Tsujimoto: A lot of people in Japan told me it had been a while since they'd actually sat down to play a game on a home console. That was really great to hear. I think there are more opportunities to play AAA games compared to the old days. The collaboration with Square Enix was really special. You hear in-game jargon that people who had been playing *MH* have never heard before, and people have told me that taking on specific roles to play the game is fun too.

A Serious Collaboration with *Final Fantasy XIV*

Interviewer: Now that you've brought it up, I'd like to talk about this. It wasn't included in this book since it was a collaboration quest, but the collaboration with Square Enix to add Behemoth to *Monster Hunter: World* must have been a huge surprise to many people.

Fujioka: The collaboration with *Final Fantasy XIV* (*FFXIV* for short) was… I've never seen a collaboration between games that was as serious as this before. Basically, they picked a fight with us and we accepted! Everyone: [*laughs*]

Tokuda: They approached us saying, "You know, there are too many easy collaborations between games these days." Producer Naoki Yoshida of Square Enix said, "Let's have a serious collaboration with the pride of our video games and players at stake!"

Fujioka: Mr. Yoshida is a man of strong commitment, so we told him that we'd give it everything we had. As a result, although it isn't our monster, the Behemoth seems to have left a very strong impression on *MHW* players.

Tokuda: Our developers were already interested in seeing what kind of chemistry it would create if we used ideas from *FFXIV* or other massively multiplayer online role-playing games. Their collaboration proposal was just what we'd been waiting for. Our imaginations exploded, and it didn't take long for us to decide what we wanted to do. [*laughs*] Many of the developers on our team were *FFXIV* fans, so they were very passionate, saying, "We need to push it this far!" There wasn't any talk of "Aren't we overdoing it?" at all. [*laughs*]

Fujioka: No, there wasn't. As a matter of fact, I think it was more like, "Can't we push it a little more?" Behemoth was a monster whose battle structure was not like any of the monsters we had, so the first thing we asked the developers to do was to think about which of the already-existing monster data we could reuse for it. Since we were the ones who'd decided to have this collaboration, we showed some consideration and asked them, "Maybe we could base it on Nergigante's structure?" But after taking a look at the data and 3-D model Square Enix sent us, we came to the conclusion that it would be better and quicker if we just developed the monster from scratch rather than reusing any of our data. [*laughs*]

Tsujimoto: This was the first time we'd collaborated with another game to introduce a monster. So I was ready to face any hardship as the producer…but this was something I had promised Mr. Yoshida eight years ago, so I wanted the development team to go all out with it.

Fujioka: The characters in *FFXIV* use all kinds of magic spells. We thought it would be interesting if the buff-looking Behemoth would use incredible spells. We managed to use Behemoth to do things we wouldn't have been able to do in our usual *MH* style of game design. Our Behemoth suddenly creates tornadoes and drops lightning on you. [*laughs*] So we were free to do anything.

Interviewer: You had been freed from the mold of *MH*?

Tokuda: That's right. We included the Ecliptic Meteor feature from *FFXIV* too. We thought we had to do it since it was a collaboration, after all. [*laughs*] Behemoth turned out to be a great monster to combine *FFXIV*'s style of limiting the player's actions along with *MH*'s style of action. This was truly a godsend for us. [*laughs*]

Adding New Content While Checking on the Players

Interviewer: How did you decide on the schedule for the downloadable content (DLC)?

Tokuda: We had already decided to add Deviljho, Kulve Taroth, and Lunastra when we were working on the original monsters.

Fujioka: We had also decided on doing Behemoth too, but we couldn't decide on a specific date for that since we needed to talk with Square Enix about scheduling.

Tsujimoto: There were many features that weren't even planned back then too. The Arch-Tempered Monsters are one of them.

Fujioka: The Arch-Tempered Monsters were something we decided on to reexcite the players. We had planned to add seasonal events for spring, summer, autumn, and winter, but we wanted something to excite the players in between those. We had a rough estimate of player progression after the game was released…but it was a lot faster than we expected.

Tokuda: Yes, they were fast. It would have been better if we had added Deviljho, the first large update, earlier, but we couldn't do that due to problems with our development schedule, so we decided to add Arch-Tempered Deviljho first.

Interviewer: I never knew that.

Tokuda: Our original plan was to add Deviljho and Arch-Tempered Deviljho a little after that, but judging from how quickly the players were beating the game, an ordinary Deviljho wasn't enough to catch their interest—especially the endgame players. That's why we immediately added Arch-Tempered Deviljho as a surprise. That was something we decided by ourselves.

Tsujimoto: I decided over the phone with Tokuda two days before its release. [*laughs*] That's why it wasn't on the schedule. It was an arbitrary decision by us. [*laughs*]

Everyone: [*laughs*]

Tokuda: We kept checking the player's responses and progression to determine the schedule for the updates and additional quests. By the way, the most hunted monster in the past year has been the Great Jagras. Over a hundred million of them have been hunted all over the world, so in order for it get revenge on the players, we introduced an unbelievably strong and rewarding Great Jagras to celebrate the first anniversary. [*laughs*] We actually used Great Jagras's data for reference when we created Kulve Taroth, but for this Great Jagras, we reimported Kulve Taroth's movements to it and even added a new move.

Fujioka: It's an incredibly strong and vengeful Great Jagras, created by keeping track of the players' shared progress.

Everyone: [*laughs*]

The Joy of Worldwide Acceptance

Interviewer: What kind of game did *MHW* turn out to be for you?

Tokuda: I've always loved *MH* and joined Capcom because the concept of the game intrigued me, but I've always believed that *MH* was a game that had potential to be recognized by the whole world. I was honored

to be the director of this game and sometimes caused trouble for my development team, but I've never lost sight of that goal. As a result, we managed to create something everyone loves. In that sense, this turned out to be the most memorable game that I've ever worked on. I believe we were able to create something that delivers the excitement I felt when I played the original *MH* for the first time.

Fujioka: As someone working in the gaming industry, I've always wanted to experience what it was like working on a so-called AAA game. This was a great experience for me. I was able to work with high-end technology and get firsthand experience of just how much effort goes into development. There are other titles like this at Capcom, and I had always heard it was tough, but hearing about it and actually doing it were totally different. I worked on this game believing that it would be a learning experience for the staff and that it would solidify Capcom's foundation even more. I think we've succeeded in doing that by presenting the players with intriguing information during the regular global events and creating a timeline to follow until the game was released. I needed to work on the sales strategy too, so I knew it would be tough, but now that I've done it, I'm glad that I was able to go through with it to the very end.

Tsujimoto: Right. Introducing *MHW* to a worldwide audience was a major goal of this game, and the code name we gave it during development was even "World," but like Fujioka said, this game boosted everyone's confidence. And I'm not only talking about the development—I mean the advertisement and sales as well. All of that gave us confidence, so it became a very important game for us. Also, having worked on its localization, we now have a better idea of what we must do to stand on the worldwide stage when developing a game. We managed to clear the tough task of a simultaneous worldwide release, which led to people really commending us. I'm satisfied with the results it has managed to produce. Personally…it was such an enormous project…so it was a heck of a lot of work.

Everyone: [*laughs*]

Interviewer: What did you think is the most difficult part of sharing news with a worldwide audience?

Tsujimoto: First, you need to have a good grasp on where you'll be sharing the information. It took lot of hard work to decide which information to share as well as when and in which order. We made delicate adjustments to what to tell the fans depending on the event too. For example, we'd announce the collaboration quests at a fan event, and so forth.

Fujioka: We also needed to think about what kind of news the fans of a specific country would enjoy.

Interviewer: So you changed the contents of what you showed the players depending on the country?

Fujioka: Not the contents, but how we presented it. I had the impression that the United States had a lot of action gamers, so I introduced the game in such a way that they would get a good idea of the game design. On the other hand, in Europe, the fans put more emphasis on the setting and world design, so I added more of those details for them. Many of the Japanese fans are interested in the features of the game, so I'd

focus the presentation on how many things there were to do in the game–things like that. I thought the video game news media of each of those regions would have a hard time keeping track of the information we disclosed unless we controlled what we presented to them.

To the Fans Who Bought This Book

Interviewer: May I have a word or two for the fans who picked up this book?

Fujioka: First, thank you very much for purchasing this book. I truly believe that *MHW* is about the details. We focused on the smallest details, from single pebbles to bugs, and carefully designed them and placed them into the world. And each of those small details interacts with one another. These details pile up on each other, adding depth to the game…and help you get absorbed into the gameplay. That's why this book is so thick. The thickness of this book is a result of the hard work all the developers put into the game, so please don't hesitate to read every corner of every page. This book will be published worldwide too, so I hope the overseas fans will enjoy this. I always felt jealous whenever I saw a localized book from another country being sold at a store in Japan. We wanted to publish a book like this too! So, this book is packed with our feelings. [*laughs*]

Tokuda: The fields in *MHW* include features that are a lot more fantasy-like than the previous games. We added a realistic ecosystem to balance that, so I'm sure you will gain a better understanding of how we created this game by reading this book. Also, I believe that an ecosystem is not complete without creatures that feel alive, so I hope you will go back to check on the rare activities of a monster, such as when Anjanath sunbathes, after reading this. And it's not only the monsters–this book has information on the geology and endemic life, which can be hard to notice in the game. You will probably be able to enjoy the game from a different perspective after reading this book.

Tsujimoto: I think the biggest difference from previous games is the improvement in presentation. You will probably be surprised to see the effort we put into the smallest details. That includes the weapons and armor too, so why don't you go back to the game to check if the things you read in this book are really present in the game. I think it'll be fun to say, "What? The development team even paid attention to small details like this?"

Interviewer: Lastly, I would like Mr. Tsujimoto to end this interview by talking about the future of the Monster Hunter series.

Tsujimoto: I think we have been able to appeal to players all over the world by aiming the game toward a worldwide audience. Players being connected online beyond their borders was a new step for the *MH* series. This series will continue on, but what kind of *MH* will we present to you next? Obviously, we will be creating the game for the players and others, so I hope you will look forward to the future of *Monster Hunter*!

MONSTER HUNTER: WORLD

STAFF CREDITS

Planning, Editing, Organization & Writing
Kazuya Sakai (ambit Co., Ltd.)
Taketsugu Ishida

Organization & Writing
Yukari Tasai (Chapter 3)
Masafumi Fujiwara (Chapter 5)

Writing Assistance
Yu Oshima (Chapter 2)

Interview Photography
Takaaki Moriya

Editorial Assistance
Hiroyasu Hongo
Junko Miura

Proofreader
Daisaku Sato

Text Design
YUNEXT Co., Ltd.
Hiroshi Tamura
Yumiko Sasaki
Akiko Takemoto

Cover Design
Freeway Co., Ltd.

Art Director
Hiroshi Tamura (YUNEXT Co., Ltd.)

DTP
Witch Project Co., Ltd.

Printing & Bookbinding
Toppan Printing Co., Ltd.

Supervision & Cooperation CAPCOM Co., Ltd.

Producer Ryozo Tsujimoto

Director Kaname Fujioka Yuya Tokuda

Yugo Togawa Shino Okamura
Sachio Kuno Reiko Sakata
Naoki Kanetomo Shuhei Kurose
Shinya Edagi Hiromi Sasayama
Shinichi Shiohara Yasuyuki Takagi
Sayaka Kembe Hiroko Tsukagoshi
Kojiro Ogiwara Suzuka Kameshima
Luo Weibiao Ayumu Nishino
Masahiro Ota Noriyuki Nagata
Yuto Okutomi Jin Seokmin
Kana Mishima Koji Osugi
Kenichi Miyahara Takumi Okadaue
Emi Kawase Sachiko Fukuda
Tokio Noda Saori Watanabe
Sayaka Seno

Masahide Akitake Yoshitaka Kiyono
Noriomi Ito

Special Thanks to
Monster Hunter: World Development Team

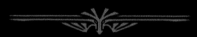

Monster Hunter: World
The Official Complete Works
VIZ Media Edition
English Staff

Translation: Tetsu Miyaki, Kumar Sivasubramanian,
Gregory Werner, & Joe Yamazaki

Designer: Kam Li

Editor: David Brothers

Printed in China

Published by VIZ Media, LLC
P.O. Box 77010
San Francisco, CA 94107

10 9 8 7 6 5 4 3 2 1
First printing, August 2020

DIVE TO MONSTER HUNTER: WORLD was published by Ambit Co., Ltd.
First edition: January 2019.

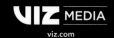

viz.com